# Arts of the South Seas

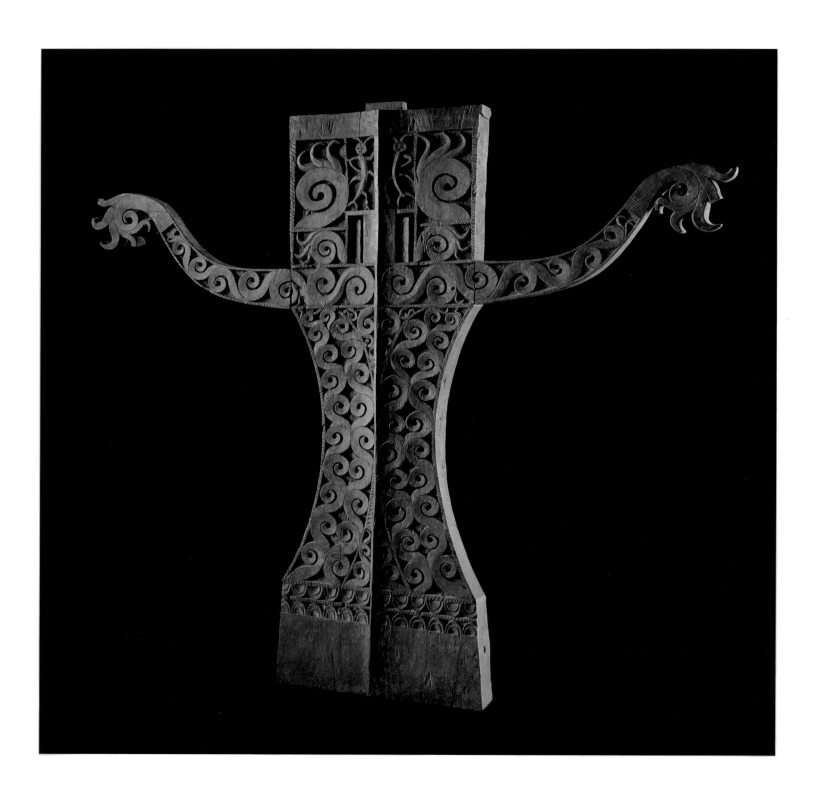

# Arts of the South Seas

## Island Southeast Asia, Melanesia, Polynesia, Micronesia

The Collections of the
Musée Barbier-Mueller

Edited by Douglas Newton

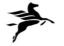

Prestel Munich · London · New York

# Contents

© Copyright 1999 Prestel Verlag
Munich · London · New York

Front cover: Large mask. Cane frame, strips
of coconut fiber. Nose stick and eye in wood.
Witu Islands. (See fig. 11, p. 211.)
Photo: Pierre-Alain Ferrazzini.
Back cover: Statuette. Hardwood. Carved
without the aid of metal tools, it represents a
divinity. Nukuoro Atoll, Caroline Islands. (See
fig. 6, p. 359) Photo: Pierre-Alain Ferrazzini.
Frontispiece: Domestic altar (tavu) in hard-
wood evoking the founding ancestor of a
noble "house". Selaru, Tanimbar Islands,
Southern Moluccas. Height: 130 cm.
Photo: Pierre-Alain Ferrazzini.

Photos of objects are by Pierre-Alain
Ferrazzini, with the exception of the following
pages where the objects were photographed
by Wolfgang Pulver, Munich: 18, 19 (no.3),
20 (no. 4), 35, 37 (no.2), 42 (no. 5), 46, 47,
(no. 14), 49 (no. 20), 53 (no. 3), 54 (no. 5), 57,
58, 61, 66, 71, 73 (no. 4), 75 (no. 8), 76 (no. 11),
85 (no. 28), 92, 95 (no. 9), 99, 103, 123 (no. 16),
129, 133, 134, 135, 151 (no. 11), 167, 173, 175
(no. 5), 181, 185, 189 (no. 1, 2), 196 (no. 11),
197 (no. 14), 199, 204 (no. 26, 27), 208 (no. 5, 7),
213 (no. 15), 215, 216, 219, 220, 221, 223, 227,
228, 230 (no. 9), 241, 263, 286 (no. 2, 3), 288
(no. 5), 291 (no. 10, 11), 292 (no. 13, 15), 296
(no. 20), 299, 301, 302 (no. 5), 304 (no. 11),
307 (no. 2), 308 (no. 4, 5), 310, 313 (no. 12, 13),
315 (no. 4), 316, 318, 325 (no. 3, 4), 329, 337,
338 (no. 12a), 339, 340 (no. 14, 16 a and b),
341 (no. 18), 345 (no. 5), 348 (no. 1), 349
(no. 4), 350, 351, 354 (no. 12), 357, (no. 2), 360.

Library of Congress Cataloging-in-Publication
is available for this title.

Prestel-Verlag
Mandlstraße 26
D-80802 Munich
Germany
Tel.: (89) 38-17-09-0
Fax: (89) 38-17-09-35

4 Bloomsbury Place
London
WC1A 2QA
Tel.: (171) 323 5004
Fax: (1710 636 8004

16 West 22 Street
New York
NY 10010
Tel.: (212) 627-8199
Fax: (212) 627 9866

Prestel books are available worldwide. Please
contact your nearest bookseller or any of the
above addresses for information concerning
your local distributor.

Translation from the French by
David Radzinowicz Howell

Copy-edited by Bernard Wooding

Designed and typeset by WIGEL@xtras.de
Cartography by Annelie Nau, Munich
Color separations by ReproLine, Munich
Printed and bound by Passavia Druckservice
GmbH, Passau

Printed in Germany

ISBN: 3-7913-2092-0

# Foreword

Jean Paul Barbier

This book is the logical outcome of the notes I collected and published in 1977 under the title *Indonésie et Mélanésie*. It is also something in the way of an acknowledgment of failure.

Though the art of the Maori and the Marquesas Islands has been the subject of numerous monographs, the abundant cult and magical artifacts from Borneo, Sulawesi, and the Batak of Sumatra remain by and large neglected. In the last few decades, however, archaeologists and historians of civilization have started to stress the cultural links between the Indonesian and Philippine islands with Oceania, both territories of vast extent settled by Austronesians (defined as peoples speaking Malayo-Polynesian languages).

The reader will see for himself the close "family resemblance" between works created in places thousands of kilometers apart and at widely differing dates. These parallels remain difficult to account for since any hypothesis presupposing widespread contact between such far-flung peoples is to be discounted. It seems rather that Austronesians shared a peculiar sensitivity, a taste for specific types of form and motif that authors such as Carl Schmitz believed quite distinct from those of non-Austronesians, such as the Papuans of New Guinea.

Be that as it may, the dream of men as Schmitz and his predecessor in this area, Felix Speiser, of drawing up a classification of the styles of the entire South Seas from the Philippines and Indonesia through to outer Polynesia seems, in our more pragmatic times, to have lost its urgency. This book resists any temptation of this nature: I did not suggest such an undertaking to the editor and he never proposed anything of the kind to

me. In fact, Douglas Newton has chosen instead to present works (many of which have never been published before) which are aesthetically pleasing to Western eyes and "tell the story" of the culture in which they were born in the most persuasive manner possible.

I have the suspicion that Douglas Newton might have liked to add a chapter or two to a work whose structure he had pondered for so long: considerations of size, however, preclude such additions. His original intention remains nonetheless intact: to present the islands of the Philippines and Indonesia on an equal footing with those of Melanesia, and more abundantly than those of Micronesia and Polynesia, since, apart from the more established national museums, these latter regions are rarely represented by important artifacts in public or private collections.

Finally, the reader will find relatively few reproductions of shields in the following pages, since a book devoted to shields from tribal societies from all over the world is to appear in English subsequently to this volume.

May I take the opportunity of warmly thanking not only Douglas Newton himself, but also all those who answered his request for material: Professor P. Bellwood, Dr. A d'Alleva, Dr. H. Beran, Dr. R. Boulay, Dr. F. Clunie, Dr. G. Corbin, Dr. P. Dark, Dr. J. B. Duarte, Dr. G. Ellis, Dr. G. L. Forth, Dr. T. Gavin, Dr. A. Hanson, Dr. D. Hicks, Dr. J. Hoskins, Dr. K. Huffman, Dr. C. Ivory, Dr. A. Kaeppler, Dr. S. Kossak, Dr. L. Lincoln, Dr. A. Molnar, Dr. D. Moore, Dr. H. Nooy-Palm, Dr. C. Orliac, Dr. M. Orliac, Dr. P. Peltier, Dr. D. Rubenstein, Dr. D. Smidt, Dr. A Viaro, Dr. A.-M. Viot, Dr. D. Waite, and Dr. A. Ziegler.

I should also like to thank Laurence Mattet, general secretary of the Musée Barbier-Mueller, for undertaking what was a lengthy process of coordination; the various institutions who graciously gave permission for reproducing photographic documents; and of course those museums exhibiting a selection of the material reproduced in this volume, particularly Alain Nicolas, Head Curator of the Musée des Arts Africains, Océaniens, Amérindiens at Marseille, his colleague Marianne Sourrieu, and of course Corinne Diserens, Director of the Marseille Museums. In advance, I should like to convey further thanks to Christophe Vitali, Director of the Haus der Kunst in Munich, with which we have gladly collaborated over many years and which will stage this exhibition in 1999.

Finally, I am delighted to be able to thank Jürgen Tesch and Peter Stepan at Prestel, Munich, and Adam Biro and Marlyne Kherlakian at Éditions Adam Biro in Paris who made the realization of this ambitious project possible.

# The Austronesian Dispersal

Peter Bellwood

As the most widespread ethnolinguistic population in the world prior to the European colonizations of the last few centuries, the Austronesians settled more than half of the earth's circumference in tropical latitudes, only escaping into cooler climates to reach New Zealand and Easter Island. Today they number about 270 million people and speak more than 1,000 different, although related, languages. Their dispersal, a process which occurred mainly between 5,000 and 1,000 years ago, took them ultimately from a homeland in the region of southern China and Taiwan to places as far away as Madagascar, Hawai`i, and Easter Island (fig. 1).

Research on the prehistory of the Austronesians has now become a multidisciplinary industry involving the work of many scholars, not just linguists and archaeologists but also social anthropologists, geneticists, paleoanthropologists, palynologists, and environmental scientists of many kinds.[1] From the outset, it is essential to remember that the Austronesians are defined as such because they all speak Austronesian languages. This circumstance alone is a guarantee of a high degree of shared ancestry and history, but it is easy to observe that Austronesians today are not a unified population in terms of biological affinity — the speakers of Austronesian languages share a wide range of Asian and Australo-Melanesian phenotypes — and neither are they a single "type" in terms of society or culture. Essentially, we must be aware that Austronesian languages, cultures, and biological gene pools have not evolved locked together as a single entity through prehistoric times, but have rather blended together or drifted apart from time to time according to historical circumstances.

The languages of the Austronesian family, and the cultures to which they belong, share to varying degrees an ultimate common ancestry located on the Asian mainland at least 6,000 years ago. This can be seen not only through the languages, but also (admittedly to a hazier extent) through comparative archaeological, anthropological, and art-historical observations. Over the past 6,000 years, the Austronesians have undertaken an immense amount of colonization, leading to cultural divergence and adaptation to new, strange, and often highly challenging environments. Their colonizations also brought them into varying degrees of contact with the pre-Austronesian populations of insular Southeast Asia and Melanesia — people whose ancestors had settled these islands more than 35,000 years ago and who, in the case of parts of New Guinea, had already developed systems of agriculture independently of the Austronesians. In the case of Indonesia and the Philippines, it appears that the pre-Austronesian populations were still hunter-gatherers, and in these areas the dominance of Austronesian languages and cultures today is much stronger than is the case in New Guinea. It is not possible to examine these issues of interaction in depth here, but assimilation of, and interaction with, preexisting peoples have clearly been of significance in regions as far east as the Solomons, beyond which no pre-Austronesian populations ever managed to penetrate. The extent of Pleistocene, pre-Austronesian, colonization in insular Southeast and the western Pacific is shown in fig. 2.[2]

Our knowledge of Austronesian prehistory is clearly based in the first instance on the linguistic rather than the biological or archaeological evidence. The Austronesian languages form a coherent group — only a few rare examples resist classification. They are characterized by a great deal of shared core vocabulary and many other aspects of grammar and phonology.[3] In order to study the prehistories of unwritten languages, linguists favor a process of comparison involving the identification and geographical plotting of cognate items in living or recently recorded languages (cognates are features shared by languages as a result of common origin rather than borrowing). They are then able to identify genetic subgroups of languages by plotting the distribution of uniquely shared and innovated cognates. These language subgroups can be ordered hierarchically, as in the case of the most widely accepted classification of the high-order Austronesian subgroups, that by Robert Blust (fig. 3).[4]

Blust's classification is here considered the most acceptable in terms of its rigor, despite the existence of some disagreement over the precise position of the Formosan languages in the Austronesian family tree.[5] The classification implies a southern Chinese (Fujian coast?) origin for the pre-Austronesian roots of the family (perhaps related at this distant remove to the contemporary roots of the Thai and Austroasiatic language families), followed by a colonization of Taiwan (the linguistic homeland of Proto-Austronesian), and then a dispersal southward through the Philippines into northern Indonesia. From here (the general region of northern Borneo, Sulawesi, and the Moluccas), later population dispersals proceeded westward to the Malay Peninsula, southern Vietnam and Madagascar, and eastward to Irian Jaya and Oceania.

This population dispersal, involving thousands of communities across a period of about

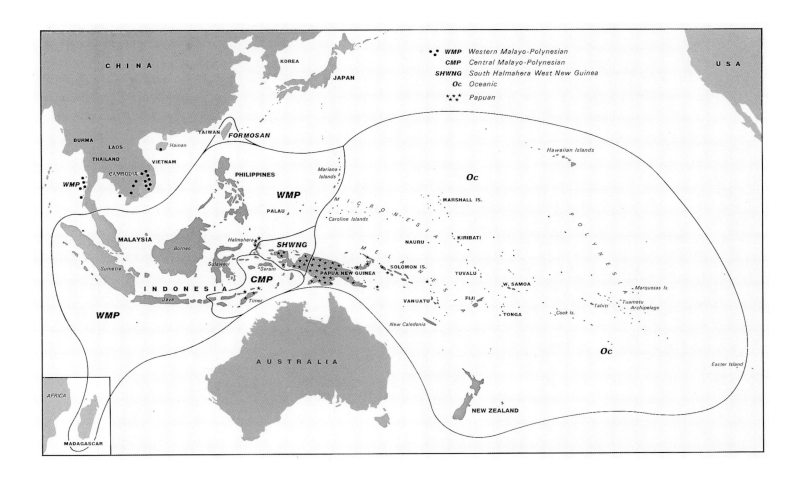

5,000 years, from about 4000 B.C. to A.D. 1000, was a phenomenon of great complexity, some details of which will continue to give rise to scholarly disputes. For instance, was Taiwan really the first place off the Chinese mainland to be colonized by Austronesians? Did the colonization of Oceania commence from the Moluccas or the Philippines? And how important was contact between eastern Polynesia and South America? Such quibbles often cause great excitement among specialists, but they do not affect greatly our overall view of the Austronesian colonization process. Many fine details may have been lost or masked due to the erosive actions of

time, but enough can be recovered to make an attempt at understanding the process of Austronesian colonization worthwhile for our understanding of human prehistory as a whole. By all indications it was a very remarkable story.

The seeds of Austronesian expansion were sown at least 3,000 years before the Austronesians themselves began to emerge as an ethnolinguistically distinct people via their migrations to and beyond Taiwan. Technically speaking, Austronesians have only existed in an ethnolinguistic sense since the period of Proto-Austronesian, located

presumably in or close to Taiwan about 4,500 years ago. Earlier populations are, by definition, pre-Austronesian.

Between 10,000 and 8,000 years ago, as the temperate and tropical regions of the earth became warmer and wetter after the retreat of the Pleistocene glaciers, small groups of people located in the Levant, the New Guinea Highlands, and the region between the Yellow and Yangtze Rivers in China began to cultivate and domesticate plants for the first time. The exact reasons for these developments, which also occurred independently in Mesoamerica and the Andes, are only just

2 Current absolute radiocarbon, thermoluminescence, and optical luminescence dates for human occupation in Wallacea, Sahul, and western Melanesia (includes dates published to late 1996).

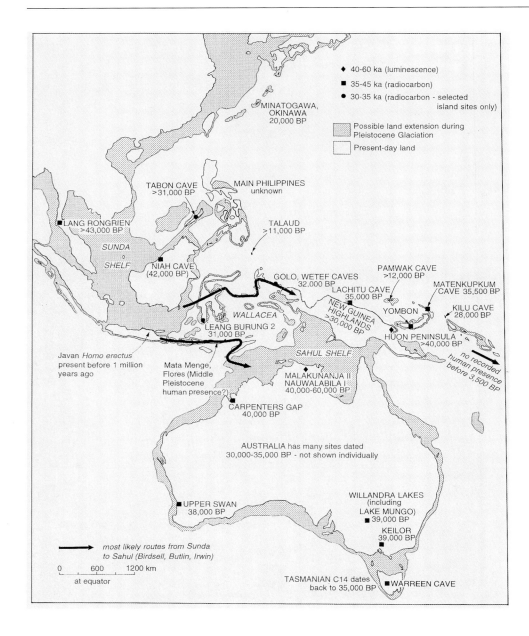

to develop. For reasons which are still not completely understood, some of these in turn switched rapidly from hunting and gathering to agricultural forms of subsistence before 8,000 years ago. Animal domestication, the inventions of pottery, carpentry, and woodworking (essential for making canoes), and substantially increased human populations were the inevitable results in both the Levant and China, although the independent agricultural homeland of New Guinea seems to have followed a less rapid course of overall cultural development.[6]

In both the Levant and China, expansions of human cultural systems became imperative as agricultural economies replaced hunting and gathering, which was a consequence of populations moving into previously unfarmed regions, or of developments in the technology required to feed larger numbers of people, or of a combination of both of these. In a world only lightly populated by hunters and gatherers, those groups who first developed systematic agriculture had a short-lived but unchallengeable edge in the best agricultural environments. Constant outward colonization into neighboring untilled lands was the reaction of many successful groups, although the indigenous hunters often put up strong resistance along the fringes of agricultural viability, as in northern Europe and North America or in the interior rainforests of Southeast Asia.[7]

The early Austronesians were one such group of agriculturists who were offered an opportunity to colonize new lands previously settled only by sparse groups of hunters and gatherers. These colonizations followed developments in maritime technology, presumably in southern China and Taiwan,

beginning to be understood as archaeologists and environmental scientists tease new data from the past. In both the Levant and China, the early Holocene combinations of warmer and seasonally wetter climates and the concomitant radiations of annual grasses

suitable for domestication, such as millets and rice in China and wheat and barley in the Levant, were obviously of great significance. The improved environmental conditions allowed increasingly competitive, dense, and sedentary populations of hunter-gatherers

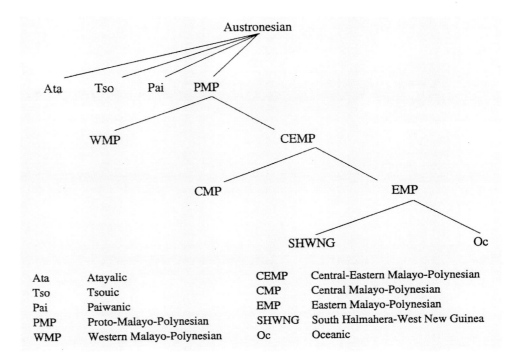

3 Structure of the Austronesian language family, after Robert Blust. There is currently debate about the primary position of Formosan in this scheme and the number of subgroups of Formosan. From Tryon 1995.

| Ata | Atayalic | CEMP | Central-Eastern Malayo-Polynesian |
| --- | --- | --- | --- |
| Tso | Tsouic | CMP | Central Malayo-Polynesian |
| Pai | Paiwanic | EMP | Eastern Malayo-Polynesian |
| PMP | Proto-Malayo-Polynesian | SHWNG | South Halmahera-West New Guinea |
| WMP | Western Malayo-Polynesian | Oc | Oceanic |

which made it possible to cross oceans easily and regularly. However, despite the glamor of ethnographically recorded Oceanic voyaging traditions, maritime skills alone were not the sole cause of Austronesian expansion, at least not in the earlier stages (although the status given to navigators was an increasingly important reason for later voyages of discovery in Remote Oceania). Systematic agriculture was probably of far greater overall significance, since it would have been indispensable for the rapid growth of a healthy population and imperative for colonizing Oceanic islands with limited terrestrial resources.[8] One of the earliest mainstays of the Austronesian economy in Southeast Asia was rice, although this crop was never taken as far as Oceania and many tropical crops such as coconuts, taro, yams, and sago were added to the economic plant roster as Austronesians expanded southward into equatorial regions. Rice was first cultivated about 9,000 years ago in the middle Yangtze region by people who could not be called Austronesians — they lived far too long ago — but who might have been in part ancestral to later populations in southern China, including the earliest Austronesians.

As we have seen, the Austronesian language family did not come into separate recognizable existence until after the period of Proto-Austronesian, a stage probably located in Taiwan, possibly between 6,000 and 5,000 years ago if archaeological correlations are any guide. Concerning these archaeological correlations, it is crucial to note that the reconstructed Proto-Austronesian vocabulary indicates a people growing rice and millet, with domestic pigs and dogs (and perhaps chickens too), canoes, knowledge of tattooing, and the ability to use a bow and arrow.[9] Very soon after the Proto-Austronesian phase, in

the Proto-Malayo-Polynesian phase of fig. 3 (possibly located about 4,500 to 4,000 years ago in the Philippines), they were building substantial timber houses, making pottery, using sails and outriggers on canoes, and looms (probably backstrap) for weaving, and chewing betel. They had also added the tropical tuber and fruit crops listed above to their diet. Indeed, most of these Proto-Malayo-Polynesian additions (except for the tropical crops) probably existed in the climatically more temperate Proto-Austronesian phase in Taiwan as well, but clear linguistic proof of this in the form of pan-Austronesian cognates has not survived and many Taiwan aboriginal languages have now been replaced by Chinese.

In terms of archaeology, there is evidence of agricultural societies in coastal southern China

(southward from Zhejiang through Fujian to Guangdong Province and Hong Kong), and perhaps in northern Vietnam, after about 7,000 years ago. People in these societies lived in sedentary villages, domesticated pigs and chickens, made pottery and polished stone tools, and cultivated rice. Again, it is important to stress that such early East Asian Neolithic cultures cannot be equated with Austronesians *per se,* but it is interesting to note that many artifact types typical of insular Southeast Asian and Oceanic archaeological cultures are very widespread on the Asian mainland as well. These include red-slipped and/or painted and cord-marked styles of pottery, knee-shaped wooden adz handles, untanged or stepped and polished stone adzes, art styles emphasizing the uses of spirals and circles, and bones of potentially

4 Some items of material culture from early Austronesian societies. Items coded NW and NWE are Proto-Austronesian, whereas those coded as WE are better reconstructed as Proto-Malayo-Polynesian only. After Blust, from Bellwood 1997a.

| Class of material culture | Reconstruction code | Terms |
|---|---|---|
| House and contents | NWE | house/family dwelling |
| | WE | ridgepole, rafter, thatch, house-post, storage rack above hearth, notched log ladder, hearth, public building |
| Tools, utensils, weapons | NWE | bow, shoot an arrow, rope/cord |
| | WE | putty/caulking substance, comb, conch shell trumpet, cooking pot, nail, pillow/wooden headrest, digging stick, bamboo trail- or pitfall-spikes, torch, hew/plane |
| Arts and crafts | NWE | needle |
| | NW | loom (early Western Malayo-Polynesian only?) |
| | WE | plait/weave, draw, whet/sharpen, sew |
| Adornment | NW | tattoo |
| Refreshment | NW | drunk (adjective) |
| | WE | lime for betel quid, betel nut |
| Hunting and fishing | NW | hunt, go hunting |
| | WE | bait, bamboo basket trap for fish, kind of fishnet, fishhook, fish drive, dragnet, derris root fish poison, bird lime, snare |
| The canoe | NW | canoe/boat |
| | WE | canoe, canoe paddle, outrigger, rollers for beaching a canoe, sail, canoe bailer, to paddle, rudder/steer, raft, cross-seat in a boat, punting pole. |
| Domesticated animals | NWE | domesticated pig, dog |
| | WE | cock/rooster |
| Garden and field | NWE | rice (E cognates not beyond west New Guinea), pestle, garden/cultivated field, sugarcane |
| | NW | husked rice, mortar, cooked rice, winnow, rice straw, millet |
| | WE | to weed, *Alocasia* sp. (an aroid), breadfruit, ginger, citrus fruit, banana, yam, sago, taro, fallo' land, to plant, melon |
| Food preparation | NWE | to smoke meat or fish |
| | NW | salt |

N (north) = Formosan; W (west) = Western Malayo-Polynesian; E (east) = Eastern Malayo-Polynesian.

domesticated pigs, dogs, and chickens (the wild ancestors of domesticated dogs and chickens are not native to insular Southeast Asia, and neither are wild pigs native to islands east of Sulawesi). An excellent assemblage of this early and potentially ancestral type comes from the site of Hemudu, in the lowland coastal region of Zhejiang Province, which dates from about 7,000 years ago.

In Taiwan, archaeological cultures identified by such features made an appearance at some uncertain time between 4500 and 3000 B.C.,[10] in the earliest instances perhaps without rice cultivation, which could have been introduced to the island a little later but still prior to the linguistic breakup of Proto-Austronesian. However, the carriers of a Neolithic economy to Taiwan and Peng-hu clearly knew how to make boats, a skill

doubtless developed in the many small islands (the most famous today being Hong Kong) which formed as a result of the post-glacial rise in sea level off the coast of southern China. They also made cord-marked and incised pottery and used polished stone adzes, slate spear points, and stone barkcloth beaters. Actual archaeological evidence for rice cultivation is present in Taiwan by 4,500 years ago in the form of grains and husks

embedded in potsherds, and similar evidence for rice is already attested by this time far to the south in the cave of Gua Sireh, located in the equatorial latitude of Sarawak, Borneo.[11]

By about 3000 to 2500 B.C., the Austronesian population which had colonized Taiwan, presumably replacing or incorporating earlier populations of hunters and gatherers, was ready to colonize further. One of the next steps seems to have been a southward and eastward move which incorporated, possibly about 2000–1500 B.C., the Philippines, eastern Indonesia, and northern Borneo. By 1500 B.C., people reached the Mariana Islands of western Micronesia, parts of insular Melanesia (especially the Bismarcks, Solomons, New Caledonia, Vanuatu, and Fiji), and finally, by about 1200 B.C., western Polynesia (Tonga, Samoa, Wallis, and Futuna).[12] This move south and east was undoubtedly one of the most astonishing bouts of colonization ever to occur in early human history and, as we learn more about the regions of western Austronesia which are less well known archaeologically, it may turn out to have been even more extensive than we now realize (dates for initial Austronesian colonization in western regions such as Borneo, Sumatra, and Java are still uncertain, but perhaps likely to fall between 2000 and 1000 B.C.). In a period of under 1,000 years, Austronesians spread themselves from Taiwan, through insular Southeast Asia into Melanesia and central Oceania, over about 7,000 kilometers of land and sea. In order to do this, they had to cross ocean gaps up to 800 kilometers wide and develop systematic strategies for the exploration and colonization of faraway islands, strategies well described recently by Geoffrey Irwin.[13]

In the islands of Southeast Asia, the early Austronesians moved rapidly around coastlines already settled, as in Taiwan, by sparse groups of hunters and gatherers. In New Guinea, however, the indigenous peoples (as noted above) seem to have already developed techniques of yam, taro, sugarcane, and fruit (banana, pandanus) agriculture, at least in the Highlands, and possibly intensive harvesting of sago and other tree products in many lowland regions. For various reasons little understood, but perhaps reflecting both the prior existence of large populations and environmental factors, New Guinea, together with much of the Solomons and Vanuatu, seems to have been relatively avoided by the earliest Austronesian colonizers, although our knowledge of prehistory in many of these regions is still rudimentary and subject to constant revision. Later on, Austronesian descendants filled in some of the available gaps, except in the New Guinea Highlands, where Austronesian settlement never penetrated.

One point to remember is that this amazing phase of coastal dispersal from Taiwan to as far as Samoa took place at least a millennium before the better-known phase of eastern Polynesian colonization during the first millennium A.D. The archaeological traces of this expansion of the mid to late second and early first millennia B.C. are visible in a number of sites, mainly caves and rock shelters, containing red-slipped pottery, shell tools, and polished stone adzes, found through the Philippines, Sabah (northern Borneo), the Talaud Islands, northern Sulawesi, eastern Java, and the northern Moluccas. A site called Andarayan in northern Luzon has yielded rice husks embedded in potsherds dated to about 1500

B.C., and, as noted above, rice had already reached Sarawak before 2000 B.C., although here in association with a type of paddle-impressed pottery quite different from the eastern red-slipped ware and perhaps associated with an early (and probably non-Austronesian) horizon of agricultural settlement from southern Thailand, where similar materials occur in the rice-using site of Khok Phanom Di (2000–1500 B.C.) at the head of the Gulf of Thailand, and in contemporary sites in the Malay Peninsula.[14]

Palynological results from lakes in the highlands of Taiwan, Java, and Sumatra also indicate clearance for agriculture from 2000 B.C. onward, although the exact dates for these activities are not very secure. As noted, the actual dates for Austronesian colonization in the large islands of Borneo, Sumatra, and Java, and also the Malay Peninsula, remain uncertain owing to the sparseness of the archaeological record, but dates in the second or first millennia B.C. seem very likely.[15] One of the problems in these large islands with their powerful erosion regimes is that the oldest coastal Neolithic sites are likely to be buried under huge depths of alluvium, and consequently extremely hard to find and excavate. The Malay Peninsula, which today still has many interior regions populated by Austroasiatic-speaking (Aslian) populations, was probably only first settled, in coastal areas, by Austronesians less than 3,000 years ago. These Austronesians would have found agriculturists, ancestors of some of the modern Aslians, already in occupation since at least 2000 B.C.

Madagascar was probably only reached in the first millennium A.D., evidently by colonists from southern Borneo, perhaps with Malay-

or Javanese-speaking leaders according to recent linguistic analyses.[16] In the other direction, the furthest reaches of eastern Micronesia (Carolines, Marshalls, Kiribati) and eastern Polynesia (Societies, Marquesas, Hawai`i, Easter) were reached between 500 B.C. and A.D. 1000, and perhaps only by A.D. 1200 in the case of New Zealand.[17] This major phase of Polynesian colonization seems to have followed a pause lasting perhaps 500 to 1,000 years after the first colonists reached eastern Melanesia and western Polynesia (Tonga, Samoa, Wallis, and Futuna) about 3,000 years ago.

## Why did the Initial Austronesian Dispersal Occur?

I shall return to the later Austronesian colonizations, but at this stage it is necessary, before continuing the record after 1000 B.C., to move back to the linguistic and archaeological evidence in Southeast Asia to consider just what promoted all this movement and activity into lightly settled, or, in the cases of all the islands of Remote Oceania beyond the Solomons,[18] totally uninhabited regions. Why didn't the Austronesians, like many peoples in history, simply stay at home? The underlying answer, and the perspective it throws on human cultural evolution, might cause surprise. The Austronesians were not particularly unusual in being colonists. Their main claim to fame is that they happened to cross lots of wide expanses of ocean, for the simple reason that their homeland zone was located in a strategic spot close to the Asian end of the greatest series of island chains in the world.

Of course, there are many reasons why individual Austronesian colonies were founded. One important social reason is that the process of colonization itself can increase the status of an individual and his or her descendants. Micronesian and Polynesian legends (such as the famous Maori "fleet" stories) are full of the exploits of founder figures, after whom kin groups were named and whose direct descendants still form aristocratic lineages today. Some small islands might also have become over-populated quite quickly, especially if birth rates were similar to those typical of recent European colonists of fertile, relatively disease-free, and lightly populated landmasses, such as the more heavily colonized parts of Australia and North America (averaging seven children per family in European Australia in the 1840s and 1850s). The *Bounty* mutineers and their Austronesian (Tahitian) wives in Pitcairn recorded similarly spectacular growth rates. Yet overpopulation is clearly not the real reason for Austronesian expansion, and record rates of population growth may indeed be the results rather than the causes of such large-scale population dispersals.

The main underlying reason for the Austronesian diaspora, the sine qua non (albeit not necessarily the main immediate reason for all individual population move-ments), was surely the possession of an efficient agricultural economy combined with reliable access to meat sources, especially in the form of fish. A successful agricultural economy is a way of life transportable to any new and suitable environment. Hunters and gatherers cannot colonize small isolated islands on a continuing basis with easy success; often there is simply insufficient food to support a viable population. The Neolithic inhabitants of southern coastal China, between 5000 and 3000 B.C., by developing both systematic food production and also successful methods of maritime travel, were able to put their tremendous potential for demographic growth to work in new and welcoming environments. Average family sizes of at least four healthy children, who survive long enough to have children in their turn, are easy to imagine given the density of the Neolithic archaeological record in southern China and Taiwan compared to the sparse traces of the preceding Mesolithic (a circumstance paralleled exactly at the same stage in western Asia). Once colonization began, the only process to stop it, apart from geographical or technological barriers, would have been other populations equally em-powered with demographic and cultural muscle.

The early Austronesians, of course, met such populations — the Austroasiatic speakers of the Malay Peninsula, Vietnam, perhaps parts of Borneo, and the Papuan speakers of New Guinea. Such prior populations, when strongly entrenched like the Papuans, delayed the process of colonization and in the case of interior New Guinea made it nonexistent prior to modern Indonesian transmigration. Austronesians have only settled minor pockets of coastline around New Guinea, seemingly only within the past 2,000 years according to both archaeological and linguistic evidence. Indeed, the impressive dominance of the Melanesian phenotype in the western Pacific indicates strongly that some of the Austronesian languages of Melanesia spread via processes of language shift rather than colonization by speakers.[19] In other words, some coastal and island populations, descended genetically from the initial colonists of Melanesia (also migrants from Southeast Asia, but over 35,000 years

ago; fig. 3), abandoned their native languages to adopt the incoming languages of the Austronesians, in many cases at relatively early dates about 3,000 years ago.

Yet it must be remembered that this kind of language shift, while common in some regions, was overall probably rare in the totality of Austronesian history. It is not possible to explain the vast extent and relative homogeneity of the Austronesian family of languages by a process of language shift alone. Unmoving indigenous populations did not simply adopt some form of early Austronesian language and abandon their own vernaculars all the way from Sumatra to the Solomons; there are no known social mechanisms at a tribal social level which could account for such a phenomenon. For instance, none of the historical empires — Roman, Inca, Mongol, or any other — were capable of such a feat over such a large area. Also, there are no widespread indications in Austronesian language history (e.g., strong traces of substrata or interference through shift) that such a massive process of language shift ever occurred. The dispersal of the Austronesian languages must be, at a guess for at least 80 percent of the geographical distribution of the family, the result of colonization by Austronesian-speaking founder communities. This is one of the greatest, perhaps the greatest, human dispersals on record since our common ancestors left Africa.

The prehistory of the Austronesians since the "big bang" of colonization in the second millennium B.C. is obviously complex and detailed, the more so because, as with the aftermaths of all great population dispersals, the archaeological and cultural records simply become more regionalized everywhere with time and so more difficult to read in terms of long-distance correlations. People clearly stopped moving very far once the initial phase of colonization in each area was over, as one might expect. Settling in became the norm, albeit with some continuing degree of trade and intermarriage, often over long distances (witness the extensive trade networks of the New Guinea region last century). For instance, insular Melanesia at 1000 B.C. was extensively occupied by culturally homogeneous bearers of the Lapita culture (although they were not necessarily the only inhabitants — hunters and gatherers had certainly reached as far east as the Solomons by 30,000 years ago), who probably spoke only one or a few closely related Austronesian dialects. But by A.D. 1000, the Melanesian islands were dotted with literally hundreds of "settled-in" local cultures and languages. We see the same pattern in the late prehistory of eastern Indonesia, Polynesia, or wherever we look in the Austronesian world beyond the ranges of the relatively homogenizing Indianized and Islamic civilizations. Initial population dispersals are therefore much easier to describe than their ultimate region-alized products, and the intensely diversified ethnographic record of Austronesia, today numbering more than 1,000 languages and cultures, gives a graphic picture of just how much diversification has occurred.

## The Austronesian Colonization of Oceania

Since it is impossible to describe all of the wonderful tapestry of Austronesian prehistory here, I will confine myself to indicating what is known about later developments in a number of regions, particularly where archaeological records are fairly detailed.

Alagmany regions, especially western Indonesia, much of the Philippines, and many parts of Melanesia, have witnessed only sporadic research. Other regions, such as Madagascar, Malaysia, central and eastern Indonesia, Taiwan and northern Luzon, and much of Micronesia and Polynesia (especially Hawai`i and New Zealand), have recently seen much research focused on Austronesian prehistory. I will concentrate in the remainder of this essay on the Oceanic regions.

One topic which has recently been researched very intensively is the Lapita culture of parts of insular Melanesia and western Polynesia. This can be equated with the Proto-Oceanic phase of Austronesian linguistic history,[20] and involved a particularly well-documented and rapid spread of population from the Bismarck Archipelago to Samoa, late in the second millennium B.C.[21] Lapita sites are always coastal and generally of small village size, often on small islands (including some of the tiny islands later to become known as the "Polynesian Outliers," owing to later dispersals back from Polynesia), and in some cases contained stilt houses built over lagoons.[22] Obsidian from sources in northern New Britain was traded as far as Santa Cruz to the east and Sabah to the west (in the latter case far beyond the Lapita cultural sphere),[23] and occasional pieces also reached as far east as Fiji. Untanged stone adzes, shell adzes, and a range of shell ornaments and tools also characterize Lapita sites; some of the pottery was elaborately decorated by means of incision and a highly distinctive form of dentate stamping.

Although Lapita skeletons are few and all from late contexts (500 B.C. and later), those that have been studied indicate a population

with both Polynesian and "Melanesian" affinities.[24] However, we do not yet know what the earliest (i.e., about 1500 B.C.) Lapita colonists looked like, although the answer is likely to be quite close to modern eastern Polynesians. The present population of the islands of Melanesia, from the Bismarcks to Fiji, has certainly not descended solely from the most ancient Lapita groups of the Bismarcks at about 1500 B.C.; very strong gene flow from the pre-Austronesian and undoubtedly numerous populations of the New Guinea region has occurred to at least as far east as Fiji,[25] although the precise times and circumstances of this gene flow are still very hard to reconstruct. What is clear in insular Melanesia is that the Lapita culture had disappeared from the archaeological record by some time between 500 B.C. and the time of Christ, and was replaced by different pottery styles emphasizing the uses of incised and paddle-impressed forms of surface decoration. Although some aspects of these later cultures, widespread in all regions of Melanesia from coastal New Guinea to Fiji, may have partial Lapita origins (e.g., the paddle-impressed pottery in New Caledonia and the incised and applied pottery traditions in Vanuatu and the Solomons), it is clear that modern Melanesia is far more than just a transformation of Lapita. As pointed out by Roger Green,[26] the term "Melanesia" is only of loose geographical value; in human terms there is no unity and Melanesia has a very complex prehistory spanning more than one major period of migration and, in the case of New Guinea, the Bismarcks, and the Solomons, more than 30,000 years of time.

Polynesia and Micronesia, on the other hand, are relatively homogeneous in terms of language, culture, and human biology. The Polynesians are the direct descendants of the Lapita peoples who colonized through Melanesia in the late second millennium B.C., albeit also with some degree of later gene flow from western Melanesia. After the demise of the Lapita culture about 2,000 years ago, the ancestral Polynesians in Tonga and Samoa ceased to make pottery on a large scale, but other Polynesian artifact types (such as fishhooks, shell ornaments, and stone adzes) of later prehistory clearly owe much to Lapita forebears, as well as to inevitable and undeniable processes of localized innovation.[27] For instance, the eastern Polynesian stone temples (known as *marae* and cognate forms in most areas, but as *heiau* in Hawai'i and *ahu* in Easter Island and parts of the Marquesas; see pp. 327, 342, 344) appear to be the results of independent architectural elaboration only paralleled very faintly in other Austronesian regions. The same applies to the famed *moai* ancestral stone statues placed on the Easter Island *ahu*, although here we enter a confused debate about American parallels which still defies easy solution. Thor Heyerdahl has perhaps attracted more than his fair share of vituperative debate, and confident assertions about the total absence of any trans-Pacific contact between Polynesia and South America are still being made.[28] However, I think an open mind is still required on this issue.[29]

The Micronesians are basically of dual origin. The Mariana Islands were colonized from Taiwan or the Philippines about 1500 B.C. Early archaeological sites there have a decorated form of pottery rather like Lapita (related red-slipped and stamped types also occur in the Cagayan Valley in northern Luzon, dating to about 1000 B.C., and in the contemporary Yüan-shan culture of northern Taiwan). The other Micronesian islands

— Carolines, Marshalls, Kiribati, and possibly Yap — were apparently colonized by late Lapita populations from central Melanesia about 2,000 years ago, perhaps from the eastern Solomons or Vanuatu. During the past 2,000 years the Micronesians, whatever their origins, have met and intermarried widely. For instance, the Yapese network of trade and tribute recorded in ethnographic times spanned a huge region from Yap into the Carolinean atolls. But the Mariana and Belau people still speak languages of Western Malayo-Polynesian affinity, whereas the other Micronesians speak Oceanic languages. So trade and intermarriage, which occurred through all the islands of Micronesia, have not erased ancient linguistic differences.

Like the Polynesians, the Micronesians are also famed for their impressive stone constructions — the *latte* house pillars of the Marianas with their massive capstones, and the remarkable basalt-walled enclosures for high status dwelling and burial which still stand at Nan Madol on Pohnpei and Lelu on Kosrae (Carolines). In Southeast Asia very few monuments of such complexity have survived from prehistoric times, except for some terraced structures found in Sumatra and Java, and the Neolithic remains of stone-walled houses at Peinan in Taiwan. However, ethnographic Indonesia does still have surviving traditions of megalithic construction, especially in northern Sumatra, Nias, and Nusa Tenggara, and large-scale ceremonial stone construction has certainly flourished during the phase of Hindu and Buddhist influence from India since the middle of the first millennium A.D. Indeed, one of the characteristic features of the Austronesian world in prehistory and ethnography was the use of stone for architectural purposes,

especially for temple and burial constructions. Some of the largest *marae* constructed in eastern Polynesia in late prehistory even vie in size with some of the temples of the Maya and other ancient civilizations.

In addition to their stone monuments, Polynesians and Micronesians also developed many anthropologically famous examples of complex chiefdom-type societies with hereditary ranking, although true bureaucratic states as those of the ancient empires of the Old and New Worlds (including the Indic states of Indonesia) never developed. The interacting population units of Oceania were simply too small and not sufficiently densely settled to allow true states to form. The Hawaiian islands came close with their four large chiefdoms of the late eighteenth century, but Captain Cook and those Europeans who followed him intervened and imposed a new form of domination over the old.

In parts of western Indonesia, of course, the interaction between Indian ideas of religion and kingship and the chiefdoms of late prehistory produced civilizations of great intensity and longevity. So too did the impact of Islam in Madagascar, Malaysia, and insular Southeast Asia. The smaller and more vulnerable populations of much of the Pacific were not so lucky at first, but the growths this century of human rights, independence, and cultural pride are hopefully bringing rapid changes. The twenty-first century should be an interesting one for all of the Austronesians, who may well number over 300 million people as we enter the next millennium.

# Bronze and Iron Age Indonesia

Steven Kossak

1  **Tympanum of a large drum**

Bronze. Heger I type. The (restored) sides are
decorated with "soul ships." Eastern Java.
Beginning of the Christian era. Diameter 150 cm.
Inv. 3333.

The art history of Bronze Age Southeast Asia
is only beginning to be studied. The least
documented, and therefore most poorly under-
stood, area within that subcontinent is that of
insular Southeast Asia. The main categories
of objects that have been found there are
ceremonial prestige objects (including drums),
weapons, and betel-nut paraphernalia. The
precise dating of these objects is speculative:
they are generally hollow cast so that no
analysis can be made of their cores and most

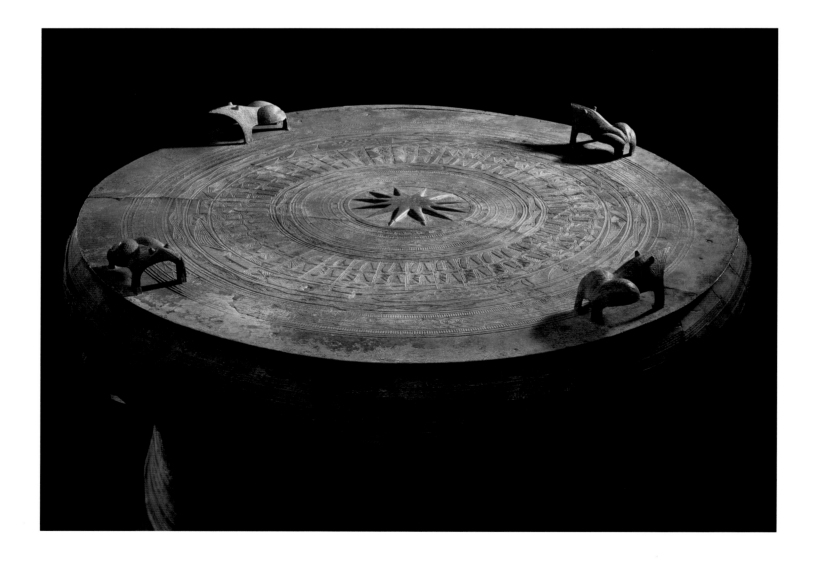

are surface finds that lack an archaeological context. Many of the large-scale prestige objects may have come to the islands as barter, as they are close in form and decoration to those of the Bronze Age Dong Son culture of Vietnam. The dating of this material remains highly speculative except in the case of some of the drums, where closely related types have been found in southern Chinese tombs.

From as early as the second half of the nineteenth century, kettle drums, many of obvious antiquity, were found in both Indonesia and mainland Southeast Asia. A group of related drums have also been excavated from Yunnan (southern China) Han tombs, supplying an incipient date for at least some types. Miniature drums, many of which are decorated with elaborate three-dimensional figurative ensembles, have also been found in tombs in Dieng (southern China). These were used as containers for cowrie shells, which served as barter (money). Up until recent times, percussion instruments made entirely of cast metal were the musical mainstay of both mainland and insular Southeast Asia. These included bells, gongs, xylophones, and drums, none of which used blown air, strings, or skins to resonate. Rather, the production of sound was integral to the one-piece construction of the instrument. In Southeast Asian cultures, this connoted eternity as well as the magical properties that were associated prima facie with metal and metalwork. Ensembles of such instruments, such as gamelans, continued in use into the twentieth century in several of the courts of Southeast Asia. Large sets of tuned bells have been found dating from as early as the eleventh to twelfth century B.C. in China, pointing to the early importance of percussion instruments throughout this part of the world.[1]

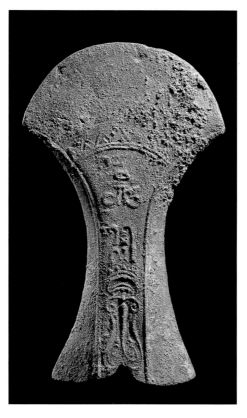

3  **Blade from a ceremonial ax**

Bronze. Of unknown provenance, this ax might well come from Roti Island lying to the west of Timor. Two similar but complete axes have been found on the same island, the hafts made from a single piece and equipped with a spherical counterweight to balance the blade. Douglas Newton (Barbier and Newton 1988) draws comparisons between the decoration on this fragment with that on a far older Lapita ceramic from Oceania, whereas this type of object is normally classified among the borrowings made by Indonesia from the Southeast Asian Bronze Age culture known as Dong Son. Beginning of first millennium. Breadth 17 cm. Inv. 3739. (See also fig. 4, p. 170.)

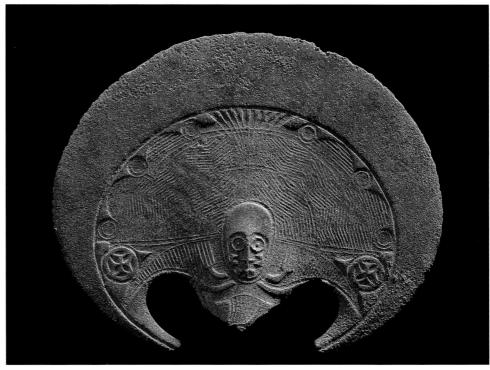

**4 Sword**

The iron blade has almost rusted away. The hilt is bronze and has over time acquired a blue-green patina. Eastern Java. First millennium. Height 33 cm. Inv. 3330-A.

**5 Box**

Bronze with blue-green patina. A container for lime, which was chewed with betel nuts. The running double loop decoration is a pattern introduced from Dong Son culture. A number of such lime containers are known, all coming from eastern Java. Beginning of first millennium. Height 18.7 cm. Inv. 3341.

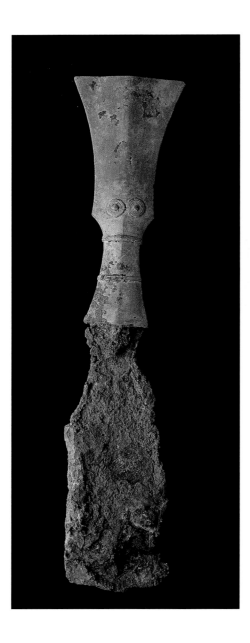

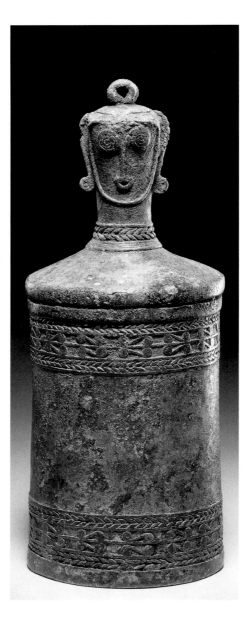

The earliest type of drum is classified according to its shape and decoration as Heger I and is dated from 500 B.C.–A.D. 500 (fig. 1). Some of these, such as the one in the Musée Barbier-Mueller, are extremely large and most are finely cast with thin walls and top. Typically, the tympanum is decorated with a geometric design in low relief including a band of stylized flying birds (herons or occasionally phoenixes) that ring a raised sunburst. The sides are also adorned with geometric and stylized animals and so-called "soul ships." On large drums of this type, four three-dimensional frogs adorn the quadrants of the tympanum and face counter-clockwise. The croaking of frogs is both a harbinger of, and a reaction to, rain, the source of fertility. Frogs are also associated with both the moon and sun, whose shapes are echoed by the circular form of the tympanum as well as by the solar decoration at its center. For all of these reasons, frogs are considered auspicious. Four double strap handles bridge the base of the convex belly of the drum and its upper concave shoulder. Such drums have been found throughout Indonesia—mainly in Java, but also in the small eastern islands. Fragments of tympanums have also been found in Irian Jaya (western New Guinea).

A large number of weapons have also been found in Indonesia. Many are in the form of bronze blades which must have been hafted to wooden handles (fig. 2). Some of these blades, which may have had a primarily ceremonial use, are extraordinary for the power and beauty of their shapes and decorations (fig. 3). Others have vestiges of iron blades and were probably weapons. The hilt in fig. 4, which is only minimally adorned, has a dynamic profile. It is not clear whether the two series of

concentric circles with raised dots at their centers are meant to be eyes.

A distinctive feature of insular Southeast Asian culture is the presence of utilitarian objects associated with the chewing of the areca nut wrapped in a betel leaf, a mild narcotic digestive. In order to chemically break down the nut, powdered lime is added. Both containers for lime and small spatulas for its transfer are found in Bronze Age Indonesia. The handles of the spatulas often terminate in small animals (fig. 6). In Indonesia as well as India, where the practice of chewing *pan* continues today, these two main components are combined with spices and wrapped in a leaf before consumption. Many of the finest Indonesian lime containers are anthropomorphic, with a cylindrical body, a cover with sloping shoulders, a short neck, and a head with stylized features (fig. 5).

## 6  Bronze objects

Reportedly unearthed from a site near the sea in eastern Java that Bali dealers call Lumajang. On the left, a miniature hourglass drum resembling an Alor *moko* (see fig. 6 in the "Flores" chapter): the lid can be removed and the object perhaps served as a lime container (height 7 cm). Center, top: three pendants in the form of animals (heights 4.2, 3.8, and 4.45 cm). Center, middle: a lime spatula with a zoomorphic handle (length 8.3 cm). Center, bottom: bracelet with spiral decoration (width 11.19 cm). Right: sword hilt similar to that shown in fig. 4 (length 18 cm). Inv. 3331, 3337, 3339, 3338, 3332, 3342, 3330-C.

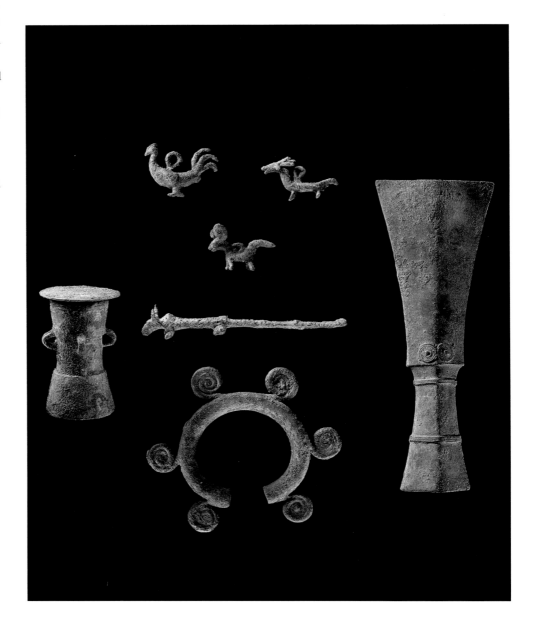

# The Island of Nias

Alain Viaro and Arlette Ziegler

Erratum: This map replaces the map reproduced on page 22.

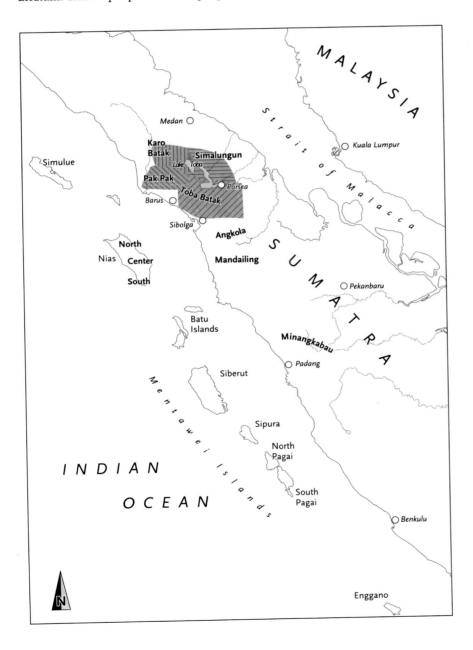

The sheer abundance of jewelry, weapons, and wood or stone sculptures from Nias seems on first sight to be out of all proportion to the tiny dimensions of the island (100 by 40 kilometers). It should not be forgotten, however, that in the last quarter of the nineteenth century, when it was settled by the Dutch colonial power, there were 1,400 villages on the island. In spite of its small size, Nias can be divided into three distinct cultural zones sharing a common Austronesian heritage: the south (one-ninth of the surface area), with its wide shoreline plains well suited to rice fields and palm groves, is peppered with large villages in which the houses are built around a central plaza (fig. 1); a mountainous central area (two-ninths) in which little fortified hamlets have grown up on the summits; and the north (six-ninths), with its low-lying hills separated by marshy estuaries only sparsely inhabited but where houses of an oval design not occurring in the Mentawei Islands have been built. In short, in terms of social organization, dialect, architecture, wood statuary,

1 Street in the village of Bawömataluo, in southern Nias. The chief's house is visible in the background. A second street at right angles to this one passes in front of the house. Photograph Jean-Louis Sosna, 1990. Barbier-Mueller Archives.

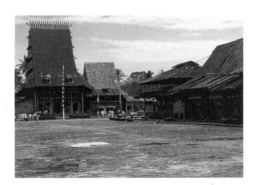

2 **Shield (*baluse*)**

Wood, reinforced horizontally with woven wicker.
Southern Nias. Height 126.2 cm. Inv. 3292-2.

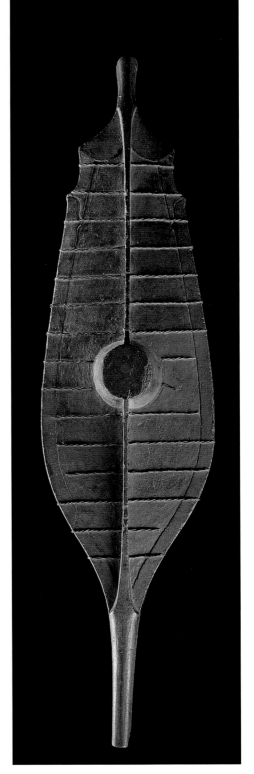

and stone monuments there are wide variations between the north, center, and south of the island. It is therefore not possible to speak of a single Nias culture, as some authors seem on occasion to imply (see map p. 22).

## A Warrior Society

Until the onset of the twentieth century, when it was eventually to suffer the full impact of Christianization and Dutch colonialism, the island had been the theater for a highly complex warrior society.[1] Two main features were common to the central and southern parts of the island: head-hunting and the accumulation of wealth through war (either by slave-taking or as a result of the gold obtained from military forays). Such head-hunting expeditions were "ordered" by nobles on the most important feast days, as was the construction of extraordinary chief's houses (*omo sebua*) that constituted the greatest glory of the village. In the south, so as to earn the *kalabubu* necklace (fig. 3)[2] that would promote him to adult status and allow him to sit on the village council (*orahu*), a young man would be expected to return from such sorties with a head. In his left hand, a warrior would carry into battle the lightweight *baluse* shield (fig. 2) that some authors have interpreted as having the form of a crocodile's head seen from above.[3] Other items of defensive armor included an iron breastplate (*baru oröba*), helmet (*takula tefaö*), and face guard (*bumbewe tefaö*), which were also made of iron (fig. 4). Breastplate and shield were used to parry thrusts from spears (*hulajo*) or swords (*balatu*), since the bow and arrow—though present on the nearby Mentawei Islands—were unknown on Nias. The decoration of the sword hilt is particularly interesting (fig. 5). Because of the size of the *lasara* monster's head—whose lips twist back

like a strange forest flower to reveal an impressive set of jaws—the space available for gripping the weapon has been severely curtailed.[4] On the beast's neck there squats a vaguely anthropomorphic figure sometimes described as a monkey: it is meant to be a *beghu* (or *bechu*), a spirit about whom there is a dearth of reliable information. The basketry ball adorned with animal teeth that is affixed to the sheath is itself bound with beautifully made wooden figurines.[5] Commonly, swords were equipped with only two or three figurines of this type: the one illustrated is exceptional

3 Young man dressed for a "war dance." He wears the *kalabubu* (a necklace made from round sections of coconut) and carries a sword (*balutu*) and shield (*baluse*). All the objects shown are old. Photograph Jean Paul Barbier, 1974.

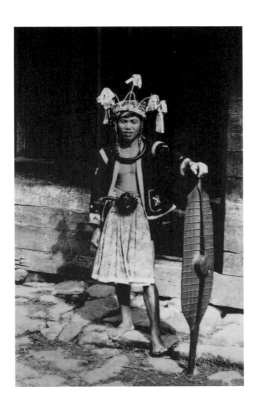

## 4 Armor

Including iron breastplate (*baru oröba*), helmet (*takula tefaö*), and artificial mustache (*bumbewe tefaö*). Southern Nias. Height 155 cm. Inv. 3292-1, 3292-2, 3292-3.

## 5 Sword hilt (*balatu sebuai*)

Decorated with a woven rattan ball onto which are fixed small wooden anthropomorphic figures that help to ward off evil spirits. The hilt represents a dragon (*lasara*). Length 73 cm. Inv. 3252-C.

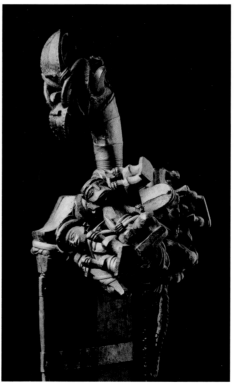

in being furnished with eight. Also preserved in the Musée Barbier-Mueller is a sword whose brass handle was cast by the lost-wax process, a technique also employed in the making of oil lamps.

## The Feast System as a Foundation of Social Organization

The most striking feature of the island's social organization is without doubt the complexity of the feast systems, which were linked to the construction of stone monuments and ritual consecration through the use of gold. Each individual on Nias, be he a noble or commoner, must be in a position to throw feasts if he is to ensure his acceptance within local society. The most important feast days may allow the individual to attain the rank of *balugu*. In the central area, these feasts consecrated the foundation of a village; to the south, they were held following fierce competition between *si'ulu* nobles for the post of village headman; in the north, they were an occasion for mustering together all the fragments of a clan (*madö*) dispersed around the various hamlets into a complete *öri*. In all these cases, the feast days demanded the provision of pigs in the form of *urakha* prestations that included parts of the animals consumed raw or cooked during the celebrations.[6] The supplying of pigs created within and between the various groups a network of obligations, the dynamics of which entailed the production of surpluses: it was in assuring this economy that slave trading played an essential part. It was also during some of these feasts that the stone monuments that constitute the most remarkable feature of the Nias landscape were erected.

Other festive celebrations were held to consecrate the gold ornaments (*ana'a*) that

symbolized social prestige. Contrary to what is commonly thought, the Niha did not extract a single fleck of gold from their rivers. Their goldsmiths only knew how to work metal acquired in exchange for slaves. For noblemen and noblewomen, crowns, earrings, and necklaces made from precious metals (figs. 9, 10) were ordered in quantities and in an order of manufacture appropriate to each village. The jewelry (fig. 11)—a veritable treasure trove which aroused much envy[7]—was kept in chests that were considered the embodiment of personal wealth.[8] In the south, representations in stone of these caskets would be placed outside the houses of certain nobles and could also be found on interior wooden panels (fig. 6).

Society was organized into two classes, the people and the nobles,[9] to which can be added the priests of the traditional religion (*ere*), who could be taken from either social class, and finally the slaves. Each village possessed its own corpus of rules, drawn up at its foundation, that fixed the quota of ranks, the rites of passage from any one to the next, the feasts governing the acquisition of a given grade, the equivalent weights and measures for goods such as gold, hogs, and rice, the use of common land, and the penalties covering transgression of the laws. In the south of the island, the villages formed into what were small independent states, headed by a chief who could be recruited only from the nobles (*si'ulu*) by a general meeting of the menfolk (*orahu*). In the south, in addition to the nobles and the common people, there also existed a class of advisors or councillors (*si'ila*) who played a valuable intermediary role between the headman and the rest of the population. The north possessed a very original structure consisting of confederations of villages, each

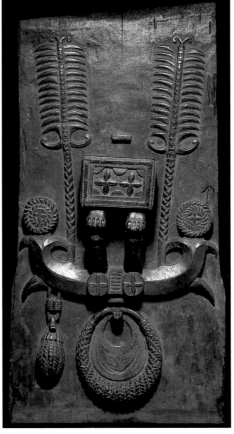

6 **Interior wooden panel from a house**

Carved wood. The decoration shows a *nifatali* necklace and a single earring. In the center is a jewelry casket. This carving was clearly commissioned for a man, since a woman would wear a pair of earrings. Height 61.5 cm. Inv. 3270.

7 A shrine carved from a single piece of hardwood positioned on the side wall of the chief's house in Bawömataluo. Formerly an ancestral statuette (*adu zatua*) would have been placed on the seat. Photograph Alain Viaro.

8 The large chief's house (*omo sebua*) in Bawömataluo, the largest village in southern Nias. Photograph Alain Viaro.

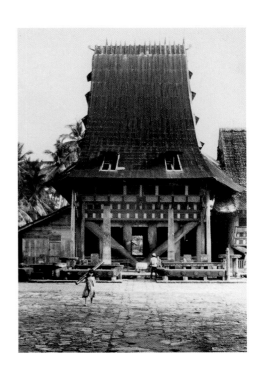

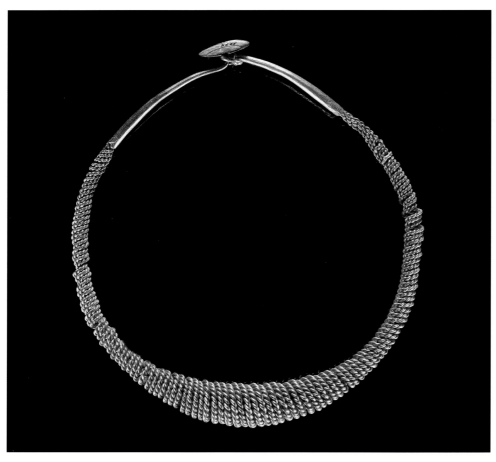

**9  Necklace (*nifatali*)**

Formed from a thick twist of gold cable.
Height 19.5 cm. Inv. 3275.

**10  Jewelry for a woman**

Gold. Comprising a crown (*takula ana'a*), a pair
of earrings (*gaule*), and a choker (*nifatofato*).
Southern Nias. Height of crown 16.5 cm; width
of earrings 12 cm; width of choker 22 cm.
Inv. 3265-A, 3265-B 1 and 2, 3265-C.

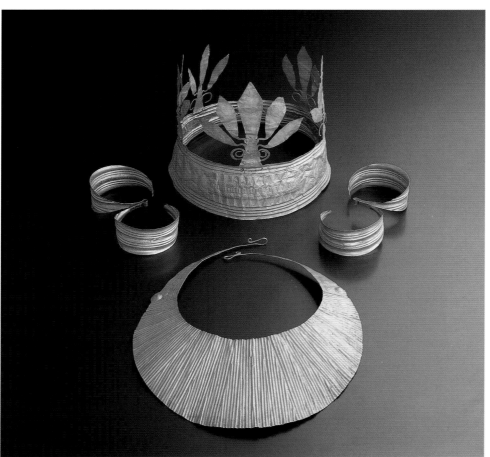

11  Village chief from southern Nias, photo-
graphed at the age of ninety in 1990. He still
possessed his gold jewelry, testifying to the rank
acquired through the organization of all the
necessary feasts. Photograph Jean-Louis Sosna,
1990. Barbier-Mueller Archives.

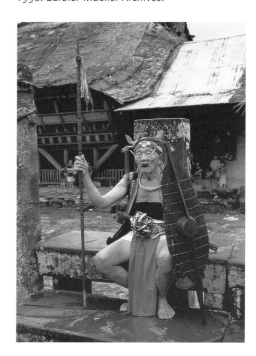

12 **Monument (*osa osa*)**

Stone. In the shape of a seat, the front of which represents the head of a dragon (*lasara*), symbol of the lower world, while the tail is that of a bird, symbol of the higher world. Length 107 cm. Inv. 3253-A.

13 **Monument**

Stone. In the form of a seat, with three dragon heads and three tails. It commemorates a feast held by a man in a bid to ascend the social hierarchy and acquire superior rank. Length 102 cm. Inv. 3253-H.

12

identified with a given clan (*öri*). Each village also had its own chief, whose position in the hierarchy was determined in relation to the headman of the clan (*tuhen'öri*). In the center, where villages are long-established and relatively small, the distinction between nobles and common people was less cut-and-dried. The bravest and the wisest individuals might attain the status of headman, after, of course, laying on the mandatory feasts.

## Architecture

Almost all the island's villages possessed a chief's house (*omo sebua*). Only four of these survive, all in the south, two being in a state of severe disrepair. The largest, at Bawömataluo (fig. 8), is 32 meters deep, 10 meters wide at the front, and 21 meters high. Like all important Nias constructions, it is erected on a forest of stilts.[10] The most immediately impressive element is the huge steep-pitched roof. Closer inspection reveals panels carved with plant motifs and rosettes dotted about the high overhanging facade, as well as the three typical *lasara* heads, as tradition demanded for a house of this sort. The ends of the joists (*sichöli*) supporting the side walls are also carved. One enters the *omo sebua* via a central stairway, which leads into a vast communal room with space for a hundred people that gives on to the street. In the past, Nias artists turned their attention to the smallest details, from clothes hooks to door latches. The decoration shows flowers and animals, which,

14 Abandoned village in the Gomo district, central western Nias, with stone monuments erected during the "feast of merit" organized by the local nobility. Photograph Morley, 1972.

13

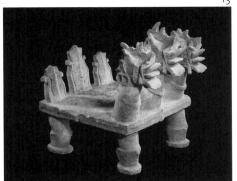

**15  Statuette of an ancestor**

Wood. Depicting a woman (identifiable by the fact that she wears two earrings). Women were closely associated with the prestige and rank of their spouses. Height 27.5 cm. Inv. 3264.

**16  Statuette of a male ancestor (*adu zatua*)**

Wood. Central Nias. Height 45.5 cm. Inv. 3250 D.

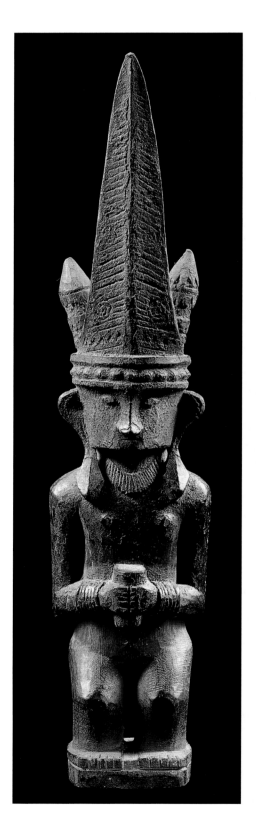

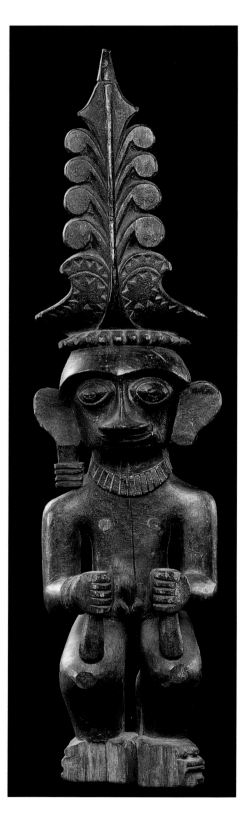

on the central pillar (*chölöchölö*), symbolize the components of the society. The side walls are each lined with two panels (*laso so hagu*) depicting the sets of male and female gold jewelry that the building possesses. Above the front righthand panel, a double shrine housed effigies of the male and female ancestors (*adu zatua*; fig. 7). Only the houses of the nobility (not solely that of the headman) were decorated with such panels, since only aristocrats were permitted to own such articles of personal adornment.[11]

In the center of the island, the chief's house was just as ornate as in the south, though the idiom is patently cruder. Two elements recur: the monitor lizard, carved on the facade or on the fore-beam of the public room—where the lizard's forked tongue symbolizes the wisdom of a chief who knows how to talk to the worthy and the evil alike—and the *lawölo*,[12] reminiscent of a hornbill with outstretched wings (and occasionally a human head) wearing a *nifatofato* necklace. This carving is an integral part of the building, forming the finial of the central joist in the public room. Another element which recurs is a little personage clasping between its hands a betel pot, symbol of the hospitality traditionally incumbent upon the master of the house.

The oval-shaped dwellings of northern Nias are not generally decorated, except for their high stilts, which are adorned with fluting or rings on the facade side, and the jigsaw-patterned window stiles.

### Stone Monuments

These monuments (anything from simple megaliths to anthropomorphic statues that testify to consummate mastery in carving)

Stone. The sculpture represents an ancestor of
high rank. Northern Nias. Height 131 cm. Inv. 3259.

are status symbols for the living erected only
on special feast days. In the south, the statues
are placed in the open space in front of the
*omo sebua* where the men congregate.[13] The
most impressive of these vast ensembles in the
south is without doubt that of Bawömataluo.
The seats, the columns, and the carved stone
slabs evoke the great wealth and grandeur of
this village as it was at the beginning of the
nineteenth century.[14] In the center of Nias,
especially in the region of Gomo, the terracing
in front of a house can literally subside beneath
the sheer weight of stone monuments (fig. 14).

18 In addition to ancestral effigies, there existed
about one hundred types of anthropomorphic
wooden statuary endowed with magical functions.
The priest would invent a new form in response to
any given situation. Below, the *adu hörö*, designed
to atone for the violation of an interdict.
Photograph Vidoc, Amsterdam, before 1914.

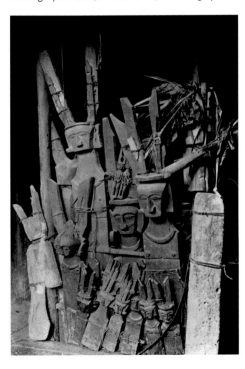

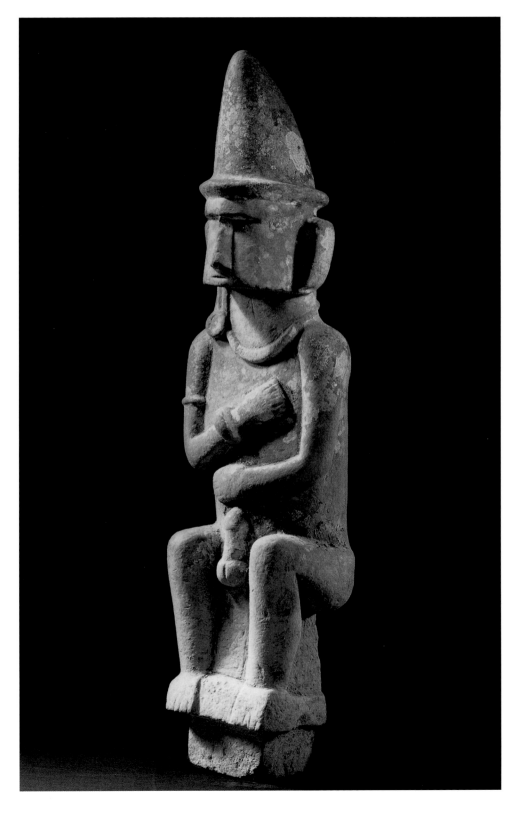

Hardwood. Represents an ancestor wearing a headdress. Such turbans are not unusual and other naturalistic sculptures of this type are preserved in museums in Amsterdam, Berlin, and Jakarta. Height 40 cm. Inv. 3250-C.

Hardwood. Represents a high-ranking ancestor. Northern Nias. Formerly Groenevelt Collection (before 1939). Height 68 cm. Inv. 3250-B.

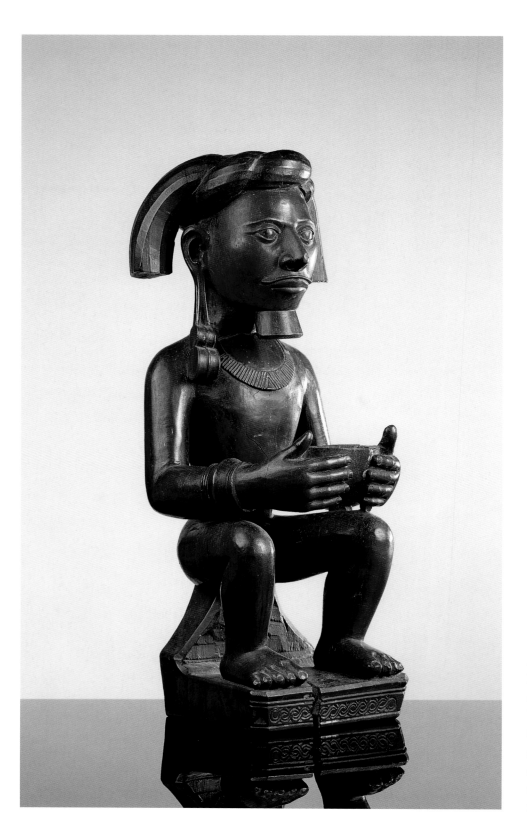

Stone monuments, such as the anthropomorphic statues, the seats of honor (*osa osa*) with between one to three *lasara* heads (figs. 12, 13),[15] and the high *behu* pillars topped by the figure of a rooster, stag, or *lasara* all display virtuoso artistic skill.

Finally, in northern Nias the monuments visible at the front of the house are for the most part megaliths (vertical or horizontal), though the region is also home to the most impressive anthropomorphic statues of all, the *gowe*, towering fully 3.5 meters high (figs. 17, 21).

### Effigies of Ancestors and Prophylactic Statues in Wood

Wooden anthropomorphic statuettes existed in all three regions of Nias. Some, especially those from the north, display exceptional sensitivity and talent.[16] The priests of the traditional religion knew the type of statuette any given situation demanded and out of which woods custom held such a "fetish" should be carved.[17] The effigies that served as prophylactics against ill health, misfortune, or war—often simply human-headed sticks— were probably worked by the *ere* themselves as representatives of the goddess Silewe Nazarata on earth.

On the other hand, ancestral effigies (*adu zatua*), whose presence is attested in most houses, were for the most part the handiwork of real artist sculptors who would sometimes be brought in from a neighboring village. Carved in memory of the deceased, the *adu zatua* were consecrated by the *ere* during a complex ceremony at which the figurine was attached to a stone monument standing in front of the house by a ring of palm leaves:

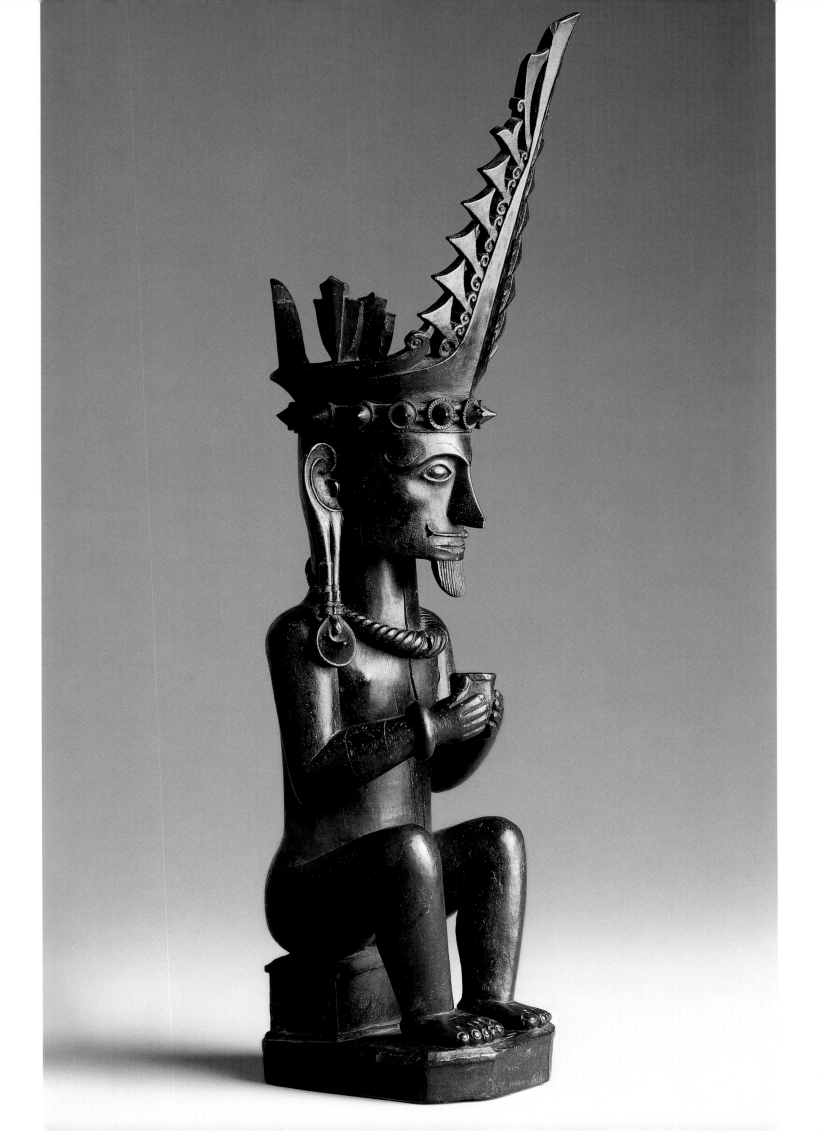

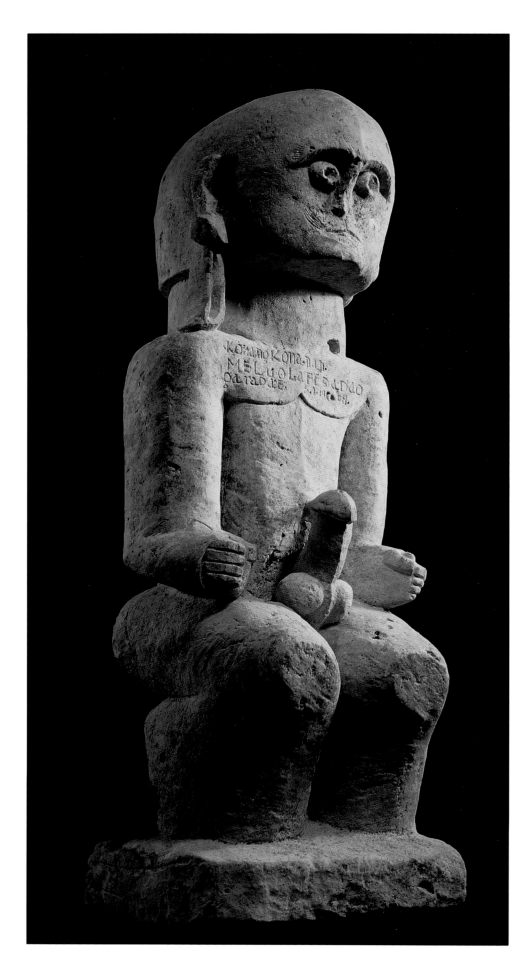

Stone. The effigy of the mythical ancestor who protected a noble's house or perhaps a whole village. Gomo district, central eastern Nias. Height 122 cm. Inv. 3261.

thus were the souls of the dead joined to those of the living. *Adu zatua* may depict male (fig. 16) or female figures (fig. 15), the latter being recognizable by the fact that they wear a pair of earrings, whereas men sport only the one. Sometimes difficult to distinguish clearly from the *adu zatua*, the statuettes known as *adu siraha salawa* are just as remarkable (figs. 19, 20). Dedicated to a particular village chief or a forebear who founded a clan, their function is identical.[18]

Apart from effigies portraying ancestors, there also exist a large number of anthropomorphic statuettes in wood whose generic name throughout the island is *adu*. One of the most spectacular (whose height can approach that of a man) is the *adu hörö* (fig. 18), executed in atonement for the violation of an interdict (missionaries employed the word *hörö* to translate the notion of sin). The statue can possess the characteristics of either gender[19] and wears on its head a two-pronged ornament that certain anthropologists (following in this von Heine-Geldern) have equated with the forked posts of Assam in northeast India.

Wooden household items are rare, the most frequent being stools and little benches fixed with a metal blade for scraping coconut (figs. 22, 23).

Finally, it must be conceded that the arrival of mass tourism has put a new face on such traditional practices. Today, statuettes and carved panels are offered to tourists, especially in Bawömataluo, where even those of modest talent work to supply the growing market.[20] Dances for tourists have also ousted traditional ceremonies and personal adornments in solid gold have been supplanted by pathetic imitations in tinfoil.

## 22 Coconut-grater

Hardwood. Resembling a small stool, the object was used to shred coconut pulp. A metal rasp would have been fixed to the head of the figure. Central Nias. Length 41 cm. Inv. 3267.

## 23 Stool

Hardwood. In the 1970s, stone examples of such stools could still be seen standing in front of the houses of the nobility in the south of the island. Height 38 cm. Inv. 3268-3.

## 24 Head

Stone. Probably at one time part of a statue (*gowe*) erected in front of a house, doubtless representing a high-ranking ancestor. Gomo and Tae River district, central eastern Nias. Height 30 cm. Inv. 3256.

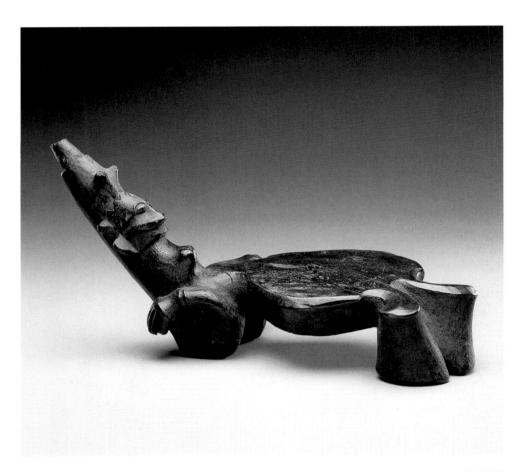

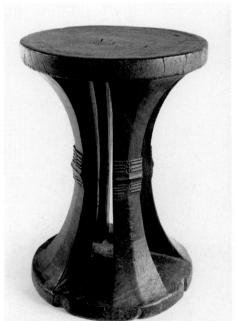

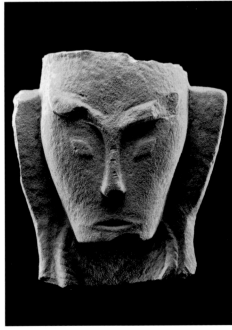

# The Mentawei Islands

Jean Paul Barbier

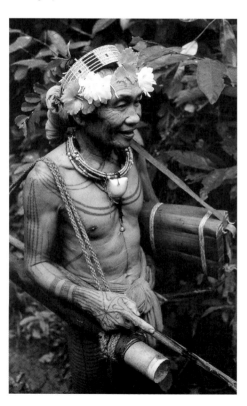

1 Shaman from the island of Siberut in the forest. Photograph Olivier Lelièvre.

The Mentawei archipelago is situated to the south of Nias opposite the central area of the west coast of Sumatra. Sailing past this group, one sees little more than a close-knit mass of tall trees on the four main islands, followed by a collection of three dozen uninhabited islets. The four larger islands are from north to south: Siberut (the largest at 110 kilometers long), Sipora, and the two Pagais (or Pageh).

For a number of years now, reports illustrated with photographs of great beauty have been emerging on the subject of the inhabitants of the Mentawei, who live in an untouched state, their material culture, beliefs, and social organization having changed little from ancestral times. In fact since 1854, the year in which the archipelago was officially absorbed into the Dutch colonial empire, contact with the "civilized world" has not had too detrimental an effect on the traditional lifestyle in Mentawei. It was only in the 1950s that Catholic missionaries began seriously to tackle the thorny challenge of stamping out "paganism." This objective remains unrealized to this day, except for Pagai where the indigenous peoples had been Christianized some time previously. Nevertheless, in recent times important changes have begun to take place, if one is to judge by the impressive number of dugout canoes, carved panels from traditional houses, wooden sago platters, drums (unheard of until recently), anthropomorphic posts, and other objects vital to the continuity of ancient customs that are now flooding the antiques markets at Medan, Jakarta, and Bali. A portable drum (not reproduced here), for example, was acquired in 1996: its export certificate was difficult to obtain, not due to its value as an ethnographic document or as an "antique," but

rather because it was stretched with the skin of a species of snake protected by the Washington Convention.

The most important person in the Mentawei community has always been the shaman (fig. 1). Through his knowledge and the power he derives from communicating with the supernatural world, the shaman is an ever-present figure since no important act can take place without the customary ritual or sacrifice.

The inhabitants of Mentawei can be distinguished from those of the geographically neighboring populations of Nias and the Batak of Sumatra by a wide range of specific cultural features. First and foremost, they build no megalithic monuments and possess no sculpture in stone. They are also the only population in western Indonesia to use a bow and poisoned arrows[1] and to practice tattooing (fig. 1). The Indonesian authorities have striven vainly to stamp out tattooing, but without tattoos no man can be considered to have reached adulthood. The inhabitants of Mentawei also have no knowledge of mining or metalworking, knife blades (fig. 6) and spearheads being imported from Sumatra or sold on to them by Malay seamen, who also supply glass beads, brass armbands, and, more rarely, watches and mirrors. The most important import is cotton fabric, which is used to make loincloths. In former times these would have been made from barkcloth (*tapa*). When dressed for a festival or ceremony, the inhabitants of these islands—with their tattooed bodies, filed teeth, headdresses made of feathers and hibiscus flowers, and other personal adornments made of shell and seeds—resemble nothing more than glittering works of living art.

Hardwood carving. The ears are made of recycled metal; the antlers are natural. Nineteenth century. Siberut (?). Height 52 cm. Inv. 3290.

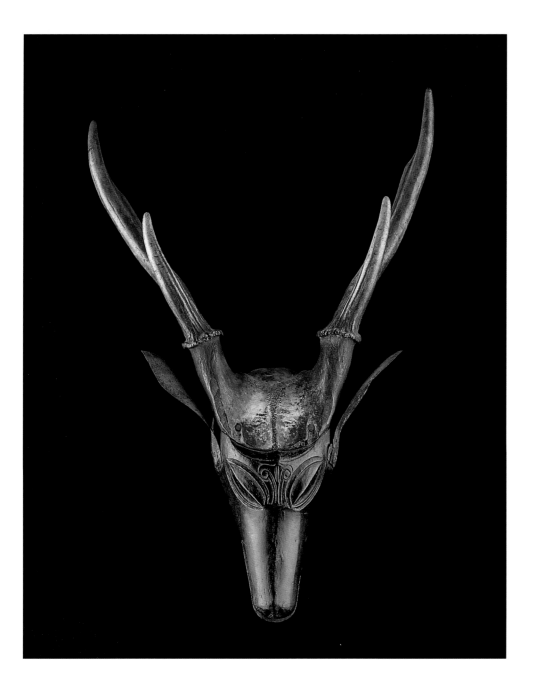

**3 Panel-shrine (*jaraik*)**

Hardwood. Placed against the wall separating two inner rooms in the "great house" (*uma*). The motif carved in low relief and picked out with red and black symbolizes the World Tree. The five monkey skulls serve to keep the souls of the animals within the house and, by attracting their living counterparts, ensure successful hunting. Height 163 cm. Inv. 3299-2.

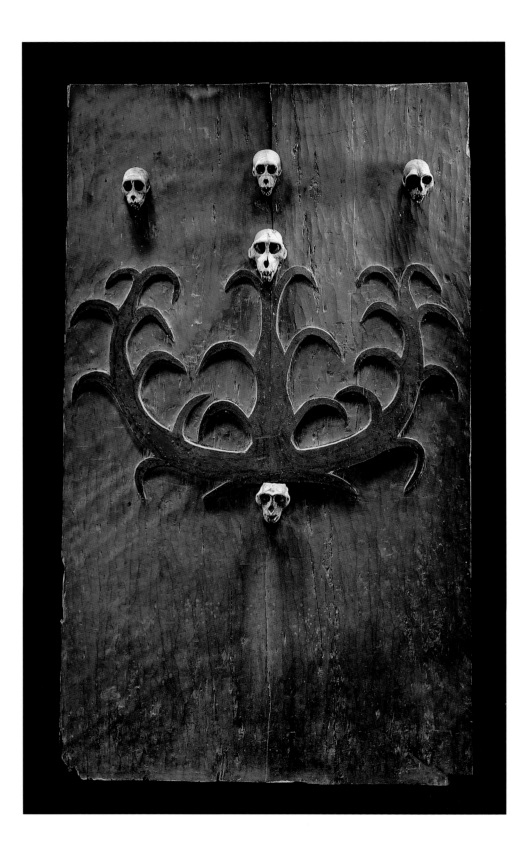

## The *uma*

The word *uma* is patently a local variant of the Indonesian term *rumah* ("house"). Until recently, the traditional "great houses" were constructed without the use of a single metal nail, everything being held together with pegs. About 30 meters long, 10 meters wide, and 6 meters high, the *uma* is raised on stakes in such a way that the habitable floor stands a full meter above ground. As among the Batak, the house is thought of as a miniature representation of the cosmos: the floor symbolizes the sublunary world in which men live and the area beneath the floor stands for the subterranean world in which lurk evil spirits and a disturbing deity known as Teteu responsible for earthquakes. The roof meanwhile signifies the *manua,* or vault of heaven.

## The Decoration of the *uma*

The front area of the house is set out as a veranda, a communal space that leads into one or two sizable rooms. In houses on the island of Siberut there stands, on the main wall that separates the two principal rooms, a *jaraik*. Carved in vague imitation of a stag's antlers with the tines ascending like branches, it is in fact a representation of the World Tree. It has been compared to an adornment commonly found in low relief on houses on Nias, the *saïta*.[2] The *jaraik* can be an openwork carving or else, as in the case of the example reproduced here (fig. 3), it is worked in high relief on a solid wooden panel. It is always found in association with monkey skulls, one in the openwork variant and from three to five for the panel version.

In earlier times, in addition to painted and incised animal skulls, the beams supported

4 **Panel**

Hardwood. Decorated with a high-relief carving
of a monkey. From a wall of a "great house."
Siberut. Height 129 cm. Inv. 3299-7.

5 **Paddle (*sinaiming*)**

Hardwood. Siberut. Length 170 cm. Inv. 5449-3.

remarkable wood carvings commemorating
the slaying of game (fig. 2). These carvings
were intended to call their living companions
to them and thereby induce them to suffer
a similar fate.

The hearth of the *uma* could only be lit on
the occasion of a ceremonial feast. Spaces
in the house reserved for sleeping obeyed
the rules for gender segregation.

Other carved panels and doors from the *uma*
present figures of animals or men in profile:
in this case, allusion is usually being made
to head-hunting, which used to be practiced
throughout the archipelago before it was
eradicated by the colonial authorities. On
some polychrome low reliefs, only the feet
and the hands of the man are visible: these are
known as *kirekat* and function as a memorial
to a deceased individual.

**Other Types of Carving**

Both military expeditions and head-hunting
forays have engendered a vast iconography
whose symbolic language is difficult to decode
with precision. In general, sculptors from
Mantawei are to our eyes rather less gifted
in representing the human or animal figure
in sculpture in the round than the Batak or
than their neighbors on Nias, both of whom
are as at ease in relief work (*gorga*) as in three-
dimensional carving (*gangana*). One should
not contend, however, that the aesthetic sense
of the Mantawei is stunted compared with
that of adjacent ethnic groups. Their taste for
attractive forms, for example, is apparent in
their wooden paddles—objects of singular
importance for a people living along the shore-
line and whose favored form of transport is
the single-hulled canoe (fig. 5). The blades of

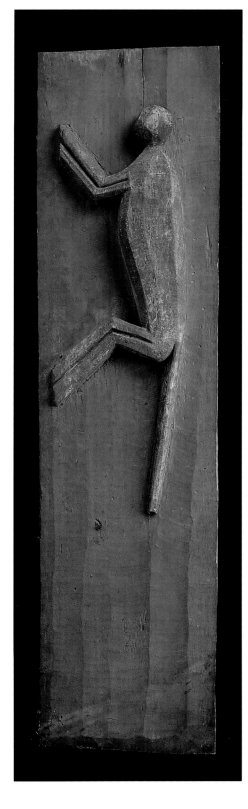

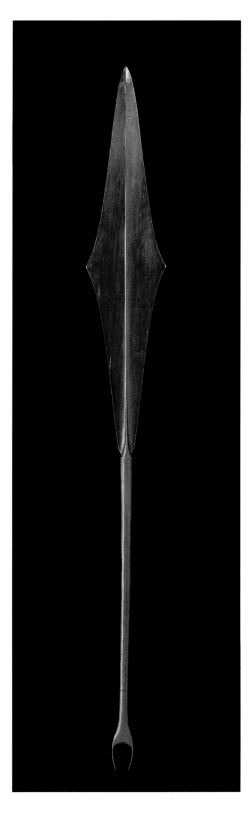

### 6 Knife (*pattei*)

The hardwood handle is decorated with the figure of a bird. The iron blade was obtained by barter from Sumatran mariners, metalworking being unknown on the Mentawei Islands. Length 33 cm. Inv. 3291.

### 7 Shield (*koraibi*)

Wood. The central portion has been reinforced with half a coconut shell. Black and red paint applied to a plain-wood base with a shiny patina. The reverse is decorated in a similar manner. The handle has been cut out from within the coconut-shell boss. Formerly Professor Hans Meyer Collection (Leipzig, before 1914). Height 107 cm. Inv. 3299.

these paddles offer a striking but entirely fortuitous resemblance to the dance spears or sticks from the little island of Niue, in central Polynesia.

The trophy statuettes portraying head-hunting victims are crude, as are the anthropomorphic poles that decorated certain *uma* in Pagai.[3] On the other hand, the elegance of the islanders' tattoos, with their penchant for scrolls and spirals, resurfaces in the decoration painted on their shields, far finer on Pagai it should be noted than on Siberut (fig. 7). These light-weight wooden shields, decorated on both faces, often allude cryptically to regional notions of cosmogony and to the antagonism between the higher and lower worlds. On the piece reproduced, a crocodile is positioned vertically beneath a standing bird: fixed here for all eternity, the two beasts thus guarantee the stability of a dualistic system according to which the sublunary world wherein man dwells can only survive if the powers of good and evil remain forever in balance.

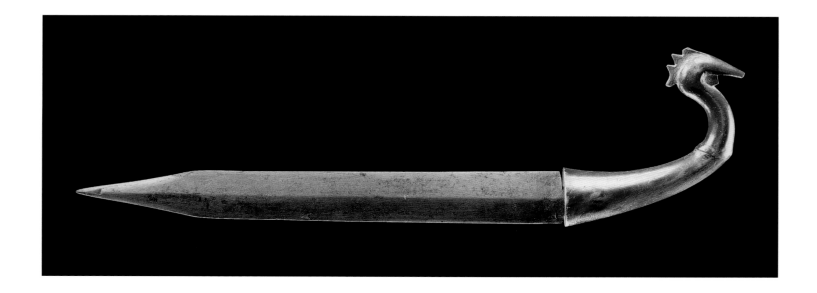

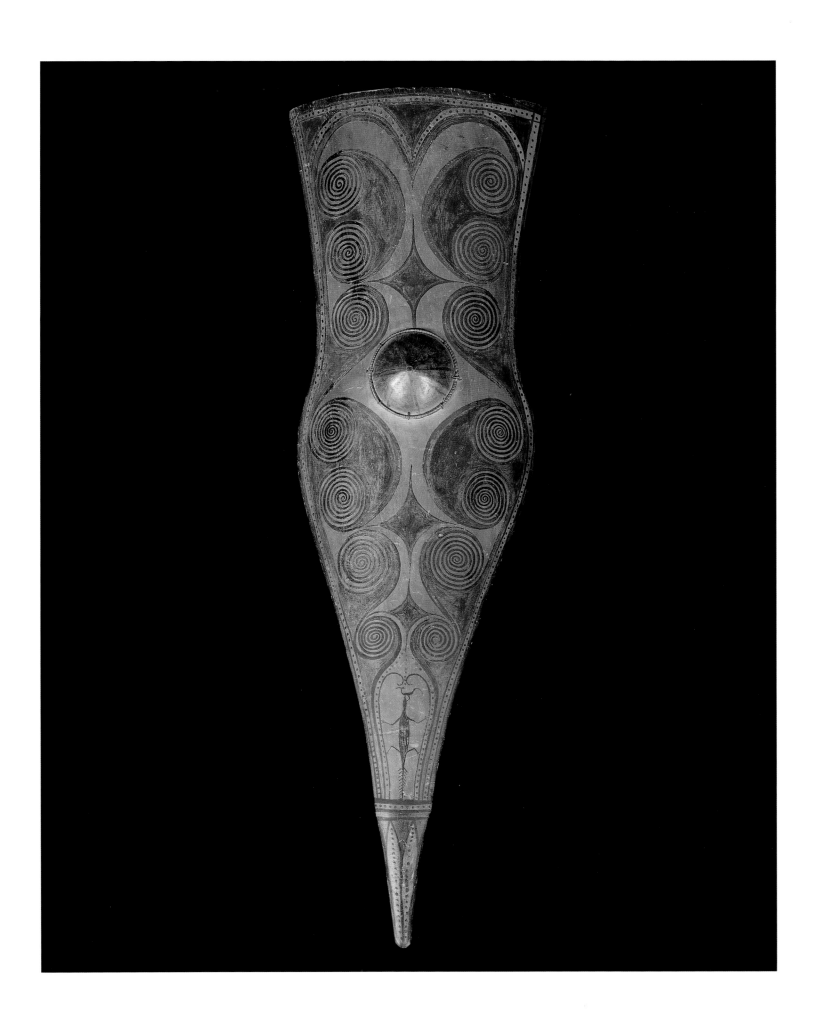

39  The Mentawei Islands

# The Batak of Northern Sumatra

Jean Paul Barbier

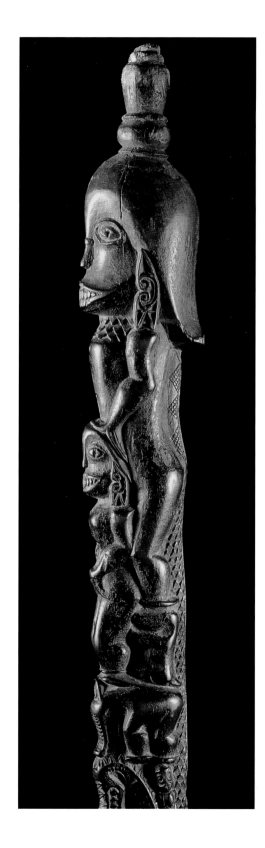

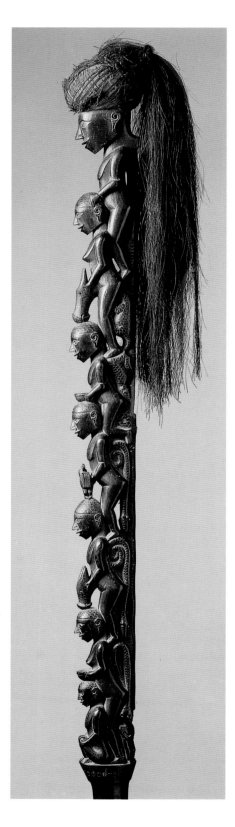

From time immemorial, travelers have told tales of a warlike, cannibalistic people living in the north of Sumatra: the Batta, or Batak. In reality, this people is comprised of six different groups, closely related linguistically, who claim a common ethnic identity, though some reject the assertion of the most populous group, the Toba, to be accepted as the region's "original" ethnic entity (see map p. 22). From north to south, the six groups are: the Karo, the Simelungun (or Timur Batak), the Pakpak, the Toba, the Angkola, and the Mandailing. The last two groups were Islamicized over a century ago. From their ancient traditions they now preserve only the social organization, consisting of exogamous and patrilinear clans, in spite of the influence of the Minangkabau (the Mandailing's neighbors) among whom descent is matrilinear. The Karo, who inhabit a mountainous region, were at one time under the relatively unobtrusive sway of the Muslim sultans of Aceh, in the extreme north of Sumatra. Aceh itself entered into ongoing maritime trading relationships with

3 This curious monument houses two stone statuettes (*pangulubalang*) of somewhat rustic appearance that protected a village near Muara, south of Lake Toba.
Photograph Jean Paul Barbier, 1980.

**11 Statue**

Stone. A high-ranking personage riding a *singa* (the monster being represented not as a snake, but as a four-footed animal, presumably a water buffalo, elephant, or horse). These monuments were often set up during the lifetime of the individual, whose high social status and superior "life force" (*sahala*) they embodied. Toba. Barus hinterland. Length 92 cm. Inv. 3106.

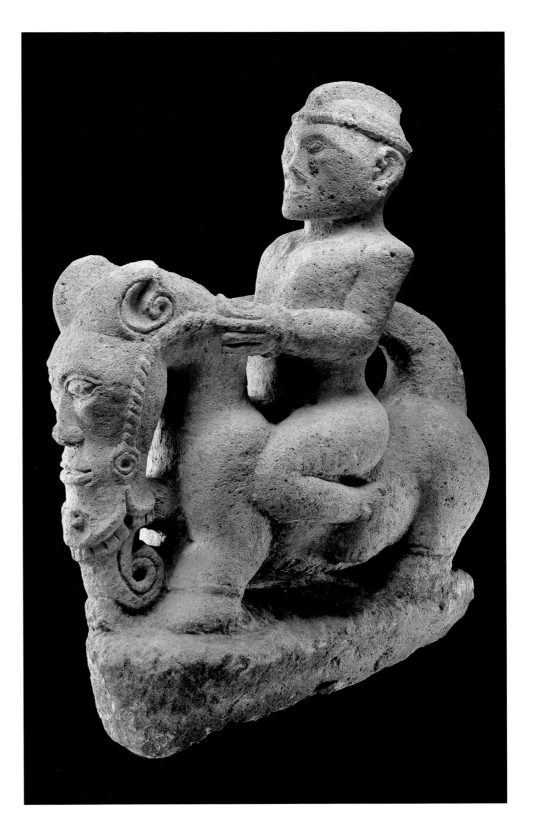

through prowess in war, or else by skillful management of one's inheritance and trade. The Pakpak Kalasan, who have still not been studied today,[1] make a firm distinction between these two categories of renowned ancestors. Fearsome warriors are given a commemorative statue on which they are shown astride a horse, while the others are portrayed sitting on an elephant. This observation simply serves to illustrate the various ways *sahala* can be obtained, since, at the outset, these important personages rode neither elephant nor buffalo nor horse, but the *singa* (figs. 10, 11), a particularity that even the most venerable Batak have forgotten but which is attested by the iconography.

To the south of Lake Toba and on Samosir Island there stand many magnificent houses with pointed gables (fig. 8). The sloping sides are supported by two long beams that end in a monstrous head with great round eyes and lolling tongue. The Batak call this mythical monster *singa*. By the nineteenth century, the Toba were already unable to recall its symbolic significance, maintaining simply that it brought luck or warded off evil spirits. In certain villages, about twenty years ago, people were still aware that such monsters could not be used to decorate the abode of any individual indiscriminately and that before they could be laid into position a human sacrifice was necessary. In front of a house in the north of Samosir (fig. 9), a stone marked the place where the remains of a young girl had been interred at the time of the building's construction. No great leap of imagination is required to realize that the whole beam is a single gigantic serpent with a three-horned head. In some cases the head of the *singa* is attached to the body of a quadruped, and occasionally the quadruped itself is covered

The side lugs resemble ears and are probably an allusion to the World Tree (*haihara*) that is often carved or painted on the exterior walls of traditional Toba habitations. Toba. Height 127 cm. Inv. 3171-A and B.

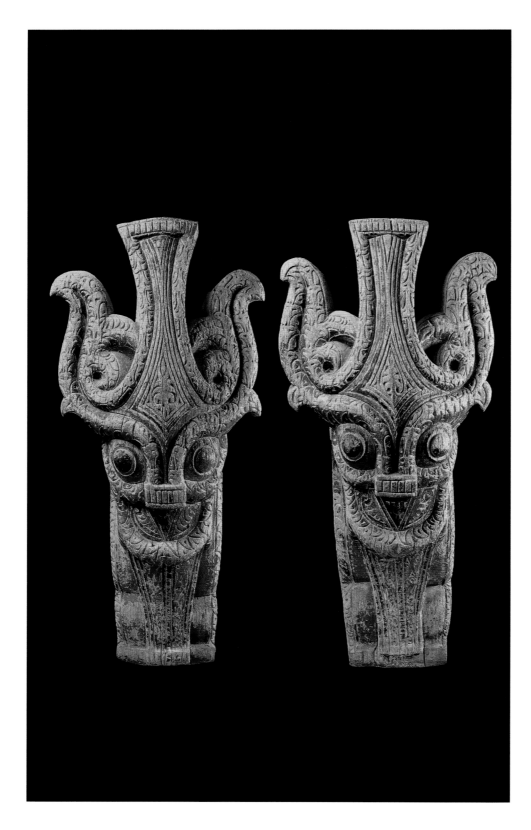

with scales, proof, if further were needed, that the serpent and four-footed incarnation are one and the same beast. It is not possible to rehearse here the mythological background that allows the monster to be identified as a representation of a divinity from the lower world called Naga Padoha, whose task it is to carry the median world in which man dwells on its back.[2] The chief (unlike the magician) was invested with important ritual functions, since it was he who was responsible for carrying out the sacrifices appropriate to each Toba god. It is therefore no great surprise that the headman should come to be valued as the representative of his people, over whom he rules through his *sahala*—that power of the soul often reinforced by particular expertise in the realm of magic. Just as logically, the chief, the very essence of humankind, is depicted seated on a *singa*, while his house is placed—like the world it represents in miniature—on the back of the *singa* snake.

This second principle is also alluded to in delicately carved articles such as the knife in fig. 15. The handle has been shaped into the torso of the powerful personage (chief or sorcerer) who possessed it, while the guard is carved in the form of a *singa* in whose neck are encrusted a number of human teeth intended to recall some propitiatory sacrifice. There also survives a figure in brass (worn to a sheen) who sits astride a *singa* carved out of the same piece as its wooden base (fig. 14). Long ago, the whole piece would have formed the upper section of another type of magic wand, described as the "assistant" or "concubine" of the main one. The principal wand was known among the Toba as the *tunggal panaluan*, while the "concubine" was known as *tungkot malehati* (the first word signifies not only "stick," but also a man's second wife).

### 13 Small receptacle (*guriguri*)

Chinese porcelain enclosed in a basketry lattice. The vessel was designed to hold the most efficacious of all the mixtures the magician prepared, the *pupuk,* which contained organic matter of human origin. The lid of this *guriguri* represents a female figure whose body, like that of the four-legged *singa* on which she rides, is covered in scales. The horned snake and the scale-clad buffaloes are effigies of Naga Podoha, the great three-horned cosmic serpent on whom the earth rests. Toba. Height 14 cm. Inv. 3181.

### 14 Tip of a magic wand

The figure is in bronze and the mount is wooden, both having acquired a patina over time. These wands, called *tungkot malehat* in Toba, always incorporated a single figure or "rider" on the pommel (see also fig. 10). Toba (?).
Height 24.5 cm. Inv. 3111.

### 15 Magician's knife (*piso ni datu*)

The magician in person (?) is seated on a human-headed *singa.* The figure's torso and the back of the creature's neck are encrusted with minuscule human teeth (according to an examination by Dr. Christian Simon, Department of Anthropology of the Faculty of Science, Geneva University). Toba. Formerly Tom Murray Collection. Height 32.5 cm. Inv. 3104-K.

### 16 Magician's knife (*piso ni datu*)

Exhaustive explanation of the decoration on this piece would require a complete study. A figure sitting astride a coiled serpent is grasped round the stomach by the quadruped-type *singa.* Eight other human figures are placed step-wise one above the other, some on the sheath, others up on the hilt. The "archaic" Toba style apparent here is reminiscent of the magic wand in fig. 1, and the knife itself has occasionally been described as a *pakpak.* The *pakpak* we know of, however, are far more angular, with sharper edges. The enigma remains unsolved. Height 62 cm. Inv. 3104-H.

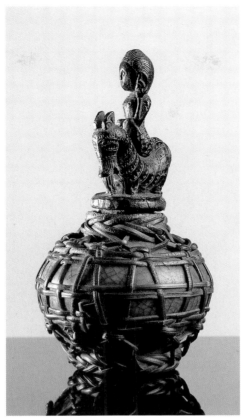
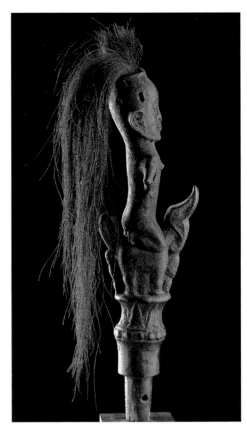
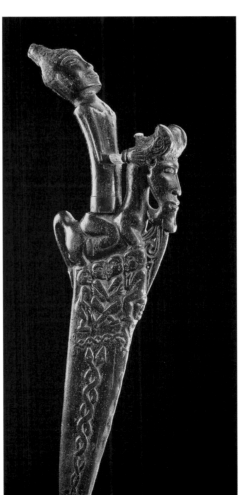
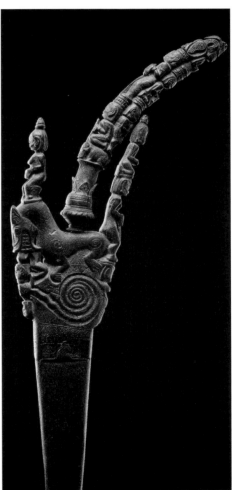

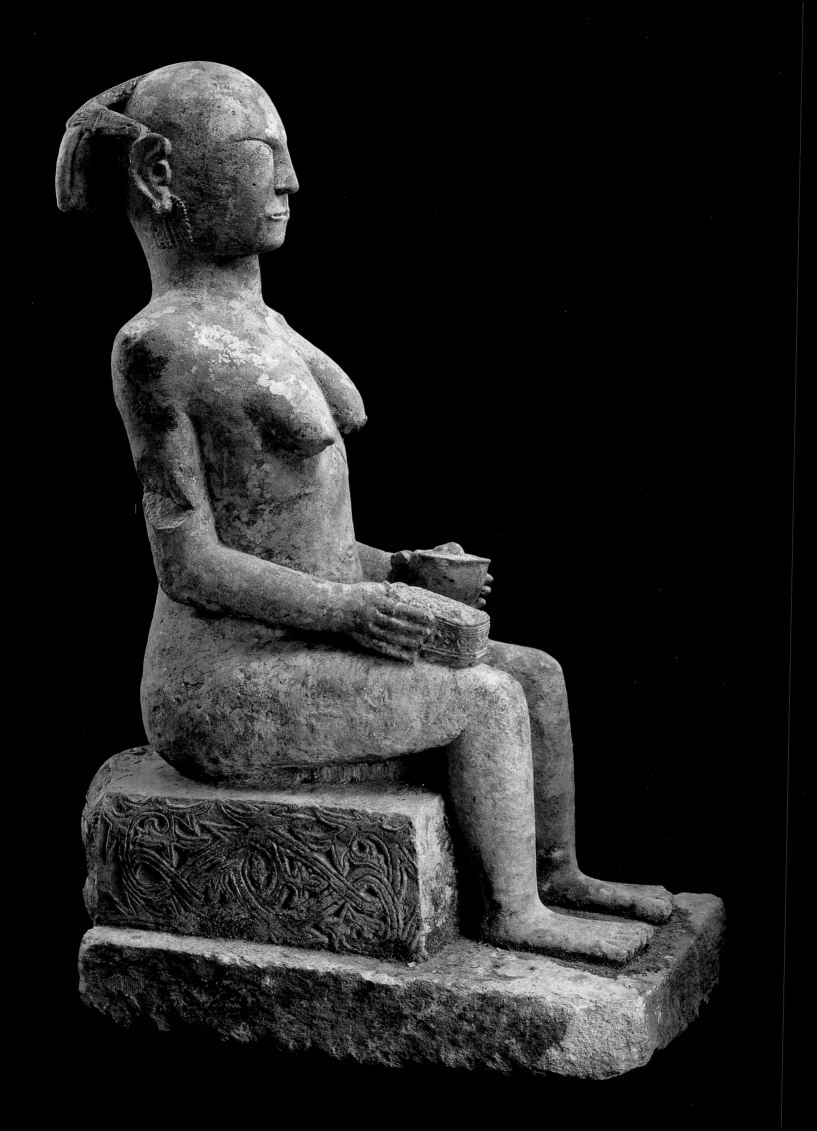

## 17 Portrait statue

Stone. Showing Ronggur ni Ari, from the Barutu clan of the Pakpak Batak, wife of a chief and magician of the Simanjuntak Toba clan, from near Barus. First half of the nineteenth century. A complete study of this remarkable piece has been undertaken (Barbier 1993). Toba. Height 116 cm. Inv. 3196-1.

Incised, carved, or molded effigies of the *singa* appear on countless architectural elements, statuettes, articles of a magical or everyday nature, weapons, and items of jewelry (figs. 12, 16, 18, 19). The characteristic art of the Toba is large-scale stone statuary, and this is true to a lesser extent of the Pakpak. However, such work is extremely rare among the Simelungun. Among the Toba, the task of carving was allotted to specialized *datu panggana*, meaning "magician-sculptors" (*ganagana* is the local equivalent of the Malay and Indonesian *patung*, meaning "sculpture"). Villagers possessing such a stone effigy of an ancestor (which could be life-size; fig. 17) often know the name of the sculptor, as well as the identity of the person portrayed and the number of generations separating him or her from their living descendants (thereby allowing for approximate dating). It has become clear that renowned "artists" from villages a great distance away were called upon to execute the portrait. This phenomenon makes identification of regional styles singularly arduous, all the more so since these "magician-sculptors" might settle far from their home village to learn their trade and tended to blend their native tradition with that of the region where they were apprenticed.

It is impossible to enumerate here all the distinct types of magical-cum-religious artifacts that a *datu panggana* might produce. Mention should be made, however, of the masks used by the Karo (fig. 20), the Toba, and the Simelungun, primarily in the course of funeral ceremonies; doors to rice stores (*sopo* in Toba), invariably decorated with the figure of a lizard, emblem of the fertility goddess Boraspati ni Tano (fig. 24); carved lute necks (*hasapi* in Toba; fig. 21); and the

## 18 Large vertical plank (*santung*)

A decorative element from the front of either a house (see fig. 8) or a rice store. When the *singa* is shown frontally in two dimensions it is always endowed with "floral ears," although these also occasionally occur in three-dimensional carving, as in fig. 17. Toba. Height 216 cm. Inv. 3192-L.

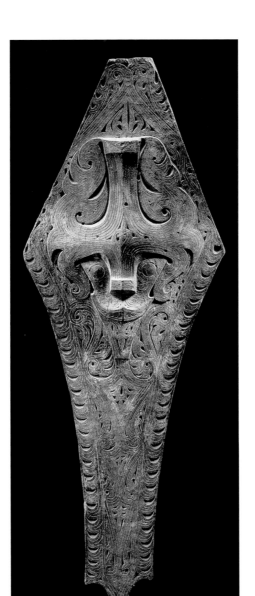

## 19 Man's armlet

Silver. The *singa* is here portrayed in the form of a snake. Toba. Diameter 8 cm. Inv. 3170-1.

## 20 Helmet-mask of the *toping* type

Once used by a "great magician" (*guru na bolon*) during certain ritual dances. During the ceremony, the dancer would also brandish carved wooden "hands." Karo. Height 45 cm. Inv. 3129.

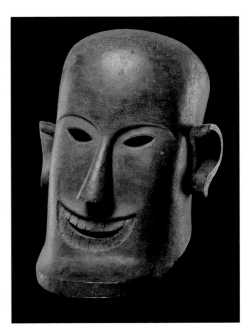

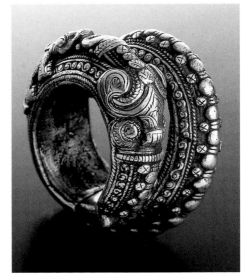

**21  Two-string lute (*hasapi*)**

Hardwood. The finial is carved in the shape of a woman sporting what appears to be a bird on her head. These lutes also existed among the Karo and the Pakpak, where the terminal figure is given a more schematic and angular treatment. Toba. Height 73.5 cm. Inv. 3168.

**22 and 23  Two powder flasks**

Wood and water buffalo horn, with an iron chain. The face motif, in which the heads decrease in size toward the top, has not been satisfactorily explained. Toba. Heights respectively 18.2 cm, 15 cm. Inv. 3174, 3119.

**24  Door to a rice store (*sopo*)**

Hardwood decorated in high relief with a lizard, symbol of fertility. Toba. Height 127.5 cm. Inv. 3191.

little powder flasks or horns (figs. 22, 23) and musket-shot holders (the Batak abandoned shields for firearms long ago; today the former are only wielded at war dances).

A closer study of the pieces slumbering in the storerooms of a number of Western museums would quite possibly allow one to build up an outline classification of the different styles, such as the author of the present article has attempted in his *Messages de pierre* (1998). The task is less onerous for the stone sculpture of the Toba, since a number of monuments remain in situ in the villages where they were made. Easily portable items, however, have passed from owner to owner, so their exact provenance is now impossible to establish.

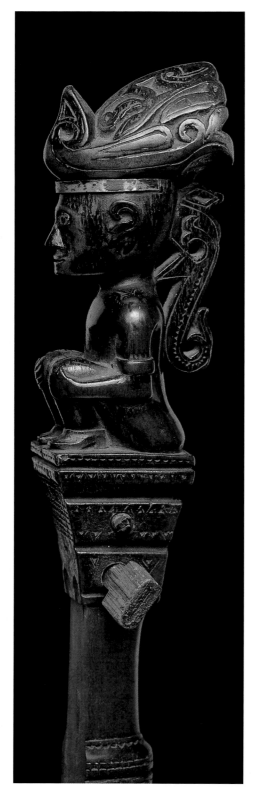

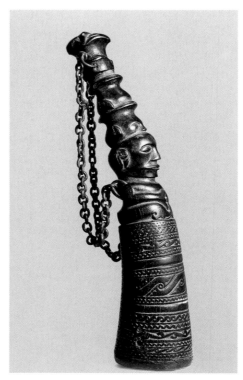

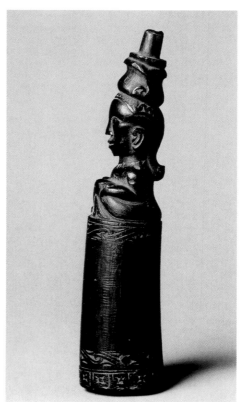

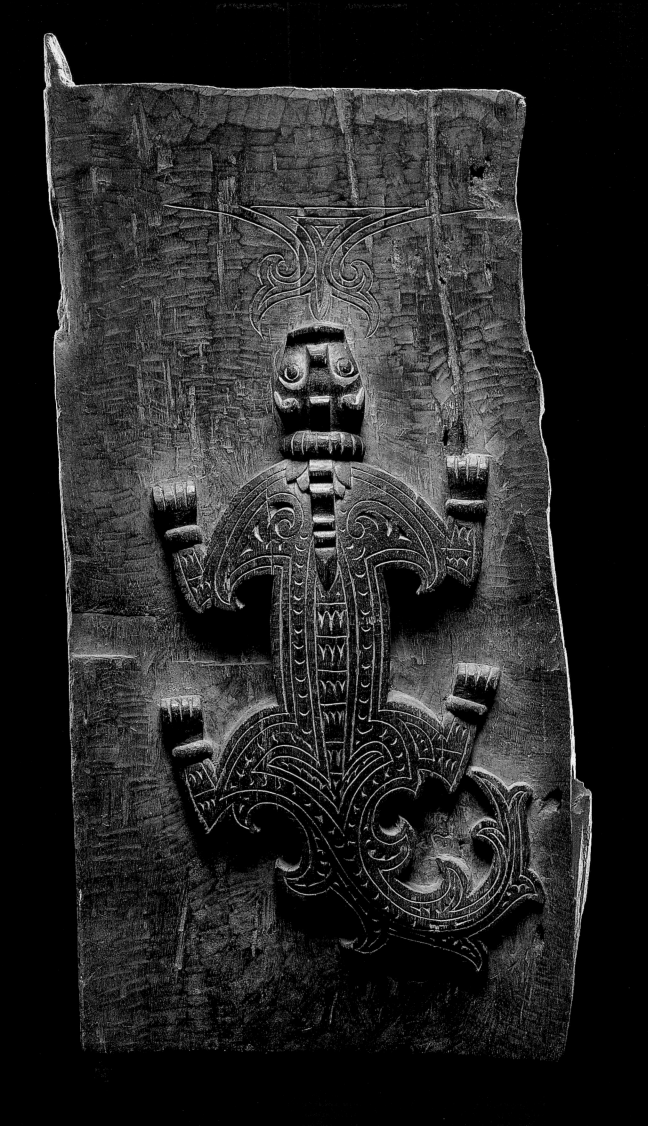

# Lampung

## Art Forms and Ritual in Southern Sumatra

Jean Paul Barbier

The province of Lampung occupies the
southernmost tip of the enormous island
of Sumatra. Bordered on the northeast by
the Mesuji River and to the northwest by
the mountains encircling Lake Ranau, it is
inhabited by three interrelated groups: the
Abung, who live in the western part, the
Pubian, restricted to a small central area,
and the Paminggir, who inhabit the coasts
(*pasisir* in Indonesian) and who began to settle
in Abung territory between the Sungkai and
Abung Rivers at a relatively recent date.
Two high-peaked mountain ranges straddle
the valley of the Semangka River, which dis-
gorges into a bay of the same name deep in
Paminggir country.

Little is known of the ancient ancestor cult
religion of the area.[1] Greater familiarity with
it might help to explain certain motifs and
scenes that figure on the famous fabrics from

**Lampung – Sumatra**

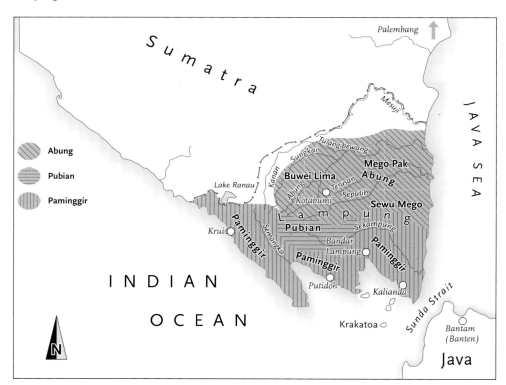

1 *Papadon* seats, which gave their name to
the ceremonies described in this chapter, were
formerly made from stone blocks. After Funke
1958, fig. 40.

the region, a few of which are reproduced here. In fact, part of the kingdom of Srivijaya (capital Palempang), pepper-rich Lampung had been governed by the sultans of Bantam (Banten) since the sixteenth century. From that time Islam gained ground among all three groups (the final converts probably date from the end of the eighteenth century at the latest), although they continued to observe many of the prescriptions enshrined by *adat*.[2] It is safe to say then that rites such as human sacrifice were abandoned because they were outlawed by the colonial authorities and later by the modern Indonesian state, rather than as a direct consequence of the conversion of these groups to Islam.

### *Papadon* feasts

The Abung attracted studies both in the nineteenth and in the middle of the twentieth centuries.[3] The Pubian and the Paminggir seem to have awakened less interest, at least until recently, when it was realized that the latter were the creators of the celebrated "ship cloths," impressive fabrics whose length can attain several meters.

The traditional ceremony of the *papadon* seems to have been familiar to all three groups mentioned above and is relatively well known, even though the data we have proves on occasion inconsistent. The *papadon* system itself is based on costly feasts organized by an individual so as to obtain a higher social position and in the process acquire a new title or honorific name. There exist striking parallels between the *papadon* feast and the *owasa* ceremony on Nias, with which it can be usefully compared. The existence of this type of feast has never been described as occurring among the Batak, though elderly

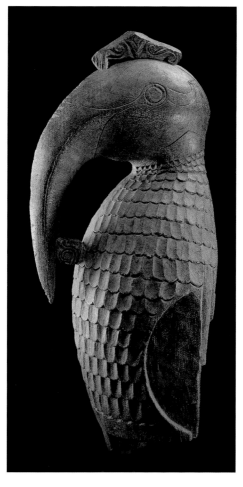

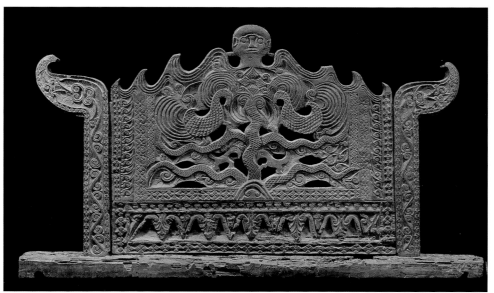

2 **Large bird effigy**

Wood. Apparently carved in the shape of a hornbill. This piece decorated the "chariot" (*rata*) in which a member of the nobility would be seated during a *papadon* feast. Abung. Southern Sumatra. Height 89 cm. Inv. 3241-1.

3 **Chair back (*sesaka*)**

Carved wood. Part of the "seat of honor" (*papadon*), on which the organizer of the feast would sit. Abung. Southern Sumatra. Width 214 cm. Inv. 3241-2.

**4 Cloth (*tampan*) of the *darat* (inland) style**

The decoration is composed of geometrical patterns, primarily "key" shapes derived in fact from angular spirals. Dimensions 66 x 79 cm. Inv. 3240-29.

**5 Cloth (*tampan*) of the *darat* (inland) style (?)**

Cotton. Supplementary weft.
Dimensions 75 x 59 cm. Inv. 3240-20.

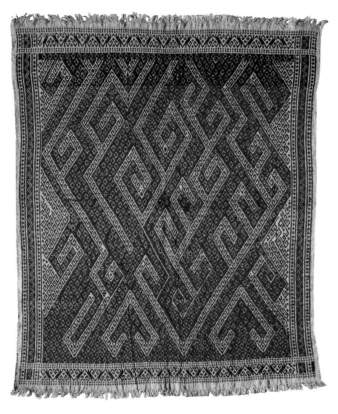

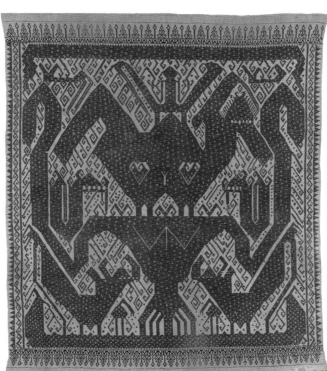

informants do refer to great feasts given in the past by powerful or rich personages when the donor was invested with a new name. Similarly, the Minangkabau and the Redjang of central western Sumatra used to operate a system according to which particular titles could be acquired by the members of noble families. It can be safely assumed that the elevation of a noble to the summit of the social ladder through such redistribution of wealth (primarily in the concrete form of the countless animals consecrated in sacrifice and subsequently eaten by the guests) constitutes a throwback to an ancient socioreligious heritage common to all the various Sumatran groups. This might explain why there are markedly similar stone monuments (such as "seats of honor," statues of horsemen, and gigantic ceremonial mortars) throughout the huge island.

The Abung are divided into three major federations: the Buwei Lima in the northwest, the Mego Pak to the northeast, and the Abung Sewu Mego (the largest group) throughout the rest of Abung country (see map p. 52). The first of these federations comprises five subtribes or clans (*buwei*); the second, four; and the third, nine. The territory occupied by a *buwei* is termed a *marga*. Each *buwei* is further subdivided into subclans called *suku*, a word that also designates the area or district of the village (*tiuh*) inhabited by the members of the subclan. The *buwei* are endogamous and the *suku* are exogamous, filiation being patrilinear.

At the head of each social entity stands the chief. The village headman (*penyimbang tiuh*) occupies a position above that of the subclan chiefs (*penyimbang suku*) who make up the village council (*proatin tiuh*), while the chiefs

6 **Cloth (*tampan*) of the *pasisir* (coastal) style**

Cotton. Supplementary weft. Characterized by horses "dancing" on either side of a ship's mast that represents the World Tree. West Lampung coast, around the Bay of Semangka. Dimensions 58 x 58 cm. Inv. 3240-32.

7 **Cloth (*tampan*) of the *pasisir* (coastal) style**

Cotton. Supplementary weft. East Lampung, from near Kalianda. Dimensions 72 x 72 cm. Inv. 3240-22.

of the *buwei* comprise the democratically constituted supreme council of the confederation. The function of the *penyimbang* being hereditary, only the higher Abung aristocracy was historically able to ascend to the four grades (three among the Paninggir) that constituted the ideal *cursus honorum* of every individual who inherits political power. In fact, before being allowed to take on his role, the chief of a clan or village had to be in a position to organize the requisite feast days. The applicant was taken to the meeting house (*rumah sesat*) that lies in the center of the village square aboard a four-wheeled "chariot" (*rata*) adorned with a bird effigy (fig. 2). He is enthroned on a seat from which the whole ceremony derives its name, the *papadon* (fig. 1), in former times built from a block of stone (*papadon batu*). The seat-back (*sesako*) of the "throne" is carved with curvilinear patterns in relief and symbolic figures representing birds, elephants, human beings, creepers, and trees (fig. 3). This removable seat-back is carried off to the candidate's house after the ceremony, the chariot and seat itself remaining in the communal house. Finally, the candidate has the right to have carved a "door of honor" (*lawang kori*), through which he can pass only once as he sets off from his house on his way to the ceremony.

A war dance still recalls the ancient obligation incumbent upon the aspirant to arrange a successful head-hunting raid. In similar vein, a supplementary "tax" has evolved that now supplants the traditional system of slave sacrifice.

The successful candidate to this "right to the *papadon*" is henceforth licensed to wear clothes of a particular color, to carry two or

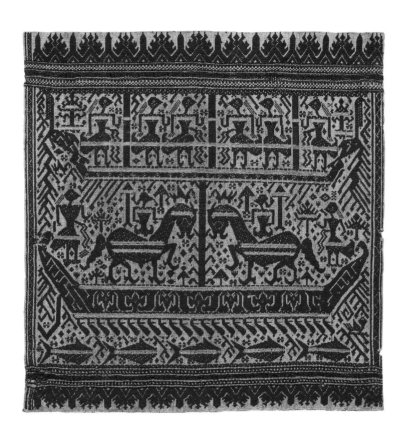

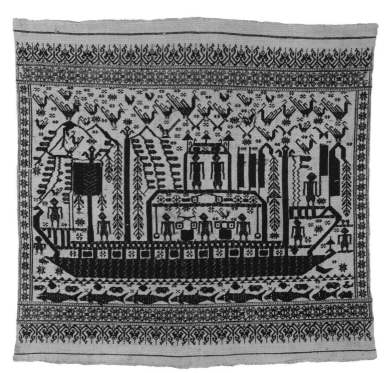

## 8 Mat

Bamboo strips. The pyrographed decoration on the honey-colored ground shows sun motifs in the center and in the corners, and elsewhere crescent moons, flying birds, and small vessels, some ferrying passengers; also as yet undeciphered inscriptions. West *pasisir* region (?). Dimensions 80 x 110 cm. Inv. 3240-12.

several *keris* (daggers) at his belt, and to be accompanied by one or more underlings carrying sunshades.

When Lampung came under the authority of the Javanese sultanate, the latter assented to

investing wealthy individuals with honorific titles, which had hitherto been restricted to the sons of headmen. This newly acquired rank, however, did not entitle the possessor to reach the position of chief of a subclan, village, or clan.

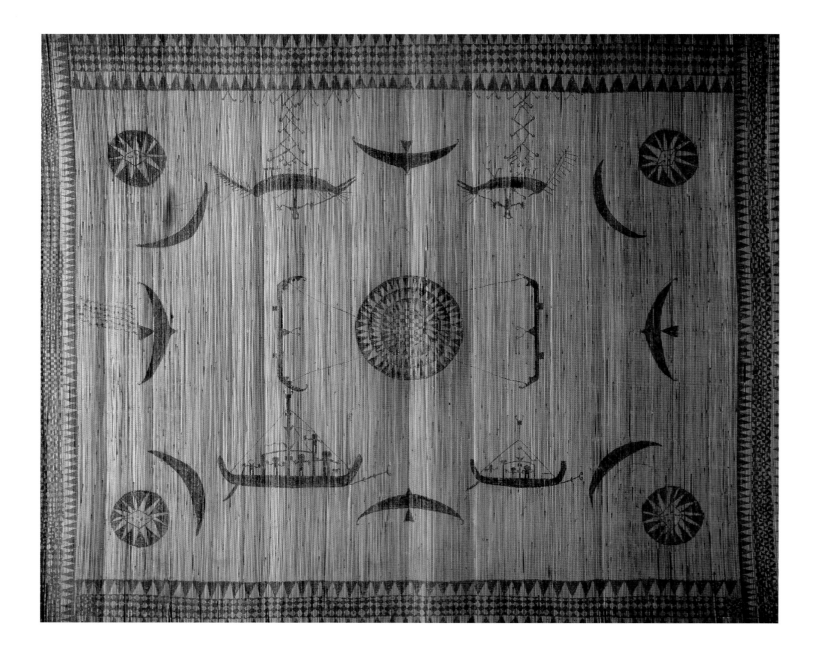

9 **Large cloth (*palepai*)**

A rarer type than the cloth showing boats in fig. 12 (detail). The design, blue on yellow, features a frieze of figures wearing strange head-dresses who appear to be kneeling. *Pasisir* region. Length 340 cm. Inv. 3240-5.

## Ceremonial Fabrics

Lampung ceremonial cloths do not form part of a garment. They are woven using the supplementary-weft technique and belong to three different categories, the first alone being common to all three population groups (Abung, Pubian, and Paminggir), the two others being produced exclusively by the Paminggir.

First in size come the *tampan,* small fabrics, square in shape, the sides measuring between 30 and 80 centimeters; then there are the oblong *tatibin,* never longer than a meter; and finally the great *palepai,* often called "ship cloths," which can be anything between 3 and 5 meters in length. These cloths date for the most part from the nineteenth century, the last examples apparently being manufactured around the time of World War I.

*Tampan* (figs. 4, 6, 7) are used in the same way by all three Lampung populations. They are brought out on the occasion of any rite of passage—childbirth, weddings, feast days, acquisition of *papadon* grades—and can fulfill a wide range of roles. They are used as covers for food containers or for seats, draped over the shoulders of a participant at a ceremony, used to swaddle a newborn infant, and as cloths laid under vessels em-ployed in magic practices so as to prevent them coming into direct contact with the surface beneath. The decoration on a *tampan* comprises a key-shaped, angular, geometrical pattern that contrasts strikingly with the curvilinear style of the wood carvers of these same regions. The technical constraints imposed on the weaver by the supplementary-weft technique evidently has some bearing on this characteristic.

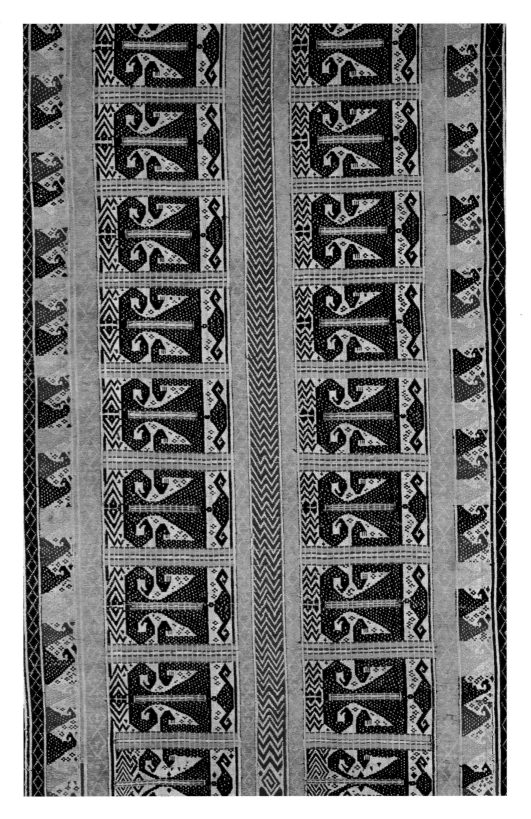

Dark blue cotton embroidered with a gold-thread pattern representing horsemen and figures in boats. Abung. Southern Sumatra. Height 118 cm. Inv. 3240-13.

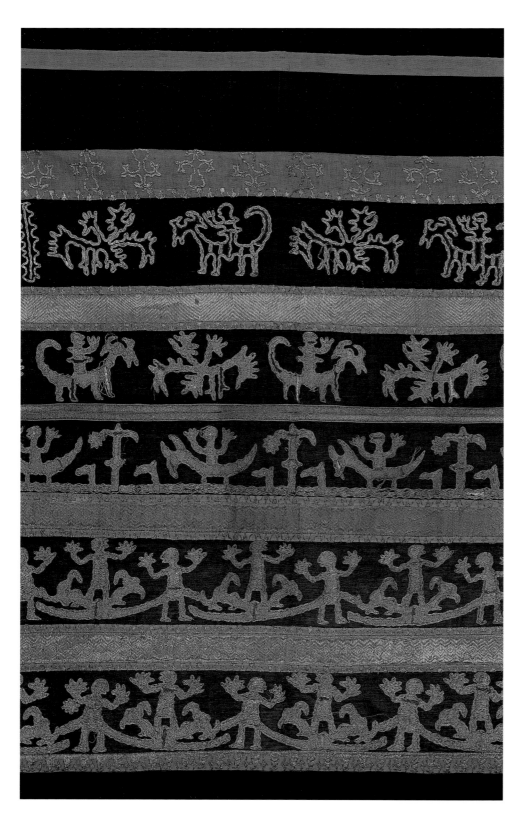

The square cloths from the Lampung interior (*darat* style) are decorated with a purely, or principally, geometrical, abstract style (fig. 4), whereas fabrics from the coastal regions occupied by the Paminggir (fig. 6) often include figurative scenes (*pasisir* style). Features include animals, a vessel with people aboard, the World Tree, various types of building (perhaps alluding to the *sesat* in which the ceremonies took place), and "shelters of honor," under which stands a personage alone, a couple, or, in rare cases, a group. The boats are armed with cannons and adorned with gongs, evoking an immediate comparison with the "soul ships" of the Dayak of Borneo.

Rehearsing an argument now familiar to art historians, Alfred Steinmann established a lengthy pedigree for these characteristics, leading from the vessels that convey the plumed figures of bronze Dong Son drums to more modern representations of boats in the arts of archaic Indonesia.[4] Research undertaken in Lampung, however, has never succeeded in demonstrating that the "soul ship" motif observed among the Dayak finds a genuine echo elsewhere.

It cannot be affirmed with certainty therefore that the boats shown on *tampan*, and which can be of grandiose dimensions on *palepai*, do in fact represent the souls of the high-ranking dead sailing off toward the world beyond. It is true nonetheless that, unlike the situation among the groups of the interior where *tampan* might belong to anyone, *tampan* among the Paminggir are solely the property of aristocratic families. Be that as it may, the symbolism of the ship can be applied to a man or his family at many stages throughout his life, and not merely at the moment of death.

The Paminggir coastal areas to the east (around the town of Kalianda) and to the west (the fringes of the Bay of Semangka) were the birthplace of both styles treated here. The eastern *pasisir* style shows a preference for depicting two- or three-masted vessels sailing across a stretch of ocean which is home to various species of crustacean, fish, and turtle (fig. 7), while birds fly overhead. The superstructure of the boat supports human figures: on the upper deck stands a man (or a couple), clearly of high rank. In the western *pasisir* style the vessels are of less impressive size. Two "dancing" animals are placed on either side of a central mast; here (fig. 6), they are horses, but lions and buffaloes also occur.

Other *tampan* (fig. 5) have as their central motif a half-bird and half-dragon monster, or else a human figure whose legs grow into tree roots and which it is tempting to take for an image of the World Tree. The natural tints used on *tampan* are red, blue, and yellow, all melding with the beige that is the color of undyed cotton.

*Palepai*, produced exclusively by the Paminggir, are among the most spectacular textiles of the tribal world, together with the fabrics of Pre-Columbian Peru. Their very dimensions are extraordinary—the example in fig. 9 measures 3.4 meters and the one reproduced in fig. 12 is no less than 4.63 meters long. Their manufacture represents an astonishing technical feat. The best known are illustrated with a pair of long-hulled vessels where both stern and prow are decorated with curved spars, picked out in red or blue on a yellow

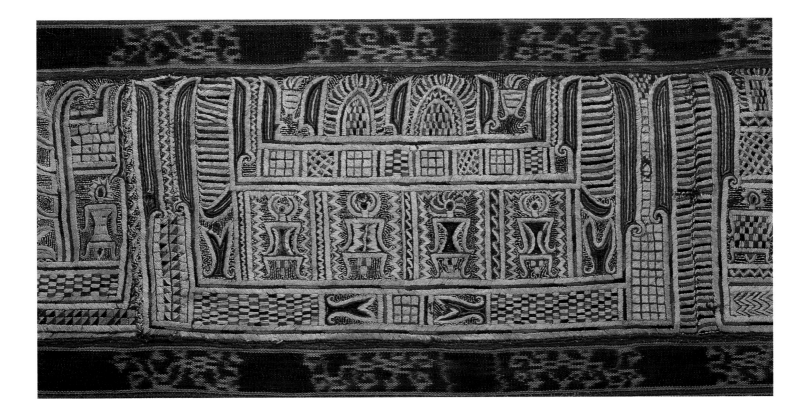

ground. The ornamentation in fig. 12 is of outstanding richness: in the middle of groups of people dressed "Javanese-style" in blue and red stand masts strung with pennants, parasols, and trees (almost certainly representing the *kayu ara*, an artificial tree constructed from bamboo from which were hung lengths of fabric during important feast days).

Other, much scarcer *palepai* (fig. 9) depict a series of human figures in blue on a yellow ground. They seem to be sitting on their haunches: on either side of their heads there is a spiral, perhaps intended to recall the *siger*, the gold or gilt brass "horned" headdress worn by women.

These long bolts of cloth were hung from the walls of the meeting house during the ceremonies held to mark each rite of passage. The two types of decoration that we have examined briefly resurface on *tatibin*, which rarely measure over 1 meter and which are also found uniquely among the Paminggir.

## Bamboo Mats

The precise origin of these mats made of strips of pyrographed bamboo has not yet been established. The example reproduced here (fig. 8) is supposed to have come from the Bay of Semangka region. In the middle and in each of the four corners sun motifs are visible, while lunar symbols and small boats whose passengers stand either side of a mast decorated with prongs are arranged over the rest of the composition. The border is etched with a double pattern of *tumpal* (sawtooth). There also appear inscriptions (as yet undeciphered) apparently inscribed in

a phonetic alphabet peculiar to southern Sumatra. These mats (mentioned but not described by Funke) have an obvious ceremonial role. They are rare in the extreme and have never been subjected to detailed study.

## Garments

Photographs taken in Lampung early in the twentieth century make it possible to gain some idea of the splendid attire worn by aristocratic men and women during the numerous festivities which punctuated their lives. Lack of space restricts us to two examples here. The first is a cotton skirt (*tapis*) of Abung origin (fig. 10), on which the gold-thread embroidery on a dark blue ground depicts a small sailing vessel laden with various personages, together with horsemen and birds. The second is a detail of the silk embroidery decorating another cotton skirt (fig. 11), where the embroidered borders are separated by ikat areas.[5] These outer bands are illustrated with an ornamental motif of a sailing vessel with a very high prow and sternpost; on the deck stand four schematic figures. This ceremonial garment was also made in the mountainous region inland.

The keen interest manifested by collectors for what were formerly termed "Krui" cloths, from the name of a tiny Indian Ocean port mistakenly thought to be the manufacturing center for "ship cloths," has shed partial light on the peoples who actually created these fabrics and the context of their ancient ancestral beliefs. The country inhabited by one of these populations, the Abung, is to this day dotted with megalithic monuments, mere blocks of unworked stone, the only evidence of ancient rites such as the *papadon* ceremonies,

which, though modified by the enduring influence of Islam, were perpetuated to early in the twentieth century. If archaeological investigation is ever undertaken, perhaps anthropomorphic or zoomorphic sculptures will be uncovered that might permit scholars to determine whether there was indeed a cultural link between Lampung and the more northerly Pasemah region, where numerous monolithic monuments have been discovered, including effigies of horsemen and other figures carrying bronze drums on their backs.

Whatever the future may hold, the enigmatic and sumptuous "ship cloths" are enough in themselves to ensure for southern Sumatra a place of honor among all the regions of "outer Indonesia" we have dealt with so rapidly here.

Cotton. Supplementary weft. Decorated with two vessels lying side by side. The boats are picked out in red. Each is equipped with a mast in the basic shape of a tree. To the left and the right of the central mast, couples (the man in red and the woman in blue) stand shaded beneath the kind of parasols reserved for nobles. Eastern *pasisir* region (from around Kalianda). Length 463 cm. Inv. 3240-2.

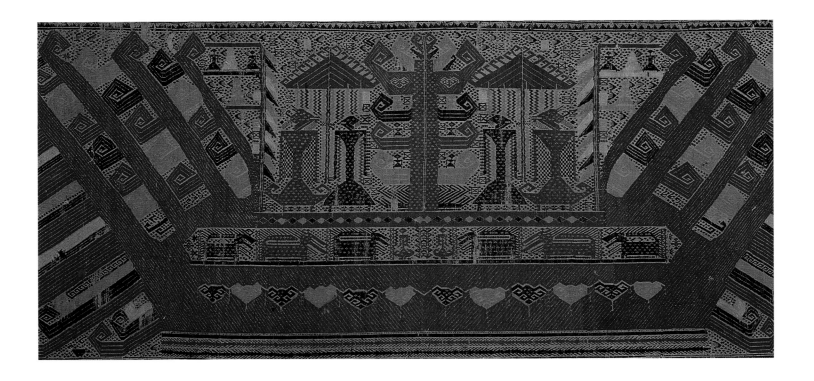

# The Iban of Sarawak

Traude Gavin

**Borneo**

The Iban are a people of northwestern Borneo who speak a single Ibanic language with only minor regional dialect variations. Today they number about 500,000, the majority of whom live in the Malaysian state of Sarawak. Traditionally, the Iban reside in longhouses built along rivers of the interior and sub-coastal districts, practicing shifting hill rice cultivation. Despite an increase in migration to urban areas in recent years, the great majority remain in longhouse settlements. Today, in addition to hill rice, Iban farmers cultivate cash crops such as rubber, pepper, and cocoa.

## Status and Prestige

Iban social structure is classless. Status differentiation is gained through personal achievement, rather than inherited rank. The result is a highly competitive society. Formerly, one means for men to gain status was the pioneering of primary jungle for swiddens. The leader of a migration into new territory secured for himself a position of prominence and prestige. In addition, the family of the man who first claimed a tract of jungle acquired the right to farm the land in perpetuity. In some districts of Sarawak (for example, the Baleh River basin), vast areas of rainforest were made available to Iban settlers as late as the 1920s.[1] More than three generations later, the descendants of the first settlers tend to be in a more advantageous financial position than those who moved into the area later, when no more primary jungle was to be had. In other regions (such as the Saribas district), inherited inequalities in landholding reach back much further, to the beginning of the nineteenth century.[2] In other words, although Iban society still lacks a class system as such, the distribution of

wealth as far as farmland is concerned has become permanent.

In the past, the foremost means of acquiring prestige was to participate in head-hunting forays. The man who brought home an enemy's head acquired immense prestige, and even higher honors were bestowed on the leader of a fighting group of warriors. Head-hunting has been a custom of the past for some time (fig. 1). The last rebels to defy the Brooke Raj were ousted from their upriver hideouts in the 1930s.[3] However, the rites dedicated to the cult of head-hunting (*gawai amat*) survive in a modern context. Formerly, a head-hunter's progression in status was validated in a series of ascending stages of rites. The first stage was appropriate for a man who merely participated in a raid, while the highest stage was reserved for the most successful of war leaders. The central feature of these rites, which last several days and nights, is the bards' chanting, inviting the god of war, Singalang Burong, to attend the feast held in his honor. Today, these rites are sponsored by men in positions of social and political prominence and power. Then as now, the endorsement for holding such a rite is derived through dreams. Generally, a deity or deceased relative appears in a dream to give his or her blessing. Often, the blessing is issued as a command, threatening ill health or even death should it be disregarded.

## Women and Weaving

Formerly, women gained respect by being accomplished housewives, mothers, and farmers. However, the main prestige activity for women was the weaving of ritual textiles. As a gender-defining activity, weaving is equated with head-hunting. For example,

the unborn child is said to be given the choice between a spear and a weaving implement and by choosing one or the other determines being born as either boy or girl. Weaving as a whole (but more specifically the treatment of yarns prior to dyeing with morinda, called *ngar*) is referred to as the "women's warpath" (*kayau indu*).

Iban weavers produce blanket-size cloths (*pua*; fig. 3), skirts (*kain*), loincloths (*sirat*), and jackets (*kelambi*) in various supplementary weft techniques (*songke, sungkit* [fig. 2], *pilih*).

1 Young Iban warrior carrying two head trophies. Photograph Charles Hose. Barbier-Mueller Archives.

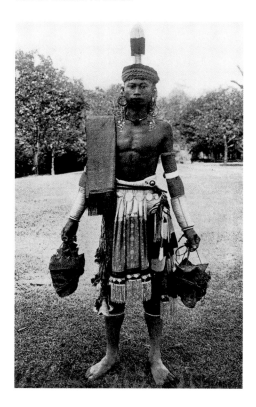

**2 Cloth of the *pua sungkit* type**

Cotton. *Sungkit* is a supplementary weft technique which today is practiced by few Iban weavers. This appears to have been the case in the past as well, as early *sungkit* cloths (such as the example featured here) are quite rare. Little is known about the motifs shown, some of which are exclusive to the *sungkit* technique. Height 196 cm. Inv. 3462-18.

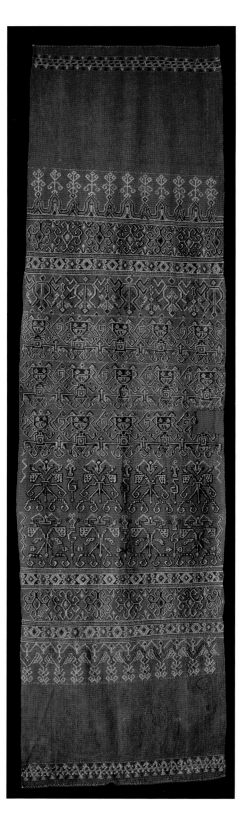

The main technique employed for ceremonial skirts and the all-important blanket-size *pua kumbu* cloths is ikat. The ikat technique is practiced throughout the Indonesian archipelago and is found in many other parts of the world as well, particularly in Japan and India. Ikat (*kebat* in Iban) is a resist-dye process in which bundles of the warp or weft, or both, are wrapped or tied off to prevent penetration of the dye, thus creating a pattern before the weaving stage is reached.

An accomplished weaver is capable of producing various types of textiles in different techniques. Above all, she is expected to weave high-ranking *pua* patterns (see below). More advanced weavers are able to create their own cloth patterns, inspired in dream visions. The highest accomplishment is to lead the *ngar* process mentioned above, in preparation for dyeing with morinda. No weaver will dare to carry out the more advanced tasks without being authorized to do so in a dream. This largely holds true today.[4]

Weaving is still practiced today, but rarely outside a longhouse setting. Even the most enthusiastic weaver usually quits weaving after moving to an urban area. The reason usually given is that "there is no time." It is only in a longhouse situation where little or no diversions are on offer that women will set up their looms in order to "pass the time," as they say. Today, additional incentives for producing textiles do exist. One such incentive is to weave specially designed small cloths for the tourist market; another is to enter cloths in local competitions organized by the government. However, the financial gains of producing cloths for sale are negligible. If calculated on an hourly basis, the amount barely registers; and the prestige gained from

doing well in weaving competitions cannot be compared to the opportunities available to Iban men in the civil service, business, and politics.

In urban life, weaving continues as a means of accumulating prestige and status, albeit in an entirely new form. Since the 1980s, it has become fashionable among the urban Iban elite to accumulate collections of Iban textiles, purchased from local traders. Occasionally, some of these cloths are exhibited locally and published.[5] The Iban owners of these collections are rarely weavers themselves and often have been raised far from a longhouse setting. At least one motive for forming such collections is to provide an alternative to exodus for the Iban who remain in the longhouse. To the less privileged, the buying up of textiles is just another means of competing for status, but they would rather see their cloths disappear into Western shops and museums than into the coffers of a fellow Iban.

## Ritual Function of Cloth

Perhaps the most basic function of cloth is to mark a ritual as such. At least in a longhouse setting, whenever cloth is in evidence it can be assumed that some form of ritual is taking place. Cloth indicates to both gods and humans that ritual is under way and that their attention and respect is requested.

Objects are placed on top of cloth, covered by it, or wrapped in it. Ritual textiles are employed during rites of passage. A newborn infant is carried in a cloth to the first ritual bath in the river. A *pua* cloth is draped over a child and its grandmother during their ritualized "first meeting." *Pua* cloths cover the corpse and are included as grave-goods.

3  **Cloth (*pua kumbu*) (detail)**

Cotton. Warp ikat. Today textiles continue to play a central role on ceremonial occasions. Formerly, cloths with powerful patterns were used to ritually receive trophy heads from warriors returning from a foray. Dimensions 183 x 112 cm. Inv. 3462-9.

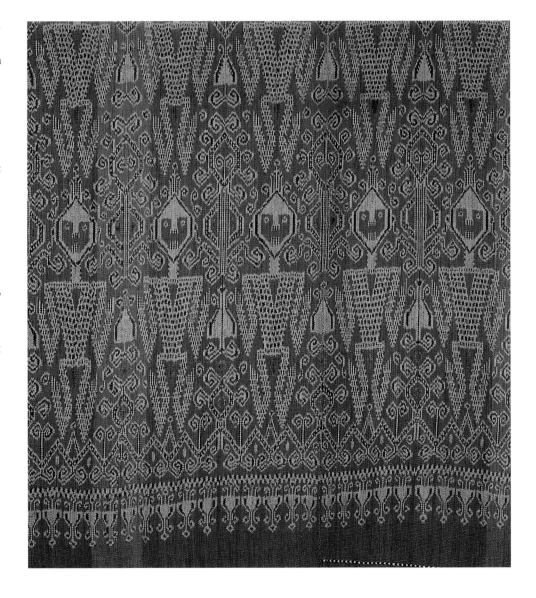

**4 Group of measuring sticks (*tuntun*)**

Hardwood. Commonly referred to as "pig charms," *tuntun* consist of a squatting figure at the end of
a long wooden stick. Such sticks were used to measure the correct height of the trip-cord when setting
a spring trap for wild boar. Heights of the four pieces, from right to left 52 cm, 54 cm, 51.1 cm, 51.7 cm.
Inv. 3438-B, 3438-C, 3438-E, 3438-G.

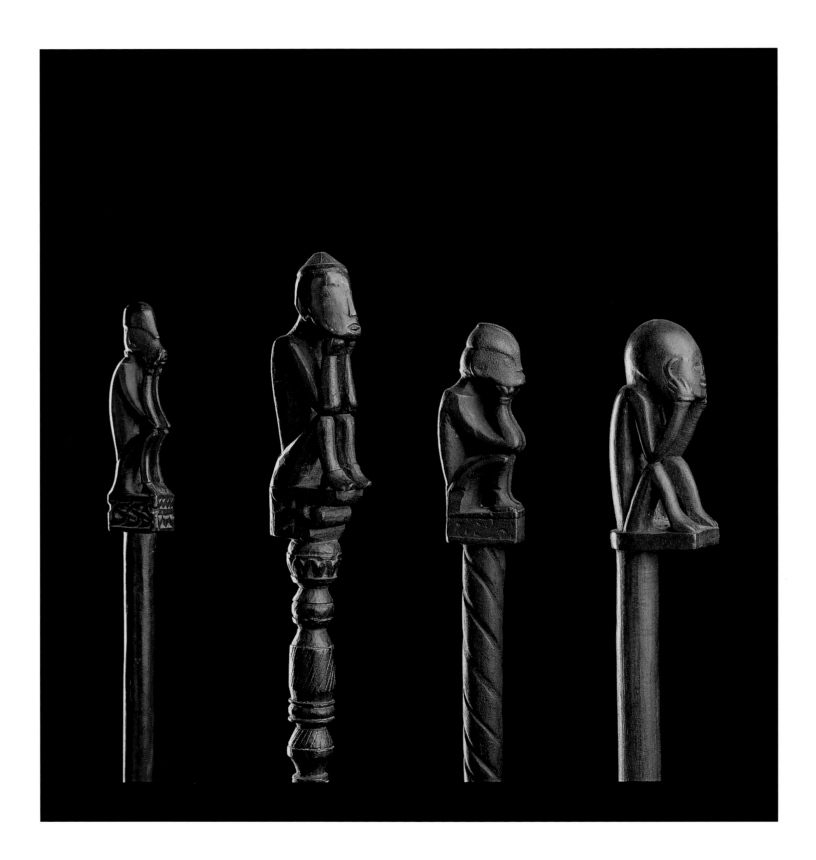

5  **Figure (*tuntun*)**

Hardwood. The greater length of this measuring stick indicates that it was used for setting traps for deer rather than for wild boar. This type of squatting figure is common throughout Southeast Asia. Height 63.7 cm. Inv. 3438-K.

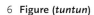

6  **Figure (*tuntun*)**

Pig trap charm. Height 52.5 cm. Inv. 3438-A.

In healing rites, *pua* are wrapped around a specially constructed shrine and cloths are suspended as a barrier to close off the long-house apartment. Ritual functionaries, such as bards and shamans, cover themselves with cloths for protection when performing ritual tasks.

During major rites, such as the head-hunting rites (*gawai amat*) still performed today, textiles are used throughout. The most important occasions are as a cover for the shrine that is erected for the duration of the festival; as an awning above sacrificial pigs; and for the reception of the pig's liver on a plate to be read as an omen. Formerly, the most exalted function of cloth was to ritually receive trophy heads (fig. 1) after a raid before carrying them into the longhouse.

Today, most Iban are Christians. However, this does not preclude the ritual use of cloth and often the two practices are found side by side. For example, for a traditional offering small plates containing various ingredients are arranged on a *pua* cloth and then combined on one large plate by the officiant to be presented to the gods. Today, it is not unusual for a lay priest to sprinkle holy water on the same offering while uttering a Christian prayer.

**Iban Cloth Patterns**

The oldest Iban cloth patterns resemble those found on plaitwork mats and baskets. The characteristics of these shared patterns are that they cover the entire surface in an unbroken design, consisting largely of coiled vinelike patterns.[6]

Iban weavers assign names to most motifs and even parts of motifs. Names may also

be given to a composition as a whole. These latter names function as titles which indicate not only the level of difficulty of the pattern, but also the ritual occasion for which it is appropriate, and the rank of the weaver authorized to make it. Many titles are well-known rank referents. For example, the "divided" pattern (*bali belumpong*) is widely

**7  Statue (agum)**

Carved wooden figure with a shield in the right hand. Like other ethnic groups in Borneo, the Iban carve wooden figures, some of which were commonly used as guardian figures for both farm and longhouse. Mujan longhouse. Sepak River. Second Division. Height 35 cm. Inv. 3471.

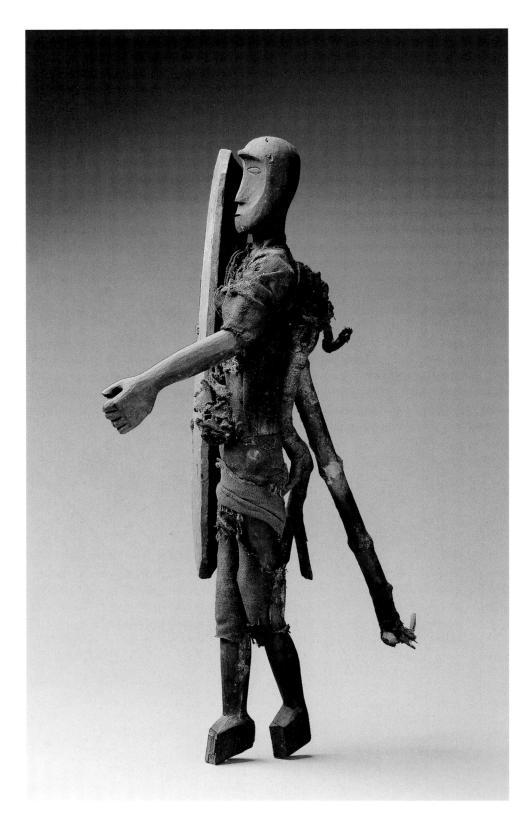

known as a high-ranking pattern only certain weavers are allowed to make. The name refers to the pattern's distinctive feature of a large unpatterned section in the center that divides it into equal sections (be-lumpong). Other famous titled patterns, such as the trophy head pattern (buah rang jugah) and the mythical tiger pattern (buah remaung), do not depict or represent trophy heads or tigers, but indicate the patterns' high rank by association.[7]

However, many names merely serve as a reference system to distinguish different kinds of motifs and patterns. Often, names are descriptive of what a design looks like, rather than what it represents. In other words, motifs called "bamboo shoot," "pigeon's eye," "leech," and "bird with a comb" do not depict or represent these objects, as has often been assumed.[8] Rather, these names function as mnemonics to recall and refer to motifs and patterns, similar to the checkerboard, herringbone, and hound's tooth patterns from a Western context.

Today's patterns continue to incorporate many of the old motifs. The overall arrangement and style of the large pua cloths also remain unchanged. However, there is a distinct move toward more graphic and literal depiction, and most modern patterns include large human figures. In addition, the use of aniline dyes and commercial cotton has become the norm all over Sarawak.

Undeniably, weaving as a cultural institution no longer occupies as prominent a position as it did in the past. It is also clear that most cloths produced by today's weavers do not exhibit the same standard of excellence as those made by their forebears. However, despite the enormous changes that have

**8  Hornbill effigy (*kenyalang*)**

Carved from a single piece of wood. Carved bird images continue to be a prominent feature in the hornbill festival (*gawai kenyalang*). At the culmination of the rites, the effigies are raised on tall poles, usually pointing downriver. Formerly Nelson A. Rockefeller Collection. Length 173 cm. Inv. 3464-B.

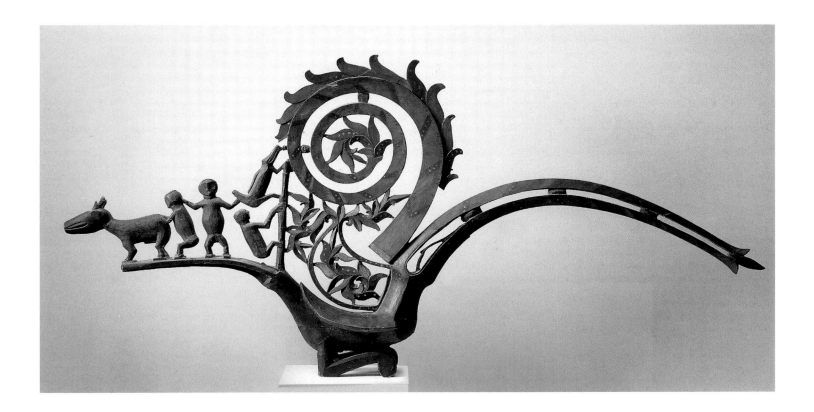

occurred in the lifestyle of the Iban people over the last half century, woven cloth and its manufacture continue to have significance that goes beyond mere nostalgia for the past.

## Carving and Sculpture

While the production of cloth is exclusively a women's affair, the necessary tools are crafted by men. Apart from the fairly simple apparatus of tying frame and backstrap loom, there are some tools, such as weaving swords and shuttles, which formerly were elaborately carved.[9]

Perhaps the most impressive Iban sculptural carvings are the so-called "pig charms" (*tuntun*; figs. 4–6), which consist of a squatting figure

at the end of a long wooden stick. *Tuntun* means "at the right height" or "time for."[10] In this context, the term refers to the function of the stick, which is to measure the correct height of the trip-cord when setting up a spring trap for wild boar or deer.[11]

The use of spring traps was outlawed over a century ago and the motive for carving measuring sticks no longer exists. There is, however, another notable Iban carving that continues to feature prominently in present-day head-hunting rites. This is a carved hornbill figure (*kenyalang*; fig. 8), which at the culmination of festivities is hoisted on a tall pole to be "sent off" to distant lands. In the past, this was done to weaken the enemy before an imminent attack, but today the

**9  Box (*lupong manang*)**

A bark box which was used by the shaman for keeping amulets and other paraphernalia employed in healing rites. The carved figures were intended to guard the contents. Height 28 cm. Inv. 3454.

purpose is to capture fortune and fame for the festival sponsor. Older examples of hornbill figures are minimalist carvings with beautifully balanced swooping forms, while modern versions tend to be much larger, with elaborate detail, gaily painted and festooned with tinsel.[12]

## Shaman Masks among the Sarawak Iban*

Iban masks, such as the example from the Musée Barbier-Mueller (fig. 10), are between sixty to eighty years old. The Iban, however, performed fewer masked ceremonies than other Dayak groups in Sarawak (particularly the Kenyah).

Iban masks were worn by a shaman during ceremonies in which he would take on the persona of one or more supernatural beings and appeal to them for help. People who had fallen ill because the soul had left its rightful home, the body, were treated by soul-catching rites involving the use of such masks. Following a protracted examination of the forest, the shaman would select a tree from which the mask would be carved. Once fashioned into the desired shape, the mask is held over the hearth and fumed black.

A mask could fulfill many roles, such as personifying a demon requiring exorcism, promoting good harvests, and embodying certain nature spirits or those of a particularly revered ancestor. They could also be used during funeral rites.

These masks, unlike those belonging to the groups living in Kalimantan, were abandoned following World War II, when the overwhelming majority of the Iban converted to Christianity or Islam, the latter being the preferred choice of the population today.

The Iban themselves will not willingly touch a mask since they are thought to harbor evil spirits. They were never kept in the house, the shaman alone handling them.

Lacking the refinement that characterizes the craft of the Kayan and Kenyah in the east of the island, the crudely carved masks of the Iban are not easily found in Sarawak and have become exceedingly rare. Any which were not at one time sold off were destroyed long ago.

*This section is a summary of an essay written in 1983 by Abdul Kassim Bin Ali, at the time curator at the Museum of Ethnology in Kuala Lumpur.

10  **Mask**

Hardwood. The flattened face is black in color, the only relief element being the nose. The mustache is painted in white on a dark background, lines of the same color also appearing around the eyes and over the teeth. The hair and beard are made of monkey fur. Height 32 cm. Inv. 3416-D.

# Kalimantan

## The Indonesian-Governed Area of Borneo

Anne-Marie Vion

1  Chariot fitting in bronze with silver inlay. Late Zhou (third century B.C.). After Rodgers 1985, fig. 29.

2  Detail from the decoration of a Dayak incised bamboo, including the *aso* motif. Nineteenth or twentieth century. After Rodgers 1985, fig. 30.

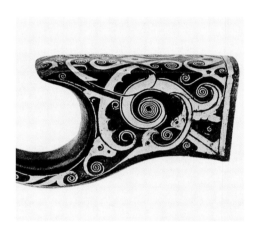

Borneo is the third largest island on the planet after Greenland and New Guinea. Politically, it is divided between the famous sultanate of Brunei (which, by linguistic corruption, gave the island its name), Malaysia (to which Sarawak and Sabah belong), and the Republic of Indonesia, which possesses the largest segment: Kalimantan.

The name "Dayak" given to the populations living in Kalimantan is somewhat misleading. Linguistically, *dayak* is the equivalent of *raya*, giving Sulewesi the term *to raya,* meaning "the people of the highlands." Moreover, some of the Islamicized Dayak of the coastal area speak Malay. Frequent confusion results from certain authors basing the cultural frontiers they establish between different groups on purely linguistic criteria.[1]

Here, as elsewhere, in order to distinguish what is authentically Dayak from borrowings from foreign artistic repertories it is necessary to take into account centuries-long trading contacts. The commercial ebb and flow culminated in the import of objects manufactured in China and Southeast Asia, such as the famous dragon-painted china jars, precious articles that even today are treasured by many families living in regions remote from the coast. But both the numerous Chinese and Malay, who had themselves settled on the coastline, and the ongoing processes of Islamicization, already well under way in the nineteenth century, should also not be neglected.

The complex curvilinear style that characterizes objects produced in Borneo proper has been subjected over time to a host of influences. Comparisons drawn (following the work of Heine-Geldern)[2] between depictions

of Dayak "dragons" and very similar motifs occurring in China in the middle of the first millennium B.C., however, should be treated with the utmost caution (figs. 1, 2).

Nevertheless, it is not beyond the bounds of possibility that these patterns may have been introduced, like the objects they adorned, without this necessarily reflecting any direct Chinese influence on Borneo—though the manifest Islam impulse (and this is just one example of the religion's impact) to favor the adoption of floral motifs over the proscribed human and animal figure was clearly felt. Be that as it may, thousands of kilometers and at least two millennia lie between the artifacts in question. At the present state of our knowledge, one can but presume that their extraordinary resemblance, admittedly disconcerting, is entirely fortuitous.

We do not know when the first human populations arrived on the island of Borneo. In a cavern in Niah (Sarawak), a skull has been found that has been carbon-14 dated to 40,000 to 35,000 years ago. According to Peter Bellwood, if that date can be relied upon, these remains would have to be accepted as the earliest Australoid yet recovered.[3] These Australoids began burying their dead at a much later date, about the onset of the Holocene epoch (about 10,000 years ago). They were annihilated, chased out, or absorbed by the Austronesian population that began expanding about the fifth millennium B.C. The place from which these incursions set out has not yet been pinpointed (modern archaeology favors southern China or Taiwan, or else the northern Philippines), but these Austronesians—who were Mongoloid populations—made landfall in Borneo during the fourth millennium.

3  **Man's jacket (*bajo kulit kayu*)**

*Tapa*, or barkcloth (liber from certain trees pulped and beaten into a resilient fabric), decorated with motifs of pairs of forequarters belonging to the *aso* ("dragon," but literally "dog"), drawn in ocher with soot-black highlights. Height 64 cm. Inv. 3414.

4  **Decoration on a large mat (detail)**

A group of nomadic hunter-gatherers, the Punan, excel in basketry and mat weaving. The same mat also has patterns showing "soul ships" sailing among angular spirals. Overall dimensions 176 x 78 cm. Inv. 3462-24.

### 5 Basket

Punan (?). Height 25.5 cm. Inv. 3493.

### 6 Headdress ornament

Brass. This openwork plaque is decorated with a monster (the same one found on shields and tomb entrance doors) with characteristic large eyes. Its role was to ward off evil spirits. Height 14.2 cm. Inv. 3480-1.

### 7 Pair of earrings

Brass, lost-wax process. These earrings represent *nagas*. There are larger and heavier earrings of this type representing, for example, figures or *aso* with the coiled body of a snake. Certain authors suppose that these heavier adornments were manufactured for trade. In fact, as evidence given by the inhabitants of the Upper Mahakam proves, such earrings were indeed worn—though they might still have been copied. Length 7 cm. Inv. 3455-A and B.

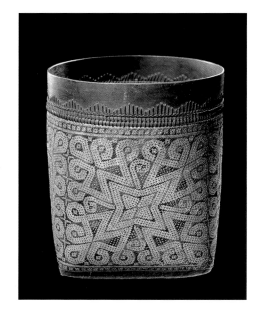

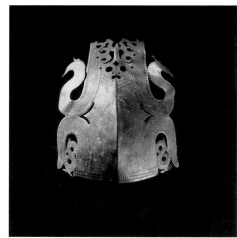

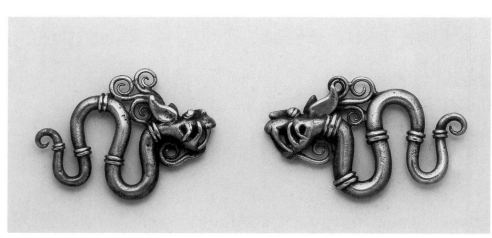

The settlement of the island was not of course completed overnight, but stretched over many centuries. Metalworking entered the picture shortly before the Christian era and brought to a close a Neolithic period, during which pride of place had been enjoyed by ceramics and vegetable pulp cloth (*tapa*), which was still being manufactured in the twentieth century (fig. 3). The weaving of cotton was to attain a high level of technical proficiency among certain groups, such as the Iban of Sarawak.[4] Other groups continued to weave strips of rattan, in order to make mats (fig. 4), containers (fig. 5), and hats.

The specialty of the Penan and the Punan, nomads who had remained hunters and gatherers of berries, was rush matting, which they would exchange with the sedentary Dayak for foodstuffs and other basics. Roaming over great distances, the Punan possessed no other art form, though it would be imprudent to attribute systematically all items of wickerwork contained in Western collections to them alone (figs. 4, 5). Women from certain other populations, such as the Danum Ot Dayak, were adept basket weavers too, making conical hats adorned with a bead mesh of curvilinear pattern in which the ever-present dragon (*aso*) also figures. The motifs (fig. 25) were created by threading beads onto fiber strands. The beads were imported from the Orient, possibly China, and some, as identified from their size and uneven surface, were several centuries old. The use of cotton yarn is a more recent development.

These bead adornments are detachable and could be removed from a worn out hat—or disused baby-sling—and affixed to a newly

## 8 Warrior armor

The jerkin is cut from the pelt of a tiger cat. The headpiece, ornamented with tufts of hair, is covered with a beading mesh decorated with the *aso* dragon motif. The headdress is made from the feathers of the great hornbill, a bird symbolically associated with head-hunting. Kenyah-Kayan peoples (eastern part of Kalimantan). Total height as shown in the photograph 190 cm. Inv. 3462-S.

8

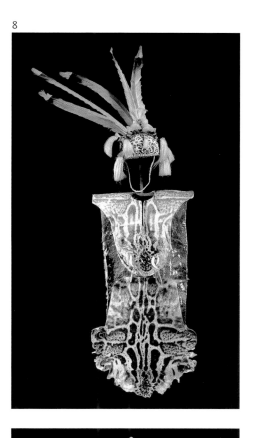

9

made one. Such decoration was commonplace among the tribes in eastern Kalimantan, especially in the large complex of Kenyah and Kayan groups located in the central area near the Sarawak frontier.

Among the many disjointed animal forms used, certain types recur: forms in which the members terminate in spirals (fig. 2); in which the two forequarter sections of the *aso* are coupled in an S-shape, a double scroll loop articulated about the dragon's head, its eye remaining clearly visible (fig. 3); and in which the jaws gape like the corolla of some bizarre plant bristling with teeth (figs. 16, 17). Among all these zoomorphic malformations, one encounters a geometrical decoration particularly well suited to the weaving of wicker or dry grass (is this unique to the nomadic Punan?). These adornments, made up of irregular spirals or exaggerated twists, are also visible on the attractive wickerwork baskets (fig. 5) and on the mats featuring figures with upraised arms and outsized hands (fig. 4) that certain authors have related to the Indo-Chinese Bronze Age Dong Son culture. It is not known, however, how this tradition could have reached the distant islands of the Philippines and Indonesia. Possibly through the migration of isolated groups, through sea-trading merchants on the lookout for spices, or simply through the circulation of objects whose forms or decoration were then taken up by local artists.

Owing to the absence of copper, zinc, and tin ore, the Dayak have never evolved into the brilliant workers in metal met with on more fortunate islands. They did manufacture small quantities of brass jewelry (fig. 7), produced from imported ingots, and iron sword blades (*mandau*),[5] whose wooden sheathes

### 9 Shield

Wood. The curvilinear decoration, centered on the goggle-eyed face of a monster, is partially concealed by layers of human hair advertising the head-hunting success of the owner. Kenyah-Kayan complex. Height 132 cm. Inv. 3400-B.

10 The shield ornamentation as it appears without the human hair—or horsehair—present on most examples is clearly visible on this early photograph of a Dayak warrior. Photograph Charles Hose. Barbier-Mueller Archives.

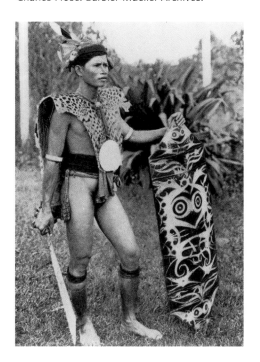

## 11 Large statue of the *hampatong* type

The function of the *hampatong* varied from one population to another. It could be a "guardian of the village" designed to ward off malicious spirits, a defense against epidemics, a likeness of a servant destined to serve the dead in the next world, or an effigy of the deceased himself. Height 245 cm. Inv. 3488.

## 12 Effigy sculpture

Ironwood. A life-size statue of a man of high status. A support with four upright members makes it possible to balance on the head of the carving a Chinese jar containing the bones of the male subject (the jar is not original), who is shown standing on a carved version of the receptacle. Height 207 cm. Inv. 3401-E.

13 Kenyah longhouse on the Kayan River at the end of the nineteenth century. Photograph Nieuwenhuis. Barbier-Mueller Archives.

14 Tomb of the Klemantan Dayak (?) built in the shape of a house. The profusion of sculptures was matched by the objects belonging to the deceased and his kin (conical hats decorated with beading, weapons, etc.) that lay nearby. Photograph Charles Hose. Barbier-Mueller Archives.

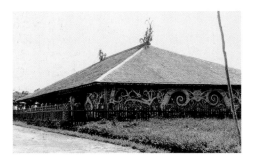

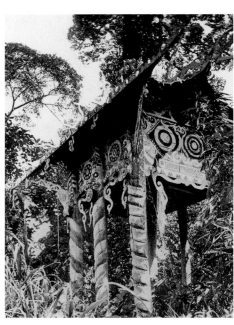

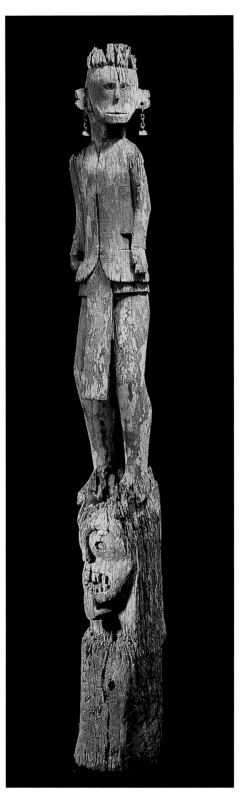

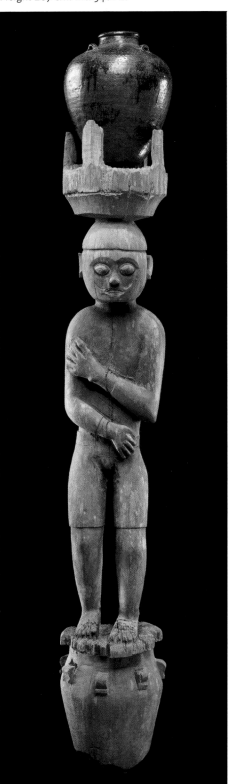

Ironwood. Carved with the effigies of a man and a woman, these posts were originally part of a funerary monument. There existed numerous variants on this type of monument, from real miniature houses elevated on four piles (fig. 14) to coffins supported on one or two posts of circular section, not to mention the *sandung* that were sited next to habitations. The bony remains stripped of their flesh were laid to rest in a Chinese ceramic jar placed upon the head of an effigy representing the deceased (see fig. 9). These two strange carvings with their disjointed bodies probably came from Kalimantan-Sarawak border country. Heights 96.5 cm, 100 cm. Inv. 3472-A and B.

and bone or antler hilts are carved with overlapping patterns (fig. 23) from the center of which an *aso* dragon (literally, "dog") emerges. The Dayak were indefatigable warriors and armed conflict between various groups was endemic. The sword could be used in conjunction with a spear, but the bow and arrow were unknown, while the familiar blowpipe and poison dart were in principle only employed for killing game. Armor comprised a leather jerkin or basketry breastplate, a shield, and a sort of helmet covered with beadwork mesh and stuck with feathers that seems better adapted to war dances than to the heat of battle. Among the Iban, the shield was woven in rattan. Within the groups of the Kenyah-Kayan complex (fig. 10), every surface open to decoration—shield faces being the most obvious examples—incorporated curvilinear designs arranged around the *aso* dragon, or centered on another motif known as the "shrimp" (*usang*), probably a representation of a sea monster related in some way to the Indian *makara*.

Any attempt to explain and classify the characteristic patterns of carvings and other artifacts produced by the Dayak requires a perfect acquaintance with the symbolic import of the images transmitted by their "tribal religion," where the reenactment of myths and acts of genuine magic are of overriding importance. Only the religion of the Ngadju (as a result of the work by the missionary Schärer) and that of the Iban are well enough known to us. The beliefs of a large number of other ethnic groups are, and doubtless will remain, forever a mystery to us. The relationship between, on the one hand, the practice of head-hunting (common to all Dayak; see fig. 1 in the preceding chapter), megalithic stones, the erection of funerary monuments

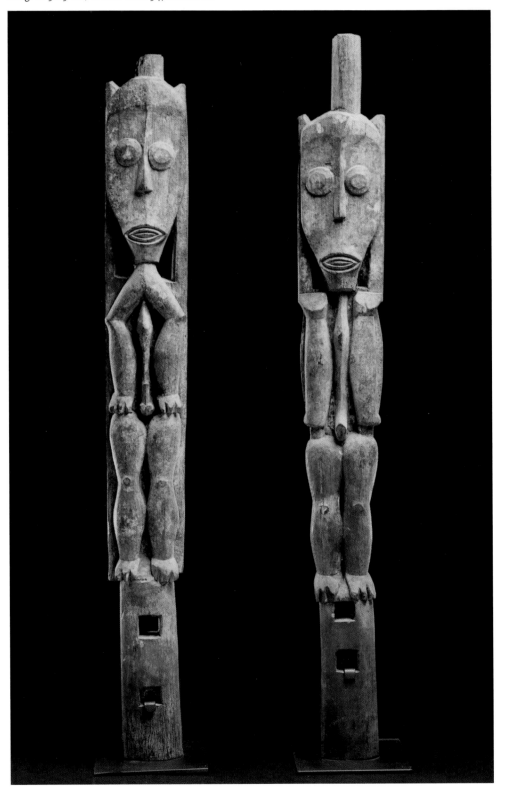

Ironwood. Section of a funerary monument. Below the apotropaic monster with large round eyes (*udoq*) an *aso* is visible, its immense jaws gaping wide to the right. Probably the Kenyah-Kayan complex. Height 120 cm. Inv. 3412.

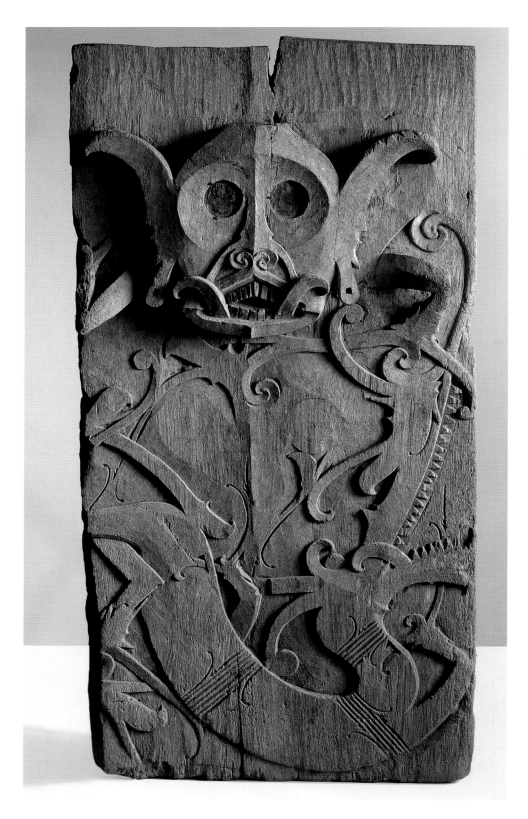

supported by posts (fig. 15), the posts of the *hampatong* type (fig. 11), and the statues depicting the dead (fig. 12) and, on the other, traditional religion, is the focus of much learned theorizing, but no unqualified conclusions can as yet be drawn.

An excellent summary of the work of Schärer has been published by W. Stöhr.[6] The Ngaju possess two supreme divinities: Mahatala[7] and Djata. The latter is represented as a water snake and stands in opposition to a celestial divinity figured by a bird—an opposing pair widely found in dualistic systems. Ngaju ritual concentrated on a feast called *tiwah* that occurred at the second burial of every high-ranking personage. As in numerous other regions of Indonesia and the Philippines, the body was initially buried "provisionally" in order to give the family time to amass sufficient funds for a more complete funeral, at which the bones would be washed, sorted —only the skull and long bones being conserved—then placed in a suitable receptacle. During the *tiwah*, prayers were offered up to Tempon Telon, the god charged with ferrying the souls of the dead, pleading with him to transport the deceased to the desired destination. There exist depictions of this "final journey" where Tempon Telon is at the helm of a funerary vessel laden with gongs that conveys the deceased's kith and kin seated on chairs.

These Dayak "soul ships" have been the object of intense speculation. Their resemblance to the ships shown on southern Sumatran fabrics has drawn some scholars to apply the term "soul ships" to such craft too. This assumption is yet to be proved, however, as is the proposition that the long-hulled boats that figure on the two-thousand-year-old

<br/>

**17 Panel**

Ironwood. Originally from a funerary edifice.
Four *aso* face one another in pairs below the
goggle-eyed monster (*udoq*). Kenyah-Kayan.
Height 124 cm. Inv. 3490.

bronze kettledrums of the Dong Son culture
are also vessels ferrying the souls of the de-
ceased to the land of the dead.

The *tiwah* was characterized by slave sacrifice
and it is conceivable that certain *hampatong*
represent these servants, condemned to follow
their master into death and serve his needs
in the afterlife. Though it scarcely appears
at all on carvings, sculpture, or low reliefs,
the World Tree played a salient role in the
mythology of all the Dayak of Kalimantan.
A number of tribes of the Kenyah-Kayan-
Bahau complex believe that the Tree, the
source from which all life flows, was born

18 Bone receptacle in the shape of a model
house (*sandung*) standing next to a dwelling
inhabited by Danum Ot Dayak. Photograph
Molengraaf. Barbier-Mueller Archives.

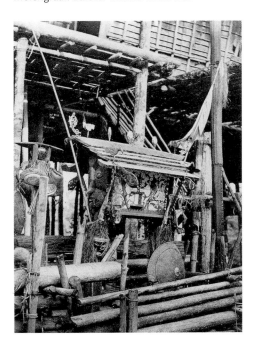

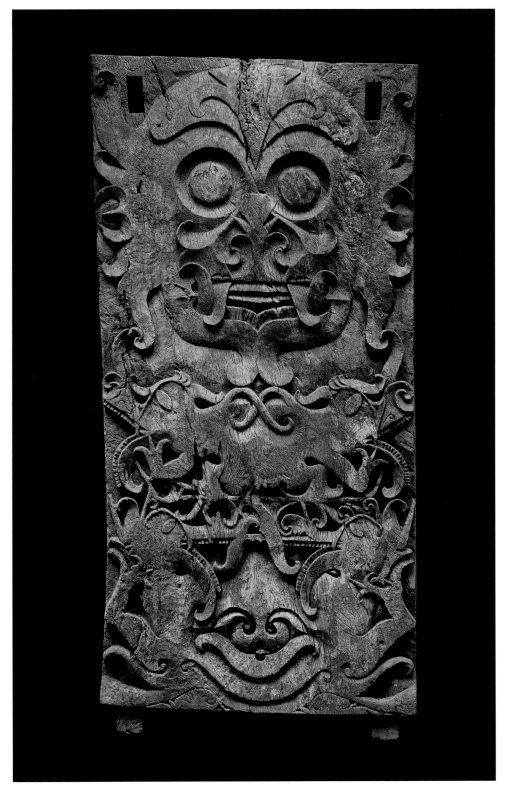

### 19 Mask

Wood. The face is that of a Javanese male. These characters (the Javanese, the white man, etc.) only began to appear in carving during the twentieth century. Apo Kayan group. Eastern Kalimantan. Height 22 cm. Inv. 3427.

### 20 Baby carrier

Hardwood inlaid *conus* shells. A mother would have used such a carrier to carry her baby on her back. The main motif is a heart-shaped human face, repeated three times, typical of the style of the Modang, the creators of the large anthropomorphic posts. The base was carved separately. Height 33 cm. Inv. 3420.

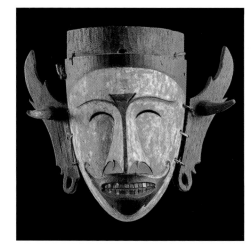

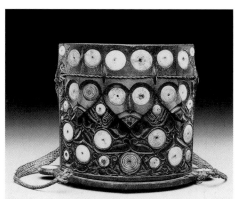

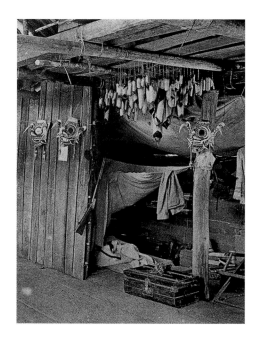

21 Interior of a longhouse of one of the Kenyah-Kayan groups, in which there hang three *udoq* masks. Photograph Vidoc, Amsterdam.

of the supernatural union of the earth with a sword hilt that fell down from the sky. The roots, trunk, and upper branches of the Tree each correspond to a separate world, to a successive level ruled by particular divinities that can be evoked by appropriate symbols. This symbolic language again has not been exhaustively studied—but is there any way in which it *could*, since it varies from group to group, and the tribes of the Dayak number about 300?

All Dayak groups practice ancestor cults and are, or were, convinced of the crucial importance of increasing the spiritual strength of both the individual and the community by magical-cum-religious acts, the most vital of which was, once again, head-hunting. In the historical past, this practice attained such levels that whole ethnic groups were wiped out, the victims of raids perpetrated by more bellicose neighbors. The custom of building longhouses (large communal dwellings for the whole village; fig. 13) possessed a primarily defensive purpose. The youngest couples had their place closest to the entrance, as this was considered less secure than the center where the headman was lodged.

Houses and tombs provided an opportunity for the Dayak to give free rein to their skill as carvers (figs. 13, 14). Although many sculptures in the round survive, it is in the low-relief carvings that the *horror vacui* so characteristic of Dayak art finds its fullest expression. The compositions on the doors to the sarcophagi (fig. 18) that Kenyah-Kayan peoples erect near their dwellings to house bone remains are often of interesting design and skillfully executed (figs. 16, 17). The most widespread motifs include a monstrous head with huge eyes intended to ward off harmful spirits, and

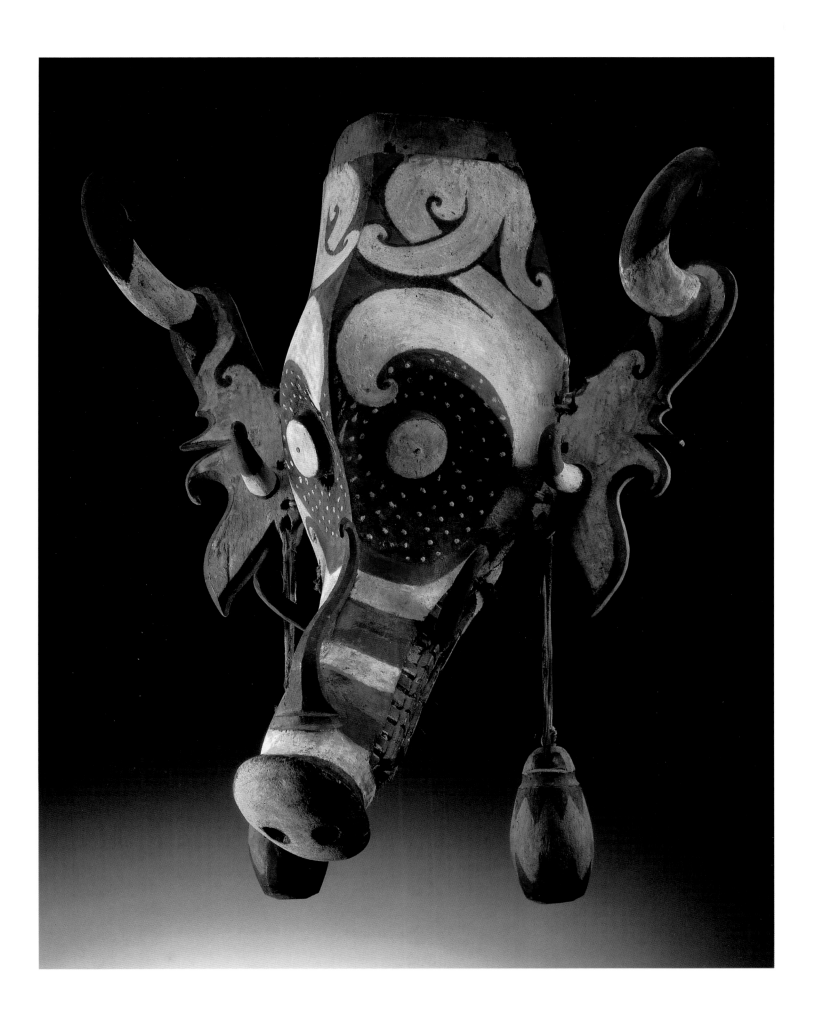

81 Kalimantan

## 23  Saber (*mandau*)

The stag-horn hilt is carved with a monster whose identity is difficult to establish. The scabbard is decorated all over with *aso* motifs. A little side sheath carries a short-bladed all-purpose knife. The iron blade was made locally. The whole piece is adorned with glass-bead pendants. Unidentified group, eastern Kalimantan. Length 88 cm. Inv. 3494.

23

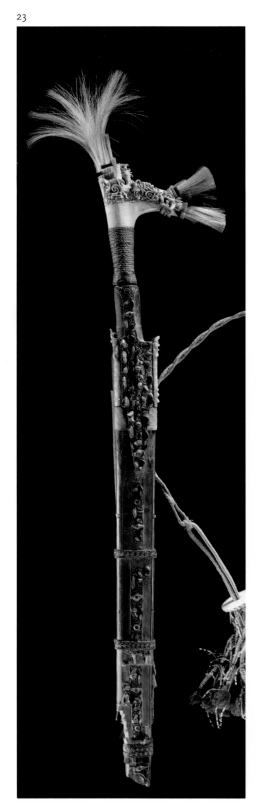

24

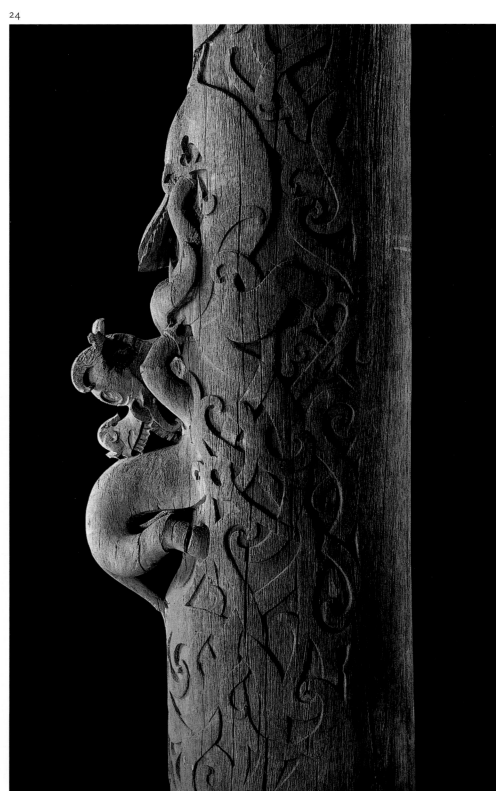

Ironwood. Part of the support to a funerary construction (central section only, the two undecorated end sections have been sawn away). The diameter of the tree employed for this solid carving must have been huge. An *aso* emerges from the network of spirals on the surface of the post. Kenyah-Kayan. Present height 156 cm. Inv. 3484.

the ever-present *aso*, whose body is covered with spiral protuberances. The monstrous heads sometimes appear in the shape of a heart and are perhaps derived from the human heads adorning bronzes made under the influence of the Dong Son culture. They resurface on the carriers used to transport babies on the back (fig. 20), which were also made out of basketry decorated with glass-bead mesh.

The essentially two-dimensional quality of Dayak sculpture also comes to the fore in those carvings that, at first sight, might seem unsuited to such a treatment. Examples of the tendency include the nonanthropomorphic posts acting as supports to special tombs in the form of a small house (fig. 24). Here, the artist was often content to carve an *aso* out of a solid tree trunk (though it might at first appear that the motif is an applied one, the piece is in fact taken from a single shaft) and overlay it with a network of loops, suggestive once again of the mythical dragon. When we come to the *udoq* masks of the Upper Mahakam, there is evidence of an attempt to break free of the planar surface: they depict either a hog's head or, more oddly, monsters in which a hornbill has been hybridized with a dragon. Unique to the Apo Kayan and to the Kenyah, these masks served to conjure up spirits from the bush to purify the village. All are remarkable creations in terms of form and polychrome decoration, and are radically different from the far more rudimentary masks made by the Iban.

Dayak art includes a number of other creations, such as knives for cutting rice, sabers (fig. 23), jackets (fig. 25) and skirts decorated with glass beads, work-boards used by women to make basketry articles and beading, and

25 **Jacket**

Cotton, entirely covered in beads. The decoration shows small figures depicted frontally. Maloh. Length of jacket 46 cm. Inv. 3462-A.

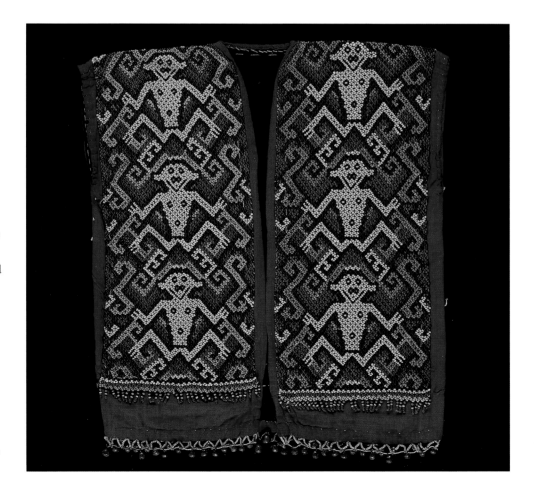

Ironwood. Of medium size, ancient and heavily weathered. The two figures carry knives or swords that do not conform to the Dayak canon. The style, especially evidenced by the slanted eyes, is from central Kalimantan. Repainted a number of times, the last coat applied was blue. Bidang. Central Kalimantan district. Heights 119 cm, 116 cm. Inv. 3495-A and B.

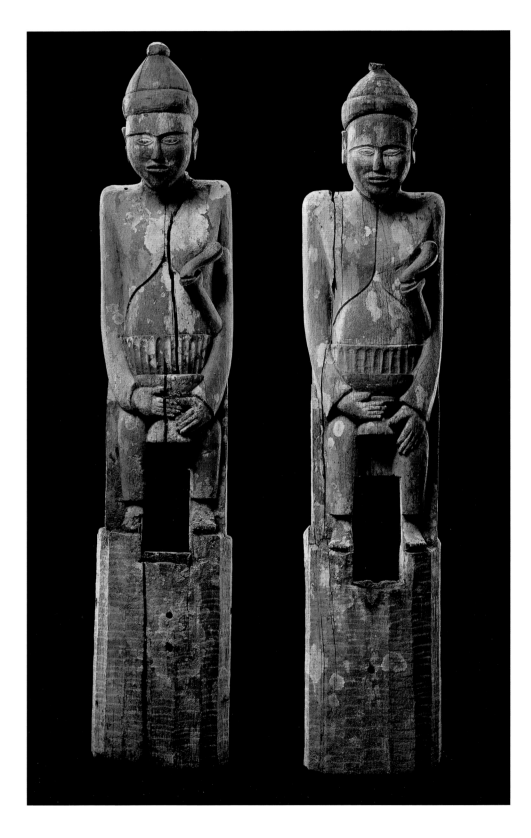

back-pieces from baby carriers adorned in the same way as doors to *sandun*. The collections of the Musée Barbier-Mueller contain hundreds of artifacts from Kalimantan, making it difficult to select particular examples. We have sought simply to give an idea of the richness of Dayak art (figs. 26–28). This richness is evident in the extraordinary ease with which their sculptors moved from one register to another, from monumental sculpture to the most unassuming artifact, attaining equal success with each—a rare phenomenon indeed among tribal artists.

We have reproduced a particularly grandiose example of a Dayak anthropomorphic post (fig. 11), but there also exist tiny amulets (generally in very hard wood) which formed part of a magician's necklace. In spite of their small size, these carvings are invested with such power that they too are turned into monumental works. This observation also holds good for the Iban of Sarawak, whose pig charms (*tuntun*), completely free from mawkishness, are worked with impressive vigor.

It is highly probable that the exploitation of the forestry resources of Borneo, conspiring with the penetration of Islam into even the most remote village, will, in the space of a few decades, lead to the extinction of all surviving Dayak cultures. By then, perhaps some attempt might at last have been undertaken to synthesize the data available and build up an initial inventory of this great island's heritage. For, although the number of objects held in Western collections runs into the tens of thousands, nobody has as yet studied them systematically, even in the light of the scant information presently at our disposal.

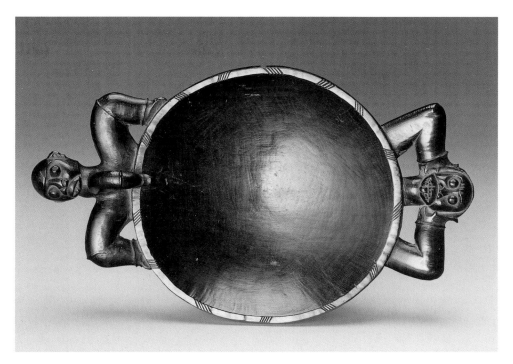

## 27 Ceremonial platter

The carrying handles figure two demons. The piece was brought back to England at the beginning of the twentieth century. Formerly Herbert Rieser Collection. Width 40 cm. Inv. 3402.

## 28 Carving

Ironwood. The figure of a large feline, probably sawn from the top of a *hampatong* post (a complete piece of this type is to be found in the Rijksmuseum voor Volkenkunde, Leiden). Height 58 cm. Inv. 3444.

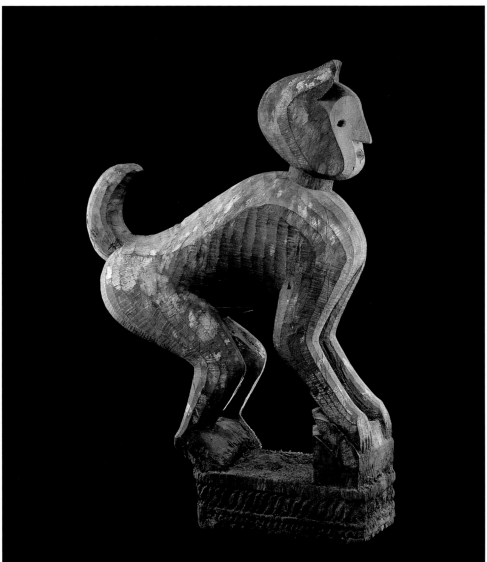

# Lombok

**Anne-Marie Vion**

A deep submarine trench separates Bali from Lombok, a small island that never formed part of Sunda, the subcontinent which—prior to the end of the most recent period of glaciation about 8,000 or 10,000 years ago—extended down from Malaysia, and included Sumatra and Java.

No more than a quarter of an hour by plane from Bali, Lombok is at present undergoing headlong transformation into a tourist "paradise." Its magnificent beaches are coveted by major hotel chains, while in the mountainous and volcanic regions to the north and extreme south traditional customs that two centuries of Balinese domination and fifty years of Dutch occupation had already undermined are fast being abandoned—a situation further promoted by the Islamicization of the entire indigenous population.

The indigenous peoples are comprised of a few Bodha communities, who occupy villages along the west coast and are assumed to be the oldest occupants of Lombok, and the majority Sasak community.

The latter are divided into the Waktu Lima and the Waktu Telu. The latter, living for the most part in the mountains, have been less profoundly Islamicized than the Waktu Lima, who are found in the towns on the central plains and who consider the Waktu Telu somewhat as uncivilized pagans. Both communities, though distinct culturally (and these differences in turn are gradually being eroded), possessed a similar social and political organization that splits society into three classes: nobility, commoners, and slaves. This hierarchy remained intact until 1895, when the colonial administration outlawed slavery. At the summit of the Sasak social

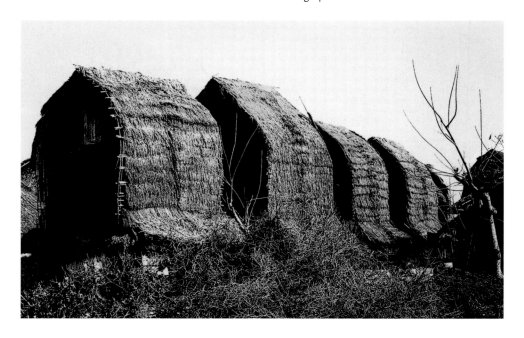

1 Sasak rice stores (*lumbung*). Such constructions belong to a past world that is fast vanishing. Photograph Kal Müller.

Light wood, worn to a sheen through use.
These masks borrowed from Balinese dancing
and Javanese *topeng* masks. Height 21.5 cm.
Inv. 3320-A.

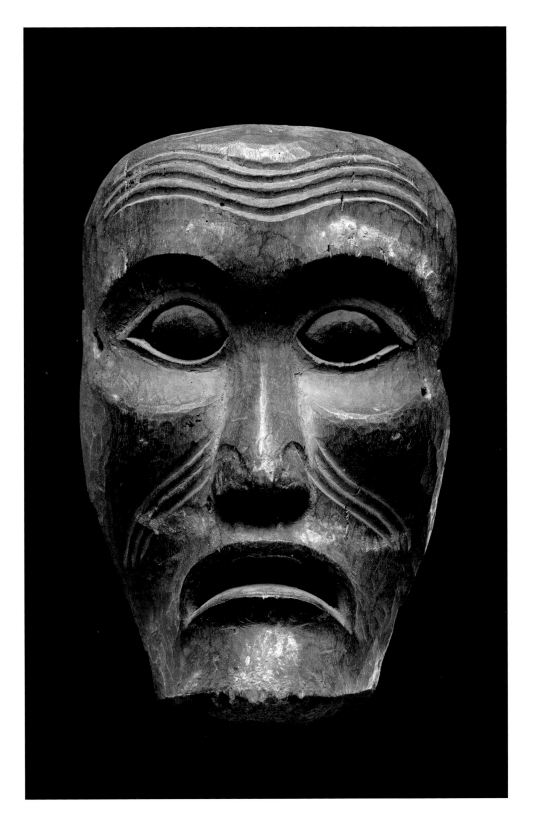

pyramid stood the headmen, priests, and ma-
gicians.

Traditional houses, ceremonial roofed plat-
forms, and rice stores very similar to those
on Bali can still be seen in the villages of
Waktu Telu. Tombs are built up into little
knolls surrounded by and topped with rocks.
Among the Waktu Telu, the presence of a
small mosque in each hamlet has not pre-
vented the survival of a belief in ancestor and
nature spirits. These supernatural beings are
the object of cults and offerings designed to
appease them and obtain their protection.

There are two types of religious ceremony:
those which concern the rites of passage of
the living community (birth, name-giving,
circumcision or, for the girls, ear-piercing,
weddings, etc.), which are called *gawe urip*,
and those held in a funerary context, known
as *gawe bedina*.[1] Masked dances, borrowed
initially from the Balinese and the Javanese,
but less frequent on Lombok, brought with
them the production of carved wooden
masks (fig. 2) which have not as yet been sat-
isfactorily studied. The best-known carvings
from the island are in fact lime spatula han-
dles (*pelocok*, pronounced "pelotjok"), which
feature unidentified supernatural beings (fig.
3) in a squatting position. These beings are
also found on other objects, such as dagger
hilts and loom shuttles (figs. 4, 5). This pos-
ture, which is seen emerging from elements
of floral decoration also borrowed from
Balinese art, is to be found on Borneo and as
far away as the Moluccas. As such, it can be
confidently ascribed to a jointly held ancient
tradition that called for portraits of eminent
forebears or mythical figures, although we
have no precise data on local Sasak styles.

### 3 Lime spatula (*pelocok*)

Fitted with an iron blade. Such Sasak hardwood or horn spatulas and knife handles display considerable originality. The figures—and this is rarely the case in anthropomorphic "tribal" sculpture—are imbued with life. They put their hands over their ears (as here) or cover up one eye. These pieces are miniature masterpieces of a most dynamic carving style. Height 17.3 cm. Inv. 3325.

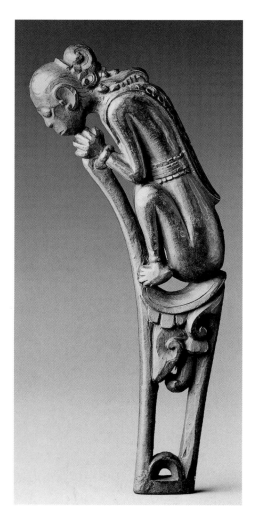

### 4 and 5 Two loom shuttles

Hardwood. Carved with two squatting figures (a man and a woman judging by the different hairstyles and headdresses), these instruments were most probably ceremonial in function. The base and the floral motifs are indicative of Balinese influence (Lombok was conquered by the Balinese in the eighteenth century). Sasak. Height each 25 cm. Inv. 3321-A, 3321-B.

### 6 Stone sculpture

This statue of a woman from the north of the island is the only Sasak stone carving as yet published. The face and torso are carved in a most naturalistic manner, the gesture made by the hands pushing down against stomach and belt being particularly remarkable. According to Anang Suradha—an antique dealer originally from Lombok—it shows an ancestor, the wife of the founder of a clan. The base of the piece has been carved as a pillar of square section. Height 105 cm. Inv. 3334.

No scholar had remarked on the existence of anthropomorphic statuary among the Sasak until the publication[2] of a stone pillar-statue (fig. 6) showing a female figure pressing her hands against her hips in a most expressive manner; its provenance (from the north of the island) is secure, and the face is not without parallels with the one on the mask reproduced in fig. 2. Is it now too late to establish whether this sculpture represents a unique piece (which is unlikely) and what it might have signified for the Sasak people? Only prolonged field study will allow significant conclusions to be drawn and so confer on the ritual art of the Sasak a worthy place among the other traditional crafts of outer Indonesia.

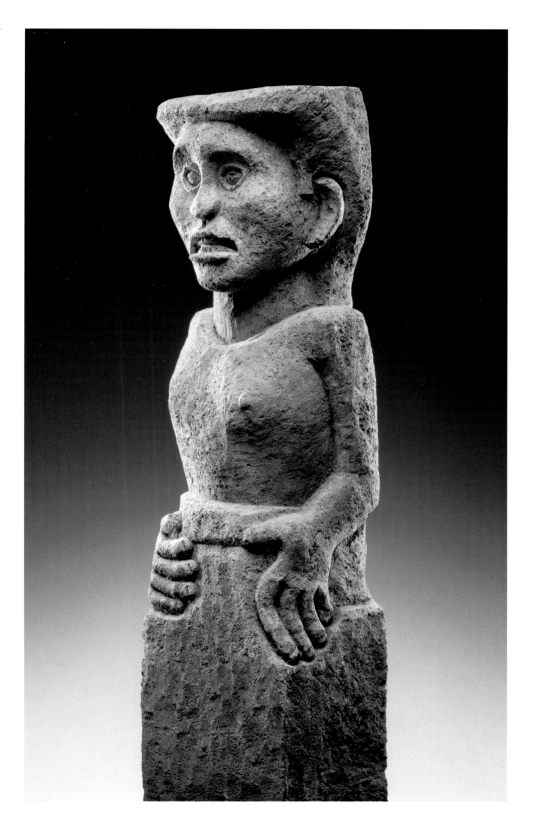

# Sulawesi

## The Wood Carving of the Sa'dan and Mamasa Toraja

Hetty Nooy-Palm

**Sulawesi and the Lesser Sunda Islands**

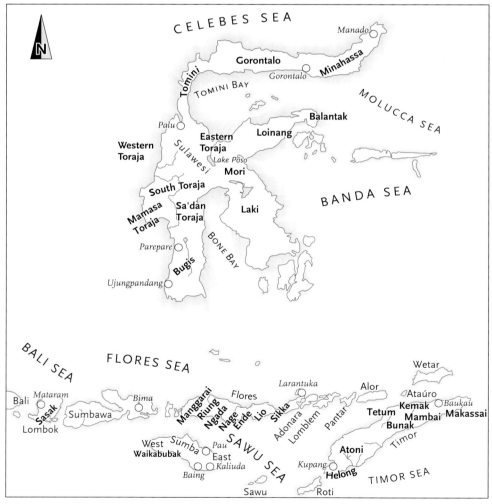

1 **Two small statuettes**

Brass. These figures are known as *tau-tau* in certain regions, and always comprise a male and female couple. Central Sulawesi (Kaili, Pamona, Kulawi, Lake Poso). Heights 7 cm, 7.9 cm. Inv. 3631-A and B.

The Sa'dan and Mamasa Toraja live in a mountainous area in the interior of Sulawesi (see map). These highlands are intersected by two rivers, the Sa'dan and its tributary, the Mamasa. The tribes are named after these rivers: Sa'dan and Mamasa Toraja (Toraja being a general name given by the Buginese to all non-Islamic mountain people).

Today, the regions inhabited by these two ethnic groups are among the most visited tourist areas of Indonesia. Surprisingly, until the dawn of the twentieth century the Sa'dan and Mamasa Toraja were quite unknown to the outside world. Their only contact with other people was with Buginese traders. The Toraja exchanged their forest products —coffee, woven mats, and slaves—for Indian cloths, Javanese batiks, beads, Dutch coins, and guns.

Sa'dan Toraja culture could be classified as megalithic: menhirs were erected as memorials to the dead and the remains of the deceased were buried in rock chambers hewn out of the cliffs. Fortified villages were built on escarpments and the entrance was reached by a staircase of slabs. Mamasa country, however, being devoid of limestone cliffs (with the exception of the eastern part) does not show these megalithic traits. However, being closely related to each other, the Sa'dan and Mamasa Toraja shared many cultural traits, some of which are common to other megalithic peoples in Southeast Asia.

The principal domestic animal is the water buffalo; the bull is a status symbol and the chief sacrificial animal. In myth and in daily life, the animal is close to man. The bull, which is considered brave and macho, is supposed to ward off evil. A powerful and brave man is

Stone. The double four-leafed "flower" pattern on the chest is sometimes read as being the fruit of a sacred tree (*pa'bua'tina*). Central Sulawesi region. Exact place of origin unknown. Height 54.8 cm. Inv. 3633.

compared to a bull, as is the Old Lord, Puang Matua, the Toraja high god. As is the case with people, buffaloes are divided into ranks, depending on their color and the length and size of their horns. The piebald ones (unknown elsewhere in Indonesia) and the jet-black specimens are valued the most. The horns adorn the houses; the head-gear of male dancers and ritual functionaries is decorated with a pair of horns, real ones or brass imitations. The buffalo figures extensively in Toraja art.

As is the case with other megalithic peoples in Southeast Asia, buffaloes, being precious, are not used as draft animals. Until quite recently plows and harrows were drawn by men, mostly bondsmen who worked in the fields. Of these fields, the irrigated, rain-dependent *sawahs* are the most valued. Rice, a sacred food, is a staple of their diet.

The rice fields are the property of the rich noblemen and of the commoners. As men and women have equal access to the inheritance, both sexes can own fields.

A bondsman or slave seldom owns precious buffaloes, being at the bottom of the hierarchical order, which traditionally consists of three ranks: noblemen, freemen, and slaves. In the three small states in the southeast of the Sa'dan Toraja region, each of which is governed by a prince, the ruler and his family are the apex of the pyramidal structure. The Toraja family system is a cognatic descent one, which means that it is neither patrilineal, nor matrilineal, but that both lines, irrespective of sex, are equally important. However, it is the ancestors who count most, in particular the ancestors who are supposed to descend from heaven (*to manurun*). The heavenly

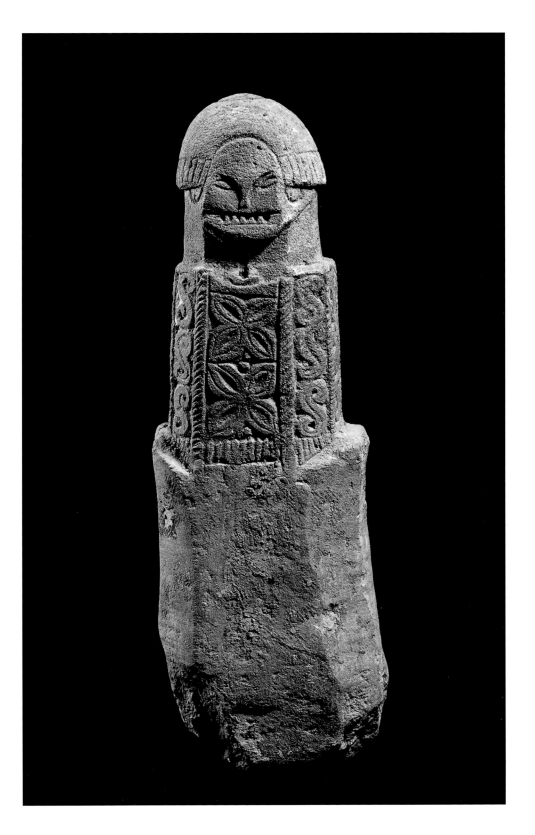

**3 Large cloth (*pori situtu'*) (detail)**

Cotton. Pattern in warp ikat technique. Toraja fabrics deserve their high reputation. This is a large *pori situtu'* from the Rongkong district, in the north of the Sa'dan Toraja region. These textiles were made not as garments but to be exhibited at major festivals. Dimensions 308 x 147 cm. Inv. 3620-2.

being, landing on earth, founded a house (*tongkonan* or *banua*) and sometimes such a house was built by a couple of these celestial beings. It is clear that only the princes and the noblemen are of *to manurun* descent.

## Modern Times

Since the Toraja region was subdued by the Dutch in 1906, the slave trade and slavery have been abolished. Missionaries followed in the wake of the civil servants and, although they did not make many converts to begin with, today approximately 70 percent of the Sa'dan population is Christian, and in the Mamasa region the percentage is even higher. The mass conversion in quite recent times is one of the biggest causes of change in traditional Toraja society. Other factors include modern education, the founding of vocational training centers, the migration of the young

4 The Toraja houses (*tongkonan*) in the Sa'dan River region have become familiar following the development of tourism in Sulawesi. Photograph Gérald Baeriswyl. Barbier-Mueller Archives.

to Ujung Pandang (the capital of South Sulawesi) and to other islands of Indonesia, and the struggle to achieve a modern lifestyle. The vocational training schools did not favor a training in the old crafts, which consequently deteriorated.

However, the ancient cultural traits have not completely disappeared. Dances are still performed, and pottery making, wood carving, and the weaving of mats and cloth are still practiced.

**The House of the Living**

The Mamasa and Sa'dan areas are also among the few regions in Indonesia where traditional houses can still be seen and are still built. They are a striking feature in the landscape and resemble moored vessels, with which they are often compared (fig. 4). They all have the same rectangular ground plan. They are built on piles and have saddle roofs which are upturned at the ends. There are variations in style. The Mamasa houses and those in the western part of Tana Toraja (the region inhabited by the Sa'dan) have lower walls and a rooftop which is flattened in the middle. The houses in the central and eastern regions of Tana Toraja stand on high piles and have rather steep roofs, which is quite a recent development. The older houses, which can still be found in the remoter areas of Tana Toraja, look more solid and lack the refined embellishments of the newer type of dwellings.[1]

As well as being a place to live in, the Toraja house is also a religious and social center for the family, its visible material status symbol. Conforming to the ranking order (an important aspect of Toraja society), dwellings vary

**5 Cloth (*mawa*) (detail)**

Two sorts of particularly sacred and precious cloths are found among the Sa'dan Toraja. One, called *sarita*, is long and very narrow; the other is the *mawa*, where the patterns are painted directly on to a length of cotton fabric. The reproduction is of a detail from the center of a very old *mawa* showing two figures with water buffaloes. This cloth was probably originally from the mountains that separate the Sa'dan River from Lake Poso to the north, but it was discovered near Rantepao in the Sa'dan region. Dimensions of the detail illustrated 60 x 50 cm. Inv. 3620-4.

**6 Detail from a piece of barkcloth (*fuya*)**

The dyestuffs used for the sun pattern decoration are of natural origin. The dominant tone is pink, the little crosses in between the circles being blue-green. *Fuya* is the Sulawesi equivalent of the Polynesian term *tapa* (barkcloth). *Fuya* is a venerable tradition, dating from before the development of cotton weaving. It was perpetuated among the northern Toraja up to the nineteénth century. This piece is probably from Palu. Dimensions 100 x 70 cm. Inv. 3620-10.

**7 Headcloth (*fuya*)**

The dominant colors are pink and black. This length of *fuya* was originally designed to be worn on the head, like a turban or headdress (*siga*). Leboni region. Dimensions 91 x 92 cm. Inv. 3620-1.

## 8 Figure (tau-tau)

Wood. Eyes in shell. This carving representing a high-ranking dignitary would have been intended to accompany his remains deposited in a chamber hewn out of the cliff face. Rows of such *tau-tau* would gaze down into the valley at their descendants continuing with their lives below. The figure's arms and legs are jointed, and a piece of cloth of the *mawa* type has been thrown over his shoulders as a covering. Sa'dan Toraja. Height 105 cm. Inv. 3618.

from "low" to "high" in rank. The most important are the ones which descended on earth with their celestial inhabitants, or the houses which were built by the *to manurun* on top of a rock or cliff. The Dutch ordered these *tongkonan* to be demolished and rebuilt in lower, more accessible places for reasons of control. Every house of status has its personal name, such as Banua Puang "The House of the Lord," Tongkonan Manaek, named after a famous ancestress who founded the first house in the Nonongan region (the name Tongkonan Nonongan is also used), and Banua Sura', "The carved house," a *tongkonan* in the village of Ba'tan.

The Toraja house is not only a status symbol, it is also a cosmic symbol. In traditional religion the cosmos is tripartite, and the house has the same division. The roof is compared to heaven, the living compartments represent earth, and the room under the dwelling, dark and dirty, the underworld. The central pillar of the house figures the cosmic axis.

The tripartite cosmic world is not only reflected in house construction, cardinal points also play their part in the division of yard and house. In religion and ritual, east is the sphere of life, west the region of death. The *tongkonan* is divided according to the same principles. The ridge of the roof stretches in a north-south direction. As the roof symbolizes the sky, the two posts that support its overhanging ends bear the name *tulak somba* meaning "supporting what should be honored"—that is, the roof. The northern facade of the house, in particular the triangular upper section, is extremely sacred, being associated with the deities of heaven (heaven being associated with the north in religion). The ground plan of the house, in particular the section occupied

9 **Figure**

Wood, eyes in shell. The shirt and bonnet are of imported cotton. Adjustable head and members. This type of effigy—known as a *pea-pea*—was to accompany the remains of a child. Sa'dan Toraja. Height 55 cm. Inv. 3646.

10 Houselike tomb built by the Mamasa Toraja. Two anthropomorphic statues stand guard at the entrance; the one on the left is in the Musée Barbier-Mueller. Photograph N. Heyning, 1949–50. Vidoc, Amsterdam.

11 **Bead dance apron (*sassang*)**

Worn by women at funerary ceremonies. The apron is wrapped around the waist over other clothes, the fringes hanging over the thigh. Sa'dan Toraja. Height 45 cm. Inv. 3620-8.

9

10

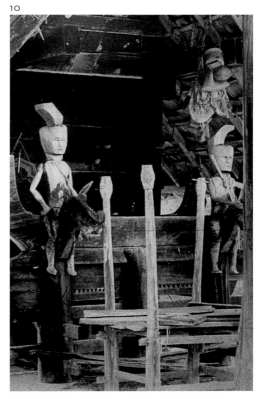

by the rooms, is also divided according to the cardinal points. The southern room is the place where heirlooms are stored: sacred cloths, beaded ornaments, krisses, and other weapons, which, according to tradition, are brought by the ancestors called *to dolo*—"the forefathers of long ago, who came from the southwest, from overseas," and who landed on Sulawesi in the remote past. Their "counterparts" are the aforementioned *to manurun*. Grouping things, people, animals, plants, and ritual in dual sections or opposite categories is a typical Toraja trait. The central room is divided into two sections: the east side is connected with the sphere of life and the preparation of food, so the hearth (kitchen) is located here. The west side of the room is used when the festive part of the death ceremonies start. Before that time, because the deceased is considered "unclean," the flesh of the corpse not yet being decayed, the body is kept in the southern room, swathed in layers of cloth, with a final covering of red flannel. This roll, looking like a huge pillow, is then decorated with sacred ancient cloths, old coins, beaded orname.nts, and krisses.

After some time, if the deceased is a person of high rank the bodily remains are transported to the floor under the storage compartment of the rice barn, which is opposite the house of mourning. Rice is considered to be of heavenly origin and when all the mortuary rites are observed, the soul of a man or woman of status will rise to heaven to take its place in a constellation, becoming a guardian of the rice.

A funerary effigy is placed on the front side of the granary floor. This doll (*tau-tau*; figs. 8, 9) has been carved by an expert (*pande tau-tau*). The effigy is thought to house the soul of the

11

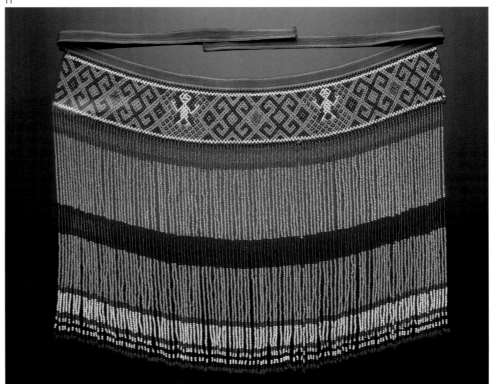

**12  Coffin in the shape of a water buffalo**

Entirely covered with incised patterns, including water buffalo heads (compare with fig. 18). The animal's legs were carved separately and the horns are those of a real water buffalo. Sa'dan Toraja. Length 225 cm. Inv. 3643.

deceased, hence the image is sacred. As is the case with the deceased, the *tau-tau*, which means "little man," is served food, betel, and palm wine. The statue is dressed in full nobleman's attire. As is the case with other rituals (the *bua'*, a feast for the community, the *merok*, a feast for the family, or celebrations concerning the *tongkonan* itself, such as the

rebuilding or renewal of the roof), the house is decorated with heirlooms: sacred cloths, beaded ornaments (fig. 11), krisses, and, in modern times, with a portrait of the deceased.

Even without all these ornaments, the house looks decorated, its walls being covered with wood carving. The carving is colored, the

main colors being black, white, reddish-brown, and yellow. As the buffalo is such an important element of the culture, buffalo designs are among the most prominent. Doors, shutters, and other vulnerable spots where evil spirits might enter the house are adorned with a stylized buffalo head (*pa'tedong*), because the buffalo, the macho animal and brave one, can ward off evil. Even more striking are the life-size bulls' heads carved in the round (*kabongo'*), which decorate the facade and the *tulak somba*. Provided with real horns, they often represent an expensive buffalo which has been slaughtered at a high-ranking death ritual. Frequently, another image is placed on

13  **House-shaped sarcophagus**

Decorated over the entire surface with interlocking patterns, including water buffalo heads. See fig. 17 for such coffins in situ. Sa'dan Toraja. Length 254 cm. Inv. 3645.

## 14 Saber hilt

Hardwood. The back-to-back double loop is a common relief. Sa'dan Toraja. Overall height 76 cm. Inv. 3610.

## 15 Lidded box

Hardwood. The piece is decorated with curvilinear loops, as well as geometric angular "key" patterns to the left and right. The latter are probably imitations of designs used on fabric, since weaving techniques rendered fluid or curved lines impossible. Some authorities hold that such motifs represent a distant echo of those on Chinese objects formerly imported into the archipelago, whereas the sawtooth (*tumpal*) and rosette ornaments would have been copied from Indian *patola* textiles, common heirlooms in Sulawesi family treasures. Sa'dan Toraja. Diameter 27 cm. Inv. 3612.

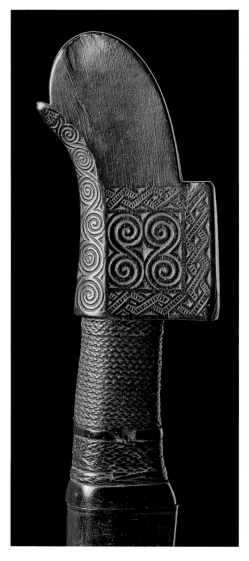

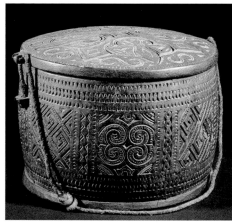

the neck of the *kabongo'*, that of a bird's head with an elongated neck, which figures in myth. This *katik* is also the testimony that the *tongkonan* has been the center of the big *bua'* feast. The *tongkonan* in Sangalla' are devoid of this kind of decoration.

Another carved wooden bird which catches the eye is the rooster. The triangular sacred piece on top of the front gable is decorated with two cocks facing each other. Each bird mounts a sun disc (*barre allo*). The two roosters are greeting the daybreak (day means light and life). Sometimes the inner side of a shutter on a house is also decorated with a cock (if one opens the window, the bird is greeting the day). Other motifs derived from the animal world are *pa'bulu londong*, "the feathers of a rooster," which is a genuine Toraja motif as it is depicted on old, now obsolete coffins, and *pa'tanduk rape*, "outstretched horns," which depicts a stylized pair of elongated buffalo horns and is also found on old coffins (figs. 12, 13). These horns are absent on the walls of the *tongkonan*, but are depicted on a board which is placed in a house of status. This board testifies that the house has taken part in the celebration of a big *bua'* ceremony, as does the *katik* on the front gable of the dwelling.

Huge dragonlike animals, sometimes represented with a protruding tongue, decorate the fronts of the old houses in Mamasa. A pair of human figures, probably ancestors, is placed on the front of several Mamasa dwellings. With the Sa'dan Toraja, such human figures are unusual.

Other motifs in Tana Toraja are the kriss, which is an important weapon (fig. 14), and *pa' kapu' baka*, "the basket tied with cords,"

which is a variation of a design well known in Balinese and Batak culture (in Bali it figures the two world snakes, with the Batak it is the *bindu matoga* motif).

Designs depicting leaves and foliage in an elegant and stylized form are very frequent. These motifs, partly derived from imported Indian cloths (which are considered sacred), refer to fertility. Nearly every important *tongkonan* has its decoration of *pa'daun bolu*, "the betel leaf," which is probably inspired by the paisley motif on Indian cloths. The rows of triangles, generally known as *tumpal* in literature, also figure on the house ornamentation. Other wood carving motifs are without any doubt from the ancient Dong Son tradition: meanders and spirals in all their variations—hooked, single, double, and embellished with tendrils. Every motif on the house walls has its special place and, despite the abundance of these designs, the impression is one of order and equilibrium.[2]

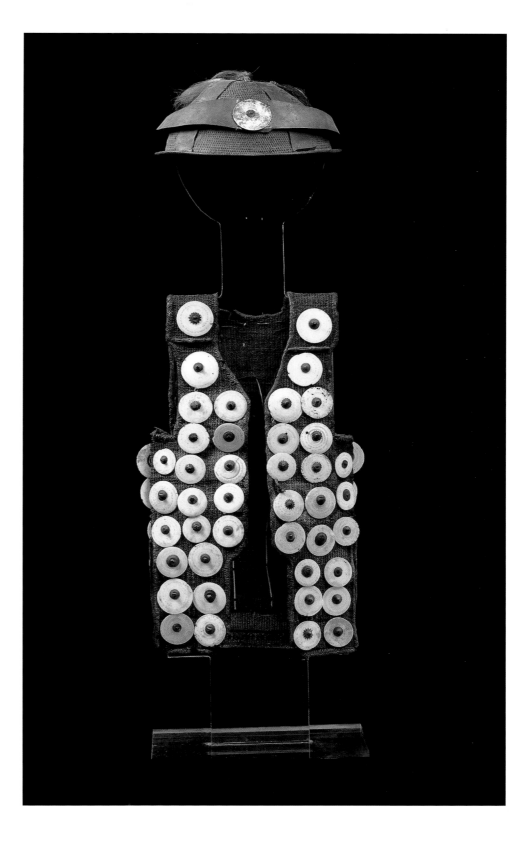

16 **Warrior's costume**

The thick fiber tunic is studded with shell disks and fastened by a horn or wooden button at the center. The helmet is decorated with a disk of identical type and incorporates two metal horns (another allusion to the ubiquitous water buffalo). Sa'dan Toraja. Height of tunic 73 cm; diameter of helmet 36 cm. Inv. 3506-A and B (tunic), 3611 (helmet).

## The House of the Dead

The opposite of the house of the living is
the grave, "the house from which no smoke
escapes." Before being transported to their
last resting place on earth, the bodily remains
are lifted from the floor under the rice barn
and placed in a bier in the shape of a Toraja
house. A cortege is organized, with buffaloes,
war dancers wearing horns on their helmets
(fig. 16), the widow or widower, functionaries
who played a part in the mortuary rites, and
friends and relatives. The *tau-tau* (figs. 8, 9)
has its own sedan, which, like the bier, is
beautifully decorated. After remaining for
some time on the plaza, where the final rites
for the deceased are carried out (including
the slaughtering of many buffaloes, which
are supposed to escort the soul of the dead
person to the hereafter), people start to pro-
ceed to the grave. The cortege has the same
formation as before, only this time the number
of buffaloes is quite small. The bodily remains
are taken out of the bier and the roll contain-
ing the dead person is carried to the rock
chamber, a hazardous enterprise when the
tomb is high up in the cliff. The opening of
the grave is sealed by means of a small wooden
door, often adorned with a stylized buffalo
head (fig. 18). The *tau-tau* is placed in front
of the rock chamber, often leaning on, or pro-
tected by, a horizontal bar carved in the rock.

Constructing tombs is a tedious, unhealthy, .
and dangerous job. The chambers are hewn
out of the stone by means of adzes and chisels,
providing room for many deceased, who have
all been in the family. An exception was the
slave who had served his master during his
lifetime; after his death, he too was deposited
in the rock tomb. Sometimes a cavity is made
in a boulder to receive a deceased person of

17  Different types of Sa'dan Toraja funerary
monuments. In the foreground, a houselike coffin
(of recent date). In the background and to the left,
a disorderly pile of old coffins. In the center,
a gallery construction (instead of the traditional
chambers dug out of the rock) in which are dis-
played a number of *tau-tau* statues. Photograph
Évelyne Robin. Barbier-Mueller Archives.

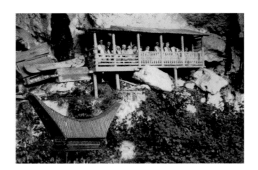

high rank. A houselike structure is erected over the grave and the *tau-tau* will be placed inside. In Mamasa, which is lacking cliffs except for the eastern part of the region, such houselike structures are quite common. The body is laid in a coffin in the shape of an animal—a bull or a fantastic-looking mythical beast. A pair of anthropomorphic figures, guardians, are put in front of the grave (fig. 10).

As we have seen, the Sa'dan Toraja also customarily made coffins. They were shaped like a boat, a buffalo (fig. 12), or a house (fig. 13). No doubt they were used for people of high rank. It is not known why the Toraja abandoned this kind of burial, but it may have been because of a fear of robbery, as the coffins were laid in easily accessible places: caves, caverns, and ridges in the rocks. Alternatively, it could have been that putting the corpses in rock chambers was a new fashion.

18 **Small door**

Hardwood, faded by weathering. The water buffalo's head has been carved with singular sensitivity. The incurved shape between the animal's horns is presumably a representation of the World Tree. Sa'dan Toraja. Height 44 cm. Inv. 3608.

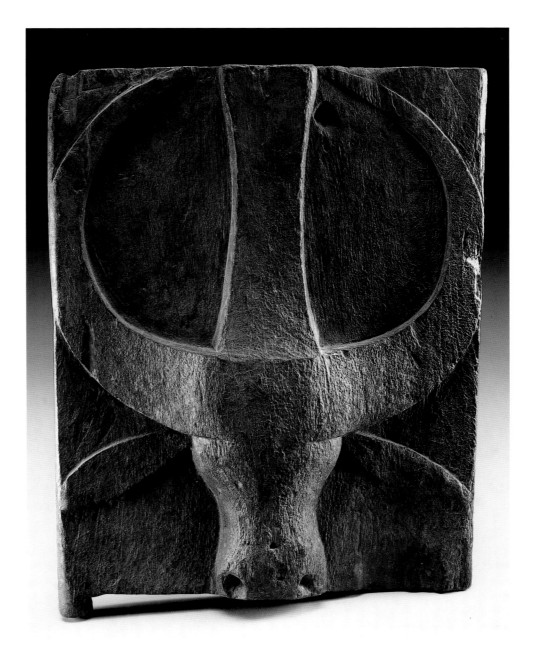

# Flores

Introduction by Jean Paul Barbier
Studies by Andrea K. Molnar and Gregory L. Forth

**1 Bust**

Stone. Of Manggarai origin, but the exact provenance is unknown. This sculpture has a companion piece also preserved in the Musée Barbier-Mueller. Height 62 cm. Inv. 3525-53.

**2** Four stone busts standing on a stone-built platform (out of the middle of which there grows a tree). The sculptures (severely damaged, but readily identifiable) were sold by a Balinese curio dealer in 1987. Village of Lao, Manggarai country, western Flores. Photograph Vidoc, Amsterdam.

**3** Megaliths in the village of Bena, Ngada country. Photograph Jana Ansermet, 1980. Barbier-Mueller Archives.

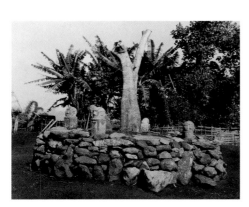

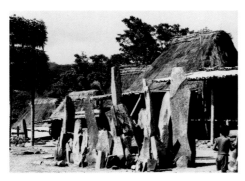

Flores, one of the Lesser Sunda Islands, is a long, narrow island with rugged relief and luxuriant vegetation. It is occupied by a number of groups with markedly different cultures (see map p. 90). These are, from west to east, the Manggarai, Riung, Ngada (they pronounce their name "Nad'a"), Nage, Ende (Ende being also a district), Lio, Sikka (the name of an ancient kingdom whose main city was Maumere), and the people of Larantuka, who are linguistically and ethnically closer to the Solor, Pantar, and Alor islanders. The last named often have very dark skin and tightly curly hair, Papuan

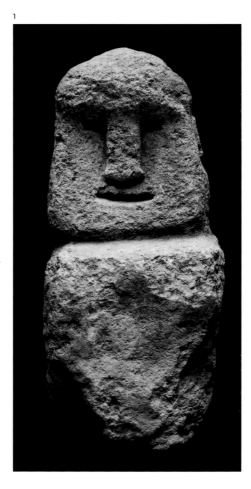

1

features which are rarely met with among the Manggarai at the other end of the island.

The Manggarai lived for some centuries under the rule of the sultanate of Bima, in eastern Sumbawa. Although Bima put up some resistance, the western part of Flores transferred to Dutch control in 1907, and it was only following World War I that Catholic missionaries met with measurable success in converting the region. Until relatively recently, the villages (*beo*) preserved shrines formed out of terraces of disklike rocks (*kota*) placed around a tree on which stood four ancestral effigies roughly hewn into busts, and arranged alternately male and female, in pairs (fig. 1). In the 1980s, these busts began to appear on the Balinese antique market (fig. 2), as did silver and gilt metal jewelry and masks of unknown function (fig. 4), although Andrea K. Molnar has noted their resemblance to similar items from Timor and asked whether the latter might also have come from the extreme east of Flores and not from west Timor. Our present state of knowledge does not permit us to conclusively settle such questions, as nobody has ever described or even observed a mask dance on Flores.

The Manggarai subsist by swithen cultivation of corn (maize) and dry rice (irrigation being introduced only after World War I). The number of buffalo possessed is indicative of their owner's prestige and they can be used to form part of bridewealth or as a sacrifice made to "nourish" the village's stone shrines with blood.

The patrilinear society of the Manggarai was composed of three social classes: the nobles (or "lords," *karaeng*), commoners (*ata leke*), and slaves, a nonhereditary class comprised

## 4 Mask

Wood. Partial limewash, other areas charred. A piece of fur is nailed to the chin. The lower section has been rubbed to a shine by repeated handling, indicating that this mask, like others from Timor, was probably held by the chin. Presented as being from Manggarai country. Height 42.6 cm. Inv. 3525-50.

of prisoners of war, victims of fate, insolvent debtors, etc.[1] As elsewhere in Indonesia, the preferred marriage was between "cross-cousins" (asymmetrical kinship), the most suitable wife for a man being the daughter of his maternal uncle. This system is also met with among the Nage, whereas for the Ngada, children belong either to the father's or to the mother's clan, depending on whether or not the bride-price has been paid. This explains why they have altars for both male (*ngadu*) and female ancestors (*bhaga*).

According to Koentjaraningrat,[2] the Manggarai believe in a creator god called Mori Karaeng (or, as Kennedy contends,[3] Moring Agunaran), from *mori* ("master") and *karaeng* or *keraeng* ("lord")—hence "lord of lords." The ancestor spirits have the ear of this all-powerful divinity and can intercede on their descendants' behalf. Nature spirits, benevolent and malevolent, are differently named depending on where they reside and on the role they fulfill. The most pernicious are called *djin* or *setan*, names derived from two very similar parent words in Arabic, showing the extent of Muslim influence under Bima rule, particularly perceptible to the west of the island.

No author has as yet described in detail the stone statues placed on village shrines, though it can be supposed that they represent the founding ancestor of the village (*beo*) or enlarged clan (*uku*). Ngada religion is now better known thanks to the work of Father P. Arndt, who lived with them for a number of decades.[4] Their supreme deity is called Deva, but is more familiarly known as Mori Mézé (signifying the same as Mori Karaeng among the Manggarai). The celestial divinities Deva and Nitu (Earth Mother) are both creator

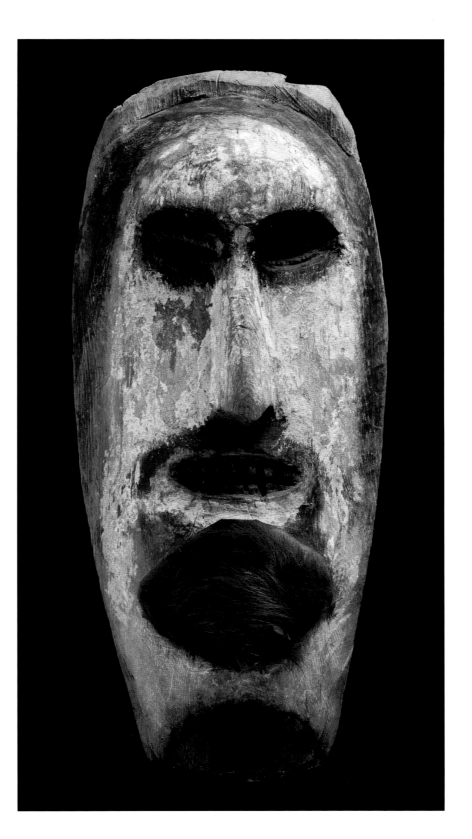

5 and 6 "Male" shrine (*ngadu*) in Ngada country. On the summit of the wooden post under the roof is carved a curvilinear pattern, surmounted by a face (fig. 6). Photographs Jana Ansermet, 1980. Barbier-Mueller Archives.

7 "Female" shrine (*bhaga*) in Ngada country. The carved wooden plank on which the miniature "house" rests is visible. Photograph Jana Ansermet, 1980. Barbier-Mueller Archives.

5

6

7

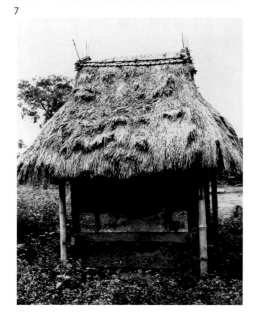

gods. For Arndt, this dualistic religion is reflected in the social order. Arndt makes some comment on the megaliths that abound in the villages of the Ngada, though without entirely satisfying our curiosity. Some are tombs, others seem rather to have been erected to honor the prestige of some individual or family. No stone statuary exists at all, their lithic monuments being either upright slabs or dolmens (fig. 3).

The Ngada, who are past masters in the arts of cotton weaving (see p. 108), produced no relief wood carving. On the other hand, they did incise patterns of curvilinear type into the single post that supports the conical roofs of their "male" shrines (figs. 5, 6) and decorated the side panels and inner thresholds of "female" shrines in the same low-relief, looping style (figs. 7, 8, 12, 13; see p. 107).

The Ngadas' neighbors to the west are the Nage. Although primarily concerned with study of the Ende, Van Suchtelen has also left us with the first significant corpus of data on this group.[5] Strange to say, Nage art, in spite of some early photographs and the information gathered by Rouffaer,[6] has been neglected by all books on the subject of "outer" Indonesian cultures. LeBar, in an otherwise precious compilation, makes no mention of it at all. It took the 1981 international traveling exhibition on the "Art of the Archaic Indonesians" (Geneva, Brooklyn, and Dallas) for two Nage ancestral statues and a rider to be correctly attributed (a large-sized Nage horseman photographed by Rouffaer had been previously ascribed to the Ngada, doubtless an error that slipped in at publication). Luckily, research intensified in the 1980s after a member of staff of the Musée Barbier-Muller, Jana Ansermet, with the

assistance of the Indonesian government, made a meticulous photographic report in 1980 on both the Ngada and the Nage. In 1983, Susan Rodgers made an all too brief visit to Flores that nonetheless gave her an opportunity to collect valuable data on the role played by jewelry and personal adornment in the social life of various ethnic groups. She noted that, "as among the Ngada, Nage art frequently relies for effects on an antagonism between masculine and feminine principles that form two fundamentally complementary spheres. It is through the underlying strength of this theme that Nage art can be integrated into a conceptually coherent whole."[7] For his part, Gregory L. Forth led a far more thorough program of research among the Ngada and the Nage that supplies much of the material for his commentaries below.

Farther to the east, toward the center of the island and near the south coast, live the Ende, relatively close culturally to their eastern neighbors the Lio, although they have been subjected to many other influences, in common with all coastal (*pasisir*) peoples. Both form patrilineal clans and possess strict social divisions (nobles, commoners, and, formerly, slaves), although the indigenous religion has been deeply eroded by the adoption of first Catholicism then Islam, today promoted by the federal government. Rodgers notes that more remains survive of megalithic culture among the Lio than among the Ende, as shown by the example of Walotopo, a village near the coast where many shrines and a considerable amount of stone terracing still subsist.[8]

In the note on the Lio statuette in fig. 22, Molnar refers to the group's "origin house." Very few of these wood carvings have sur-

Decoration from the lower half of a panel running down the side of a female ancestor shrine (*bhaga*). The main motifs shown are horsemen encircled by spirals and other carvings representing precious gold jewelry (especially *taka* pendants whose form is reminiscent of smaller versions of the *marangga* of Sumba). Ngada country. Total length 372 cm. Inv. 3525-48.

Gold pendant. Alor. Length 8.9 cm. Inv. 3743-1.

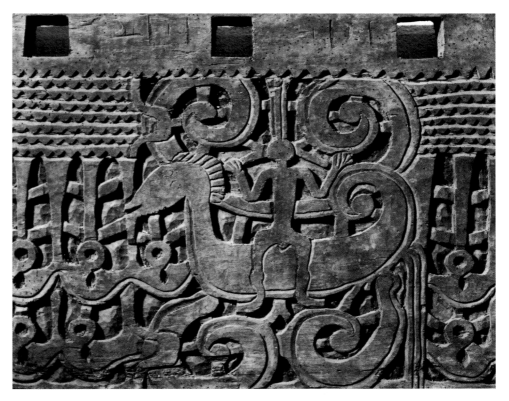

vived, however, and the Lio were no more concerned than the Ende with stone statuary, a genre which (until further information becomes available) seems to have existed on Flores only among the Manggarai.

We conclude this brief introduction with some observations on the easternmost tip of Flores and on the islands that from here continue the chain in the direction of Timor. These include Solor, Pantar, and Alor, on which some groups speak non-Austronesian (Papuan) languages and whose inhabitants are sometimes of pronounced Papuan appearance. Without entering into a description of their beliefs or social life, it is worth remarking that the overriding image in Alor iconography is the *ulenai*, a guardian spirit briefly touched on by Cora DuBois that adopts the shape of a sort of snake, or *naga*.[9] Wooden carvings of this being are found affixed to posts or carved on sword guards (fig. 10)—bearing a striking resemblance to examples made by the Atoni of Timor—and also appear on gold articles, for instance on pendants worn as talismans (fig. 9).

Alor and Pantar are also famous for their *moko*, bronze hourglass handdrums of small size (fig. 11) whose outline is based on models similar to the gigantic example in the temple of Pejeng, on Bali. These *moko* varied in significance depending on age and size, but had their place in every ritual. The oldest were probably locally cast, though for hundreds of years now they have been imported from Makassar and Java.

Following this brief overview, there follows a more detailed examination of seven pieces from central Flores: five wood carvings, a pearl-embroidered "sarong," and a crown, or diadem, made of gold.

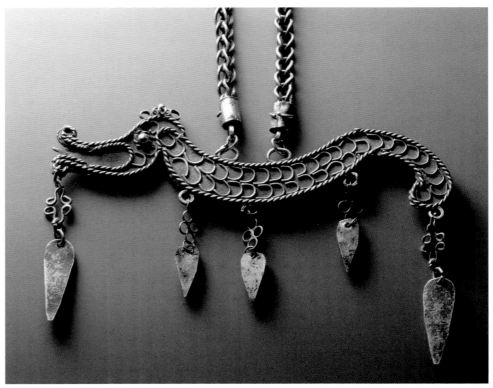

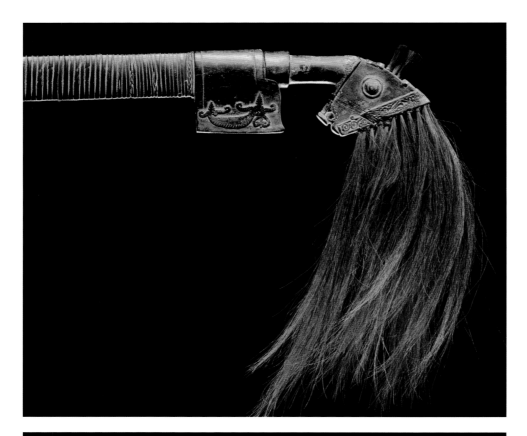

**10 Effigy of a guardian spirit (*ulenai*) (detail)**

Low relief. It adorns the hilt of an ancient Alor sword. The hilt (once tin-plated) is topped with tufts of horsehair. The overall shape is similar to that of swords from Timor (Rodgers 1985, fig. 113), though there the scabbard would be entirely covered in low-relief geometrical decoration, whereas here it is wrapped in rattan strips that have been worn to a sheen. Overall length 65.5 cm. Inv. 3798-4.

**11 Two small drums (*moko*)**

The older example (on the left) is decorated with small heart-shaped faces, simplified versions of those appearing on the giant "Moon of Bali" drum at Pejeng. Ernst Vatter writes that Alor people speak of drums found in the ground called *moko tanah* ("earth drums"). The same author quotes from a report by Lieutenant de Croo (January 1916) which states that the oldest drums were found on the island of Pantar, from which this piece came, together with field photographs. The other is of the *moko jawa* type (a term indicative of the fact that the majority of these drums are imported from Java). Heights 65 cm, 57 cm. Inv. 3797, 3717.

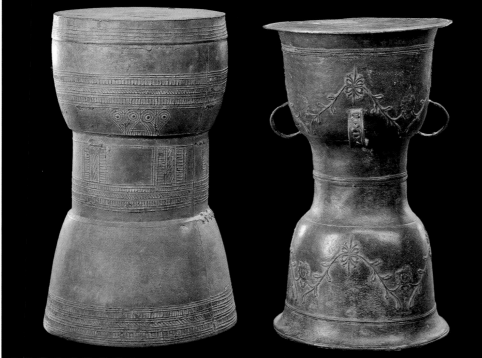

# Threshold of a Ngada Ancestress House
by Andrea K. Molnar

12 **Inner threshold (*kawa péré*)**

Hardwood. From a "woman's" shrine. Ngada. Length 155 cm. Inv. 3525-47.

The *kawa péré* (fig. 12) is an extensively carved wooden board which serves as an elaborate threshold leading from the veranda to the inner sanctum (*oné*) of an origin or named house (*sa'o ngaza*) or inside the ancestress house (*bhaga*), which is a small-scale version of the origin house without the veranda. A small step (*tolo pena*) is carved out of the single piece of wood used for the threshold. The *kawa péré* is a characteristic part of the architecture of the origin houses and ancestress houses of a clan among the Bajawa culture group in the Ngada regency of Flores Island. Indeed, no other houses are permitted to possess a *kawa péré* or any of the other carved boards and posts that identify a structure as an origin house and serve as a material symbol of the clan itself. Each clan possesses two origin houses, the trunk-rider house and the tip-rider house (*sa'o saka pu'u* and *sa'o saka lobo*)—the trunk house being the more senior in relation to the tip house. The *bhaga*, or ancestress house, represents the founding ancestress or the wife of the clan's founding ancestor.

The circular, winding, S-shaped motifs represent the fruits of the tamarind tree (*i'e nage*) and symbolize the numerous descendants of the named origin house of the clan. The dragonlike stylized horse motif is called *jara* ("horse"). Indigenous informants insist that this motif represents a horse and not a dragon. The horse represents the material wealth and status of a clan (*woé*) and also in some places serves as an item of bridewealth. A similar type of horse motif is found on the ikat (tie-dyed) textiles that only members of the nobility are entitled to wear. On some *kawa péré*, motifs of other items of wealth and status can be found, such as those representing gold earrings (*bela*) and ax-shaped pendants (*taka*).

13 Inner threshold of a "woman's" shrine. Ngada country. Photograph G. P. Rouffaer. Courtesy Koninklijk Instituut voor Taal-, Land- en Volkenkunde in Ned. Indië, The Hague.

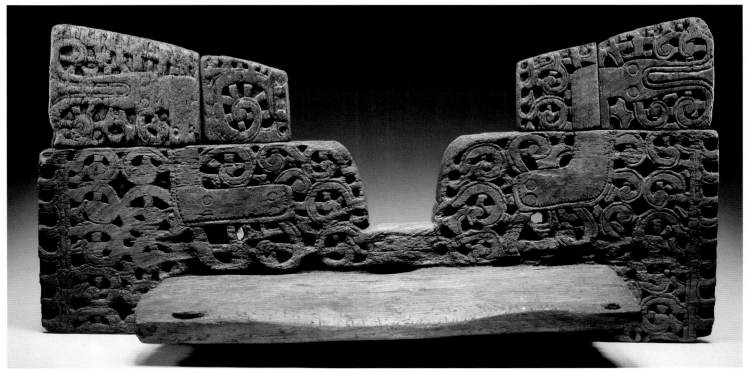

# Ngada *lawo wutu* Skirt
by Andrea K. Molnar

14 **Tubular skirt (*lawo wutu*) (detail)**

Cotton with glass bead decoration. Ngada.
Length 160 cm. Inv. 3525-21-E.

*Lawo wutu* (fig. 14) is a highly valued woman's tie-dyed (ikat) textile and is uniquely decorated with stone bead designs. This textile exemplifies one of the four weaving styles found in the Ngada regency of Flores Island, more specifically the Bajawa culture style. Only noble women (*ga'é mézé*) were allowed to make and use *lawo wutu*. *Lawo* refers to a woman's tubular skirt, while *wutu* means "beads." The horse motif present both in the form of the ikat designs as well as in the bead patterns clearly identifies the wearer as being a member of the highest rank.

Although *lawo wutu* textiles were sometimes worn by noble high-status women, they had another and more significant function. They were used for receiving a child of noble rank, born to a noble woman, upon the infant's introduction to the community during an early life-cycle rite. Rank in the Bajawa culture is inherited through the mother.

The most significant geometric bead designs represent insects—mosquitoes and spiders—which in the traditional belief system represent the physical manifestations of the human soul (*maé*). Receiving a newborn noble infant in a *lawo wutu* ensured that the soul of the child would be securely fastened to it (albeit symbolically), and also signified that the child was a viable new member of the community. The *lawo wutu* was also held to magically transfer a long and prosperous life to the noble infant.

The horse and chicken motifs of the bead work also represent the material wealth and status of the noble family. The chickens also symbolize the personal inherited slaves (*ho'o*) of the new child. The chickens may also signify the sponsoring of future sacrificial feasts by the family. The human stick figures have been interpreted by local informants as representing the significant ancestral spirits of the newborn who will guard it from all harm and misfortune.

# Nage Monumental Horse (*ja heda*)

by Gregory L. Forth

15  **Monumental horse (*ja heda*) and rider**

Hardwood. Nage. Length 300 cm. Inv. 3525-8.

16  Wooden horse (*ja heda*) standing beneath the eaves of a ceremonial building. Nage country. Photograph G. P. Rouffaer. Courtesy Koninklijk Instituut voor Taal-, Land- en Volkenkunde in Ned. Indië, The Hague.

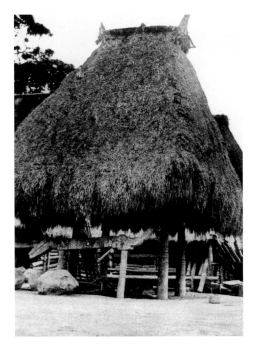

These wooden horses (fig. 15), known as *ja heda* (*ja*; dialectal *jara*), are named after ceremonial buildings called *heda* (dialectal *yeda, yenda, enda*). Erected on two decoratively carved posts, the statues are placed immediately in front of these buildings. In the Nage region *heda* are found at the seaward end (or "tail") of major villages, while in Keo (located immediately south of Nage) they are built at the landward (or "head") end. In both regions the buildings are used to store trophy horns and skulls of sacrificial buffaloes. The wooden statues themselves serve no particular purpose and their significance is now obscure. Evidence from the Nage region suggests that they may represent a *naga*, a mystical creature in the form of a large flying snake with the head of a horse. Capable of conferring wealth and power on favored individuals, these beings are in turn identified as spirit guardians of major villages founded by prominent leaders. The naked male rider, simply called *ana deo* (the term also applied to the paired statues shown in figs. 17 and 18), may represent a human founder able to gain exceptional power and fortune by successfully mounting and riding on a flying *naga*. In some instances a female rider sits, sidesaddle, behind the male. The statue depicted here probably derives from the Keo region, as indicated by the elaborate carving and porcelain inlay on the body of the "horse." The motifs are the same as those found on houseposts and posts supporting these and other statuary (notably the *ana deo*). That both "horse" and male rider possess erect penises probably indicates an association with fertility and fecundity.

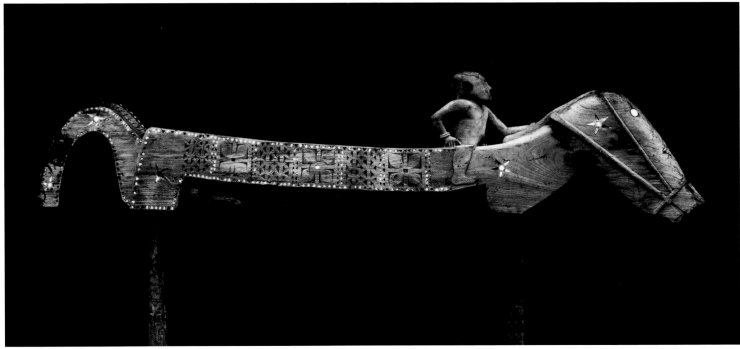

# Two Pairs of Nage Ancestral Figures (*ana deo*)

by Gregory L. Forth

17 **Pair of ancestral effigies (*ana deo*)**

Male and female. Nage. Heights (figures only)
53.5 cm, 56 cm. Inv. 3525-9 A and B.

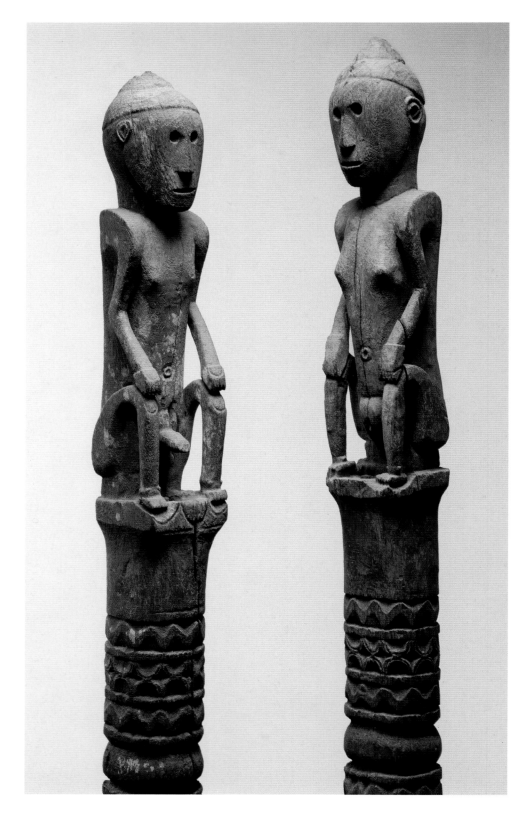

Among the Nage these anthropomorphous figures known as *ana deo* (fig. 17) are erected on either side of a ladder giving access to a cult house (*sa'o waja*), the ritual and political center of a lineage or local segment of a clan. In the Keo region, the same naked figures are found in front of small, normally uninhabited buildings erected at the seaward end of a village. In both cases, the male figure is placed on the (heraldic) right and the female on the left. Although the statues are sometimes described in the literature as representations of ancestors, the attribution is doubtful. In the Nage region, they are more often associated with the tutelary spirit of a cult house, a being identified with the physical building and especially with the spirits of the wood from which it is constructed. The reason for the nakedness of the figures is no longer known to their creators, though they share this feature with riders of the wooden horse statues (fig. 15); the name *ana deo* (*ana* means "child" or "person," the sense of *deo* is unknown) does not resolve these questions.

Two other exemplars of *ana deo* anthropomorphous statues are shown in fig. 18. The protuberances on the heads represent top-knots or buns of hair as traditionally worn by adult Nage and Keo men and women. The figures are carved at the top of wooden posts. These posts differ from other decorated posts found in ritually important buildings only by virtue of the rectangular or cubical platforms serving as seats. Three common motifs are clearly shown here. In the centers of the posts are several rows of triangular zigzags. Just above these can be discerned a single series of faintly inscribed shapes locally identified as fern fronds. Above these, and also in this instance on the platforms supporting the human figures, are sets of four lozenges

18 **Pair of ancestral effigies (*ana deo*)**

Nage. Height (figures only) 34.5 and 35 cm.
Overall heights 164 cm, 150 cm. Inv. 3525-10 A
and B.

sometimes described as flowers or butter-
flies. Whether any particular significance can
be attributed to the motifs is unclear. The
posts terminating in the anthropomorphous
statues also feature a central bulbous shape
designated as a "pot" (*podo, pondo*). Such
"pots" further appear on the trunks of forked
sacrificial posts (*peo*) erected in the centers of
major villages. Although sometimes linked
in local exegesis with commensality, nurture,
and food offerings for beneficent spirits, small
pots of this shape are also used for storing
heirloom valuables kept in the same sorts of
buildings, which in both Nage and Keo feature
the naked human figures.

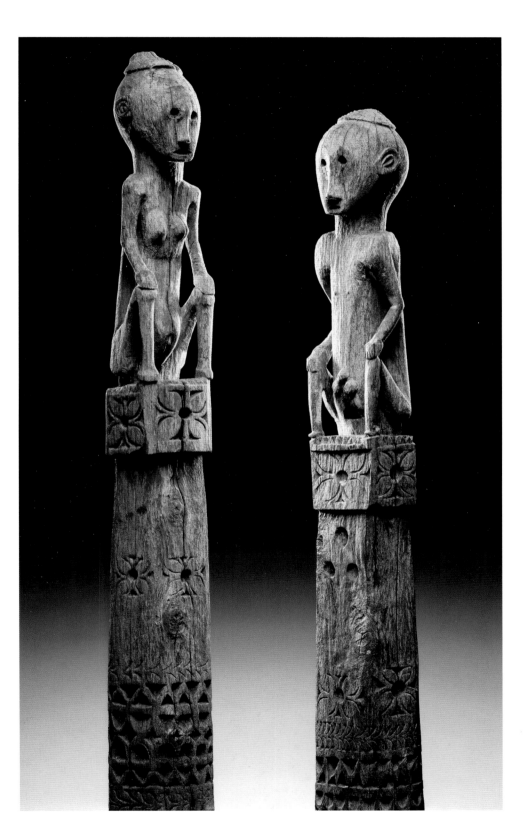

19 Pair of ancestral effigies in situ, near the village
of Boawai, Nage country. Now in an American
collection. Photograph Jana Ansermet, 1980.
Barbier-Mueller Archives.

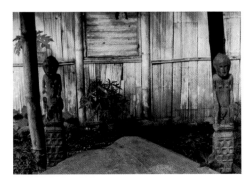

# Nage Man's Headdress (*lado*)
by Gregory L. Forth

20  **Male headdress (*lado*)**

Gold. Nage. Height 47 cm. Inv. 3525-5.

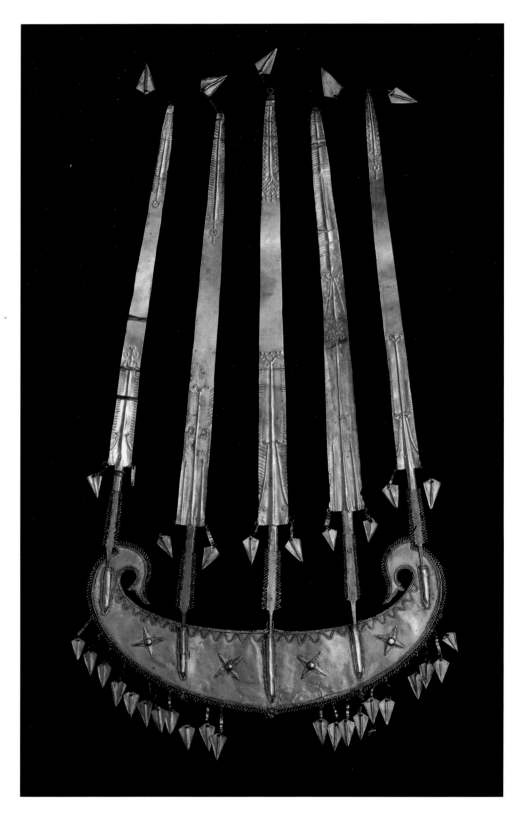

Found among the Nage and Keo people of central Flores, the name of this object—*lado wea*—translates as "golden headdress" (fig. 20). Such headdresses are the exclusive possessions of persons of high rank. Most notable among these are men who take the lead in sacrificial rites focused on forked wooden posts (*peo*) erected in the center of major villages. The ornaments are worn by ritual leaders on the occasion of collective water buffalo sacrifices performed when inaugurating sacrificial posts and other major ceremonial buildings.

The lower crescent of the headdress, possibly representing either buffalo horns or a sailing vessel, is tied to the forehead over a headcloth, while the several metal "plumes" point upward. In this respect, these headdresses resemble the headdresses, also called *lado*, made from the tail feathers of a cock which ceremonial leaders wear when a new sacrificial post is brought into a village and erected.

21  Nage men in the 1920s wearing *lado* headdresses. In 1983, the one on the left, by this time an octogenarian, met Susan Rodgers and was able to explain the function of the headdress to her (Rodgers 1985). Courtesy Rautenstrauch-Joest Museum, Cologne.

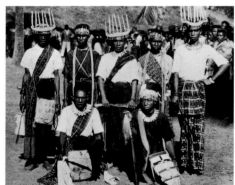

# Lio Ancestral Statuette
**by Andrea K. Molnar**

## 22 Statuette

Hardwood, cloth. Traces of red and black paint.
The arms were carved separately. Lio.
Height 61 cm. Inv. 3525-11.

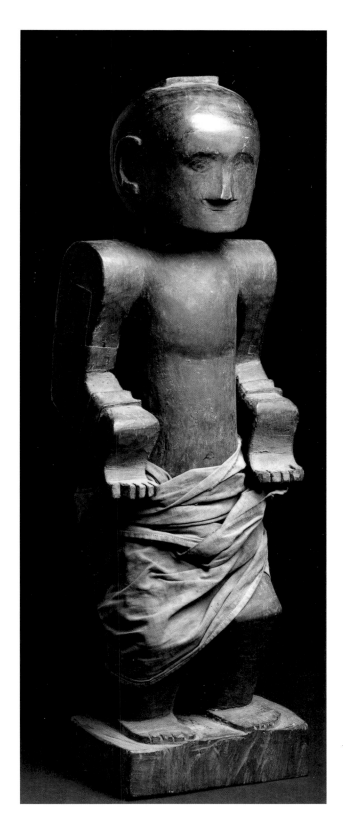

This hardwood statue (fig. 22) was made by the Lio culture group of the Ende regency of Flores Island. The statue was painted in red, wearing a red loincloth. The loincloth was probably added to preserve modesty after the introduction of Catholicism in the Lio region. The use of red paint is quite appropriate since red has a common spiritual association in the local traditional belief system. Indeed, this statue represents the founding ancestor of the cult house or origin house (*keda*) in a Lionese village. It was positioned on the ledge of the wall inside the *keda* and was part of the traditional architecture.

Its upward turned palms served as a place where offerings were placed (a pinch of cooked rice and meat) for the founding ancestor of the ritual community belonging to the *keda* during various ritual performances inside the house.

Statues of this type were often subject to destruction by the Catholic Church in their early attempts at proselytization and waging of "war" against ancestor worship. It has been suggested that the loincloth covering the explicitly carved genitalia was added as a way of appeasing certain particularly zealous priests, thereby saving the statue from destruction.

## 6 Ancestor effigy

Founder of a clan or a village, wearing a *marangga* ornament on the chest. Today, this is the largest stone sculpture from the area in any Western collection. Originally from the region around Waikabubak (west Sumba). Height 140 cm. Inv. 3656.

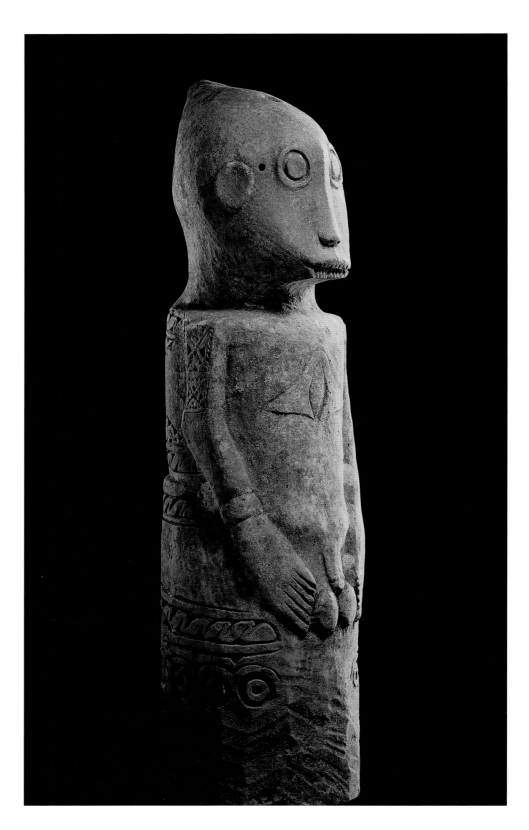

of ritual speech and music underscores the highly aural nature of Sumbanese ritual, which is based on a model of hierarchical communication regulated by an elaborate etiquette of deference, pleading, and respect.

East Sumba, which makes up two-thirds of the island, is home to one-third of the population, who live on high, dry grasslands, herding horses and growing gardens of corn and tubers. West Sumba receives more rainfall and has fertile valleys where rice, coffee, cloves, and coconuts are grown. Its population

7 Photograph taken in the early 1970s showing the statue in fig. 6 in situ. This valuable document was given in 1976 to J. Gabriel Barbier-Mueller, who was working on a photographic report on Sumba, by the person who took it, Achmad Aljoufri.

Stone. The head and bust are fairly naturalistic in style, while the lower half of the body has been treated as a pillar of square section that would have been sunk into the ground. The function of this piece is the subject of debate. Webb Keane is of the opinion that the statuette represents a *katoda*, a shrine for sacrifices and libations made to ancestral spirits, a hypothesis supported by a photograph taken in 1976 by J. Gabriel Barbier-Mueller of a similar statue standing in the middle of a group of sacred plants. See Webb Keane's description and the photograph of the statue in situ in Barbier and Newton 1988, p. 286. Height 69.8 cm. Inv. 3685.

is larger and culturally more diverse, speaking ten different languages and maintaining an achievement-oriented, competitive society fragmented into many small, autonomous domains.

The highest deities are never addressed directly, but approached through a series of intermediaries. Each boundary or barrier (the village gates, the steps to the house, the stone foundations of the ancestral tombs) is guarded by a pair of spirits, one female and one male, who must be named and propitiated as the speakers advance on their imaginary journey to the source of mis-fortune. When an important ancestor or deity is upset, he may also have many deputy spirits who will also demand their due for minor infractions of ritual protocol or pro-cedure. Each death or calamity is usually overdetermined—the result of several forms of neglect, which the living must atone for in order to make peace with the dead.

The highest-ranking deities are double-gendered and are addressed as mothers and fathers who together may bestow the blessings of fertility and prosperity on their charges. The Creator, known as Amawolo Amarawi ("the one who wove us and formed us"), combines the female activity of binding threads to pre-pare them for dyeing with the male activity of metal smelting. Although only rarely invoked in traditional rituals, this mother/father figure is believed by the Sumbanese to preside over a heavenly kingdom located seven or eight levels above the earth.

Anthropomorphized objects (fig. 3) used to communicate with the spirits (the drum and spear, guardians of the house and gates) and specific ancestral figures (figs. 6, 7) are on a

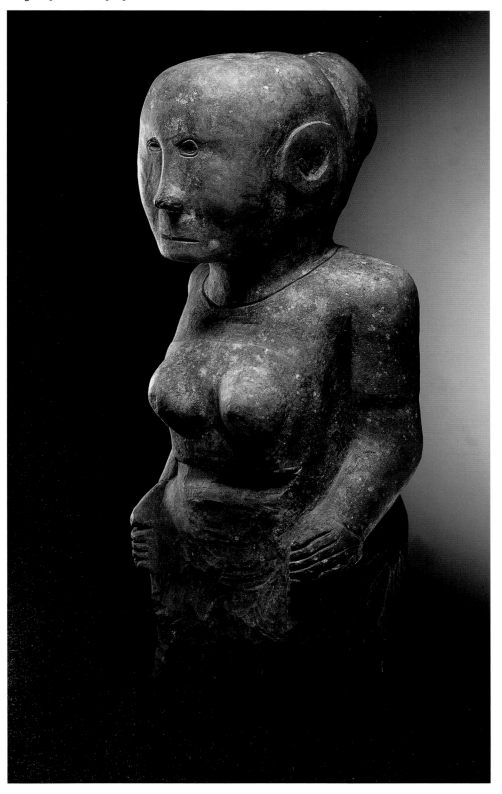

### 9  Funerary stele (*penji*)

A richly decorated example from the southeast of the island. See fig. 10 for such monuments in situ. Bottom, the figuration of two *mamuli* pendants with, above, carvings of two other *penji* standing back to back. In the upper register, an image probably of the deceased on a horse, flanked by two further *penji*, gongs, animals, and more *mamuli*. The other, smaller figure of a horse and rider perhaps represents an ancestor of the dead man. Carved in high relief on the back of the stele are two turtles; animals such as these, with crocodiles and fishes, were said to inhabit the lower world. The stele is decorated differently on the other side. Height 241 cm. Inv. 3686-B.

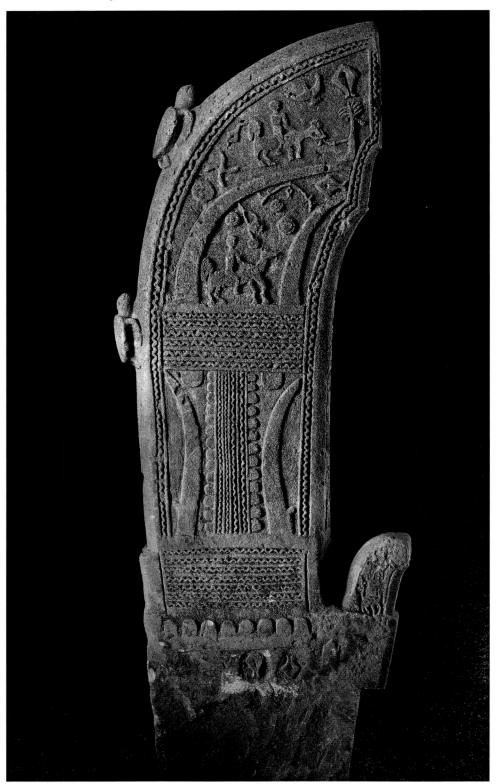

lower level, composed of spirits invoked in female/male pairs. The ancestor who controls lightning, for instance, is invoked along with his sister Tila, who holds the magic net he uses to snare human and animal victims. Male figures control the sky powers of thunder, lightning, and rainfall, but female figures (figs. 1, 8) are associated with the earth and the origin of rice, the sea worms, and garden crops.

Inya Nale, the goddess called the Mother of the Sea Worms, is celebrated in a rite which coincides with the annual swarming of many colored worms (*Leodice viridis*) along the western and southern coasts of Sumba. The high priest of the calendar, called the Master

10  Tomb in southeast Sumba. The *penji* is decorated with high-relief animal figures symbolically allied to death, such as fish and turtles, as well as depictions of prestigious articles belonging to the deceased: gongs, jewelry, and horses. Photograph J. Gabriel Barbier-Mueller, 1976.

Each example represents a particular local style from the southeast of the island. The one to the left is commonly referred to as a "horse's head" in the region where it comes from. Heights respectively (from left to right) 145 cm, 155 cm, 124 cm. Inv. 3686-I, 3686-K, 3686-D.

of the Year (*mori ndoyo*) or the Lord of the Moon (*rato wulla*), predicts the day that the worms will swarm by counting the lunar months and correlating them with astrological and seasonal indicators. On the day he selects, thousands of Sumbanese go down to the beaches to collect the worms in the early hours of the dawn. An abundance of worms augurs well for the coming rice harvest, since it is said that the soul of the rice goddess has been reincarnated in the new crop.

The worms are "entertained" with the *pasola* (fig. 2), a form of traditional jousting in which hundreds of horsemen ride across a field along the beach and throw lances at each other to knock off their opponents from another district. Some human blood must always be spilled on the *pasola* field as a sacrificial offering to the worms and growing rice plants, but fatalities are said to occur only if a taboo is broken. Failure to observe the ritual silence, which lasts several months, before the *pasola*, or the ban on collecting food from the sea during that period, will remove the protection of the ancestors and allow riders to be killed by lances striking directly the eye, head, or throat.

*Marapu* traditions in east Sumba place greater emphasis on the authority of the ancestors and the permanent lines of alliance exchanges, which are defined by asymmetric alliance —the practice of women from a given group marrying out in only one direction, so that marriage exchanges form a sort of circle. In most of west Sumba, formal exchanges are not prescriptively regulated, and the more complex circulation of heirloom objects and persons defines an open field for competition and communication with the invisible powers. Individual skills in speaking or singing can

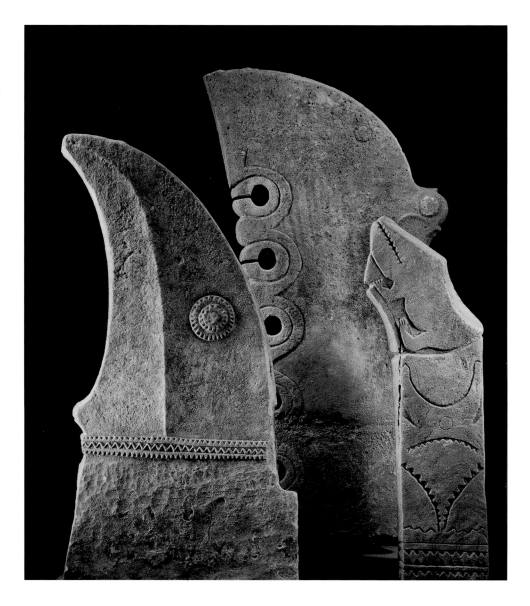

**12  A *woridi* and two *mamuli***

Though scarcely discernible, the motif decorating the piece at bottom left is a "skull-tree" (*andang*). East Sumba. Height of *woridi* 8.1 cm. Inv. 3660-7. Heights of *mamuli* 8 cm, 6.6 cm. Inv. 3660-9, 3660-3.

**13  Gold ornament (*marangga*)**

Worn on the chest, particularly in the west of the island, although some high-ranking families from the east also possess *marangga* as part of the sacred family treasure. Width 30 cm. Inv. 3676.

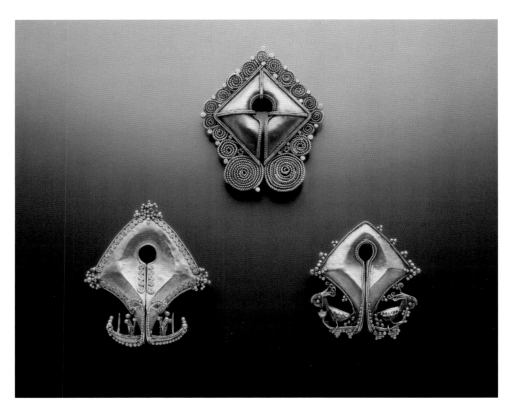

become a springboard to renown, establishing a political base and a substantial number of followers. Wife-givers enjoy a certain prestige all over the island, however, and are believed to bestow blessings of fertility and good health on their wife-takers.

Status is expressed differently in east and west Sumba. In the east, tombs are marked with *penji* (figs. 9–11)—stone memorials decorated with crocodiles, turtles, and other sea creatures symbolizing a noble birth and maritime ties to the sources of imported wealth like *patola* cloths and Javanese krisses. When human figures occur, they are depictions of human "possessions"—slaves and personal attendants whose spirits are said to travel along with the deceased at the funeral. A male attendant leads or rides the dead man's horse in the funeral cortege, while a female one guards the body in the house and mourns it with dirges. The figures of the bearers of the body can also be depicted on *mamuli* pendants (fig. 12), either in positions of supplication or prepared to go to battle to avenge the death.

In the west, symbols of wealth acquired on land predominate—including gold jewelry such as the crosspiece breastplate (*marangga*; fig. 13), and horses and buffaloes. The tomb of a west Sumbanese Big Man is constructed during his lifetime to display his accomplishments. That of an east Sumbanese noble is finished by his descendants to celebrate his aristocratic status.

The exchange of gendered wealth objects —"male" weapons and livestock for "female" pigs and cloth—defines a hierarchical ranking system in the east, but a more flexible system of shifting inequalities in the west.

Gold. From the treasure of the *raja* of Pau (in the east of the island). Some of these necklaces do not fasten, consisting of long chains with each end terminating in the head of a stylized snake. Length 74 cm. Inv. 3675.

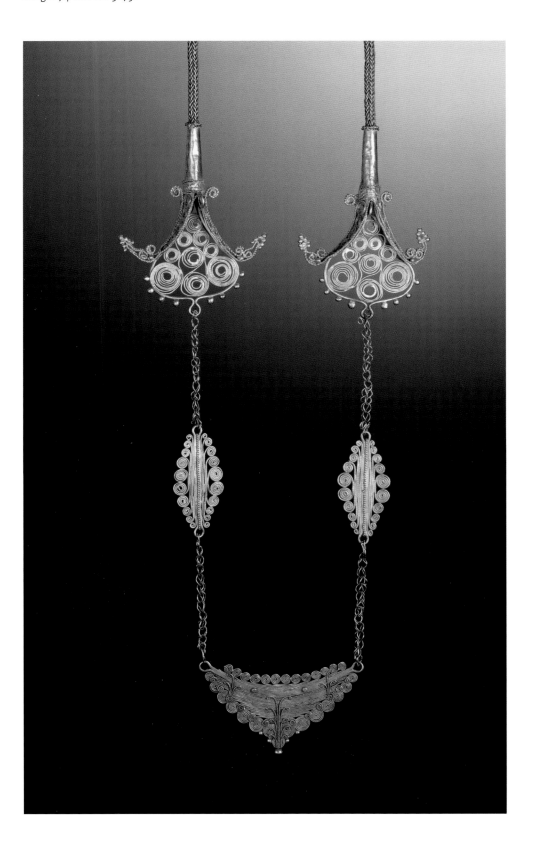

The royal families of east Sumba require very high bride-prices of over a hundred horses. They must then confirm the status of the bride by transferring fine gold jewelry along with her as she travels to her new home. This jewelry can include ivory bracelets, moon-shaped headpieces (fig. 15), delicately filigreed neck pendants (fig. 14) and—for a particularly splendid bride—a betel box decorated with images of jewelry and carried by a personal attendant (fig. 16). A girl of noble birth in east Sumba is called "the daughter of the father son and mother moon," and images of these celestial bodies on her finery remind everyone who sees her of her lofty rank.

Another common image on Sumbanese cloth (fig. 18), also found on the elaborate tortoise-shell combs worn by aristocratic women (fig. 17), is the skull-tree. Before pacification in the 1920s, rival domains on Sumba would take heads from their traditional enemies and hang them on a treelike altar in the center of the village. The number of skulls hanging on the tree reflected the bravery of the warriors of that village, who are sometimes depicted dancing beside the skulls or in the form of roosters mounted on horses. The skull-tree shows how new domains could be conquered and encompassed within the sphere of power of a particuarly warlike local lord.

Sumbanese cloth is woven with unusually large, bold patterns which have attracted foreign buyers for over a century. The *hinggi*, or man's cloth, is worn draped over the shoulders or tied around the loins during a man's lifetime. When he dies, it can also serve as a funeral shroud, and at noble funerals hundreds or even thousands of cloths may be used to wrap the body.

Gold, worked in repoussé. Known as *lamba* in the east and *tabelu* in the west, this was one of the most treasured possessions that could be owned by a noble family. It was worn by a slave or the descendant of a slave during funeral ceremonies. Such an ornament would be stored in its own hardwood box in two halves tied together with strands of woven rattan. Width 30 cm. Inv. 3682

The *hinggi* made for commoners are woven by binding white motifs in thread against an indigo background. The cloths of the nobility go through another dye bath using the reddish root of the *kombu* plant (*Morinda citrifolia*). The most important heraldic motifs, like the skull-tree or the dancers, can only appear on noble cloths, but images of *mamuli* pendants and animals (horses, roosters, shrimps, and crabs) are found on all cloths.

The cloths are organized into large horizontal bands, markedly different from the conventional warp stripe patterning of most other Indonesian textiles. Over the centuries, the Sumbanese have imported certain images of external power, such as the rampant lion from the Dutch coat of arms or the Indic *naga* snake/dragon, and these are sometimes placed in the center of the cloth band to emphasize its function as noble regalia.

Women's *sarungs* are tubular flat cloths, which may be ornamented with beads and shells, or a special embroidery technique called *pahudu* (in east Sumba) or *pahumbi* (in west Sumba). A large human figure, usually with hands raised in a dancing posture, is depicted on some eastern cloths, while in the west more geometric designs labled as animal parts ("the buffalo eye," "the horse's tail") are found. The same motifs which are put on the cloths were also traditionally tattooed onto women's bodies, especially the thighs and forearms, as a mark of noble rank. They are also said to be a visual sign that a fine bride-price was paid, and for this reason they depict the animals (horses, buffalo) or gold jewelry (*mamuli*) presented by the groom's family.

Textiles encapsulate the pattern of exchanges which they are part of, showing how male feats of bravery and daring can lead to successful marriages and many descendants. The skull-tree, although it is a tree of death, is also a symbol of fertility, since an avenged death allows new life to be born. The form of the *mamuli* pendant is interpreted as a representation of female genitalia, with a round uterus protected by triangular tubes curving up on either side, with the opening "guarded" by fierce male animals (lions, stallions, roosters) or warriors. Female fertility and

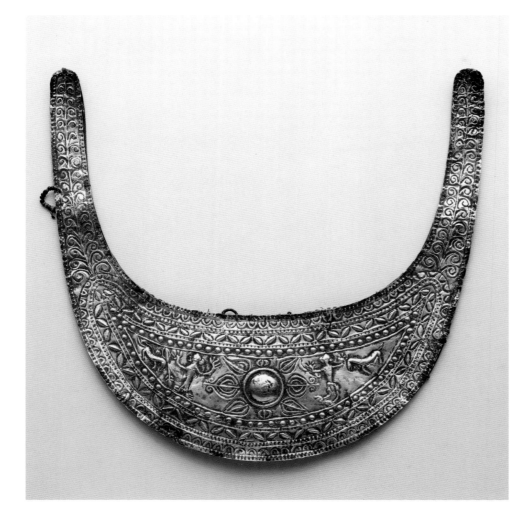

**16 Box**

Wood. Blackened and decorated with plaques of silver in the shape of triangles, moons, stars, and human figures. It is not known where the piece was collected. Height 21 cm. Inv. 3668.

**17 Woman's comb**

Tortoise shell. The motif in the center is a skull-tree. Height 16.5 cm. Inv. 3650-B.

reproductive power is here graphically controlled and channeled by male wealth and violence.

The Sumbanese are unusual in Indonesia in that they make up the vast majority of the population of their own island, and so they have not been extensively influenced in the past by coastal Muslim populations, colonial governments, or Christian missionaries. Now that the Indonesian state is improving education and transportation, the island's religious conservatism cannot be expected to last. But even with an increasing number of Christian converts, the Sumbanese remain loyal to the complex exchanges of animals, objects, and women that bind them to their ancestors, and respect the *marapu* through ritual actions rather than verbal prayer. These social exchanges can continue as forms of custom (*adat*) for many more generations, and remain a vital part of cultural life.

**18 Man's cloth (*hinggi*) (detail)**

This ancient garment—it was in a Dutch collection from the beginning of the twentieth century—shows figures (slaves?) with raised arms. Dimensions 240 x 126 cm. Inv. 3651-H.

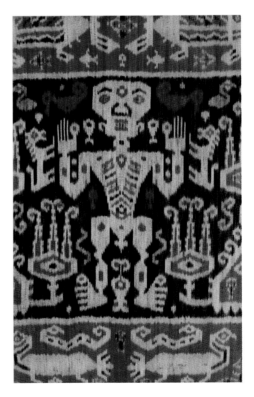

# Ataúro

Jorge Barros Duarte

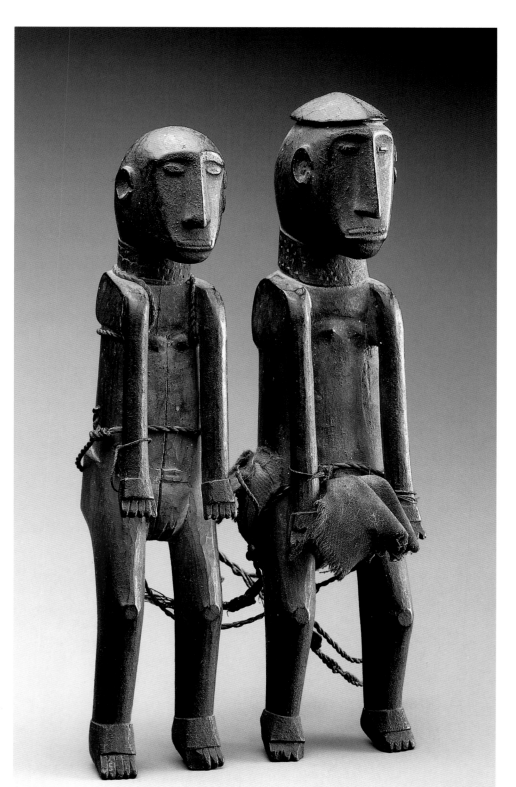

1 **Pair of ancestral effigies (*itara*)**

Hardwood. Remnants of fiber cloth. The length of sennit cord was used to hang such statuettes from the *ruma-tara* post in the traditional chief's big house (*ruma-pera'ik*). Heights 20.3 cm, 21.5 cm. Inv. 3794-A and B.

Ataúro, also known by the Malay name Pulu Kambing ("Goat Island"), is a small mountainous island of 140 square kilometers, approximately 27 kilometers to the north of Dili, capital of East Timor. It has a population of less than 5,000 people. Its highest point is Mount Manu Koko, just over 300 meters high.

There are three main languages spoken in Ataúro, all of which belong to the Austronesian family: Resuk, spoken in Makili, Raklung'u, spoken in Makdadi, and Rahesuk, spoken in Beloi and Bikeli. Manroni is still heard in the area corresponding to the former administrative division of the same name, but it is being progressively supplanted by Raklung'u.

2 *Itara* statuettes hanging outside a house for an in situ photograph. Photograph Jorge Barros Duarte.

Another facet of Ataúro art was the crafting of sabers (*obi* or *opi*) and lances—both those intended for everyday use (*tepa*) and those offered during the marriage ritual. The latter, called *ite'a*, can be as much as 3 meters long, staff and blade included, and weigh up to 7 kilograms. These objects are the product of simple metalworking techniques, but are highly appreciated by the Ataúro and their neighbors on others islands.

**6  Adz**

Hardwood haft, the iron blade being bound on with rattan. This carved tool is of a type commonly used by Ataúro craftsmen. Length 33 cm. Inv. 3792.

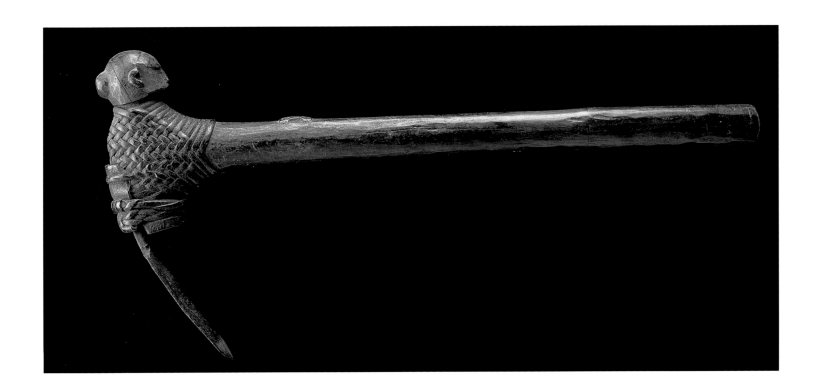

# Timor

David Hicks

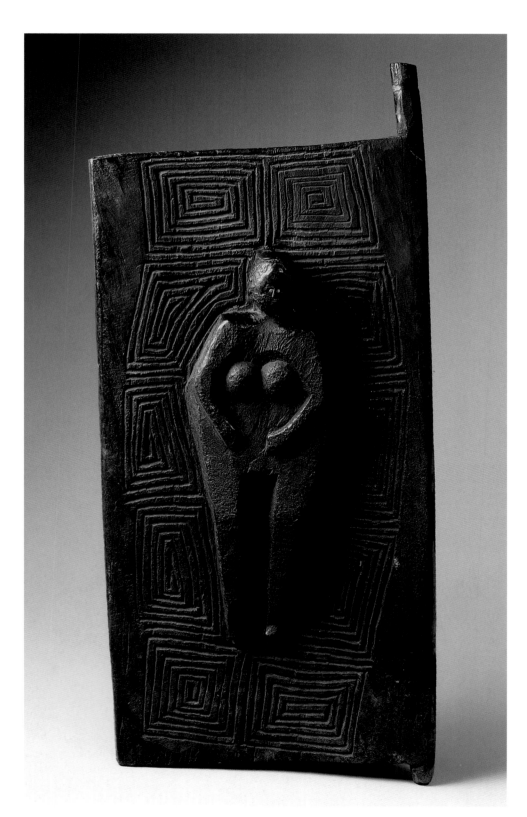

Timor, an island in the far southern corner of the Southeast Asian archipelago, is home to various language groups. Their exact number has not yet been determined, but it appears at least fifteen can be identified. They comprise the Fataluku (Dagada), Makassai (or Makassae), Nauhete, Wai Ma'a (or Uai Ma'a), Kairui, Tetum (or Tetun, Tetu, Teto, or Belu), Gaioli, Mambai (or Mambae), Tokodé, Eme (or Kemak), Bunaq (or Bunma'), Atoni, Autauroan, Halong, and Idate.[1] As this parade of designations indicates, alternative designations are available to confuse the provenance of artistic creations and make identification abstruse. The art created by the Nauhets, Wai Ma'a, Kairui, Galoli, Tokodé, Atauroan, and Idate is virtually unknown, and their social institutions and verbal art forms have been poorly reported in the literature.[2] Most of the material art identified as Timorese therefore comes from the Fataluku, Atoni, and Tetum. The Fataluku live at the eastern tip of the island, the Atoni in most of the western half, and the Tetum in two sections, one straddling the middle of Timor, the other occupying a portion of the southeastern coast. The entire Tetum population (fig. 2) has, accordingly,

## 1 Door

This door, of Tetum origin, is made of hardwood and features a geometrical concentric spiral pattern encircling a female figure in very high relief. The eyes are inlaid with little shells clipped into hollowed-out disks. Numerous types of such doors occur, decorated with geometrical designs either on their own or combined with symbols, such as a face with horns (head-hunting) or a pair of breasts (fertility). Since the beginning of the 1980s, no objects of Indonesian origin have been subjected to so many forgeries as these Timor doors. Height 131 cm. Inv. 3736.

3 **Trap door (detail)**

On a sliding panel made from a thick plank, two birds are carved at one end. Previously described as having come from the center of Timor (Barbier 1984), it would now appear that the piece comes rather from the west of the island and is of Atoni origin. The panel would have been fixed to the ceiling and slid horizontally to allow access to a space under the roof timbers. According to Appel (1988), such panels are located in buildings whose lower floor serves as a meeting house, the attic being used as a granary. The pattern of lines in relief tracing round a series of little circles (also in relief) is typical of the *horror vacui* prevalent in Timor art. Also of note are the swastika-like geometrical spirals in the middle of the diamond-shapes. All these motifs are also to be found, for example, on sword hilts, numerous horn spoons, and on certain architectural features. Overall height 215 cm. Inv. 3713.

been subdivided into the Northern Tetum, Southern Tetum, and Eastern Tetum.[3] It should be remarked that as a consequence of the Indonesian military occupation of East Timor, during which populations have been compulsorily relocated, the pre-1976 sites of many local groups have altered. Another point to bear in mind is the cultural and social heterogeneity that frequently characterizes a language group. Northern Tetum doors (fig. 1), for example, famously depict carvings of human beings and animals (fig. 3), but this type of artistic representation does not occur in the Eastern Tetum region of Vikeke, where doors are made from split bamboo

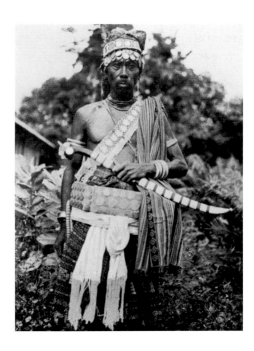

2 Tetum village headman (Belu). The disks around the head and on the cloth sash are made out of silver coinage. The use of gold is infrequent on Timor. Photograph B. A. G. Vroklage.

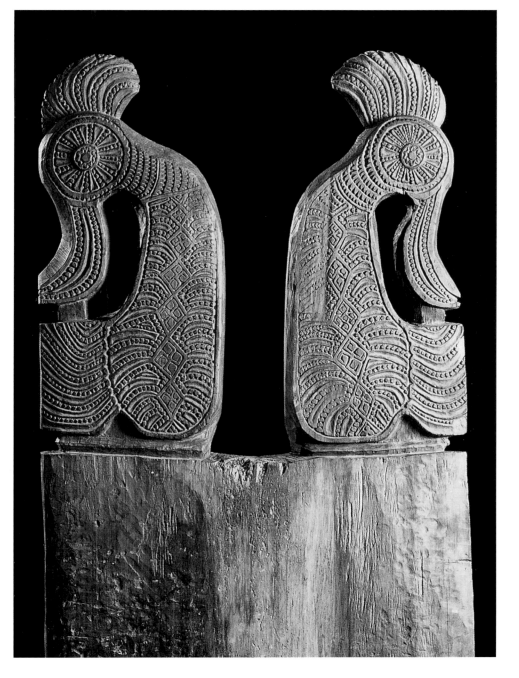

**4 Shoulder cloth (detail)**

The elaborate decoration was achieved by the supplementary weft technique using chemically dyed yarn. Ranks of horsemen and standing men and women facing the viewer alternate with horses, dogs, and geometrical patterns that were perhaps invested with some unknown symbolic significance. Tetum. Central Timor. Overall dimensions 175 x 70 cm. Inv. 3719-25.

instead of massive wood. Finally, although Timorese art—at least as it finds expression in weaving and sculpture—has achieved some recognition among scholars, no systematic study of Timorese art has yet been made.

The animals most commonly represented in these artistic media are both feral and domestic.[4] They include crocodiles, deer, snakes, fish, shrimps, pigeons, buffaloes, horses, dogs, and cockerels. Deer, snakes, fish, shrimps, and pigeons may be portrayed simply for aesthetic pleasure, but the depiction of the other species can have more social import. The relationship between crocodiles and human beings, for instance, is important in folklore, and there are oral narratives that tell of adventures in which crocodiles as divinities interact in quasi-human fashion with villagers. In the iconography of some ethnic groups, Timor is cast in the shape of a croco-

dile, and legends describe how human beings arrived in Timor astride the back of a crocodile. The buffalo, besides being an important unit of wealth, is the prime ritual sacrifice. Horses and dogs are regarded as helpful companions, while the cockerel is a symbol of male bravery and procreative capacity.

The best-known art form on the island is weaving, which is a female activity everywhere it is practiced (figs. 4–6). The techniques used in Timorese weaving resemble those in other parts of the Indonesian archipelago where a spindle is employed. Modern yarns have reduced the amount of work involved in weaving, but yarns made in indigenous fashion from cotton are still used. The ikat ("to tie") method is used, which involves tying bundles of yarn together by wrapping around them at selected places *lontar* palm leaves that have been scraped thin. The rest of the

bundles remain white and uncovered, and are dipped in the darkest of the dyes selected for use. When they have dried the bundles are wrapped in *lontar* leaves to cover those places already dyed. As before, the rest of the bundles remain uncovered and are then dipped in a second color. The process is repeated should a third color be desired.

Indigo, black, and red, supplemented by yellow, blue, and white, are the most common colors found in the cloths, though these may come in various shades, with red, for example, appearing as terra cotta or an almost orange hue. The colors and the patterns woven into the cloth vary according to linguistic affiliation and locality. The Atoni are said to favor indigo and red, whereas the Southern Tetum prefer indigo.[5] The Eastern Tetum favor red and black; the Makassai, blue and black. Patterns may consist of geometric designs

or human figures, animal figures, trees, houses, and boats. Cloths, whether worn by men or women, play an essential part in Timorese social organization and religion, and their significance is particularly evident at marriage. Practically everywhere in Timor marriage is an institution which establishes and reinforces established jural, economic, and ritual bonds between lineages. The bride's lineage provides the bridegroom's lineage with masculine and feminine cloth and pigs, in exchange for buffaloes, pectoral plates worn by men, and sundry other prestations. The total value of these gifts can be high in the case of politically prominent families, but the symbolic meaning of the goods ranks as important as their economic value. They signify the mutual interdependence binding both groups together. Cloths are also given to the wife-takers at birth rituals and when a house has been constructed. Among the Atoni, the finest cloths are reserved as winding-sheets at funerals,[6] but elsewhere, too, corpses go to their graves shrouded in such cloths.

The masculine art of carving is second to weaving as the most celebrated of the Timorese arts, and finds expression in three principal media: wood, stone, and buffalo horn. Wood is the most common of these materials, and on it and in it are fashioned geometric patterns and human and animal figures which decorate house doors, posts, pillars, pounding sticks (fig. 7), stools (fig. 8), and spoons (figs. 9, 10). Freestanding human figurines and animals are also carved, as are wooden masks (figs. 14, 15), which in some localities are worn by men when they dance. Ancestral figures (fig. 18), whose continual involvement in daily life as ghosts of the dead exceeds that of other spiritual agencies,

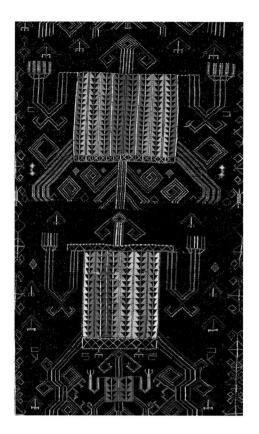

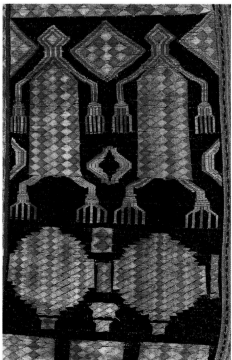

5 **Sarong (detail)**

In cotton, comprising three sections sewn together. The predominant tone is indigo. The pattern has been built up using chemically dyed supplementary weft yarn. It shows highly stylized human figures with raised arms. The lower personage is protecting a tiny individual between its legs, while the upper one seems to be endowed with an animal tail. Atoni, c. 1930. Overall dimensions 150 x 118 cm. Inv. 3719-14.

6 **Skirt (*sarong* or, in Tetum, *tai*) (detail)**

The main motif comprises couples of asexual, frontally facing figures. The following description of the cloth was given at one time by Mrs. Nabholz of the Museum der Kulturen Basel: "The warp *ikat*—known as *futus* in the Belu (Tetum) region—generally forms a regular and schematic design of interlocked diamond-shapes. The supplementary weft technique, where the pick is inserted by hand through the warp ground, is called *sui* by the coastal Belu/Tetum and *raroti* among members of the same populations living in the mountainous interior. Dynamic and asymmetrical combinations of *sui* motifs (using thick yarns of cotton and occasionally silk) have sometimes resulted in the technique being mistaken for a type of embroidery." The same writer added that the anthropomorphic motifs were called *fut ema*. Tetum. Overall dimensions 160 x 79 cm. Inv. 3719-4.

### 7  Ceremonial rice-planting stick

While researching the Buna of central Timor, Berthe observed the crucial importance of certain rituals designed to replicate primordial gestures described in creation myths. For example, the local priest would imitate the planting of the very first rice grain by the culture hero (consistently present in one form or other, though his persona may differ depending on the ethnic group concerned). In hollowing out a space in the stick just beneath the human figure, the carver was careful to leave a loose cylinder of wood in the cavity. When the stick is beaten in time to the chants and dances that accompany the first rice grain ritual, the rattle shakes up and down. It might be thought that the figure on the top of the planter is the founding hero, but it is also conceivable that it represents the priest himself or his mentor: we can only speculate. Tetum. Overall height 149 cm; height of the figure 20 cm. Inv. 3705.

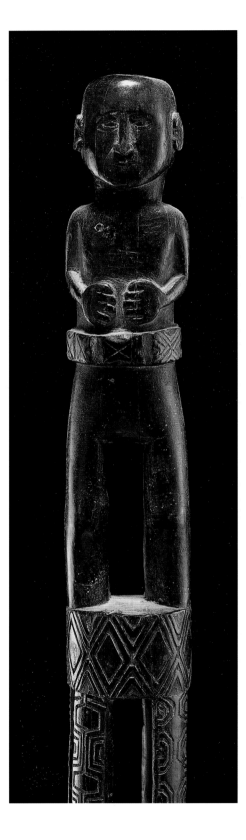

including divinities, are frequently represented as wooden figures.[7] Divinities, too, are portrayed in wood. Ancestral ghosts and divinities also provide motifs for stoneworking (figs. 16, 17), which is particularly widespread in the more mountainous regions. Notable examples include altars for sacrifices and tumuli erected to honor deceased kings. Buffalo horn, black or white, is the preferred medium in some localities, such as in the Eastern Tetum region of Vikeke.

Another Timorese art is metalworking in silver, which is a masculine activity. The objects produced include bracelets, necklaces, and combs, which may be elaborated into filigree patterns or left plain. However, the most socially important silver adornments (they may also be of gold), are circular pectoral plates worn by men and various types of headdresses worn by both sexes (fig. 13). Unlike bracelets and necklaces, these are heirlooms owned by wealthier families and passed down from generation to generation. The plates, as previously remarked, form part of the set of gifts given by the wife-takers to their wife-givers on the occasion of marriage, and in this way many of them circulate between families.

Basketry offers a wide scope for artistic motifs. Among the most popular objects for decoration are pouches (kohe in the Tetum language), which function as receptacles for tobacco, betel leaf, and areca nut. These pouches are small enough to fit into the hand and are provided with lids. The dried palm leaves from which they are made are decorated with the usual Timorese motifs dyed in a variety of colors, including blue, green, and red. Men make the palm leaf strips and cords, which women then fashion into whatever

18 **Statue of an ancestor (*ai tos*)**

Hardwood. Formerly erected on a mound built of rough-hewn stone. The eyes are made from shell disks. The face is less weather-beaten than the body because it was protected by a large capstone placed across the top of the head (the stone here is a model in polystyrene). Northern Belu/Tetum country. Height 91 cm. Inv. 3726.

19 Sacrificial post with raised slab for offerings. Central Timor. Tetum. Photograph B.A.G. Vroklage, 1953.

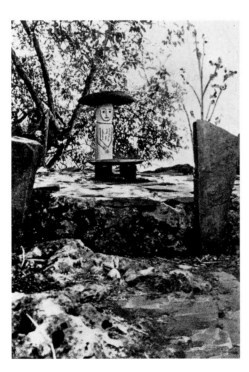

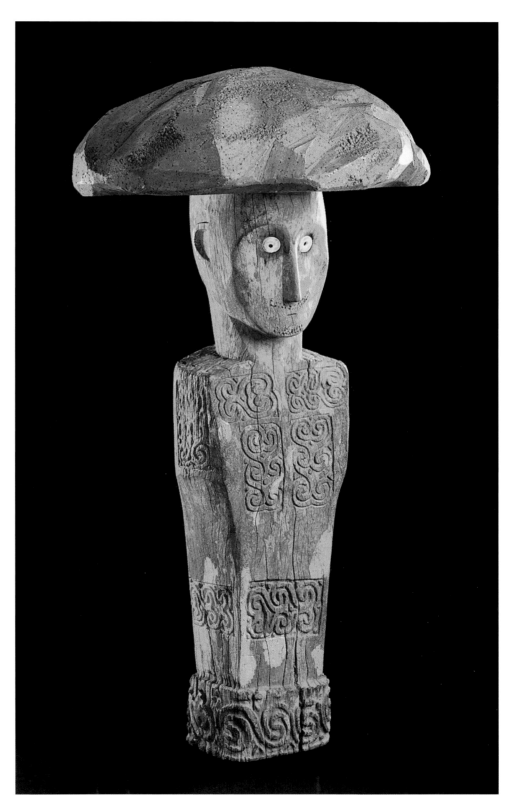

# The Southern Moluccas

**Anne-Marie Vion**

**The Moluccas (Maluku)**

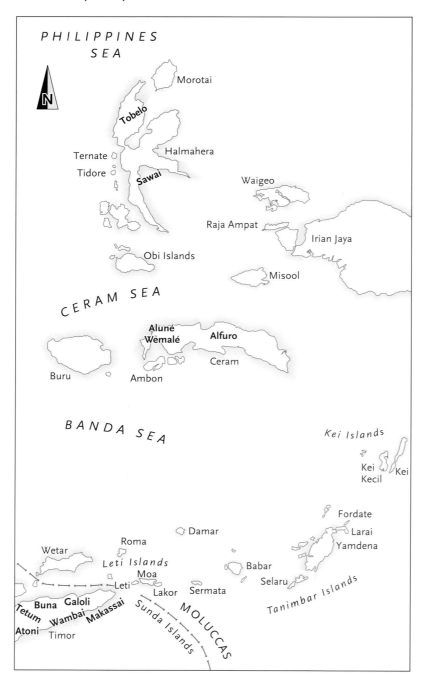

In the colonial period, the term Moluccas was restricted to the central and northern isles of Ambon, Ceram, and Halmahera, famous for the abundant spice crops that, even before the arrival of European explorers, were already being exported to Java, India, and China. As early as the fifteenth century, a powerful sultanate based on Ternate had converted to Islam and begun propagating the faith throughout the neighboring islands, though inland head-hunting populations were to persist in their traditional lifestyles for long after. The Muslims on the coasts referred to them by a pejorative term of Arabic origin, *Alfuro*, the equivalent of "pagans" or "barbarians." We have no information that might imply a widespread tradition of carving, but ceremonial shields encrusted with shells —long and narrow on Ceram, and smaller and flared toward top and bottom on Halmahera (fig. 2)—have been collected.[1] We will leave to one side the island of Wetar—where Elbert observed the presence of wooden statuettes close stylistically to examples from Ataúro and Larantuka-Alor—and concentrate instead on three island chains that have many characteristics in common: Leti, Babar, and Tanimbar. The latter has benefited from admirable studies by Susan McKinnon.[2] Prior to her work, researchers had to rely on missionary reports whose objectivity, in spite of considerable curiosity and intelligence on the part of their authors, was not necessarily irreproachable. Drabbe's publication remains nonetheless remarkable,[3] even though the writer himself contributed (in a process encouraged by the colonial authorities) to the abandonment of the large "named" noble houses on Tanimbar in favor of little shacks with space enough only for a single family. Drabbe was also responsible for stripping some houses of large quantities of sacred objects.

2 **Shield**

Hardwood. Inlaid with shell and reinforced with rattan weave. Employed in dances rather than combat. Halmahera, northern Moluccas. Acquired by Josef Mueller before 1939. Height 76 cm. Inv. 3530-1.

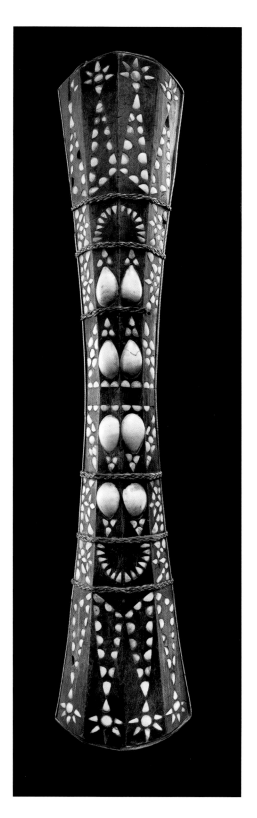

Leti is a minuscule archipelago comprising only three inhabited islands: Leti, Moa, and Lakor. An excellent summary of the religious life of the islanders has been given by Stöhr,[4] who makes no mention, however, of the countless anthropomorphic statuettes of all sizes called *iene* that were apparently effigies of ancestors, temporary dwelling places for the souls of the departed.[5] The smallest were lined up along the roof beams in the house, though they could also be taken on journeys as talismans. The largest effigies—those of the founders of the chiefs' house—were equipped with little bowls for offerings as well as plinths (also separately carved) which had a cavity serving as a receptacle for further votive gifts (fig. 3). Other, larger examples were erected in the communal area of the village. Riedel does not state that these are representations of the founders of the village, being instead of the opinion that they are "protective spirits" (*nitu*). On the other hand, he does specify that the headdress on each statuette reflects the wearer's social rank.

Precious little wooden "masks" encrusted with shells and set with curved wild hog

tusks were in fact ornaments to be gripped between the teeth by participants in certain types of ritual. The biggest feast on Leti, called *porka*, took place every seven years. It was a ceremony designed to call down the blessing of supernatural beings on the fields and the women, thereby ensuring their fertilization. Because of the sexual abandon that accompanied such feasts, they were outlawed by the Dutch authorities.

No face mask in the true sense of the term has been recorded on Leti, or on any of the other islands mentioned in this text. On the other hand, standing drums carved out of palm tree trunks, the cylinder being supported by a sturdy figure squatting on its haunches, do occur. Of a different type from our example (fig. 4), the drum in the Musium Pusat in Jakarta is carved into the shape of an acephalous personage surmounted by the resonator, which takes the place of the missing head.

On Babar, too, ancestral effigies in wood can be found. Like those on Leti, the figures have their arms crossed, while those from Tanimbar seem instead to adopt the pose of *The Thinker*. The most remarkable artifacts on Babar are the large gold pendants women wear over their breasts (figs. 6, 7). They sometimes resemble deep platters or soup plates decorated with symbolic motifs (fish and birds) and can reach sizable proportions. However, on Leti and Kisar, as on Timor, chest ornaments are normally limited to silver or gold disks (fig. 5).

We now come to the Tanimbar archipelago, the most thoroughly investigated of the island groups thanks to the work of McKinnon. No large noble houses survive from earlier times on the islands of Yamdena and Selaru. They would have encircled the central "square" of

1  Sacred house (*sibua*) among the Alfuro ("pagans") of Halmahera. Northern Moluccas. Photograph Vidoc, Amsterdam.

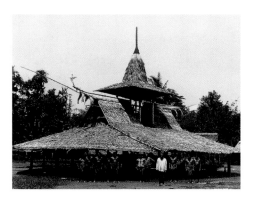

### 3 Ancestral effigy (*iene*)

Wood, with a sooty patina. This effigy apparently came from the village of Nuwewan on the island of Leti, its personal name being "Lekmasa." The statue comes apart into five pieces that fit together with tenon joints. The squatting position with arms crossed is peculiar to Leti, and, to a lesser extent, the Babar archipelago. Height 130 cm. Inv. 3555.

### 4 Large drum

Hewn from a single trunk of palm, a tree rarely used for sculpture in the Philippines or Indonesia. Leti. Height 87.5 cm. Inv. 3588.

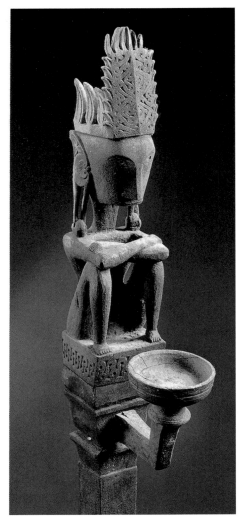

the village, which was strategically located on a cliff top and protected by a wall of cacti. The village was reached by a stone (or on occasion wooden) stairway at the foot of which stood monolithic guardian statues. The inhabitants formed a community bound together by a cult acknowledging a single supreme divinity, Ubila'a, to whom sacrifices and offerings were made during any ritualistic event, including head-hunting expeditions, military forays against an enemy village, or incantations made to counter the various scourges, such as epidemics, that were thought to emanate from a supernatural force.

The main Ubila'a shrine was located in the stone enclosure which defined the meeting place between the houses. In the dwellings proper, offerings were laid on a shelf on the right as one entered and facing the most important shrine, the *tavu*. Still to the right of the shrine, but this time toward the rear of the house, hung a platter for gifts intended to obtain the good offices of Tanimbar's "celestial spirits" (*nit ratan*).

The lofty frontages of these houses, with their peaked gables formed from two planks crossed into a V-shape thrusting into the sky, are no longer to be seen today. The Dutch colonial government at one time ordered their demolition and resettled the villagers in the cities. In their tiny shacks daubed in limewash and roofed in corrugated iron, today's inhabitants of Tanimbar certainly have no space for a *tavu* shrine (see frontispiece). These monuments also vanished between the beginning of the twentieth century and World War II, when the Japanese occupied Tanimbar and any aristocratic "named houses" that by some miracle had been left standing were quickly razed to the ground.

The ancestral shrines (*tavu*) that constituted the focal point of these houses now only survive in a few scattered examples in Dutch, German, and Swiss museums. So scarce are they that not a single specimen is conserved in collections in the United States or Australia. These shrines are comprised of a thick plank carved into a two-dimensional representation of the human body: the outstretched arms attached to the trunk are perhaps supposed to evoke the kinds of women whom Drabbe photographed dancing in a state of trance.[6] The figure, entirely covered in uneven, interlocking spirals, has no head. A horizontal plank would have been installed on the squared-off neck; upon this, the ancestor's

skull was placed, lying on a valuable Chinese plate (fig. 8). Hence, the skull itself provided a "head" for an ancestral effigy that was itself charged with protecting the house.

Some authors, such as Forbes, believed that the *tavu* was an effigy representing the supreme divinity, Ubila'a. However, Riedel maintains that only ancestor statues were kept in homes. McKinnon, for her part, thinks there is no doubt about the relationship between the *tavu* shrine as a whole and the ancestors (*ubun nisin*)—the shrine was where the ancestors were honored with sacrifices.

Although the majority of such shrines are oriented toward no particular gender, some display male or female attributes. Carvings of jewelry (such as were worn by individuals of both sexes) bring to mind the hereditary treasure—the family itself—living in the house. McKinnon is therefore of the opinion

**5  Disk**

Gold. Incised with the figures of two "dancers" dressed in a kind of ritual costume with headdresses. Leti. Diameter 13.2 cm. Inv. 3560.

**6  Dish-pendants**

Gold. Babar archipelago. Dimensions (from left to right) 26.2 cm, 19.4 cm, 11 cm, 15 cm. Inv. 3574, 3567, 3525, 3587.

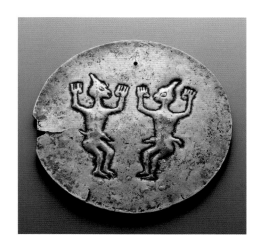

7  Women from the Babar archipelago wearing gold pectoral dishes as pendants. On their heads they wear "crowns" bearing a central decorative motif of a small face. Photograph Vidoc, Amsterdam.

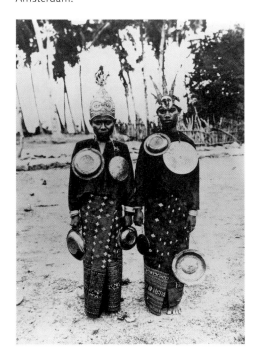

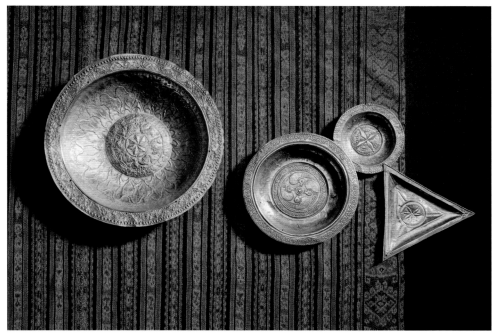

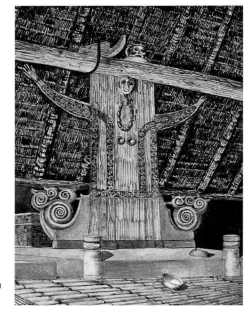

8  This drawing shows a house shrine in a domestic setting in the Tanimbar archipelago (see frontispiece). The skull on the horizontal beam represents the head (missing from the type of shrine shown in the frontispiece) of the sculpture. Drawing taken from Drabbe 1940.

9  **Prow board (*kora ulu*) from a large dugout canoe**

Hardwood. Tip restored. Tanimbar. Formerly Jef van der Straete Collection. Height 163 cm. Inv. 3578.

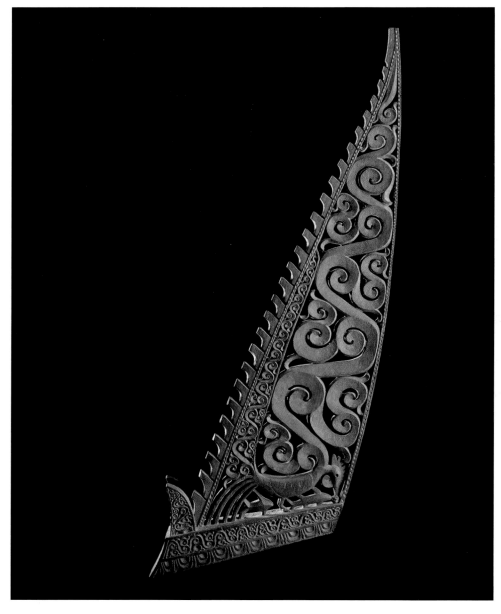

that the purpose of the carved shrine is to summon up the spiritual power of the community of ancestors, rather than to represent the founder of the house alone.

The interlinked spirals of the "Tanimbar style" emerge once more, if in a more rudimentary form, on the bases supporting Leti statuary. Less predictably, we also find a counterpart to this style among the Papuans of Cenderawasih Bay in the northwest of Irian Jaya (Indonesian New Guinea).[7]

The boat is of great symbolic significance on a number of Indonesian islands. Some Tanimbar villages are even built around a stone-block platform in the shape of a boat, while the villagers call themselves a "crew." Stone ships of this sort were sometimes adorned with a stone prow piece decorated with dragons, fish, birds, and, on occasion, composite human figures, delicately worked in imitation of the islanders' openwork wooden prow heads.

A number of different types of craft were sailed by the people of Tanimbar as they traveled over great distances in pursuit of trade. Only the largest vessels, however, were decorated with a prow piece carved out of very hard wood and adorned with shellwork (fig. 9). The decorative carving on these *kora ulu* pieces is most elaborate. On the base, there figures an animal (in this case a bird) of perhaps totemic significance. From this lower section, single (*kilun etal*) or double (*kilun ila'a*) spirals ascend the length of the piece. The animal on the base is often a monster bearing its teeth, very like the beasts ensnared in a network of spirals on the highly decorated openwork bone plaques that adorn certain ceremonial combs (fig. 11).

There can be no doubt that this monster is cousin to the Dayak's *naga*, to the *ulenai* of Alor, and to a legion of other snake-dragons representing the underworld. The bird by contrast signifies the celestial realm.

Pieces of jewelry, which formed part of the family inheritance, played a crucial role when presented as ritual gifts at ceremonies. They are especially widespread in Tanimbar where many were made of silver. A rarer gold example—a pendant hung with a strange anthropomorphic figurine—appears in fig. 10; it is possibly the work of a Chinese craftsman.

Fearless fighters like their counterparts on all the southern isles, before they faced an enemy or set off on a head-hunting raid the warriors of Tanimbar would dress in the most flamboyant apparel (fig. 11).

Wooden and stone statues of varying size would be set up to protect the fields and sacred places. They may represent mythical heroes or the founding ancestors of the clan (fig. 12). Such effigies have been found on the islands of Kei and Aru still farther to the east. The inhabitants of islands near New Guinea show traces of having mixed with the black populations of their vast island neighbor, but many features of their cultures are analogous to those of the three archipelagoes discussed here.

The southern Moluccas can only ever be a minor chapter in the story of "archaic" Indonesian civilization. Nevertheless, in the island's house shrines the sculptors of Tanimbar have left ample proof of their spectacular inventiveness and skill in works that surely figure among the most astonishing in the South Seas.

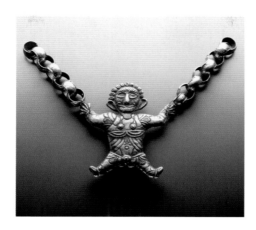

**10 Pendant**

Gold, with part of its thick chain. This example is typical of the islands of Tanimbar. Early photographs show a uniformity of style that has puzzled collectors. Indeed, these figurines in repoussé metal have nothing in common with the wood carving and stone sculpture of the islands. They may have been produced by foreign metal craftsmen. Height 7.5 cm. Inv. 3586.

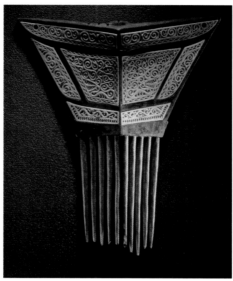

**11 Comb**

Hardwood, with plaques of openwork inlay in carved bone. The decoration shows a dragon surrounded by the asymmetric spirals characteristic of Tanimbar art. Formerly Museum für Völkerkunde, Berlin (before 1900). Height 24 cm. Inv. 3557.

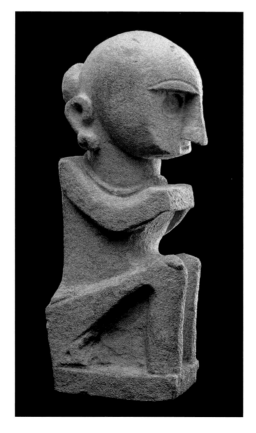

**12 Statuette**

Chalk limestone. The hands have been restored. Effigy of a distant ancestor which served to protect the fields. N. de Jonge and T. van Dijk reproduce two similar pieces of the same provenance (1995, pp. 102–3). Wooden ancestor statuettes of identical size and shape were placed on the plank surmounting the *tavu* shrine (fig. 8). Village of Alusi Karwain, Yamdena Island, Tanimbar archipelago. Collected some time in the 1950s. Formerly De Vries Collection. Height 36 cm. Inv. 3590.

# The Philippines

**George R. Ellis**

**Philippines / Taiwan**

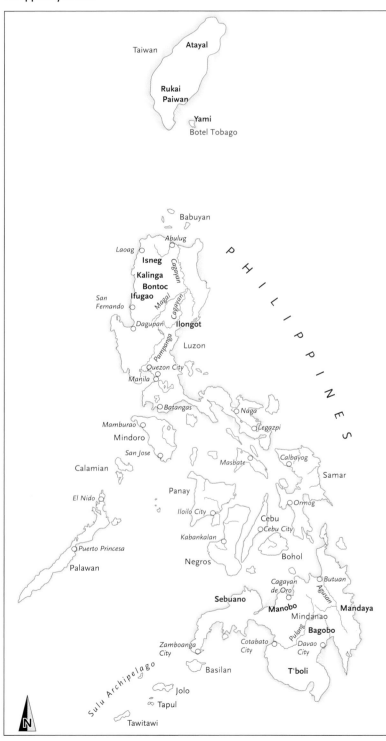

Located southeast of mainland China, the Republic of the Philippines is an archipelago of over 7,000 islands which stretches from north to south for more than 1,600 kilometers. Total land area is slightly greater than the British Isles or the state of Arizona. Bounded on the east by the Pacific Ocean and on the west by the South China Sea, the bulk of the landmass is made up of eleven islands: Luzon, Mindoro, Masbate, Palawan, Panay, Negros, Cebu, Bohol, Leyte, Samar, and Mindanao. The largest are Luzon and Mindanao. Approximately 900 islands are inhabited. The country is customarily divided into three main island groups: Luzon and Mindoro make up the northern group; the Visayas (Samar, Leyte, Cebu, Masbate, Bohol, Negros, Panay, and Palawan) form the central islands; Mindanao, Basilan, and the Sulu and Tawitawi archipelagoes comprise the southern division.

The total population is approximately seventy million. Eighty percent of the people still live in

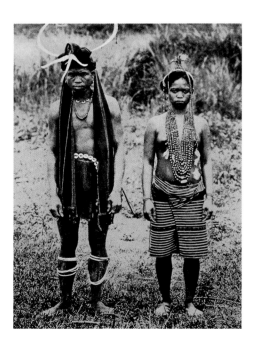

rural areas. Today, over one hundred distinct Philippine cultural groups exist and more than seventy different native languages (including Tagalog, Cebuano, and Ilocano) are spoken. The official languages are Filipino (largely based on Tagalog) and English. Although Muslims, Buddhists, traditionalists, and Christians practice their respective religions, currently over 80 percent of the population are professed Roman Catholics.

The ancestors of some of today's Filipino population probably entered the Philippines by crossing the land bridges which linked Taiwan with Luzon and Borneo to Palawan. Archaeological evidence indicates that early Filipinos occupied the Cagayan Valley of

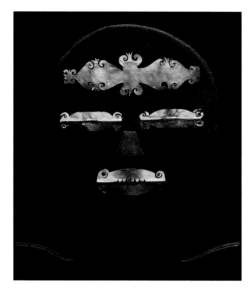

**3 Funerary mask**

Gold, comprising four leaves of metal placed on the forehead, eyes, and mouth of the deceased. Northern Mindanao. Ninth to eleventh century. Lengths 11.6 cm, 5.75 cm, 5.55 cm, 6.2 cm. Inv. 3549-37 A, B, C, and D.

**4 Large man's necklace (*sipatal*)**

Mother-of-pearl, glass beads, cornelian, and silver. Isneg group. Length 109 cm. Inv. 3528-8.

2 Dead girl (from the Bontoc group) seated on a "funeral chair." Note the richness of the ornaments and fabrics, and the mother-of-pearl earrings. Barbier-Mueller Archives.

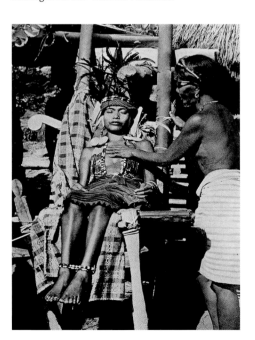

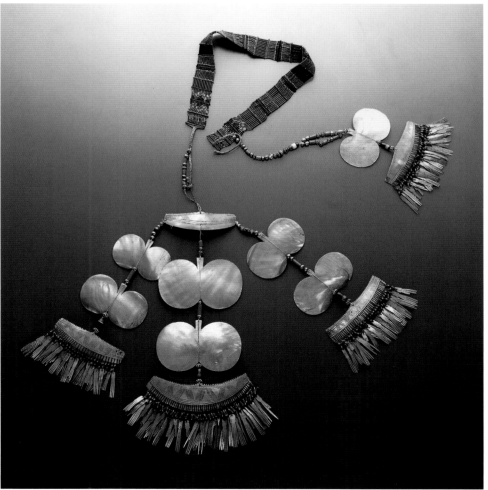

## 5 Headhunter's armlet (*tankil*)

Boar tusks. The wood-carved figure is larger than the norm and is probably the handle from an old gong recycled as a bracelet ornament. Ifugao. Height (figurine alone) 10 cm. Inv. 3508.

## 6 Spoon

Patinated hardwood. The handle represents a standing man. Ifugao. Height 26.1 cm. Inv. 3500-C.

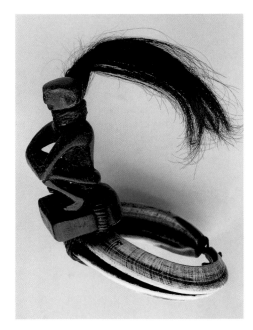

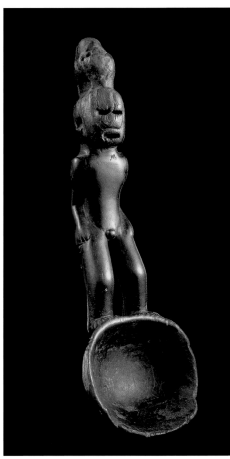

northern Luzon more than 200,000 years ago. To the south in Palawan, a number of archaic sites have been investigated, of which the best known are the Tabon Caves. Evidence has been found which proves that this site was occupied for at least 30,500 years.

About 10,000 years ago the sea level rose, cutting off the land bridges between the Philippines and neighboring islands. About 5000 B.C. proas or dugout canoes were developed and outriggers may also have evolved around the same period. The result was the beginning of increased movement between islands and between eastern Indonesia and the southern Philippines. These early southern Filipinos spread throughout the islands, and the foundations of Filipino culture, as it was known at the time of Spanish arrival in the sixteenth century, were established during this period.

The earliest artifacts found in the Philippines are flaked stone tools. Over thousands of years the Filipino "tool kit" became increasingly sophisticated and polished stone adzes, soapstone beads, shell bracelets, and pottery were made. By 1500 B.C., an impressive range of materials were utilized and sophisticated pottery and items of personal adornment were produced. Funerary pottery production around 1000 B.C. includes one of the country's best-known cultural icons, the Manunggul Jar. Over the next 2,500 years, increased trade with China and Southeast Asia resulted in the importation of large quantities of Chinese, Thai, and Indonesian ceramics, which are found in association with burials, as well as items made from jade, glass, and precious metals. The indigenous arts also flourished and limestone burial urns and spectacular gold jewelry are all worthy of special note (fig. 3).

7 **Female figure (*indungdung*)**

Brass. The base is made of wood and the strands are of fiber threaded with beads. Worn by a high-ranking woman for a marriage ceremony. Ifugao. Height (figure) 10.5 cm. Inv. 3512.

By the fifteenth century, Islam was established as a dominant force in the south, especially in coastal areas of Mindanao and the Sulu Archipelago, where it influenced the artistic forms and styles evolving in these areas.

In 1521, Ferdinand Magellan made the first European landing in the Philippines and prepared the way for the subsequent exploration and colonization that drastically altered Philippine social, religious, economic, and cultural development for almost 350 years.

Spanish influence on many aspects of Filipino life was far-reaching and obvious throughout the islands, but in the mountainous regions of northern Luzon, the interior of Mindanao, the Sulu Archipelago, and other isolated areas, existing cultures were less affected and the indigenous arts were maintained into the twentieth century. Here, the rugged terrain and armed resistance to colonization offered by the residents, combined with the firm foothold of Islam largely in the coastal regions of the south, made possible the continued use and development of traditional arts.

## THE NORTH

The mountains of northern Luzon rise to heights of over 2,700 meters. For thousands of years people have lived in isolated valleys and areas featuring in some cases spectacular rice terraces which cascade down steep slopes to swiftly flowing streams below. Nine cultural groups are found here: the Ifugao, Bontoc, Kalinga, Kankanay, Tinguian, Isneg, Ilongot, Gaddang, and Ibaloi (figs. 1, 2). A wide variety of work in all media, including a rich and varied textile tradition bolstered by exquisite items of personal adornment, is present. Basketry is also highly developed. Perhaps best known

**8 Helmet or hat**

Wood carved in the shape of a face. Glass beads for the eyes. Fiber cord. Ifugao. Formerly Museum für Völkerkunde, Vienna. Diameter 24 cm. Inv. 3519.

**9 Forehead ornament**

Formed from the skull of a monkey bound to a rattan headband. Threaded mother-of-pearl. Ilongot. Length 28.6 cm. Inv. 3534.

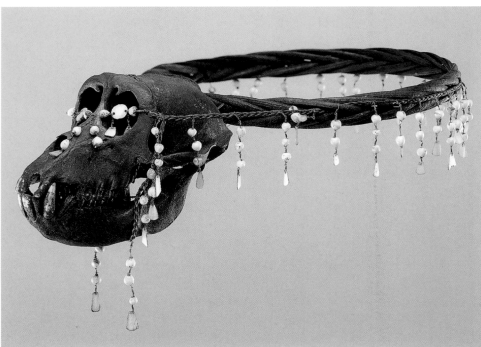

in the West, however, is figurative wood carving, together with utilitarian wooden objects used in both secular and religious contexts. Although it is clear that wood carving was once far more prevalent and widespread in prior centuries, the Ifugao, Kankanay, Bontoc, and Ibaloi were its primary practitioners in the twentieth century. Of these, the Ifugao are best known.

Weaving traditions seem to be associated with cultures that engage in wet-rice farming; dry-rice cultivators depend on imported textiles or barkcloth for their needs. Thus the Tinguian, Kankanay, Bontoc, Gaddang, and Ifugao are the region's primary weavers.

**Personal Adornment**

The most dramatic textiles in the north are blankets. Worn for warmth, these are also used extensively on ritual occasions, especially at the time of death (fig. 2). Blankets are displayed during funerary ceremonies and were wrapped around the body for both primary and secondary burial.

The basic form of dress is a loincloth for men and a *tapis* (skirt) for women. This basic garb is complemented in some areas by blankets, belts, bags, headcloths, and jackets. Among some groups these garments are embellished with bead, metal, and shell ornamentation, which is often extremely profuse.

Ornaments include necklaces (fig. 4), earrings, armlets, leglets, and head pieces made from wood, shell, glass and ceramic beads, metal, including gold, silver, and copper, feathers, and various combinations of these. Work with shell, sometimes combined with metal and fiber, is especially beautiful. One well-known ornament which combines wood with

## 10  Door panel

Decorated with a large-scale human figure of indeterminate sex. The gouged channels are characteristic of the work of the Kankanay, particularly skilled carvers from the upland ranges. Kankanay. Height 157 cm. Inv. 3549-42.

## 11  Window shutter (detail)

Human figure in high relief. Kankanay. Overall size 120 cm. Inv. 3520.

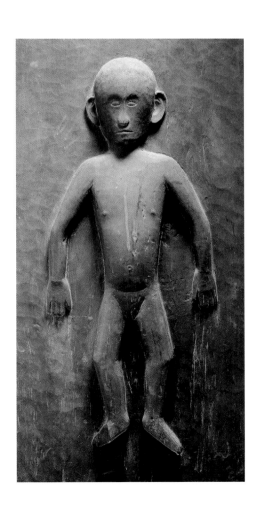

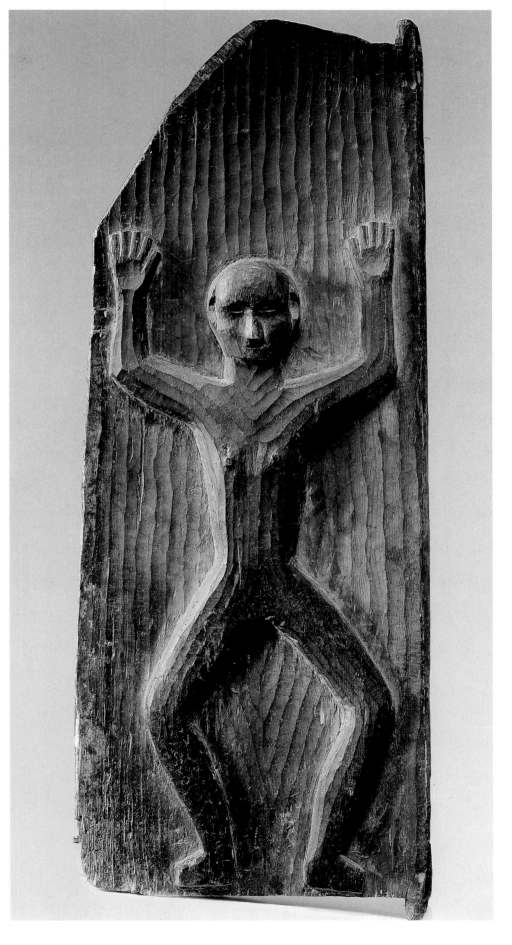

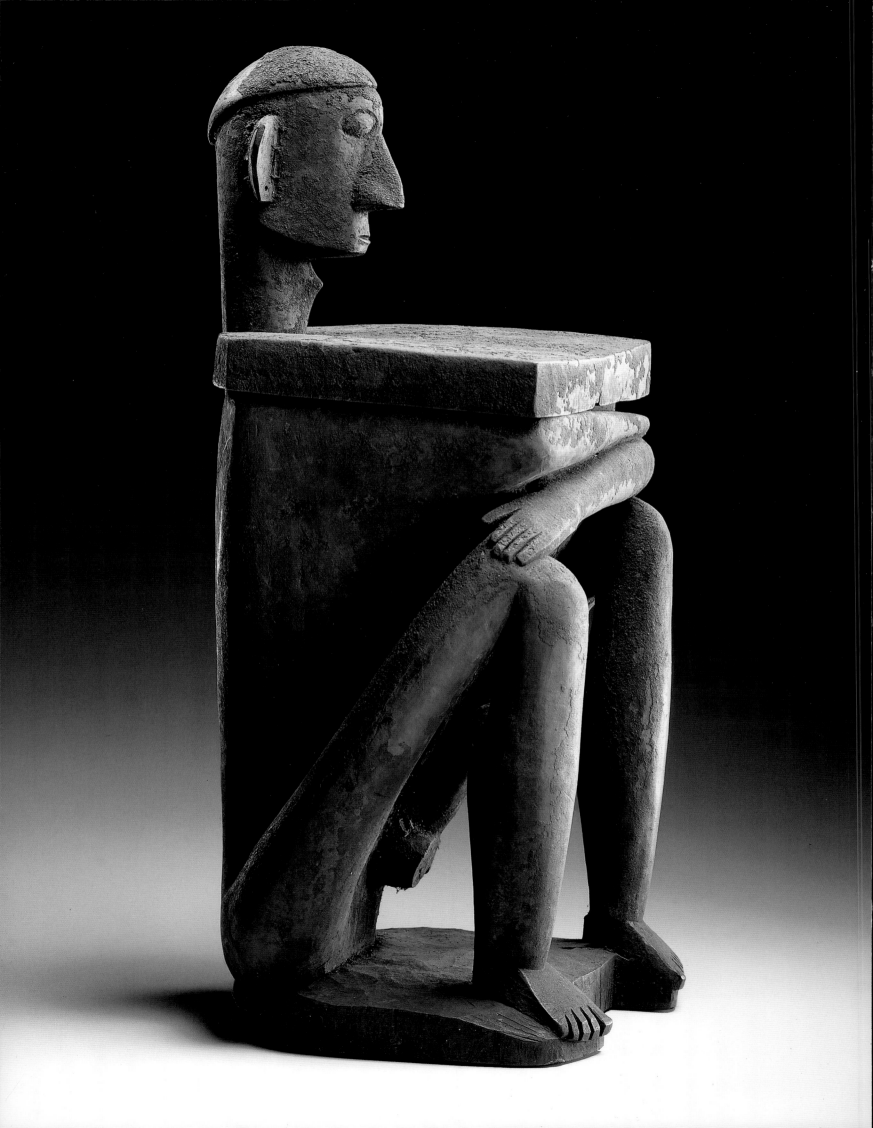

12 **Box (*punamhan*)**

Hardwood. The figure's torso serves as a receptacle that can be closed with a lid. The receptacle still contains pebbles, cereal grains, and other ingredients sprinkled with dried blood for magic purposes. Ifugao. Height 65.7 cm. Inv. 3541.

boars' tusks are the armlets worn by Ifugao (*baningal*), Bontoc *(abkil)*, and Kankanay males (fig. 5). Among the Bontoc, the wearing of these armlets was associated with head-hunting, but sources only refer to use in dancing by the Ifugao and Kankanay.

Most ornaments are not figural, but a notable exception is a brass head ornament worn by upper-class Ifugao women during marriage ceremonies. These figures (*indungdung*; fig. 7) are standing with arms fully extended at right angles to the body. Ears are pierced for attachments and a hole at the top of the head serves as a receptacle for feathers and other decorations.

Hats are worn by Bontoc, Kalinga, and Ifugao males. Bontoc and Kalinga examples are primarily woven, but Ifugao hats (*oklop*) are carved from a single piece of wood. Most are not decorated, but some display a human face carved in relief (fig. 8). These hats are worn during hunting, working in the forest, or traveling, and may be used as containers for food or water when necessary. The carving is said to be purely ornamental and has no religious or ceremonial significance.

Elaborate headdresses are also worn by Ifugao, Kankanay, and Ilongot males (fig. 9). These normally feature the beak of a horn-bill, although other attachments (such as a monkey skull) are sometimes used.

## Utilitarian Objects

Throughout the Cordillera people manufacture a wide variety of utensils and containers, which are used in all aspects of everyday life. Utilitarian objects are often handsomely crafted and decorated, which indicates a

desire to create objects that are beautiful as well as functional. Some of these objects are used by everyone, while others are restricted to members of the upper class. Still others have special ritual functions in addition to their ordinary uses.

13 **Box (*punamhan*)**

Hardwood. Originally owned by a sorcerer-priest. It is fitted with two handles, a stylization of the pigs' heads that adorn simpler, rectangular containers. On the lid sits a *tinagtago* figure with crossed arms. Ifugao. Height 48 cm. Inv. 3533.

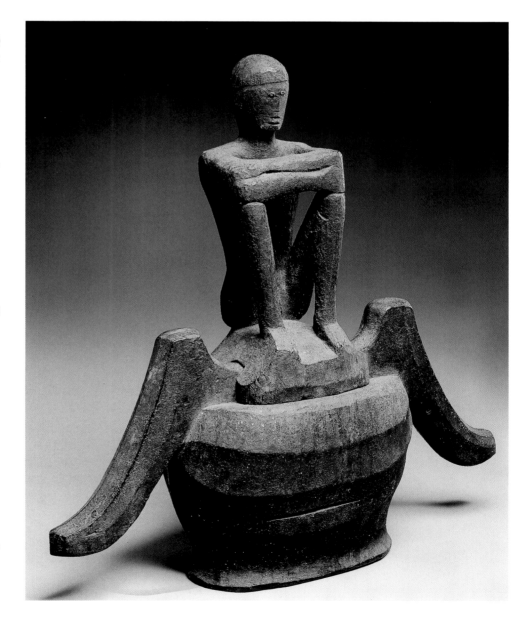

Wood. It represents the guardian of a rice store. The type is rare; two similar pieces are known, one in the British Museum and the other in the Ethnographic Museum, Budapest. Southeast Ifugao (Hungduan). Original Josef Mueller Collection. Acquired prior to 1939. Height 63 cm. Inv. 3510.

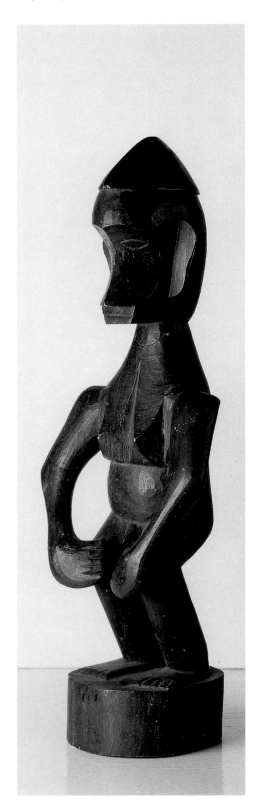

Spoons (fig. 6), ladles, gong handles, jar covers, and food containers are sculpted from wood. Numerous handles of both spoons and ladles are carved in human form and these are among the most beautiful works created by mountain artists. Although the Ifugao are generally credited with these pieces, the Kankanay once produced and used equally fine examples. Ifugao spoons (*pakko, idu*) are stored in special baskets (*ayad*) when not in use and males carry them in their hip bags while away from home.

Baskets are mostly made by men and are used throughout the mountains. Often they were the specialty of certain towns and areas; some supplied raw materials and others finished baskets. For the most part, baskets serve strictly utilitarian purposes, but some play a specific role in ritual and others are frequently used in ceremonial contexts.

### Architectural Decoration

The Ifugao decorate their houses and granaries with figural representations of various kinds. For the most part these carvings seem to have no ritual significance, but there are exceptions. Not present among the Ifugao are carved window shutters and doors found in the Kankanay area (fig. 10), which are adorned with low-relief human, lizard, or crocodile figures. There is insufficient documentation available to determine if these figures are purely decorative or have some ritual or religious function.

### Sculpture

At one time, figurative wood carving was much more prevalent than it is today, and in northern Luzon and other areas traditions have been lost or greatly diminished through accultura-

tion. Early reports on mountain carving are scant, but it is evident that figurative carving was not always monopolized by the Ifugao as it has been for the greater part of the twentieth century. Evidence would suggest, however, that figurative wood carving was most prevalent in the Kankanay and Ifugao areas in the past, as is the case today.

Figurative sculpture is primarily used for ritual purposes. Priest's boxes (*punamhan*) used by the Ifugao are often decorated with appendages at either end in the form of pigs' heads. Used by priests officiating at ceremonies, the lids of these boxes normally feature plain low-relief lizards, although crocodiles are sometimes found. In very rare instances, a three-dimensional figure may be carved as a part of the lid (fig. 13). Although this general type of priest's box is most often associated with rice and rice ritual, some boxes may also have had special functions associated with sorcery and disease. One documented example is carved in the shape of a seated male figure, the the box itself forming the torso of the figure (fig. 12).

The most common sculptures from the mountains are complete standing and seated male and female figures. These may be up to 1 meter high, but most are less than 60 centimeters. The majority are Ifugao in origin, but examples have been collected from the Kankanay and Ibaloi areas.

The best-known examples of wood sculpture found in the entire region are carved by the Ifugao. Called *bulul*, they represent a class of deities associated with the production of bountiful harvests, capable of miraculously increasing the rice both before and after it is stored in the granary. Although primarily

associated with rice ritual, they are not confined to this function. *Bulul* is in fact a generic term for types of consecrated images.

*Bulul* are carved as seated or standing human figures (figs. 14–16), although in the Kiangan area pigs *(binabbuy)* as well as humans are sculpted. Seated figures are depicted with legs drawn up and arms folded across them; hands are placed on, in front of, or just above the kneecap, or the forearm rests just above the kneecap. There is no absolute reference to human anatomy: legs become arms and sections of arms are placed in accordance with sculptural dictates rather than observed reality.

*Bulul* are usually made in pairs, one male and one female, but there seems to be no consistent correlation between sex and posture. In some instances, it is difficult to tell whether a figure is male or female, since sexual parts are often very schematically treated. Breasts are rarely indicated, although nipples are shown on both male and female figures. Many are or were dressed: loincloths for males and *tapis* (skirts) for females. Most seated male figures have a space between the buttocks and the base, through which the loincloth is passed. Hair is sometimes inserted in holes in the head and bits of metal or shell are placed in the eye sockets. All stand or sit on a base, which is usually divided into two horizontal sections by a sharp indentation on all sides. This "hourglass" shape is reminiscent of the shape of Ifugao rice mortars, strongly suggesting that, in fact, *bulul* are depicted sitting on such mortars.

Considerable stylistic variation exists, from masterful cubist renditions with heart-shaped faces to others which adhere more closely to

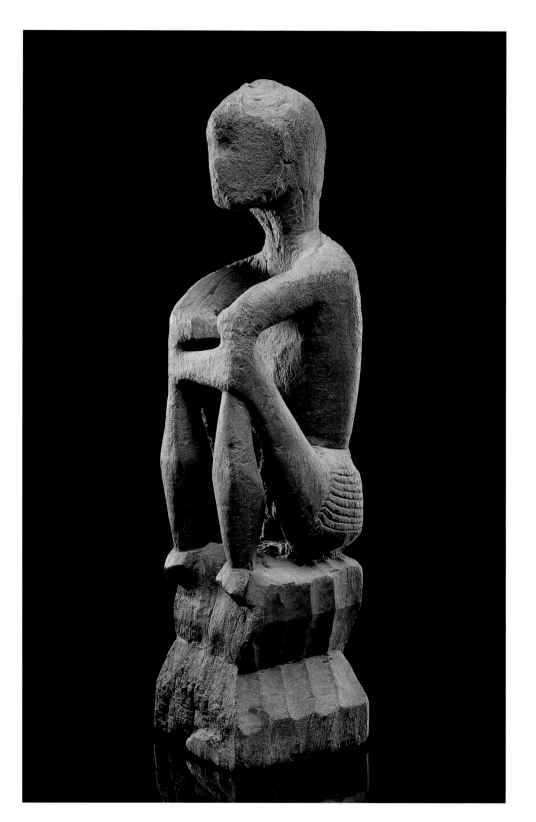

Wood. Standing figure. Ifugao. Height 75.5 cm.
Inv. 3532.

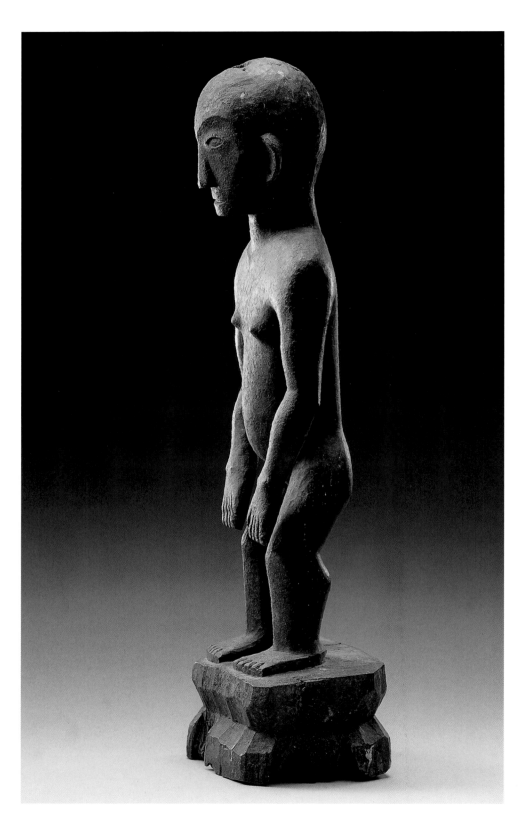

natural form. *Bulul* carvers were generally selected from among the kin group of their patron and consequently there is considerable variation in quality and style, although the best available carvers were always chosen for this task.

## THE SOUTH

In isolated interior sections of Mindoro, Palawan, and Mindanao, as well as the coastal regions of western Mindanao and the Sulu Archipelago, the indigenous arts also continued to flourish into the twentieth century. Here the arts can be roughly divided into two distinct categories. One represents those cultures which fell under the influence of Islam after its fifteenth-century introduction. The other is comprised of cultures which were converted neither to Islam or Christianity. The former are located largely in western Mindanao and throughout the Sulu Archipelago. The major Muslim groups in this area are the Maranao, the Tausug, the Yakan, the Bajau, and the Samal. The latter are found in the interiors of Palawan and Mindoro, as well as throughout eastern Mindanao. Included are the Mandaya, the Bagobo, the Manobo, the T'boli, and others.

In the Muslim areas, wood carving, metalwork, and weaving are highly developed. Carvings on boats, houses, grave-markers, and household goods utilized lavish decoration which includes leaves, vines, buds, triangles, zigzags, and ropelike borders. The term *okir* is used to describe all these motifs, but it is also applied to the technique of decorative carving and the resulting carved designs. Although the word is generally applied to wood carving, it has also been used to describe design elements in metalwork and fabric. The widespread use

Hardwood. The figure of a horse on which is fixed a separately carved stake (the phallic form indicating that the deceased was a male). Manubol Island, Sulu Archipelago. Length 105 cm. Inv. 3549-38.

of these motifs is a reflection of the Islamic prohibition against the use of animal or human representations, which, however, in a few instances continued to exist among Muslim groups.

Among the Maranao, the *okir* motif is prominently used in the decoration of architectural elements, particularly the ends of extending floor beams in the houses of prominent members of the community. The size of the house *(torogan)* reflects the status and power of its occupant. *Okir* also dominate the decoration of Bajau houseboats and the sides of boats throughout the Sulu area. The use of this carved motif is extremely widespread, including supports for backstrap looms, Koran stands, and covers for containers, as well as other household objects. Scabbards and the handles of weapons also display *okir* designs.

## Figurative Sculpture

Some figural carving has escaped Islam's prohibitions. Most conspicuous are two Maranao art forms. The first is the *sarimanok*, a bird with outspread wings and a fish either under its claws or hanging from its beak. The other takes the form of a horse's body with a woman's face, a figure said to have carried Mohammed's body to heaven. This

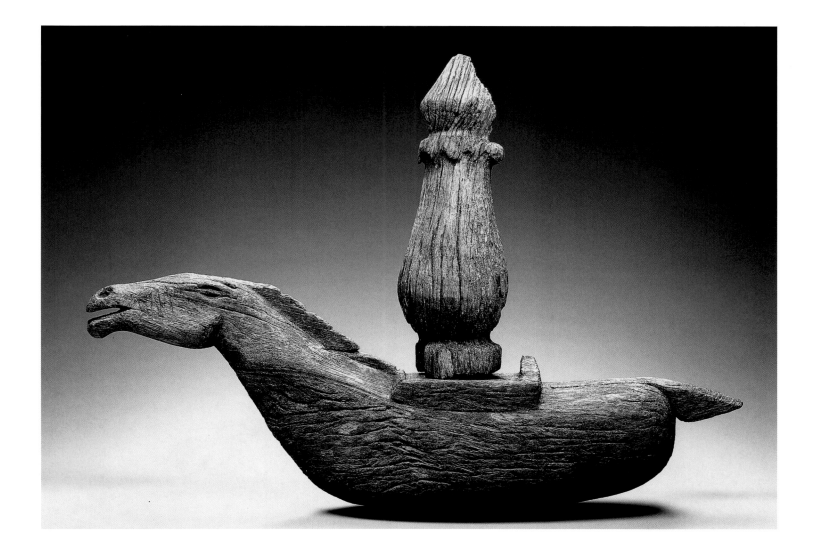

configuration may be of more recent origin. Both figures are now widely produced for the tourist trade.

The carved handles of weapons and their blades sometimes feature a *naga* motif. In addition to wood, these handles are also crafted in horn, ivory, or metal. Other handles are in the general shape of a cockatoo or parrot with a high crest.

Samal artists carve beautiful grave-markers with *okir* motifs. The shape of these markers reflects the gender of the deceased. Male markers are generally phallic in form, while female graves are designated by flat panels covered with curvilinear, symmetrical motifs topped by a comblike element. This differentiation does not seem to apply to children's graves. Grave-markers are carved in wood or coral and are among the most striking examples of sculpture found among the Islamic groups. The example depicted is clearly a man's marker, but it is unusual in that the support seems to represent a horse's body (fig. 17). Horses were used in Sulu for transportation as well as for military purposes. This "horse" grave-marker is probably a reference to the high status of the deceased.

## Utilitarian Objects

Many Islamic groups, as well as some traditionalists, work in metal, particularly brass and copper. While the forging of bladed weapons seems more developed in Sulu, Mindanao manufacturing centers specialize in containers. Perhaps the best known, and most aesthetically pleasing, are silver inlaid Maranao examples such as betel boxes (*lutuan*) and large jars with lids (*gadur*). Betel boxes are generally divided inside to hold the three ingredients necessary for betel nut chewing (lime, betel leaf, and areca seed). This mixture acts as a mild stimulant, chewing being a part of the fabric of social interaction among most groups in the region. Such boxes are among the most beautiful metal objects produced and are frequently covered with elegant *okir* motifs. Other categories of container include trays (*talam*), teapots (*kendi*), pot stands (*panalugadan*), and cuspidors (*dudai*).

Some traditionalist Mindanao mountain groups also make containers, but these are generally smaller in scale and restricted primarily to betel boxes. Highlanders are best known for bells, anklets, bracelets, and other small objects used to adorn the body and various items of apparel.

Other utilitarian objects of considerable artistic merit include baskets, mats, flags, bamboo tubes, hats, shields, armor (fig. 18), and musical instruments.

Baskets are used to carry and hold aquatic and agricultural products. Decorated examples are used to carry personal effects and are "worn" on special occasions. Among many traditionalist mountain groups, baskets incorporating woven designs as well as extraordinary beadwork are made. Beaded pieces produced by the Bagobo are among the most elaborate found in the region as well as the most aesthetically pleasing of all Filipino examples.

Mats used as bedding or underbedding are the specialty of the Muslim groups. Best known and admired are those woven by islanders from Laminus and Ungus Matata in Tawitawi and Cagayan de Sulu. Here mats exhibit a wide range of geometric patterns and striking colors.

## Personal Adornment

Items of personal adornment include anklets, bracelets, combs, necklaces, pendants, and earrings, the body itself acting as the ground for more permanent transformation such as tattooing and teeth decoration, which often indicate social status. All groups in the south practice some form of personal adornment, but highlanders are generally more elaborately embellished and bedecked.

Textiles are woven utilizing yarn made from abaca and cotton, silk being less common. Abaca, the most common material, is derived from a type of wild banana, which grows throughout many parts of Sulu and Mindanao (fig. 19). Both commercial and natural dyes are used to color yarn and cloth before and after weaving. Designs are achieved by techniques which include tie-dye, ikat, embroidery, and batik. Among the Muslim groups geometric patterns prevail, but designs among highlanders such as the Mandaya include both human and animal motifs. As with their baskets, the Bagobo cover trousers and jackets with geometric beadwork which is dazzling to the eye.

Finished fabric is fashioned into clothing, primarily skirts, shirts, trousers, and blankets. Sashes and headcloths are present, these being more common among the Muslim groups. The use of different items of clothing varies according to group and sex.

## Conclusion

As remote areas have become more accessible and subject to outside influences, the conservative fabric which previously sustained local cultural traditions has considerably

## 18  Armor (kurab-a-kulang)

Buffalo horn plates held together by brass links. Applied silver ornaments. An identical type of suit is in the museum at Manila. It was collected in the province of Lanao del Sur, on the island of Mindanao. Height 73 cm. Inv. 3549-46.

## 19  Costume and jewelry of a noble woman

The jacket is entirely covered in embroidery. The skirt, buffed to a shine with a pebble, is in abaca fiber from a wild banana (*Musa textilis*). Bagobo ethnic group, southern Mindanao. Inv. 5349-10 to 15.

weakened. Today, the vast majority of indigenous cultures which were largely intact through the first quarter of the twentieth century are in a state of rapid transition and a system of values and interests which more closely reflects that of the majority of Filipinos is evolving. Indigenous arts have disappeared or seriously declined in both quantity and quality. Change is not new to the Philippines, however, and contemporary artists whose work frequently draws inspiration from their past are receiving increasing national and international attention. Let us hope that today's Filipinos will not lose sight of their shared cultural heritage reflected in the arts of the Christian lowlanders, traditionalist highlanders, Muslim coastal dwellers, and the rich substratum of prehistoric arts.

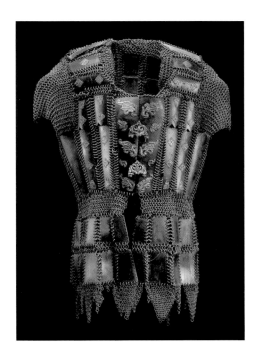

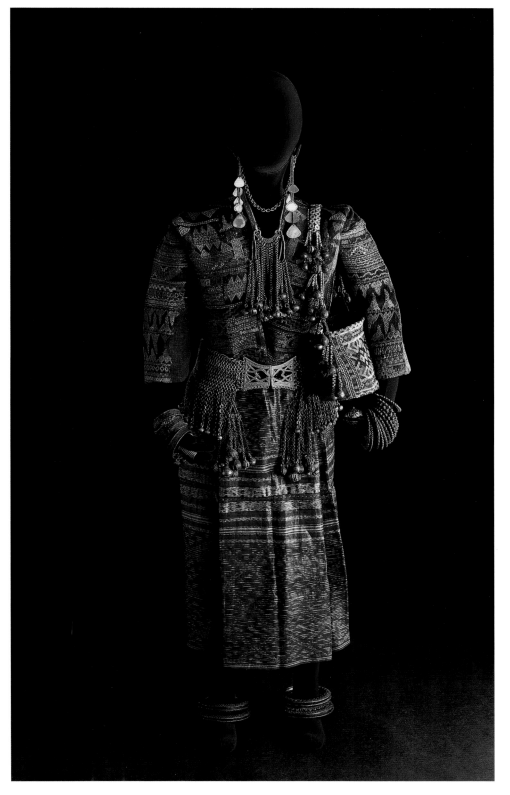

# Taiwan

Jean Paul Barbier

1 **Panel (*tari*)**

Wood. Black, red, and white paint. The figure is carved in high relief and the eyes inlaid with porcelain shell. This heavy panel would have been placed in the center of a house. Paiwan group, Budai subtribe. Height 200 cm. Inv. 3010-2.

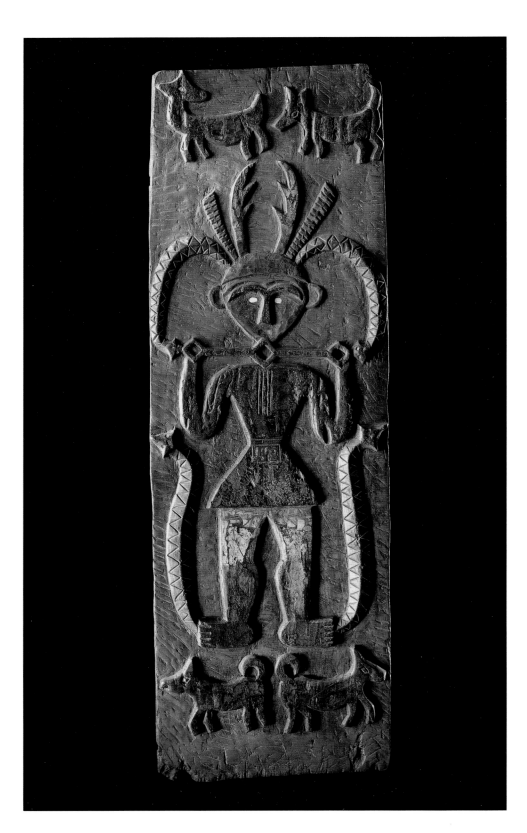

Until the seventeenth century, the island of Taiwan (formerly Formosa) was populated by groups culturally and linguistically related to the inhabitants of the northern Philippines. At that time, however, the process of Chinese colonization accelerated and the indigenous populations were gradually driven into the mountains to the east (see map p. 146).

Today these people, all of whom speak Austronesian languages, make up barely 2 percent of the total population, even though they still occupy half of the island's surface area. Few of these "Indonesians" were absorbed by the settling Chinese, who generally left them alone (although they disparagingly called them *Sua-huan*, "savages of the mountains," and other such names). The native groups thus continued to live in keeping with their ancestral customs and managed, up until recent times, to preserve intact a tribal civilization based on a model close to that of their Indonesian cousins (for instance, the Dayak on Borneo and the Ilongot of the Philippines).

From north to south, the following tribes (themselves divided into subtribes and clans) have been identified: the Saisiat, the Atayal, the Sedeo, the Tsuo or Tsou, the Ami, the Bunun, the Rukai, the Puyuma, and the Paiwan. The outstanding subtribe is the Budai, which has a rich religious iconography. The little island of Botel Tobag off the southern coast is inhabited by the Yami, a population associated culturally with the islanders of the northern Philippines.

The indigenous peoples are generally exogamous, but what is considered as clan affiliation differs sharply depending on the tribe, some observing patrilineal and others

matrilineal kinship rules. Subtribes vary in dialect and in social organization. For example, the Bunun were subdivided into six subtribes each (with one exception) numbering several thousand individuals and an endemic state of war reigned among some of these.

The archaic Taiwanese had a corpus of myths that varied extensively from people to people. The few studies accessible to the non-Orientalist (many studies have appeared solely in Japanese) allow for the identification of many of the usual Indonesian themes, while other forms seem more specific to Taiwan. There exists a copious body of myths telling of the gift of grain (rice and millet) to the earliest men. Different stories refer to the world above, to a heavenly realm from which all good things descended to earth, and still others tell of how the cereal crops were purloined or otherwise obtained from the lower world.

Among the Taiwanese, the human body is treated in a style not wildly dissimilar to that appearing in China at the end of the Zhou and beginning of the Warring States period (that is, by the fifth century B.C.). Human figures may have horns or stick out their tongues, as on the famous Chinese wooden statues from Chang-sha. The practice of endowing a human head with antlers is quite unknown in Indonesia, although victims' skulls and warrior headdresses can be decorated with water buffalo horns. Finally, a common motif is a figure, squatting or frontal, in a froglike pose, also encountered in China during the Zhou.

On the panel in fig. 1, which used to serve as the king post for a Paiwan (Budai style) house, these horns are plainly visible. The

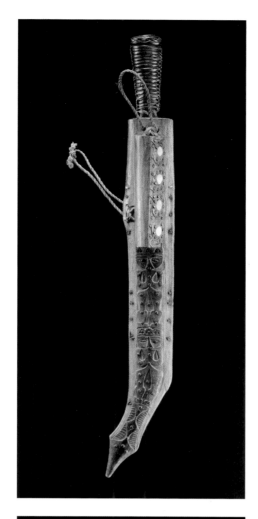

## 2 **Knife**

Hardwood handle and sheath. The eyes and body of the relief figures are inlaid with small brass disks. Each of the four snakes at the top of the sheath coils around a central circle of white porcelain shell. Paiwan group. Length 57 cm. Inv. 3010-1.

## 3 **Tunic**

Cotton, entirely decorated in red and white shells worked with a file before being applied singly. Atayal tribe. Height 94 cm. Inv. 3010-10-1.

## 4 Central housepost (*tomok*)

Hardwood. Traces of black, red, and white paint. Yami tribe. Botel Tobago. Height 235.5 cm. Inv. 3010-4.

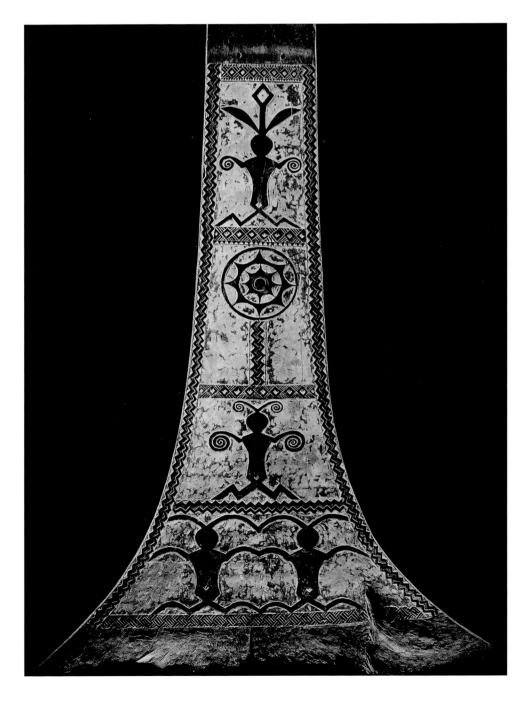

standing figure's head is encircled by snakes whose bodies are decorated with a sawtooth or chevron motif. Is this the image of an ancestor hatched—as the myth had it—from a serpent's egg? Or are the snakes too symbols of unseen forces that control fertility? One thing is certain: the reptile must be somehow connected to the mythical forebear of the inhabitants of the house. The ancestor himself, as can be seen, carries a "wedding cup" made from two small vessels attached by a shaft and carved from a single piece.

The same figure appears twice in a vertical frieze running up a Paiwan knife sheath otherwise decorated with a coiled-serpent motif common in the region (fig. 2). On the front of the "men's house" in the village, coiled snakes are replaced by a horizontal frieze of heads, in allusion to the magical-cum-religious practice of head-hunting at one time so prevalent among the indigenous Taiwanese.

Yunghai Peng reproduces two photographs of such skull "shelves."[1] The first, from the Atayal, is merely a row of bone remains lying on bamboo cane, but the second, of Paiwan origin, is strikingly reminiscent of the monumental daises (called *tzompantli*) piled high with skulls found in Mexico. Very much in the megalithic building tradition of Southeast Asia, the Paiwan construction is made up of a number of stone layers with shelters left for one or two skulls separated by rough-hewn masonry that bears the weight of the layer above.

The archaic Taiwanese were also skilled weavers. One of their creations is an astonishing presentation tunic (fig. 3), which is entirely covered with beads fashioned

Riveted silver plates, with two eyeholes. Its basketry
box with a hardwood lid is also shown. Yami tribe.
Botel Tobago. Diameter 34 cm. Inv. 3010-15.

individually out of the pearlshell of a species
of giant Pacific clam.

The Yami housepost (known as *tomok*) from
the island of Botel Tobago (fig. 4) is quite
distinct from the Budai example. Its slender
shape and almost planar bas-relief decoration
are very unlike both the forms and the imagery
favored in the south of Taiwan near Botel
Tobago, and in the northern Philippines,
where material culture tends to resemble
that of the Yami. The central sunlike motif
(*mata-no-tatara*) on the *tomok* is the same as
that which adorns both sides of the sternpost
on the splendid Yami canoes, and which is
called the "eye of the boat." As for the little
figures with limbs terminating in tight coils,
they represent a mythical entity that appears
to be the Yami "culture hero," Magamaog.[2]

This idiosyncratic "Yami style" has bequeathed
no significant examples of sculpture in the
round and three-dimensional pieces are for
the most part scarce throughout Taiwan. Just
one intriguing object is reproduced here: a
riveted steel-plate helmet from Botel Tobago
(fig. 5), its authenticity vouchsafed by an old
field photograph (von Buschan).

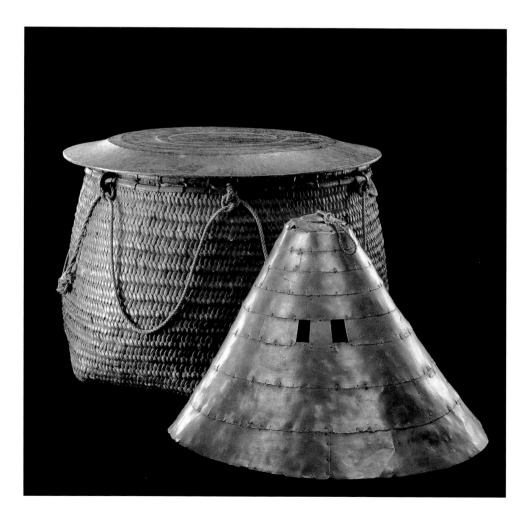

# Early Papuans and Melanesians

Douglas Newton

The two continental masses, Sunda and Sahul, prior to the last Ice Age, about 10,000 years ago (from Peter Bellwood, *Man's Conquest of the Pacific*).

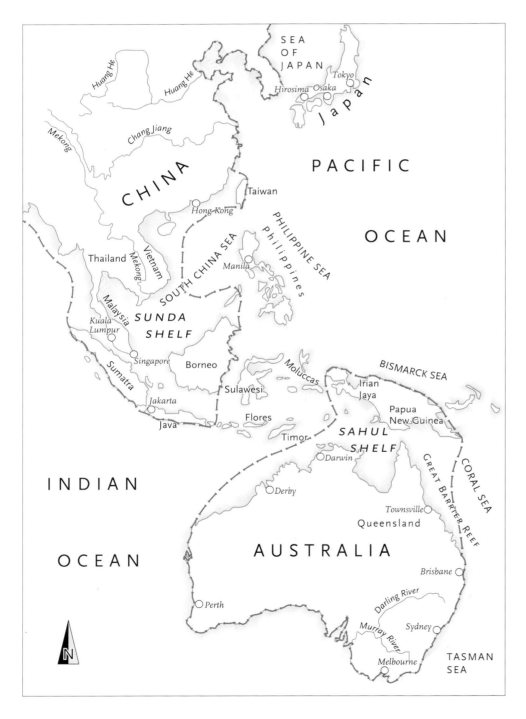

The birth of the Pacific cultures had its origin in an ancient climatic and geological event: the formation of two great landmasses, based on what are now Southeast Asia and Australia, which came into being during the last Ice Age of the Pleistocene epoch. The planet's universal cooling led to periods of massive glaciation in the northern hemisphere; in the southern hemisphere its effects in a predominantly oceanic area, though lesser, were still powerful. Sea levels sank and shorelines advanced: the western Pacific was never less than about 50 meters lower than now; at about 150,000 and 50,000 years ago it was as much as, or deeper than, 150 meters below today's level. This prodigious recession laid bare enormous areas of continental shelf off the coasts of Asia and in the western Pacific.

In Asia, the Sunda Shelf reached out from China far enough to encompass Taiwan, Borneo, and Malaysia, Sumatra, Java, and Bali, and a neck of land connected the shelf to Sulawesi. To the east, the Sahul Shelf embraced a continent comprising New Guinea, Australia, and Tasmania. To the northwest, the continent reached toward the eastern islands of the Indonesian archipelago. At the same time, of course, the distances separating all the islands between Sunda and Sahul were also greatly reduced, as were those between Sahul and the oceanic islands of Melanesia to the east.

The retreat of the ice caps at the end of the Pleistocene epoch, following the onset of a warmer climate, changed these conditions completely. By about 11,000 years ago, the rising waters had drowned much of the exposed land, and Indonesia, Tasmania, Australia, and New Guinea took their present

form. The process was virtually complete by about 8,000 years ago. Simultaneously the Melanesian islands west of Sahul, and the smaller islands of Indonesia, shrank as the waters between them increased.

Long before this, people from the coasts of Sunda set out eastward across the sea. Why and when they did are not clear, but need and curiosity have always been driving human impulses: as coastal people, the ocean was to them another homeland and a highway. Their watercraft may have been bamboo rafts. The periods of low water levels were obviously the most favorable, as more islands would have been visible from one to another. Once at sea, what concerned the voyagers must have been what they could see on the horizon, but very likely a few dozen kilometers more or less would have mattered very little. How long the voyages lasted is equally a matter for speculation; theoretically the journey from Sunda to Sahul could have been accomplished in as few as fourteen days or less.[1] More probably people percolated from island to island over a long period and, where visibility between the islands existed, on return journeys from time to time. Migrations may have been undertaken deliberately, by chance, or, in the long run, a combination of both purpose and chance. It is surely unrealistic to think in terms of a single migration, in the classic sense, taking place at a single time. The human movements into Sahul were more complex in many ways. The evidence of skeletal remains from Australia suggests that humans of differing physical types—two or even three—migrated from Southeast Asia.

The people probably spoke languages remotely ancestral to the modern Australian languages and the hundreds of Papuan (or non-Austronesian) languages of New Guinea and some of the Melanesian islands. Their material culture must have been similar to the dominant mainland Southeast Asian culture of the period. This included stone "waisted tools" or "waisted blades," roughly oval, indented at the sides, and bifacially chipped around the edge. They are adaptable to various uses, and the indentations point to their having been hefted in adz- or axlike fashion. Waisted blades were widespread among the early phases of the western Pacific cultures. They have been found in Australia and Papua New Guinea, as well as the islands of New Britain, New Ireland, and the northern Solomons, which were settled later.

## Australia

As it is conceivable that the earliest cultures throughout Sahul, as super-continent, had certain elements in common, it is appropriate to consider briefly those of what is now Australia. The climate, in a cool phase, was humid; the land was fertile and well-stocked with animal life. The coasts were probably bordered with mangrove swamp, while inland much of the country was covered in tropical rainforest interspersed with grassland and scrub. There was a wide variety of edible plants. Even the central desert was far less arid and extensive than now. The fauna was spectacular, including species of giant herbivores now long extinct, and predators were few. Generally speaking, it was an ideal environment for a hunting-gathering way of life, which the incomers either continued or adopted. To the north was a great plain, bordered on its coasts with mangrove swamp. Its interior, broken with hills whose tops are now visible as the islands of the Torres Strait, was occupied by an enormous freshwater lake (Lake Carpentaria) about 450 kilometers long and 250 kilometers wide.[2] Further north still, the southern lowlands of what is now New Guinea were covered in tropical rainforest.

A period for the earliest arrivals in Australia has been suggested by excavations at a site called Jinmium in the northwest of the continent. It includes a huge sandstone boulder that served as a shelter, the lowest level of which has rendered stone tools and ocher dated at about 128,000–104,000 years ago. Above this are thousands of cupules (small circular pits) pecked on the walls of the shelter, dated between 82,000 and 67,000 years ago.[3] These dates, however, are very strongly disputed. Other much later sites in west Arnhem Land (northern Australia) date back to 60,000–53,000 years ago. Besides stone tools, the people were using red and yellow ochers—treasured materials that had to be transported long distances.

As far as we know, there was a hiatus lasting many thousands of years before the inhabitation of Australia developed. The infusion of new immigrants is one possible reason. Many more sites exist from the period after 38,000 years ago, particularly throughout the southeast of the continent, Tasmania, the arid central deserts, and coastal western Australia. By 30,000 years ago, in fact, all the major areas were inhabited and the population was showing a steady rise throughout the following millennia.

Evidence of artistic production is extensive in Australia from the earliest periods. It can be grouped as body decoration; rock art, painted

or engraved; and, at 20,000 years ago, a form of rock wall engraving called digital fluting in parallel grooves.

When the ocean finally submerged the Torres Strait, it swept away all traces of the early inhabitants of those lowlands. Moreover, it cut Australia off from the northern cultures, except for a measure of contact across the strait that continued until recent times. Under a variety of very different geographic, climatic, and biotopic conditions, Australian cultures developed with a great deal of variation regionally, and richly so, but along very different lines from those of the islands to the north and east.

## New Guinea

Logic demands, and some information suggests, that the earliest people in New Guinea lived initially on the coasts and probably in the far west in Irian Jaya (now a province of Indonesia). There is also of course a second possibility, which does not rule out the first, that people migrated northward from what is now Australia. Structurally, the Australian languages and those of the New Guinea Highlands have much in common.[4] This suggests an ancient kinship and might imply that the earliest inhabitants of Australia and, at least, the New Guinea Highlanders coming from the same area were similar linguistically and physically.

What routes the first incomers from the west subsequently took are not established. Any entry from the west would allow for at least two further possibilities: eastward along the coast, which would have been the normal route for seafarers; or again eastward, along the vast cordillera that runs west to east the whole breadth of the island, forming its spine. Alternatively, people could have moved inland from the coast. Nothing at present seems to suggest that both kinds of movement could not have taken place, with the proviso that present archaeological information is regrettably uneven in its distribution. With the excavation of a number of sites in Papua New Guinea (east New Guinea), the archaeology and prehistory of the Highlands are fairly well known. On the other hand, a mere handful of northern lowland sites have been investigated. But if the ancient highlands and lowlands were in many ways different, they were not totally distinct realms: interaction between them began a very long time ago.

The earliest evidence of settlement in New Guinea comes from the northeast coast. About the time of human arrival, the coast was a long shoreline interrupted by the mouths of rivers which, at the point where the mouths of the Sepik and Ramu Rivers subsequently formed, swept inland to form the shores of a deep gulf, now called the Sepik Sea. It then continued southeast, as it does to this day, rounding the Huon Peninsula (Morobe Province), which protects the waters of the Huon Gulf to its south. It is this stretch of coastline which has yielded the earliest evidence of humanity in Papua New Guinea. The central point of the coast must have been inhabited early, although its oldest site, on the coast near the international border, dates from 35,000 years ago. But the very earliest site known is well to the east: Fortification Point in the Huon Peninsula, an uplifted coral reef dating to 45,000 years ago.[5] The tools found include waisted blades. Their owners presumably exploited sea and river resources, as well as local vegetation and animal life. But these big heavy blades,

1 A Huli tribesman with face paint and human hair wig, playing pan pipes. Southern Highlands, Papua New Guinea. Photograph Mark Graham, Gamma.

clumsy as they are, and the possibility that they were hefted, suggest that they might have been used for clearing woodland.

### Island Melanesia

About this period, migrants also began moving into Island Melanesia from bases in New Guinea. If they had left from the nearest point, the Huon Peninsula, their longest leg would have been about 60 kilometers across the Vitiaz Strait. Beyond this they would have remained in sight of land all along the south coast of New Britain until they reached the narrow Saint George's Channel, across which lies the southern tip of New Ireland. In fact, by 35,000 years ago they reached west New Britain, where, far from being simply coastal dwellers, they were soon exploiting the inland resources of rainforest environments.[6] They arrived at the long east coast of New Ireland and were living in rock shelters by 33,000 years ago.[7] A much longer journey of 180 kilometers, with only the small islands of Nissan and Ambitle intervening, took them to Buka, the northernmost of the Solomon Islands, by 28,000 years ago.[8] The Admiralty Islands were reached by 20,000 years ago. This completed, with minor exceptions, the peopling of the arc of the Bismarck Archipelago. Nor had the colonists gone unprepared for islands far less rich in animal life than New Guinea. They took with them, or began to import and acclimate to their new homes, potential food resources, both animal and vegetable: phalangers (opossums), wallabies, bandicoots, and, inadvertently or not, rats, together with taro and *Canarium* nuts. Whether pre-ceramic period emigrants reached the remoter islands of Vanuatu and New Caledonia is debatable, but there seems no doubt that they had the technical ability to do so.

The sheer length of the distances the people were traveling makes it emphatically clear that the era of the crude modes of transport such as the bamboo raft had long vanished into the remote past. The islanders had surely entered the age of sail millennia before. Long range inter-island trade had begun as early as 20,000 years ago, when obsidian (volcanic glass used for sharp blades) was carried from sources at Talasea on the west coast of New Britain to Matenbeck on New Ireland, over 350 kilometers away. We can see in these

Stone. Wooden haft. The rear section that counterbalances the weight of the blade is wrapped in finely woven yellow and black rattan. Central west Highlands, Papua New Guinea. Width 76.5 cm. Inv. 4159.

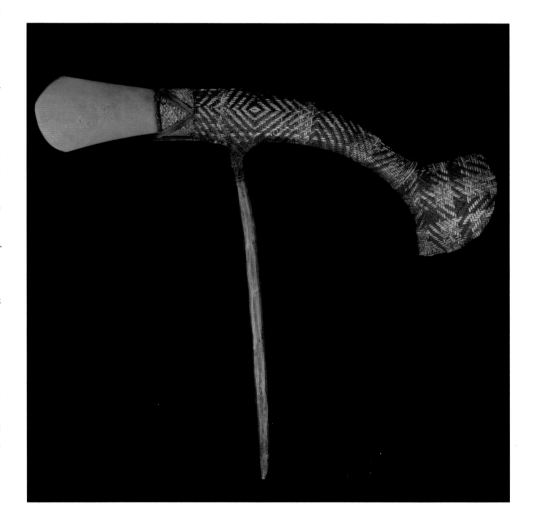

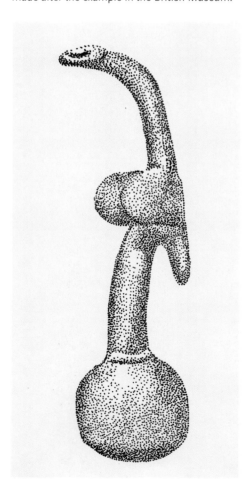

3 Stone pounder. Objects of this type have been found throughout the eastern region of Papua New Guinea, as have small mortars. Drawing made after the example in the British Museum.

voyages the tentative roots not only of the populating of the rest of Melanesia that took place much later, and the many short-range links between neighboring islands that existed until recently, but also the beginnings of the great trading complexes of the north and southeast New Guinea coasts and the Massim area.

**The New Guinea Highlands**

The first signs of human occupation in the Highlands are traces of the burning of wood and swamp vegetation about 26,000 years ago in the Baliem Valley (Irian Jaya).[9] This took place at a number of other sites as well in subsequent periods, both in Irian Jaya and Papua New Guinea. An obvious reason would be for the hunting drives that the Sepik Valley grasslands are used for today, but it is also suggested that burning was intended to foster the growth of *Pandanus* nut trees.[10]

The earliest known inhabited mountain site in Papua New Guinea is in the east and dates from 24,000 years ago.[11] Kosipe was on open land at the top of a ridge. These people also practiced forest clearance by burning-off and again their equipment included waisted blades. The habits of these hunter-gatherers were like those of the early Aborigines: people probably visited Kosipe seasonally to collect pandanus and to hunt. Cave shelters served in the earliest times as hunting camps. There were also more permanent settlements, at least at a later stage: in the Eastern Highlands Province, about 17,000–18,000 years ago, people lived in oval houses walled with saplings or slender posts, and with circular hearths bordered with rocks.[12]

Meanwhile, there was continuing contact between New Guinea and the surrounding

islands, and within New Guinea itself. The Melanesian trade in obsidian extended as far as the Eastern Highlands.[13] Trade specifically between the Highlands and the coast was developed by soon after 11,000 years ago, when people in the Eastern Highlands were obtaining marine shells from the north coast —cowries and others—presumably to be strung into bands for personal decoration.[14] At later periods pearlshell and other species of shell were traded up from the south coast.

In New Guinea, as in Australia, the use of colors for body ornament (fig. 1) or ritual purposes is implied by the use of red ocher and other colored oxides as early as 15,000 years ago,[15] and in markedly increasing quantities as time went on. As for less ephemeral art, there is a hint in certain caves. Digital flutings of Australian type exist in caves in the Southern Highlands; though undated, they may also reflect human presence in the region at about 20,000–15,000 years ago, thus raising "the possibility of a single continental cave art" in Sahul for this period.[16]

**Early Agriculture**

A signal event in the history of the New Guinea Highlands was the beginning of agriculture, with all it implies for the invasion and modification of the natural environment and society. Whether introduced from Southeast Asia or a local invention, the earliest known pieces of evidence are at Kuk, a site in the swamplands of the Wahgi Valley, near the central point of the mountain cordillera, beginning about 9,000 years ago. The crop was probably taro, possibly a domesticated indigenous species. Several phases of increasingly intensive cultivation took place there, shown by the remains of extensive drainage systems of

increasing complexity over time, seemingly reflecting not only the growth of agriculture, but also a substantially increasing, nucleated population dependent on it—one that was necessarily, of course, united in larger settled communities to perform cooperatively large-scale tasks.

At this period, stone tools changed from the heavy waisted blades to new forms. By 6,000 years ago, polished lenticular adz-axes were made from stone at suitable quarries and were traded widely through the Highlands. These implements became the universal woodworking tool of New Guinea down to very recent years (fig. 2).

The scene appears to have changed again with the introduction of the Highlanders' present main crop, the sweet potato, which may have taken place about 1,000 years ago. The consequences of this innovation may even have included considerable social changes, one of them being an increase in population that enforced migrations to lowland areas. Domestic pigs were transported from Indonesia to New Guinea about 6,500 years ago or before: the breed may have originated in Halmahera.[17] They were soon brought into the Highlands, and the ability to produce surpluses of sweet potatoes for their feed might then have led to the breeding of large herds, which in turn fueled the creation of the grand contemporary competitive exchange ceremonies involving the mass slaughter of pigs. The continuing Southeast Asian connection was not altogether a one-way street. Sugarcane, perhaps domesticated in New Guinea, was introduced to Southeast Asia about 5,000 years ago, while phalangers were established in Timor either from New Guinea or the Malukus 4,500 years ago.[18]

An archaeological and art-historical problem is posed by the utilitarian and figurative stone carvings discovered predominantly in the Highlands. They fall into three subgroups: figures with no known function; pestles (fig. 3); and bowls (or mortars).[19] One important manufacturing center was in the central Highlands, notably the Wahgi Valley, but they were also made in other areas. Their age is unclear: only a few fragments of mortars (but no carvings) have been found in excavations; they are dated to about 4,500–3,500 years ago.[20] The variations they show suggest that the tradition of stone sculpture was a long one that underwent several changes and included several local styles; some were also clearly traded long distances. Possibly these objects were a trait of the agriculturalists that they abandoned with the change in crops.[21] Suggestions that the carvings were influenced by, or are even skeuomorphs of, Southeast Asian bronzes do not hold water, chronologically or stylistically. Whether ancient or relatively recent, they are the most striking examples of pre-contemporary New Guinea art, to which they are evidently ancestral.

**The Ancient Lowlands**

While people continued to inhabit coastal sites, the earliest known inland Sepik site dates from 14,000 years ago. It is in the Saraba Hills, also called Holokain or Numbuk, which rise abruptly from the grassland plain north of the middle Sepik River. One of its rock shelters is rich in rock paintings, rare in the Sepik. Of unknown but probably recent date, the paintings are placed high on the walls. At its earliest phase at least, the hills were presumably in the middle of the Sepik Sea or on its verge.[22]

Near the mouth of the sea itself, about 6,000 years ago, an island was inhabited by people who largely lived on fish and shellfish.[23] Shells were used as cutting tools and weights for fishing nets, and also to make lime for chewing with betel, a habit and plant which came from Southeast Asia. The people also had small quantities of obsidian, possibly imported from the Admiralty Islands. Giant clam shells (*Tridacna gigas*) were used to make arm-rings and adzes.[24]

Pottery first appeared in New Guinea at the Sepik Sea sites about 5,700 years ago, the forerunner of the multifarious Sepik pottery traditions of today. Moreover, about 5,500–5,300 years ago other central north coast people were making well fired globular cooking pots. These were technically good enough to suggest that the craft had already been practiced for a long time.[25] Some

4 Fragment of Lapita ceramic (detail; compare with fig. 3, p. 19). Gawa, Reef Islands, Solomon Islands. c. 1000–900 B.C. (Green 1979b, p. 22, fig. 13).

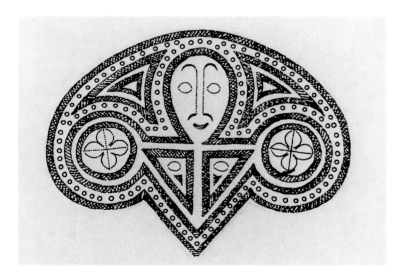

shards were found at Wanelek, in hills near the Ramu River about 125 kilometers south of the Sepik Sea, dated to about 5,500 years ago. However, while some pottery was imported to the Eastern Highlands from the lower hill areas in exchange for stone blades, it was never adopted in the Western Highlands.[26]

At this time the landscape of northeast New Guinea was changing. The Sepik Sea slowly began to fill with silt washed down from the Highlands by its tributary rivers. By 1,000 years ago the sea had gone, replaced by the present great plain through which wind the Sepik and Ramu Rivers.

**Pottery and Austronesians**

The origin of pottery in Asia and the Pacific islands has been linked to the origins of the Austronesian languages. Pottery makers in the Chinese southern mainland and before 6,500 years ago in Taiwan, according to linguistic and archaeological theory, were "Initial Austronesians." These people spread first southward, to the Philippines, Malaysia, and Sulawesi, and then eastward, the languages diversifying. The making of pottery remained a constant of material culture among all of them, and the dates of finds fall in a close range from roughly 5,000–4,000 years ago.[27] Compared to the New Guinea dates, some of the extant Southeast Asian dates fall toward the latter part of this period. In any case, the final linguistic stage was the formation of the Proto-Oceanic languages, from which rose the Pacific Austronesian languages of the present. These dates suggest that potting was a "pre-Austronesian" craft in New Guinea. In this case, potting might have been spread through the Melanesian islands

along trade routes from northern New Guinea well before Austronesian influence.

## Lapita

Beginning about 3,600 years ago, a culture dubbed Lapita, after a site where some remains were discovered in New Caledonia, took root off the northeast coast of New Guinea in the islands of the Bismarck Archipelago. Whether the islands were its "homeland" or whether it was introduced has been the object of much research and debate, but opinion seems now to lean to the latter possibility, even though its immediate origins still remain speculative. The people presumably spoke an early Austronesian language, or languages.

The most spectacular Lapita product, at its finest in the Early Western phase in the northern Bismarck Archipelago (3,600–3,200 years ago), was pottery in the form of plates, bowls, and carinated vessels. These are superbly decorated with dentate impressed or incised designs (figs. 4, 5) composed of a multitude of motifs in horizontal registers. The designs included human faces, which were seminaturalistic at first but in the course of time, and over an expanding area, became more stylized.[28]

The Lapita people engaged in extensive trade, in which obsidian was a characteristic item, and eventually in actual colonization. The culture, including its products in pottery and obsidian, was carried during the Western Lapita phase (after 3,200 years ago) through-out the already settled islands of Melanesia: New Britain, New Ireland, and the Solomons. In all these, Austronesian languages largely replaced earlier Papuan languages. Bearers

of the culture became the founding popula-tions of Vanuatu and New Caledonia, and in the Eastern phase, beginning about 2,000 years ago, arrived in Tonga, Samoa, and Fiji in what is now western Polynesia. Here it evolved into the founding culture of all Polynesia.

Lapita was a much more powerful historical factor in the development of Island Melanesia and the further Pacific islands than it was in New Guinea, which adopted non-Austronesian languages only in a few small enclaves (see map p. 172). Even so, where art is concerned, some of its motifs and—less conspicuous but equally important—its organizational principles have also endured there.[29] They can be traced in Melanesia and are even more readily discernible in Polynesia.[30] What remains unexplored is what must have been Lapita's powerful legacy of myth, ritual, and custom.

5  Lapita vase reconstituted from fragments. Paoancarai Lagoon, Malo Island, Vanuatu. Drawing taken from a photograph by J. D. Hedrick.

# Irian Jaya

Dirk A. M. Smidt

### 1 Prow board ornament

Wood. This prow board is rather different from the more familiar prow ornaments, which are larger and have more sustained openwork (see fig. 3). It is closer to boards from eastern Indonesia, whose trading links with, and cultural similarities to, the Papuans of Irian Jaya are well documented. The ornament is said to have been collected in the Raja Ampat Islands, but a rather similar example exists in the Rijksmuseum voor Volkenkunde in Leiden, which was found on Biak Island, one of the three large islands in Cenderawasih (Geelvink) Bay. Length 69 cm. Inv. 4007.

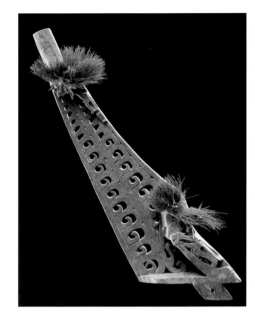

**Irian Jaya**

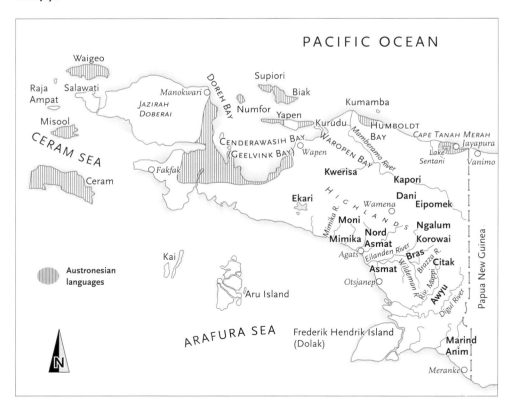

*Every Papuan possesses a certain artistic sense, and all are accustomed to apply it. It is for this reason that no member of Papuan society makes art his sole means of existence.*

G. A. J. van der Sande (1907)

New Guinea, the second largest island in the world, resembles a bird with its head raised in the northwestern end, which was aptly coined "Bird's Head." The western half of New Guinea comprises approximately 400,000 square kilometers and has a population of 1 million people native to the island. The total population numbers 1.6 million people, including past arrivals and recent transmigrants from other parts of Indonesia. The political division between West New Guinea (Irian Jaya) and East New Guinea (part of Papua New Guinea) is an artificial construction. Geographical features, languages, social systems, and cultural expressions run across the border. There is a great diversity of landscapes and ecosystems: from sandy beaches on the coast, via swamps and muddy rivers, savanna-type landscapes and lush tropical forest, to mountain peaks covered in snow and ice. Linked to this natural habitat, there are different modes of livelihood, from sea fishing to riverine fishing using traps and nets, from the processing of sago (the main staple in low-lying areas) to elaborate systems of horticulture in the Highlands. There are also distinctions in human types: an Asmat can be clearly recognized from a Marind-anim, a Dani from the Baliem Valley, or a man from Biak Island. Some 250 languages are spoken. Many groups have found their own spot, albeit often temporary or semipermanent. These groups should not be considered as isolated units, but rather as being linked with other groups through trade complexes. There is diversity in art forms,

## 2 Large bowl

Wood. In the shape of a dog (?). A label is inscribed with a note in the hand of Jacques Viot, who procured the object in 1929 at Kurudu, Kaipuri Island, Cenderawasih Bay. Formerly Pierre Loeb Collection, Paris. Acquired from Le Corneur and Roudillon in 1963. Length 76 cm. Inv. 4003.

## 3 Canoe prow

Wood. It is made up a series of openworked planks slotted into a base. Here and there, at various heights, little faces evoking ancestor effigies (*korwar*) are visible, their skulls adorned with sprays of cassowary feathers. Collected by Pierre Langlois at the beginning of the 1960s. Yapen Island, Cenderawasih Bay. Length 185 cm. Inv. 4006.

which, together with other cultural traits, make up the specific identities of many particular areas.[1]

West New Guinea art as such does not exist. There is art from many specific areas, each marked by its own style, substyles, and even personal styles. Art is produced in varying contexts using both local and imported materials. It goes beyond the well-known categories of masks, figures, shields, paintings on barkcloth, and pottery to include ephemeral arts such as body decoration. Moreover, in ceremonial contexts art objects are used in conjunction with music, dance, and oratory. We should even be aware of aesthetic considerations being applied to "the order of gardens, the spatial arrangements of villages or dance grounds, or the moment of transmission of a gift."[2] We should also take into account the endemic significance and symbolism attached to particular objects which may not look spectacular in our eyes. For example, a string bag is not only of great practical use in daily life in many New Guinea cultures but may also play an important role in all sorts of social processes (including gender relations) and ceremonial events, and often has mythical and sacred connotations as well. The art of West New Guinea is dominated by men, but female aspects are apparent. The making of carvings is men's work and in many areas this is usually done in the context of the ceremonial men's house, which is out of bounds to women, children, and unitiated youths.

Art from West New Guinea is not static but dynamic. It changes in the course of time, while balancing a continuous tradition with innovation and individual artistic creativity. Usually there is a religious dimension to it. The interaction between human beings and

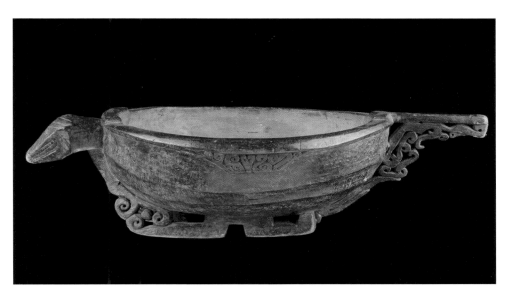

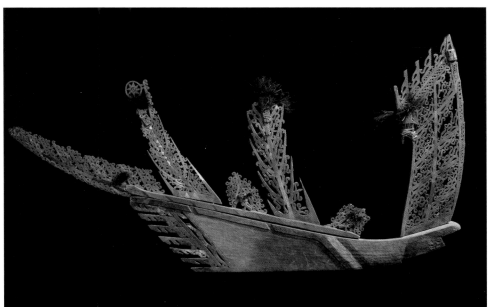

**4 a, b, and c  Three statuettes (korwar)**

Hardwood. In earlier times, such statuettes consisted simply of a carved wooden body on which the skull of the deceased would have been placed. The large figure to the left is supposedly a prow ornament. It was collected by Jacques Viot on his 1925 expedition and transferred by him to Josef Mueller in 1938. The sculpture in the middle formerly belonged to Ralph Nash and was previously housed in an unidentified German museum. Cenderawasih Bay. Heights respectively (from left to right) 42.5 cm, 30 cm, 22 cm. Inv. 4002-B, 4002-A, 4002-C.

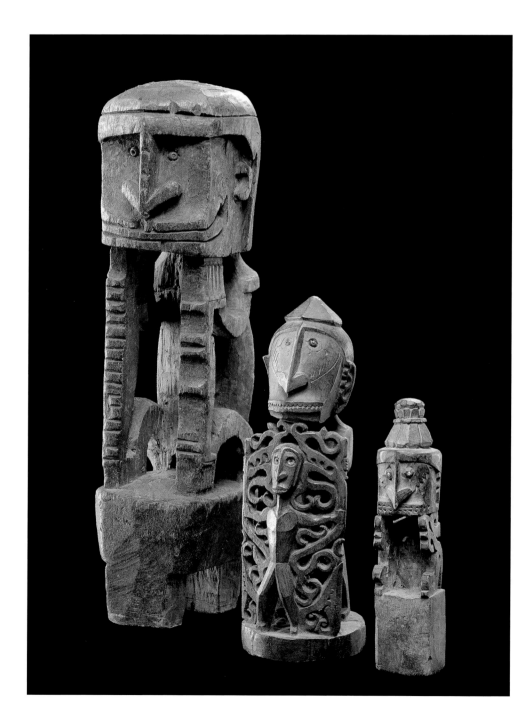

the supernatural world, and the expression of the deep emotional and spiritual bond between man and environment take place through art. Thus art plays a role in food-providing activities such as hunting, fishing, and horticulture, as well as in matters of illness and health. In traditional warfare, ancestral spirits embodied in wood carvings advised, supported, and protected. Art played a distinct role during rites of passage, particularly initiation, first menstruation, marriage, and death. Tied in with most of these activities is the role of art in underlining political status and authority. In some areas this function can be seen in impressive architectural structures, canoes, and much ornamentation. An overview of major art styles follows.

## Geelvink Bay

The enormous Cenderawasih Bay, better known as Geelvink Bay, located in the nape of the "neck" of the Bird's Head, stretches from Manokwari in the west to the mouth of the Mamberamo River in the east. This bay, which includes several large islands such as Biak, Yapen, and Numfor, has become the scene of an art style of its own which can be delineated as far as Waigeo in the northwestern tip of the island.

Northwest New Guinea forms an intermediate zone between Indonesia/Southeast Asia to the west and Melanesia to the east. Leaving Indonesian influences as a result of the recent political situation aside, this area of New Guinea, being the closest to Indonesia, has been comparatively strongly influenced by cultures to the immediate west and indirectly via trade complexes by cultures farther afield. Imported items like glass beads (fig. 7), porcelain, and cotton fabrics have been

adopted as treasured value goods, playing an essential role in bride-price and dispute negotiations and other forms of ceremonial gift exchange in the Bird's Head and Geelvink Bay areas. Imported beads in various colors are used to create the geometrical designs on the pentagonally-shaped dance aprons which are typical for the Geelvink Bay area. These aprons, usually decorated with fringes of cotton strips, used to be worn by young women. After iron was introduced from the Moluccas, Biak and Doreh Bay developed as producing centers of iron articles such as spearheads. People from northwest New Guinea were not only at the receiving end. The inhabitants of Biak in particular became a dominant force in the area. Their strategic position and the possibilities of shipping enabled them to exert influence as far as the northern and southern Moluccas and beyond to the west, and up to Humboldt Bay in the east. They developed a reputation as raiders, pirates, and slavers. Due to the scarcity of fertile land on Biak, about 500 years ago people migrated to the Raja Ampat Islands, which became the link between New Guinea and the Moluccas. Shipping using canoes fitted with sails, outriggers, and plank-boarding has also enabled inter-island and coastal contact between groups within the Geelvink Bay area proper, and this has resulted in mutual influences which have blurred strict style boundaries. As in other parts of New Guinea and the Pacific, a canoe could be seen as a symbolic representation of a social group. War canoes had elaborate prows consisting of various separate ornaments which could be slotted into a basic structure (figs. 1, 3). The scroll pattern in the prow ornament is sometimes interpreted as coral or as octopus tentacles, and may in general refer to spirits inhabiting the waters.

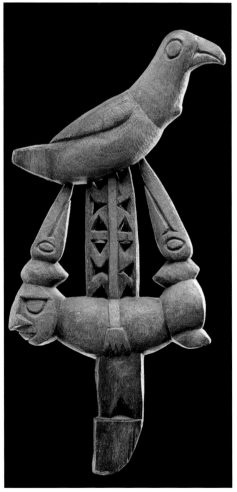

5 **Platter**

Hardwood. The underside is decorated with six little *korwar* figures each positioned at the end of a row of asymmetrical spirals. A label in the hand of Jacques Viot (1929) states the provenance: "Orerambo [or Orframbo] village, Kaipuri Island." This note is accompanied by a curious explanation: "Cover for turtle hunt." Original Josef Mueller Collection (date and place of acquisition unknown). Diameter 37 cm. Inv. 4004-2.

6 **Prow ornament**

Wood. Merat Island, Sarmi coast area. Original Josef Mueller Collection. Acquired prior to 1939. Height 36 cm. Inv 4054-A.

### 7 Dance apron

Decorated with glass beads threaded on fiber yarn. Red cotton fringe. Cenderawasih Bay. Length 56 cm. Inv. 3462-6.

### 8 Platter

Hardwood. Lake Sentani region. Length 105 cm. Inv. 4078.

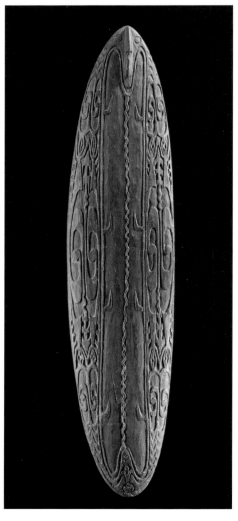

Wooden images with uplifted arms from islands near the northwestern point of New Guinea reflect the *fan nanggi* (literally "nourishing of heaven") ritual as performed by priests to invoke the help of the supreme god Manseren Nanggi (Lord of Heaven). The detachable arms of these images are indicative of eastern Indonesian influences. Apart from the belief in a supreme god, ancestor worship played a major role in the life of the people from Geelvink Bay. *Korwar* figures (fig. 4), with their angular and straight lines, planes, and anchor-shaped noses, have become the trademark of the style of this area. They served as the vehicles of communication between the living and the dead. Most *korwar* images are carved of wood, but some have a human skull surmounting a stylized wooden body, and they are sometimes wrapped in imported cloth. The carved body is frequently rendered in a seated position with the knees drawn up, in reference to the posture in which the dead are interred. Standing figures, particularly prevalent in Doreh Bay, are more rare. In the latter case, the arms often extend before the figure and hold a staff, a snake, or an openwork "shield" characterized by a scroll pattern, placed in front of the figure. The snake may have both positive and negative connotations, being associated, for example, with rejuvenation and new life, or the nether world. In some examples, a smaller figure is placed in front of the main figure or the openwork "shield" (fig. 4b). The combination of the rigid style of the figure itself and the curvilinear designs of the "shield" reflect an older and newer tradition respectively.

*Korwar* means, by and large, "soul of the dead," which implies that the soul of the dead has entered the image. *Korwar* figures can be

## 9 **Drum**

Hardwood. The sides are decorated in low relief with a bird-headed anthropomorphic figure above which swirl interlocked spiral shapes. The membrane is made of cassowary skin held in place by strands of rattan. Original Josef Mueller Collection. Acquired from Pierre Vérité in 1938. Height 63 cm. Inv. 4050.

found as far afield as the Raja Ampat Islands and the Bird's Head area, but their central region extends from Doreh Bay in the northwestern section of Geelvink Bay to the island of Yapen in the northeast. Many *korwar* images were destroyed under missionary pressure, although some of the surrendered *korwars* had, in the eyes of the people and unknown to the missionaries, lost their power and could easily have been parted with. *Korwars* were made above all to appease the souls of people who died unnatural deaths—such as women who died in childbirth or the victims of violence—and the souls of people belonging to leading families. The dead were usually buried, but important people were first interred inside a model dugout canoe and then the skull was fitted to a wooden *korwar* image. The bones were laid to rest in bone chests sometimes decorated with *korwar* images. These, together with the *korwar* figures, were preserved in sacred locations, such as crevices, caves, or rocky ledges.

*Korwars* were usually made by specialists. Their skill went hand in hand with their magical abilities and their capacity to act as intermediaries between the living and the dead and to fulfill a role as priest or shaman (*mon*). Upon completion of the image, the soul of the dead person was called upon to enter it and a state of trance by the acting priest formed an indication of this. *Korwars* could be called upon in the event of illness, when several such images were placed around the sick person, or were consulted as oracles, used to avert a calamity, or to give protection on a journey. Small *korwar*-type images were worn as amulets (fig. 4c). During important moments in life, such as births and marriages, the souls of the dead might be sum-

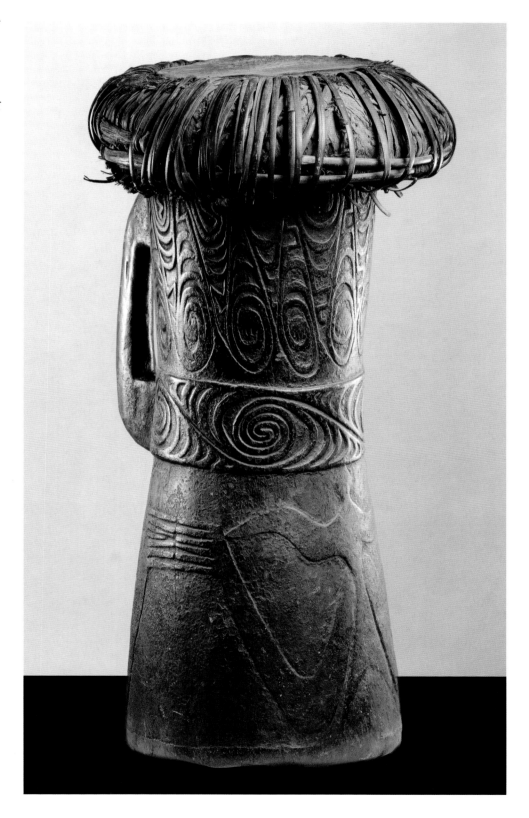

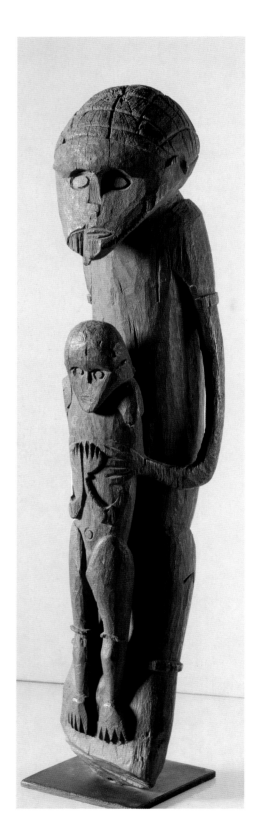

moned to enter the *korwar*. A priest held the *korwar* in his hand or placed it on his shoulder or head. If the *korwar* image moved, this was a clear sign that the spirit of the dead had entered the image. Apart from enacting positive functions, such as aiding, protecting, and healing, *korwars* could also become dangerous by making people sick or even killing them. If a *korwar* did not live up to its expectations, the image might be smashed to pieces, burnt, thrown away, or sold.

The *korwar* motif is the dominant motif in the art of the Geelvink Bay area. Small versions of *korwar* images (fig. 5) or *korwar*-style heads are carved in the handles of drums, at the top ends of shields, in bone chests and headrests, at the top ends of sago stirrers, in openwork canoe prow ornaments (fig. 3), and in relief on the surface of the tubular bellows used in ironworking on Biak.

10 **Statuette**

Ironwood. The piece is sometimes known as a "mother and child," but it might instead represent an individual and his guardian ancestor. Collected by Jacques Viot in 1929. There survives a photograph of a Papuan carrying this sculpture (Kooijman 1959, fig. 43) taken during Viot's expedition. The left arm has been restored. Lake Sentani. Formerly collections of Helena Rubinstein and Ralph Nash. Height 73 cm. Inv. 4051.

## The North Coast: Wakde-Yamna, Humboldt Bay, and Lake Sentani

As a stylistic region, the north coast stretches from Wakde-Yamna in the west to Aitape (Papua New Guinea) in the east. This region can be subdivided into three major style areas: Wakde-Yamna, Humboldt Bay, and Lake Sentani. In the distant past, Indonesian influences here have been minor in comparison to northwestern New Guinea. North coast sculpture tends to be rounder and fuller than the *korwar* sculptures of Geelvink Bay. In two-dimensional art, the scroll patterns of Geelvink Bay are replaced by S-shaped double spiral motifs in strictly symmetrical fashion.

A most important aspect of north coast art is the making of wood carvings for seagoing and coastal canoes. These canoes have a double outrigger for better protection and balance in rough water, and the sides are raised by means of lashed-on splashboards or planks. Both the sides of the hull and the planks above it have graphic patterns carved in them, rendered in rather contrasting styles: airy and flowing in the former, compact and rigid in the latter. Usually all sorts of fish and birds are depicted. The motifs on the planks are clan-related, particularly the design near the bow. With regard to such clan emblems "the rules of conformity are at their most rigid," but on the other hand "a carver does not gain a reputation merely through executing correct carvings, but also through his innovations and these can be applied to the hull of the canoe."[3] Other parts of the canoe are also decorated. Prow and stern have carved decorations showing a combination of human heads, and bird and fish figures. Some prow ornaments are attached as separate carvings,

This post was in the house of a chief (*ondofolo*), and was found at the beginning of the 1960s in the waters of Lake Sentani, into which many such "pagan" carvings had been thrown by missionaries. The "wings" emerging from the top of the post are tree roots (partly restored). A human figure carved in very high relief protrudes from the front of the post. On the back is carved the silhouette of what is now an extremely weather-beaten and time-worn round-headed figure. Height 258 cm. Inv. 4055.

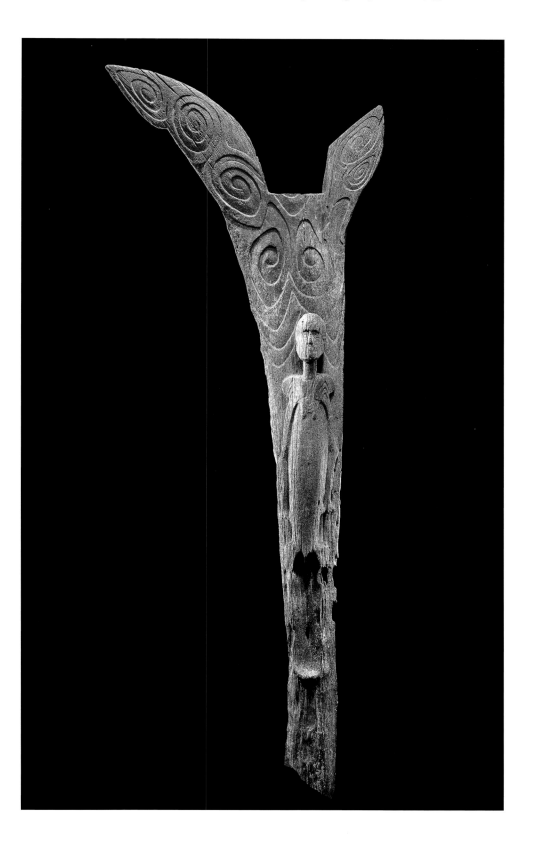

allowing for a striking vertical impact. This vertical tendency has been associated by some scholars with the Austronesian cultural stratum. In fact, the prow ornament may be seen as "the head of a handsome man," since the decorated canoe itself is equated with a man in festive dress.[4]

Three different types of prow decoration can be discerned: a vertical bar with one or two horizontal cross bars (fig. 6); S-shaped; and a horizontal Y- or V-shaped structure. The latter is typical for the Wakde-Yamna area. The S-shaped structure, consisting of stylized fishes topped by a bird's head and slotted into the space between the two raised boards which converge at the bow, is typical for the Humboldt Bay area, including a stretch of the coast between Tanahmerah and Vanimo.

Ceremonial carvings played an important role in the ceremonial houses, which have all disappeared now. The ends of beams sticking out through the pyramidal roofs had all sorts of carved decoration, mainly in the shape of animals such as birds, lizards, and pigs. Other ceremonial wood carvings are drums with designs carved in relief, head ornaments, slave blocks, and shields with graphic patterns mainly consisting of spiral motifs. Figures of human beings, ranging from comparatively large examples carved in a compact style to very small ones carved in a freer, more "expressive" style, are notable works of art from this area.

## Lake Sentani

Lake Sentani, situated approximately 36 kilometers from the provincial capital Jayapura at 70 meters above sea level, is 24 kilometers

**12 Drum**

Wood. Relief decoration painted in black, red, and white. Marind-anim. Height 80.5 cm. Inv. 4248.

**13 Drum (*em*)**

Wood. Lizard-skin membrane. The handle is framed by two rows of double loops (the bottom has been slightly restored). The instrument's sides are engraved with relief patterns of two hands—those of a supernatural being—and cockatoo beaks. Both are head-hunting symbols. Region of the mouth of the Lorentz River. Asmat. Very old. Formerly Jac Hoogerbrugge Collection. Height 50 cm. Inv. 4251-A.

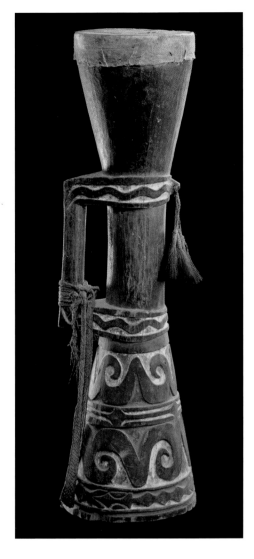

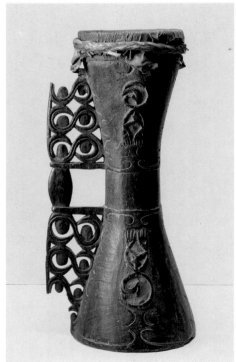

long. Sentani culture is shared by some 25,000 people, while approximately 37,000 people, including newcomers, live in the Sentani area. At Doyo Lama, on top of a hill to the northwest of the lake, an impressive site of petroglyphs and megaliths is preserved. The engravings on the many boulders, which are suggestive of Micronesian influence, seem to depict animals like birds, lizards, and fishes, as well as faces of ancestors or mythical beings. A circle of megaliths is seen by the local population as mythical or ancestral people turned into stone. Dong Son ceremonial socketed bronze ax heads, imported in the past through trade contacts via Southeast Asia, were found in the lake region at the beginning of this century.

Lake Sentani has become famous for some most impressive and moving human figural sculptures (fig. 10). Their merit as great works of art has been internationally acknowledged. The sculptural art of Lake Sentani fulfilled a role in the context of the ceremonial men's and chiefs' houses. Integral parts of such structures were posts carved out of trees in which two of the buttress roots were left intact (fig. 11). These were decorated with sculptural carvings and curvilinear motifs in relief, placed upside down (similar in concept to Asmat *bisj* poles; fig. 19). Also part of these houses were carved sun discs. Some of these sculptural works were retrieved from the lake many years after the houses had been burnt and posts and sculptures thrown into the lake under missionary and government influence in the 1920s. In fact, much ceremonial Sentani art, linked as it is to the position of the hereditary chiefs (the *ondofolo*), is an indication of the elevated status of the chief, his special relationship with the supernatural world, and his power to

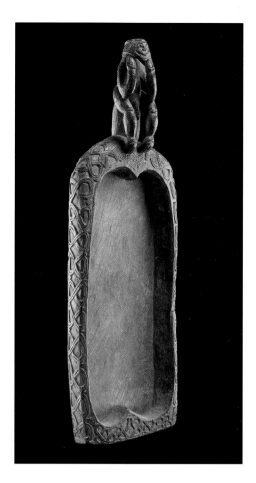

**14 Ceremonial platter**

Hardwood. The outer face of the rim is covered in a curvilinear pattern consisting of adjacent double loops. The upper part is decorated with a squatting human figure with its head in its hands. Asmat. Formerly A. M. G. Groenveldt Collection. Height 70 cm. Inv. 4253.

**15 Spear shaft (detail)**

Ironwood. The openwork central section is flat and shows simplified human figures and praying mantises, symbols of head-hunting. Asmat. Formerly Jac Hoogerbrugge Collection. Overall height 193 cm. Inv. 4254.

---

draw on resources of nature and manpower, including the most able artists of his community. Motifs carved in ceremonial objects may be indicative of the owner's position in the social hierarchy. This applies for example to the magnificent drums, decorated with curvilinear motifs in relief, sometimes flanked by motifs in a freer style (fig. 9).

Balance and symmetry are perhaps the key characteristics of Sentani art, which also includes what has been termed "commoner's art." The designs carved on food dishes (fig. 8), suspension hooks, canoe prows and paddles, the bodies and waist bands of drums, coconut, bamboo, and calabash lime containers, and bamboo tobacco containers are refined and harmonious. The S-shaped double spiral motif and interconnected scrolls are typical style elements sometimes used in connection with a rendering of parts of an animal, for example a turtle or lizard. The art of Lake Sentani seems tranquil and controlled by an inner equanimity. It has been suggested that this tranquillity and balance must have been instilled from childhood by the necessity of keeping one's balance while maneuvering in narrow canoes on the waters of the lake.

Sentani has a reputation for painted barkcloth, examples of which are seen as works of art in their own right. The barkcloth itself was made by women, while the men made the designs. In the past, barkcloth skirts were worn by married women only and were displayed over the grave of the wearer upon death. At the beginning of this century, some women were already wearing cotton petticoats and barkcloth skirts were gradually discarded. In the 1920s, however, painted Sentani cloths caused a sensation in Western art circles.

## Mimika

The Mimika, who are also known under their language name Kamoro, number some 8,000 people. They occupy a southwestern coastal strip between Triton Bay and the Otokwa River, which borders Asmat territory in the east.

Mimika and Asmat art are related. To some extent, comparable types of objects are used, such as huge ancestor poles, openwork canoe prow ornaments, paddles, drums, and masks made of knotted rope with attached wooden eye pieces. In both areas, two-dimensional surfaces are carved in relief on ancestral tablets and shields respectively.

Much Mimika art features openwork and low-relief carving and is characterized by asymmetrical irregular designs giving the impression of "jerky nervousness."[5] These designs are applied to a variety of wood carvings, including figures, ceremonial tablets, sago pounders, food bowls, canoes, paddle blades, and drums (of which the grip is sometimes carved in the shape of a human figure). Openwork carving also occurs in three-dimensional carvings such as *mbitoro* (*mbi* means "spirit"), huge ancestral spirit poles. Ceremonial tablets (*yamate*), not found among the Asmat, are of two kinds. The "closed" type is virtually symmetrical in outline and carved on one side with designs in relief (fig. 21). The other type is asymmetrical and carved in openwork fashion. *Yamate* were stuck in the ground in front of the feast house specially built for the *emakame* feast, which is based on the creation myth.

The main motifs in Mimika art are human and animal images, and "abstract" patterns.

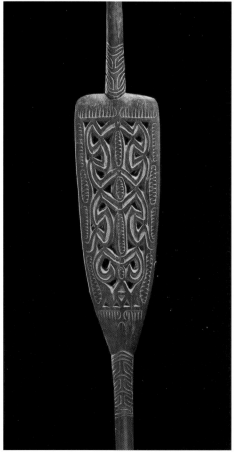

## 16 **Ax**

Stone, hafted in wood. The meaning of the curvilinear pattern would appear to be complex (Smidt 1993). Stone was a very rare material in the alluvial region in which the Asmat live, and blades were imported from the north. Axes were considered sacred and each had its own personal name taken from an ancestor of the person to whom it belonged (often his maternal grandmother). Height 79.5 cm. Inv. 4255-A.

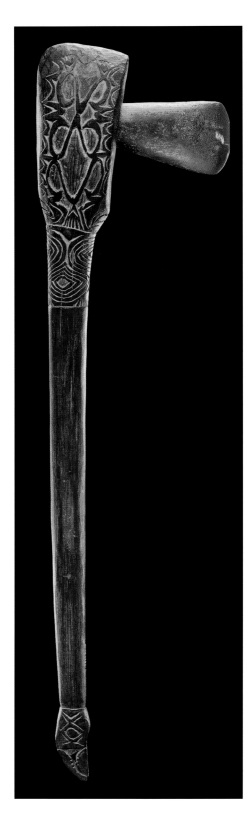

Animal images include freestanding carvings of the cassowary, crocodile heads carved as the ends of roof beams of ceremonial houses, and ceremonial head ornaments in the form of a stylized hornbill. An often recurring oval-shaped motif called *mopere* (navel), depicting the maternal navel, is the symbol of the essence of life. Placed at the knee and elbow joints of human figures, this motif is indicative of motion. Like the Asmat, the Mimika have mask costumes made of knotted rope, which is attached to a framework of rattan hoops.

### Asmat

Asmat art is the most publicized of all in West New Guinea. Asmat wood carvings have a number of qualities which appeal to Western eyes: their sculptural strength, their unique, monumental concept, and the use of stylized "abstract" patterning on two-dimensional objects. Asmat art is considered by some to be more "aggressive" and "dynamic" than that of other areas (figs. 16–20). Asmat wood carvers appear to fear nothing and the conceptual boldness of their works makes their reputation as fierce head-hunters plausible. Asmat art, it seems, is above all meant to emanate strength and power, rather than harmonious refinement.

Some 65,000 Asmat live in a large area of mud, flood forest, and numerous winding rivers and streams on the southwest coast of New Guinea. Sago, extracted from the pith of the sago palm, is the staple diet, supplemented by hunting and fishing. Although a government post was established in 1938, it was not until the 1950s that the Asmat area was brought under government control.

## 17 Shield

Mangrove wood. Decorated with three figures in a squatting position, facing the viewer, and outlined in narrow strips in relief. Painted red, white, and black. The horizontal black band across the top is typical of a coastal region around the village of Otsjanep (M. Rockefeller 1967, p. 147ff.). Acquired from Maurice Bonnefoy in 1969. Height 118 cm. Inv. 4250-A.

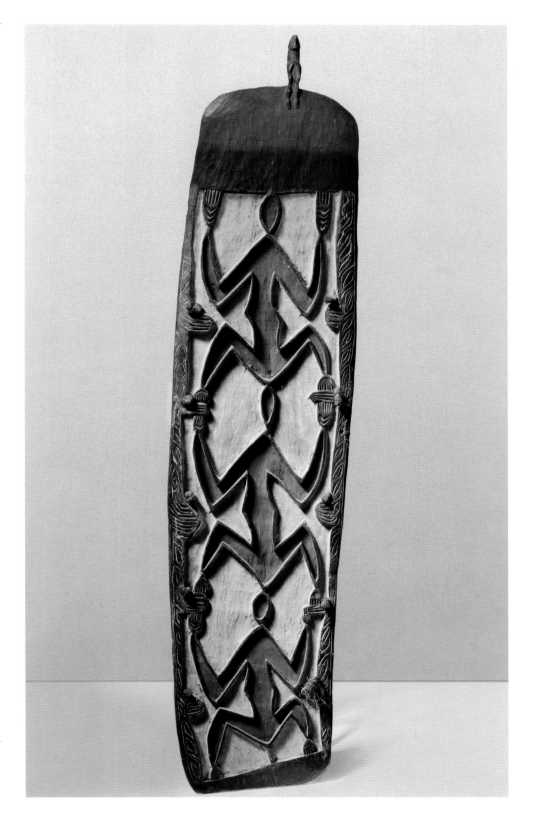

The main raison d'être of Asmat wood carving is to serve as a vehicle for appeasing the ancestors. Every death has to be avenged in order for the souls of the dead to move to the realm of the ancestors; if not, they will continue to roam and trouble the living. Wooden images are made for certain rituals to remind the living of their duty to avenge the dead. Thus the large ancestral poles (*bisj*) are made and erected in front of the ceremonial men's house for the *bisj* ceremony, which in the past formed the prelude to a head-hunting raid (fig. 19). Head-hunting was a sacred duty laid down by a mythical hero, and it was of paramount importance for the fertility and survival of the group. Enemy skulls were an essential prerequisite for the initiation ritual to supplement the life-force of the initiate with that of the victim, above all located in his skull. Other factors which played a role were the need to increase one's own sago and fishing potential, the desire for prestige, and the urging by women to avenge the death of a husband, a brother, or a son. The women had their own sanctions if the men would fail to act in a manly way: ridicule, nicknaming—such as "[worthless] piece of meat" and "man that stayed home for fear"—and the witholding of sexual favors.[6] Success in head-hunting was a major yardstick of a man's political, economic, and sexual prowess. Ancestor figures and motifs referring to head-hunting are the dominant elements in Asmat art. The praying mantis, the hornbill, the black palm cockatoo, and the flying fox are frequently used as head-hunting symbols. As the female praying mantis sometimes bites off the head of her male partner after mating, she is an appropriate symbol for head-hunting and is rendered in highly stylized form in openworked spear blades. The flying fox and the birds are appropriate because

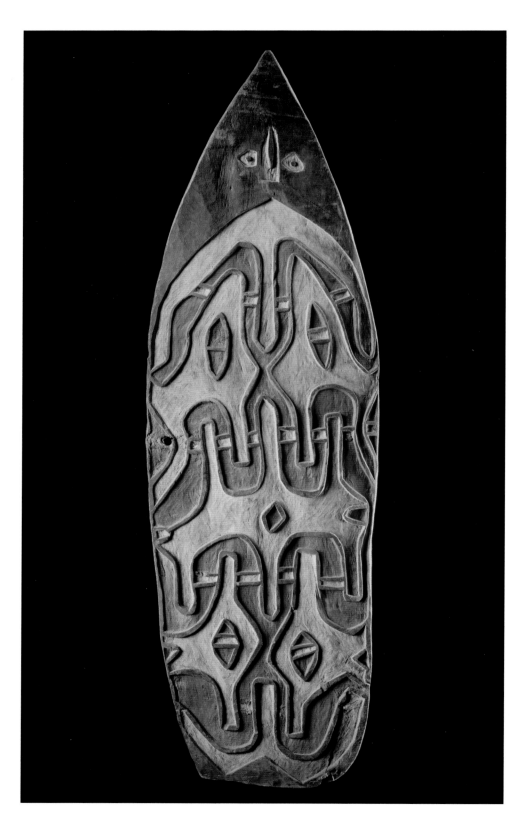

they eat the fruits from the trees which are equated with the skull and brains of human beings. Trees are humanized because, according to the creation myth, the first human beings were carved out of wood before being animated.

Many of the older Asmat figures in collections are carved in the "knee-elbow" stance: the legs are in a squatting position, the arms are raised, and the elbows are close to, or attached to, the knees. Sometimes such a figure is carved as the handle of a dish (fig. 14). This "static" posture may well be associated with the posture in which one is born and buried, but it may have an even more dynamic association and refer to a phase in the creation myth. After the mythical hero Fumeripits had carved human figures in the knee-elbow position, he brought them to life by playing a drum (fig. 13). Gradually the elbow and knee joints became disconnected and the figures became more upright.

In warfare, shields were not just used as defensive props. The designs on the shields,

18 **Shield**

Wood. Attributed (in an inscription on the back) to an (unidentified) ethnic group or location called Jari. This shield can probably be ascribed to a group living on the Brazza River, in the northeast Asmat region. Such a hypothesis is supported by the item's pointed shape, the face incised into the upper section and the fluid forms used to indicate the limbs of a human figure. Height 164.5 cm. Inv. 4250-I.

including head-hunting and prestige symbols such as the shell and bone nose ornaments worn by homicides, served to strike terror in the enemy. The supernatural power emanating from a new shield named after a relative of the bearer whose death had to be avenged must have been strongly felt. In the northwestern region, a son could inherit the shield owned by his father, which was solemnly handed over to him by a village leader, the son responding by promising to fight as well as his father had done. In the central Asmat area, a shield was usually destroyed or split in two halves upon the owner's death as a token of grief. Images of ancestors of the canoe owner are carved in the ornamented prows of ceremonial canoes. Head-hunting symbols are also included in the design.

In the Asmat region, several styles, substyles, and even personal styles can be distinguished. In a recent survey, twelve style areas were delineated.[7] Differences in the range of objects in each area were also revealed. For example, no *bisj* poles occur in northwest Asmat, while

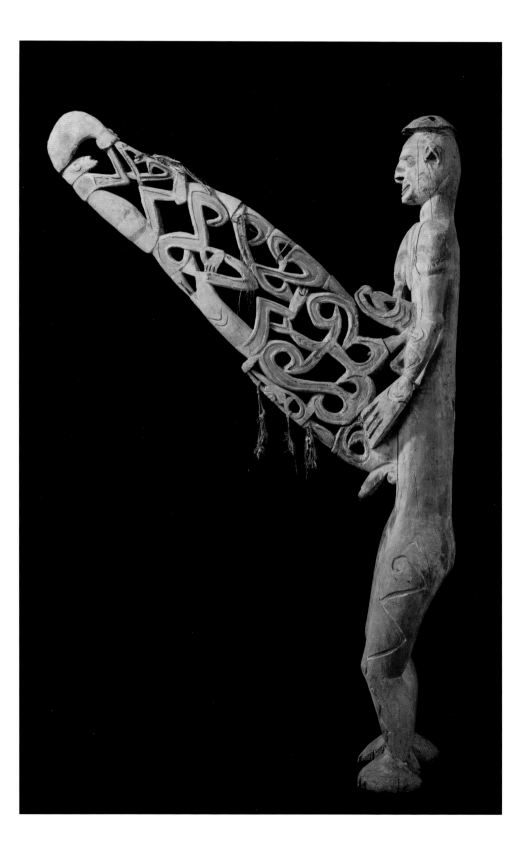

19 **Ancestral effigy (*bisj*)**

The figure (sculpted in a mangrove trunk) displays a prow board carved from a flat section of tree root. Coastal area of central Asmat region. Collected by Tony Saulnier in 1959. Height 205 cm. Inv. 4252.

Carved onto the tip of a hardwood stick. Asmat.
Acquired by Josef Mueller before 1939. Length
62 cm. Inv. 4257.

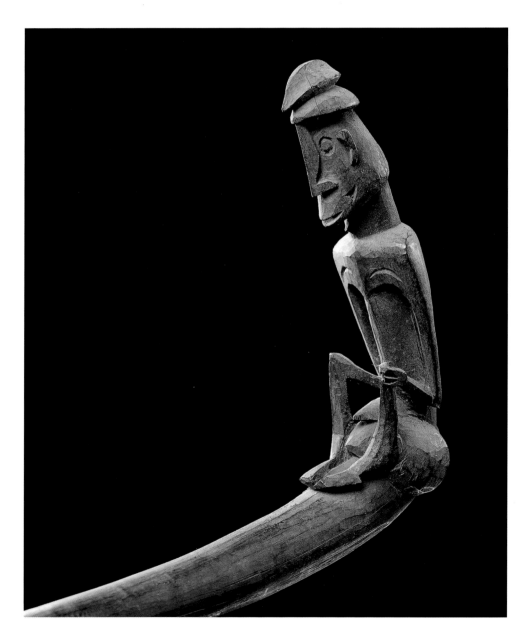

soul prows are only found in that particular
region. The distinction between northwest
and central Asmat styles can be clearly
demonstrated by shield forms and designs.
Shields from central Asmat tend to be rec-
tangular, decorated with a few large motifs,
and are often topped by a carved figure, the
*tjemen* (penis) of the shield (fig. 17). Northwest
Asmat shields tend to be roughly oval in shape
and are covered with numerous relatively
small motifs. Shields from neighboring areas
within the Asmat domain, such as Citak and
Brazza (fig. 18), as well as other groups further
to the east such as the Awyu, have their own
characteristics.

## Marind-anim

The Marind-anim, numbering approximately
7,000 people, occupy the southernmost part
of Irian Jaya close to the border with Papua
New Guinea. Their area stretches from
Kolepom (Frederik Hendrik Island) in the
west to beyond Merauke. They live both
along the coast, consisting largely of beach
and low dunes, and in the hinterland along
the rivers. Their main staple is sago and
coconut with fish, garden produce, and meat
from hunted animals such as the kangaroo,
cassowary, and pig. The Marind-anim have
a reputation for head-hunting. Even areas
which are now within the domain of Papua
New Guinea were raided and these activities
prompted the Dutch Indies government to
establish a post in 1902, which later became
Merauke.

Their most impressive art form was theatrical
and ephemeral and was centered on *dema*
—primeval beings, primordial ancestors,
tribal founders, creation heroes, clan totems
in the shape of human beings, animals, and

plants—who came to life in theatrical performances. The costumed actors transformed themselves into *dema* beings. By reenacting such mythical events, the community took part in them. Each *dema* figure constituted a living work of art lavishly decorated with plant and animal features. For example, effigies of totem animals of clans, such as birds and fish figures made of softwood and inlaid with multicolored seeds, could be part of the outfit. A *dema* figure as a whole might even resemble a sago palm, a banana tree, a cassowary, or even a sunburst, to name just a few examples. These dramatic performances were accompanied by singing and drumming. The drums, often very large, have incised and painted curvilinear patterns, particularly in the lower section (fig. 12). Other items, such as canoes, paddles, and shields, are also decorated in a limited way.

## Postscript

This brief survey of the arts of West New Guinea is far from comprehensive. For example, we have not mentioned several cave painting sites, notably those found at the MacCluer Gulf, the panels produced by the Jali in the central Highlands, which are carved and painted with linear and meandering motifs, and the "sickness shields" and barkcloth paintings from the Yafi area (120 kilometers south of Jayapura).[8]

The mosaic of West New Guinea art, sketchily laid out by outsiders, should be augmented in the future. Further research should enable us to fill in gaps in our knowledge, keep track of new developments which are taking place all the time, and, above all, approach the art of West New Guinea on its own terms.

21 **Ceremonial tablet (*yamate*)**

Wood. Displayed at feasts. Made by the Mimika, who live west of the Asmat. Length 83 cm. Inv. 4250-K.

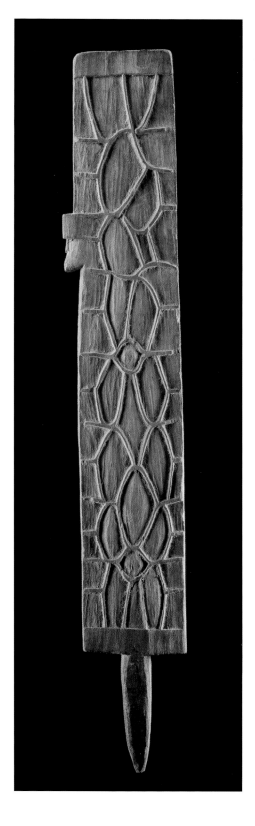

# The Sepik

**Philippe Peltier**

"I fill with wonder." Had this motto not already been adopted by that most magical of French poets, Guillaume Apollinaire, it might well have been specially coined to describe the art of the Sepik River region. This wonder results as much from the sheer quantity of marvelous objects as from the extraordinary inventiveness of the forms produced in this unforgiving swamp, for long hidden from the eyes of the world in a corner to the north of the New Guinea Highlands. At the end of the nineteenth century, the early explorers traveling down the meandering Sepik River were forcibly struck by the region's cultural diversity and by the beauty of the villages on the banks, over which towered the so-called "men's houses" (fig. 3). In a Sepik village, every object, from the smallest teetotum to the gigantic king posts bearing the long ridgepoles, from

the most everyday, such as a bowl scooped from a coconut, to the most unexpected-looking ritual article, is likely to be painted, carved, or incised. The Sepik was to become known throughout the world as an astonishing laboratory where the most intriguing formal experiments were undertaken with equal success, no matter on which material or objects they might be performed.

Presented with rows of such objects in a museum, the art-lover is likely to be dazzled not only by the teeming invention and multifarious forms on display, but also by the disturbing ease with which the craftsmen of the Sepik turned from sculpture in the round to carved or painted surfaces. The local artists seem to be able to play with surface, covering it with geometric devices in curve and counter-curve, sometimes hiding it completely within

**River Sepik Region**

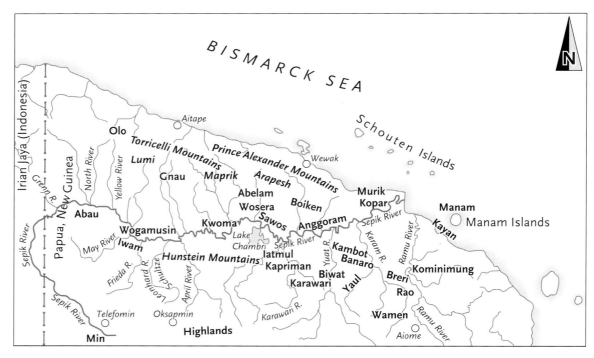

## 1 Female figure

Hardwood carving. Traces of paint. The shoulders show scarifications identical to those on the female figure of the suspension hook described in fig. 5. Probably Angoram, middle Sepik River. Height 135 cm. Inv. 4080-7.

## 2 Openwork figure

Medium hardwood. The body has been silhouetted from a plank, only the head and the totemic animal on the stomach being in the round. Objects of this type, called *atei*, are ancestral effigies. They are placed in the cult houses, where they are consulted before head-hunting expeditions (Bühler 1969). Kopar people. Singarin village, lower Sepik River. Acquired about 1950 from W. Eckert, Basel. Height 191 cm. Inv. 4081.

3 Men's ceremonial house. Iatmul people. Tambanum, middle Sepik River. Photograph A. Roesicke, 1912–13.

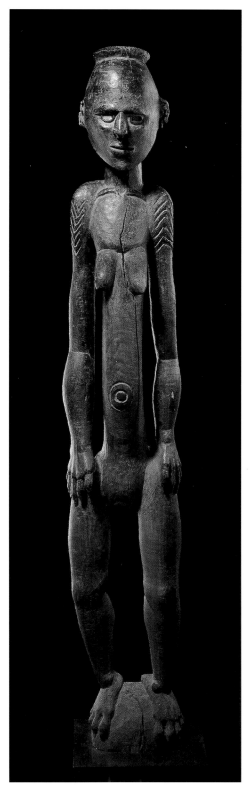

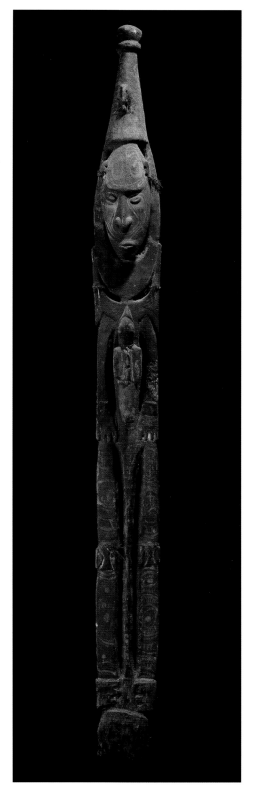

## 4 Flute-stopper

Hardwood. Shell inlay for the eyes. Cassowary feather decoration (missing). Precious heirloom belonging to a "rope," a hereditary group comprising a man, his daughter, and her sons (Mead 1963). These human figures were supposed to represent the offspring of an ancestral crocodile spirit. Biwat people. Yuat River region. Collected 1918–22 by William Harrison-Briggs from the Londip Plantation, Kotoko. Formerly A. A. Blouxham Collection (Sydney). Height 43 cm. Inv. 4061.

## 5 Suspension hook

Hardwood. Face overmodeled with a mix of clay and soil. The hook represents a woman, perhaps pregnant. Such hooks were to be found both in dwellings and cult houses and were used to suspend various vessels and other objects out of the reach of rodents, though in some cases skull trophies were also hung from them. A hook of this large size would probably have hung in a ceremonial house. Some of these hooks-statues have an overmodeled skull for a head, in which case the figure is probably an ancestor effigy. Iatmul people. Middle Sepik River. Formerly in the collections of the Übersee-Museum, Bremen, A. Speyer (Berlin), Ralph Nash, and van der Schyff. Height 126 cm. Inv. 4092.

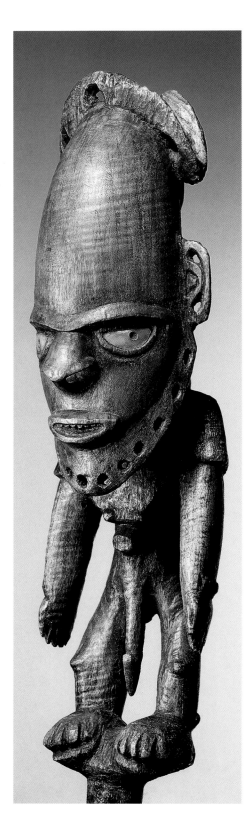

this swirling network. If some pieces composed of interwoven figures are of baffling complexity, others, built up from deftly interlocking geometric shapes, seem disconcerting in their very simplicity. As to materials, everything the natural world puts at their disposal—shells, leaves, roots, thorns, teeth, feathers—is pressed into service. Some of these materials are chosen precisely *for* their ephemeral nature. Many reports tell of pieces that took a long time to assemble being allowed to survive for only a few fleeting moments: elaborate masks, impressive sculpture complexes, or even skillfully cut flower and leaf assemblages that are just left to float away on the waters. It is the brief life of such works, blown away with the slightest breeze, which constitutes one of the essential components of their beauty.

Clearly Sepik art, as elsewhere in Melanesia, is not restricted to sculpture alone. However, sculpture does illustrate the astonishing capacity of Sepik artists to imagine strange and often radically disparate formal solutions. We will take as our starting point the large number of ways in which the human figure is presented.

The first example shown is a sculpture probably originating from the Angoram region in the lower Sepik (fig. 2). The only elements of strong relief are provided by the figure's head and the little animal pressed to its chest, the rest of the body being flattened out, almost like a Chinese shadow puppet. The overall effect is obtained by a meticulously sawn slender plank, which, in the past, would have been brightly painted. The figure's joints, it is true, are picked out with slight incisions, but the treatment of the upper body defies any logical explanation: the neck is a triangle

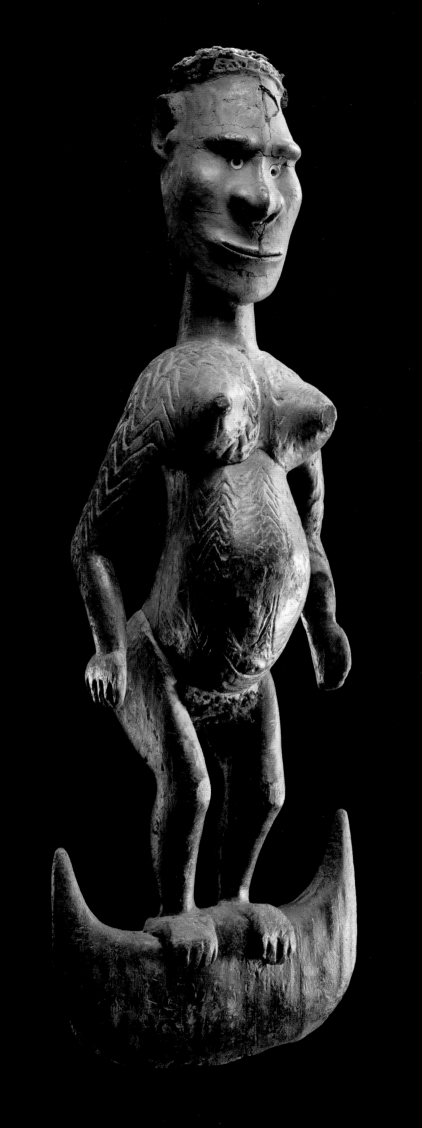

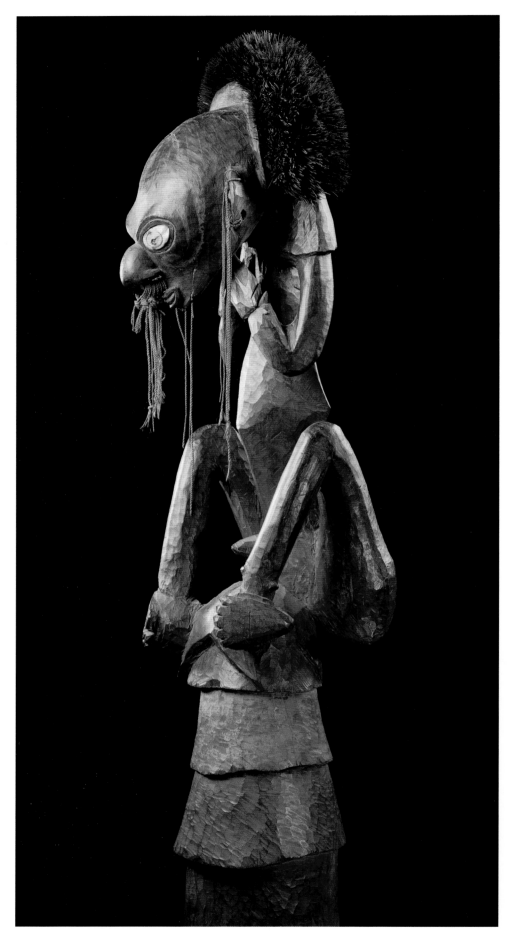

6a and b **Ridgepole finial**

Hardwood. Traces of paint. Squatting male figure
wearing a bonnet of cassowary feathers. The
eyes are inlaid with mother-of-pearl and lengths
of fiber twine hang from the face. Biwat people
(sometimes known as the Mundugumor). Yuat
River, a southern tributary of the lower Sepik
River. Formerly collections of A. Speyer (Berlin)
and W. Eckert (Basel). Height 146 cm. Inv. 4077.

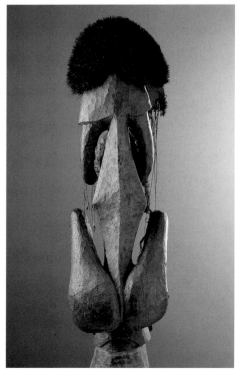

## 7 Male figure

Hardwood carving. Traces of paint. Abelam people. Prince Alexander Mountains. Height 135 cm. Inv. 4080-2.

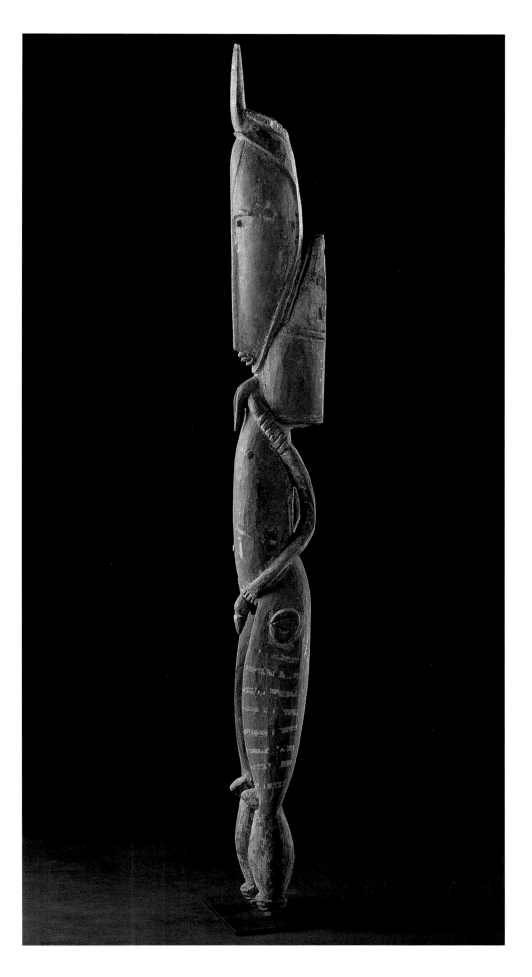

whose form is based on an exact replica of the shoulders. The second example derives from a different approach to form entirely. It is a Iatmul support hook strongly carved into a three-dimensional figure with over-modeling on the head (fig. 5). The eyes, made from two pieces of pierced shell, peer out unsettlingly. It is above all the body, how-ever, which attracts our attention. Everything about it is taut—the rounded stomach, the flexed legs, the arms that underscore the legs and belly in artful counterpoint, and the conical "shells" of the pointed breasts. The piece attains a naturalism rarely if ever equaled in the art of the Sepik.

The Yuat ridgepole finial (unless this be a ceremonial object of as yet unknown use) presents a quite different formal rationale (figs. 6a and b). A male figure sits back slightly on top of a conical plinth. All the tension in the piece arises from the precarious balancing act performed by the figure as he braces his legs beneath his body and tilts his head for-ward in an attempt to preserve his equilibrium. All depends on an intricate amalgam of forms and stresses that resurfaces, if attenuated, in an anthropomorphic flute-stopper of Biwat provenance (fig. 4). One further surprise, however, awaits the viewer in his encounter with the ridgepole finial; from the rear, the personage is reduced to a bare geometrical shape, an elongated lozenge, boxed in yet emphasized by the volumes representing the figure's arms and legs.

Such elaborate and adroit combinations of abstract volumes are amply and disturbingly demonstrated in an Abelam carving from Maprik Province (fig. 7). Seen from the side, the personage is built up of three simple rigid masses; the arc of a circle representing

## 8 Figure

Hardwood carving. Some black, white, and red
paint. Abelam people. Collected about 1900 by
Dr. Hugo Schauinsland. Formerly Übersee-
Museum, Bremen. Height 123 cm. Inv. 4080-1.

## 9 Sculpture

Carved in very heavy wood. Bright yellow, black,
white, and red paint. Collected in the early 1950s,
this carving adorned a ceremonial house.
Abelam people. Prince Alexander Mountains.
Height 119 cm. Inv. 4080-10.

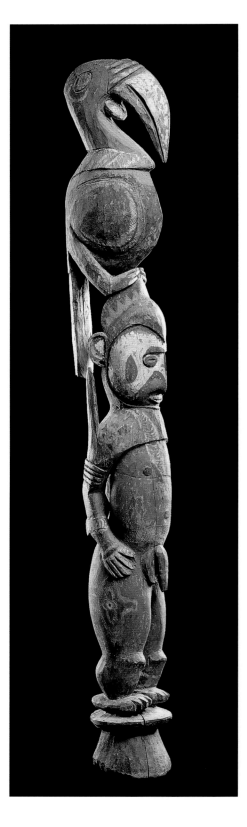

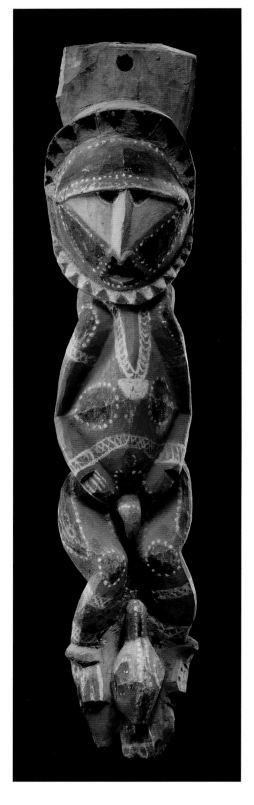

Hardwood. Paint. A ritual object that was planted into the ground. Iatmul people. Middle Sepik River. Height 75.8 cm. Inv. 4064.

the arms links these three volumes, underscoring a formal relationship between the statue's neckpiece and penis.

These few examples (that we could refine practically ad infinitum) demonstrate the virtuosity with which Sepik art exploits all the resources sculpture offers, seamlessly integrating naturalism with abstract formalism. In Sepik art, these two devices that seem so at variance to Western eyes can cohabit harmoniously within one and the same work. The Biwat finial ornament is a striking example of this phenomenon: by a strange yet fitting quirk of fate, the geometrical shape of the figure seen from the rear simultaneously resembles the gigantic body of a jungle insect.

The richness of Sepik creativity lies primarily in a capacity for constant self-transformation, for creating a plethora of meanings for each object—sometimes to the point of rendering deciphering an inextricably complex task. This potential for intricacy, much admired by the Surrealists, can surface in the most unforeseen guises. It occurs, for instance, on a Iatmul flute-stopper (fig. 10), where it is pushed to an unprecedented degree: at first glance, the figure looks like that of a bird and nothing more. On closer analysis, however, the image takes on an infinitely more complex identity: the bird's beak constitutes the head of yet another bird, the eye being read as that of a crocodile whose jaw is in turn provided by the lower portion of the bill belonging to the first bird.

This type of multilayered reading can be found again in the incised section on the side of a horizontal slit-gong cylinder from the lower Sepik, or on those from the coast

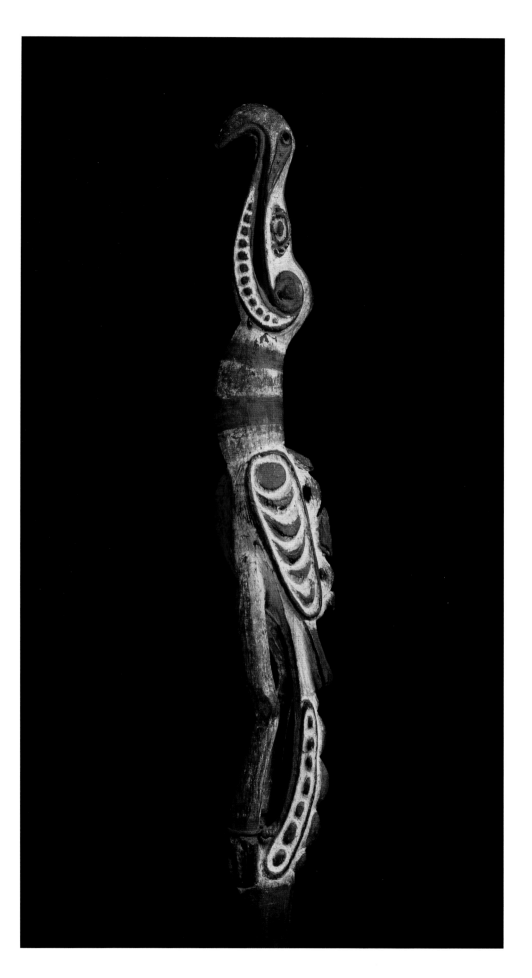

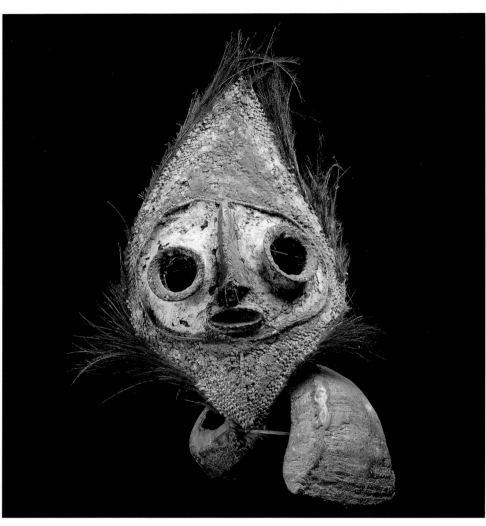

## 11 Bridewealth currency

Formed from a marine shell (*Turbo mamoratus*) topped with a basketry ornament in the shape of a face. Coated with colored limewash. Cassowary feathers. Boiken people. Northeast Papua New Guinea. Height 46 cm. Inv. 4080-3.

## 12 Slit gong

The complicated design of the two openwork handles is structured around figures of ancestors with the long, beaklike noses typical of the style of the Kaian people. Sepik-Ramu coastal area. Formerly Herz Jesu Hiltruper Mission Collection, Hiltrup, near Münster. Length 168 cm. Inv. 4085.

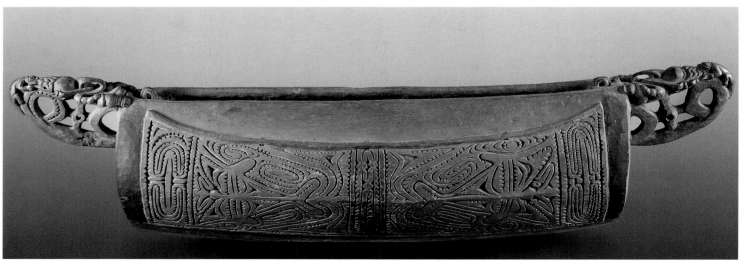

Turtle shell and fiber. Incised geometrical and
animal patterns. Coastal region, probably made by
the Murik people at the mouth of the Sepik River
as a trade item. Height 16.7 cm. Inv. 4093.

Hardwood, with a crusty reddish patina. Small
nassa shells for the eyes. In imitation of the shape
of a mask. Murik people. Sepik River mouth.
Formerly Charles Ratton Collection. Height 11 cm.
Inv. 4063-A.

between the Sepik and Ramu Rivers (fig. 12).
On first sight, the drum's lower register is
made up of an interlaced sawtooth motif,
divided in strict symmetry either side of a
lateral axis. All this is unsurprisingly classi-
cal in terms of Sepik art. A second reading,
however, relegates this pattern to the back-
ground, as at least three animal figures leap
out at the viewer: a fish, a crocodile, and a
wild pig. The intertwined pattern that struck
us at first is now suddenly thrown into the
background to serve as a decorative back-
drop. Yet this ornamental ground is most
probably nothing of the kind; to be certain
of its exact status, it would have to be analyzed
in the light of further ethnographical research.
This hesitation—or more exactly, our incapac-
ity to accord a rightful value to patterns—
further demonstrates the limits of a formal
approach, useful only in that it can point us
in the direction of feasible interpretations.

If, sadly, Sepik objects often leave us non-
plussed, we must concede that our knowledge
in this area is for the most part deplorably
deficient, to the extent that we are forced to
rely on hypotheses and models. Our ignorance
extends not only to the significance of the
objects themselves, but to the circumstances
surrounding their collection, since they were
often gathered in the greatest haste—almost
haphazardly in some cases—and we there-
fore lack information about the more basic
background.

In the Sepik region, any act can serve as a
pretext for ceremony, whether part of daily
life (for example, the building of a dugout
canoe) or of a more exceptional nature (head-
hunting, for instance). The most fascinating
of all these ritual events are indisputably the
initiation ceremonies for young men. The

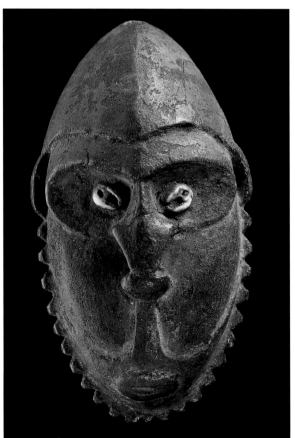

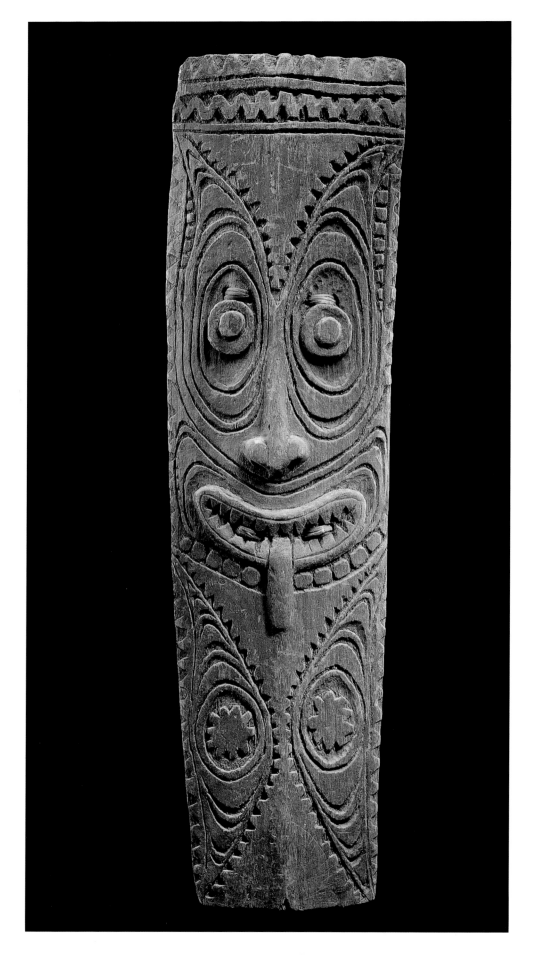

### 15 Shield

Hardwood, curved. The main theme of the once painted decoration is a huge central face. The eyes are contoured by a series of heavy rings; the long tongue hangs out of its mouth. A wood strip serving as a handle is bound to the back by strands of fiber. Iatmul people. Middle Sepik. Formerly Georges Sadoul Collection (Hôtel Drouot sale, Paris, 1929). Height 156 cm. Inv. 4097.

### 16 Shield

Hardwood, from a flat plank narrowing toward the base. The bas-relief carving is picked out in color (black, white, and red). Other objects of a similar type make it clear that the central triangle is derived from the superimposed faces of ancestors, here rendered by broken lines and diamond shapes. Banaro people. Upper Keram River. Height 130 cm. Inv. 4062.

rituals take place in an enclosed space, well out of sight of the women of the village, and rely on complex scenarios, suggestive at once of a theatrical performance and an ordeal, since they incorporate both physical and psychological violence. During these events, the youthful initiates discover the existence of a certain number of hitherto secret objects, only sharing in the mysteries surrounding their creation at a later stage. By the end of the initiation cycle, the adolescents have become utterly divorced from the world of the womenfolk. They acquire the right to be seen with signs marking their newfound status, such as portable lime pots or armbands; and only now will they start to live in the men's house appertaining to their group (several such men's houses are located on the main street or stand in the various quarters of the village). Now is the time for the initiates to be finally let into some of the many secrets these buildings conceal. Some of these boys will gain profound knowledge of the ancient chants narrating the story of their ancestors' wanderings and the cosmogonic myths that speak of the origin of all things and of their magic. They will be told of the signification of each and every ceremony, of every image, and learn too of their origin and function. Their wisdom will inevitably earn for them an elevated social position, since a man's personal power depends on being adept at manipulating various series of words designating names, places, and special objects. To be effective, however, this information must not be shared with all: the source of power lies in knowledge remaining esoteric. If some of the images and articles are indeed visible to all men, their real meaning should not be openly revealed. The purpose of the most important objects, like the interpretation of the most significant myths, is not an un-

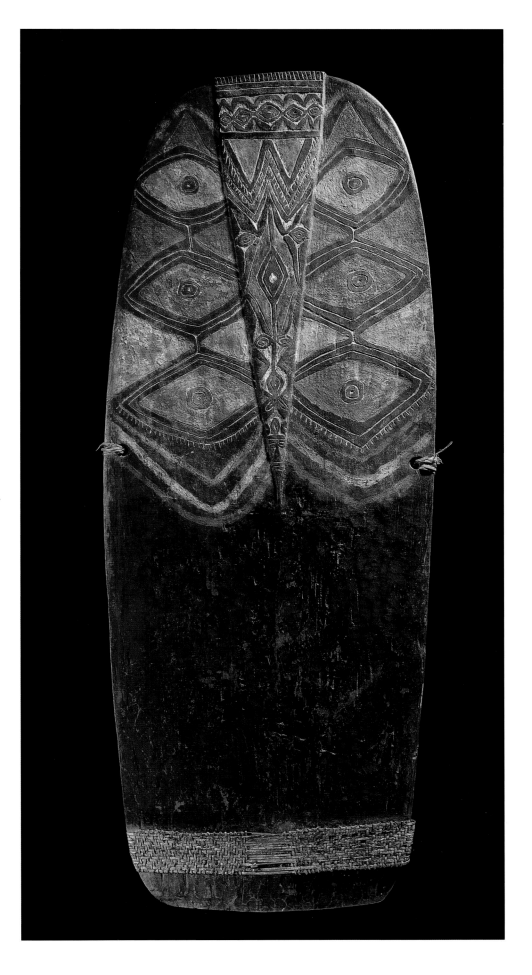

**17 Small mask**

Hardwood with painted decoration. Rim bound with basketry. Fiber. With a long, beaklike nose, this type of mask was not worn over the face but fixed to a sacred flute. Kopar people. Lower Sepik River. Acquired about 1945. Formerly W. Eckert Collection (Basel). Height 33 cm. Inv. 4067.

**18 Small "mask"**

Hardwood with shiny patina. A fragment of a very old carving that was once mounted on a flute. The body of the statuette being severely damaged, the head was transformed into a "mask" designed to hang from a large ceremonial flute. Biwat people (Mundugumor). Yuat River. Formerly A. Speyer Collection (Berlin). Height 21.5 cm. Inv. 4094.

**19 Small mask**

Hardwood encrusted with shellwork. Cassowary feathers and fiber. The smallest shells (nassa) are not glued with resin but sewn using fiber cord. Such objects were attached to ceremonial flutes. Dimiri or Yaul people. Yuat River. Height 31 cm. Inv. 4088.

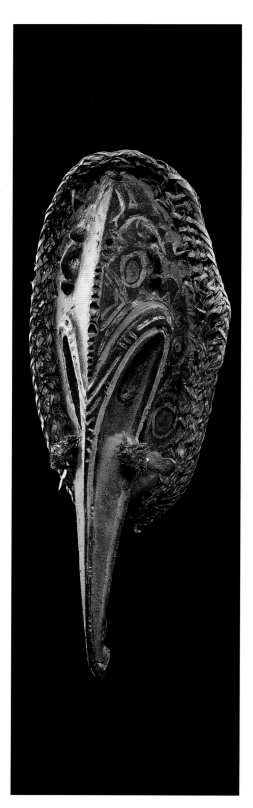

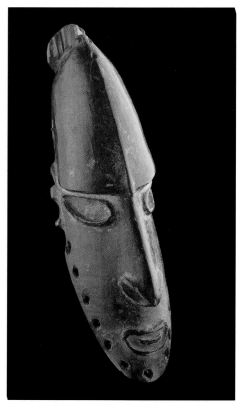

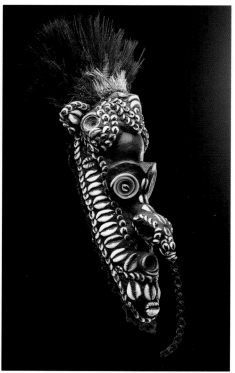

ambivalent matter, however. Though every myth, every object is a mnemonic for its possessors, it also stands at the focal point of a subtle interconnected system that only the most thoroughly instructed adept can ever hope to master. The more complicated an object, the more involved a form, the more susceptible it is to multiple interpretation. In the Sepik, objects are political instruments manipulated almost exclusively by the male members of the community, so it is easy to understand how, when such objects are sold, their true import is almost never divulged to the buyer.

Space does not allow us to describe in any detail many of these objects. We should mention, however, the bridewealth currency of the Boiken (fig. 11); the armbands with incised motifs from the coastal region (fig. 13); the shields whose decorative scheme and form (flat or curved) varies from group to group (figs. 15, 16); the masks, usually tied as amulets to a fiber string bag, fixed to walls in the men's house, or hung from ceremonial flutes (figs. 17–20); the ancestor skulls with resin or clay modeling (fig. 21); insignia of prestige such as ceremonial stools (fig. 23); Iatmul hourglass drums (fig. 24); ceremonial spears (fig. 25); pottery made by the women of the lower and upper Sepik (fig. 26); the great shields carved using stones (fig. 29); and, finally, among the Telefol, the wooden panels serving as entrance doors to their houses (fig. 30).

In order to be able to read such objects in the correct light, however, our interpretative strategies require honing. In the West, reading a sculpture or painting of the classic kind consists in identifying the gestures and objects shown in order to decipher the narrative de-

**20 Cult hook**

Hardwood. Carved in the form of a human face. This type of object, called a *garra*, often has several hooks. On this example there are two: one on the forehead and one on the chin. Rao people. Keram River. Inv. 4071-E.

**21 Ancestor's skull**

Overmodeled with a mix of resin and clay. Painted decoration, encrusted with shell (cowrie and nassa). Nose ornament of beads and mother-of-pearl. Iatmul people. Formerly Náprstek Museum, Prague. Height 17 cm. Inv. 4089.

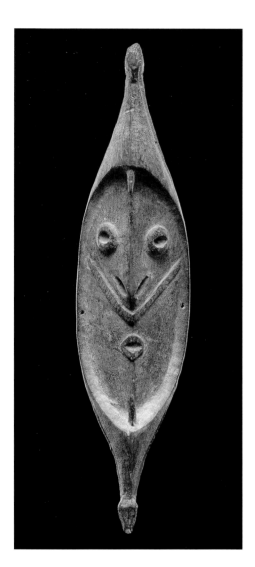

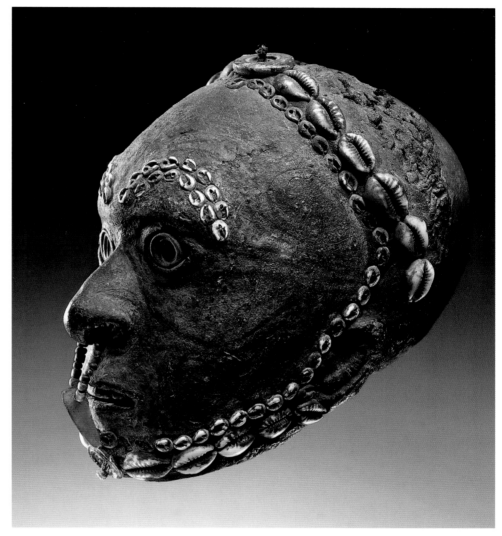

22 In the Sepik region, most wooden masks do not have eyeholes since they were placed over a basketry cone rather than directly onto the head. Stranger still are these oversize masks made from sheets of sago bark, often large enough to be carried by several individuals simultaneously. Iatmul. Photograph A. Roesicke, 1912–13.

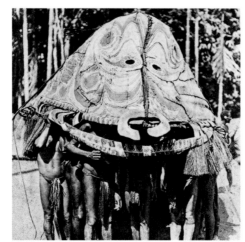

## 23 Ceremonial stool

"Debating stools" or "orator stools," which in fact are chairs emblematic of their owner's status, are among the best-known middle Sepik artifacts. The back of this one is shaped into a long narrow face, the carved relief being relatively static, though it is decorated with a delicate curvilinear pattern picked out in white and red. Another small mask is carved onto the inner face of the seat-back. Kapriman people. Blackwater River. Collected by A. Bühler. Formerly Museum der Kulturen, Basel. Height 112.5 cm. Inv. 4098.

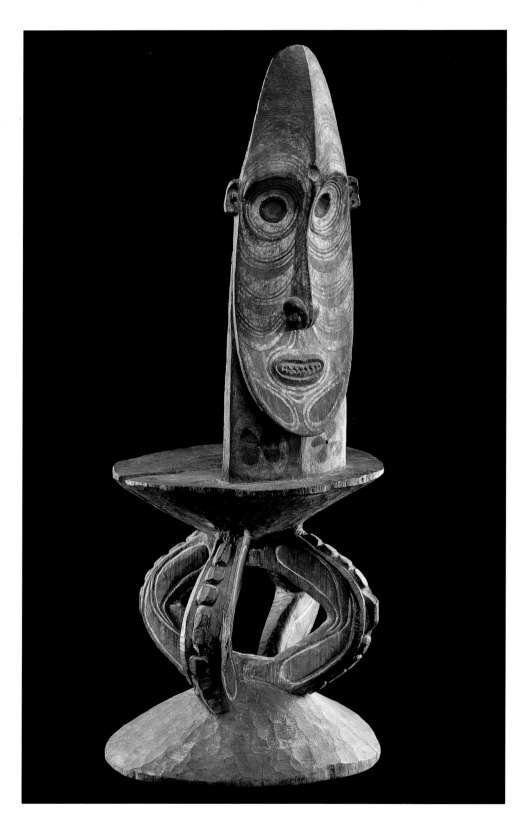

picted. In the Sepik, and in Melanesia generally, the process of reading is rather different. Rituals constitute a system that runs parallel to that of words: they do not simply *mimic* the cosmological events narrated in myths, but expose to view actions that communicate in their own right. In other terms, they inculcate areas of knowledge in a specific form —that of things as they are seen, not as they are spoken of in words. Numerous theatrical effects are exploited in ritual so as to facilitate the transmission of such messages: sudden, unexpected appearances, and the complex use of screens, for example, or a skillfully arranged "script" of "scenes," or again extravagant actions and outlandish behavior, as for instance in the cult of the yam considered as a being in its own right and bedecked with its own mask (figs. 27, 28). To be effective and tractable to the memory, every representation has to be executed to perfection and, more importantly still, must slavishly observe the rules that are enshrined—or that are thought to be enshrined—in tradition.

No words can adequately capture the meaning of these objects. Unspoken in their purpose, to seek to comprehend them is to lend an ear to other voices.

**24 Hand drum**

Hardwood. The carrying handles are carved in the shape of a bird and a crocodile. Iatmul people. Middle Sepik. Bought from Ernst Ascher on October 27, 1938. Formerly Museum für Völkerkunde, Berlin and Walter Bondy Collection (Berlin). Height 86.5 cm. Inv. 4086.

**25 Spear (detail)**

Hardwood, bamboo blade. Iatmul people. Middle Sepik. Formerly Professor Czeschka Collection (Hamburg). Total height 239 cm. Inv. 4099-4.

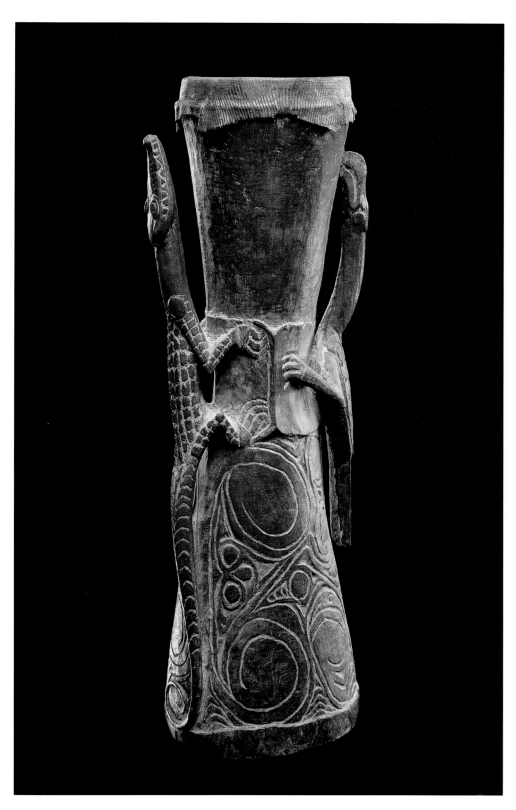

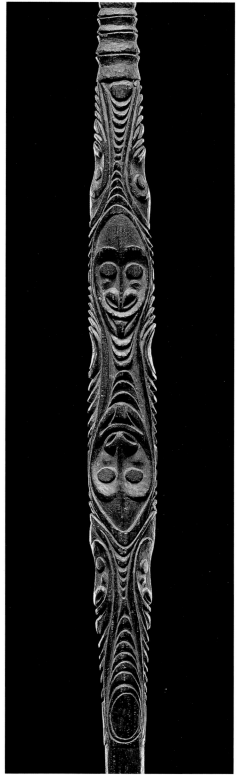

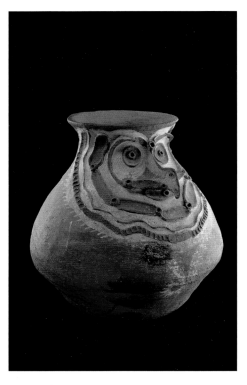

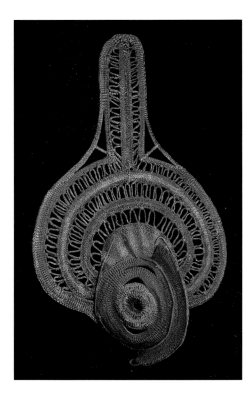

**26 Storage jar**

Earthenware vessel for sago palm flour. Often very large, these receptacles are formed by women, while men add the relief decoration. Iatmul people. Aibom, near Lake Chambri, middle Sepik area. Height 46 cm. Inv. 4096.

**27 Pseudo-mask**

Basketry. Designed for attachment to ceremonially displayed yams. The length of such "masks" may exceed 1 meter. Abelam. Maprik district. Height 48 cm. Inv. 4080-6.

**28 Helmet-mask (*baba*)**

Basketry. Traces of paint. These masks resemble the head of a hog, an animal that plays a crucial symbolic role as mediator between the world of men and the supernatural realm. *Babas* are brought out for funeral ceremonies. Abelam people. Height 42 cm. Inv. 4080-8.

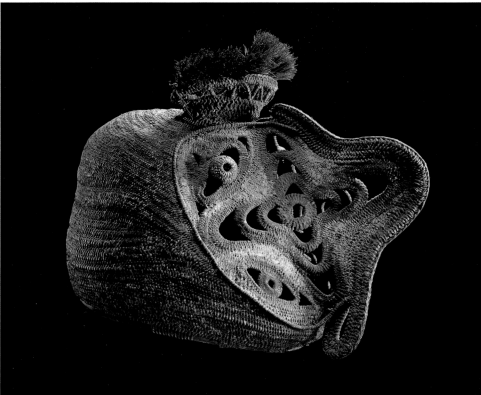

## 29 Shield

Carved with stone tools. The low-relief color decoration portrays two highly stylized faces. Left-hand side restored. Abau people. Upper Sepik River. Height 165 cm. Inv. 4065.

## 30 Door board (*amitung*)

Wood. Carved from a single tree trunk, decorated with colored (red, white, and black) geometric bas-relief patterns. The inhabitants would enter the house through the aperture. Telefol people. Telefomin village, upper Sepik River. Height 303 cm. Inv. 4099-5.

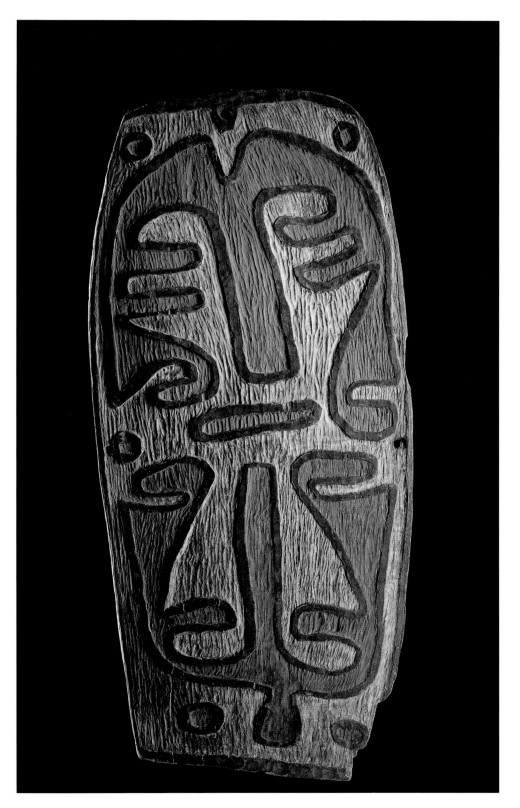

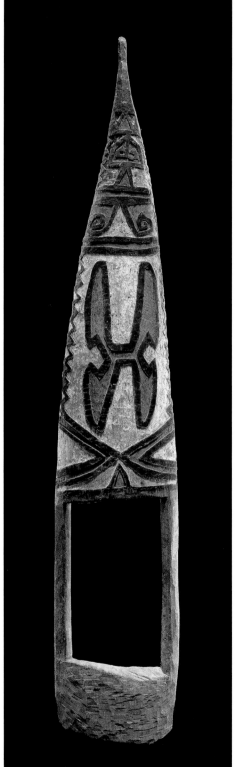

# Astrolabe Bay, Huon Gulf, and West New Britain

Philip J. C. Dark

1 Man from the village of Bogadjim in Astrolabe Bay with an ancestral figure (*telum*). After Stephen Chauvet 1930, fig. 351. Barbier-Mueller Archives.

2 Model of a cult house in the Huon Gulf region. After Stephen Chauvet 1930, fig. 15. Barbier-Mueller Archives.

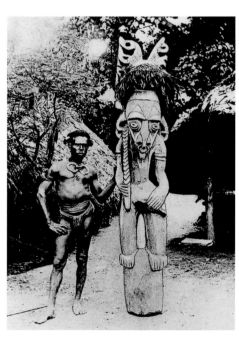

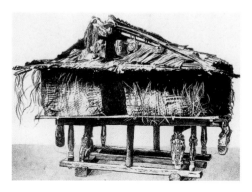

Geographically, this region of Papua New Guinea's northeast coast consists of three basic areas. The Astrolabe Bay area extends from Siar north of Madang in the west to the Rai coast of the Huon Peninsula in the east and includes the people in the mountains inland and also on the offshore islands, such as Sio and Bilibili, and, across the Vitiaz Strait, Karkar and Arop Islands. The Huon Gulf area lies to the east of this and includes the Tami Islands and the Siassi Islands between the Vitiaz and Dampier Straits. Across the Dampier Strait, the area of west New Britain extends along the north coast to Talasea and Witu Islands, and along the south coast as far as Kandrian.

Although there are noticeable differences in the art forms of the region, to the extent that they can be considered as style provinces, one finds a certain number of common themes. These are expressed in sets of artistic forms which function in defined cultural contexts. These artistic forms are similar —figures, masks, designs, ornamentation, and complexes of these—although there are differences in appearance.[1]

It would be false, however, to give the impression that this region was self-contained or isolated. Indeed, trade took place to the west, along the north coast of New Guinea, and to the east, in New Britain. Outside the region, traits are to be found which cannot but be related to those present in it. The carving styles as far away as Sentani, Humboldt Bay, Aitape, Vanimo, and Walomo have features suggestive of earlier connections.

The art of the region was not all produced during the same period and thus comparisons should be made with caution. However, the

3 **Ancestral figure (*telum*)**

Wood. Traces of black and red paint. Collected before 1900 by Dr. Hugo Schauinsland on Bilibili Island, Astrolabe Bay. Formerly Übersee-Museum, Bremen. Height 134 cm. Inv. 4131.

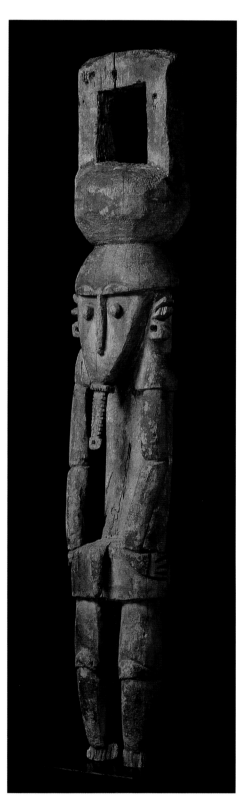

4 **Carving**

Hardwood. Incisions highlighted with lime. The carving represents a standing figure whose penis is being swallowed by a snake. A large hole allows for the piece to be suspended upside down (as can be seen from fig. 2). Tami style. Collected in the nineteenth century. Height 47 cm. Inv. 4134.

period under discussion is relatively short, lasting almost exactly a hundred years. For the Astrolabe Bay area, Bodrogi's admirable surveys of the literature[2] and of collections made by Mikloucho-Maclay in 1871, by Fenichel in 1891–93, and by Biro in 1897,[3] present major data on art forms. But the records made by the early travelers provide little information on the aesthetic and social aspects of the people. Change in Astrolabe Bay was rapid and devastating. The Germans began colonizing the area in 1884 and bought up all the land for plantations, although the indigenous people avoided contact where possible. The situation was exacerbated by the missionaries, who would have the people give up all their beliefs and associated practices as "heathen rubbish."

Astrolabe Bay carvings in the form of human figures (*telum*; figs. 1, 3), masks, animal carvings (fishes, birds, lizards, and tortoises), dance rattles, bullroarers, dance clubs, shields, bowls, and drums were, apparently, mostly carved with stone axes and shell knives. Bamboo combs and boxes, coconut cups, and items of turtle shell were worked with animal teeth and shells. Other art forms include the decoration of barkcloth (fig. 8) and the manufacture of pottery. No record survives of the costuming and human ornamentation of those participating in festivals and ceremonies, which provided the contexts for major expressions of the arts.

In contrast, the record for the Huon Gulf area was made somewhat later than that for Astrolabe Bay. From 1885, when the Germans formally annexed New Guinea, carving was done with iron tools (axes and nails). Also used were bone chisels (tibia of cassowaries) and points, and pigs' tusks for smoothing

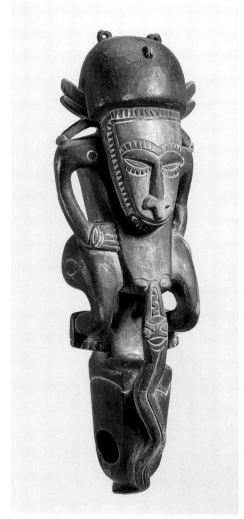

## 5  Small betel mortar

Hardwood. Traces of red pigment. Incisions
highlighted with lime. Kneeling figure. Tami
style. Formerly Professor Czeschka Collection
(Hamburg). Height 17.5 cm. Inv. 4116.

## 6  Neckrest

Hardwood. Traces of red and black pigment.
Incisions highlighted with lime. Tami style.
Formerly Professor Czeschka Collection
(Hamburg). Height 17 cm. Inv. 4113.

## 7  Large spoon

Hardwood. Traces of red and black pigment.
Incisions highlighted with lime. Used for grated
sago. The shaft is tipped with a kneeling figure;
another, half-man, half-animal, decorates the top
of the bowl. Tami style. Overall height 75.5 cm;
height of the figure 15.5 cm. Inv. 4114.

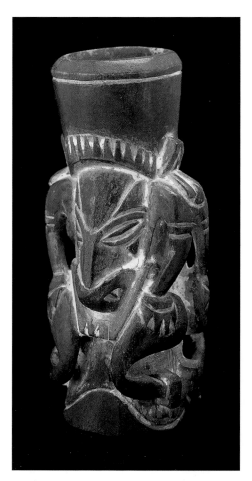

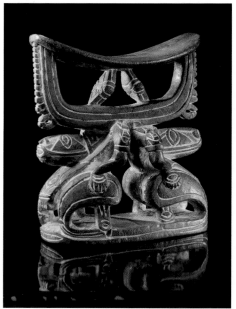

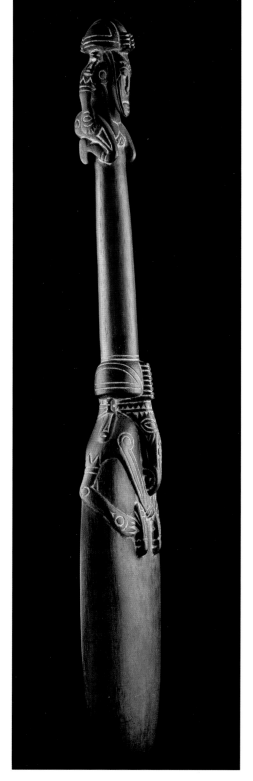

and polishing. Much of the art that circulated was produced by artists of the Tami Islands, hence the practice of referring to Huon Gulf art as Tami art. The Tami artists were still working up to 1941, when they "lost their tools during the war."[4] Living subsequently near Finschhafen, they began to carve again with great panache for the tourist industry in Lae in the 1960s. The Huon Gulf inventory is somewhat larger than that of Astrolabe Bay. It includes, in addition to figures and houseposts, hanging statues (figs. 2, 4), carved house planks, betel (fig. 5) and taro mortars, headrests in great numbers and varieties of design (fig. 6), hooks, ladles (fig. 7), and many bowls, variously decorated, for both domestic use and formal festivals (figs. 9, 15). The Tamis found they could not meet the demand for bowls, so the Siassi Islanders began carving them in the 1920s.[5] Tami carved and painted masks (fig. 13) ceased to be made soon after contact and initial missionary activity.[6] Hats for *sia* and masks for the *tago* cult of coconut bast were also produced, although few survive, perhaps because, like the *tumbuan* of the Kilenge, they were burned on the conclusion of a cycle of ceremonies.[7]

West Britain has a similar range of forms to Astrolabe Bay and the Huon Gulf.[8] However, there is a time difference, as few items from west New Britain date from the early part of this century. Most collecting and investigations have taken place since World War II, although a few Germans, such as Stephan and Parkinson, made observations on the area. In 1900, the Witu Islanders used two types of constructed mask—one of painted coconut bast (fig. 11), the other of painted barkcloth—and one carved form (fig. 12).[9] Both types were still being made in 1966.

They differ in form from Kilenge and Tami masks, but their function was similar.

The extent and elaborateness of trade in the region have been the subject of a number of studies.[10] Of vital importance to the movement of goods, ideas, and cults was the outrigger canoe, a major form of maritime ingenuity and artistic expression. There were three basic types of canoe: a deep-sea canoe for trading across straits or long distance; a smaller version for more immediate coastal trade; and a small one for use close inshore of the reef. In the Astrolabe Bay and Huon Gulf areas, the largest examples had two large washstrakes (possibly because the cargo carried may have been less bulky than those transported further west). The Astrolabe Bay

9 **Bowl**

Hardwood. In the shape of a fish (tail tips restored). Tami style. Formerly James Hooper Collection (exchanged by him with Henri Kamer in the 1960s). Length 63.5 cm. Inv. 4110-A.

8 **Ceremonial *tapa***

Not from Astrolabe Bay itself, this tapa comes from the inland region of the Saruwaged Range that parallels the coast between the bay and the Huon Gulf. The stylized pattern represents yams. Wantoat people. Length 129 cm. Inv. 4261.

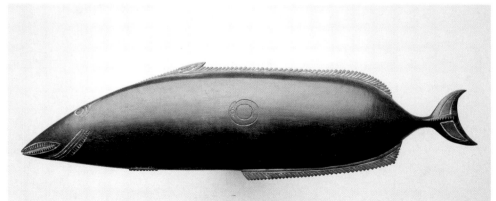

Hardwood (one of the "ears" has been restored). Traces of red, black, and white paint. The exact place of origin of this very unusual piece is not known. It was collected at the beginning of the 1920s on the little island of Sio that lies between Astrolabe Bay and Umboi Island by Stöhsel, a missionary (information communicated by Dr. Waldemar Stöhr, Cologne). It offers a good example of the spread of the Tami style. Formerly Rautenstrauch-Joest Museum, Cologne. Height 44 cm. Inv. 4111.

Cane frame, strips of coconut fiber. Nose stick and eye in wood. Red, black, and white paint. Witu Islands. Collected by Lajós Biró in 1900. Formerly Ethnographic Museum, Budapest. Height 66 cm. Inv. 4475.

and Huon Gulf type was decoratively painted on the sides and had splendidly carved prows, sterns, and ends to the storage fore and aft. The west New Britain canoes had paintings on the prow and stern.[11]

Trade items were produced by different peoples as specialties, resulting either from their occupying a particular eco-niche, which yielded an item others had not got, or from developing a specialty and then making it a monopoly. Nassa shell money, for example, was made near Talasea in the eastern extremity of the region and in the Huon Gulf. Items of trade were valued in fathom lengths of shell money, which, as with wooden bowls from Tami and pots from Sio and Bilibili, was an essential item of a traditional bride-price in west New Britain. Obsidian was only to be obtained from Talasea and was traded from there all the way to Madang, from where red paint reached New Britain. The Talasea obsidian was also traded by the Siassis to the Salamaua Peninsula, where stone for adz blades, vital to carving, was obtained. The development of specialties for exchange is exemplified by the Tami Islanders, who had to import much of their food against their wooden bowls. Mandok and Aramot in the Siassi Islands were similarly placed in relation to Umboi Island, specializing in making bowls and canoes. Clay was only available in certain places, thus leading to the production of pots as a specialty in islands such as Sio and Bilibili. But as well as essential material items, the needs of a festival might require the obtaining of pigs by trade, or dogs, which, for example, the Arawe and Kilenge traded to the Siassis.

There is little early record of the role of artists. Surmising from observations on the Kilenge

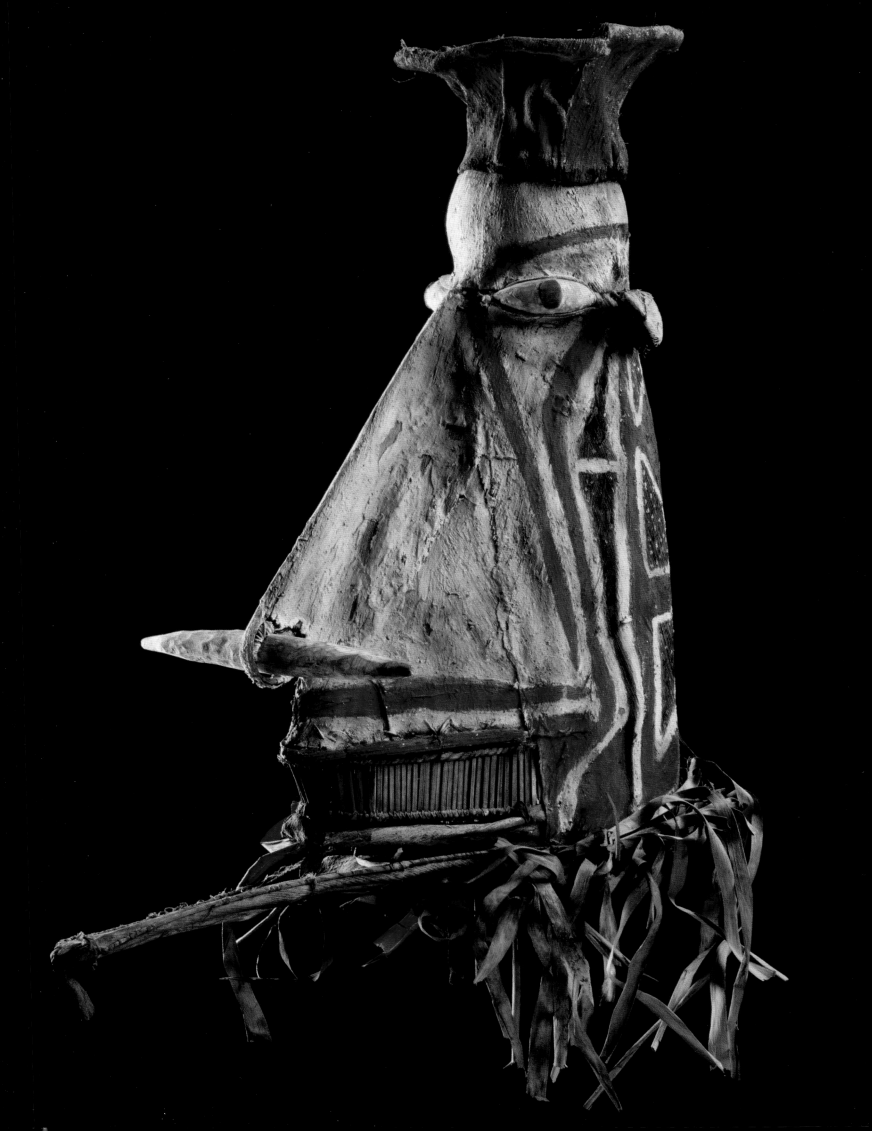

Wood. Red and white paint, blue-green plant-
based stain. Witu Islands. Formerly Herz Jesu
Hiltruper Mission Collection, Hiltrup, near
Münster. Height 58.5 cm. Inv. 4476.

Hardwood. Traces of red, black, and white paint.
Such masks were exhibited in cult houses and
not worn. Tami style. Formerly James Hooper
Collection. Height 41 cm. Inv. 4117.

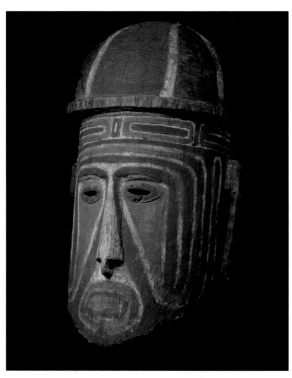

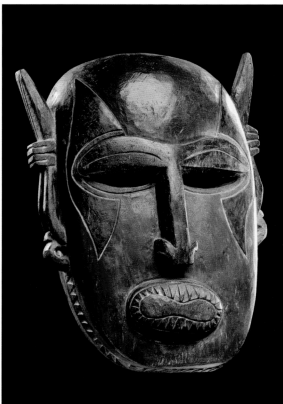

of New Britain, skill in the production of art
was in the hands of certain craftsmen, some
of whom were recognized as master artists
(masters of all the arts) and some as artists
having a particular skill.[12] Generally, the oldest
son would succeed his father as an artist.
Some women were recognized as having
particular skills at certain crafts. While drums,
masks, headdresses, and dance wands were
objects of art kept stored away in eaves (their
static role), their active function was to serve
as accoutrements of performance. Here much
of the art of New Guinea tended "to serve
the personal embellishment of participants
in ceremony or festival," in which voice and
musical instruments played major roles.[13]

What is left of the art of the region are a
number of fine objects, often displaying skill
of the highest order. But these objects all
functioned in particular cultural contexts,
some enhancing the focus of ceremonies,
others embellishing festivals or architecture,
or serving as personal decoration. Through
their particular forms and designs, they
represented myth and legend, symbolizing
belief, signaling supernatural sanctions on
conduct, and expressing, through representa-
tions of ancestors, origins and kinship. There
are indeed themes that give the region
a sense of unity, based on common cultural
elements, but with local differences in artistic
expression. This is evident in the similarities
in form and ornamentation in the three
major areas, and also in the use of similar
forms in comparable contexts.

A major artistic feature is the carved human
figure. In the *telum* of Astrolabe Bay, used
to support the beams in men's houses,
ancestors—guardian spirits—are represented
in large form, one above the other. Smaller

ones are propped against the wall of a hut. The Kilenge of west New Britain had a similar center pole in the men's house. Tami men's houses had life-size figures painted in red, black, and white as houseposts. These were comparable to the *telum* figures of Astrolabe Bay and similar to those of the Kilenge and Siassis. Carved figures hanging from the ends of beams were a feature of houses in Astrolabe Bay, Tami, and west New Britain, and are suggestive of the tall *telums* of Astrolabe Bay.[14] In May 1872, Mikloucho-Maclay described a men's house with several *telums*, "some of which were as big as a man," and "a large wooden mask with openings cut out for the eyes and mouth, which was worn at the time of special feasts."[15] The mask featured in male circumcision, which took place in a special cult house in the bush (the "ghost"

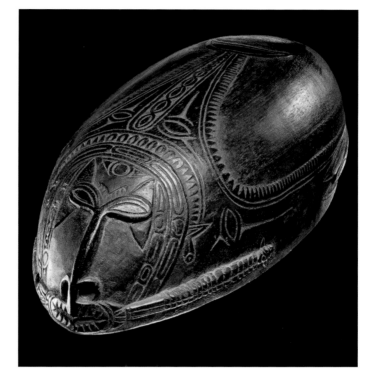

### 14 Bowl

Hardwood. Oval or canoe-shaped. The face that decorates one end of what is surely the oldest of the six Tami-style bowls in the Musée Barbier-Mueller seems to extend into a triple-peaked head-dress. Gladys A. Reichard, who has made a close study of these objects (1933, see bibliography), believes that it might in fact represent an evil spirit called *buwun*. Length 47 cm. Inv. 4110-B.

### 15 Large bowl

Hardwood. Decorated at each end with a relief carving of a face. A crocodile appears between them. The faces are framed by snakes curling around the rim of the bowl. Tami style. Length 87 cm. Inv. 4110-D.

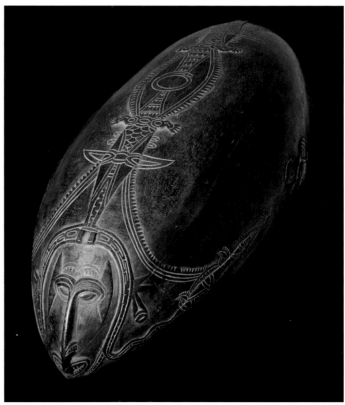

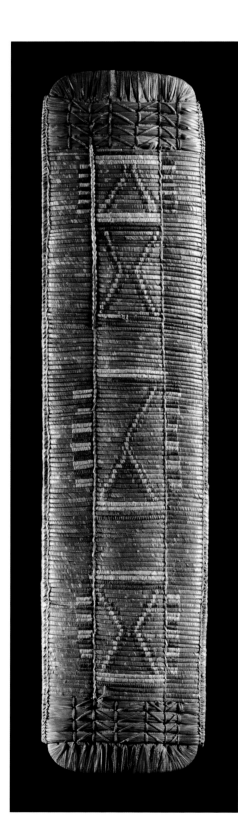

cult), from which women and children were excluded. By 1894, men's houses had taken over this role from the cult houses. The sides of men's houses—and also of some ordinary ones—were decorated with planks carved and painted with figures. On the Kilenge men's house in Ongaia village were to be seen, in 1970, decorative planks, one of which showed a crocodile with a pig in its mouth. An identical plank is pictured on a model Tami house in the Neuendettelsaumuseum. These images may symbolize the consumption of the novice, later to be reborn. A small model house would be put by each father beside his son's couch in the house when the novice's circumcision wounds were healing. House models were made in the Huon Gulf (examples of which survive in collections) but not in New Britain. The mask had its counterpart elsewhere in the region. It existed in the Huon Gulf, but by the beginning of contact with Westerners it was no longer regarded as a *balum* cult object, although it continued to fulfill this function in the Siassi Islands until 1910. The extant masks must have been used only to decorate the house, as they have no holes for attaching to the face of the wearer (fig. 11).[16] Miniatures sometimes decorated the Tami model houses. *Nausung* masks, which were similar in appearance and func-

tion to the masks made in Astrolabe Bay, were made until recently by the Kilenge in west New Britain, and also in the Witu Islands and elsewhere. Not only are the forms of these masks comparable throughout the region, but the cults they served also have characteristics in common. The same kinds of paraphernalia were also used, including the bullroarer, which was used to keep women and children away.

The myth recounting the origins of the bullroarer in the Huon Gulf is similar to that given by the Kilenge.[17] *Nausung* is a wild spirit of the bush, a violent creature who will tear down trees, and the Kilenge enact this when he is summoned. The original bullroarer of the myth was called *nausung*: "It is for the sound of *nausung*. Now we will make a face of the *nausung*," I was told. Masks were made at the request of the families "who put their designs on it in their men's house ... The name of a *nausung* is chosen for a famous name in the men's house." Only one mask is danced at circumcision. The others are placed outside the men's house, indicating the relationship of ancestors (and ghosts) to the masked cults of the region.

A major theme of the art of this region concerns the myth of two culture heroes who were brothers. The myth is found widely throughout the region and is prominent in accounts of origins.[18] Among the Kilenge, one of the brothers, Mooro, had the head of a man and the body of a snake, while the other, Aisipel, was like other men. Mooro was wise and gifted; Aisipel was a foolish troublemaker. The principal forms representing the subject of the theme are head (or face) and a snake or a human figure with a snake symbol either on its own or with another head or figure.

16  **Shield**

Made of three boards held together with fiber cord. The surface is overlaid with strips of rattan, stained red, black, and yellow. Karkar Island. Collected by Giovanni Bettanin (before 1900). Formerly Ethnographic Museum, Budapest. Height 117 cm. Inv. 4130.

## 17 **Club or staff**

Hardwood. Traces of red, black, and white paint. Its upper part is decorated with a head on top of which curls a snake. Formerly Pitt-Rivers Museum, Farnham, Great Britain (before 1900). Overall length 84.5 cm. Inv. 4112.

They occur in the art of the Kilenge, Siassis, Tami, and in Astrolabe Bay. The face motif mirrors *nausung* masks and their parallels in the region. In Tami art, the snake and face are extensively represented on items such as drums, hooks, model house boards, and planks, and occur in association with masks, crocodiles, and men's houses (figs. 14, 17). The representations seem to be particular expressions of the basic theme of the myth, which symbolizes a dualism inherent in the societies of the region, namely the opposition of sib groups and the cooperation of kin. In the Huon Gulf, the snake, with its human head which can change to the form of a girl or a boy, can attract and harm, expressing the opposition of the brothers in the myth—and indeed in society, a society of one-upmanship where big men, supported by their sibs, vie with each other for power and the prestigious acknowledgment of power.

While the form and function of art may be similar in the cultures of the region, the contexts in which it functions differ in expression and content due to historical forces and local factors. The Siassi Islanders say they learned the *tumbuan* (coconut bast masks of west New Britain) from the Kilenge.[19] *Sia*, with its cocked hats and chorus of performers playing carved hourglass drums, existed in New Britain at the turn of the century. The Kilenge said they got it from the Siassis. It existed among the Tami and also on the New Guinea mainland. Mikloucho-Maclay, who was at Bongu in 1876, recounts the mimetic dances he saw performed and which were a major feature of *sia*.[20] The giant *bukuma* headdress of the Kilenge, with its fan of canes and feathers 4–5 meters in diameter, originated among the Kilenge but was acquired by the Siassi Islanders before

1910. However, in its ritual context it became changed and it was combined with *sia* and *nausung*, and the Tami *tago* cult. The *tago* masks were constructed bast forms with face markings similar to those on wooden masks. The Tamis claimed they came from New Britain, the Kilenge that their wooden *nausung* masks came from the Tamis.

Art in this region was dynamic, with new ideas, forms, and complexes being interchanged and absorbed rapidly. Consequently, there was a diversity of local styles, which were nonetheless related because they were based on shared themes. These styles were very different from those found in other regions of New Guinea.

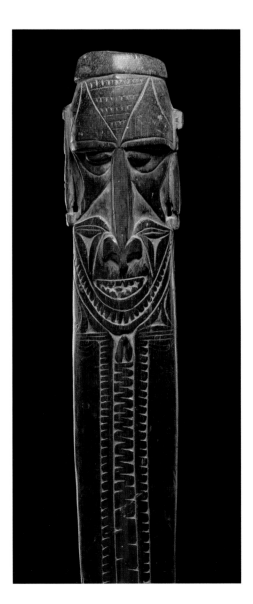

# Massim

**Harry Beran**

1 **Splashboard (*lagim*)**

Hardwood. Prow attachment for a dugout canoe.
Trobriand Islands. Height 70.5 cm. Inv. 4150-A.

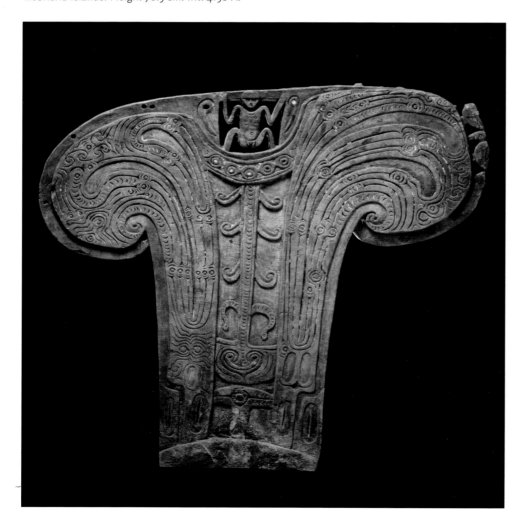

Massim is a term used by Westerners to refer
to the art and people of Milne Bay Province of
Papua New Guinea in the far southwest of the
country (see map p. 224). The term is prob-
ably a corruption of Misima, the name of one
of the islands in the province and is not used
by the people of the province themselves.

The Massim inhabit a coastal and island
world, where they live off fishing, hunting,
pig raising, and subsistence gardening. Like
a few other New Guinea coastal peoples,
they speak Austronesian languages. Massim
communities are divided into clans, each
with a number of totems, of which bird totems
are the most important. In the Trobriand
Islands and Marshall Bennett Islands, sub-
clan membership determines hereditary rank
and the right to rule. In other parts of Milne
Bay Province, power is wielded by men who
have gained repute through personal accom-
plishment. Death is a major ceremonial oc-
casion marked by a series of feasts, during
which the deceased's valuables are distributed.
Other major life transitions, such as birth,
the reaching of adulthood, and marriage,
are accompanied by little or no ritual.

Not much is known about Massim history
before Western contact. There are prehistoric
megalithic structures, rock paintings, and
rock engravings in the district, but nothing
is known about their origin. Pottery shards
show that some of the islands have been
inhabited for at least 2,000 years,[1] but no
Lapita pottery has so far been found in the
Massim district.[2] Trobrianders believe that
their original ancestors emerged from holes
in the ground in a fully social state. Waibadi,
the paramount chief of Kiriwina in the
1980s, could recite the names of his eighty
predecessors.

## 2 **Shield**

Wood (some restoration). Decoration in black and red paint, with white for the ground. The patterns have been interpreted in a number of different ways (recently summarized by Benitez-Johannot 1998). Objects of this type do not seem to have been carved in the twentieth century. Trobriand Islands. Height 78 cm. Inv. 4163.

Ancient funerary pottery, different in design from contact-period pottery, is located in caves in the Trobriand, Nuamata, and Woodlark Islands.[3] Ancient canoe ends have been discovered in caves in the Trobriand and Marshall Bennett Islands.[4] The local people knew of their existence, but could not estimate their age. Cone shells with engraved curvilinear motifs, probably several hundred years old, have been found in ancient middens in Collingwood Bay, on the edge of the Massim district, and on a beach in the Trobriand Islands.[5]

The curvilinear motifs engraved on the prehistoric canoe ends and shells bear some similarity to the present Massim style. However, there are so few ancient artworks that it is difficult to judge whether their designs are in the Massim style or in a style from which this style may have developed.

Although the Massim culture district was one of the earliest Melanesian culture districts to be identified, little research has been published on Massim art since then and there is no comprehensive publication on the subject.[6] Among the things that are poorly understood are the precise function of some objects, the way in which artworks are used with magic, the meaning and symbolism of Massim iconography, the evaluation of artworks by the Massim themselves, how people become artists in areas other than the Trobriands, and to what extent artists or schools of artists develop personal styles.[7]

Massim artworks are plentiful both in number and type. There may be as many as 40,000 Massim pieces in Western collections—or about one for each of the 38,000 people who lived in Milne Bay Province about 1900.

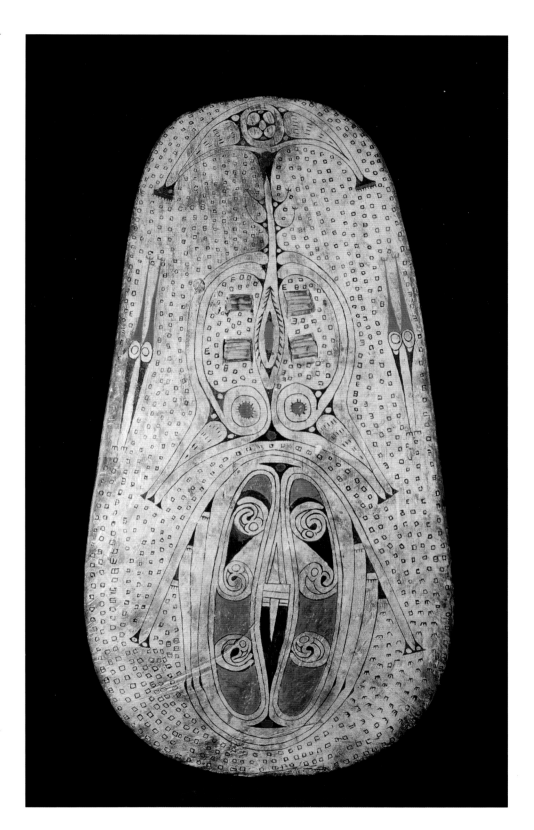

## 3  Flat stick

Ebony. Incised with decorative spirals. The tip is carved into the shape of a bird. Original Josef Mueller Collection. Acquired prior to 1942. Height 82 cm. Inv. 4165-B.

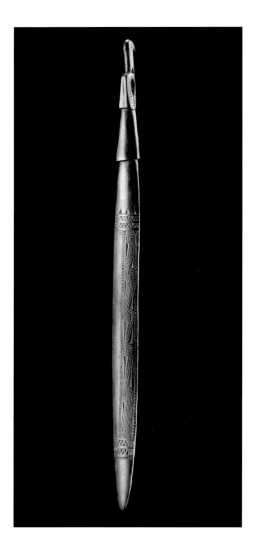

## 4  Dance shield (*kai diba*)

Wood. Traces of red, black, and white paint. Trobriand Islands. Length 63 cm. Inv. 4153.

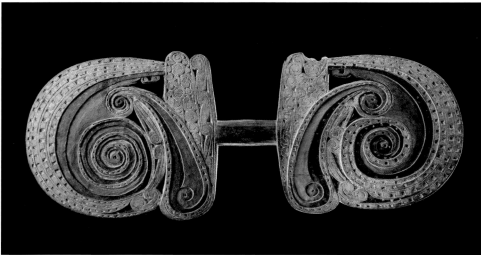

Many of the Massim communities are linked by the *kula*, a trading cycle in which necklaces and armbands are ceremonially exchanged. The British anthropologist Bronislaw Malinowski's description of the *kula* has made the Massim, especially the Trobriand Islanders, famous well beyond anthropological circles, but he published little on Massim art.[8]

The *kula* sailing canoe is probably the greatest Massim artwork, and in particular the *kula* canoes called *nagega*, which, in the twentieth century, were made in the eastern and southern parts of the district. They are impressive seagoing constructions, capable of carrying dozens of sailors, and have richly carved prow and splashboards and many other beautifully carved components, such as prow attachments, rope blocks, paddles, and mast forks. *Nagega* canoes also used to be made in the Trobriand Islands, but they were replaced in the nineteenth century by *masawa* canoes, which are less splendid, but swifter and easier to make. *Masawa* splashboards usually have one or two small human figures carved in the middle of their top sections (fig. 1). If the figures have the right magic said over them, they protect the canoe and attract *kula* items to it.

The South Australian Museum is one of the few museums to have a complete, fully documented *kula* canoe, including a *masawa*. More common in museums are the fine seaworthy model canoes built from separate components much like real canoes and used as toys by both adult men and children. In the Trobriands, hereditary masters of model canoe racing can give the order for a race. In these races the losers are also winners: they are entitled to raid the winner's house and take anything they fancy.

Equally fine, although less grand than *kula* canoes, are Massim dance paddles (fig. 4), war shields (fig. 2), clubs (fig. 3), presentation ax handles (figs. 6, 7), betel-chewing utensils (figs. 5, 8, 9), and clay pots.[9]

In the twentieth century, dance paddles (fig. 4) appear to have been used only in the Trobriand Islands during the annual harvest festival. However, similar paddles were possibly formerly used in the D'Entrecasteaux Islands, as were long, slim dance wands in the south, perhaps in Milne Bay.

In the 1890s, Samuel B. Fellows obtained and published a detailed interpretation of the motifs on a Trobriand war shield (fig. 2).[10] According to Fellows, the motifs on the shields represent fish, snakes, birds, stars, rainbows, and spear holes. He reports no unified symbolic meaning of the motifs. E. R. Leach has speculated that the shield's painting represents a flying witch, much feared by Trobriand Islanders. R. M. Berndt has rejected this hypothesis on the grounds that males who perform war magic over shields would have nothing to do with female sorcery involving flying witches. He suggests the shield's motifs symbolize human copulation, thus serving as a visual form of abuse of the enemy, since copulation is a fitting subject for verbal abuse in the Trobriands and there is a taboo on copulation during warfare.[11]

Interestingly enough, the crescent-topped motif in the top half of the shield, which Berndt interprets as a penis, is identical in shape to the shell-money holder (fig. 5). This object is interpreted by Sabari Islanders, in the Louisiades, as a human figure with a penis. During the contact period, painted shields have been made only in the north,

5 **Lime spatula**

Turtle shell, rimmed by roundels of shell money. Lime spatulas of this high quality formed part of dowries and were carried by women in ritual dances. Grass Island (southern Massim region). Height 27.3 cm. Inv. 4160.

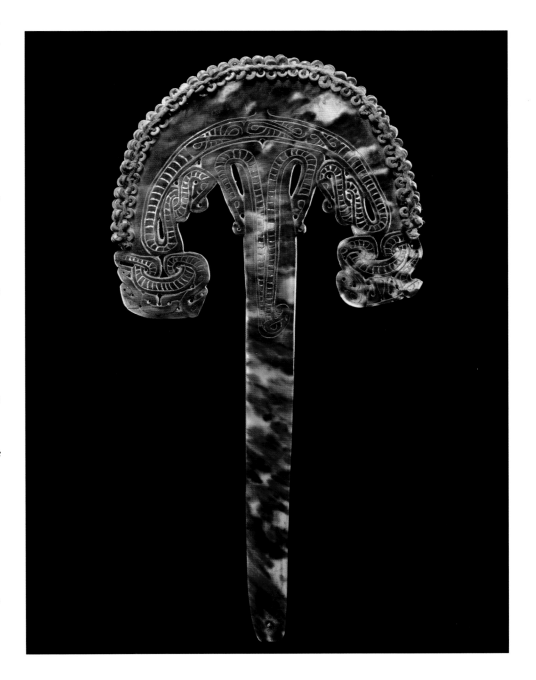

Black nephrite. Broad, flat haft strapped on with rattan. Blackened with soot. Axes with large handles were until recently quite common in the Trobriand Islands. Length 62 cm. Inv. 4070-A.

and shell-money holders only in the south. But a motif of the same shape as these holders also appears prominently in the lower half of some old *masawa* splashboards, most likely made in the center or north of the Massim district. This motif probably represents a human being, perhaps a mythological hero. Therefore, Trobrianders may well have been familiar with the anthropomorphic significance of this motif.[12]

The Trobriand shields are unique in Massim art in having their design painted rather than carved and painted. In the south, two completely different types of shield were used. An oblong type was made in Misima Island (and probably other places) and used throughout the south. An oval type was also made in the south, but the extent of its distribution is not known. All the shields were used as a defense against spears, since the Massim did not use bows and arrows.

The Massim used a variety of clubs, whose striking section is nearly always flat and has a sharp or serrated edge. The latter may be derived from sawfish snouts, since there is a report of such a snout being used as a weapon in the Brumer Islands.[13] However, the Suau people in the southwestern quarter of the Massim district also used pole-shaped clubs with stone heads.[14] The shafts were made locally, while the stone heads were presumably imported from the Papuans to the west, and so, no doubt, was the design of the clubs. Most flat clubs consist of ebony or blackpalm.

Finely carved ceremonial ax handles are used for the presentation of nonutilitarian polished greenstone ax blades (once mined in Woodlark Island), which are among the most important valuables in the Massim district (figs. 6, 7).

The betel-chewing utensils of the Massim are perhaps the finest of all the betel-chewing societies in the world. The handles of the spatulas are carved as human figures (fig. 8), various animals (fig. 9), canoes, plants, and abstract designs. Mortars, used by people with poor teeth to crush betel nuts (seeds of the areca palm), are sometimes carved in the shape of human figures, canoes, or drums.

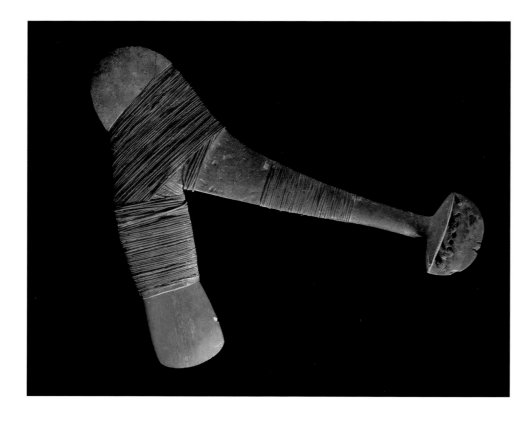

Lime pots have finely woven stoppers. The pots made in the Trobriands are beautifully decorated all over with burnt-in designs; those made in the south are plain, but the stoppers have pigs' tusks with shell tassels inserted into them. Betel nuts and betel-chewing utensils are carried in baskets. The most elaborate consist of a set of three nested baskets, which enable their owners to hide some of their betel nuts.

There are various other kinds of traditional Massim artworks and artifacts, most of which are attractively made. Among hunting and fishing objects are fishing net floats, fishhooks, fishing kites, fishing spears, carved wooden hooks to secure nets used to catch wild pigs, and clubs to kill the pigs once caught.

Household utensils include food hooks (very rare), bowls and platters, food stirrers, shell spoons and coconut scrapers, anvils and taro mashers, and prehistoric stone pestles used as nutcrackers in Rossel and Sudest Island. Elegant adzes, together with mallets to drive engraving tools, are used to produce carvings.

Women's skirts in the Trobriands are many-layered, colorful, finely constructed garments. The most common toilet article is the comb. One type, a comb with a long, sometimes curved handle with a tassel, is worn in the hair as an adornment. Other adornments, some only worn on special occasions, include earrings, nose sticks, woven-fiber armbands and belts, and necklaces. The jawbone of a recently deceased husband may be worn by his widow as a necklace or armlet before it is deposited in a cave.

The dwellings and yam stores of high-ranking Trobrianders are fine structures with carved gable boards. Spars protruding from the front are decorated with carved animals and stone rings. Headrests are rare, with finely carved ones apparently being confined to the southern Massim. Early in the twentieth century, there was an aqueduct at Bartle Bay on the north coast of the mainland that carried water from the hills to the village. Its support posts were topped by squatting human figures that carried protective magic.

7 **Ax**

Greenstone. The wooden haft is decorated with low-relief bird motifs and looped patterns. Exact place of origin unknown. Axes with slender handles are widely used in the south of the Massim area. The stone blades (*beku*) are made on Woodlark Island, and are widely traded. Original Josef Mueller Collection. Acquired prior to 1942. Length 68 cm. Inv. 4263.

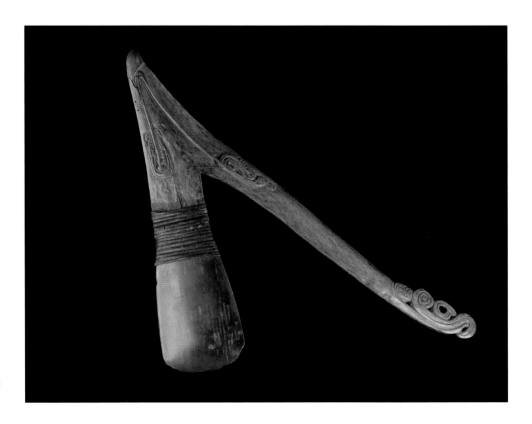

8  **Lime spatula handle (detail)**

Black hardwood. The end of the handle is carved in the round with a squatting figure. D'Entrecasteaux Islands. Height 32 cm. Inv. 4151-A.

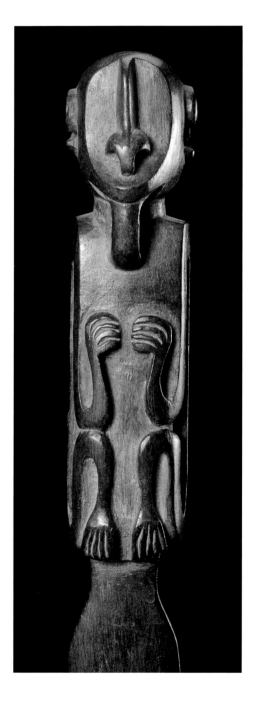

Freestanding human figures are rare in Massim art. However, some were used to protect homes from sorcery in the Trobriands, the Marshall Bennett Islands, and in Normandy Island.

The main Massim musical instrument is the drum. In most parts of the area small and large drums are made, the former being as small as 25 centimeters long in the Trobriands.

The most important Massim valuables are, of course, the shell-disk necklaces and shell armbands ritually exchanged in the *kula*. The partners in the *kula* form a geographical ring: necklaces go round it in a clockwise direction, armbands counterclockwise. Some of the excitement of the *kula* is due to the exchange being delayed: a partner receives an armband in one sailing season and is then expected to provide a necklace of comparable value in the next. The most valuable *kula* items have been round the ring many times, acquiring patina and history, and are renowned throughout the district. Participants in the *kula* can acquire fame and status by temporarily obtaining well-known *kula* items.

Other valuables include: the polished greenstone ax blades (figs. 6, 7) for which the presentation ax handles already mentioned are used; various items of jewelry that are signs of chiefly status in the Trobriand Islands; necklaces with circular pendants made from pig tusk or bailer shell; belts sewn with rows of shell disks; shells that are used in a currency system in Rossel Island and to a lesser extent in Sudest Island; shell-money holders (fig. 5) made from turtle shell or ebony with crescentic tops (the turtle shell pieces are also used as lime spatulas); and bundles of

banana leaves with an impressed design made by women in the Trobriands.

The precise function of rope blocks with human figure components and of disks once worn on the head during certain dances is unknown. Only in some cases is the social significance of the designs on lime spatulas and betel nut mortars understood. Some spatula designs are reserved for chiefs and are, therefore, a sign of their status. Sorcerers seem to favor clapper spatulas. A person who knows the right magic can get a tree spirit to inhabit an anthropomorphic spatula handle for protective magic. That artworks are used with magic is clear enough, but how exactly are freestanding figures used in protective magic? How are the figures on staffs used for sorcery or healing magic? And why do sorcerers favor clapper spatulas?

The aesthetic judgments expressed in this article are made from a Western viewpoint. The only published evidence of how the Massim evaluate their art is provided by the assessments of the late Chief Narubutau, a master carver himself, of a range of canoe boards.[15]

The task of producing artworks is divided between the genders. Men produce wood carvings, and women pottery, baskets, and skirts. Both men and women produce the shell disks from which necklaces are constructed.

In the Trobriands, the carving of the fascia boards of chiefly dwellings and yam stores, of *kula* canoe boards, and of some types of lime spatula is the preserve of men trained as carvers within a master-apprentice system.[16] Both carving skills and the knowledge of magic relating to carvings are passed on

within this system from master to apprentice. In Milne Bay villages, the carving of *gebo* war canoes is the preserve of certain families.[17] Little is known about how carvers acquire carving skills in other parts of the Massim district.

The stylistic analysis of Massim lime spatula types suggests strongly that schools of carvers and even individual carvers develop their own variations of the Massim style. This is especially noticeable with regard to spatulas with anthropomorphic handles, of which there are about one thousand in Western collections. The most distinctive personal style in Massim art is probably that of the Suau carver Mutuaga (c. 1860–c. 1920), who made certain well-known spatulas with drummer figure handles.

Western understanding of Massim carving is poor compared to the understanding of the carved art of some other Melanesian culture districts. Even less is known by outsiders about other Massim art forms, such as body art, dancing, songs and singing, and story-telling and oratory, although all are important to the Massim. However, as we have seen, the main social functions of Massim art are to mark status, to express individual personality, to support the use of magic, and to express parts of the Massim belief system.

9 **Lime spatula**

Black hardwood. Flat. The engraved pattern shows double loops and bird heads. On the top of the handle perches a bird. Massim area. Height 50 cm. Inv. 4151-B.

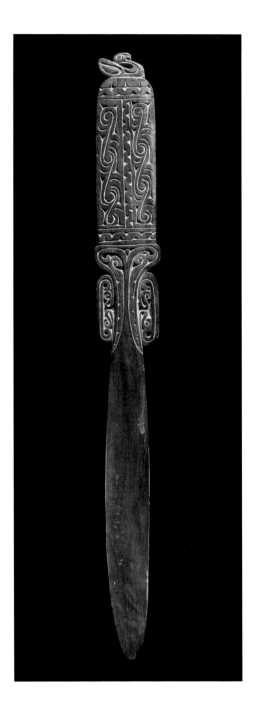

# Gulf of Papua, Papua New Guinea

**Douglas Newton**

It has often been said that "style" in the visual arts is manifested by discernible congruities between the works of an individual artist, of a region, or even a number of regions during a particular historical period, detectable by comparing very direct likenesses of visual elements. On these grounds, we can speak of a special style that is characteristic of art in the Gulf of Papua region of Papua New Guinea. There are people of several cultures living around the Gulf (although most of their cultural traditions disappeared over half a century ago), and details of their art vary markedly.

The Gulf of Papua is an enormous geographical feature of New Guinea's south coast, an expanse of water 400 kilometers wide and 200 kilometers deep that indents the coast opposite northern Australia. The east has a sandy shoreline; the central and western areas are an enormous waterlogged plain of swamp and forest traversed by small streams and large, sluggish rivers with many small islands forming their deltas. Altogether the population now amounts to about 53,000 people. There are major differences between peoples of the east and the central-west region. To a considerable extent, these coincide with, and also reflect, the two distinct environmental zones in which they live. There are historical factors that play a part as well: the easterners claim to have migrated from the hills to their northeast, while the central and western groups place their origins on Kiwai Island at the mouth of the great Fly River, at the far end of the Gulf.

The easterners inhabit about 160 kilometers of the coast. The Motu people, who live still further east, call all these groups "Elema," and this name has been adopted by linguists

**Papua/New Guinea**

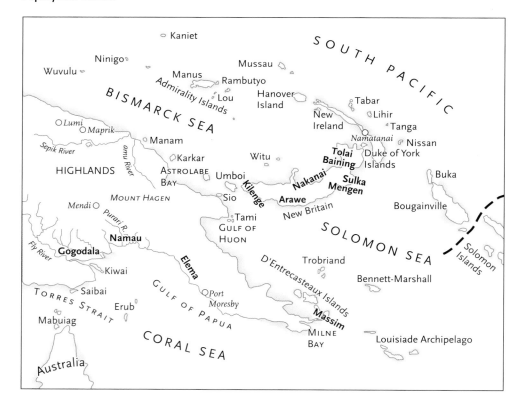

2  **Shield**

Wood. The carving shows two symmetrically doubled faces schematized into the mouth and the elongated, comma-shaped eyes. Traces of red, black, and white paint. Elema. Formerly James Hooper Collection (purchased in Caledonian Market, London, in 1927). Height 80 cm. Inv. 4205.

and anthropologists. They comprise about a dozen separate groups, in total about 35,000 people, all of whom speak mutually intelligible dialects of the same language. Each group is divided into several villages by the sea that are themselves subdivided into a number of hamlets. Behind the villages lie swamps, where the sago palm flourishes, and tracts of bush the Elema burn off to make gardens. Sago flour from the palms and taro, yams, coconuts, and bananas from the gardens are the main food sources.

Each hamlet had a ceremonial house, an architectural feat of considerable grandeur. In plan, it was a rhomboid tapering from a broad front to narrow back wall. The facade was a huge pointed Gothic arch, its peak rising some 18 meters above the ground; this section continued through the depth of the building, gradually decreasing in height to the rear.

1  View of the interior of a men's house in the delta region of the Purari River, in the central area of the Gulf of Papua coast. The Gulf style is evident on the ancestral boards (known as *kwoi* in this region, although the Elema call them *hohao*), on the drums decorated with low-relief carvings, and some small masks. Barbier-Mueller Archives.

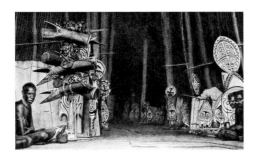

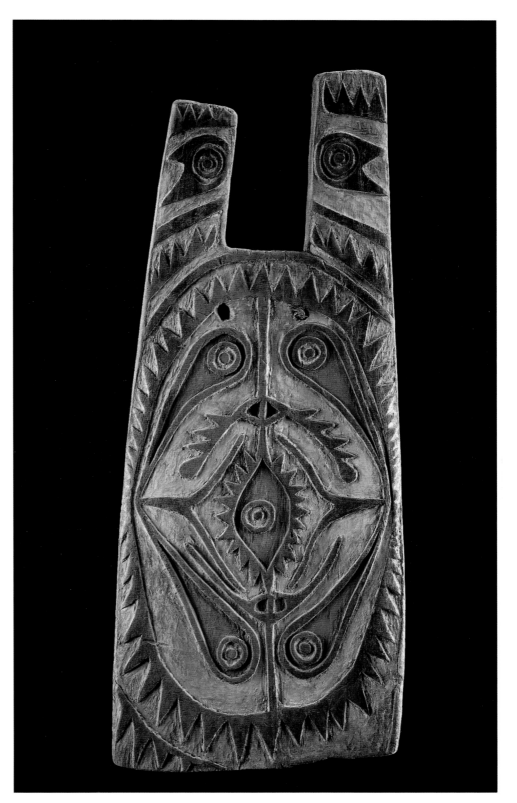

225  Gulf of Papua, Papua New Guinea

## 3 Mask (*eharo* type)

*Tapa* stretched over a cane frame. Heightened with red, white, and black pigment. This mask, collected before 1865 by a British missionary, was sold at the beginning of the 1970s with a companion piece (very similar to this one, but without the protruding mouth that has since been restored). The second mask is now in an American collection. Elema. Height 123 cm. Inv. 4203-A.

The cathedral-like roof was supported on two rows of columns, so that the spaces between them formed niches in the side aisles. Over and in these niches were hung masks, drums, the flat wooden plaques called *hohao*, and the sacred bullroarers (fig. 1).

The *hohao* and the sacred bullroarers are carved in low relief with human figures. These figures represent the ancestral spirits inhabiting them and have navels symbolizing origin places. The figures are sometimes shown standing. Sometimes they squat in "hocker" positions, and quite often consist only of faces linked to designs which have no anatomical significance, but which are named after plants or geographic features. Elema two-dimensional art is, in fact, very much one of images drawn on a white background. The same principle is to be seen on the war shields (not employed anywhere else in the Gulf), with their symmetrically doubled faces and comma-shaped eyes (fig. 2). These embody the joint function of supernatural protection (in the mask looking up to the carrier's face) and aggression toward the enemy (in the face looking outward).

Elema masks are constructed of cane frames covered in barkcloth. There are three principal types; the simple conical *kovave*, used at the initiation of boys; *eharo*, or totemic dance masks, worn by visitors from other villages who come in great numbers to celebrate festivals; and *hevehe* or *semese*, impersonating spirits who come from the sea. If *kovave* and *hevehe* are standardized, the *eharo* appear in a staggering wealth of imagery. They are also conical, with a face at the bottom, but are surmounted with figures of the creatures of nature, including plants, and even comic characters. Fig. 3 shows one of these great masks topped with a bird whose widespread wings must have waved slowly up and down in time to the dancer's movements. *Hevehe* are like the *hohao* in form, but are of enormous size (up to 6 meters in height), with circular eyes and long, fanged jaws at their lower ends.

## 4 Large mask

*Tapa*, dried leaves, and imported cloth (indigenous restoration?), stretched over a cane framework. Era River delta region (?). Height 215 cm. Inv. 4203-D.

---

Between the *hevehe* masks, the *hohao*, and the bullroarers, we can detect immediately that there is a striking recurrence of a dominant form: the ellipses with pointed ends. The facades of the ceremonial houses are identical with their upper parts, uniting all of them in a single scheme of visual elements and symbolic cross-references. This is repeated in the art and architecture of the people to the west of the Elema, although to a diminishing degree toward the western border of the area, and not at all near the Aramia River and among the Gogodala people. This visual unity exists in spite of certain very different cultural traits. For example, the Elema, like all New Guinea groups, engaged in warfare, but unlike the central Gulf people they did not practice concomitant cannibalism. There were also contrasting aspects in the ritualism of the two areas, particularly in modes of initiation, which were more elaborate and rigorous to the west.

The closest central Gulf groups are the Purari, around the estuary of the great Purari River, the Urama, and the people of the Era River and Wapo Creek. Most of them are aquatic peoples oriented toward the riverbanks instead of the sea, and hunting and fishing play an important part in their economy. The swamps, often subject to flooding, are so rich in sago palms that great quantities of the surplus flour were traded to the Motu in exchange for pots.

Purari ceremonial houses were on the same model as the Elema's, but even larger in scale, and with gables that canted a long way forward from the building. Purari and Urama masks correspond to the different types of Elema masks, and the former's *kwoi* boards correspond to the *hohao* of the latter. The bullroarers are identical in form. In spite of

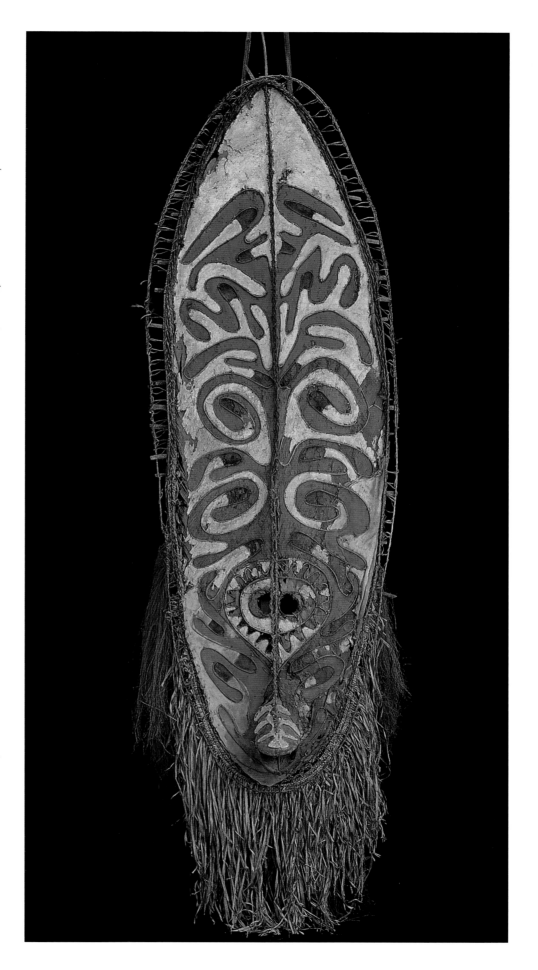

227 Gulf of Papua, Papua New Guinea

**5 Board (*kwoi*)**

From the central region of the Gulf of Papua (Era River). It is decorated with an anthropomorphic motif, the "portrait" of a guardian spirit. The bowed shape of this *kwoi* derives from the fact that it was carved from the side of a disused canoe. Height 192 cm. Inv. 4200-D.

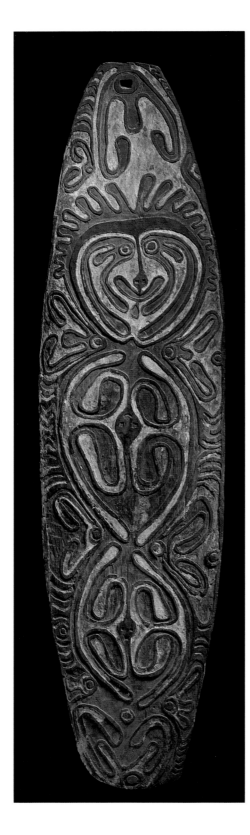

the coincidence of these overlapping traits, there are, however, marked stylistic differences between the ways they are treated. Instead of the dense, angular, and serrated design features that are so striking in Elema art, those used by the Purari are more linear, and also curvilinear. The *kwoi* certainly has borders of chevrons as a rule; but otherwise the most frequent motif appears to be the scroll, sometimes as a solid shape, but more often expressed in parallel lines. The face is abridged, sometimes having a small toothy mouth, but often none at all; the rest of the body rarely appears, except for the navel. Their great masks are divided on the vertical axis by a spine from which spring scrolls, like hanging tendrils, outlined by cane strips on white ground and painted in red and black. The example in the Musée Barbier-Mueller is most likely, on stylistic grounds, to be Purari (fig. 4).

The same types of masks and boards existed in the next groups westward, the Iwaino of Urama Island and the people living around the Era River and Wapo Creek. The large elliptical Urama and Era-Wapo masks closely resemble those of the Purari, but the motifs on them are far simpler; a second type of basketry mask from these areas is dome-shaped, with long protruding jaws. The sacred boards of the Urama are also quite simple, their decoration being limited to faces in the middle bordered with chevron bands. On the other hand, Era-Wapo boards are long ovals and have neatly outlined faces that are wider than they are high toward the top. The rest of the board is densely covered with exuberant decoration that features a motif of two C-shapes back to back, linked with a circle or diamond in the middle (fig. 5). When repeated, as they often are, these motifs can be

visualized as multiple images of the human figure. The same motifs also appear on the carvings called *bioma*, large and small silhouette human figures usually posed in the hocker position (fig. 6). They were closely associated with racks containing captured human skulls and the rows of pig skulls lined up on the floor under them. Each pig skull had a small *bioma* placed on top of it.

A further important trait of this area is the huge zoomorphic basketry figure called *kaiaimunu*. This was of great sanctity because it was considered an actual supernatural being and it was kept in a secret compartment of the ceremonial house. It is a four-legged creature with a tapering, tubular body and an enormous head with gaping jaws. Formally, it replicates both the ceremonial house itself and the "fish mouth" type of drum used throughout the Gulf.

The populations of the western Gulf, around the Omati, Kikori, Turama, and Bamu Rivers, were said by the central Gulf people to be the source of much of their cultures, in spite of obvious discrepancies in their lifestyles and art. Their villages, for instance, were actually communal longhouses that in some places had small private houses for married families standing along their sides. The interior of the longhouse was divided into niches belonging to individual clans.

Although the same repertoire of objects was found throughout this area, the Kerebo of Goaribari Island, at the mouth of the Kikori River, were clearly the most productive and accomplished artists. They too carve sacred boards which are long and narrow. Some are in the elaborate style of the Wapo, but the majority have only a single figure, with an

## 6 Anthropomorphic carving (*bioma*)

Hardwood. Covered with a low-relief curvilinear pattern. Red, black, and white paint. Central region. Era River. Formerly from a Hungarian collection, then Ralph Nash (London). Height 130 cm. Inv. 4201-B.

enormous head, posed in the hocker attitude. These *gope* are collectively known as "crocodile-guardian spirits," and, as usual, have personal names. Individuals own small examples, while the clans each own large ones up to 3 meters high. Some have apertures at their lower ends and it is reported that they were worn over men's heads in a way that would give a very similar appearance to the large elliptical masks of the other Gulf groups. Otherwise, the masks of this area were the basketry domed type, with long noses.

A clan's collection of human trophy skulls was laid on a shelf in the clan's niche, with pairs of carvings called *agibe*. Flat silhouette figures, *agibe* have great round heads, torsos, and arms, and projections between the arms and torsos to which the skulls were attached by loops of cane. The large *agibe* were called males and the smaller ones were females (fig. 10).

Finally, on a tributary of the Bamu River lies the country of the Gogodala. The main subjects of their art include human and animal figures, and immense ritual canoes. The principal feature is a pervasive application to all such objects of elaborate, abstract, mainly curvilinear designs that are heraldic and totemic emblems of the Gogodala clans. Their art also differs radically from that of all the other Gulf groups by its lavish use of polychrome, enhanced by applied colored seeds and panaches of feathers. There is almost nothing comparable elsewhere in New Guinea, except among the Marind-anim of Irian Jaya and some of the Highlands groups. One of their few links with other Gulf styles is that they also make elliptical masks. Those of the Gogodala, however, are small in scale, are made of light wood, and have carved heads fixed at the lower ends (fig. 7).

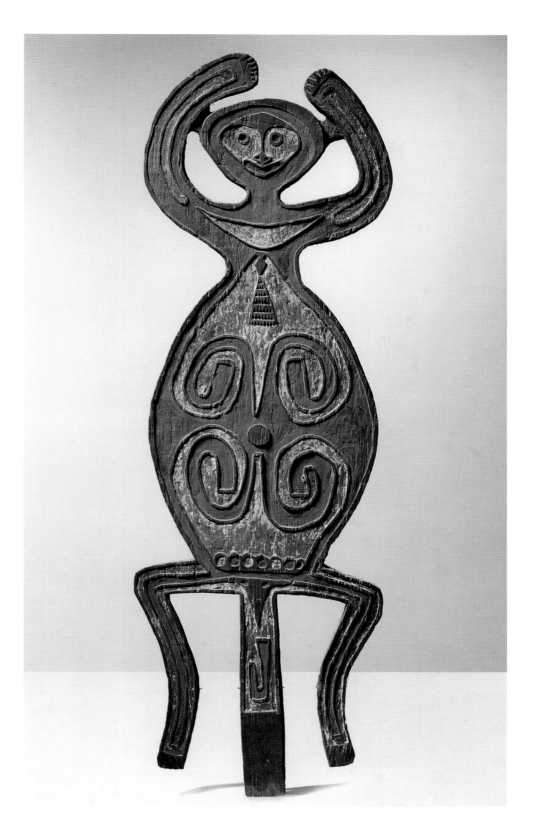

## 7 Mask (*ikewa*)

Softwood, with *Abrus* seeds set around the eyes. Painted decoration. The nose has been separately carved. This type of object was not fitted over the face but on to a board or light helmet crest (*diba*). Gogodala people. Aramia River. Collected by Paul Wirz. Formerly W. Eckert Collection (Basel). Height 21 cm. Inv. 4231.

## 8 Belt

Bark. Decorated with the incised curvilinear patterns characteristic of the art of the Gulf of Papua. Formerly Webster Collection (before 1900), then Pitt-Rivers Museum, Farnham, Great Britain. Width (at broadest point) 8.5 cm. Inv. 4212.

## 9 Drum

Wood. Lizard-skin held in place by strands of rattan. Central region of the Gulf of Papua. Formerly in the W. Eckert Collection (Basel) and original Josef Mueller Collection. Height 73.5 cm. Inv. 4213.

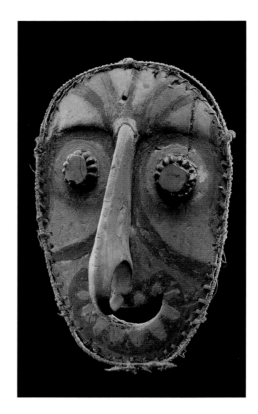

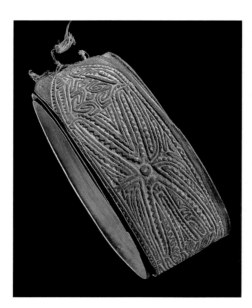

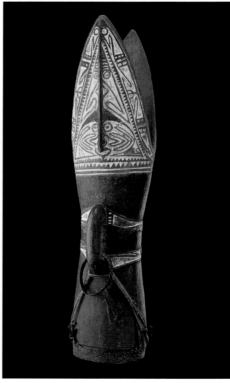

It is unnecessary to recapitulate in detail three aspects of Gulf art briefly touched on here. They include the overlapping among the groups of types of objects; the recurring formal correspondence between types of object —houses, boards, drums (fig. 9)—and the near universality of certain design motifs (of which many more examples could be given). They are, however, powerful arguments for judging the Gulf to be a genuinely distinct style area, one which, moreover, is a geographically limited one: across the Fly River, in Irian Jaya (see pp. 172–87) and east of the Elema (see pp. 216–23), we find radically different styles.

An interesting question remains. It was noted as long ago as 1902 (Foy) that some equivalents existed between the arts of the then German (in the north) and British (in the south) sectors of New Guinea, not to mention their social and ritual life. Recent research has disclosed an increasing number of very close relationships, including some in the central mountain ranges of the island —far too many, in fact, for pure coincidence to be a convincing argument to account for them. A new explanatory theory is needed, perhaps one that would modify our views of Melanesia's prehistory.

**10 Skull rack (*agibe*)**

Hardwood, with low-relief decoration. For hanging skull trophies. Red, black, and white paint. Executed with stone or shell tools, rather than metal ones. Kerebo people. Goaribari Island. Formerly Webster Collection (prior to 1898), then Pitt-Rivers Museum, Farnham, Great Britain. Height 70 cm. Inv. 4204.

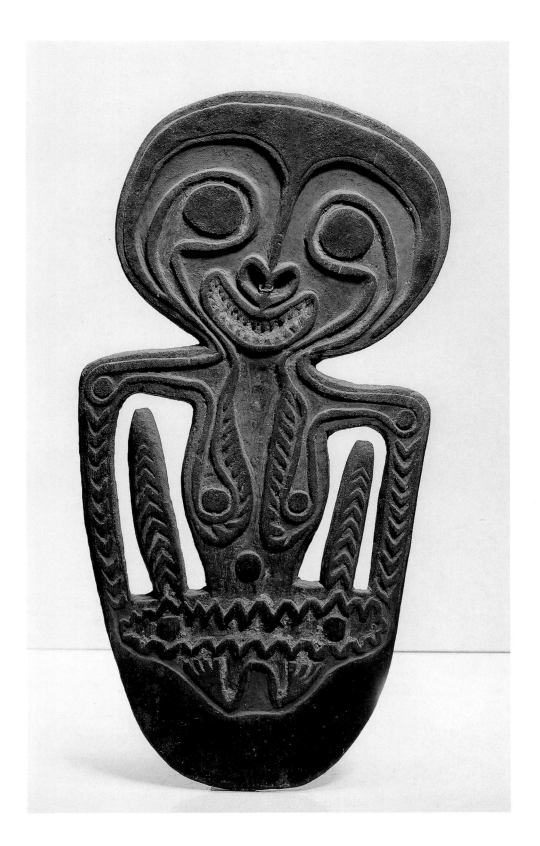

# Torres Strait

David. R. Moore

The Torres Strait Islanders are a sturdy, dark-skinned, cheerful people of Melanesian origin. It is not yet known how long they have inhabited their islands, but it seems likely that the eastern islanders arrived later than the remainder, because their language is a variation on the western Papuan dialects, whereas the remainder of the islanders—the northern, western, and central people—speak a language undoubtedly derived from Australian Aboriginal dialects, though with an overlay of Papuan phonology and phraseology.

At the first significant contact with Europeans, in the 1840s and 1850s, the Torres Strait Islanders were based on some thirty islands, but in their magnificent seagoing canoes they voyaged far and wide in their pursuit of food and trade. Torres Strait lies between Australia and Papua New Guinea and is about 150 kilometers across at its narrowest point. It is mostly quite shallow, not more than 10–15 meters deep, and includes numerous reefs, keys, and sandspits, all of which produce seafoods, such as fish, shellfish, turtle, and dugong. The other main staple was yams, which grow naturally on rocky heights. When these were unavailable, during the northwesterly monsoon season, the suckers of a type of mangrove were used as carbohydrate.

The inhabited islands in the west are old volcanic islands and are not very fertile, whereas the eastern group are more recent volcanic islands which produce good soils. The northern islands are composed of silts from the Papuan rivers and the central islands are mainly sandspits which have consolidated and sustain some plants and trees. Some of the islanders grew coconuts and bananas, as well as root crops such as yams, taro, and tobacco.

The islanders had a universal kinship system and a series of totemic myths. These differed from group to group, but did tie together throughout the Strait. The well-known turtle-shell and wood masks and headdresses were mainly used in ceremonies celebrating these culture heroes and their creative acts.

## Myths, Legends, and Masks

Our knowledge of the ethnography of the Torres Strait comes mainly from the work of Professor A. C. Haddon and his colleagues. Haddon first visited the Torres Strait in 1888–89 as a marine biologist. While working with islanders, he collected a lot of information on the old way of life and some 600 artifacts. Subsequently he decided to specialize in anthropology and in 1898 he led the Cambridge Anthropological Expedition to the Strait. With a notable team of experts, he collected what information was still available, as well as a large collection of artifacts (some 2,000 in all). His collections are mainly to be found in the Cambridge University Museum of Archaeology and Anthropology and the Museum of Mankind (British Museum). His findings were published in the *Reports of the Cambridge Anthropological Expedition to Torres Straits* (1904–35).

Haddon reported that the principal culture hero of the western islanders was Kwoiam, always described as a mainland Aborigine who fought with spear and spear-thrower rather than the bow and arrow of the islanders. Operating from Mabuiag (Jervis Island), Kwoiam went raging through the islands, taking heads. Ultimately he was killed on Pulu, a small island near Mabuiag, by warriors from Badu (Mulgrave Island) and Moa (Banks Island) when his spear-thrower broke.

**1 Mask**

Turtle shell. Traces of paint, fiber cord, and human hair (ears restored). The vernacular name of such masks was *buk* or *krar, kara* in the western islands (this last word signifying "turtle shell"), and *op* ("face") in the eastern islands, the region from which the present example comes. The funerary rites at which it would have appeared were called *keber.* Masks very similar to this one in the British Museum, London; and the Metropolitan Museum of Art, New York; are supposed to have come from Erub Island. In 1886, the German ethnologist Finsch was already writing that it had become impossible to obtain turtle-shell masks in the Torres Strait region. Acquired by Josef Mueller in Paris in the 1930s. Height 39.5 cm. Inv. 4242.

The main myth in the central islands was that of the Four Brothers, named Sigai, Kulka, Malu, and Sau. They came from the west and carried out various creative acts for the islanders. But during a quarrel Malu speared Sau and the brothers divided up. Malu went to Mer (Murray Island), Sau to Massid (York Island), Kulka to Aurid, and Sigai to Yam (Turtle-backed Island).

The cult of Malu (who had a secret name, Bomai) was studied in some detail by Haddon on the island of Mer, so that we know a great deal more about it than the other hero cults. It was carried out in a series of complex secret rituals, culminating in the showing of large turtle-shell masks in a dance accompanied by the sacred drum, Wasikor (which still exists).

These basic myths have been outlined because the well-known turtle-shell masks (figs. 1, 3) and headdresses from Torres Strait were mostly used in secret ceremonies celebrating the creative acts of the culture heroes, and in particular initiation and funeral rites. The masks are made from turtle-shell plates, carefully shaped and curved, then lashed together and usually decorated with incised patterns infilled with white ocher. Often they incorporate both animals and human figures. Sometimes they are adorned with cassowary feathers and nut rattles. Large masks in wood were made in some of the islands. They are powerful, semi-naturalistic elongated images, dressed with human hair (fig. 5). They paraded at night during celebrations of the harvest of certain fruit.

Although these masks may seem grotesque to some people, it must be remembered that they were used in highly secret ceremonies,

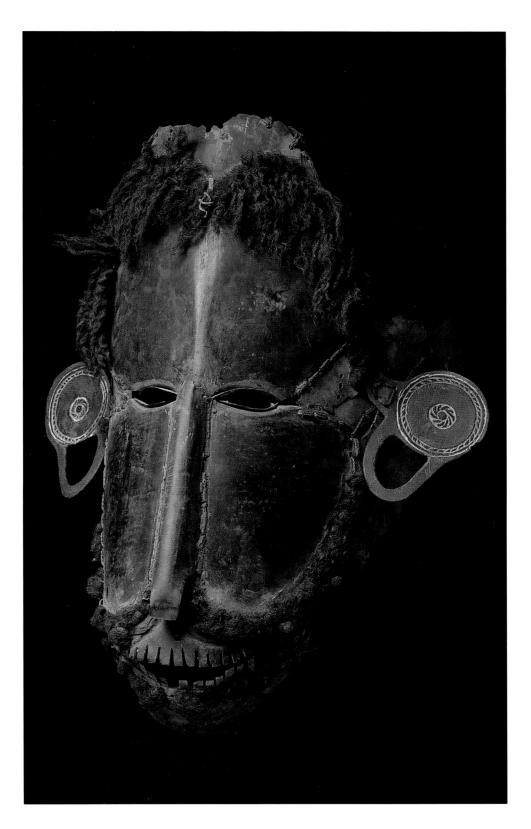

## 2 Arrow foreshaft

Hardwood. Traces of paint. Known as *parulaig* or *parag* in the western islands and *opop* in the eastern islands. The figure is in the style of the mainland Daudai area, the best-known examples of which are wooden statuettes with oblong faces and angular bodies. Haddon wrote that he knew of only two figures shown complete (including the feet) on an arrow shaft. Douglas Newton has published this piece (1995), giving Binaturi River, New Guinea, as its place of origin. Length 21.5 cm. Inv. 4243.

## 3 Mask

Turtle shell, freshwater shells, cassowary feathers and quills, nuts, and fiber for the face, placed over a base cut out of a disused metal can. The neck is held in place by a belt imported from the Gulf of Papua. This famous piece was collected in 1871 or 1872 by the Reverend S. McFarlane and sold by E. Gerrard to Dresden a few years subsequently. It was described (but not reproduced) by Mayer in 1889 (p. 3, no. 6361) and reproduced by D. F. Fraser (1978, fig. 10). Mabuiag Island. Formerly McFarlane Collection, then the Staatliches Museum für Völkerkunde, Dresden. Length 50 cm. Inv. 4244.

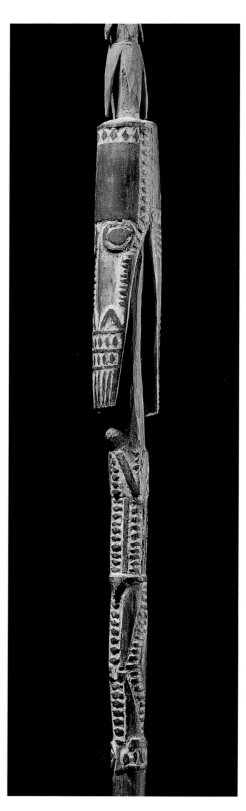

4 Initiation ceremony with mask dance in the Torres Strait Islands. The fish-shaped turtle-shell mask in the center is similar to the one in the British Museum. Drawing A. C. Haddon, 1901–35. Barbier-Mueller Archives.

usually performed at night by the light of camp fires. The dances were accompanied by the steady beat of the drums and the chanting of events from the myths. They were designed to impress and even terrify the participants, and they doubtless performed this function very efficiently.

**Other Forms of Art**

Much less well known are the stone carvings of the Torres Strait Islands. These were made mainly in the eastern islands. Natural volcanic stones or coral pieces bearing a resemblance to human faces or figures, or to sea and land animals, were used in various forms of magic, such as rainmaking or promoting garden growth. Often, however, such objects were skillfully carved to enhance their appearance. For example, carvings of pregnant women were made to be placed in the camp when everyone was away. This was supposed to keep the fires alight. Some carvings were believed to represent the ancestors and confer magical powers on the user.

Many objects were carved in wood and painted with ocher to represent animals or humans. These were carried in ceremonial or magical dances. Lifelike human figures were made from wood, bamboo, reed, and plant fibers for both hostile and live magic. Articles of personal adornment were also elaborately carved and incised with geometrical patterns. Ear and nose ornaments were widely worn; necklaces and pendants of turtle shell, pearl-shell, and conus shell were common; belts were elaborately woven and decorated.

Ceremonial headdresses for war and dance were worn by the men. The traditional *dari* headdress consisted of large white seabird

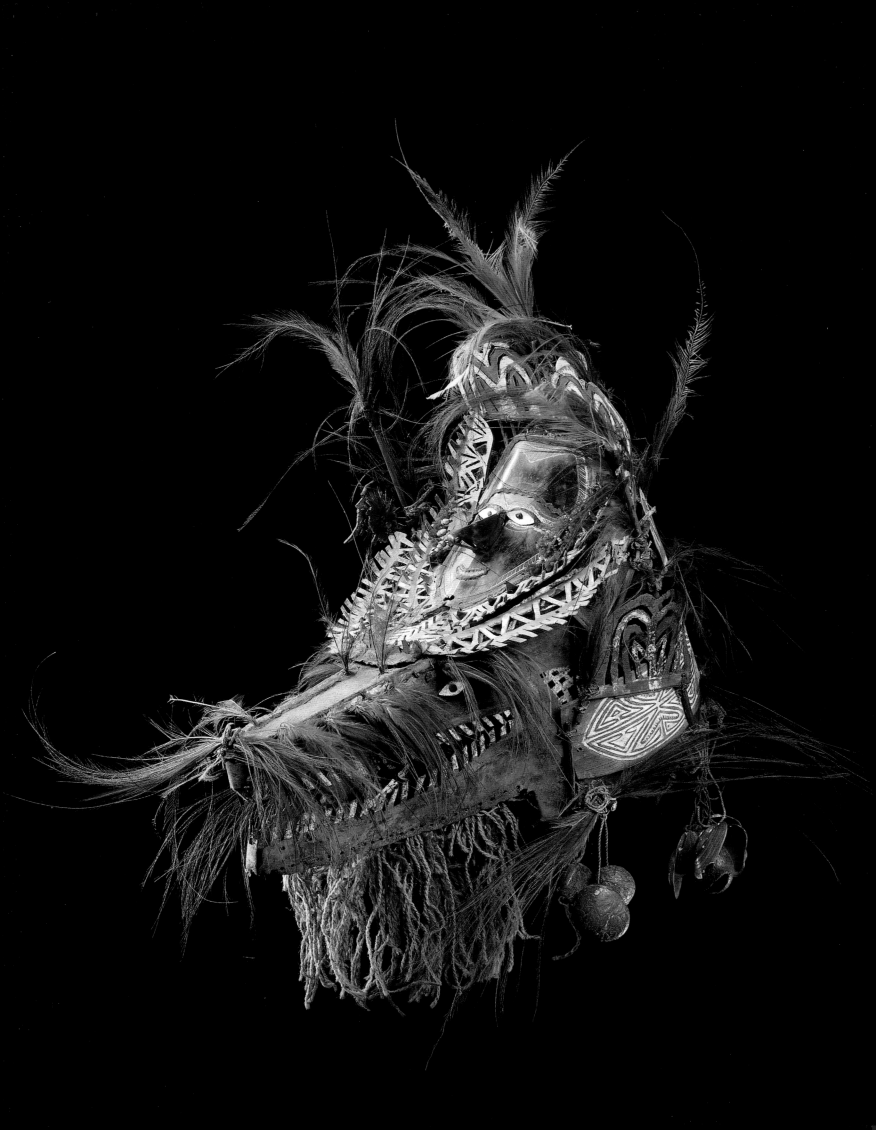

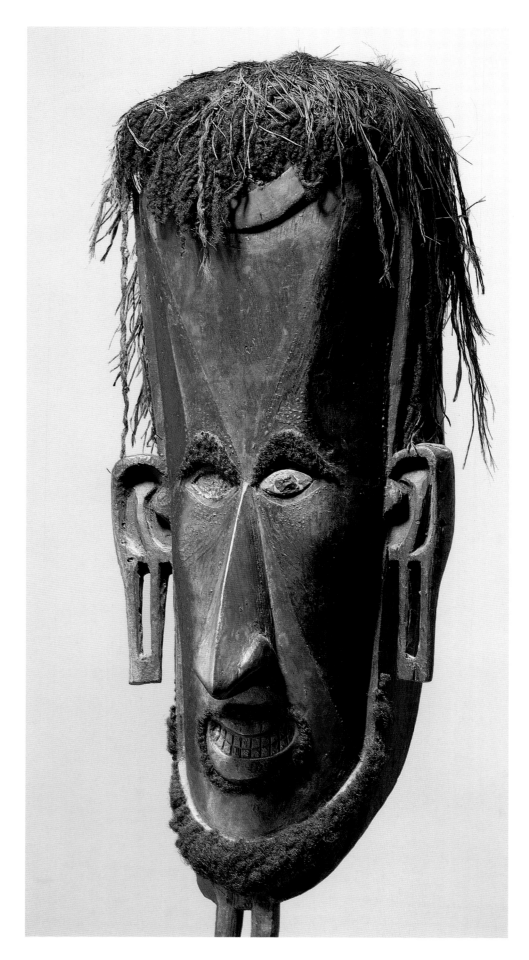

feathers woven into a fiber. The other type was made of cassowary feathers sewn into a narrow headband.

The women were responsible for all woven artifacts, such as bags, mats, and the large sails of the canoes, which were made from woven strips of pandanus leaf.

**Imported Artifacts**

Many of the most important possessions of the islanders were obtained by trade from Papua New Guinea. Chief among these were their canoes. Hollowed-out tree trunks up to 15 meters in length were brought from the Fly River in single-outrigger form. The islanders added a second outrigger and washstrakes, and rigged them for sailing. They adorned the hulls with incised decoration and added various attachments. These canoes, which could carry up to about twenty people, were beautiful and very seaworthy. The big *warup* drums were also imported from New Guinea, but again were decorated and added to by the islanders (fig. 6). Bows and arrows (fig. 2) and stone clubs also came from the Papuans, as well as cassowary feathers, bird-of-paradise plumes, and pig tusks, which were all used in body decoration. In return, the islanders paid pearlshell and conus shell pendants, turtle-shell ornaments, and, on occasion, human heads restored with clay and shell. These were passed from island to island in a reciprocal system, until at last the original purchaser received the object traded for. He then had to continue payments for up to three years.

**Aesthetic Aspects**

Almost every artifact the islanders used was decorated with incised or painted designs.

Wood, human hair, fiber, and mother-of-pearl for the eyes (left eye missing). Traces of paint. According to Haddon (1913, p. 297), such masks were used during the *mawa* ceremonies designed to ensure a good harvest of *ubar* fruit (a sort of wild plum). D. F. Fraser states that twenty-two wooden masks of this type, in addition to this one, are known. Saibai Island. Formerly collections of Melbourne Aquarium (before 1900), then Frederick Cooper Smith (Mount Dandenong, Melbourne). Height 69 cm. Inv. 4241.

Hardwood. Cassowary quill, nuts, and seeds. The incised decoration represents a masked figure (?) and sharks. Nineteenth century. Length 91 cm. Inv. 4240.

Common are zigzags, V-shapes, dots, stripes, triangles, and stars. Their bamboo smoking pipes and musical instruments, such as clappers and rattles, were almost invariably highly decorated. Such decorations often included human and animal figures, and even landscapes.

The origin of Torres Strait art, and of these designs in particular, has not been much investigated since Haddon's original work. However, in 1978 Douglas Fraser published *Torres Strait Sculpture: a Study in Oceanic Primitive Art*, which was based on his Ph.D. thesis (completed in 1961) and dealt solely with the masks. Fraser considers Torres Strait art as having derived from Chinese art of some 3,000 years ago. This is a somewhat dubious claim, considering the thousands of kilometers between the Torres Strait and China and a time span of 3,000 years. One would have to establish a definite line of

development between the two areas before seriously considering such a theory.

Although Pacific art in general probably derives originally from mainland China, the infinite regional variations which have developed over such a great span of time mean that it is now not possible to claim definite prehistoric origins for the art of any Pacific area.

Torres Strait art is a unique entity, although drawing to some extent on adjacent Papuan styles, and forms a self-sufficient complex of its own. Only the Torres Strait Islanders manufactured the remarkable turtle-shell masks and headdresses, and only they produced the beautiful incised pearlshell and conus shell personal decorations, which were eagerly sought by their neighbors.

Interestingly, there is at present a revival of art production in the Torres Strait, partly stimulated by recent anthropological work and publications. Let us hope that the islanders will soon resume production of their masks and carvings for us all to enjoy, and that they might even sail once again the blue waters of the Strait in their magnificent canoes.

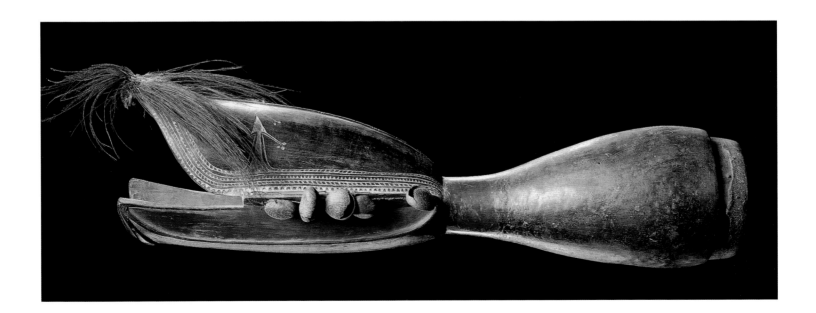

# The Admiralty Islands and the Northwestern Islands

Douglas Newton

The Admiralty Islands lie to the north of Papua New Guinea and form part of that country. The largest is the mountainous Great Admiralty Island (a name bestowed by Carteret in 1767), or Manus Island, with an area of about 3,000 square kilometers. This is surrounded by a number of far smaller islands. Some, low-lying, are in the Bismarck Sea, to the east and southeast. In the ocean to the west is the scattered group of islets and atolls known as the Northwestern Islands. All these are administratively included in Manus Province.

## The Admiralty Islands

Although the population of the Admiralties consists of speakers of about twenty Austronesian languages in four families, they are popularly divided into three major groups (the terminology reflects Manus usage): the Ussiai, the inland people living on the Great Admiralty; the Matankol of the islands; and the smallest group, the eponymous Manus of the southeast Great Admiralty coast and some outposts on the islands. The population now numbers about 20,000, having roughly doubled in the twentieth century. The society was based on patrilineal clans, and great reverence was accorded to ancestors. Religion was in fact based on fear of recent ancestors, whose ghosts were believed to punish breaches of the rather strict moral code. Their influence was not eternal, however: they suffered from obsolescence as they retreated into the past, to be replaced by more recent spirits.

Shortly after World War II, a widespread and abrupt rejection of tradition developed throughout the area, resulting in the destruction of what remained of its culture, material

1 Matankol stilt houses. Barbier-Mueller Archives.

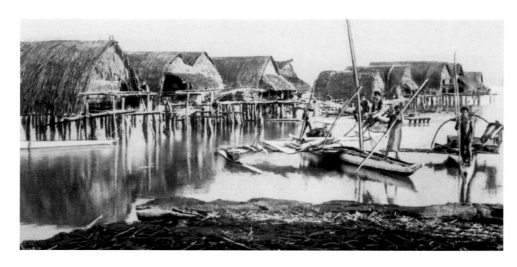

2  **Bowl**

Hardwood. Carved in the shape of a bird, standing on four short feet of circular section. Acquired by Josef Mueller in Paris before 1942. Length 47.5 cm. Inv. 4402-C.

3  **Large hemispherical bowl**

Hardwood. The handles are as usual carved separately and added on (tips restored). Matankol people. Lou Island. Formerly Herz Jesu Hiltruper Mission Collection, Hiltrup, near Münster. Length 101 cm. Inv. 4402-A.

and otherwise. Some aspects, however, are now being revived.

While, from the Western point of view, the Admiralties were discovered by the Spanish navigator Alvaro de Saavedra in 1529, and again by the Dutch navigators Schouten and Le Maire in 1616, its indigenous history is far older. They are now known to have been inhabited for at least 5,000 years by people who were evidently skilled sailors. Obsidian, or volcanic glass, which takes a razor-sharp edge, is widely used in Melanesia, wherever it is available, for cutting tools and weapons. It is found in plenty in shaft mines on the small islands of Lou and Pam, whose inhabitants were trading it to Manus by 4,500 years ago. By whatever means, the material was carried even further to New Guinea and New Ireland. This was an early manifestation of the trade in many types of product which was a prominent feature of Admiralties culture. Each group relied on the others for some items of food and manufacture; trade was accordingly active and frequent.

Thus the Matankol were the primary producers of wood carvings and decorated objects, each island having its own specialties. Baluan made bird-shaped bowls (fig. 2), ladles, and spatulas; Lou employed its obsidian sources for the blades of spears (fig. 4) and daggers, and great carved hemispherical bowls (fig. 3); Rambutyo made figures and lime spatulas; Pak made beds (used nowhere else in Melanesia) and slit gongs. Although the Matankol were neither culturally nor linguistically homogeneous, the style of their art shows a considerable uniformity. Surface designs consist largely of repeated triangles, diamonds, rectangles, and opposed curves, often in bordered bands, sometimes in openwork or

relief. These busy, if repetitious, patterns are often accented in black and white on expanses of red background, and they are generally employed as strips or in small areas rather than covering an entire object. An important and frequently used motif in three-dimensional carving is the openwork scroll.

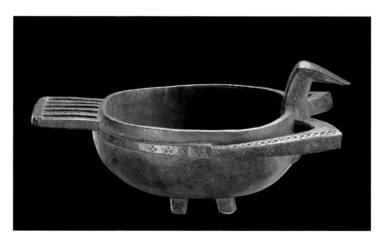

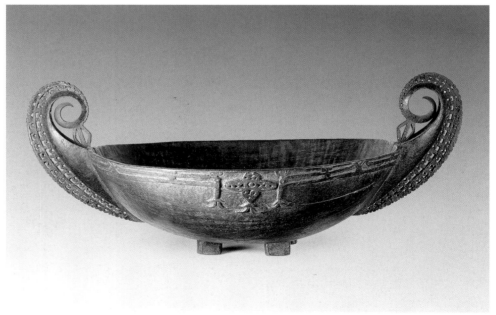

**4 Ceremonial spear foreshaft**

Hardwood. The obsidian tip surmounts a finely carved body of a man. Incrusted with little shells. Fiber. Red, black, and white paint. Matankol people. Height of part shown 67 cm. Inv. 4408.

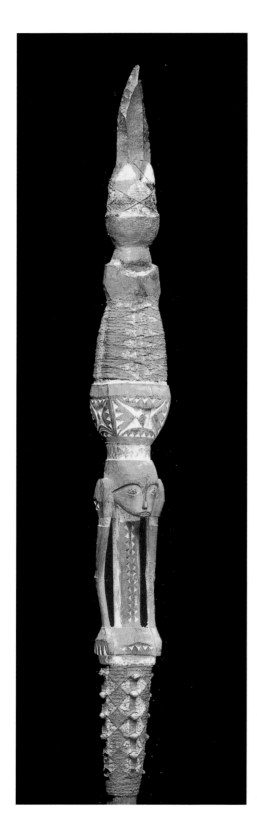

The architecture of the Admiralties was varied. The Ussiai built hemispherical or oval houses. The coastal and island groups had rectangular houses with convex roofs, often in the form of pile dwellings offshore over the water (fig. 1). External house ornamentation was rare, except for some decoration of the gables, but the men's ceremonial houses had carved doorjambs, larger-than-life-size male and female figures, probably of ancestors, placed on either side of their doors, and houseposts carved as human or animal figures.

The human figure is nearly always shown standing, with the arms hanging straight down and the hands either free or placed on the hips (fig. 6). Torso and limbs tend to be square in section, but with angular calves. Pattern bands indicate tattooing and ornaments. Heads are ovoid and the mouth is often set at a right angle to a prognathous, muzzlelike face. A male hairstyle is summarized as a cylinder capped with a sphere rising from the top of the head.

House ladders also terminate in human or crocodile figures, as do the frames and legs of the beds, which were used as girls' dowries and symbolized marital fidelity. Like many other Melanesian peoples, the Admiralty Islanders made slit gongs, which they played in ensembles of five. Some of them have the upper part of the human figure carved as a projecting lug, with the legs at the gong's other end. Open scrolls, birds, and human figures are also the themes of canoe prow and stern ornaments.

Among the most impressive Matankol objects are the hemispherical bowls (fig. 3) on four short legs, equipped with a pair of spiral handles representing crocodiles' tails, opossums' tails, or a kind of seashell. These

**5 Bowl**

Hardwood. The handles are carved into stylized figures. Formerly George Ortiz Collection. Length 47 cm. Inv. 4402-D.

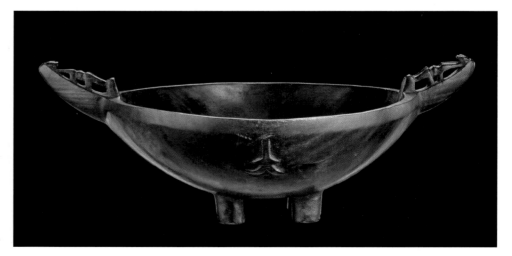

Wood. Red, black, and white paint. Showing two figures standing back to back. Myths whose heroes are twin brothers are current in a number of regions in Melanesia. Probably Matankol people. Height 37 cm. Inv. 4406.

handles were carved as separate pieces and attached with bindings and the adhesive made from crushed parinarium nuts. Pattern bands are carved around the rims. Large versions, which can measure up to well over 1 meter in diameter, were used as feast-food containers; small bowls were hung up in Manus houses to hold ancestral skulls. Other types of bowls are carved in representational style as ducks, dogs, and opossums, while others have figures as handles.

The standard repertoire of abstract and representational motifs is also applied to domestic objects such as coconut-shell oil jars and water bottles, or adapted to small carved objects such as ladle handles and openwork boards carried in dancing. Some patterns are also engraved on bamboo lime containers and shells worn on the penis for war dances.

Gourds (fig. 7) to hold lime for betel-nut chewing carried pyrographed designs. The small wooden spatulas used with them were undoubtedly the most exquisite carvings made in the area (fig. 10). The terminals show crocodile heads, sometimes with human heads or figures emerging from their jaws, and human standing figures, often above what appear to be, as in this case, spearheads.

The most striking of all body ornaments from the Admiralty Islands was worn by prestigious homicides (figs. 8, 9). These are bundles of long black frigate bird feathers, notched and trimmed, attached to small carved heads or figures. Hung at the nape of the neck, they stretched upward at an angle to the man's body.

The primary weapons were spears and daggers, although bows and arrows were

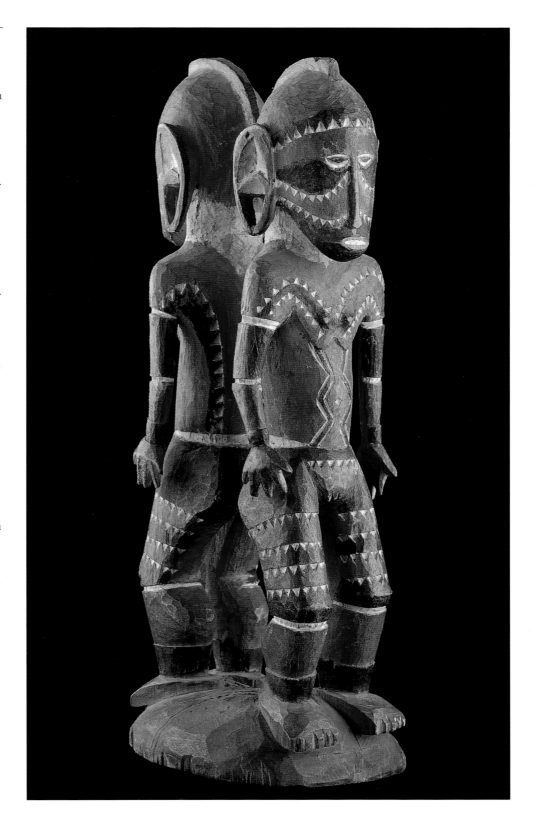

## 7 Gourd

Decorated with pyrographed curvilinear patterns. The spatula (which also survives) is in hardwood. It portrays a highly stylized figure, although it is impossible to make out. Matankol people. Overall height 43.1 cm. Inv. 4409.

## 8 War charm

The hardwood torso is affixed to partially notched and trimmed frigate-bird feathers. Traces of paint (red, black, and white). Matankol people. Acquired by Josef Mueller in Paris before 1939. Height 40 cm. Inv. 4407.

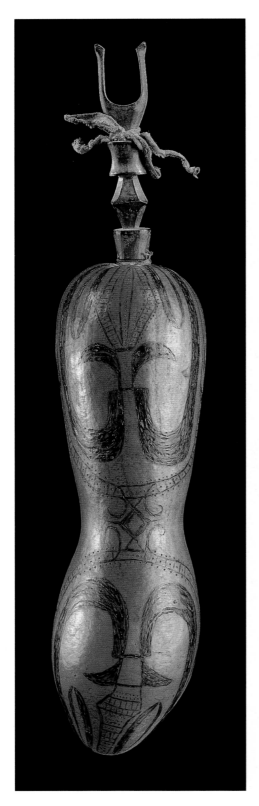

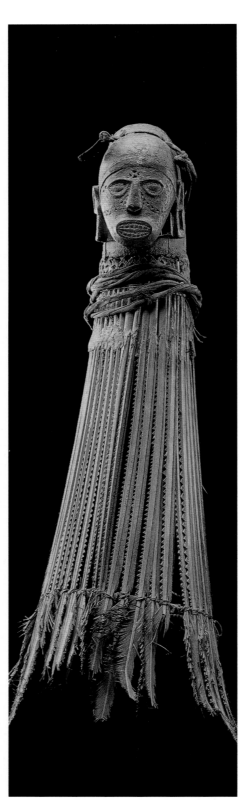

also used. About 2 meters long, the spears were tipped with patterned foreshafts or carved human figures and obsidian blades. The stubby daggers also had obsidian blades mounted on short handles.

Admiralty Islands art, generally speaking, seems to have been secular and decorative, without the passion of other Melanesian and New Guinea styles. Perhaps this was partly due to the nature of their religion, which was restrictive rather than inspiriting. The general impression created is of an art that is sturdily elegant, practical, and emotionally somewhat neutral.

## 10 Lime spatulas

Hardwood. One hung with fiber and pieces of imported fabric. Beneath the feet of the figures (who wear war charms on the napes of their necks, visible on the one to the right) are carved serrated hooks representing spearheads. Matankol people. Left: acquired by Josef Mueller in Paris before 1939. Right: acquired from Charles Ratton by Dr. Rudolf Schmidt (nephew to Josef Mueller) at the end of the 1930s in Paris. Heights 47.5 cm, 53.5 cm. Inv. 4401-A and B.

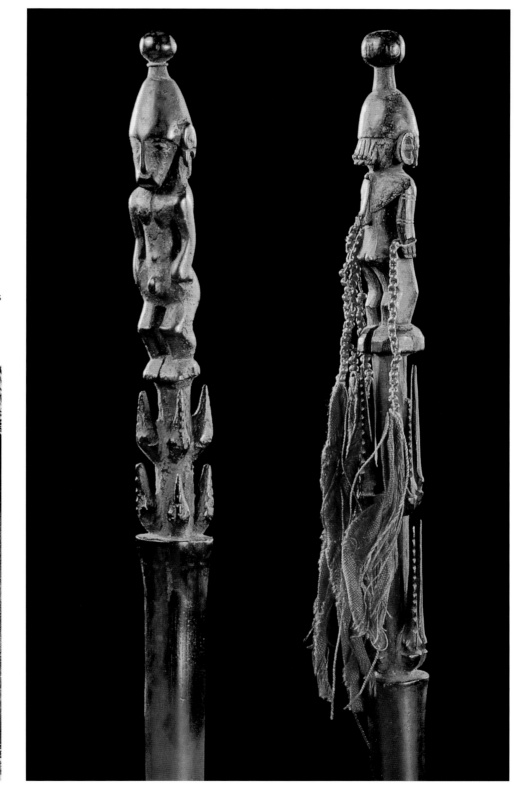

9  Matankol man wearing a war charm hung on the back of the neck. In former times, such charms would have been made of the thigh bone of an ancestor with attached feathers. Photograph Hans Nevermann, 1934.

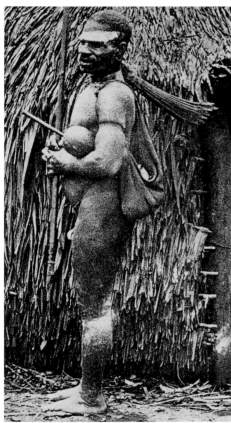

# New Ireland

Louise Lincoln

The Pacific island of New Ireland, a province of Papua New Guinea, arcs in a gentle curve around the northeast tip of neighboring New Britain, defining a portion of the outer limit of the Bismarck Archipelago (see map p. 224). In language, economy, and cultural practice New Ireland is closely linked to its island neighbors, while at the same time containing considerable internal diversity: seventeen distinct languages in use, a clearly marked division between coastal and "bush" (i.e., high-land) peoples,[1] several distinctive artistic traditions, and at present a measure of tension between "traditional" and contemporary lifestyles.

New Ireland is probably best known to the rest of the world for the ornate and inventive sculptural style of the northwest region, which proliferated astonishingly at the end of the nineteenth century. Examples of this style are widely dispersed in museums throughout the world. These wooden sculptures, known as *malagans*,[2] formed a component of an eponymous ceremonial cycle that defined and regulated social interactions and economic relations. While different sculptural styles prevailed in other parts of the island—large hermaphroditic *uli* figures in central New Ireland (fig. 2) and small limestone or chalk figures at the southern tip (fig. 3)—*malagan* sculptures are the most numerous, the most thoroughly studied, and the most spectacular.

New Ireland boasts a remarkably long history of human habitation, dating back more than 33,000 years ago to the Pleistocene epoch.[3] Considerably later, in the first millennium B.C., the Bismarck Archipelago and New Ireland in particular formed an important early staging area for the diffusion of the so-called Lapita culture—successive waves of mariners who

successfully colonized a vast sweep of islands extending eastward as far as Samoa and whose signal characteristic is a distinctive form and decoration of pottery. While the duration of Lapita domination remains controversial,[4] it is clear that its imprint remains important for understanding the subsequent development of the region.

Against such a deep context, the history of New Ireland over the past several centuries, a time of increasing contact with the outside world, seems brief but nonetheless turbulent. It is not possible to ascertain which navigator first laid eyes on the island, probably at the end of the sixteenth century, but by the early seventeenth century Jakob Le Maire, Abel Janszoon Tasman, and William Dampier had all passed and noted the landform. Tasman included in his log of 1643 a detailed drawing of men in a canoe, their distinctive equipment and body decoration already recognizable.[5] The English navigator Philip Carteret, passing the island in 1767, assigned the name New Ireland because of its proximity to the larger island he had already named New Britain.

By the first half of the nineteenth century, European and American whaling ships were pursuing their catch in the region, and New Ireland in particular, with its long and relatively navigable coastline, received numerous trading parties from the boats. Half a century later, German companies in quest of another oil source began to establish coconut planta-tions on New Ireland and nearby islands, recruiting thousands of New Irelanders as laborers. Claimed as part of the German protectorate in 1885,[6] the island was ceded to Australia at the close of World War I. In 1977 it achieved a new status as part of the independent nation of Papua New Guinea.

In the period of early contact, northern New Irelanders, like many other groups in the region, were organizing their social and religious expressions around a cycle of mortuary ceremonies. Known locally as *malagans*, these events were precipitated by the death of a prominent person (usually male) and could last over several years. Relatives greeted the death itself with intense mourning; the body was sometimes cremated or interred, sometimes placed in a remote cave, or sometimes put out to sea in a small boat. However, the death was not considered "finished" until the surviving relatives had organized a massive commemorative event involving feasting, oratory, dance and music performances, the distribution of gifts, and, in the culminating moment, a display of sculpture made especially for the occasion. It is the importance given to artistic production and display that most distinguishes traditional northern New Ireland ceremonial life from that of its neighbors.

Yet *malagans*—the events and the sculptures —were more than memorials to the dead. They were extremely expensive to organize and entailed reciprocal obligations among guests to the extent that they played a major role in the local economic structure. They provided an opportunity to initiate young boys (and, less formally, girls as well) into adult ceremonial roles. Because *malagans* brought together guests from neighboring villages as well as the host family, they were an appropriate venue in which to negotiate and settle various legal disputes, to manipulate political power, and to reintegrate the social fabric following the loss of the deceased. Finally, they provided through the sculptural display a material representation of family and clan relations, a reinforcement of the importance of lineage.

1  **Mask**

Wood. Red, black, and white paint. Fiber hair. Probably from the south of the island, this mask shows cultural and stylistic affinities with the eastern tip of New Britain, whose inhabitants (the Tolai) are Melanesians who once emigrated from New Ireland. This mask is to be compared particularly, for example, with the one reproduced in fig. 14 of the following chapter, which came from Duke of York Island. Formerly Professor Czeschka Collection (Hamburg). Height 33 cm. Inv. 4320.

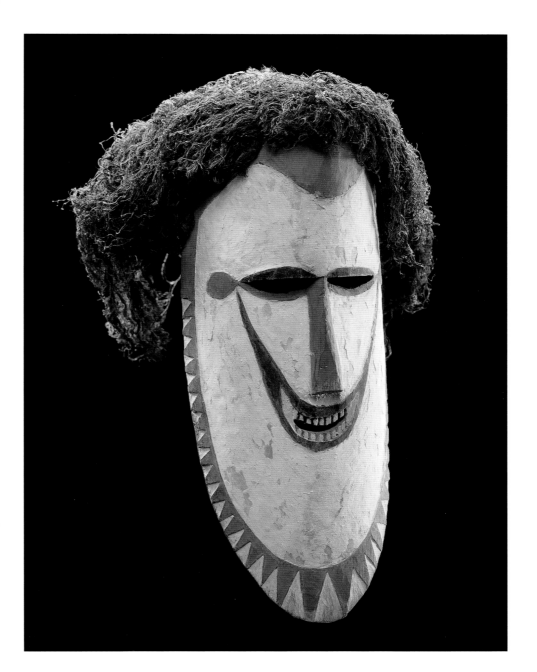

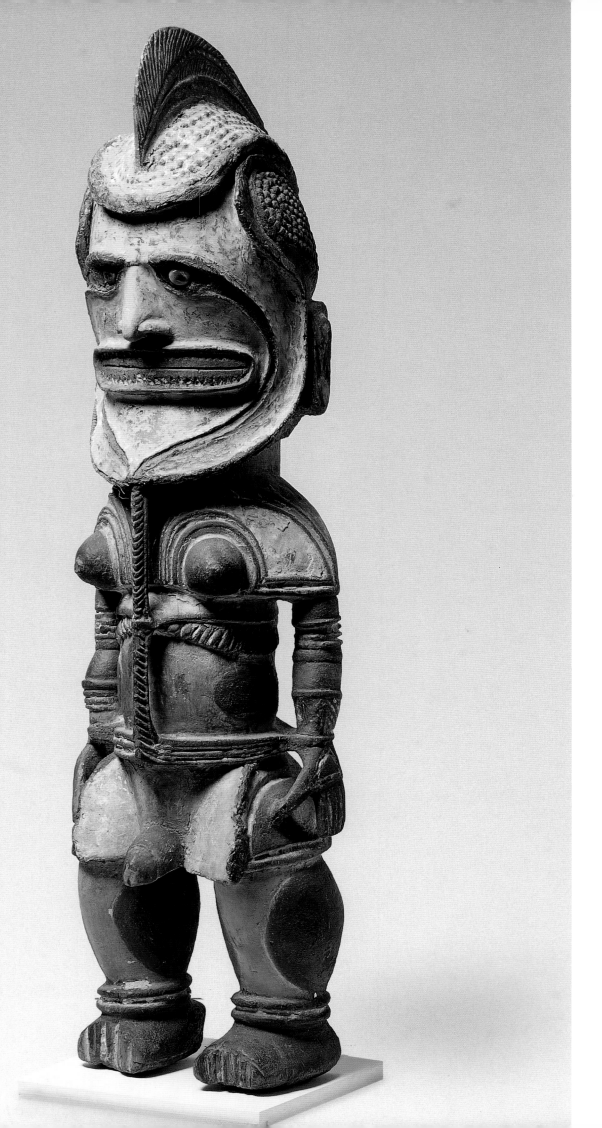

## 2 Ancestor figure (*uli*)

Hardwood. Traces of red, black, and white paint. The face has been overmodeled with black beeswax. Formerly Serge Brignoni Collection (Bern, acquired from a German museum), Charles Ratton (Paris), Jay Leff (Uniontown, Pennsylvania). Height 89 cm. Inv. 4313.

## 3 Carving (*kulap*)

Chalk. Representing an ancestor. Central New Ireland. Collected about 1890. Formerly Webster Collection, then Pitt-Rivers Museum, Farnham, Great Britain. Overall height 75 cm. Inv. 4317-B.

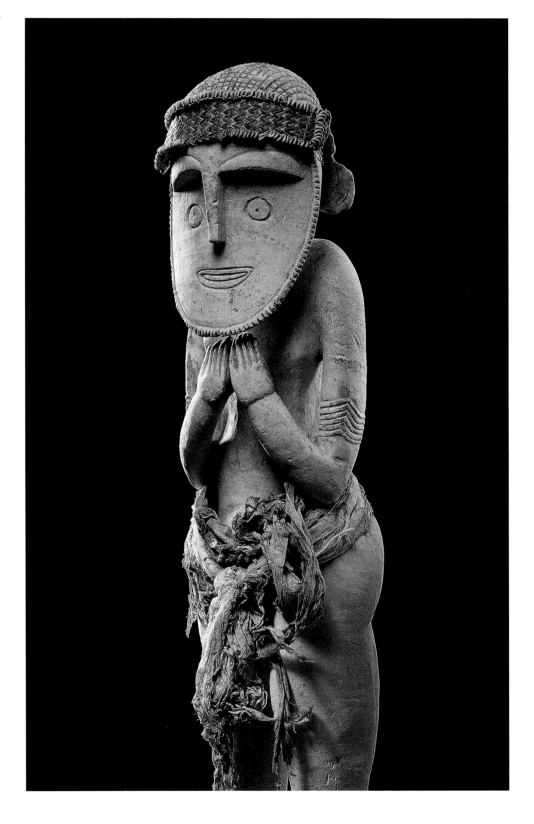

### 4  Ancestor skull

Overmodeled with a mix of earth and resin.
Eyes made of shell. Red, black, and white paint.
Northern area of the central part of the island.
Collected by the Consul Max Thiel, prior to 1907.
Formerly Linden-Museum, Stuttgart. Height
25.5 cm. Inv. 4332.

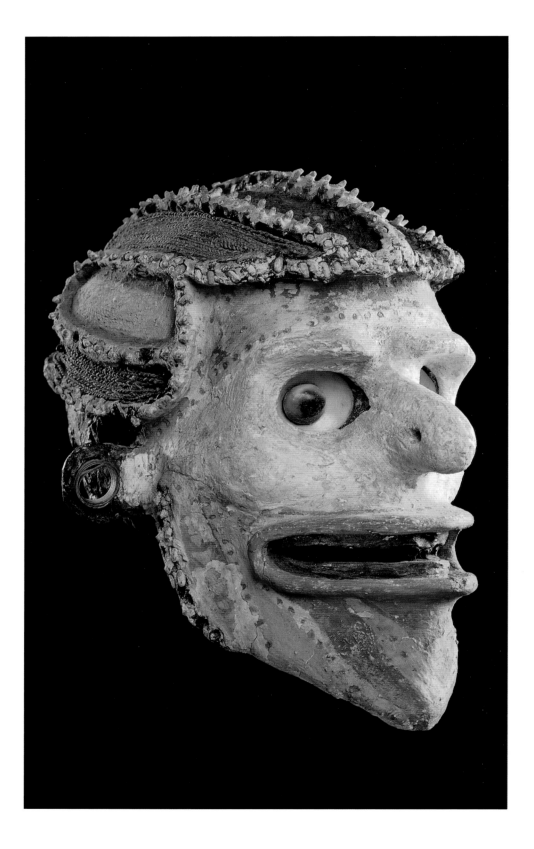

5  **Large *malagan* mask**

Wood. Painted face blackened with wax. Fiber
hair. Collected by Giovanni Bettanin before 1898.
Formerly Ethnographic Museum, Budapest.
Height 102 cm. Inv. 4337.

Preparation of the sculptures took place in
secret. The organizers commissioned a
sculptor to come to the village, sometimes
from a considerable distance if his reputation
warranted it. In a temporary enclosure sur-
rounding the men's house he carved and
painted the sculptures, assisted by family
members and guided in the design of the
pieces by his patrons. On the final day of
the *malagan* ceremony, the fence was opened
to reveal the finished works formally grouped
against a screen wall, an event comparable
in its physical and temporal structure to a
contemporary gallery installation.

Objects associated with *malagan* ceremonies
may be grouped into two general categories.
Performance objects, such as dance masks
and other paraphernalia, were often retained
and reused, while display objects, made for
a specific occasion, were discarded and
"remade" from memory at the next event for
which a particular image might be required.
The masks fall into relatively clear categories,
with canonical characteristics—*tatanua*
headpieces, made in series for line dances,
have fiber crests, *wanis* masks representing
bush spirits often have slanted eyes, and so
on. Some complex masks are also called
*malagans*. Others from the south and off-
shore islands are strikingly different, such
as the *lali* from the southeastern part of New
Ireland (fig. 7) or from Lihir Island (fig. 8).

Display objects are not so easy to classify, how-
ever. Drawing on a commonly held repertoire
of design motifs, prominent men might dream
of a new configuration of images, and then
commission a sculptor to make the piece for
an appropriate occasion. Humans, fish, birds,
snakes, pigs, and combinations of these
make up the bulk of New Ireland sculptural

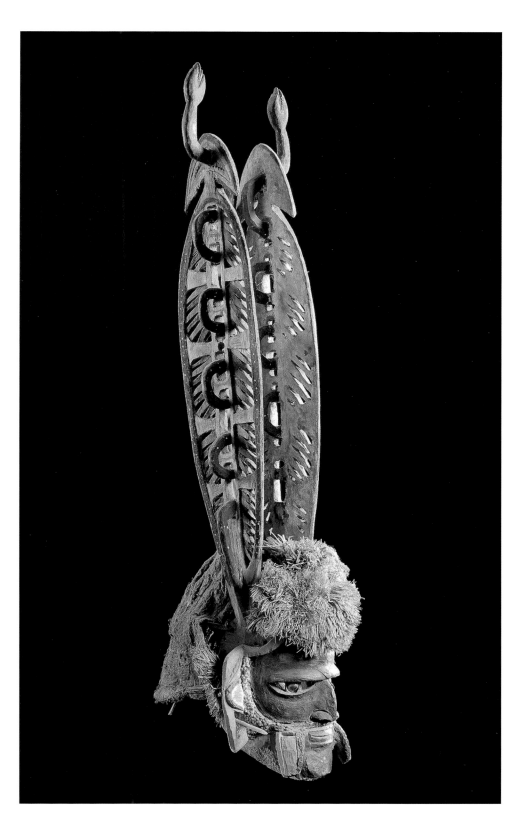

## 6 Large *malagan* mask of the *kepong* or *ges* type

The face is in painted wood. The nose (showing a bird holding a snake) was separately carved. The hair and beard are indicated by vegetable fiber. The smaller ear is made of wood, the large one being in rattan covered with barkcloth painted with a design in three colors. Formerly Heinrich Collection (Stuttgart). Height 106 cm. Inv. 4307.

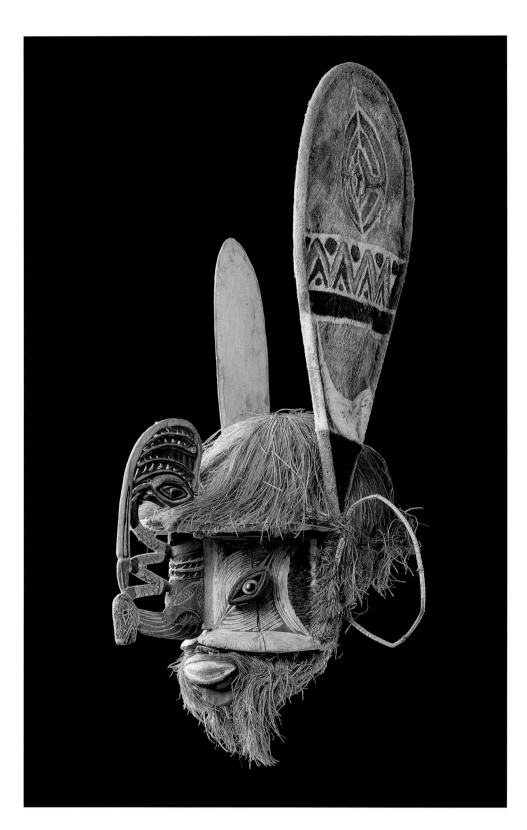

imagery. A single piece might incorporate clan symbols, ancestral figures, and a narrative reference to an event. Once made and displayed, *malagans* were understood to be owned by the dreamer, who might transfer the right to make the piece to someone else, often a younger male relative. In other words, the design itself was property that could change hands, even if there was no version of the sculpture extant (figs. 13, 14).

In form these display *malagans* show considerable variation, featuring standing figures, multifigured poles, horizontal friezes (fig. 12), and even representations of large fish or canoes filled with oarsmen. In style, however, they share a common vocabulary: the intertwining or collapsing of multiple animal and human forms; an interest in exploiting sculptural voids through virtuoso openwork; the use of snail opercula to represent human and animal eyes; and an overlay of dazzling surface pattern and ornament, often seemingly unrelated to the form beneath.

It is interesting to note that aspects of this late-nineteenth-century style are already evident in Tasman's drawing of 1643: the protruding, upwardly folded tongue; the ridged open-work coiffure; the lidded eyes; and the use of overlaid surface pattern. In the precontact period, these effects were probably achieved through the use of obsidian or shell blades and sharks' teeth, together with charring and abrasion. The earliest European contact introduced metal blades, however, which not only made the process easier but also allowed artists to push already existing stylistic conventions, such as openwork and assemblage, to greater heights. This change in technology, together with drastic economic changes,

stimulated an artistic florescence that is nothing short of astonishing.

In northern New Ireland sculpture, European sailors, missionaries, and colonial officials found all of their expectations of the South Seas fulfilled. It was, to their eyes, exotic, alarming, and "savage," and they bought or otherwise obtained it in impressive quantities from the 1880s through World War I. [7] In the trading centers, Europeans eagerly bought sculptures "the more bizarre the better"; it appears that many of these were not figures dreamt and then circulated in the ritual system and prestige economy of *malagan* ceremonies, but rather confected images that did not "belong" to anyone and were invented to sell.[8] Their interest may have briefly sustained the carving tradition even as the practice of *malagan* ceremonies was beginning to wane, as a result of population decline and the effects of Christian missionary work.

In the period following World War I, the effect of colonization in New Ireland became more acute. Missionaries actively worked to suppress traditional religion, including *malagans*. Labor was diverted from subsistence activities to coconut plantations and, in more recent years, to the extractive industries: timber harvesting and goldmining are changing not only the social and economic interactions of New Irelanders, but the landscape itself. Yet aspects of traditional life persisted, sometimes covertly, sometimes in new forms.

The move to independence in 1977 brought to New Ireland as to other areas of Papua New Guinea a quickened interest in traditional ways. The number of *malagan* ceremonies organized is increasing and so, as a consequence, is the demand for sculpture. At the

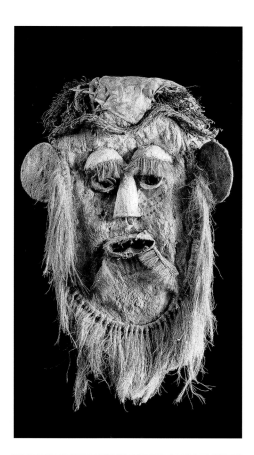

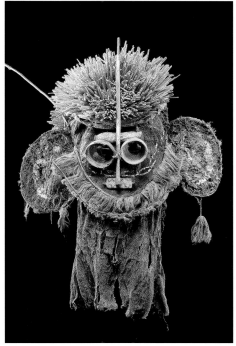

7  **Mask (*lali*)**

Barkcloth. Fiber. Vegetable material. Imported fabric for the headcloth. Although very little is known about these masks, we can see similarities in the row of dots painted on this one compared with some of the chalk *kulap* figures which originated in the northern part of southern New Ireland. Muliama region (southeastern part of the island). Collected by Richard Parkinson prior to 1909 and transferred by him to Professor Czeschka. Height 65 cm. Inv. 4316-1.

8  **Mask**

Painted barkcloth, coconut, fiber, woven pith, wood, and rattan. According to Richard Parkinson (Gunn 1997, p. 82), its vernacular name is *malangane*. It is one of the few artifacts to have come from Lihir Island east of New Ireland. Collected by Richard Parkinson prior to 1909. Formerly collections of Heinrich (Stuttgart), Charles Ratton (Paris), and Morris Pinto (Paris). Height 60 cm. Inv. 4310-B.

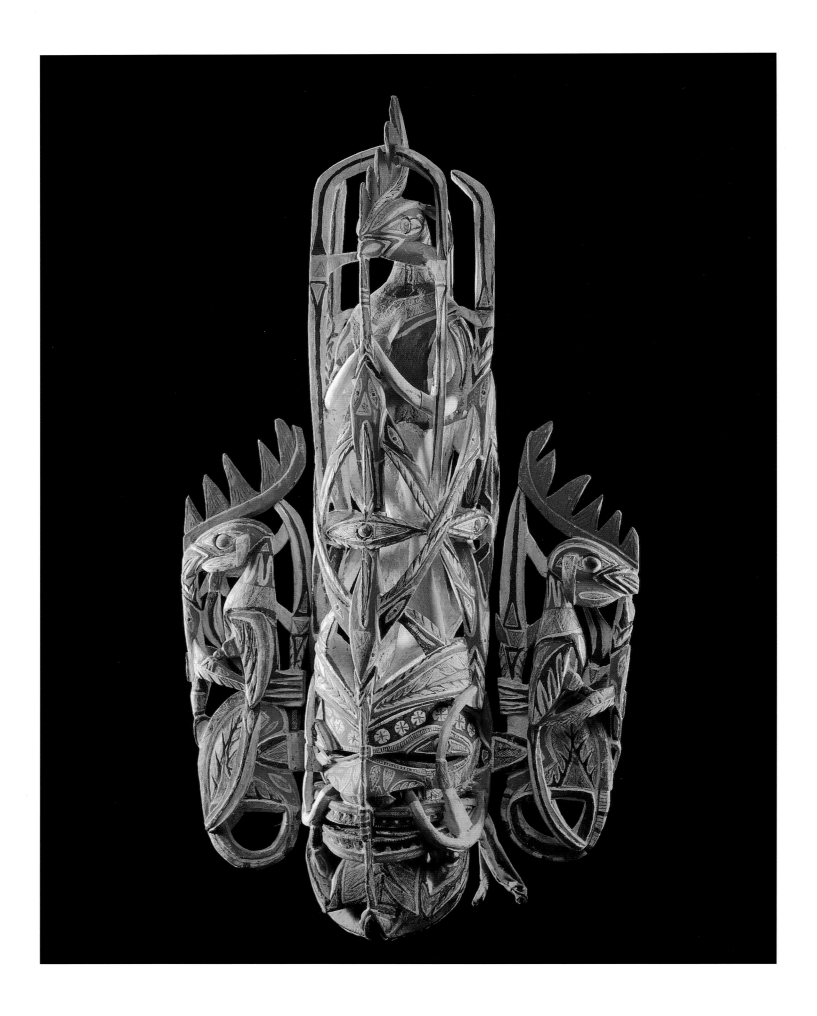

## 9  Large *malagan* mask of the *matua* type

According to Gunn (1997, p. 136), these "walking" masks were employed to suspend certain taboos at the end of a ceremony. Collected by Richard Parkinson and donated by him to the Königlichen Ethnographischen Museum, Dresden in 1895. Height 82 cm. Inv. 4318.

## 10  Architectural panel

From a house in which a girl had been confined at puberty. Pakail village, Tigak language area. Northern New Ireland. Collected by Eduard Hernsheim about 1880. Formerly collections of Dr. C. Gerlach (Hong Kong, about 1882), Museum für Völkerkunde, Frankfurt, and Arthur Speyer (Berlin). Height 105 cm. Inv. 4343.

## 11  Anthropomorphic carving (*totok*)

Wood. Red, black, and white paint. Sea-snail shell opercula. Fiber. Seeds for the hair. These ancestral effigies were carved on the occasion of the great *malagan* feasts and subsequently abandoned. Collected from Cape Sass in the Kora region by Richard Parkinson before 1894. Formerly Königliches Ethnographisches Museum, Dresden. Height 133 cm. Inv. 4328.

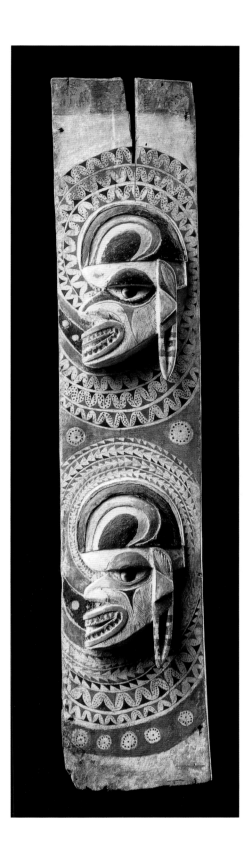

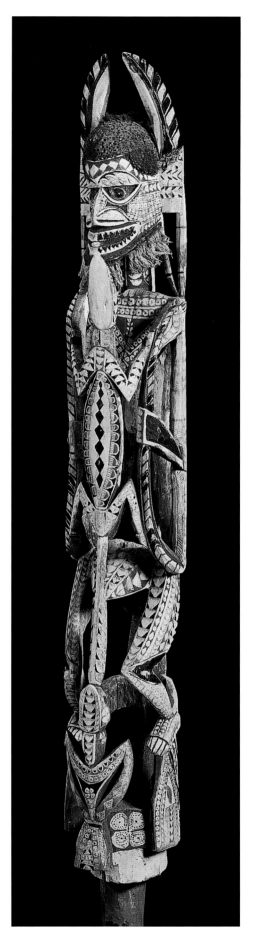

## 12 Large frieze (*vaval*)

Openwork wood. Red, black, blue (Reckitt's blue), and white paint. Horizontal *malagan* are sometimes symmetrical, as in the present example, and sometimes asymmetrical. They were exhibited formally and placed one above the other in huts specially built for the ceremonies. *Malagan* rites were supposedly invented on Tabar. Recovered by Richard Parkinson prior to 1896 on Simberi Island, part of the small Tabar archipelago to the northeast of New Ireland. Formerly collections of the Königliches Ethnographisches Museum, Dresden, Serge Brignoni (Bern), and Samuel Josefowitz (Lausanne). Length 196 cm. Inv. 4335.

same time, a growing interest in Europe and North America in "exotic" art has helped to open overseas markets. In some places on New Ireland carving is being taught formally; in others sculptors find they have willing apprentices, some of them women.

The visual complexity of *malagan* sculpture is echoed by its iconographic richness. Whatever the formal content of a piece, the overlapping of forms and patterns corresponds neatly to a philosophic objective: the representation of simultaneous or ambiguous meanings. Ultimately, a *malagan* figure is not a direct representation of the deceased, nor a simple heraldic representation of his lineage; it is rather a stimulus to memory, discussion, and commentary. Re-created whenever the occasion warrants by the owner of the rights of reproduction, a *malagan* represents its own antecedent and lineage, just as human ancestors and lineage are remembered and regenerated in society. Its complexity, its ability to suggest multiple

interpretive possibilities, allows for speculative consideration on the part of viewers: discussion, contention, and competing views. In New Ireland, *malagans* are not understood to be "beautiful"; their profundity and emotional power derived in their moment of display from their ability to evoke the past in the present.

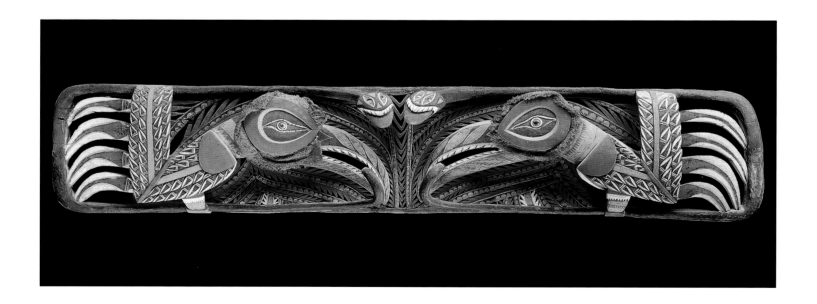

**13 Large *malagan* carving (*kepong* or *ges* type)**

Probably representing a *ges*, a person's wild spirit double. The nose was carved separately and fixed with wooden plugs. The hair is made from vegetable fibers. Collected on a voyage of the warship *Seeadler*, in 1912. Formerly Heinrich Collection (Stuttgart). Height 154 cm. Inv. 4300.

**14 Large *malagan* carving**

Anthropomorphic. Red, black, and white paint. Sea-snail shell opercula. Seeds for the hair. The outstretched arms were separately carved and are attached with mortise and tenon. The face is overmodeled with black wax. The chest is decorated with an ornament known as a *kapkap*. At one time in the curio collection of the grand duke of Baden. Formerly Völkerkundliche Sammlungen der Stadt Mannheim and Arthur Speyer Collection (Berlin). Height 162.5 cm. Inv. 4344.

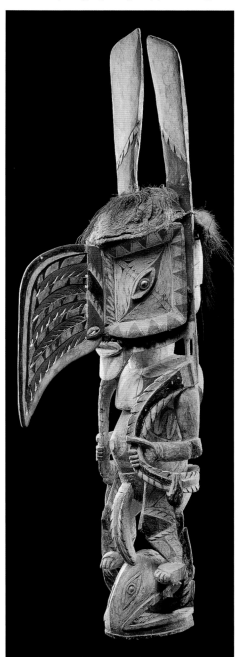

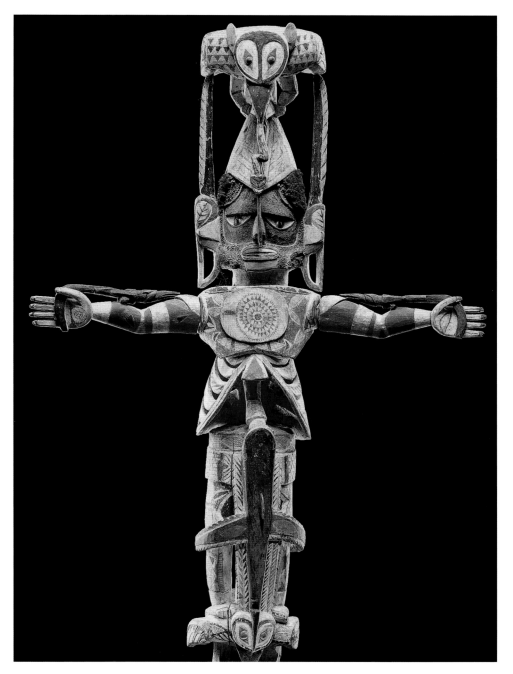

# East New Britain

George A. Corbin

1 **Large mask (*vungvung*)**

*Tapa* over a bamboo-cane framework. Kairak, central Baining. Recovered on the territory of the Butam (annihilated by the Baining) by Phoebe Parkinson in 1912, Richard Parkinson having died in 1909 (Barbier 1977, p. 85). Formerly Museum für Völkerkunde, Leipzig. Length 298 cm. Inv. 4457.

The arts of east New Britain are created by two major non-Austronesian-speaking groups—the Baining and Sulka—and the Austronesian-speaking Patpatar-Tolai peoples. The Baining can be subdivided into three geographic regions, which together encompass the mountainous regions of the Gazelle Peninsula in east New Britain: northwest (Xaxet or Chachet dialect), central (Kairak and Uramot dialects), and southeast (Mali and Asimbali dialects). The majority of the Sulka are found in the Wide Bay area, both

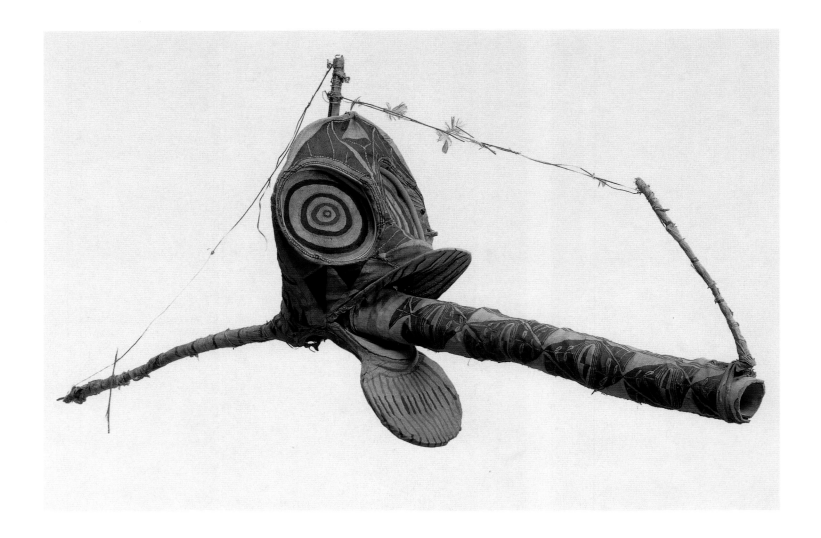

## 3  Helmet mask (*kavat*)

*Tapa* over a bamboo cane (*kavat*) frame. Paint decoration. Kairak, central Baining. Provenance identical to the mask in fig. 1. Recovered from the Kairak occupying Butam territory by Richard Parkinson's widow in 1912. Formerly Museum für Völkerkunde, Leipzig. Height 100 cm. Inv. 4461.

on the coast and in the forests inland, south-west of the Mali and Asimbali Baining. In addition, a significant population of relocated Sulka peoples have lived at Mope near the Warongoi River, east of the Uramot Baining, since about 1905. The Tolai live in the north-east section of the Gazelle Peninsula, the Duke of York Islands, Mioko Island, and the southern part of New Ireland. At the time of contact with European colonists and missionaries in the late nineteenth century, the Tolai peoples were forcibly expanding their territories into the interior of the Gazelle Peninsula, enslaving and displacing the Chachet, Kairak, and Uramot Baining among other now extinct groups (Butam and Vir speakers).

The arts of the northwest (Chachet) Baining have been known since the late nineteenth century, although the early observations, descriptions, and collections of Chachet art and ceremonies were limited geographically

2  Presentation of giant *hareicha* or *hareiga* masks among the Baining of the Gazelle Peninsula, New Britain. Photograph after Hans Nevermann, 1930.

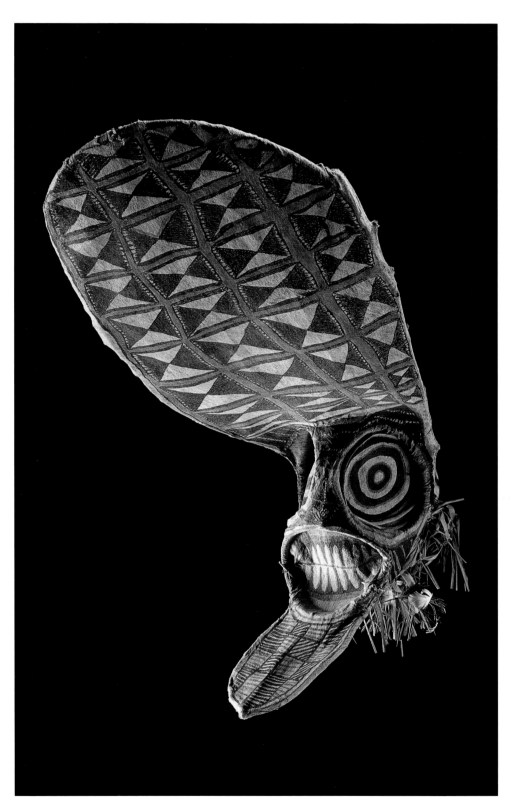

257  East New Britain

**4 Umbrella-shaped mask**

Basketry. Fiber. Woven pith. Black, white, pink, and green paint (such vegetable dyes are unique in Melanesia). Sulka. Formerly Umlauff Museum, Hamburg (prior to 1900), and Jay Leff Collection (Uniontown, Pennsylvania). Height 180 cm. Inv. 4453.

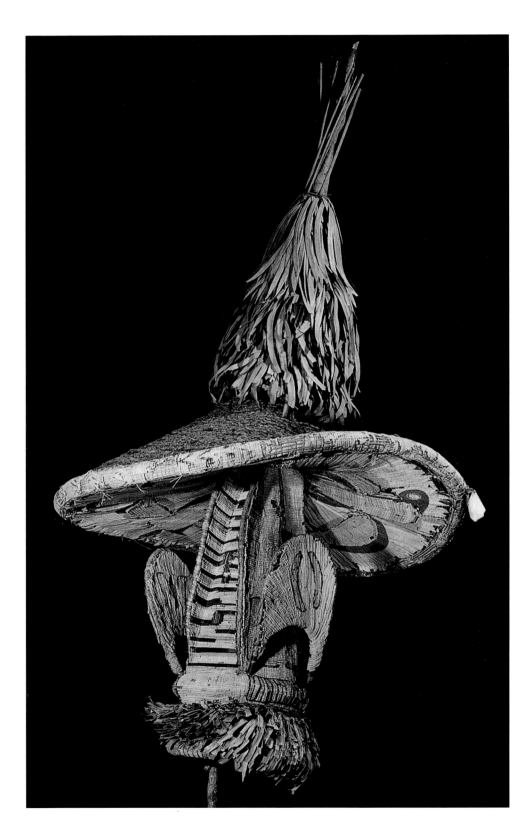

to the northern Gazelle Peninsula, in the coastal mountains between Takis in the west and Vunamarita in the east. The early literature records that the Chachet Baining held elaborate day- and night-dance ceremonies to celebrate the harvest, commemorate the dead, and initiate youths into adulthood.

The day-dance ceremony (*hirei* or *sarecha*) made use of various decorated body spears, barkcloth-covered headdresses in extended cone shapes (*sareiga*), as well as at least four distinct barkcloth sculptural forms carried on top of the *sareiga*. These included a monumental headdress piece known as *hareiga* (fig. 2)—sometimes found in both male and female types with genitalia clearly articulated—a crescent-shaped headdress piece (*ngoaremchi*), composite horizontal headdresses (*siengen*), and smaller headdress pieces representing various fauna.

At the end of the nineteenth and beginning of the twentieth century, the Chachet Baining, unlike the Kairak and Uramot Baining, did not use masks for their night dances. According to informants in the 1970s, the interior Chachet Baining learned the making and use of night-dance masks from the Kairak and Uramot Baining during the twentieth century. The intermediate villages of Malaseit and Randolit were probably the path of dissemination between the central Baining (Kairak and Uramot) and the northwest Baining (Chachet). Photographic archives, museum collections, and published literature suggest that during the pre- and post-World War II periods the northwest Baining stopped creating the monumental *hareiga* headdress pieces. However, many of the headdresses, decorated body spears, and composite display pieces made in recent years are similar in form and

## 6  Mask (*gitvung susu*)

Fiber. Rattan. Woven pith. Black, white, pink, and green paint. Cassowary feather headdress (partially restored). Wood ears (restored), eyes (original), and mouth (original), highlighted in black. The cone shape is reminiscent of a yam. Sulka. Formerly Umlauff Museum, Hamburg (before 1900). Height 73 cm. Inv. 4454.

method of use (perched on top of a long bamboo pole set into a *sareiga* headdress) to those found before World War I.

A performance of the day-dance celebration in the 1970s displayed various headdresses placed on top of long bamboo poles, together with the colossal serpent-shaped display piece (*eisingaichi*) carried by men and children. This attests to the continuity of Chachet Baining day-dance art forms over more than seventy years. Various flora and fauna, including snakes, flying foxes, birds, and cucumbers, are represented in this display. A second large display piece has also been observed since World War II. Known as *remortki*, it is tail-like, with an elongated, triangular shape.

Night masks have been collected among the Chachet, Kairak, and Uramot Baining since the early decades of the twentieth century. Exploration of the inland Chachet areas did not begin until the 1930s, becoming more

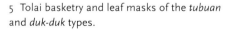
5  Tolai basketry and leaf masks of the *tubuan* and *duk-duk* types.

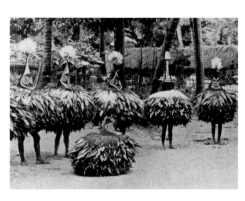

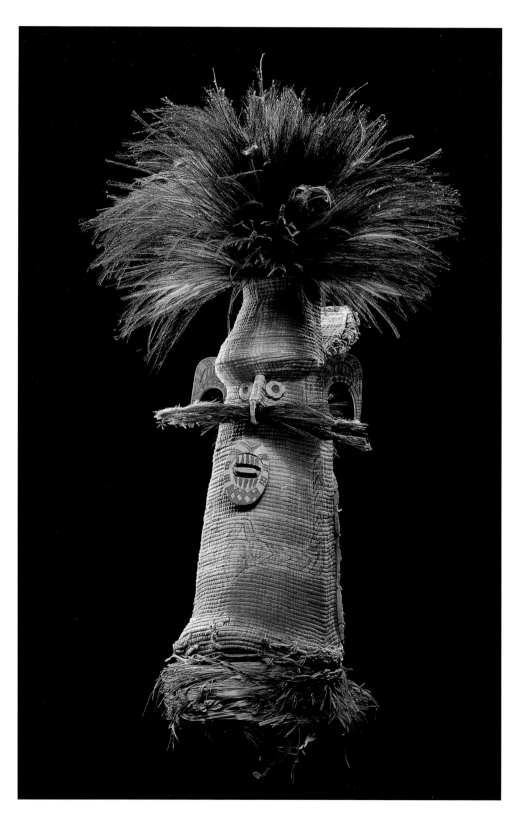

Wood. Red, black, and white paint. Strengthened with rattan crosspieces and woven rattan round the rim. Sulka. Formerly Professor Czeschka Collection (Hamburg). Height 125 cm. Inv. 4451-E.

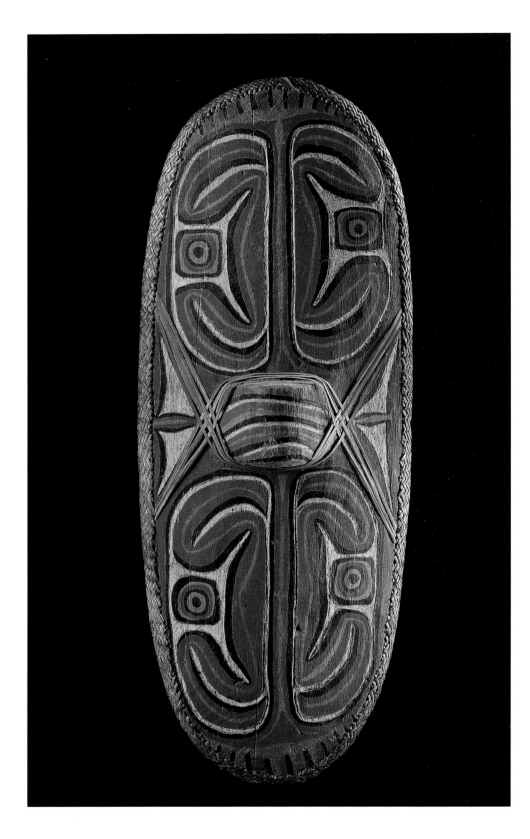

extensive after World War II. Chachet night-dance masks in early collections probably came from areas between the Gavit and Kerevat Rivers west of Atatiklikun Bay, where European missions and plantations were established at the end of the nineteenth century. Early on, it was a common practice for Baining people from inland areas to come down from the mountains to European settlements to perform the night fire dance with various masks.

The night-dance mask with the piece of bamboo covered in painted barkcloth coming out of its mouth is known as *alaspraka* or *vurbracha* among the Chachet, and *vungvung* or *vungbunka* among the Kairak and Uramot Baining (fig. 1). The red and black triangular shapes beneath the eyes represent tears. The red (male) and black (female) colors are referred to as male and female blood respectively. Similar shapes among the Kairak and Uramot Baining are said to represent the spirit crying to mourn its death. The patterns painted on the barkcloth are similar to patterns found on pre-World War I Chachet, Kairak, and Uramot art. The slightly flat, oval shape of the head is similar to early Kairak and Uramot night-dance masks (both *vungvung* and the smaller *kavat* masks; fig. 3), which informants identified as the spirit of a leaf (called *rengit* in the central Baining area). This leaf is used to wrap special flesh foods for cooking at initiation. The tree from which the leaf is taken is thought to have special magical properties to absorb evil (central Baining people sometimes committed suicide by hanging themselves from a tree known as *rangit*). The vertical struts in the front and on the top of the mask originally held side panels of either barkcloth and/or billboard-like forms decorated with pandanus leaf patterns. These

Wood. Red, black, blue-green, and white paint. Feathers, with down around the rim. Red-stained cane. Mengen, heavily influenced by the Sulka. Collected by Bruno Mencke before 1901. Formerly Linden-Museum, Stuttgart. Height 118 cm. Inv. 4451-D.

Wood. Strengthened with red-stained cane. Typical low-relief decoration representing two stylized faces. Mengen. Collected by Bruno Mencke before 1901. Formerly Linden-Museum, Stuttgart. Height 142 cm. Inv. 4451-C.

obscured the mask and its wearer from the audience at the night-dance ceremony. These side panels may also have represented a spirit power which could capture evil spirits and cleanse the dance ground of them and the spirits of the dead (especially of dead animals and plants).

The central Baining Kairak and Uramot peoples also create day- and night-dance art forms analogous to those found today among the Chachet Baining. While many Chachet Baining day- and night-dance ceremonies have been observed since the late 1960s, very few Kairak or Uramot day dances have been witnessed by outsiders. However, small helmet masks (*kavat*; fig. 3) and composite helmet masks with bamboo tubes and side panels (*vungvung*) have been recorded and collected in the past four decades. In fact, the central Baining fire dances have developed into a major tourist attraction in east New Britain. The passengers of most cruise ships which docked at Rabaul (before the devastating volcanic eruption in 1995) visited the central Baining for a night dance as part of their itinerary.

The Mali (southeast) and Asimbali (south) Baining also create elaborate art forms for day-dance ceremonies, including hats, head-dresses, and monumental display pieces carried on top of cone-shaped headdresses. Their day dance, like those of the Uramot and Kairak Baining, is called *mendas*.

The non-Austronesian-speaking Sulka live along the coastal areas of Wide Bay south to Cape Oxford. In addition, since the turn of the century there has been a large settlement of Sulka at Mope near the Warongoi River. During the late nineteenth century and the

## 10  Dance mask (*lorr*)

The overmodeled front portion of a human skull with drilled eyeholes. Traces of paint. Tolai, near the Gazelle Peninsula coast. Height 25 cm. Inv. 4452-A.

early decades of the twentieth century, the Sulka created several types of woven pith basketry masks, at least two types of decorated dance wands, carved wooden war shields, clubs, ancestor figures, poles for mortuary display in men's houses, and at least two types of decorated plank-built canoes.

The Sulka used various types of woven pith basketry masks. Masks of an anthropomorphic type known as *gitvung susu* were associated with the initiation of male youths into adulthood (fig. 6). A type known as *hemlaut* ("old man") was characterized by a central strut with a painted umbrella-like form on top. The underside of the umbrella shape was painted with patterns representing various flora of importance to the Sulka, while the anthropomorphic head below probably represents a locally known spirit. Another type of mask also known as a *susu* mask has a cone-shaped form on top, identifying it as either a *lilwong* or *to-ka-ti susu* spirit. Both represent the tip of a taro tuber, cut off and planted to start new gardens.

Three of the dance wands (*rei*) terminate at the lower end in a tapered wooden strut. During ceremonial dances, which are often associated with funerals, the strut is held by men or placed in a simple cone-shaped hat. Another dance wand terminates at the bottom with a carved anthropomorphic female figure with attributes resembling a praying mantis. The light patterns painted along the vertical axis of the dance wand represent both sea gulls feeding on the sand and various plant forms associated with the beach.

Sulka masks called *gitvung susu* have dark cassowary feather "hair" (fig. 6). The pierced earlobes and septum and the blackened teeth

are all associated with the initiation of males into Sulka adulthood. In some examples, the cone-shaped base of the mask is given a raised bulbous form, as is the lower border of the taro-shaped cone on top. This probably represents the raised welts which form on the skin of the young initiates during various ordeals associated with initiation.

War shields were made by the Sulka, the Sulkanized Mengen, and the Mengen. The traditional Sulka-style war shield (*gaile*; fig. 7) has a raised central boss (*kwie*), behind which is a carved handle (*grom*). The finely wrapped woven outer edge (*qukaptak*) served to strengthen the edges to withstand enemy blows and created an outline border for the low-relief and painted symmetrical patterns inside the oval face of the shield. The eyelike patterns and vertical noselike shapes served to create a highly abstracted spirit face with humanlike (*nunu*) attributes. These faces are thought to serve a protective function for the warrior behind the shield by warding off spears and war-club blows from enemy warriors in battle.

The Sulkanized-Mengen war shield (fig. 8) shows a combination of stylistic traits typical of Sulka war shields and the war shields of the Mengen people at Jacquinot Bay. The slight elongation of the oval shape is more common among the Mengen, as are the more recognizable humanlike faces at either end. This is especially noticeable when the Sulkanized-Mengen shield is compared with the true Mengen shield (fig. 9). These three shields are excellent examples of the cross-fertilization of traditional art styles in this area of east New Britain in the period of early contact with European cultures. In the last quarter of the nineteenth century, the Tolai

11 **Dance skull-mask (*lorr*)**

The overmodeled eyeholes have been closed over, although the mask still possesses a bite bar so that it can be held between the teeth. Tolai. Height 20 cm. Inv. 4452-B.

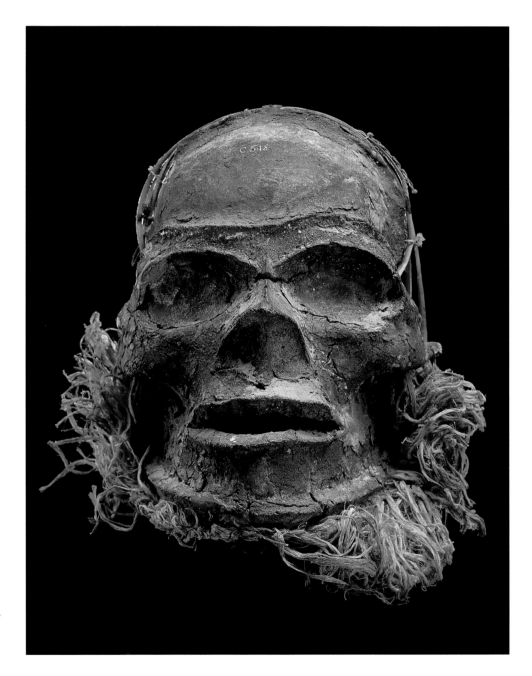

Limestone. Belonged to an initiate of the Iniet
society of the Tolai of the Gazelle Peninsula.
Recovered by Besenbruch before 1912. Formerly
Linden-Museum, Stuttgart. Height 32 cm.
Inv. 4450.

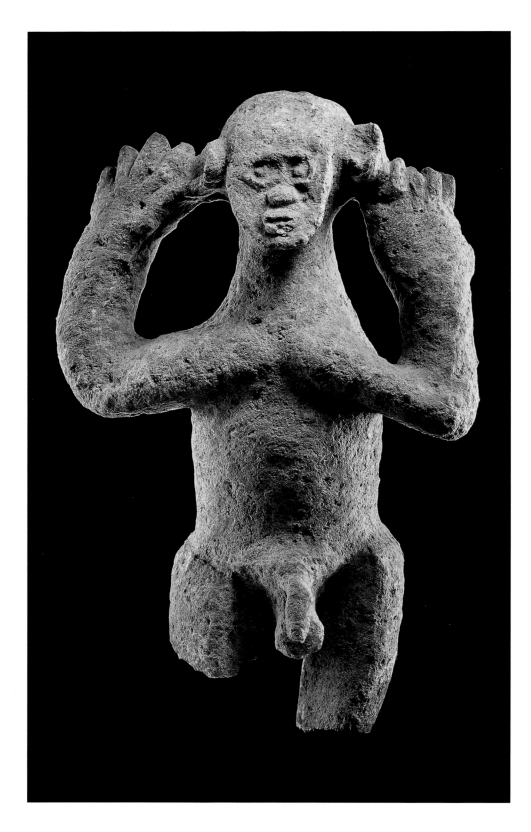

people created at least three types of mask for
use in traditional ceremonies. Two of these
were based upon the human head and face
and represented a form of ancestor worship.
Both mask types were called *lorr*, meaning
both skull and ancestor. One type used an
overmodeled human skull (frontal bones and
lower jaw) to create a human visage (fig. 10),
while the second type, carved out of wood,
consisted of an abstracted human face and
head. There were two types of overmodeled
skull mask. One had eyeholes and bite bars
for the wearer to see through and keep the
mask on his face, while a second type had
the eye areas overmodeled (fig. 11).

The carved wooden *lorr* masks have been
known since the late nineteenth century and
were distributed throughout the Tolai on the
Gazelle Peninsula, the Duke of York (fig. 14)
and Mioko Islands, and in some regions of
southern New Ireland, especially at Kait and
King villages. These masks are still commonly
made today by the Tolai for use in various
ceremonies.

Another type of mask found among the Tolai
is the cone-shaped mask of the Duk-Duk
society (fig. 5). The masks are made in two
styles: a simple female type known as *tubuan*,
which is said to be immortal, and a more
elaborate male *duk-duk* mask, which is born
and dies each year during the ceremonial
season. The female *tubuan* is a simple cone
shape articulated with large concentric cir-
cular eyes. The male *duk-duk* masks can be
differentiated stylistically from the female ones
because they have an added superstructure
with more elaborate painted and sculptural
decorations. Unlike the humanlike form of
the *lorr* costume, the *tubuan* and *duk-duk*
costumes have large skirts of leaves covering

Bamboo cane frame overmodeled with resin and clay. Fiber. Kairak Baining. Collected by Richard Parkinson before 1903. Formerly Linden-Museum, Stuttgart. Height 30 cm. Inv. 4455.

Wood. Leaves. Fiber. Scraps of imported fabric. Red, black, and white paint. Duke of York Island. Collected by Count Rudolf Festetics of Tolna in 1895. Formerly Ethnographic Museum, Budapest. Height 40 cm. Inv. 4336.

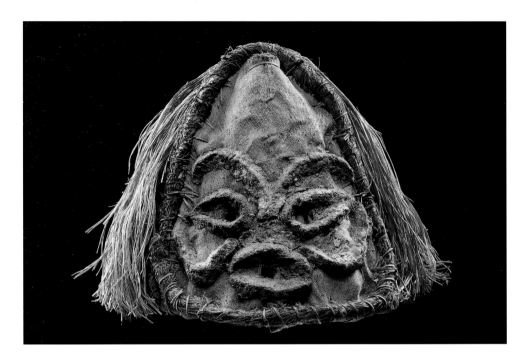

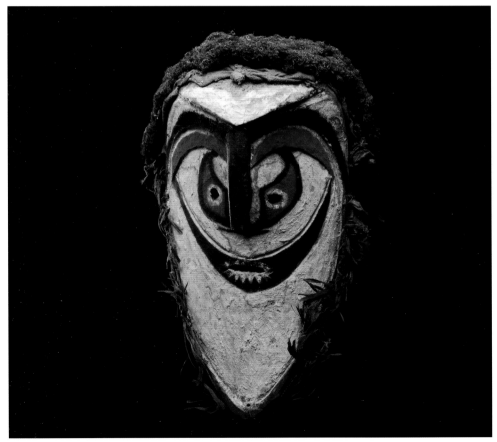

the body of the wearer down to his knees. During dances, the leaves of the costumes flap like bird feathers and the dancer's feet dig into the dirt like a bird digging into the ground.

The Iniet, or Marawot, society is another important Tolai society which uses many different art forms to represent varied ancestor and spirit entities. Male Tolai are traditionally initiated into the Iniet society during childhood, becoming in turn the initiators when they reach adulthood. The early German colonial government and the various missionary societies actively tried to suppress the activities of the society, so that it went underground, surviving in one form or another to the present day. Traditionally, there are two major types of Iniet society practice, a positive-oriented one that brings happiness and good luck (*iniet warawegugue*) and a negative-oriented one that brings sickness and death (*iniet na matmal*).

Various anthropomorphic wooden figures (some with overmodeled human skulls), wooden grotesque human/animal composite figures, carved or painted boards with evil Iniet society spirit figures (*tabatabama kaija*), and carved and painted stone (fig. 12) and chalk figures (*kulap*), were used by the Iniet in a range of ceremonial contexts.

The use of chalk and stone figures by the Iniet society has been documented to the nineteenth century. Its geographical distribution includes the Tolai areas of the Gazelle Peninsula, the Duke of York and Mioko Islands, and southern New Ireland. Here the human figure has upraised arms with hands showing the palms (fig. 12). This gesture is frequently found in a variety of

## 15 Shield

Three hardwood boards bound together with lengths of rattan. Gouged decoration with lime-wash highlights. Traces of red and black paint. Arawe people. Southwest coast of New Britain. Height 129 cm. Inv. 4451-A.

16 An Arawe man from west New Britain with his shield. Barbier-Mueller Archives. Photograph E. W. P. Chinnery. © Royal Geographical Society, London, neg. 02304.

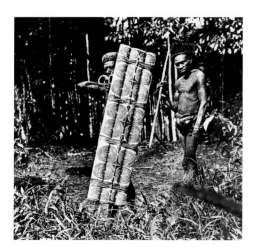

carved or painted Iniet spirits, notably the power spirit entities carved on the dance wands held by young initiates. The composite human/animal forms on the wands are probably representations of personal power spirits (*pepe*). The simple animal forms on the wands probably represent powerful animal spirits known as *kaija*, that included the snake (*wi*), iguana (*palvi*), crocodile (*pukpuk*), shark (*mong*), pig (*borai*), brown kite (*sunugualai*), crow (*kot-kot*), thornback bird (*wara*), dolphin (*taba-taba*), and kangaroo (*dek*), as well as other animals and things.

In the late nineteenth and early twentieth century, various Tolai groups made large ceremonial canoes (*gaga na pedik*) to honor high-ranking Tolai chiefs and Big Men who had died. These canoes were displayed during special funerary rites (*aminamai*) held at least a year after the actual death. At these rites there was a distribution of wealth such as shell money (*tambu*) and various foodstuffs (often pork and banana) to a large assembled audience. The family members distributing the shell money were known as "breakers of the shell money" (*tara na kutai tambu*), the men who received it were "men of the free shell money" (*atarai na ginirai*), and the women who received the money were "women of the free shell money" (*awarden na ginirai*).

These ceremonies are still held. In December 1972, for example, a mourning-day hut (*apal-na-kukup*) was set up at Vunakulkalulu village. In a photograph taken of the hut, a decorated canoe (*awanga-na-taba-taba*) can be seen on the right raised above an elaborately decorated fence (*lip-lip*). The fence surrounds the hut, which is hung with bolts of commercial cloth, flowers, plants, decorated spears (*numu*),

heirloom battle axes (*ambear*), and war clubs (*apalana*). One of the deceased Big Man's sons can be seen on the right taking a break from distributing shell money to the assembled audience. Inside the hut are large rolls of shell money (*loloi*), as well as slit gongs (*garamut*) of various sizes. The canoe's decorated prow and stern (*tamba tamba*) are raised about 2.4 meters above the canoe itself and have fishbone, tree, and dog-shaped patterns carved and painted on the raised planks. The deceased man's relatives gave the decorated spears to Big Men in attendance, along with generous quantities of betel nuts, bananas, and pork. The lavish display of cloth and clothing draped on and around the fence and hut attest to the great wealth of the deceased Big Man.

17  **Post (*burbur*)**

Wood. In the shape of a head. Douglas Newton (1995), ascribing this piece to the Mamusi ethnic group, mentions a photograph taken by E. W. P. Chinnery (about 1925) on the coast of New Britain near Moewehafen in which two of these very scarce carvings can be seen. Schmitz (1969) attributed them to the Sulka (doubtless because of the resemblance of the painted decoration to that on Sulka shields), but Damm (1969) has reiterated the attribution to the Arawe. Phoebe Parkinson's register of objects collected mentions Cape Dampier as the provenance. Collected by Richard Parkinson's widow in 1912. Formerly Museum für Völkerkunde, Leipzig. Height 159 cm. Inv. 4458.

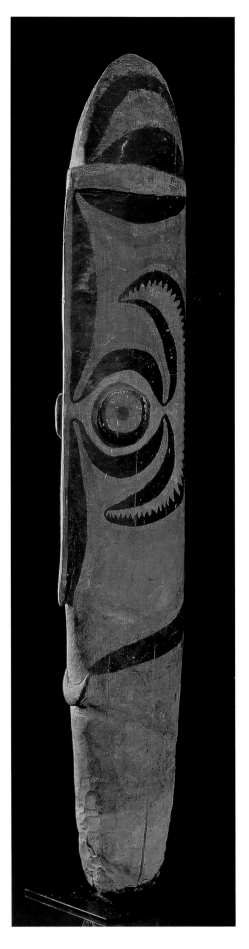

# The Solomon Islands

Deborah Waite

The Solomon Islands have been an independent country since 1978. The southernmost islands in the group, the Santa Cruz Islands, are in Temotu Province, which also includes Tikopia Island and the Reef and Duff Islands. Makira/Ulawa Province includes Makira Island (San Cristobal), Ugi, Ulawa, Santa Ana, and Santa Catalina Islands. The Nggela Islands, referred to as Florida Island in many older sources, belong to Central Province together with Savo, Russell, Rennell, and Bellona Islands. The large island of Malaita forms Malaita Province. Three other islands of similar size and social complexity are also designated as political units: Isabel Province (Santa Isabel Island), Guadalcanal Province (Guadalcanal Island), and Choiseul Province (Choiseul Island). New Georgia Island (also referred to as Rubiana or Roviana Island in many older sources) and all the smaller islands surrounding it (such as Vella Lavella) make up Western Province. Nissan, Buka, and Bougainville Islands, located in the extreme northwestern part of the Solomons chain, now belong politically to the country of Papua New Guinea.

## Makira/Ulawa Province

"Great attention is paid to the composition of their head ornaments... Some of them are made of a piece of thin rounded clam shell, faced with a very thin circle of tortoise shell beautifully carved, in which form they are worn at the side of the head and cover the brow" (fig. 1).[1] In these ornaments (*kapkap*) from Western Province, the turtle-shell disk often comprises bands of small designs arranged concentrically around a midpoint. The outermost row of designs reproduces in miniature similarly shaped pieces of tridacna clam shell which once adorned the prows of

**The Solomon Islands**

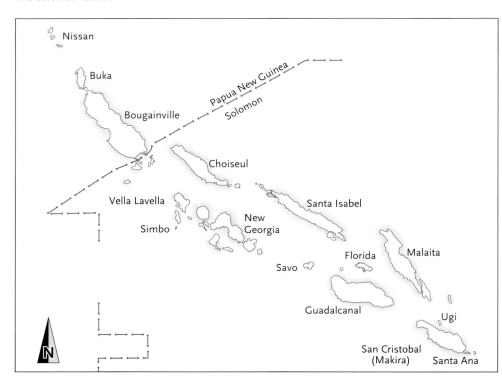

## 2  Forehead ornament (*kapkap*)

Made from a disk cut from the broadest part of a Pacific giant clam (*Tridacna gigas*), over which is attached another thin openwork disk carved from turtle shell and held in place by a strand of fiber. Headband of woven fiber. Western region of the archipelago. Formerly collections of the Royal United Service Institute Museum, London (gift of Mrs. H. Gibson in 1893), and James Hooper. Diameter 12 cm. Inv. 4512-D.

war canoes in Western Province. The ornament in fig. 2 is particularly unusual: the central design area includes images of human heads and frigate birds—symbolic referents to head-hunting as well as to spirits which manifested themselves as, or behaved as, frigate birds. On Santa Cruz, ornaments called *tema*, similar to *kapkaps* in form, were worn as pendants rather than on the head. The turtle-shell section is a vertical repeat design terminating in four downward-projecting elements resembling the wings and tail feathers of a frigate bird (fig. 3).

1  Man from Roviana Lagoon (New Georgia Island) wearing shell jewelry, including a *kapkap* on the forehead. Barbier-Mueller Archives.

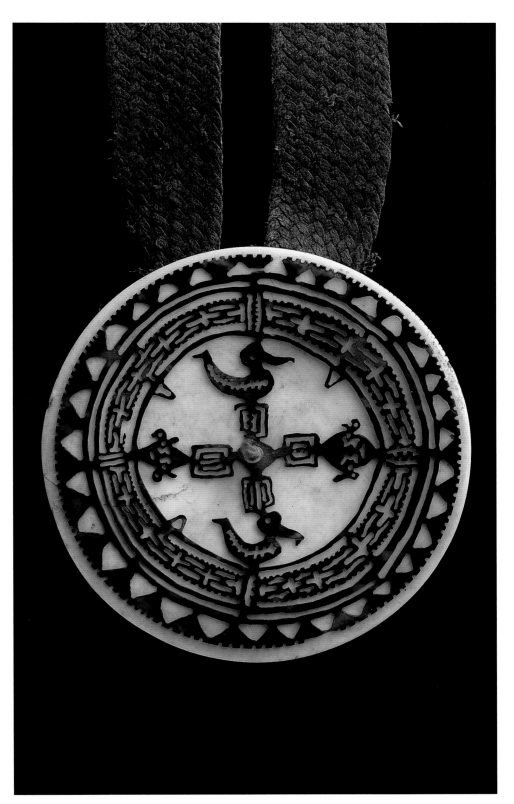

### 3 Pendant (*tema*) worn on the chest

Shell disk and stylized representation of a frigate bird in turtle shell. Santa Cruz Islands. Diameter 18 cm. Inv. 4582.

### 4 Shield-club (*roromaraugi*)

Hardwood. Shiny reddish patina. Held in the left hand, its long blade would have been used primarily to parry spear thrusts. San Cristobal Island. Length 137 cm. Inv. 4505-C.

The southeastern islanders used a unique form of shield-club held in the left hand and moved about to ward off the spears of an opponent (fig. 4). Its upward-curving blade suggests a diving fish with its dorsal fin. The name, *roromaraugi*, reputedly indicates Ugi as a source for the type. Dance staffs are a variant of the same form, though lighter and decorated with incising or shell inlay (fig. 5).

A different type of dance club comes from the Santa Cruz Islands (fig. 6). These clubs are four-sided and they taper to a point at one end and are upturned at the other. They are painted with figural and geometric designs. Traditionally they were carried in the *napa* dance, part of the entertainment at feasts held to celebrate stages in the maturation of children.

A unique form of currency is made in these islands from the red feathers of the cardinal honeyeater (*Myzomela cardinalis*). The feathers are attached to flat rectangular pieces of wood, which, in turn, are sewn to a fiber belt (fig. 7). These belts are a product of Ndende Island, but are used on other islands in the Santa Cruz group except for Utupua and Vanikoro. They have served as a major medium of exchange, especially in the procurement of brides, pigs, and various types of labor.[2]

Large numbers of bowls were made in this area. A few take the form of an anthropomorphic head (fig. 9); the angular forward-jutting lines of the face are reminiscent of images from the southeast Solomon Islands. More common are elliptical footed bowls, stained black and inlaid with shell, sometimes with elaborate handles in the image of sea spirits (fig. 8). Others are in the form

of birds with sharks below their tails. Those of medium size could contain mashed taro pudding for several people or were used for food offerings.[3]

The southeast Solomon Islands have long been noted for large, often elaborately decorated houses, which were used for storing canoes, as festival houses, and as the final repository for the bones of the elite dead. Posts carved in the form of anthropomorphic figures, often accompanied by birds and fish, were major ornamental features. Typical carved figures from this region combine angular contours and flat surfaces (particularly prominent in the head and arms) with the round contours of the posts. A majority of the images are male and relatively few are female. The female image in fig. 11 is represented wearing a skirt and carrying a child. On the whole, single figures are the rule for posts in custom houses. Paired images appear to be comparatively rare (fig. 10). Houseposts tend to represent or refer to ancestors and historical figures. A common theme depicted in such cases is that of a man in the jaws of a shark. Although this could be looked upon as exhibiting a man-shark identification having perhaps ritual and social significance, it could well refer to the accidental death of a person swallowed by a shark at sea. The person in question would have been of some importance in his village to have merited this sort of permanent recognition.

The exact provenance of several anthropomorphic images from the southeast Solomon Islands (for example, figs. 13, 14) is virtually impossible to determine. However, all the elements of the figure type correspond with other images from this region. In the case of fig. 13, the tapered profile of the base or

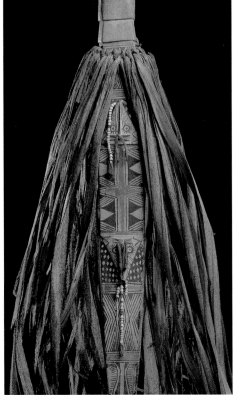

5 **Dance club**

Blackened wood. Mother-of-pearl inlay. Southeast region of the archipelago. Reportedly collected by a missionary about 1850. Formerly James Hooper Collection. Length 91.5 cm. Inv. 4528.

6 **Dance club (detail)**

Wood. Painted decoration, adorned with dried leaves, fabric, and pearls. Used during ceremonies called *napa*. Santa Cruz Islands. Overall length 84 cm. Inv. 4583.

## 7 Roll of feather money

A bark and fiber core over which the feathers of the cardinal honeyeater have been closely packed. Used in ritual exchange ceremonies, for bridewealth, and for such things as the purchase of pigs. Ndende Island, Santa Cruz Islands. Formerly René Rasmussen Collection (Paris). Length of roll approximately 9 m. Inv. 4584.

## 8 Large bowl

Wood, blackened, with encrusted fragments of pearlshell. Anthropomorphic handles. These bowls were used in ceremonies to contain foodstuffs. Islands of the southeast Solomons. Length 62.5 cm. Inv. 4502-G.

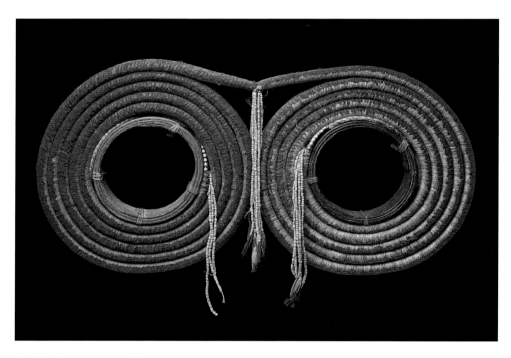

pedestal differs from the uniformly cylindrical form of most houseposts. The image may possibly have been an *aisura,* a post carving kept in a dwelling house rather than a canoe or festival house. An individual would present offerings for his personal spirit to this type of image. This might be the type of post figure depicted in a 1913 photograph showing Hector Raraana of Ulawa Island (fig. 15). The figure on the post in the photograph is similar in style. Another point of comparison is that both posts lack the crescent-shaped carvings which crown the heads of so many custom-house posts and which were intended to receive horizontal housebeams.

Only a limited number of figures exist from Santa Cruz, where figure sculpture was produced only on the main island of Ndeni and the off-lying island of Temotu. The figures represented tutelary spirits and were called *munge-dukna,* "image of a deity." The size of the image in fig. 14 suggests that it could have been one of the "miniature statuettes small enough to be carried in a man's shoulder bag [and] used for setting up the equivalent of a household altar when away from home."[4]

### Malaita

Several types of clubs are known from Malaita. *Wari hau,* or *fou,* were made by the 'Are'Are people of southern Malaita, although variants come from the Kwaio peoples. *Hau aano rereo* designates the iron pyrite knob (*hau*) and mother-of-pearl inlay (*aano rereo*). They were carried suspended around the neck, the staff hanging down the center of the back. "The wearing of it … was limited to those men who claimed the payment of blood money for a life which they had taken."[5]

Although regarded as indigenous to Malaita, other southeast Solomon Islanders may carry the *supe* (fig. 17). One of the most distinctive club types from the Solomons, it was used in warfare. The *dis* club, on the other hand, appears to have been primarily ceremonial. Those which belonged to important men were individually named and acquired a renown of their own.[6]

## Western Province

Openwork *Tridacna gigas* clam shell plaques were deposited in small huts containing the skulls of battle trophies or, on occasion, in private houses (fig. 18).[7] They come from several places in the western Solomons, notably Choiseul, Vella Lavella, and New Georgia Islands. The material links plaques of this type with shell exchange objects and war canoe ornaments. The seated figures of the example in fig. 18 may have alluded to war canoe ornaments and the frontal figure (and his missing partners) could have referred to rows of men moving in ritual or battle formation, but there is no certainty about the intended meaning of the images.

Old records describe how heads were collected and saved for commemorative value in miniature huts. Shell rings, valuable in exchange, were often attached to the preserved but unmodeled skulls. Modeled skulls constituted one form of commemoration for significant individuals in the western Solomon Islands (fig. 20), as well as other parts of Melanesia such as Vanuatu and the Sepik River region of Papua New Guinea. Modeled skulls from Western Province in the Solomons, especially on New Georgia Island, were first cleaned and dried; the features were then

9 **Bowl**

Wood, blackened. Mother-of-pearl inlay for the eyes. In the shape of a human head. Very few bowls of this type are known, the closest being in the Otago Museum, Dunedin (New Zealand), which was collected in the north of San Cristobal and described as a "sacrificial bowl." Exhibited in the Paris Universal Exposition of 1889. Acquired by Josef Mueller in 1938. Height 16.5 cm. Inv. 4502-I.

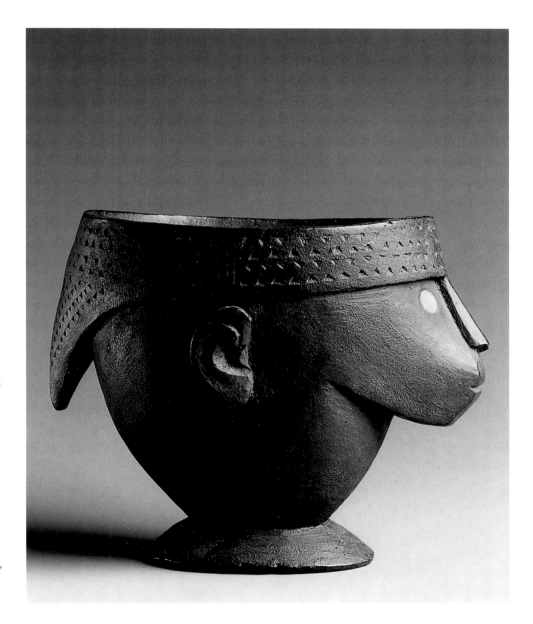

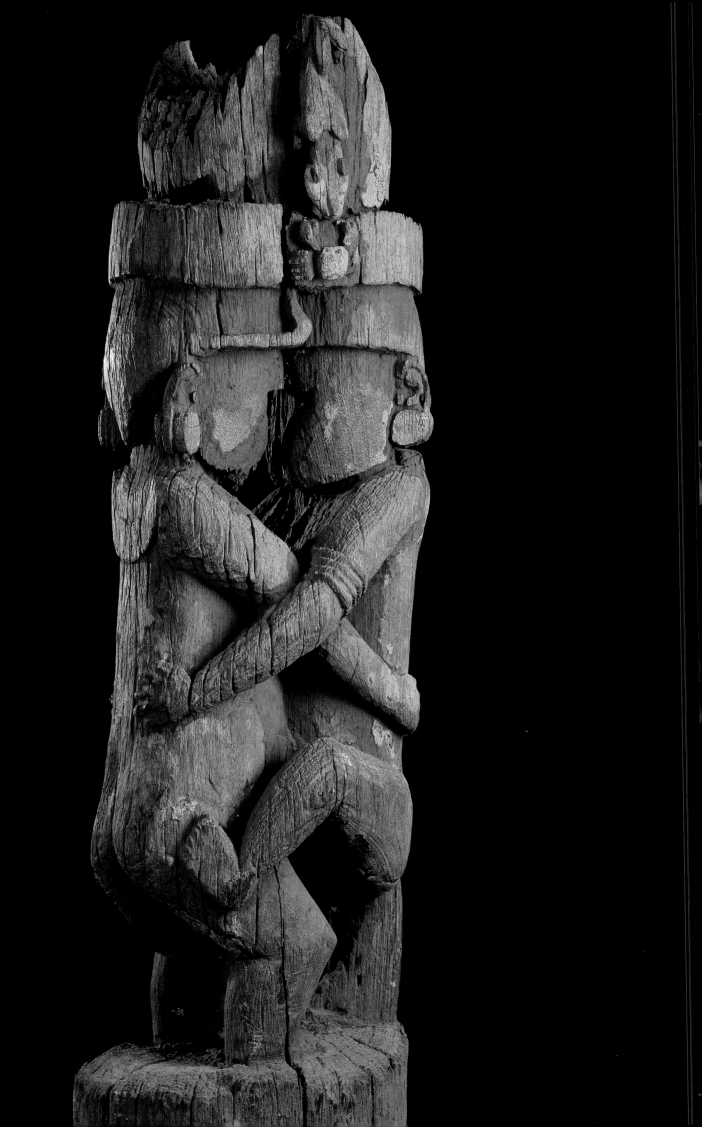

10 **Housepost (detail)**

Showing a couple in a coital position. Southeast region of the archipelago. It can today be confirmed that this carving was photographed by H. Bernatzik about 1932 at Santa Ana. The post was exposed to the elements after an American bombing raid in World War II destroyed the house it was supporting. Between 1944 and the time it was recovered, the post had been greatly eroded by the weather. Collected by P. Langlois about 1960. Height 211 cm. Inv. 4500-C.

11 **Housepost (detail)**

Hardwood. San Cristobal Island. Collected by P. Langlois between 1964 and 1969. Overall height 220 cm. Inv. 4500-A.

12 **Upper section of housepost**

Hardwood. Waxed during a lengthy period in the United States. Ugi or Uki Island. Collected, according to tradition, by Jack London in 1908. Sailing in the region on the yacht *Snark,* London and his wife recorded in their logbook that they collected eight houseposts on Uki. Overall height 163.8 cm. Inv. 4500-D.

modeled with parinarium nut paste, painted, and adorned with rows of tiny pieces of shell inset in curved lines over the face to duplicate white facial paint—presumably corresponding to that of the original face. Eyes and ear ornaments received larger pieces of shell; dried fibers glued to the head approximated hair (fig. 20).

About 1913 occurred the death of a special craftsman at Roviana (New Georgia), who "was the last of the craftsmen who applied the tita nut (parinarium) to the skulls of the departed. Now there are none remaining and the art is a forgotten one. While he was alive, it was possible to have a head modelled to order, the skull being supplied by a client."[8] The "client" sometimes procured a skull from an "old shrine" in an area deserted owing to attacks by warriors from a neighboring island or district. This, if valid, suggests that the modeling practice could have postdated the years of frequent warfare in this part of the Solomons—warfare in which the acquisition of heads was a major objective for reasons of ritual or revenge. This tentative dating cannot be guaranteed, but older records describe the collection and saving of unmodeled skulls, with shell rings attached to them, in miniature huts. Thus the modeled skulls may have had a commemorative value quite different from the older unmodeled ones. But the materials used for the modeled skulls—parinarium nut paste and nautilus shell inlay—link the modeled skulls with other man-made objects. War canoes were caulked with the same nut paste and were also painted black and inlaid with similarly shaped pieces of shell. Carved wooden canoe ornaments, as well as freestanding figures, were ornamented in the same manner. Through their construction materials, the

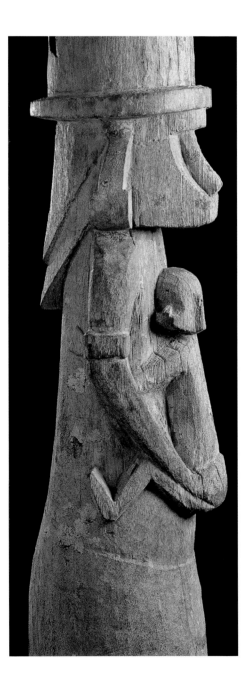

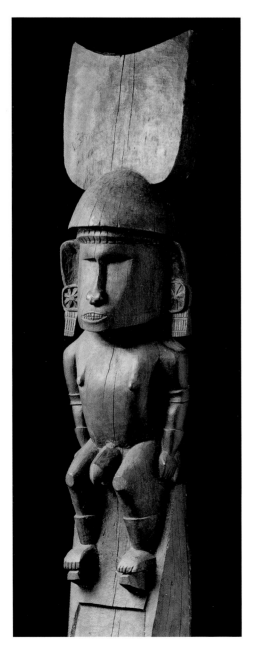

## 13  Post top (?)

Very hard wood. Female effigy with mother-of-
pearl inlay eyes. This famous carving had also
been repeatedly waxed in Europe. Formerly André
Breton Collection. Height 84.5 cm. Inv. 4508.

## 14  Statuette (*munge-dukna*)

Wood. The eyes are inlaid with shell disks.
Turtle-shell earring. The carving represents a
spirit. Santa Cruz Islands. Formerly Raymond
Wielgus Collection. Height 14 cm. Inv. 4580.

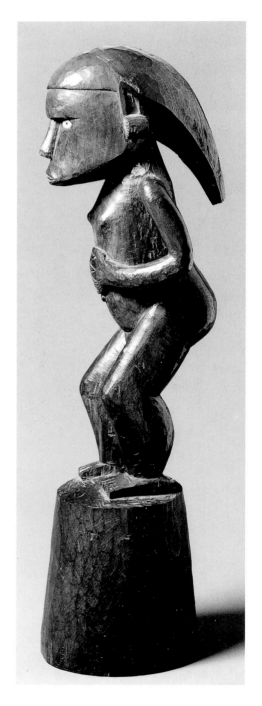

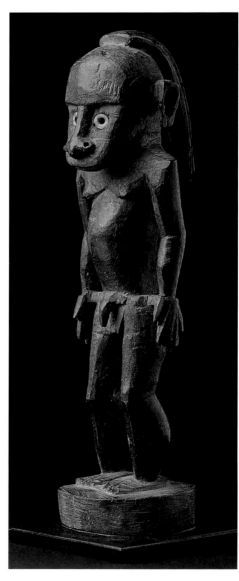

15  Photograph taken by Beattie in 1913 showing
a man named Hector Raraana, from Ulawa,
standing next to a statue of what is probably
his guardian spirit (Waite 1983, p. 136).
Barbier-Mueller Archives.

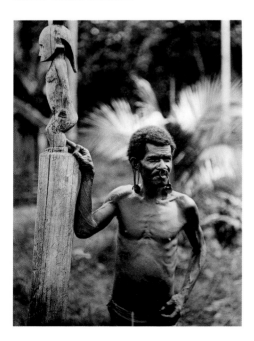

16 **Lime stick (detail)**

Hardwood. The finial shows a male figure. D. Waite tentatively attributed this carving to the southeast region of the archipelago. Formerly James Hooper Collection. Height 26 cm. Inv. 4527.

17 **Club (*supe*)**

Hardwood with shiny patina. Shaft bound with woven fiber. Used in combat and during ceremonies. Malaita Island. Length 82 cm. Inv. 4505-B.

modeled skulls were contextually grounded within a war/head-hunting matrix, even if many of them were produced after many of the head-hunting raids ceased during the first years of the twentieth century. Like canoe and other wooden carvings, modeled skulls became man-made artifacts.[9]

Figureheads, termed *toto isu* in the Marovo Lagoon or *nguzunguzu* in the Roviana Lagoon of New Georgia, were once lashed to the prow of every war canoe (figs. 21, 22). The images were carved from light wood, painted black and inlaid with nautilus shell facial patterns, eyes, and ear ornaments. The figureheads show anthropomorphic heads and arms. They may hold birds or small heads, once an obvious reference to the practice of head-hunting. They represented or embodied sea spirits who protected the canoe occupants from other malevolent sea spirits believed to be responsible for storms at sea.

Shell-inlaid shields (fig. 23) appear to have been produced in the first half of the nineteenth century in a context of war and exchange. Cane and fiber shields were made to be exchanged for shell valuables. Thus the inland Kusaghe people in northern New Georgia Island exchanged shields with people living in the coastal districts, while inland dwellers of Guadalcanal Island produced shields for exchange with the Nggela Islanders. Some also found their way to Santa Isabel.

The example in fig. 23 is a coiled shield with rounded ends that is typical of Guadalcanal production. It is comprised primarily of a length of lawyer cane coiled around itself and secured with *asa* (Lygodium vine) wrapped or twined horizontally around the coil. Additional single coils may enclose

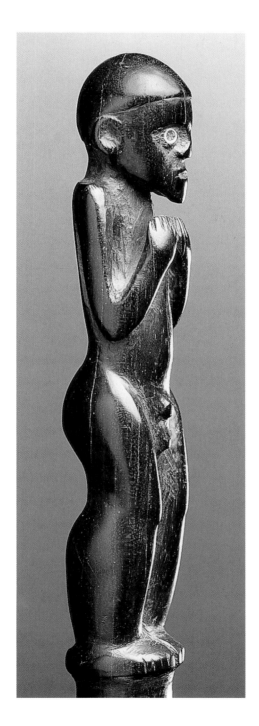

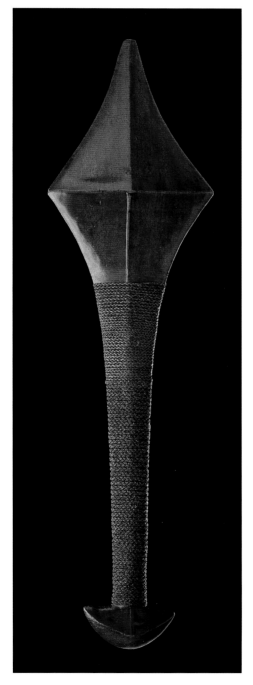

**18 Plaque**

Cut from the thick section of a giant clam shell (*Tridacna gigas*). Such plaques possess a funerary function. New Georgia region (Choiseul Island?). Collected c. 1960 by P. Langlois. Formerly Robert Duperrier Collection. Height 40 cm. Inv. 4531.

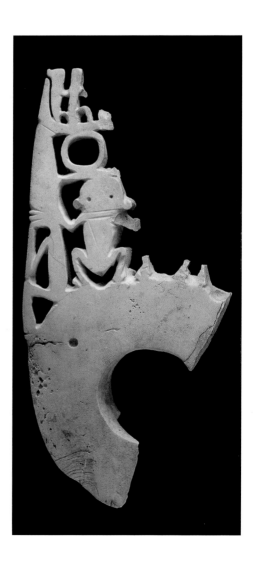

the inner coil. The slightly blunted point at the top is created by the coming together of two ends of the outer coil.

About twenty-five of the cane and fiber shields in existence have been richly ornamented. The obverse surface was covered with parinarium nut glue and inlaid with hundreds of small pieces of nautilus shell to create linear patterns which follow the direction of the coils and outline a long anthropomorphic figure in the center of the shield. Areas between the rows of shell are painted red or black. The example in fig. 23 is unique in having a small anthropomorphic figure in the bottom section of the shield (others display only small heads or faces). The principal figures with raised arms in the center of inlaid shields are a feature of certain canoe ornaments and wooden clubs, but only on clubs and shields do they have this elongated form.[10]

Some aspects of this type of shield remain something of a mystery. One is the question of where the inlay work was done. It was probably executed by the recipients, rather than the initial shield makers, as the former had greater access to shell. Why certain shields were inlaid and for whom also remain tantalizing mysteries.[11]

In 1844, Andrew Cheyne arrived in the western Solomon Islands of Simbo and New Georgia for the purpose of trading, initially in bêche-de-mer and shell. He found that already "the people refused to exchange shell for anything other than tomahawks."[12] The imported iron ax blades were set on wooden handles and "tomahawks" came to be a possession of every man together with a shield. In New Georgia, by the 1890s, "the only weapon now to be seen in canoes . . . is a tomahawk,

consisting of a trade axe head on a longish handle . . . occasionally these tomahawk handles are very well carved with figures of crocodiles . . . inlaid with mother-of-pearl and highly colored."[13] The ax in fig. 24 is a beautiful example of the appropriation of a European artifact and its assimilation into the design system of New Georgia Island. The carving and inlay, as well as the choice of predatory motifs, relate it to a number of others from the Roviana Lagoon area.[14]

### The Northeastern Islands (Papua New Guinea)

Before 1975, Nissan and Buka constituted the northernmost islands in the Solomons archipelago. Some immigrants to Nissan came from still further west, while others came from Buka. Nissan Islanders have long traded with Buka and the islands of Tabar and Aneri off the coast of New Ireland.[15]

The mask in the Musée Barbier-Mueller represents one of the standard mask types from the Nissan Islands (fig. 27). The structure of the mask consists of split bamboo covered with barkcloth, which is itself covered with a layer of parinarium nut paste modeled into features and painted with linear designs reproducing facial scarification patterns. Small rectangular pieces of wood ornamented with rows of black and white painted triangles are attached to the mask at ear level.[16] Nissan masks were said to have been worn by men in rituals held in a forest clearing forbidden to women, and also at harvest festivals.[17] On Buka and in the north of Bougainville Island, similar masks represented or contained the essence of a spirit known as *kokorra*. This spirit also appeared in representational form on carved wooden paddles (fig. 26).

Large numbers of such paddles, which have long pointed blades displaying one or more seated anthropomorphic images, are said to have originated on Buka Island, although they have also been acquired from Bougainville.[18] They were made out of lightweight wood and some paddle blades were painted: white was used as a ground color, while the figures and other images were carved in very low relief and painted red and black. Both plain and decorated types were used to paddle canoes; the decorated paddles were reportedly used with the principal decorated surface facing the canoe paddler. Ceremonial clubs and women's paddle-shaped dancing sticks received similar ornamentation.[19]

20 **Ancestor skull**

Overmodeled with parinarium nut paste. Mother-of-pearl inlay. Vegetable fiber for the hair. Formerly Middenway Collection (1920–34) and the Fiji Museum, Suva. Height 22 cm. Inv. 4533.

19 Tomb with overmodeled skull on Simbo Island. E. W. Elkington, 1907.

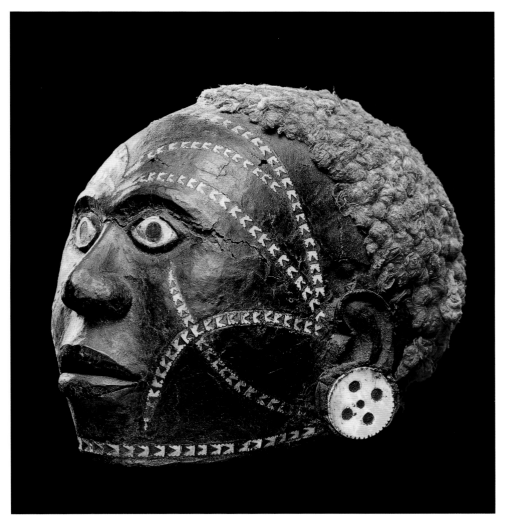

Hardwood stained black. Mother-of-pearl inlay. From a large canoe used for war expeditions and head-hunting. Collected by Count Rudolf Festetics of Tolna in October 1895. Formerly Stephen Chauvet Collection. Acquired by Josef Mueller in 1939. Height 29.5 cm. Inv. 4501-C.O.

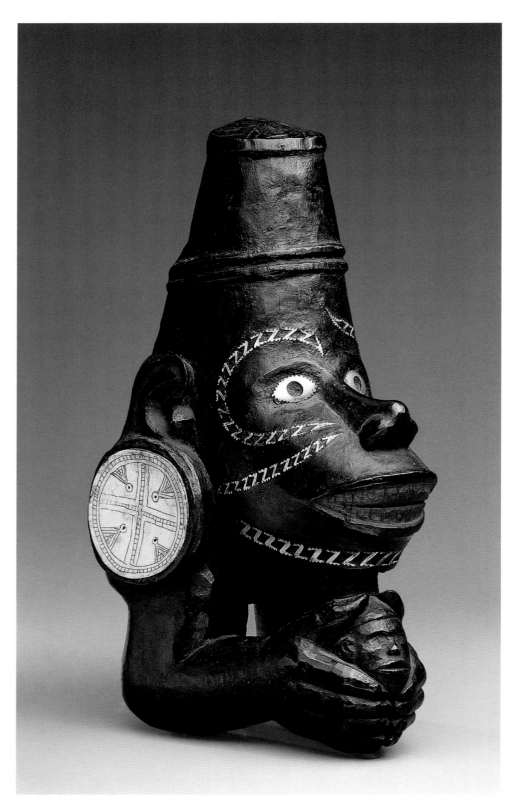

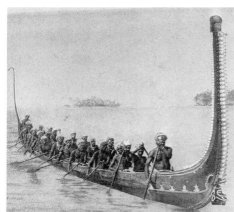

22  War canoe near Vella Lavella Island at the end of the nineteenth century. The white paintwork on the men's faces is reproduced exactly in the inlaid pearl designs on the overmodeled skull in fig. 20. Barbier-Mueller Archives.

Lawyer cane decorated with a layer of trimmed pieces of mother-of-pearl encrusted into a coat of parinarium nut paste. Some restoration. Guadalcanal Island. Acquired by Josef Mueller in 1939. Height 81 cm. Inv. 4514-A.

---

The *kokorra* image of a spirit being, though of a vague nature, is all-pervasive and is usually rendered in a seated position with updrawn knees and upraised hands (fig. 26). The large head is dominated by a pointed round shape which evidently represents hair. The hair is painted red and black, reputedly reflecting a men's custom of actually painting the hair red and black on certain social occasions. The straight serrated hairline depicted on this image corresponds to a custom recorded by Blackwood of trimming the hair "across the forehead in a special line."[20] In the paddle in fig. 26 the serrated or dentate line used to depict the hairline is also utilized to represent teeth and appears across the collarbone and shoulders and also at the waist, subdividing the body into sections and possibly referring to chest, waist, and/or hip ornaments. This segmentation of the torso is not a feature of many other *kokorra* images and may well represent a particular regional or socially referential variant.[21] The *kokorra* images may well have referred to more than one signifier —for example an initiatory spirit and an initiated male with clan-designated hair color and style—and in more than one context. Today, it is difficult to elucidate these multivalent systems of representation for canoe paddles, clubs, and other similarly ornamented artifacts from the Buka-Bougainville region.

Dance shields called *koka* were made by the Telei people of southern Bougainville (fig. 25).[22] The shield has rounded lower corners and is divided into two rectangular portions separated by a narrow vertical space. The small rectangular opening used for gripping the shield is located in the center of the bottom section. The shields, along with ornamented clubs, were once manipulated by dancers in the *unu* festival, a transition

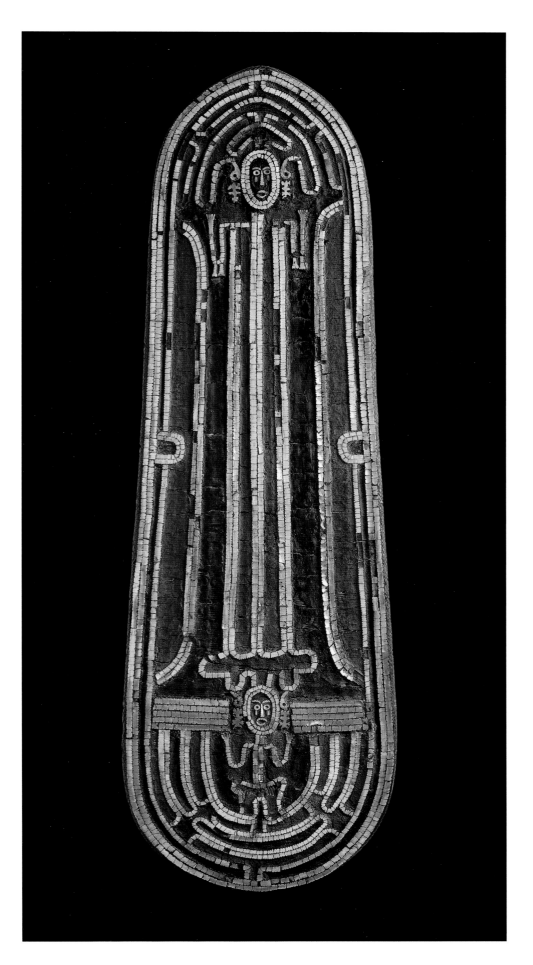

**24 a and b  Ceremonial ax**

Blackened wooden haft, encrusted with small pieces of mother-of-pearl (the photographs show the blade and the shaft). Iron blade of English origin. Acquired by Josef Mueller in 1939. Overall length 117 cm. Inv. 4505-G.

**25  Dance paddle (*koka*) or shield**

Hardwood. Incised and painted decoration. Telei people. Bougainville Island. Collected by Kibler about 1914. Formerly Linden-Museum, Stuttgart. Height 43 cm. Inv. 4506.

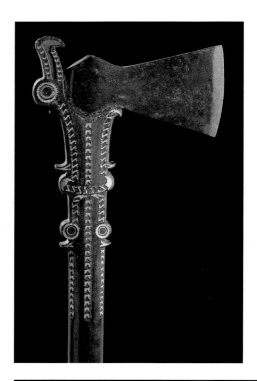

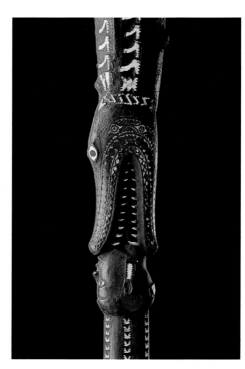

rite which marked the reception of young boys into adult society. Reportedly, the shields signified the sun, while the moon was represented by a sickle-shaped dance club, and the morning star by another club.[23] Information concerning shields and other objects suggests the possibility of a complex system of encoding references to myths, astral symbols (radial images), the turtle (a symbol of death), as well as references to places within a village.[24] The encoded visual allusions to myth, cosmic bodies, animals, and social place may well have comprised a system of multiple references communicating phenomena of social, mythical, and astral transformation.[25]

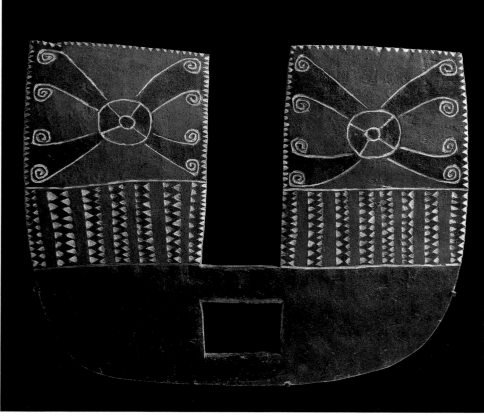

**26 Paddle**

Wood. Probably for ritual use. The polychrome low-relief decoration represents a spirit called *kokorra*. Buka Island or the northern part of Bougainville Island. Overall height 154 cm. Height of figure 34 cm. Inv. 4505-W.

**27 Mask**

Basketry covered with a coat of resin. The nose forms part of the underframe, but the mouth has been modeled. The ears are made of wood and decorated with small whitened incised triangles. The headdress is made of bark and fiber. Nissan Islands (lying between the Solomon Islands and New Ireland). Formerly Richard Parkinson Collection (collected by Parkinson about 1903) and Linden-Museum, Stuttgart. Height 59 cm. Inv. 4503.

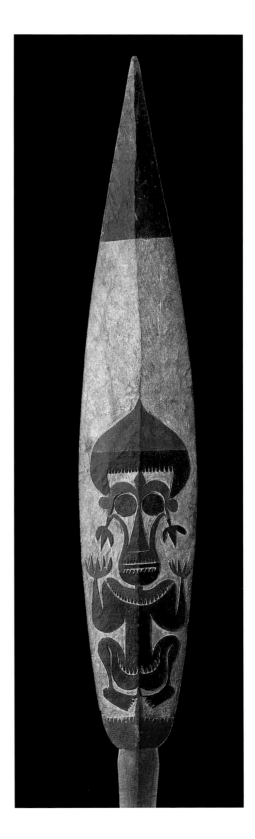

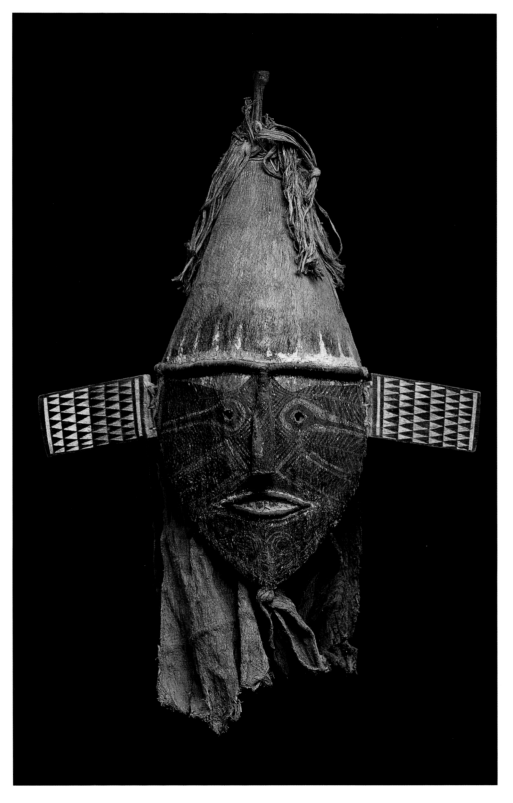

# Vanuatu

Kirk W. Huffman

**Vanuatu and New Caledonia**

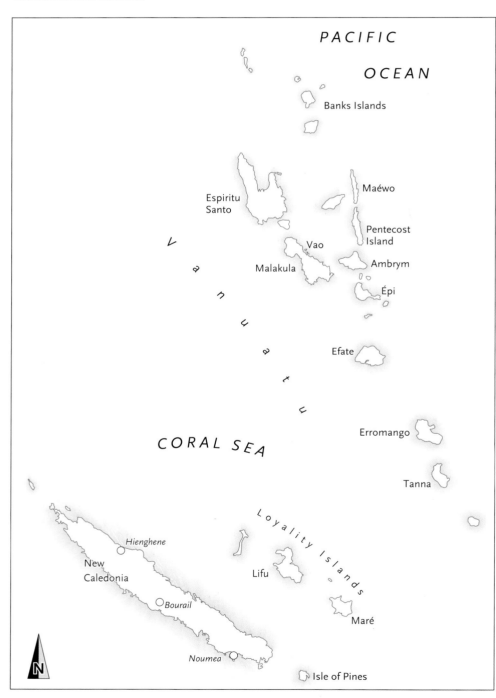

With a population today of about 170,000 Melanesian ni-Vanuatu, spread over 83 inhabited islands, speaking 113 different indigenous languages—most with subdialects—and a similarly complex series of cultural variations, it is easy to see why Vanuatu is usually passed over rather briefly in surveys of "traditional art." In relation to its small population, it has the world's highest ratio of linguistic and cultural diversity. In short, it is the most complicated spot on the face of the earth. In the short space available here, it will only be possible to skim the surface of the subject. Over 35,000 objects of Vanuatu art and material culture reside in museum collections around the world, the best collections being in Sydney, Melbourne, London, Cambridge, Paris, Basel, Honolulu, and Chicago, together with the growing collections of the National Museum of the Vanuatu Cultural Centre.

Unfortunately, many museum curators think that the Vanuatu objects in their collections represent aspects of cultures that have now died out or that these cultures, like so many others, have been modernized, "folklorized," or forgotten, but in Vanuatu this is not necessarily the case. Although almost completely wiped out by the introduction of European diseases, alcohol, firearms, blackbirding, cultural depresssion caused by certain extreme forms of missionary endeavor, and the mild confusion of seventy-four years of the world's strangest form of colonial government (the Anglo-French condominium of the New Hebrides), the ni-Vanuatu population has bounced back with incredible vitality from an all-time low of about 40,000 in the late 1920s to the rapidly growing young nation of today. Although it is almost impossible to estimate the pre-European population of the

Tree fern root. At one time painted, it was produced for the ritual that accompanied an individual's elevation to the rank of *maghenehivir*. Fanla village, northern region of Ambrym Island. During a two-month stay on Ambrym in 1966, Dr. Henri Barbier (1899–1994) forged friendships that afforded him the opportunity of acquiring a certain number of important pieces. In particular, he returned with four tree fern grade sculptures, the present one being the smallest. Height 210 cm. Inv. 4601-B.

country, a reasonable "guesstimate" would be at least 600,000. From those 40,000 people in the late 1920s have survived the myriad languages and cultures extant in Vanuatu today and the almost innumerable forms of "art," ritual, music, and dance. Much was thought to have been lost by outside observers —and some elements have been—but a lot of ritual and artistic activity went, so to speak, "underground" during the height of missionary and colonial power, waiting spiritually for the chance to reawaken at the relevant time and in the relevant form.

Certain isolated areas of the country had —and continue to have—little missionary or governement contact, with the result that traditional cultural life was able to continue almost unimpeded. One such example was the interior of southern Malakula, where the Nabwol-speakers did not fully descend to the coast and convert to Christianity until the late 1970s and the Botgaté-speakers until the late 1980s. By 1997, however, many of the Nabwol-speakers had become slightly disenchanted with the rather strict and dour form of Christianity into which they had fallen and they are now beginning to regroup periodically in another area of the interior to pursue their traditional rituals. The Botgaté-speakers, although now recently converted to Christianity, are pursuing much of their traditional ritual and artistic activities in an adroit combination, rather like the Nabwol, in which ritual payments are still made not only to the ancestral spirits but now also to God. Many of the innumerable *nalawan*-type rituals and their associated art pieces from southwest coastal Malakula, some described in great detail by Bernard Deacon in the 1920s (but never witnessed by him), were revived in the late 1970s in the move toward

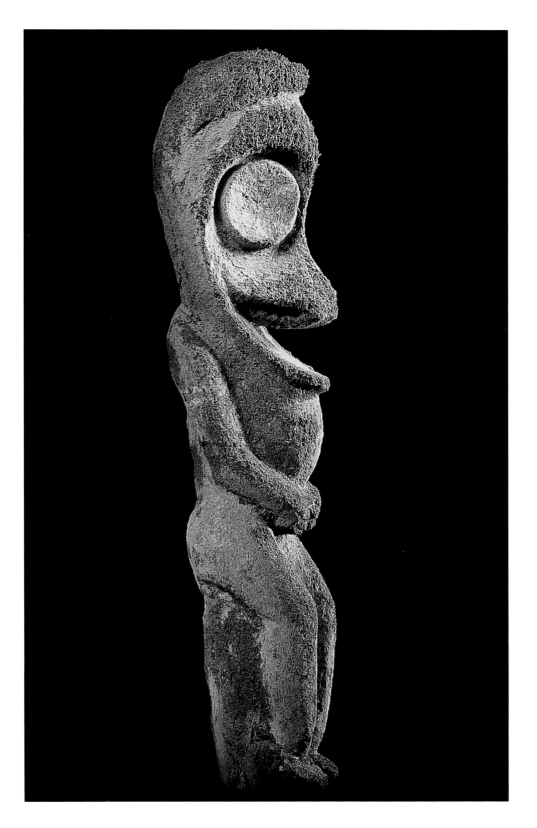

## 2 Grade statue

Tree fern root. Traces of paint. Minor restoration on the nose. Southern Malakula. Collected by the members of the expedition aboard the yacht *La Korrigane* in 1935. Height 117 cm. Inv. 4601-A.

## 3 Anthropomorphic sculpture

Limestone. Reputedly from the Banks Islands, but in fact a grade statue from an as yet unidentified group in southern Malakula. Collected in Vanuatu by Pierre Langlois at the end of the 1950s. Height 73 cm. Inv. 4607.

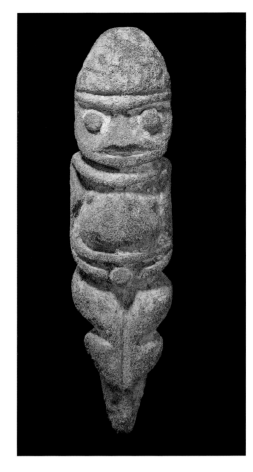

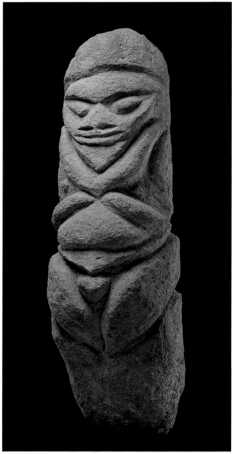

independence and are now a regular feature of cultural life in the area. Ritual reawakening of the *nalawan*-type *luan* rituals (and associated artistic material), such as *luan veüv*, *bar luan*, and, slightly later, *mansip*, had begun in the Port Sandwich area of southeast Malakula by the mid-1980s.

In the southeastern corner of Pentecost Island, in the Sa language area, the coastal village of Bunlap, together with several related hamlets, has always refused conversion to Christianity despite intense pressure over the last few generations. Consequently, minor and major rituals, such as *tatalbëan*, *warsangül*, and *naghol*, continue unabated. In another area of southern Pentecost, aspects of the supposedly defunct *chubwan*, or *juban*, rituals were revived in 1990. These are just a few examples. Most ni-Vanuatu are now Christian, but the majority have been able to combine a belief in Christianity with a respect for, and participation in, aspects of ritual life, achieving a complex and profound balancing act which enables them to retain their identity in a rapidly changing world and gives their life a depth and richness that the modern world cannot provide.

It is important to understand that the artifacts on display in museums are not produced and do not exist in a cultural vacuum. They are not produced as "art" in the European sense of the term. In fact, many of them are not even made with an emphasis on being seen by the living, but are produced within strict cultural parameters to be perceived by the living but, more importantly, to give pleasure to the ancestral spirits (or other types of spirits). For example, many of the stunning masks and ritual objects from northern central Vanuatu, which are widespread in museum

Hardwood. Prow ornament (*naho*) for a dugout, representing a frigate bird carrying an ancestor on its back. It indicates that the owner of the canoe had attained the grade of *maki*. From the small island of Vao, to the northeast of Malakula. Height 103 cm. Inv. 4611.

collections and each of which has its own name, meaning, and purpose, receive ritual spiritual power during their manufacture and retain it during the public performances of their rituals. Yet, on another level they can be said by high-ranking men to be *oli olsem flowa nomo bislama*, meaning "They are really just like flowers." They are the beautiful public but minor aspects of a ritual power. This deeper, "origin" power is present in places, objects, and art pieces which are kept hidden from the public and are seen and known only by the initiated or those who have purchased or inherited the rights to them.

This may partly explain why most ni-Vanuatu languages do not have a particular word for "art" in the European sense. Ritual objects are so inextricably interwoven with the ritual and spirit world that they cannot be split off and described by means of a term that does not have some deep ritual spiritual sense. Moreover, many of the ritual objects in museum collections overseas are, in Vanuatu terms, often incomplete. For example, certain headdress/masks may lack the intricate feather decorations (and sometimes in southern Malakula, the colored inflated pigs' bladders) and the body painting and decorations of the wearer that are essential components of the objects. Take for example the beautiful tree fern grade statue of the *maghenehivir* style and grade from north Ambrym (fig. 1). If it were the major figure in the ritual, it would be brightly painted with vegetable and mineral colors. A sacred leaf would be placed through its nose, and it would be placed upright under a large complex wooden and bamboo structure, upon whose roof platform the grade-taking male in full painted regalia would dance at the high point of the ritual. Such rituals still continue in north Ambrym, the individuals

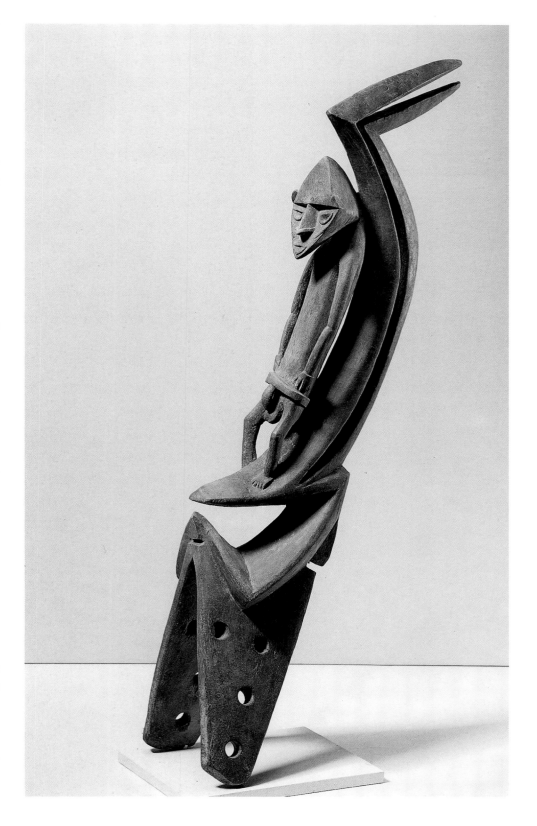

**5 Large standing one-faced slit drum (*atingting*)**

Carved out of the trunk of a breadfruit tree. Acquired at Olal in northern Ambrym by Dr. Henri Barbier in 1966. An accompanying note specifies "Melbulbul drum. Made before 1939." Height 285 cm. Inv. 4602-A.

**6 Two standing slit drums (*atingting*)**

The one on the right, carved by Mweleun Kon, has eyes in the shape of orange segments, indicative of a since extinct grade. Collected by Dr. Henri Barbier in 1966. Heights respectively 242 cm, 206 cm. Inv. 4622-A and B.

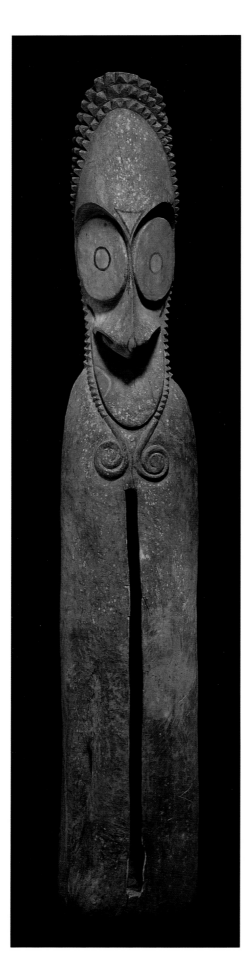

Maghekon and Bong Mweleun doubly taking a superb *maghenehivir* grade in Fanla village in 1984, and again jointly performing *maghe lon bul/maghe nem bul* there in 1990.

North and north-central Vanuatu are the classic areas for what is known in the literature as the "graded system," a complex system whereby a person buys his or her way up a series of increasingly expensive social ranks by means of castrated male tusker pigs, their value depending upon their tusk curvature. This enables an individual to gain (temporarily) more influence in the world of the living and a better life in the world of the dead. Each rise in grade and status involves the payment and sacrifice of such pigs, a sponsor from the rank aspired to, expensive rituals and regalia, and a change in name. A man thus becomes a "Big Man," now called *tsif* ("chief") in Bislama, Vanuatu's lingua franca. He does not necessarily have the overriding powers that the English term "chief" implies, but he has more influence as he is closer to the world of the ancestral spirits, who do have power.

The graded system varies from place to place. The general term for this system in Bislama is *nimangi*, but even this term is not understood everywhere in the northern half of Vanuatu. Each area has its own term for the system, for example *maghe* in north Ambrym, *nimangi* in south Malakula, *maki* in northeast Malakula, *ir'p navet/maki* in northwest Malakula, *nangi* in north-central Malakula, *warsangül* in south Pentecost, *leleboan* in central Pentecost, *bolololi* in north Pentecost, *sumbwe* in central Maewo, *hunggwe* in east Ambae, and *suque* in parts of the Banks Islands. Each system had, or has, differing numbers of ranks and titles and different

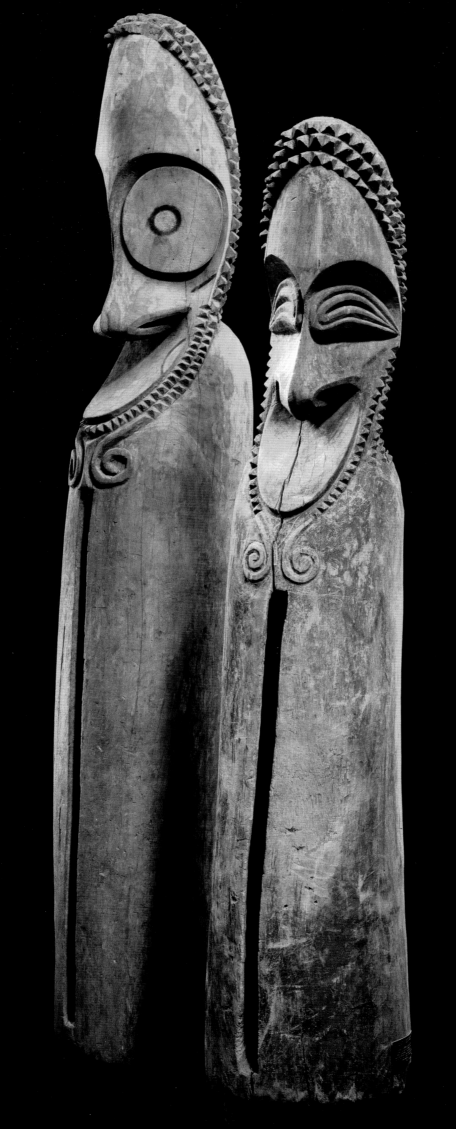

7 **Slit drum**

Decorated with three superimposed heads. Probably southeast Ambrym. Photograph Robert Lamb, before 1905. Barbier-Mueller Archives.

8  Collection of *atingting* slit drums at the end of the nineteenth or beginning of the twentieth century. Port Sandwich region, southeast Ambrym. Barbier-Mueller Archives.

9  **Large standing slit drum with heads (*atingting geht'lan*)**

The superimposed heads represent deceased forebears. Acquired at Olal in northern Ambrym by Dr. Henri Barbier in 1966. Height 388 cm. Inv. 4602-D.

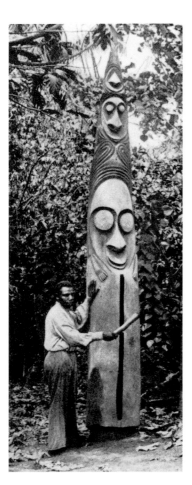

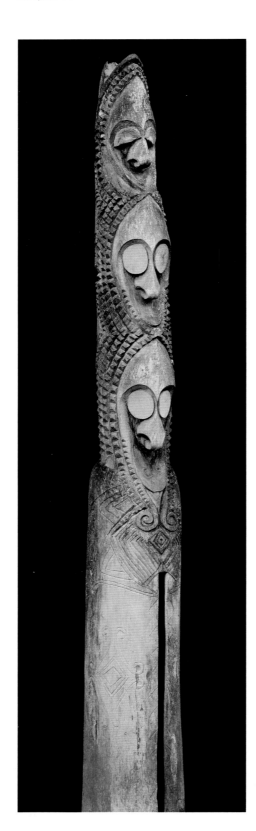

kinds of ritual paraphernalia associated with them. For example, the graded system on the small island of Tomman off south-southwest Malakula has between nineteen and twenty-two different social ranks, while the *maki* system of the small islands off northeast Malakula has only two, although each one may take twenty to thirty years to do. The fine canoe prow (*naho*; fig. 4) from the island of Vao indicates that the canoe owner has "made *maki*," because the mouth of the frigate bird is carved open (a closed mouth indicates that the owner has not yet participated in the graded system). The last major *maki* took place on Vao in January 1986, when old Tain Mal (a title purchased from Ambrym) of Singon made *maki-ru* to be given the title Melteg Mütmüt. The ritual, which he had been planning since the 1940s, took place on the megalithic dance ground of Norohure, with two hundred pigs and a spectacular pig with three tusks (purchased from Malo). In the Big Nambas area of northwest Malakula only those of hereditary chiefly lineage and special linked individuals can make *ir'p navet*, while in the neighboring Batarnar area lower ranks in the *nangi* were open to all men, but higher ranks were restricted to hereditary chiefs. In the Nindé-speaking area of southwest Malakula there was no public graded system at all of this type.

A significant percentage of Vanuatu objects in museum collections around the world are associated with these graded rituals. In many areas of Malakula and Ambrym, ritual "insignia" erected on the dance ground for the rituals tend to be of fragile plant material for the lower ranks, wood or tree fern for the middle ranks, and stone for the higher ranks. The fine tree fern figure from southern Malakula (fig. 2) is an example of one of

the many types of middle-ranking grade figures (although it might also be a grade statue from one of the female graded systems, possibly from the Malesif area). The superb stone graded figure (fig. 3) is an example of a graded figure from one of the highest ranks from a southern Malakula group. It may be a *nevat tembahav* grade figure from the Nasvang-speaking area of south Malakula, although again it may be from an associated women's graded system. Most men's graded systems had an associated women's graded system, or systems, that sanctified women's status in some way. One of the unfortunate effects of missionary work seems to have been the destruction in most areas of the women's systems without the destruction of the men's, making the social position of women less equal than it was before, when a woman could become a "High Woman" —a woman of influence, especially within the world of women, and worthy of more respect from men.

This part of northern Vanuatu is also the area of a highly sophisticated traditional copyright system, possibly much older and certainly as complex, if not more so, than European copyright systems. Almost anything could be copyrighted—songs, dances, myths, artifacts, ritual colors, and even dream visions. At the same time, in this system almost anything could be sold—social ranks, titles, whole rituals, parts of rituals, art forms or parts of them. A perpetual drive for cultural and ritual innovation spurred on an incessant intra- and inter-island trading system, with tusker pigs, hermaphrodite pigs, stringed shell bead money, or money mats being the currency needed for many of these ritual trade purchases. Negotiations might take years before completion. It was sacred trade

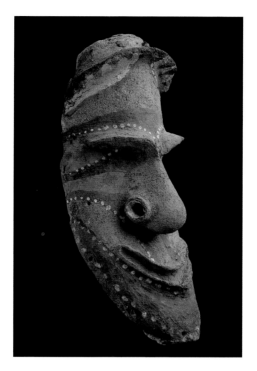

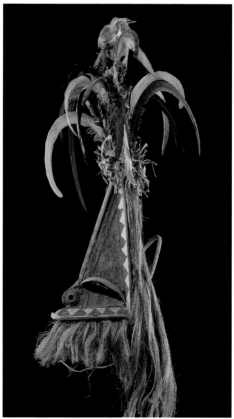

10 **Mask**

Palm tree wood. Overmodeled, with paint (black, red, and white). Probably from east or southeast Malakula. Formerly collections of the Pitt-Rivers Museum, Farnham, Great Britain (before 1900) and John Hewett (London). Height 31 cm.
Inv. 4609.

11 **Mask**

*Rom* type of mask used during *ole* dances. Banana fiber on a light wood frame decorated with a black and white sawtooth pattern. Coated with a red and green tinted slip. Vegetable fiber for the beard. Rooster plumes for the crest. Collected by Dr. Henri Barbier in the village of Fanla, northern region of Ambrym Island in 1966. Height 79 cm.
Inv. 4606.

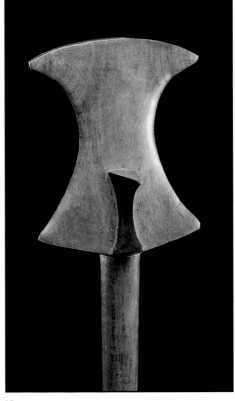

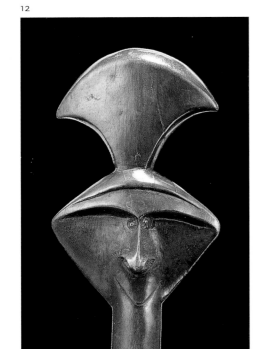

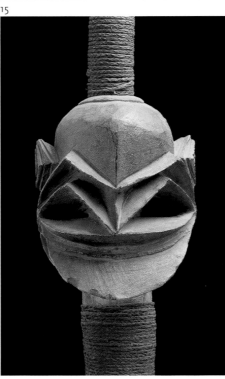

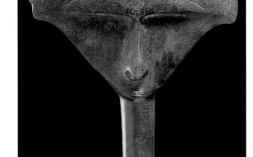

12 **Club (detail)**

Hardwood. Of the *bweten bal* ("eagle's head") type. Fiber attachment. Ambrym. This type of club is familiar because of an example brought back by Forster from Captain Cook's second voyage. Overall height 80 cm. Inv. 4605-A.

13 **Club (detail)**

Hardwood. Comparison with the specimens in figs. 12 and 14 demonstrates that the present example derives from an extremely stylized face. This very rare, old type comes from Efate. Acquired by Josef Mueller before 1939. Overall height 112 cm. Inv. 4605-C.

14 **Club (detail)**

Hardwood. This seems to be a variant on the Ambrym model in fig. 12. Left-hand side restored. Overall height 82 cm. Inv. 4605-L.

15 **Spear foreshaft**

Hardwood. In the shape of a Janus-faced human head with oversized nostrils. Big Nambas. Northwest Malakula. Acquired by Josef Mueller before 1939. Overall height 63 cm. Inv. 4608-A.

and therefore involved notions of respect but also, of course, the use of magic. Those wishing to purchase aimed for a lower pig price, those agreeing to sell aimed for a higher one. Pigs—"sacred currency," "money with a soul," "cash on legs"—were shifted back and forth over vast areas for the purchase of social status and ritual enrichment. Often loaned at rates of interest and compound interest, they provided links and (never forgotten) debts that joined large areas of the country into a sort of perpetual "pig Internet," which, to a certain extent, still covers much of the region today. Vanuatu pigs of ritual value have a beauty, style, and grace that is a constant topic of conversation among tradition-oriented ni-Vanuatu. They can have souls, a language, and personal names, providing an essential ingredient for an individual's status in life and his or her progress toward the world of the dead, where the spirits of the pigs killed in rituals are also to be found.

The circular tusks of castrated male pigs can feature as elements of ritual objects, such as the double-circle tusks carved on the fine monumental wooden slit drums from north Ambrym, known as *atingting* (figs. 5, 6). Those with two or three superimposed ancestral spirit faces are known as *atingting geh'lan*, or *geht'lan* (figs. 7, 9). It is to be noted that the ancestral faces on these slit drums lack a mouth. The slit which is beaten is the mouth and the sound is the voice of the ancestors, who speak in coded rhythms across large areas, sending messages back and forth. The complex drumming rhythms are performed by drum orchestras during rituals in Malakula, Ambae, and Pentecost, among other places. In central Vanuatu, in the Efate/Shepherds region, the slit drum

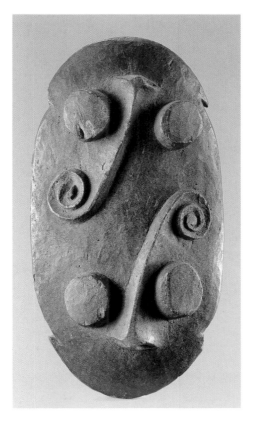

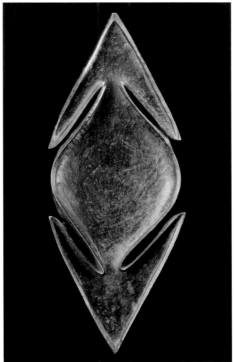

**16 Underside of a large platter**

Hardwood. For the preparation of breadfruit. The two pairs of truncated feet form the eyes of two faces; the nose terminates in a small spiral that represents the hair. Ambrym. Formerly collection of Baron F. Rolin. Length 90 cm. Inv. 4600-D.

**17 Food platter**

Hardwood. Shiny patina. The example would appear to be unique of its kind. According to J. J. Klejman (New York), who had acquired it from John Hewett (London), it was reputedly brought back from Pentecost Island (?) in the nineteenth century. Length 79.5 cm. Inv. 4600-B.

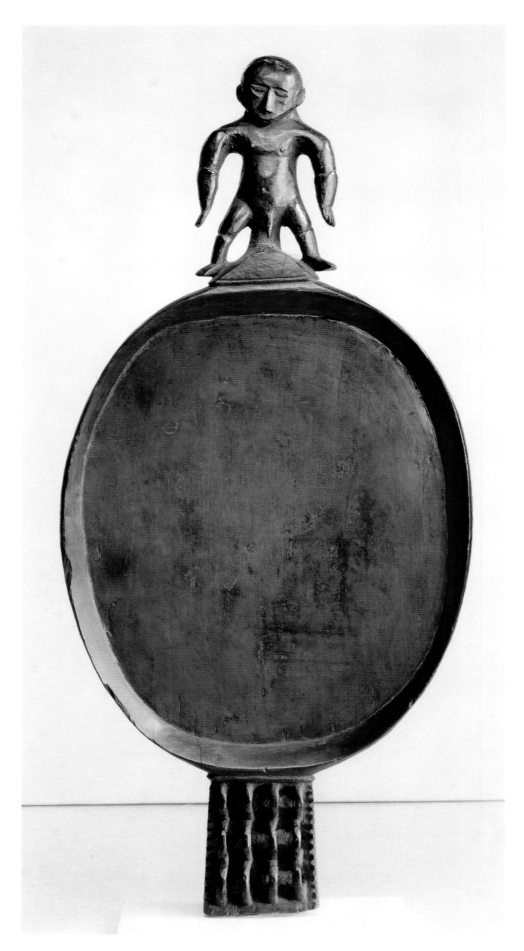

orchestras have disappeared, but here the drums tended to represent the actual voices of living or dead chiefs rather than generalized ancestors. Slit drum stylistic variations are numerous, forming an artistic chain throughout some of the northern islands, and the drum orchestras on the dance grounds provided, and still provide today in some places, an essential element in much ritual activity, whether it be for social ranking, public rituals, the public aspects of some of the more secret rituals, or for activities associated with initiation, status, or death. Such drums exist not just in the world of the living, but also in the world of the dead—in the "sky world" or in the (probably) earlier ancestral world underground or under the sea—and their rhythms are sometimes still heard by the living.

Numerous ceremonies, such as the *nimangi*, *nalawan*, and *luan* rituals in southern Malakula and Ambrym, are based around these drums. Thousands of overmodeled masks used in such ceremonies are held in museums around

**18  Large ceremonial platter**

Hardwood. Topped with a male figure. The platter is for *nalot*, a Bislama term that designates either taro cake or yam bound with coconut milk and cooked in a tightly sealed vessel. Collected during the first half of the nineteenth century by the Reverend Yates in the village of Terevin, St. Philip Bay, northern Espiritu Santo. Formerly Ralph Nash Collection. Length 87 cm. Inv. 4600-A.

the world. The mask in fig. 10 is of an early and rare style, possibly from around the Banam Bay area in east-southeast Malakula. Such masks consisted of a tree fern, bamboo, or light wooden base, sometimes covered with a spider-web "cloth" overlay, overmodeled with a vegetable-fiber paste, sometimes with a slight earth or clay slip (rights to certain types of mixtures vary from area to area), and painted with vegetable and mineral colors. The headdresses made from very light vegetal materials from northeast Malakula are rarer in museum collections because they are so fragile and because, in some cases (for example, the *tamate* headdresses of the Banks Islands and the *rom* headdresses of Ambrym; fig. 9) such objects are usually destroyed after the rituals. However, there are some fine examples (generally early) in collections, notably the superb *rom* headdresses collected by Jean Guiart in north Ambrym in the early 1950s and early 1960s. However, ritual destruction and the prohibition on the "selling" of such objects has become much stricter in the Banks Islands and in Ambrym since independence in 1980.

We have just touched lightly on a few aspects of some of the innumerable art forms from the northern section of Vanuatu (figs. 12–24). Mention should also be made of the beautiful woven and dyed pandanus money and ritual mats produced by women (although in a few areas the mats are woven by women and dyed by men), but this is a subject which should really be written about by a woman. There are certain cultural traditions in Vanuatu which it is felt outsiders should respect. If an outsider is given permission to pursue studies into aspects of Vanuatu's cultures, it is not really considered appropriate for a woman to be studying aspects of the men's world that

women should not know about and (to a slightly lesser extent) vice versa. Moreover, there are certain cultural aspects, often traditionally sacred, "tabu," or hidden, that ni-Vanuatu do not want outsiders to write about. In a world where sacred knowledge is power or influence, where copyright belongs to certain individuals, clans, or groups, and where there is a cultural emphasis on levels of secrecy, these wishes should be respected and that is what I have attempted to do in this essay.

Many ni-Vanuatu are aware of the existence of rich collections of their art and material culture overseas, and most are glad that these collections exist as they often contain certain types of objects that are no longer made, but whose "memory" or copyright holders still exist. The viewing of some of these lost or "sleeping" styles, as well as the viewing of early photographs, can spark off intense cultural discussions, often leading to a search to reawaken the rituals associated with them. Ni-Vanuatu realize, and are grateful for, the hard work that "white men" (museum curators) have done in preserving these often fragile collections. Some often wonder, though, what the "white man" actually *does* with these collections. Moreover, there are certain worries. Are all the objects dead? If not, how are those that are spiritually still "alive" kept content and spiritually fed? Are "white women" allowed to touch or get too close to certain sacred objects that they shouldn't? Vanuatu now has a new, modern museum building, the National Museum of the Vanuatu Cultural Centre, which was opened in 1995. It is the hope of many ni-Vanuatu that museums overseas will consider sympathetically eventual requests to repatriate certain selected items from their early collections.

19 **Platter**

Hardwood, with patina. For *nalot*. Northern Malakula (?). Acquired by Josef Mueller before 1942. Length 93 cm. Inv. 4600-C.

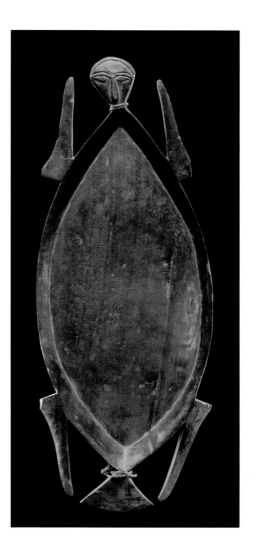

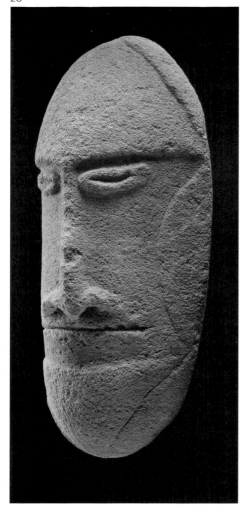

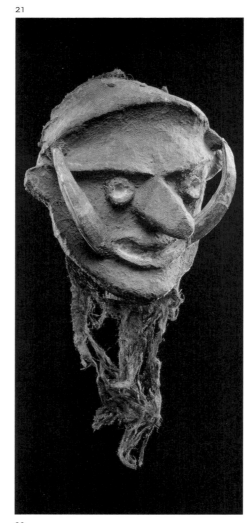

**20 Magic stone**

Function unknown. On Ambrym such stones (called *müyü ne bu*) were used to facilitate pig exchange. Precise place of origin unknown. Height 18.2 cm. Inv. 4604-A.

**21 Puppet mask (*temes nevinbür*)**

Tree fern base, vegetable-fiber paste overmodeling. Boar tusks. Red, blue, and white paint. Spider-web overlay. Malakula. Height 28 cm (including beard). Inv. 4610.

**22 Magic stone**

Function unknown. Malakula (?). Formerly Titaÿna Collection, then acquired by Josef Mueller (before 1939). Height 22.5 cm. Inv. 4604-B.

**23 Two pudding knives**

Hardwood. Left, provenance unknown. Formerly Pitt-Rivers Museum, Farnham, Great Britain (before 1900). Right, from the Banks Islands. Formerly Beasley Collection, with the collection's label. Lengths respectively 32.5 cm, 44.3 cm. Inv. 4605-D, 4603.

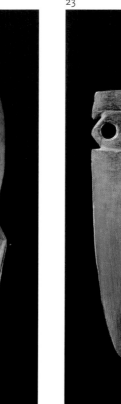

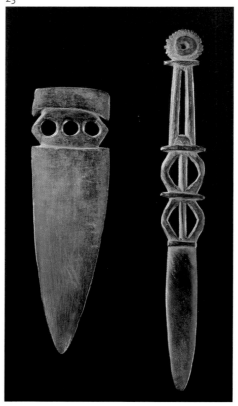

## 24 Ancestor effigy (*rambaramp*)

Cane frame with vegetable-fiber paste over-modeling for the body. Black, white, and red paint with traces of blue. Belt made of bark. The head is the overmodeled skull of the ancestor himself (the hair is made of spiderweb), and a pig's jawbone hangs around the neck. In one hand the sculpture holds a nautilus shell, in the other a curved boar tusk. Southern Malakula. Formerly collections of Georges Pluvier and Jacques Kerchache. Height 176 cm. Inv. 4621.

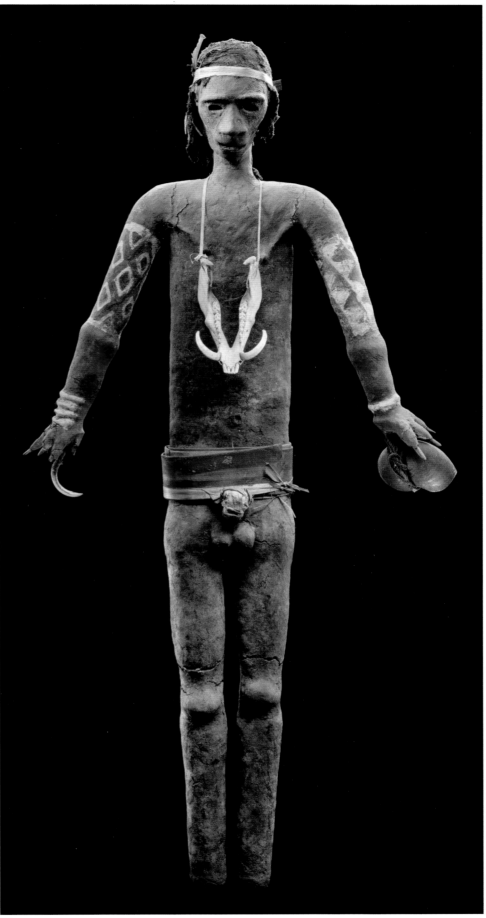

22

297 Vanuatu

# New Caledonia

## Traditional Kanak Art

Roger Boulay

New Caledonia lies at one end of an archipelago chain known as the "Melanesian arc" that stretches west as far as Papua New Guinea. From the Bismarck Archipelago, comprising Manus, New Ireland, and New Britain, this arc includes the Solomon Islands and the Vanuatu archipelago, extending south from the tip of Vanuatu to New Caledonia and the Loyalty Islands no more than 400 kilometers distant (see map p. 284). New Caledonia, then, clearly forms part of a cultural region whose underlying homogeneity has been firmly established by archaeology, linguistics, and anthropological research. Named New Caledonia by Captain Cook, who reached it in 1774, from the mid-nineteenth century onward the islands have been the theater of a missionary competition

1 A traditional Kanak great house, decorated with sculptures (doorjambs, roof finial). Photograph taken at the beginning of the twentieth century. After F. Sarasin 1917.

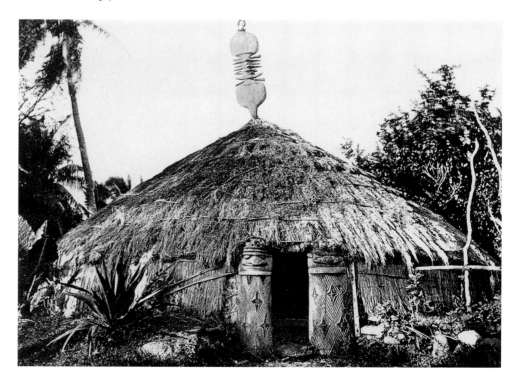

opposing the Protestant and Catholic faiths. This evangelical zeal had profound repercussions and entailed the disappearance of many customs, as well as the impoverishment and transformation of traditional art. A period of colonization followed by the annexation of the island by France in 1853 completed the process.

Though Caledonian social mores and languages (twenty-four are spoken on the island at present), and its material and artistic culture naturally exhibit many common features with the rest of Melanesia, its position at the far end of the Melanesian arc has seen the island develop a singularly original civilization of its own.

## Great House Carvings

Traditional art found outlets in two main areas: firstly, in the decoration of the "great house," or *grande case* (figs. 2–4), the men's house donated to the head of the eldest clan; and, secondly, in the various objects employed in ceremonial exchange.

The great house is adorned with carvings and sculptures on certain architectural elements, such as the roof finials and doorjambs (fig. 1), as well as the interior beams and supporting posts. The house itself is built at the top of a broad walkway, where all the most important events of social life take place. It is there, for instance, that gifts to be apportioned between the various village lineages involved in a particular celebration are laid. In a spot marked off in the grand avenue by anthropomorphic statues planted in the earth, great quantities of taros, yams, sugarcane, fabrics, and shell currency are piled up. For the most part, the statues show

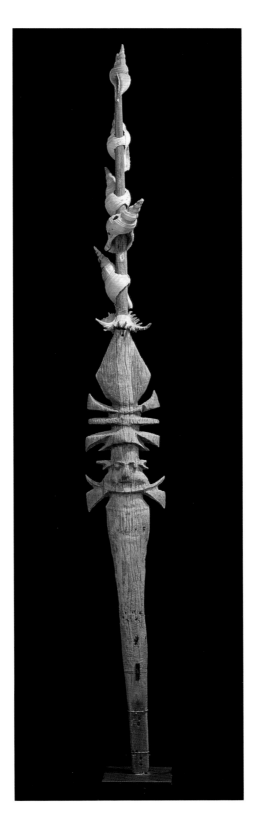

2  **Finial ornament carving**

Hardwood and triton shells. From a great house. Western coastal region. Height 283 cm. Inv. 4708.

**3 Pair of doorjambs**

Hardwood (*houp*). These jambs used to frame the door of a great house. Collected during a Brittany fishery expedition about 1870. Formerly Olivier Le Corneur Collection (Paris). Acquired from Le Corneur and Roudillon in 1967. Heights respectively 237 cm, 239 cm. Inv. 4700-A and B.

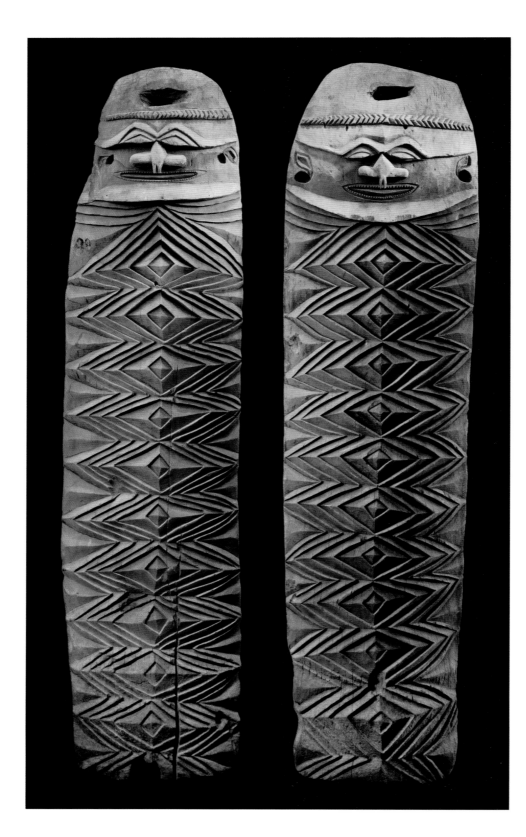

high-ranking members of the community wearing the emblems of their social status, such as headdresses of plaited rushes (*tidi*), necklaces incorporating little packets of magical paraphernalia, and armlets.

The Musée Barbier-Mueller contains a number of objects of this type, such as the finial ornament from a great house of circular plan (fig. 2). It is carved out of a single piece of *houp* (*Montrouziera cauliflora*). The top of the carved spire is always stuck with tritons (*Charnia tritonis*), reminiscent of the shell trumpet symbolizing the word of the elder that is blown to summon the villagers. These carvings rarely survive complete with their shellwork, which would normally have been left in place during aristocratic funerals and was considered an essential and significant adornment to the finial. The example from the Musée Barbier-Mueller is in the characteristic style of the Arhö-Ajie language region, between Bourail on the west coast and Houailou on the east coast. The treatment of the face can be compared to classic pieces from the Houailou region. Such ornaments were primarily intended to evoke the physiognomy of a spirit ancestor. The finials represent the community of the spirits of the dead who, once they arrive in their new abode, can henceforth preside undisturbed over the affairs of the living.

Other features from great houses include a pair of jambs collected in the nineteenth century (fig. 3) and a very old jamb (fig. 4) from a Spanish palace, to where it had been taken at the end of the eighteenth century. These elements would have been placed on either side of a door panel that was often adorned with a lintel and a threshold carved with a face. The great house is decorated

**4 Doorjamb**

Hardwood, deeply fissured. From a great house. This ancient piece was removed to Spain at the end of the eighteenth century and was preserved by the Quintanilla family from whom it was acquired. Height 168 cm. Inv. 4700-C.

---

with other sculptures, such as the outer posts supporting the jack rafters, large shelves carved with a face on the back panel, and pieces of applied carving affixed to the houseposts inside. The iconography of the doorjambs follows something of a standard pattern: a face emerges from a geometrical decor, perhaps representing the matting in which a corpse is wrapped at burial. The pattern on the example shown in fig. 4 is characteristic of the Paici-Cèmuhî language region, in the area bordered by Koné (west coast) and Poindimie, Ponérihouen (east coast). The face is decorated with the kinds of personal adornments worn by men, namely combs and a band of fronds bound round the head. This ancient piece conserves fragments of the tenon used to fix it to the wooden framework of the house.

The wood known as *houp* (*Montrouziera cauliflora*), from which the main sculptures on the island are carved, is a tree endemic to New Caledonia, much sought after for its quality timber, though its primary importance lies in its vital symbolic role. Venerable hermit of the forest, the *houp* is a tree that harks back to a time of distant ancestral origins, redolent of the first inhabitants and masters of the earth, and symbolizes the elder, the head of the lineage.

**Masks**

Like all other events punctuating social life on the island, mourning the passing of an important individual presents a befitting occasion for wearing masks (fig. 8) and carrying especially elaborate weapons (fig. 7). The carvings reproduced here show the mask's main feature, the face (figs. 5, 6), which is the foremost component among a number

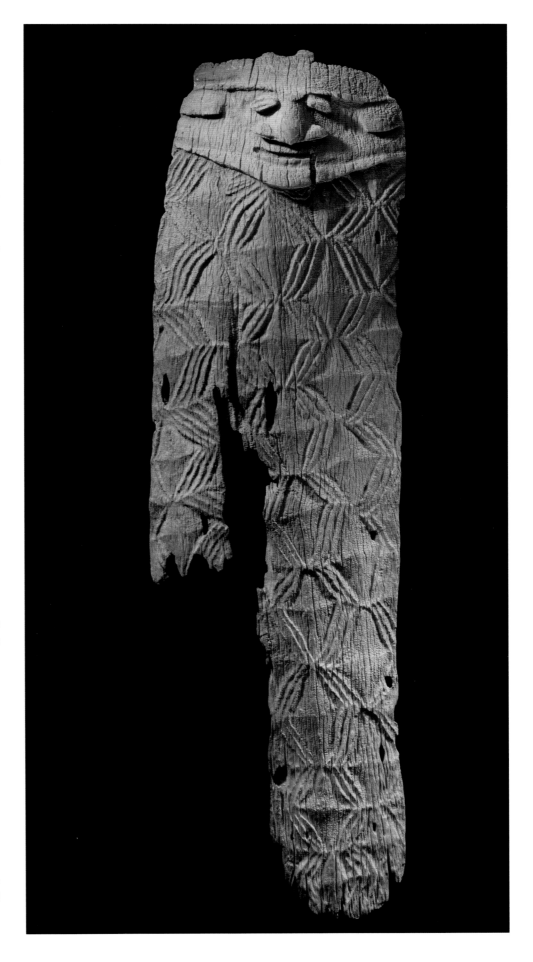

### 5 Mask

Hardwood. *Abrus* seeds, now missing, were stuck around the mouth opening. Formerly Muséum d'histoire naturelle, La Rochelle. Height (excluding fiber) 32 cm. Inv. 4703.

### 6 Mask

Hardwood. Restorations made to the upper and lower protuberances. Overall height 52 cm. Inv. 4707.

### 7 Central section of a light spear shaft

Hardwood. A figure has been carved from the body of the weapon and dyed black. Formerly J. J. Klejman, New York. Overall height 207 cm; height of the figure 25.5 cm. Inv. 4706-A.

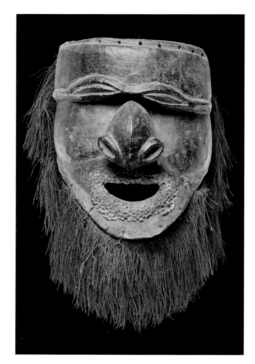

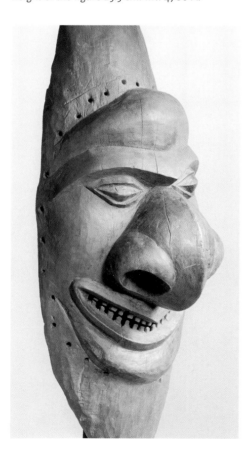

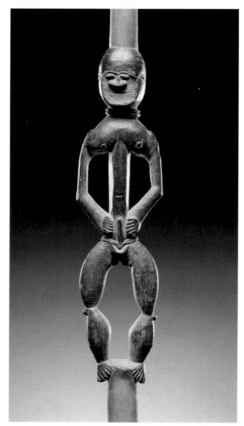

of highly symbolic elements. The complete mask, however, would include a mantel of black plumes from a local pigeon, the *notou*, that lives in areas of virgin forest. The head-dress is made using hair cut from men who stay by the corpse throughout mourning and who let their hair grow until the long period of grieving is at an end. The mask's beard is made from the same material, the plaited tufts of hair being threaded through holes that often remain visible around the edges of the carved heads.

The mask is to some extent the attribute of chiefdom. Bestowed on the headman by the founding clans, it signifies at once the original ancestor (evoked by the *notou* and the color black) and the kingdom of the dead (through the use of the hair of grieving men). In some regions, a mask would be given the name of the guardian spirit of the undersea world.

8 Old postcard showing two complete masks with their hair and (left) a cape of pigeon feathers. Barbier-Mueller Archives.

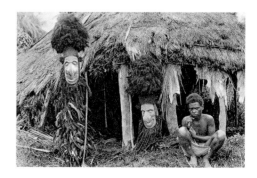

## Carved Spears

The Kanak masked figure appears during large-scale ceremonies. As his function on such occasions is to maintain order, he is armed with a club (fig. 13) and/or a light spear. The latter—also carried by the men who stick them into the roof of the great house at a point during the ritual—are often ornamented with painstaking carvings. As well as being a very rare type, the spear in the Musée Barbier-Mueller is also one of the finest in existence (fig. 7).[1]

## Objects of Ritual Exchange

Exchange is practiced through prestigious objects such as shell currency, round-bladed ceremonial axes (fig. 9), unhafted adz blades, distinctively carved weapons, and conical dance aprons made of rolled bast. Emblems of the chief's position, round-headed axes circulate between all the members of the older clans. Such axes are composite items assembled from disparate elements: the blade is commonly a disk of green serpentine (of the jadeite group) that may be, in the very finest examples, sanded flat to a thinness of 5–8 millimeters at the center. The blade is thus extremely fragile and can serve no practical purpose. Serpentine was extracted for the most part from important deposits on Ouen Island near Nouméa. From there, according to some reports, it would start out on a prolonged cycle of barter that would take it north up the coast, eventually reaching the Loyalty Islands. The symbolism embodied by the ceremonial ax (described as an "ax-monstrance" by Bruni d'Entrecasteaux's crew of 1794) is reportedly linked to ritual pleas for sun or rain. The blade is so thin that, when held up to the sunlight, it is encircled

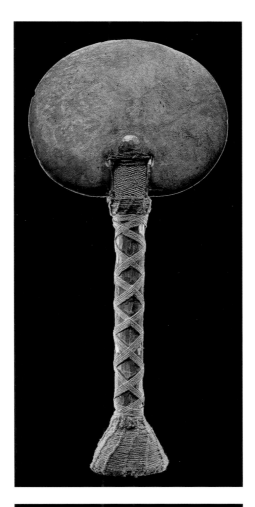

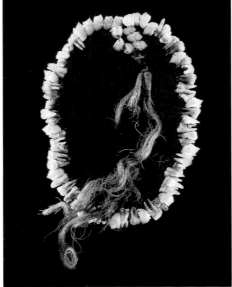

## 9  Ax

Round blade of light green jadeite. Acquired by Josef Mueller before 1942 in Paris, with a lot comprising other axes of the same type together with disklike unhafted jadeite blades.
Length 61.5 cm. Inv. 4706-C.

## 10  Necklace

Threaded with alternating human teeth and small shells. The "clasp" is a jadeite bead that was fastened to a tuft of human hair. Formerly Paul de Givenchy Collection. Acquired by Josef Mueller from Charles Ratton in 1939.
Length 75 cm. Inv. 4588.

## 11  Stake

Hardwood. Round in section and topped with an ancestral figure. In the past, these human figures crowning posts originally driven into the ground were sometimes mistaken for ridgepole finials. A similar piece, in the Musée d'Aquitaine, Bordeaux, was described by its collector (1877) as being located near the entrance door to a chief's house. Brought back to France by a civil servant named Alfassa at the end of the nineteenth century. Overall height 238 cm. Inv. 4701.

## 12  Cane (detail)

The top shows a female figure wearing a skirt. Loyalty Islands. Formerly (before 1900) Pitt-Rivers Museum, Farnham, Great Britain. Acquired from John Hewett. Overall height 82.5 cm; height of the figure 19.5 cm. Inv. 4704.

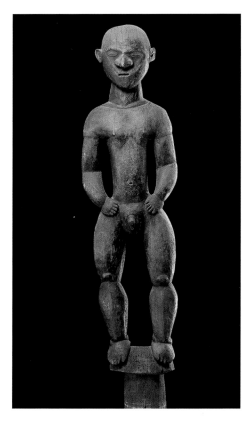

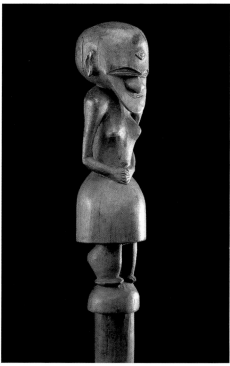

by a vaporous golden-tinged halo. The stone blades themselves are hafted with wooden shafts wrapped in barkcloth, held in place by a highly ornamental and intricate webbing design in cord plied out from tree-kangaroo fur. Such strands are also status symbols: twisted into skeins, red-dyed cords are also used in ritualized exchange, adorning or simply being handed over with other prestation articles, such as spears, mother-of-pearl knives, shell currency, necklaces (fig. 10), women's skirts, belts, and other articles of personal adornment. Among the commonest gifts were strips of *tapa*, but these were soon ousted by the bolts of imported cloth that today play such an important role in traditional Kanak life.

### Statuettes and Sculpture

Sculptures such as anthropomorphic figures surmounting posts (fig. 11), canes decorated with carvings, effigies of children lying in cradles, and representations of the *notou* pigeon number among the best-known articles of traditional Kanak art. This artistic tradition is an ancient one indeed, since such objects were among the first to be brought back by eighteenth-century mariners returning from circumnavigating the globe. Their variety and the uneven quality of their craftsmanship suggest that they were made at home, as domestic items, by carvers whose skill thus varied considerably.

### Incised Bamboo

One of the most original forms of Kanak art is incised bamboo. The most ancient traditional style probably consisted exclusively of geometrical ornamentation, but soon after the arrival of the Europeans bamboo working

turned in a fresh direction and figurative illustrations began to appear. In fact, the majority of the examples catalogued in museums parallel scenes of traditional Kanak life with what was for their creators the extraordinary spectacle of the everyday habits of the whites. The craft of incising bamboo has persisted up to the present day and is reinterpreted in a most original way in the work of today's Kanak artists. Bamboo working now unquestionably serves as a badge of Kanak identity, its imagery providing forceful and often amusing evidence of the creative rebirth of New Caledonia.

13  **Collection of clubs**

Hardwood. Acquired by Josef Mueller prior to 1942. Heights from left to right 76.5 cm, 80 cm, 73 cm, 65.5 cm, 79.5 cm. Inv. 4711, 4712, 4715, 4713, 4717.

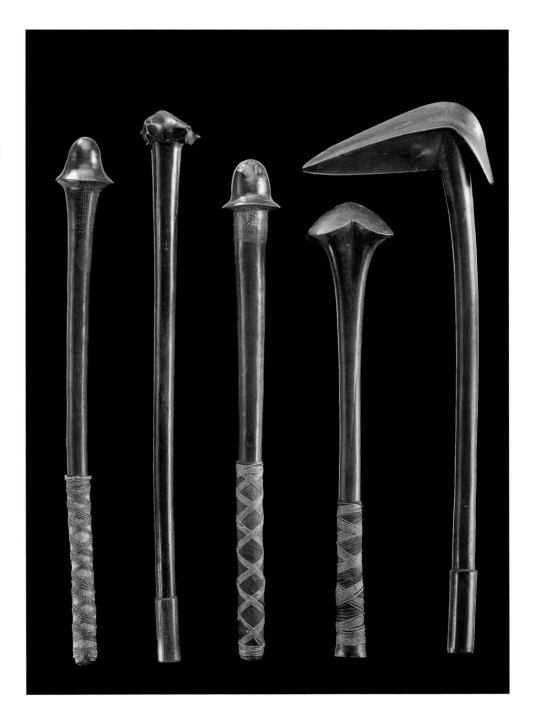

# Tonga and Samoa

Adrienne L. Kaeppler

Tonga and Samoa are major cultural groups of western Polynesia—a cultural subdivision of Polynesia which also includes Uvea, Futuna, Rotuma, Niue, Tokelau, and Tuvalu. The island groups are each culturally distinct but share basic cultural patterns and languages. Ocean voyages between these groups developed into trade networks that included the importation of chiefly spouses and certain prestige items. Ancestors of Tongans and Samoans migrated from nearby Fiji about 1200 B.C., bringing with them the Lapita cultural complex. Dentate-stamped pottery, the marker of this complex, evolved into

1 Samoan warrior holding a rifle and a fan, and dressed in a full skirt made of *tapa*. Drawing published by Friedrich Ratzel (see bibliography). Barbier-Mueller Archives.

**Tonga and Samoa**

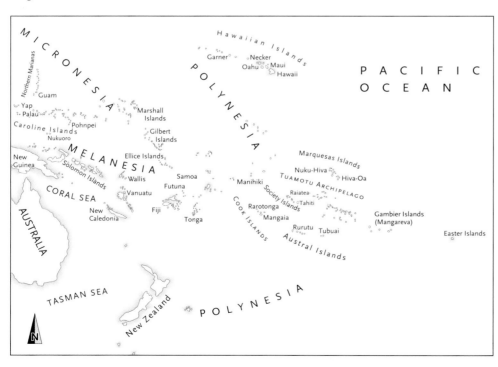

Polynesian plainware and eventually died out. The Lapita design motifs, however, and the ways in which they were combined in Tonga and Samoa formed the prototype of other artistic developments, including tattoo, incising on war clubs (fig. 2), barkcloth design, and basketry. These design organizations were still evident in the eighteenth and early nineteenth century, when the arts of Tonga and Samoa were brought to the attention of the Western world during the voyages of European explorers.

In Tonga and Samoa, the verbal and visual arts have always been integrally related and traditionally used in the service of elevating and honoring the prestige or power of individuals or chiefly lines. The most important arts today are fine mats, barkcloth (fig. 1), oratory, music, dance, and scent, all of which are still practiced and used in conjunction with the traditional arts of presentation. With the advent of Christianity and the importation of Western goods, carving of religious objects such as human sculpture and the manufacture of bowls, neckrests, and clubs lost favor.

Tonga and Samoa are like brothers that began from a similar parental tradition, but grew into different individuals. Their similarities derive from their ancestral Lapita cultural complex; their differences derive from their separate histories and subsequent colonial experiences.

The Kingdom of Tonga is the only Pacific island group that has never been colonized by a foreign power, although it was a British protectorate before it became an independent nation of the Commonwealth in 1970. Comprising 172 islands with a land area of 675 square kilometers and 100,000 people,

**2  Decoration on a club (detail)**

Produced without the use of metal tools. Set in the geometrical zigzag motifs are the outlines of two human figures. The one on the right wears a plume headdress and carries a spear in the left hand with a club in the right. The smaller figure on the left would appear to be holding two palm fronds or two short-shafted weapons with large round heads (a complete club of similar design, but without the human personages, can be seen second from the left in figure 9). Acquired by Josef Mueller in 1953 in London, from Herbert Rieser, according to whom this club had been brought back in the eighteenth century and kept by the family since that time. Overall height 111 cm. Inv. 5502-5.

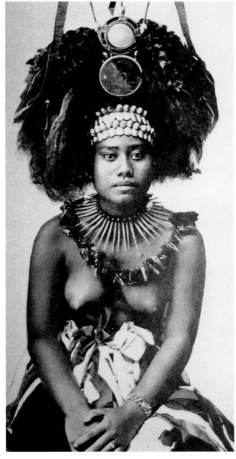

3  A *taupou* (daughter of a chief), who is charged with performing certain tasks and rituals. End of the nineteenth century. Photograph Muir and Moodie. Barbier-Mueller Archives.

**4 Neckrest**

Carved from a single piece of hardwood. Tonga. Length 44.5 cm. Inv. 5501.

**5 Neckrest**

The horizontal member is inlaid with five small disks of marine ivory and is fixed to two legs split into two feet by coir. Original Josef Mueller Collection (acquired prior to 1939). Length 46.3 cm. Inv. 5508.

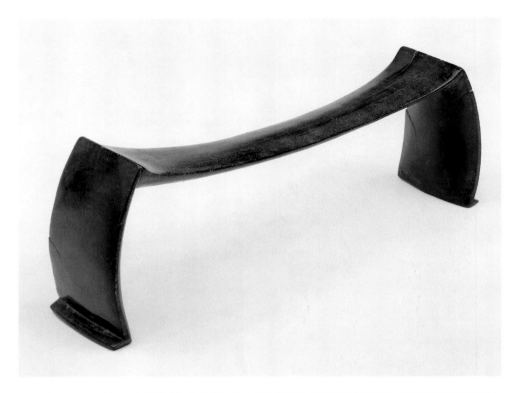

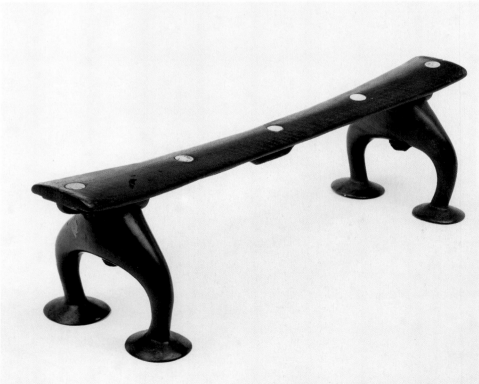

Tonga lies at the southern apex of a triangle formed with its two important neighbors, Fiji and Samoa. The present king, Taufa'ahau Tupou IV, traces his ancestry to the Polynesian gods who created and peopled the islands, and especially to Taufa'ahau Tupou I, who introduced the present parliamentary system. Tongan social structure remains one of the most hierarchical in Polynesia. Highest rank is associated with the highest genealogical blood lines that can be traced back to the first Tu'i Tonga and is based on three social principles: father's side outranks mother's side; sisters outrank brothers; and elder outranks younger.

Samoa today consists of two nations: an independent Samoa (formerly a colony of Germany and later administered by New Zealand) and American Samoa, a territory of the United States of America. The 210,000 people (170,000 in Western Samoa and

6 The huge Ha'amonga-a-maui, Tongatapu Island, Tonga. Built about 1200 to symbolize the two sons of the paramount ruler and the bonds between them. Photograph A. Baessler. Barbier-Mueller Archives.

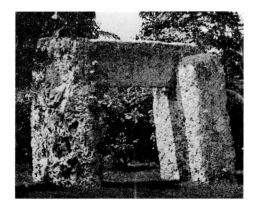

7 Tongan wooden figurine. Only a very few examples of such carvings exist. Drawing after the statuette in the Auckland Institute and Museum.

8 Wooden disk suspended from houses in Tonga. Its purpose was to prevent rats from reaching foodstuffs and other items hanging from the hooks. Drawing after the piece in the Folkens Museum, Stockholm, which was collected on Cook's second voyage.

40,000 in American Samoa) inhabit about 3,000 square kilometers divided among ten major islands or groups of islands. Traditionally, a system of Tui titles provided the conceptual framework for rank and status, but the political system was basically decentralized. Each village had its own *fono* of chiefs, and each family had its own *matai*, or family chief, who organized agriculture, fishing, cooking, and house building. Each level included a number of talking chiefs (*tulafale*), who specialized in speech making, ceremonial duties, and protocol. Each village included a *taupou*, a young chiefly woman (fig. 3) whose duties included the mixing of *kava,* and a *manaia*, a young chiefly man who organized the young men of the village. Today, the two Samoas have separate political systems based on different combinations of Samoan custom and Western democratic traditions.

**Gender Specialization**

Men and women had (and still have) artistic specializations at least partially based on where the work is carried out—men primarily work outside while women work inside. Men were concerned with the organization of space, architecture, canoes, household utensils, and the arts of war and *kava* ceremonies, while women focused on the making of barkcloth, mats, and elaborate baskets.

In Samoa, houses were (and still are) laid out with a specific order in relation to the village pathways, the concepts of center and periphery, and the orientation of the *malae* (village green). The chief's house and guest houses, which were round or oval in shape, occupied the most important positions and were raised on earth and stone platforms.

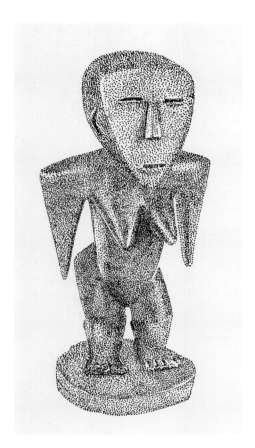

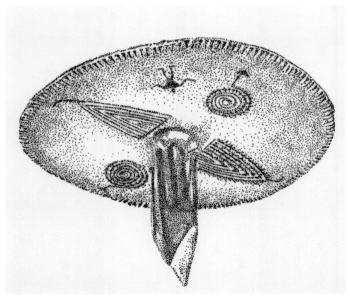

**9  Four clubs or staffs**

These examples illustrate the most familiar shapes from before contact with Europeans, as can be seen from fig. 4. Tonga. Original Josef Mueller Collection. Heights from left to right 108.5 cm, 110 cm, 112.5 cm, 96 cm. Inv. 5502-7, 5502-2, 5502-3, 5502-4.

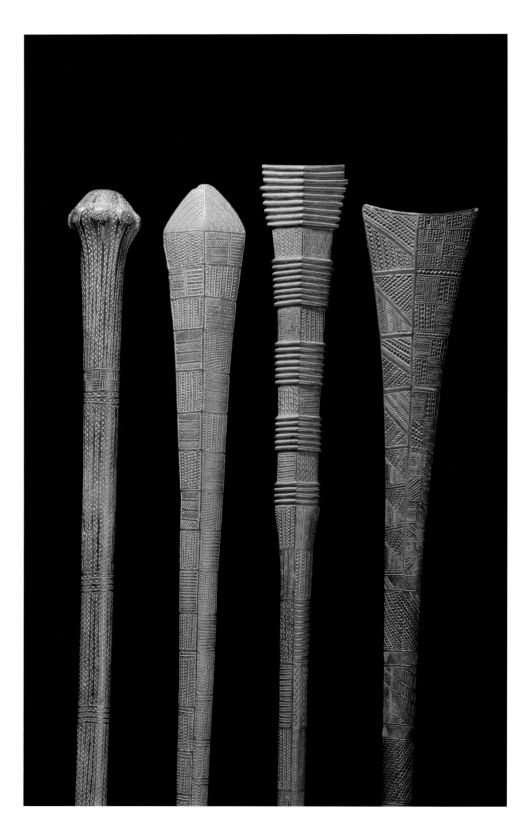

The most formal *kava* ceremonies take place on the *malae*, with each person accorded a specific place depending on his personal rank and the rank of his title.

In Tonga, huge elevated rectangular stone constructions (fig. 6) marked the historic grave sites of the highest-ranking lineage. The great oval houses of the chiefs were distinguished by complex rafter formations and rafter lashings with designs formed from coconut fiber sennit of two colors.

Household furnishings were few but aesthetically conceived. Human figures were sometimes incorporated into the houses, as in Tongan hooks. These were hung from rafters inside the house to keep food and other objects out of the reach of rats from either above or below. They consisted of a carved hook surmounted by a flat disk. The disk was painted on the underside and the hook section was sometimes made from ivory (fig. 8).

Wooden bowls were made in a variety of shapes and sizes and were used for mixing *kava,* serving food, and for holding scented coconut oil. The carving and use of these oil dishes in Tonga shows influence from Fiji, where they were used for religious ceremonies. Neckrests were carved in symmetrical and asymmetrical forms from one piece of wood (fig. 4) or with legs lashed to a wooden or bamboo crossbar with coconut fiber using a technique developed in canoe building. They were sometimes inlaid with pieces of ivory (fig. 5). Neckrests are still part of the necessary ceremonial gifts for weddings. Fly whisks were status objects made of a handle of bone or wood and a whisk of partly braided coconut fiber bound to the handle with fiber. The wooden handles varied from straight to

curved or zigzag and were sometimes recycled objects such as spear points or part of the handle of a club, which probably had *mana* (power) in their own right. In Samoa, the talking chief placed the fiber whisk over his shoulder and held a long staff as symbols of his office.

**Sculpture**

In Tonga, sculptures in female form were carved from ivory or wood. They appear to represent ancestors or gods, especially Hikuleo, a god of the afterworld, and may originally have dwelt in a god house hanging from the central ridgepole either singly or as part of Janus-figured hooks. Small ivory female images were also worn by female chiefs as charms or ornaments. Some of these figures and hooks were collected in Fiji, where, because they were made of whale-tooth ivory, they were even more sacred and were also hung in god houses. Most known Tongan figures (fig. 7) are quite similar to each other, with broad shoulders, straight loosely hanging arms, slightly bent knees, the indication of a navel, well-developed breasts, and an ill-defined neck. Facial features are in low relief, except for the ears which are well carved. Although carved in three dimensions, the figures are reminiscent of the two-dimensional anthropomorphs incised or inlaid on clubs and fly-whisk handles.

In Samoa, carved human images are rare and were apparently of minor importance. One now in the British Museum was found in 1836 with the preserved bodies of two chiefs apparently of the Mata'afa family. The figures lack the vitality of the Tongan figures, but are related in style to some Fijian figures.

The most numerous wooden objects in Tongan collections are clubs, each a work of art in its own right (fig. 9). They have a variety of shapes and serve as the medium for elaborate incising, which was done by means of a shark tooth hafted to a wooden handle (fig. 10). After contact with Europeans, nails were hafted in the same way, making possible the sharper and deeper incising of

10  Five clubs brought back by Cook in the eighteenth century. It is known for certain that such clubs were carved and worked without the aid of metal tools. They are conserved in the Museum für Völkerkunde, Vienna. After Friedrich Ratzel, 1887. Barbier-Mueller Archives.

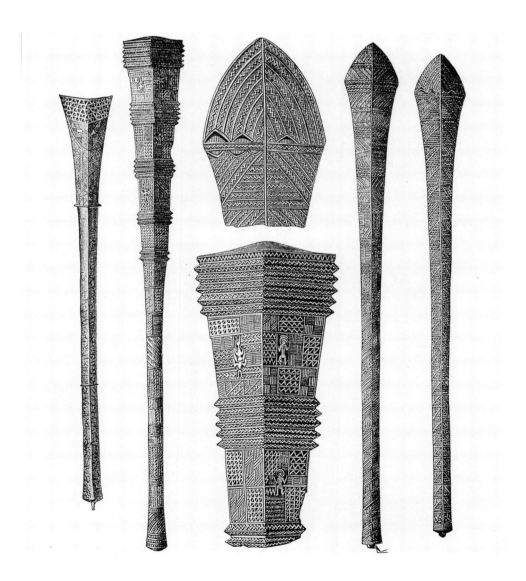

many classic examples. Incising was done in sections that were laid out in advance, often using the intersection of a perpendicular line—formed from a diamond-shaped cross section—and vertical cross lines. Each section so formed was carved to match or contrast with those around it. In the classic form, some sections have incised human and animal images set into a geometric background, while in other sections the geometric design is the main element. These geometric designs are the same as those used in barkcloth and basketry. In some cases, the incised naturalistic figures were inlaid with ivory insets. Long spears of a special type were made on Niue (fig. 12).

Clubs were also the primary Samoan weapon used for warfare and for ceremonial rivalry between villages. Battles were fought at appointed spots and involved speech making and mutual exchanges of ceremonial courtesies.

### Body Ornamentation and Personal Objects

Tongans and Samoans value propriety and self-presentation highly (figs. 1, 3). Body aesthetic is especially important for individuals of high rank. The missionary John Williams described the marriage ceremony of a woman of status in Samoa: "Her dress was a fine mat, fastened round the waist, reaching nearly to her ankles; a wreath of leaves and flowers, ingeniously and tastefully entwined, decorated her brow. The upper part of her person was anointed with sweet-scented cocoa-nut oil, and tinged partially with a rouge prepared from the turmeric root, and round her neck were two rows of large blue beads. Her whole deportment was pleasingly modest."[1]

Tattooing was traditionally important in Samoa and is still widely practiced (fig. 11). Men are tattooed from the waist to the knee. Associated with rank, status, and genealogy, tattoos were exhibited by tucking up the wraparound skirt when dancing in accompaniment to the *taupou* and on other ceremonial occasions.

An important object in Tonga was a feathered headdress (*pala tavake*), which could be worn only by the highest chiefs. It was made with the tail feathers of the tropic bird and/or red paroquet feathers, which formed an overarching crescent from ear to ear that stood out some 50 centimeters. In Samoa, a *tuiga* headdress was worn by the *taupou* or *manaia* for *kava* mixing and dancing. It consists of a barkcloth cap surmounted by human hair, feathers, shells, and other decorative elements.

11 Two Tongan men with tattoos. After Friedrich Ratzel, 1887. Barbier-Mueller Archives.

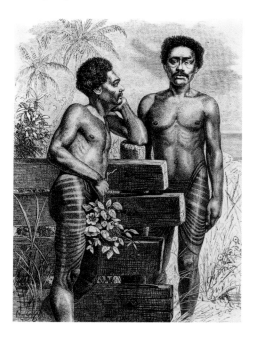

12 **Spear**

Hardwood, highly polished. From the small island of Niue. Length 170 cm. Inv. 5449-3.

13 **Club**

Inlaid with marine ivory. Clubs of this type are more common on Fiji than Tonga, but it is possible that this example comes from the latter islands. Original Josef Mueller Collection. Length 92.5 cm. Inv. 5502-8.

Ornaments included necklaces of carved ivory pieces shaped to curved points and strung (fig. 3). These necklaces are difficult to distinguish from Fijian necklaces (see pp. 314–23). Fans of pandanus leaves and coconut fiber were decorated with human hair. Decorative combs were made from coconut midribs bound together with fine sennit and enhanced with beads in Tonga and Samoa; wooden combs were carved in delicate openwork in Samoa. Flowers chosen for scent were formed into intricate necklaces and girdles. Some were simply strung from whole flowers, while others were complex constructions of pandanus keys, tiny flower petals, and ribbons made from the inner bark of hibiscus. Scented coconut oil was laboriously produced, presented in gourd containers in elaborate baskets lined with finely plaited mats, and/or applied from superbly carved wooden oil dishes.

**Contemporary Art**

Although wood incising and sculpture virtually ceased with the end of traditional warfare and the influence of Christianity, there has been a renaissance of carving for tourists and for Polynesian interior decoration. Barkcloth is still made and used for rituals such as weddings, funerals, and chiefly investiture. Baskets and barkcloth in nontraditional styles have now become artistic forms of high quality and are sold both as souvenirs and as useful and decorative objects for modern living.

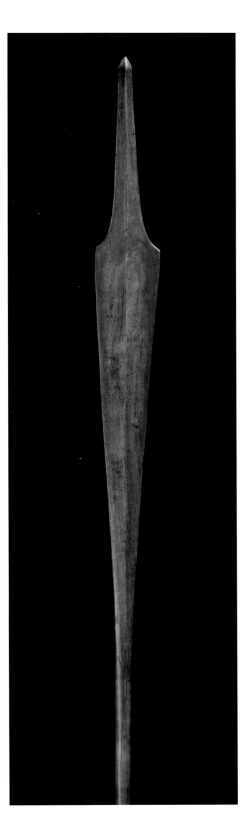

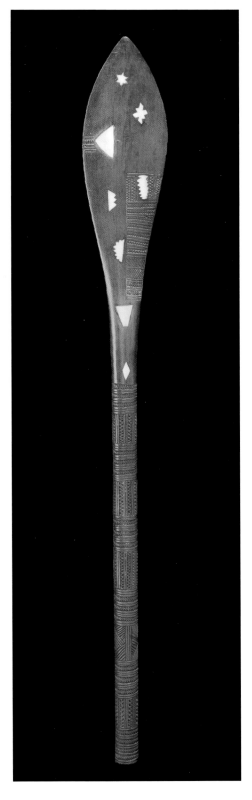

# Fiji

**Fergus Clunie**

1 The inhabitants of Fiji were obliging enough to pose in the reconstruction of a "cannibal feast" for the photographer G. L. Griffiths at the end of the nineteenth century. Postcard franked with the date 1904. Barbier-Mueller Archives.

2 Fijians building a dugout on Kadavu Island. End of the nineteenth century. Barbier-Mueller Archives.

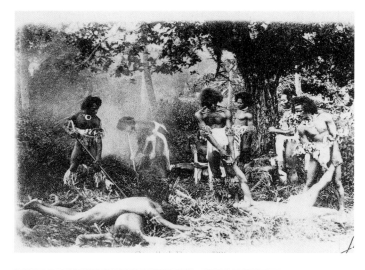

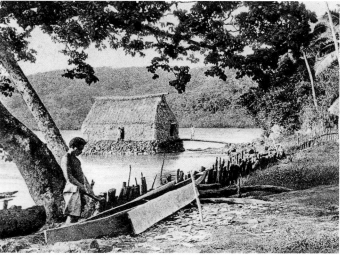

Viti, or Fiji, forms the western border of Polynesia. Hundreds of islands stud a coral reef labyrinth which straddles the 180th meridian from 177°W to 175°E and sprawls from 15°S to 21°S. They range from the volcanic masses of Vitilevu (10,386 square kilometers) and Vanualevu (5,535 square kilometers) down through smaller volcanic and upthrust limestone islands to coral cays. Fiji is ecologically much more diverse than any of the islands further east in Polynesia. This is particularly true of the higher islands, with their mangrove-fringed deltas, rain-forested windward coasts and slopes, and rain-shadowed leeward scrub and grasslands. Less well endowed are cays and islets prone to hurricane surges, which, until the careless advent of tourism, were only seasonally occupied.

The ancestors of the Polynesians crossed the sea which separates Fiji from Melanesia about 3,500 years ago. From there they were within easy reach of Polynesia. Apart from sporadic contact with kin in both Polynesia and Melanesia, for a thousand years they had the islands to themselves. Their scattered beach communities were reliant upon horticulture, hunting and gathering, reef and lagoon fishing, and offshore trolling. They and their livestock—chickens, rats, dogs, and pigs—had a devastating impact upon wildlife. About 2,500 years ago, driven by intrusion from Melanesia, the population mushroomed and began moving inland as forests were burned for horticulture, hilltops were fortified, and cannibalism—the telltale companion of ancestor worship—spelt war. Some 500 years later, changes to potting technology suggest further immigration from Melanesia. Thereafter movements from the Melanesian west ceased and intrusion came from Polynesia.

## 3  Necklaces

Marine ivory (sperm whale teeth, carved or left intact). On the left, two *wäsekaseka* or *wäetsei* necklaces; on the right, a *sisi* necklace. Original Josef Mueller Collection. Breadths respectively 32 cm, 33 cm, 32 cm. Inv. 5014-A, 5014-B, 5014-C.

## 4  Neckrest (*kalimasi*)

Hardwood. The upper cylindrical section is encrusted with serrated disks of marine ivory. The feet were separately carved and fixed by coir. Such articles were made by canoe builders on Tonga and Samoa. Original Josef Mueller Collection. Acquired before 1942. Length 65.5 cm. Inv. 5007.

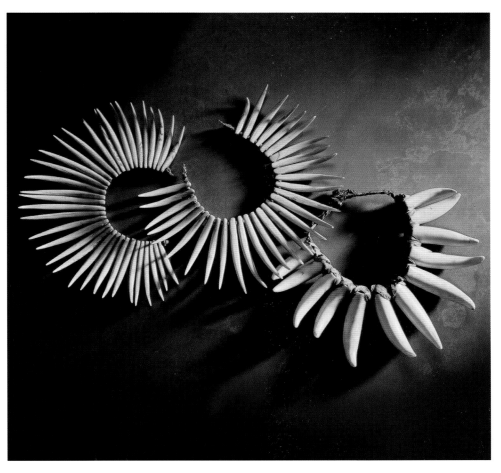

Fiji lies a few days' canoe sail downsea and downwind from Tonga, so for centuries prior to European contact the culture and bloodlines of the eastern and central Fijian islands and coastlines were influenced from there. Tongan physical and cultural infiltration and absorption into these parts of Fiji, culminating in the immigration of the chief who became the ancestor-god Degei, has waxed and waned over the past thousand years, but was rising at the time of Cook's voyages of the 1770s.

5  Inhabitant of Fiji wearing a marine ivory necklace. End of the nineteenth century. Photograph Josiah Martin. Barbier-Mueller Archives.

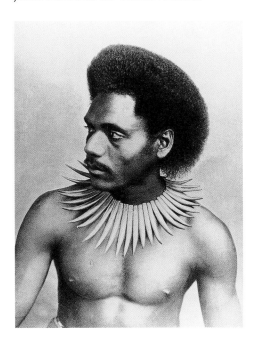

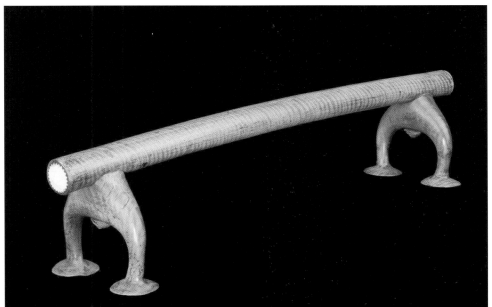

315  Fiji

## 6  Pole club (*bowai*)

Hardwood. Shiny patina. The lower half is decorated with an incised pattern. The top and bottom and areas on the shaft are encrusted with sperm whale teeth carved into stars or crescent moons. Length 126 cm. Inv. 5006.

Alhough Cook barely grazed the southeastern outliers of Fiji, he encountered Fijian visitors and artifacts in Tonga and learned something of the islands and their inhabitants from his Tongan hosts. He also witnessed the conception of a new voyaging canoe destined to profoundly affect Tonga, Fiji, and Samoa because it could beat into the wind, facilitating return voyaging between a fierce but divided Fiji (rich in yams, pigs, sandalwood dust, intricately patterned barkcloth, pottery, superb hardwoods, and red *kula* feathers), Samoa (with its incomparable mat makers and canoe builders), and naturally unendowed but centrally organized Tonga. Within years, the outmoded *tongiaki* double canoe (fig. 14) had been supplanted by the *kalia* hulled outrigger, which began welding the archipelagoes into a tighter cultural triangle.

In the wake of Cook, once unified but now divided Tonga slid toward civil war as its restless chiefs voyaged, fought, traded, and settled in Fiji. Powerful confederated chiefdoms made up of allied and subject tribes dominated by part-Tongan aristocrats held sway over the coasts and islands of eastern and central Fiji. But Tonganification weakened away from Tonga, the highlands and western shores of Vitilevu being peopled by a confusion of clans inveterately hostile to centralized authority. These were dark, independently minded people, whose men were initiated into secret societies, built conical houses akin to those of New Caledonia, and sounded end-blown rather than side-blown shell trumpets.

East and west, the basic social unit was the household, whose members descended from a deified ancestor—the *kalounivuvale*, or "household god." Households clumped into clans descended from more distant *kalouyalo*,

or deified ancestors, relationship webs being complicated by polygamy and status derivation through both parents. Clans in turn made up tribes and confederations more loosely related through intermarriage and shared descent from *kalouvu*—ancestors so long dead as to have assumed fantastic forms. Roles were inherited, clan members following in the footsteps of their forebears. This meant that while general subsistence and everyday tasks were shared, the specialist crafts were the birthright of particular descent groups, production of key artifacts often being quite localized and always a hereditary prerogative. Society was thus composed of a distribution network through which the distinctive products of the various kinship groups spread by way of food and property presentations between related and intermarrying clans, and by payment of tribute to tribal and confederation chiefs. Ultimately, Tongan navigators, piloting canoes which were built in Fiji but derived from Tonga-Samoa, distributed the products throughout Fiji, Tonga, and Samoa. There was nothing new in this cycle—it had been going on for generations—but by 1800 the tempo was rising, stimulated by the advent of the *kalia* voyaging canoe and political ferment in Tonga, aggravated by the return of battle-hardened Tongan adventurers from Fiji.

By the early 1800s, merchant ships were risking the Fiji reefs to trade for sandalwood, which was soon depleted. By the 1820s they were coming for bêche-de-mer, bringing disease, firearms, and iron tools in exchange. But above all they brought ivory. Whale ivory artifacts chanced to be the most valuable form of Fijian property and a potent political force (fig. 3). The presentation and acceptance of *tabua*—a sperm whale tooth on a woven suspension cord—bound and obligated one

party to another. The unprecedented influx of trade goods upset local power balances, as the traders dealt exclusively with those who could guarantee cargo delivery, so concentrating muskets, iron, and politically indispensable ivory in the hands of the maritime chiefdoms of central Fiji. This stimulated the arts, as fine artifacts were made for ship trading and to aggrandize rising chiefs, subvert enemies, reward allies, and entice mercenaries. As can be gauged from the surviving artifacts, until about 1840 Fiji experienced an artistic renaissance.

The appearance of the people was striking (fig. 5). Naked boys were initiated into manhood by way of circumcision rites associated with mourning sacrifices, thereafter donning the *malo* loincloth, and growing and dressing

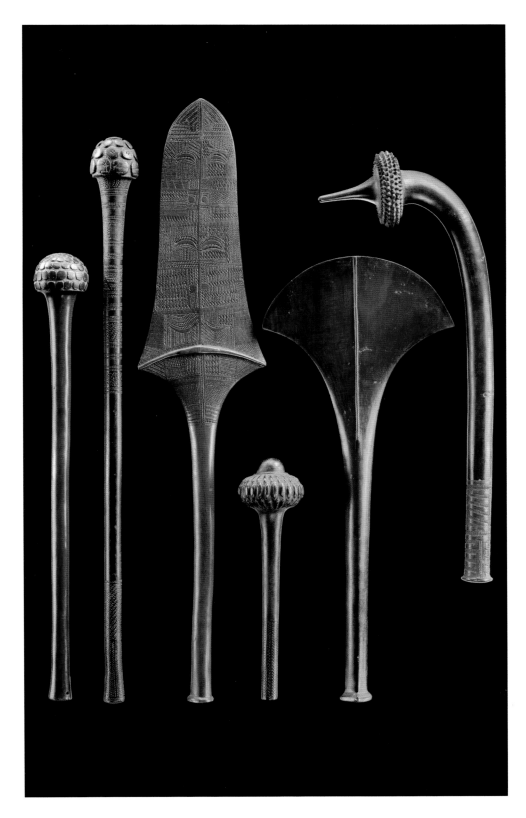

### 7 Group of clubs

Fiji. From right to left, the various types of weapon are known as: *bulibuli* (lengths respectively 84.5 cm, 107 cm; inv. 5000-B, 5000-D); *kinikini*, a weapon of Tongan-Samoan origin owned by a chief and whose large striking surface may be derived from the shape of a shield designed to deflect arrows (length 114 cm; inv. 5000-C); *ulatavatava*, a small-scale, heavy-headed throwing club (length 45 cm; inv. 5000-E); *dui*, belonging to a chief or priest, another probable borrowing from Tonga (length 84 cm; inv. 5012); and *totokia*, equipped with a sharp point projecting from a studded ball, in the shape of the pandanus fruit (length 83.5 cm; inv. 5016).

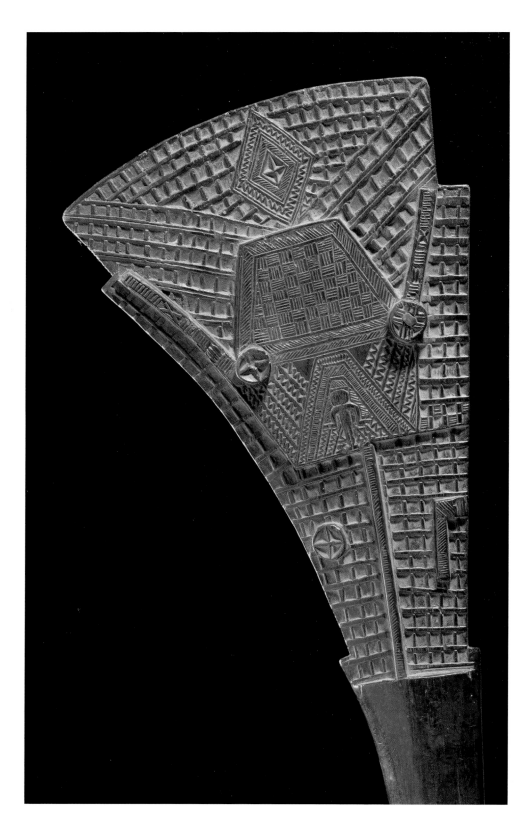

their hair. Girls were initiated by being tattooed about the loins in a manner mysteriously akin to male loin tattooing elsewhere in Polynesia, then donning the *liku* skirt of womanhood. In accord with religious demand, finger joints were amputated as mourning sacrifices and the earlobes of both sexes were pierced to accept bone, ivory, wood, or shell ornaments. Whorls and strings of cicatrices puckered the arms and torso, while both face and body were painted. Leading men boasted huge, elaborately dressed and dyed heads of hair, swathed in gauzelike barkcloth "turbans" and sporting decorative combs or long tree-fern wood or turtle-shell scratching needles. Barkcloth, a male dress prerogative, was beaten from paper mulberry (*Broussentia papyrifera*) bast by the women of certain clans living in particular localities, each of which produced peculiar products. It ranged from snowy *seyavu*, sometimes smoked into brown *masikuvui* for chiefly wear, through intricately painted *masikesa* to the coarse brown *gatuvakatoga* of Tongan type, with its rubbed decoration, and the hybrid *gatuvakaviti*, which enclosed brown Tongan cloth within a painted *masikesa* border. Its uses ranged from male loincloths, sashes, trains, armbands, and head coverings through banners, mosquito screens, and the curtain which concealed spirit house shrines to the wrapper for the

**8  Club (*gugu* or *siriti* type) (detail)**

The shape derives from that of the butterfly fish. This weapon was the exclusive property of chiefs and priests. This example incorporates marine ivory inlay. The tiny human figure in the geometrical pattern is unusual. Overall length 108 cm. Inv. 5000-A.

cord with which a widow was strangled so that she might accompany her husband into the afterlife. The elaborate decoration, like that of non-religious Fijian art, drew on natural motifs but was geometrically stylized. Ornaments ranged from human hair wigs, woven and trochus shell armbands, and braided leg and armbands to necklaces made from shell, snake bone, and beads and teeth, the last ranging from strings of enemy teeth to boar tusk pendants and whale tooth collars. Most prized were the red *sovui* shell and orange cowry pendants of high chiefs, and an array of necklaces, pendants, and breastplates carved from sperm whale teeth by canoe builders in Tonga-Samoa and Tonga-Viti. Most spectacular of these were the saber-toothed *wasekaseka* necklace and composite whale ivory and pearlshell *civavonovono* breastplates. These craftsmen also prepared ivory squares, stars, full and crescent moons (fig. 6), and birds, which were inlaid into the favorite throwing clubs, clubs (fig. 7), neckrests, musket stocks, powder horns, and even gun carriages.

Women's crafts other than barkcloth included the weaving and plaiting of mats, *liku* skirts, fans, and basketry of types defining the clans which produced them. Unique in Polynesia, the making of slab or ring-built pottery, worked with wooden paddle and pebble anvil and often decorated with applied, incised, combed, stamped, or carved-paddle impressed decoration, was the birthright of the women of maritime clans, the men of which were or had been fishermen and mercenary sailors.

Musical instruments included side-blown *davui* trumpets made from triton and bursa shells (an exception being the end-blown shell trumpets of western Vitilevu, with their

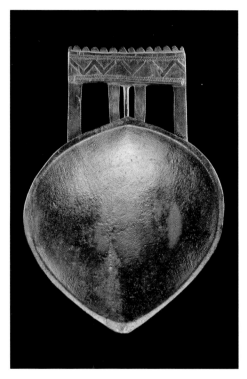

**9  Priest's *yaqona* dish**

Hardwood. Original Josef Mueller Collection. Acquired before 1942. Length 41.7 cm. Inv. 5011.

**10  Priest's *yaqona* or oil dish**

Hardwood. In the shape of a leaf. Used by a priest (*daveniwaiwai*). Original Josef Mueller Collection. Acquired before 1942. Length 63.6 cm. Inv. 5010.

Hardwood. For *yaqona*, a beverage Fijian priests offered to the ancestral spirits. In the shape of a sturdy standing male figure. This beautiful type of carving is extremely scarce. Height 35.9 cm. Inv. 5009.

distinctive coir sennit handles). *Lali* slit drums ranged from big war and spirit house drums to diminutive dance drums, further dance accompaniment being provided by bamboo stamping tubes (*derua*). Other instruments included dwarf-nut and bamboo whistles and bamboo pan pipes, both worn round the neck, bamboo Jew's harps, and bamboo nose flutes.

Houses were built communally by men. Their styles and the details of their thatch and paneling varied, most being rectangular with a hipped or gabled roof. Round-ended buildings were common in areas of strong

Tongan influence. Strikingly different were the round or square, centre-poled, conically roofed "beehive" houses of western Vitilevu. Family houses (*vale*) built about cooking hearths were occupied by women and children, the men sleeping in men's houses (*bure*), the ultimate form of which was the tall-roofed spirit house (*burekalou*) dedicated to an ancestor spirit.

While most men could plait cordage, participate in house building and fortification, and make everyday artifacts, the specialist crafts were the prerogative of clearly defined descent groups, some of them new arrivals. The building of other than paddling and river canoes had been monopolized by the Lemaki, a clan of canoe builders from Manono in Samoa, who were taken from Tonga to eastern Fiji in the late eighteenth century to exploit *vesi* hardwood (*Intsia bijuga*), the best hull timber in the Pacific. Because *kalia* were made in Fiji, it has been assumed that the Fijians, who could not navigate, somehow evolved and built the finest voyaging canoes in the Pacific for oceangoing Tongans. But nothing so unlikely happened. Instead, recognizing that the Micronesian sailing rig they were adopting was unsuited to the Polynesian double canoe, Tongan seafarers wedded it to a new form of outrigger voyaging canoe. This had an old-fashioned dugout *tongiaki* hull for an outrigger, but a much larger plank-built main hull, loosely based upon that of the *va'a alo*, a tiny plank-built Samoan fishing canoe. To build these great *kata* hulls the Lemaki were resettled in Fiji, where, under Tongan sponsorship and the protection of a local overlord, the Tui Nayau, they built the new *kalia* (*drua* in Fijian) voyaging canoes, the first of which were taken back to Tonga by the marauding Tu'ihalafatai

12  Fiji is the only region in Polynesia where the art of ceramics was not totally forgotten. On many other islands on which shards of Lapita culture pottery have been unearthed, the use of ceramics was entirely abandoned and craftsmen turned to using other materials, such as wood, coconut, and large pearlshells. This historic drawing shows a selection of Fijian designs of the nineteenth century. Josef Mueller possessed two of the kind illustrated below right. Poorly fired, they had fallen to pieces before he died in 1977. From Friedrich Ratzel, 1887. Barbier-Mueller Archives.

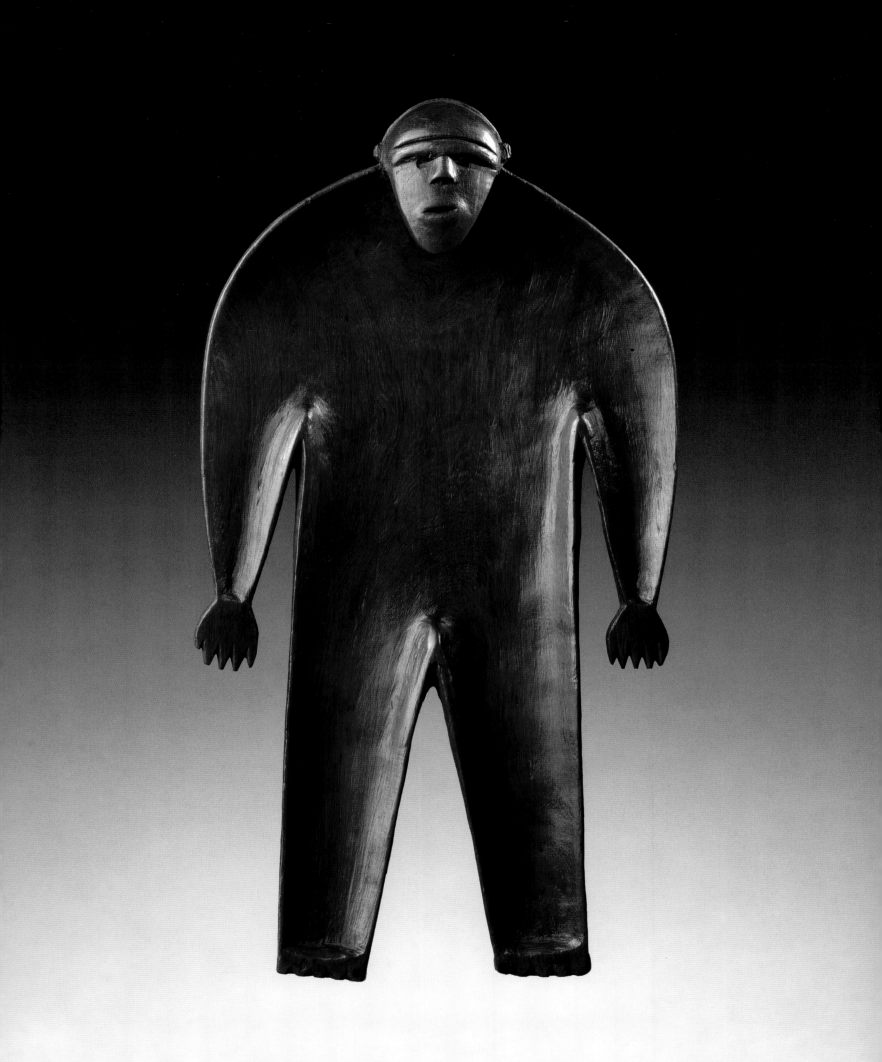

in the 1790s. Intermarrying locally and so becoming "Fijian" in due course, the Lemaki spread elsewhere to work both *vesi* and ivory, and to build canoes. Tellingly, some of what have been lauded as hallmarks of Fijian material culture—the *drua/kalia* and related sailing canoes, whale ivory ornaments, and the *tanoa* bowl for *kava*—were introduced to Fiji by the Lemaki.

Working with stone and shell adzes and gauges, but increasingly with iron and steel, the carver clans produced troughs, bowls, platters, foodpounders, basket hangers, neck-rests (fig. 4), slit drums, and other utensils, together with an astonishing array of weaponry (fig. 7). War was a major preoccupation: killing meant personal aggrandizement, a man being ritually reborn and renamed with each slaying. Boys were groomed for battle from an early age, and the Fijian arsenal was an impressive one, ranging from *iula* throwing clubs worn in the waistband of the *malo* loincloth and hurled to disable an enemy, through an array of two-handed war clubs, slings, and bows and arrows, to single- and multipointed war spears. Throwing clubs were often made from the stem and root

ball of wizened hardwoods, the simplest being *iulakobo* with their natural rootstock heads. In others the root bulb was shaped and polished. Most sophisticated were varieties of fluted- or lobe-headed *iulatavatava*. Two-handed war clubs varied even more. The spurred *gata* and *sali*—based on snake and flower motifs but often wrongly described as gunstock clubs—came in a variety of forms and were designed to cut and snap bone. Skull crushers included the *bo'ai*, which resembled a baseball bat, *gadi* pole clubs, elongated *vunikau* and studded *sokekia* root-stocks, and varieties of mace-headed *waka* and knob-headed *dromu* and *bulibuli*. Chiefs and priests bore broad-bladed *dui*, *kinikini*, or *culacula* "paddle clubs" of Tonga-Samoa derivation. Their cutting edges were designed to snap bone, while their broad blades prob-ably originated as shields for parrying Fijian war arrows and sling stones. Other specialized weapons included *gugu* and *siriti* butterfly-fish clubs (fig. 8), and the beaked battle hammer (*totokia*), the spike of which pecked a hole in enemy skulls. War arrows were often barbed like the spears and likewise tipped with sting-ray barbs. Enemy bodies were presented to a clan's war god before being cooked and eaten (fig. 1). Human flesh (*bokola*) was eaten using the fingers, but because a war god possessed the body of his priest during these ceremonies and actually ate the flesh fed to him through the priest's mouth, it was vital that his sacred portion pass unsullied. Multipronged wooden forks (*iculanibokola*) were made to pick up the flesh and pass it untouched into the priest's mouth, to be swallowed by the god within him.

Perhaps the most powerful Fijian artifacts come from *burekalou* spirit houses. These in-clude miniature spirit houses (fig. 13), which

13 Miniature spirit house conserved in the Museum für Völkerkunde, Leipzig. The illustrator has increased its size and relocated it in an exotic setting. From Friedrich Ratzel, 1887. Barbier-Mueller Archives.

14 Double-hulled dugout from Fiji. From Friedrich Ratzel, 1887. Barbier-Mueller Archives.

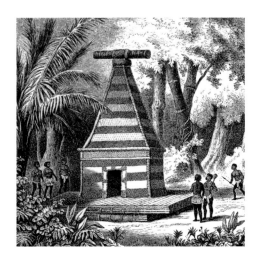

doubled as portable temples on voyages and campaigns, sometimes housing little wooden or ivory figures representative of the gods themselves, and a variety of weapons, shell trumpets, *kava* bowls, oil dishes, and other artifacts. Most remarkable are male and female ancestor images (*matakau*). These statuettes are mainly carved from wood, but include Tongan whale ivory images of superb form. Each represented the god of the spirit house they inhabited and were sometimes spiritually possessed by it. Rivaling them are a graceful range of shallow *ibuburau* or *daveniyaqona* dishes, used when *yaqona* (*kava*) was presented to an ancestor spirit which had possessed the body of its priest in order to speak with its descendants. In an ancient Fijian ceremony not derived from the Tongan *kava* ring, the god was offered and drank *yaqona* through the medium of the priest, who knelt to suck the liquid from the dish through a wooden straw, it being drawn into the god within him without being defiled by contact with his outer person, including his lips. The best dishes represent the pinnacle of the Fijian carver's art (figs. 11, 15). Carved from *vesi*, they could be leaf- and fruit-shaped, or round with stepped or whorled stands. Some represented turtles, canoes, or ducks, while others were anthropomorphic.

The Fijian cultural renaissance did not last. By the 1840s, Christianity was sapping the system as Methodist missionaries infiltrated the chiefdoms and undermined the ancestor gods. Fijian society lost its pagan dynamism. Decline was selective, the pagan being suppressed while the innocuous was tolerated. Potting (fig. 12) faltered but did not quite die out, despite competition from European ceramics and iron- and tinware, and debasement via tourist market production. The pagan *burau* rites were suppressed, but the presentation and drinking of *yaqona* according to Tongan-derived *kava* rites was essential to the functioning and decorum of the aristocracy the Wesleyans and British favored, so the artifacts associated with it continued to be produced. Today some crafts survive, or have been revived for tourism, but even where made for traditional purposes by hereditary craftspeople, the products of Christian Fiji lack the conviction and force of their pagan predecessors.

15 **Bowl**

Hardwood. For the making of *yaqona*. Fiji. According to John Hewett, London, it was brought to Europe by a sailor at the beginning of the nineteenth century. Diameter 47.5 cm. Inv. 5017.

# Central Polynesia

Anne d'Alleva

**1 a and b  Ceremonial paddle**

Wood. Austral Islands. Length 118 cm. Inv. 5608.

The shared cultural and artistic heritage of the three main island groups of central Polynesia is perhaps obscured today by the current political state of the region, for the Cook Islands are an independent nation, closely associated with New Zealand, while the Society and Austral Islands form part of the territory of French Polynesia. There are, however, complex and longstanding cultural relationships among these three island groups. The archaeological record suggests that Polynesian voyagers from the Society Islands settled the Austral Islands and many of the Cook Islands by A.D. 1000. The Society Islands themselves had been settled somewhat earlier, certainly by A.D. 600–800, by voyagers from the Marquesas Islands or western Polynesia.[1] Several islands of these three groups were in contact with each other at least sporadically before the arrival of Europeans in the eighteenth century. Ra'iatea, one of the Leeward (or Society) Islands, figures prominently in Cook and Austral lore.[2]

Though distinctive, the artistic traditions of each island group share fundamental stylistic, iconographic, and functional characteristics. Indeed, the remarkable similarities and differences between the peoples of central Polynesia have intrigued outsiders since the Cook voyages. Numerous theorists have tried to account for the cultural and historical dynamics that led to such variety and yet such similarity. Te Rangi Hiroa, for example, undertook a close visual analysis of the art

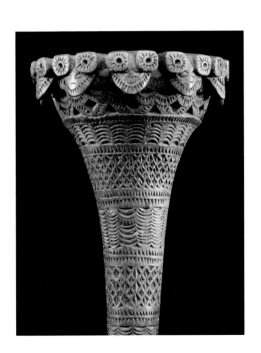

2  Large canoes in eighteenth-century Tahiti (*Cook's Voyages*, 1778, pl. XXXIV).

forms of the Cook Islands in relation to the Society and Austral Islands, as well as to the larger Polynesian context, a study that led him to reconstruct early Polynesian migrations and artistic traditions.[3] Today we can see the similarities in the arts of the Society, Cook, and Austral Islands at the time of European contact as an outgrowth of a body of artistic practices and motifs carried by the earliest voyagers, of continuing contact among the islands, and of the imbrication of the arts in enduring social, political, and spiritual beliefs and practices common to all three island groups.

In the eighteenth and early nineteenth centuries, social structure was strictly hierarchical in all three island groups. The elite, called *ari'i* in the Austral and Society Islands and *ariki* in the Cook Islands, controlled land and resources through hereditary titles. *Ari'i* or *ariki* served as both artists and patrons of the arts. Specialized artists of high rank, *ta'unga*

**3  Stone adz**

Of a type mounted on a square or, as here, round base. The great thickness of the shaft renders the tool unusable. These adzes represented a divinity of whom no images were otherwise made. Mangaia Island, Cook Islands. Height 61 cm. Inv. 5306.

**4  Seat**

Hardwood. Shiny patina. Atiu Island, Cook Islands. Original Josef Mueller Collection. Acquired prior to 1942. Length 43 cm. Inv. 5304.

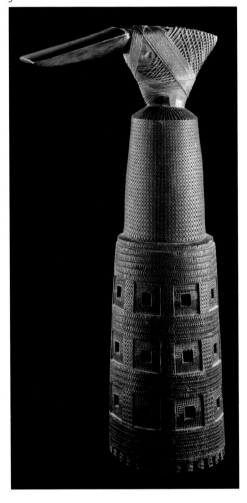

3

5  Temple (*marae*) with stone stepped platform (*ahu*) in Tahiti. Engraving taken from the reports of Captain Wilkes's journeys, 1838–42.

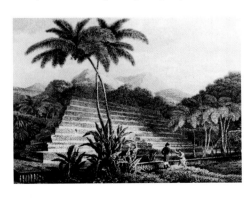

4

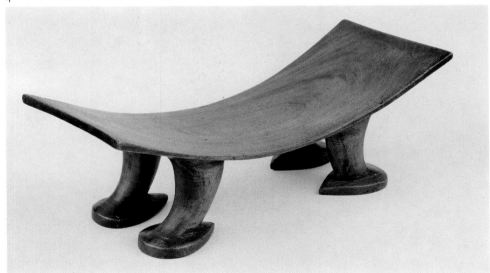

### 6 Human torso

Volcanic stone. The forceful ridge modeling on the chin recurs on some of the very few wooden Tahitian carvings that have come down to us. Such figures are open to a number of interpretations, including their use as boundary markers and in rites promoting fertility (d'Alleva 1998). Formerly collections of Paul de Givenchy and Charles Ratton. Original Josef Mueller Collection. Acquired in 1939. Height 51 cm. Inv. 5403.

### 7 Food pounder

Basalt. Used to pulp breadfruit, taro, etc. Austral or Society Islands. Formerly collections of Paul de Givenchy and Charles Ratton. Original Josef Mueller Collection. Acquired in 1939. Height 18 cm. Inv. 5451.

### 8 Statuette

Hardwood. Probably from a fly whisk or fan handle. Rarotonga, Cook Islands. Formerly James Hooper Collection. Height 12.5 cm. Inv. 5303.

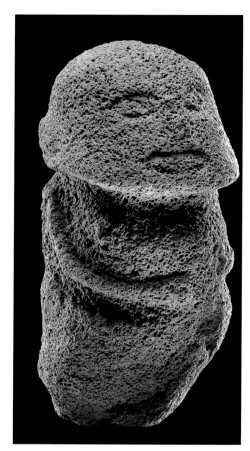

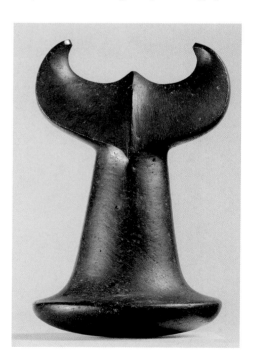

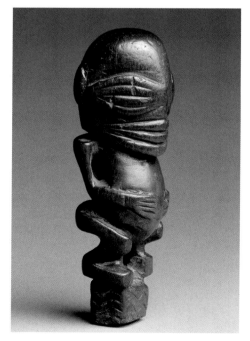

in the Cook Islands and *tahu'a* in the Society and Austral Islands, practiced tattoo and canoe building, among other arts (fig. 2). They enjoyed many privileges, one of which was the right to certain regalia and accessories, such as wooden seats (fig. 4) and fly whisks (figs. 15, 16). The arts associated with the elite were imbued with their *mana*, a spiritual power derived from the gods, and manifested this force in society. A passage from a Tahitian *marae* chant performed during the inauguration of titleholders suggests an active role for the arts in mediating the relationship between gods and humans. Recited by the priests and worshipers together, this prayer speaks of the *unu*, carved boards which incorporate the figures of animals, people, and birds, and terminate in forklike prongs said to represent the hand of the god:

> Priests: "Thy carved ornaments are to tell, they are witnesses."
> Worshipers and priests uniting: "Names, names will they disclose above, they will disclose the deeds of men."[4]

Although men were the primary sculptors and architects throughout central Polynesia, women were important artists too, working mainly in barkcloth and fiber. *Ari'i* and *ariki* women were especially renowned for their decorated barkcloth, worn by the elite and used in social exchanges. It would be a mistake, however, to see these gender roles as exclusive or fixed categories.[5] The Tahitian record, for example, suggests that the male *marae* attendants ('opu nui) made the plain, white barkcloth used on ceremonial occasions.[6] Men of the Arioi societies (dance troupes that performed on both social and ritual occasions) also sometimes produced decorated barkcloth.[7] Significant motifs

9 **Long spear**

Hardwood (restored). This spearhead illustrates the refined nature of Polynesian art. It is possible that the notches imitate those on worked stone tools. Cook Islands. Overall length 230 cm. Inv. 5305-B.

10 **Ceremonial scoop**

Wood. Austral Islands. Length 99 cm. Inv. 5606.

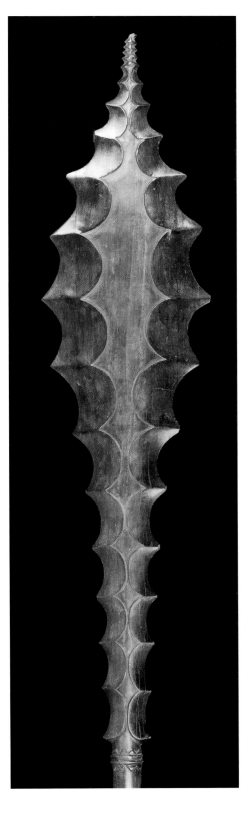

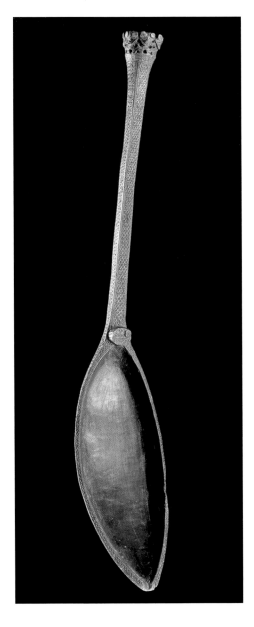

appear across media in arts made by women and/or by men. For example, the "sunburst" motif of the Austral Islands appears in both wood carvings, such as houseposts, scoops (fig. 10), and paddles (figs. 1a, 1b), and also on figural sculpture and decorated barkcloth. This suggests a body of important ideas or beliefs expressed through visual symbols by artists of both sexes and undercuts the notion that sculpture and textiles can be seen as "high" or "low" art forms in relation to each other.

The social, spiritual, and political nexus of any central Polynesian society was the *marae*, an open-air ceremonial center (fig. 5). It was at the *marae* that the gods were worshiped, titleholders inaugurated, the deceased commemorated, and marriages and alliances solemnized. Each *marae* was associated with an elite lineage, and only members of that lineage were able to claim a place in the *tapu* space of the courtyard where ceremonies took place. The fundamental *marae* structure throughout central Polynesia is a stone court-yard, but this form is elaborated in different ways.[8] In the Society Islands, the *marae* is a rectangular stone courtyard, sometimes surrounded by a low wall, with a platform (*ahu*) at one end. The platform took several shapes, sometimes appearing as stepped courses of roughly shaped basalt or coral blocks, or as a single rectangular level faced with upright slabs of reef coral. Upright stone slabs dotted the courtyard, marking the places to be assumed by priests and wor-shipers. In the Austral Islands, the *marae* structure was generally more simple: the Polynesians of Ra'ivavae and Tubua'i built large rectangular courts edged with stone slabs up to 4 meters in height. In the southern Cook Islands, Rarotongan *marae* approximated

**11 Female figure**

Volcanic stone. Society Islands. Original Josef Mueller Collection. Acquired before 1939. Height 37 cm. Inv. 5402.

12 Drawing showing the famous and unique hollow statue of the god A'a, conserved in the British Museum, London. Rurutu, Austral Islands.

13 Drawing showing a staff god. Rarotonga, Cook Islands. Conserved in the Staatliches Museum Völkerkunde, Munich.

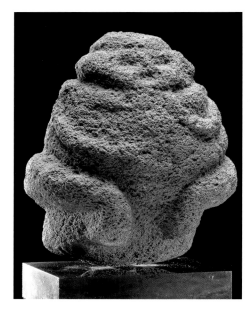

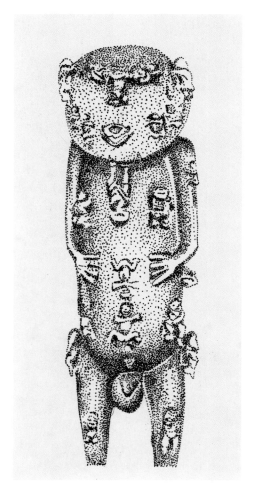

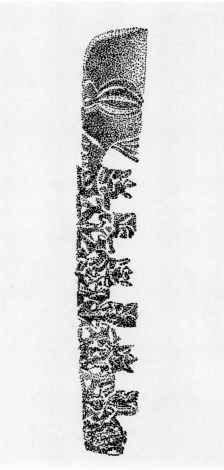

the Tahitian form, with courtyard and *ahu*, while those of Aitutaki comprised simply one or more lines of upright slabs that demarcated the sacred space.

In association with *marae* structures, both wood and stone figures represented the gods and deified ancestors. The great gods of the Polynesian pantheon—Tangaroa, Tane, Rongo, and Tu among them—were worshiped throughout these three island groups. Images served as vessels into which the god or ancestor could be called. Some representations of the gods and ancestors were figural, others more abstract, and these distinct artistic styles may have been associated with particular meanings or even spiritual beings.[9] In the Cook Islands one form of representation was an adz blade mounted on a wooden shaft (fig. 3). In the Society and Cook Islands fiber bundles, frequently ornamented with feathers, were among the most sacred god images. In the Society Islands these often bore schematic facial features and other anatomical details, but in the Cook Islands they were for the most part nonfigurative. Stone was rarely used in the Cook Islands as a medium for figural sculpture, but was quite common in the Society and Austral Islands (fig. 6). These figures are often not clearly gendered, a trait that may suggest the abstract nature of the life force or provide a kind of visual flexibility in the representation of ancestors analogous to the genealogical claims the elite asserted when tracing their rights to various titles.[10] Stone was also used for more mundane objects, such as food pounders (fig. 7).

Several postures characterize the wood and stone figures of central Polynesia, attesting to the common origins of these sculptural traditions. Figures are often hieratic,

14 **Statuette**

Basalt. Society Islands. Original Josef Mueller
Collection. Height 24 cm. Inv. 5404.

emphasizing frontality and verticality. Perhaps
most characteristic is the placing of the
figure's hands on its well-rounded stomach
(fig. 8). This may refer to the idea, documented
for the Society Islands, that the stomach is
the seat of an individual's emotions. The
*marae* attendants of the Society Islands were
called *'opu nui* ("big bellies"), perhaps in
reference to this concept.[11] The meaning of
several other identifiable postures is less
clear, although it is interesting to note that
they appear consistently either on figures
that are female or apparently genderless.
One in which a single hand is raised to the
mouth appears both in the sculpture of the
Society Islands (fig. 11) and on several of
the subsidiary figures incorporated into the
famous figure of the god A'a from Rurutu in
the Austral Islands (fig. 12). Perhaps a variant
on this posture is one in which one hand is
placed high on the chest and the other is
placed on the belly. This posture appears
both in wood and stone figures from the
Society Islands and on several small figures
of the god A'a.

The use of subsidiary figures is, in fact, a
predominant motif in all three island groups,
although it is articulated in a variety of ways.
The motif may generally be interpreted as
expressing the centrality of genealogy and
representing the strength and continuity of
a lineage, the accumulated power and prestige
of its generations. Perhaps the most famous
examples are the staff gods of Rarotonga in
the Cook Islands (fig. 13). In these figures a
large head is set atop a shaftlike body carved
with small figures, typically alternating male
and female. This arrangement evokes the
form of the spine, with the small figures like
stacked vertebrae, an image rich in genealog-
ical referents in Polynesian cultures.[12] The god

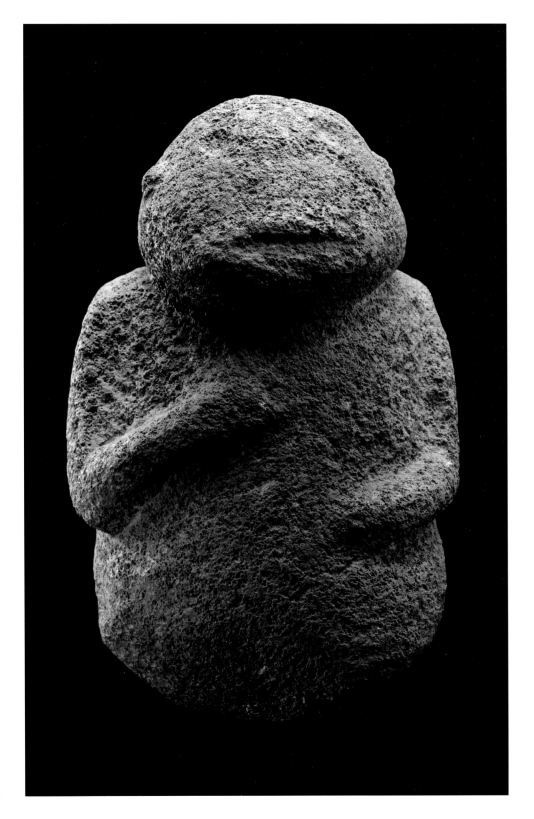

Hardwood. Of a more ancient type than the one shown in fig. 16. It was at one time believed that these objects came from Tahiti, but two of them were collected by Cook on Rurutu and Tubua'i during his first voyage. Austral Islands. Formerly Beasley Collection. Height 27 cm. Inv. 5401.

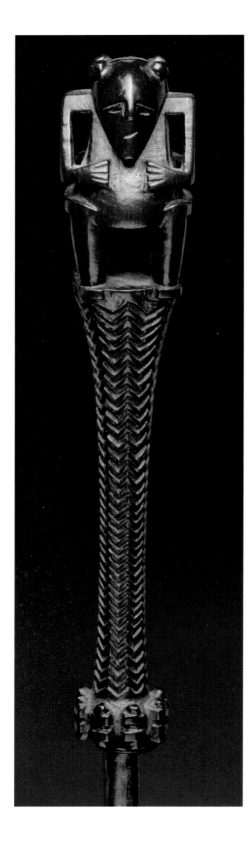

A'a presents an alternative use of this motif, with small human figures placed symmetrically over the body of the large figure and composing its facial features. According to the missionary John Williams, this figure represents the founding ancestor of Rurutu, while the smaller figures represent his descendants. Several extant Rarotongan figures, with smaller human figures ranged across the breast, also display a version of this motif.

Throughout central Polynesia, works of art were invested with meaning not only iconographically but also through performance. It was the *marae* rituals that called the god into an image, activating its potency. Often, the ritual act of binding or wrapping moved an artwork or person from a *noa*, or ordinary state, to a *tapu*, or sanctified state.[13] Figures of the gods in central Polynesia were typically wrapped in layers of barkcloth and sennit cord, ornamented with pearlshell and feathers. One of the few wrapped images that survives is the Rarotongan staff god collected by John Williams. Unfortunately, as Williams notes, the bindings of this figure may not appear in their original configuration, for customs officials had unwrapped the piece when he brought it to England.[14] Dance, too, can be understood as a ritual act that activates the power of the deified ancestors and gods by recounting in word, music, and gesture their glorious deeds. Not surprisingly, figures of dancers appear in Austral Islands art, encircling both the tall drums used in *marae* ceremonies and the ends of carved paddles (figs. 1a, 1b).

In central Polynesia, the choice of medium also created and enhanced the meaning of artworks. Materials such as pearlshell, human hair, and feathers were richly symbolic. Large

pearlshells were highly valued and exchanged as gifts between high-ranking individuals, and they often appear in breast ornaments worn by the elite. Throughout central Polynesia human-hair cordage was used in these ornaments, as well as in fly whisks—most of which are from the Austral Islands (figs. 15, 16)— eye shades, headdresses, and girdles. Evidence from Tahiti suggests that women made these braided hair cords: during the first European visit to that island, the high-ranking woman Purea indicated that the cordage she bestowed on Captain Wallis and his officers was made of her own hair.[15] Feathers, especially red ones, ornamented the figures of gods as well as the regalia of the *ari'i* and *ariki*. Cook Islanders placed red feathers under the wrappings of staff gods, along with small pieces of pearlshell, which, according to Williams, were the "*manava* or soul of the god."[16] A Tahitian chant memorializes the god 'Oro as "flying in the feathers of Hauviri," a reference both to the red feathers that ornamented figures of 'Oro and to Marae Hauviri, part of the great Taputapuatea complex in Ra'iatea.[17]

Today, the arts of central Polynesia, influenced by the introduction of Christianity and changing social and political structures, differ markedly from those of the eighteenth and early nineteenth centuries. However, in many respects the artistic traditions of the region continue to reflect the common cultural heritage of these island groups. The textile arts of women continue to be richly symbolic, as patchwork and appliquéd quilts have assumed many of the important roles, both social and spiritual, once played by decorated barkcloth.[18] Throughout the region there is a resurgence of interest in tattoo, dance, and long-distance voyaging in double canoes.

**16 Fly-whisk handle**

Hardwood. The twinned figures on the top of the handle are larger and more geometric than those in fig. 11. Austral Islands. Formerly A. Baessler Collection. Height 32.4 cm. Inv. 5453.

Museums, cultural centers, and arts festivals have all played important roles in fostering this artistic renaissance.[19] Indeed, contemporary artists look to the arts of the past for inspiration and guidance, seeing in them the spirit of their ancestors, a distinctly central Polynesian sensibility.

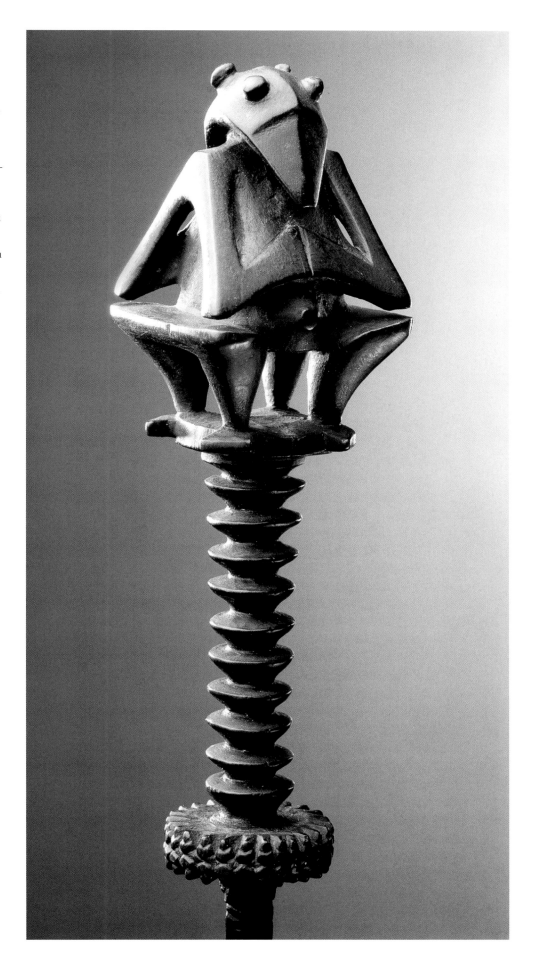

# The Marquesas Islands

Carol Ivory

Today the Marquesas Islands are a rugged and remote outpost of French Polynesia, far removed from the tourists and traffic common in many other parts of the Pacific. Yet this has not always been the case.

The Marquesas, along with the Society Islands, were a major dispersal point for the Polynesians, who ventured thousands of miles farther on to settle islands as distant as Hawai'i, Easter Island, and New Zealand. Later, after their discovery by the West, the Marquesas were for a time one of the major refreshment stops for nineteenth-century traders and whalers in the Pacific. The islands became widely known in the Western world in the mid-nineteenth century when chronicled in Herman Melville's highly romanticized tale of cannibals and South Sea maidens, *Typee*. They gained additional allure at the beginning of the twentieth century as the final resting place of the French artist, Paul Gauguin. Gauguin had been drawn to the Marquesas because of his interest in Marquesan art, especially carving. The Marquesans were expert carvers and tattooers who developed one of the most distinctive artistic styles in all of Polynesia. Today Marquesan art has become a major influence in the Pacific; its motifs and style elements have spread throughout Polynesia and have been adopted by contemporary carvers in Tahiti, Hawai'i, and other island groups.

The Marquesas Islands are an archipelago of ten islands, plus several small islets, situated about 1,200 kilometers northeast of Tahiti. Unlike most other Polynesian islands, the Marquesas have no protective coral reefs surrounding them and the islands fall in sheer cliff walls down to the sea. High mountain ridges divide the islands into separate valleys

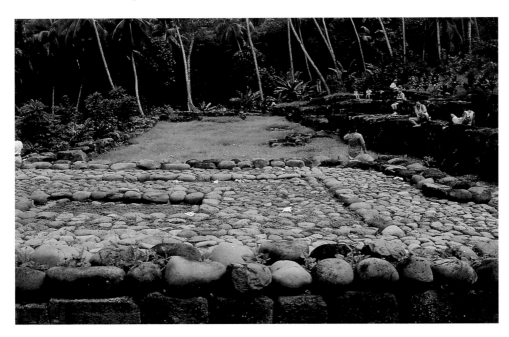

1 Ceremonial platform in stone (*tohua*), here restored. Hiva Oa. Photograph Carol Ivory.

2 **Pair of stilt steps (*tapuva'e*)**

Hardwood. Original Josef Mueller Collection. Acquired before 1942. Heights 35 cm each. Inv. 5814-C and B.

isolated for the most part from each other. The archipelago is divided into two groups geographically, the northern (or leeward) islands consisting of Nuku Hiva, Ua Huka, Ua Pou, Eiao, and Hatutu, and the southern (or windward) ones, Fatu Huku, Hiva Oa, Tahuata, Mohotani, and Fatu'iva.

Close to the equator the climate is tropical, with the northern islands hotter and drier than the more humid and wet southern islands. The Marquesas are subject to uncertain weather patterns and, especially in the northern group, have experienced prolonged periods of extreme drought, sometimes lasting years. At the end of the eighteenth century, about two-thirds of the total population (estimated at from 80,000 to over 100,000) lived on the windward, or southern, islands. Although essentially homogeneous in culture, the people from the two areas developed distinctive but closely related dialects of the Marquesan language.

Archaeological evidence suggests that the Marquesas have been a center of Polynesian culture for more than 2,000 years. The founding Polynesians, who settled the islands by at least the second century B.C., most likely came from western Polynesia, possibly Samoa. They brought with them plants, animals, technologies, and beliefs that had developed in western Polynesia from earlier foundations in the Lapita cultural complex. The Marquesans, who until European contact referred to themselves as Te Enata ("The People") and their islands as Te Fenua ("The Land"), lived in the valleys formed by the mountain ridges. Over centuries of relative isolation, the Marquesans developed their own distinctive version of Polynesian culture.

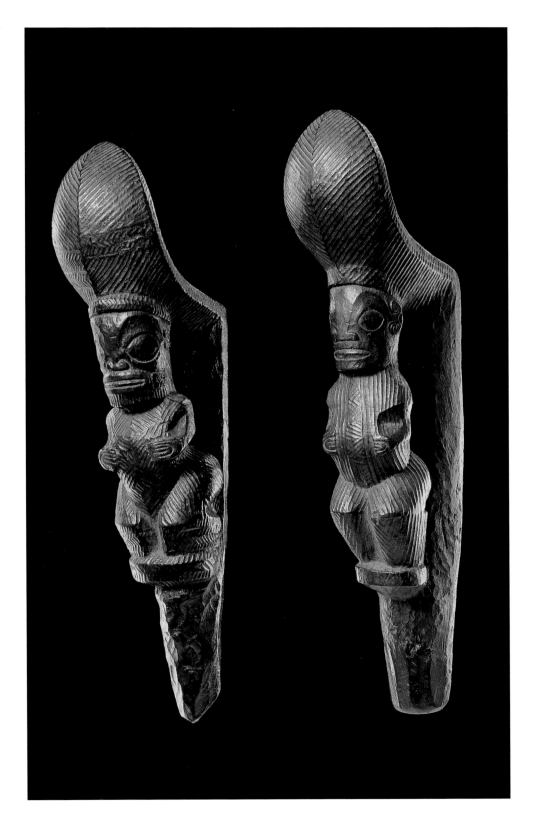

### 3 Crown (pa'e kaha)

Worn with the strips of turtle shell and white marine shell facing downward. The turtle-shell plaques are engraved with *tiki* motifs. This crown still has a number of the small shell disks surmounted with a little serrated turtle-shell roundel sewn on to the fiber headband. Original Josef Mueller Collection. Acquired before 1942. Diameter 22 cm. Inv. 5811.

### 4 Forehead ornament (uhikana)

A piece of oyster pearlshell to which is attached an openwork plate of turtle shell decorated with a design of six human heads (*tiki*). The headband of plaited fiber is adorned with a small openwork turtle-shell plaque and dolphin teeth. Diameter of the pearlshell disk 15.8 cm. Inv. 5812.

5 This eighteenth-century engraving shows how the *uhikana* forehead ornament was worn. Engraving from *Cook's Voyages*.

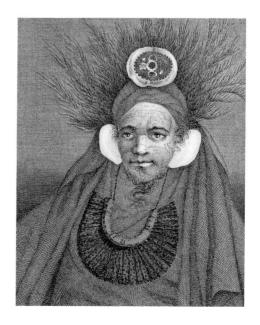

First contact with Europeans was a brief but bloody encounter with the Spaniard Alvaro de Mendaña in 1595. In less than a week, some 200 Marquesans were killed. The next meeting with *aoe,* outsiders, did not take place for nearly two centuries until the arrival of Captain Cook in 1774. His visit was also brief, but far less violent. Contact remained sporadic until the early nineteenth century. This changed dramatically after 1811 with the commencement of the sandalwood trade, and then in the 1830s with the peak of the whaling period, bringing more and more ships from around the world.

In 1842, the French annexed the archipelago and began in earnest the process of converting the Marquesans to Christianity and governing them under French law. The Marquesans suffered catastrophic population decline through introduced diseases, escalated warfare, and periodic severe droughts. By the early twentieth century, fewer than 2,000 Marquesans survived. They also experienced the legal prohibition of traditional activities and customs. As a result, by the late nineteenth century Marquesan culture had virtually collapsed. The Marquesans, however, are a remarkably strong people. Today, with more than 8,000 of them living in the archipelago, and at least that many living in Tahiti, the population has rebounded. Since the 1970s a cultural renaissance has also taken place, with the arts of all kinds a central and very vital component.

Most of the pieces presented here date from before the mid-nineteenth century. They are representative of objects which were integral to Marquesan life and which reflected central aspects of Marquesan culture. They would have been part of a wider artistic world,

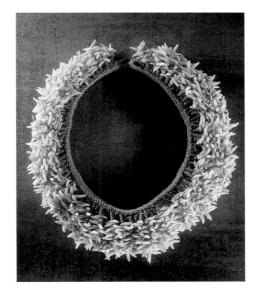

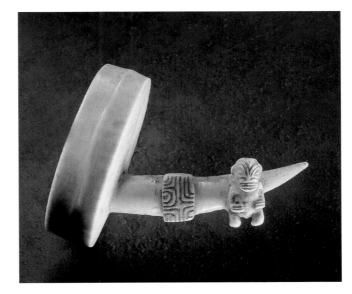

## 6  Diadem (*peue ei, ua pou*)

Fiber. Glass beads. Dolphin teeth. This piece has often been described as a necklace. Original Josef Mueller Collection. Acquired before 1942. Length 45 cm. Inv. 5819.

## 7  Small *tiki ivi po'o*

Human bone. Such ornaments were attached to sacred or otherwise important objects, such as war trumpets (see fig. 18) and drums. Original Josef Mueller Collection. Acquired before 1942. Height 3.5 cm. Inv. 5809-1.

## 8  Ear ornament (*ha'akai*)

Marine ivory. The point features a small *tiki.* Original Josef Mueller Collection. Acquired before 1942. Length 10 cm. Inv. 5815.

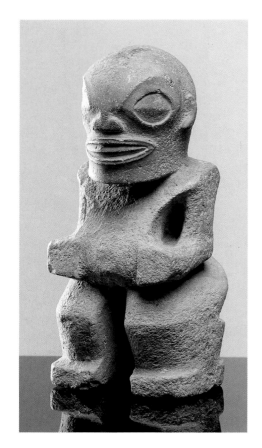

which included both the performance arts (oratory, dance, and chanting) and body decoration in the form of the most elaborate and extensive tattooing tradition in Polynesia. Many of the carved objects served as markers of personal prestige, which was based both on descent from one's ancestors and on one's abilities and success. The pieces also illustrate in their style and decorative motifs the main characteristics identified with Marquesan art, particularly sculpture. There has always been an emphasis on the human head, and the eyes in particular.

Marquesans in the first half of the nineteenth century subsisted mainly on breadfruit, which they fermented and stored in earth pits against the periodic severe droughts. This staple was supplemented by coconut, taro, and a variety of fruits, fish and shellfish, pigs and chickens, and, until some time before

Western contact, dogs. They made *tapa*, or barkcloth, for clothing and coverings from a number of plants, including the paper mulberry, breadfruit, and banyan trees. Their dwellings were scattered throughout the valleys in clusters of extended families. Several buildings, including a cooking shed, family sleeping quarters, and men's house, came to be built on a large stone platform called a *paepae*.

Marquesan society was highly flexible. Although organized basically around descent lines, it was not a rigidly stratified society. Genealogy was one mechanism by which people were ranked, since one's genealogy determined one's relationship to the gods and to the *haka'iki*, or high chief, the direct descendent of the gods and the highest-ranking person in the tribe. These family histories also established one's claim to land and other resources, and were recited at ceremonies and important events. In general, the closer one's position to the *haka'iki* (and therefore to the ancestral gods), theoretically the greater one's sacred power, or *tapu*.

Theoretically, primogeniture determined the selection of the *haka'iki*, but in reality the system was extremely flexible, with the practice of adoption, accumulation of wealth and prestige, and ability at times the determining factors.

Marquesan women often had great political and economic power, and there are numerous examples of women chiefs. The Marquesans were polyandrous, a practice unusual not only in Polynesia but also around the world. Auxiliary husbands (*pekio*) were lower status male servants who played an important economic role in the family in which they lived.

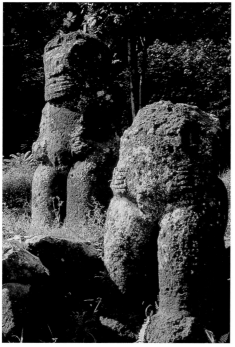

9 **Tiki**

Stone. The figure has a hole in the back of the head. The statuette might have been attached to a string and dropped into the sea to attract passing shoals of fish into the waiting nets. Original Josef Mueller Collection. Acquired before 1942. Height 16 cm. Inv. 5810-1.

10 Monumental stone statues at Hiva Oa. Approximate height of the statue on the left 3 m. Photograph Carol Ivory.

Stone. A rather large example, of unknown use.
Acquired prior to 1942. Height 45 cm. Inv. 5818.

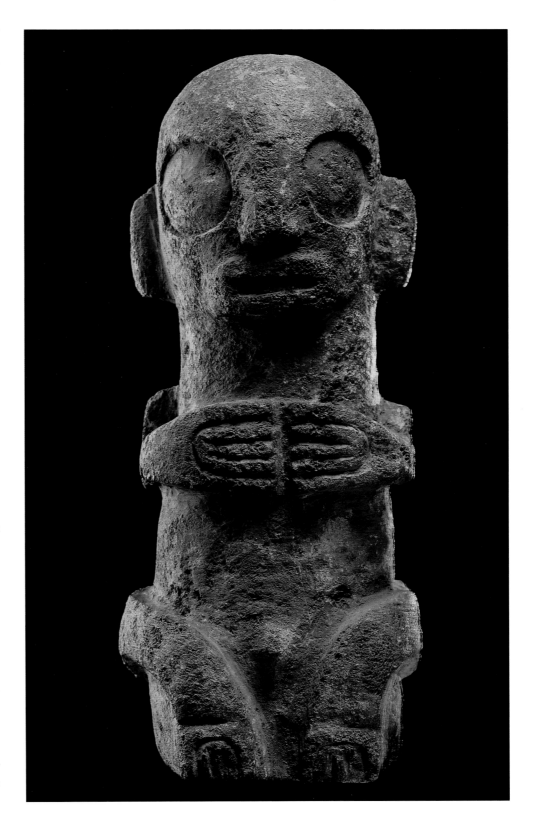

Several very desirable and powerful Marquesan
women were recorded as having ten *pekio*,
and a few had as many as forty.

Warfare was an integral component of
Marquesan life, the result of a territorial
rivalry or the need to avenge insults and
indignities, such as the capture and use of
one's kinman for human sacrifice. War
was carried on either in formal, usually pre-
arranged, pitched battles using clubs, spears,
and slings, or in ambush situations, usually
forays into neighboring valleys in search of
*heana*, human victims for sacrifice. Leaders
in warfare (*toa*) were high-ranking and in-
fluential persons in Marquesan society.

Like other Polynesian groups, the Marquesans
believed in a pantheon of gods. These in-
cluded Atea and his wife Atanua, the creators;
legendary heroes and demigods like Tu,
Tana'oa, Tane, and Ono, who controlled vari-
ous aspects of the natural world; and tutelary
gods who oversaw every activity and area
of life. The most critical gods to everyday
existence, however, were deceased ancestors
who had been deified after their death through
a series of elaborate feasts, which were an
important part of Marquesan religious and
social life.

Other feasts revolved around the *haka'iki*,
and were held to celebrate various moments
not only in his life and death, but also in the
life of his first-born child, especially a son.
Other events, such as the major annual bread-
fruit harvest, a victory in battle, or the death
of an inspirational priest (*raua*), would also
be occasion for feasting and ceremonies.
The Marquesans built huge public ceremoni-
al centers called *tohua* (fig. 1) for these feasts,
some large enough to hold 10,000 people

**Stick (*tokotoko pio'o*)**

Hardwood. Topped with a tuft of human hair. Carvings of figures occur at three places down the shaft, one reproduced as a detail here. Collected before 1840. Formerly Charles Ratton Collection. Height 153 cm. Inv. 5803-B.

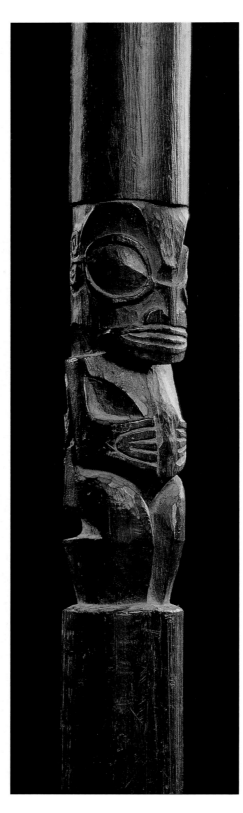

according to early-nineteenth-century European visitors. Music, dance, and sports, especially contests on stilts with elaborately carved footrests (fig. 2), were integral parts of celebrations and had ritual significance. The most important musical instrument of the Marquesans was the drum, which was carved out of wood and covered with sharkskin.

As in all of Polynesia, many activities, including the arts, were sacred and were the province of ritual specialists called *ruhuka* and *tuhuna*. These were the skilled artisans responsible for the successful production of important or sacred objects such as canoes and houses, or for the overseeing of specific activities such as fishing and tattooing. They were also in charge of the required rituals, including chants and sacrifices to the tutelary gods and ancestors, which surrounded the manufacture of an object or the pursuit of an activity, and which were necessary to ensure the success and efficacy of the project. Part of the flexibility of Marquesan society derived from the potential wealth, prestige, and power *tuhuna* could accumulate through their talents and ability, since these men could travel for work and were well paid.

The importance of the human body cannot be stressed enough when discussing Marquesan art, particularly carving. The human body is the main motif, as well as being an important medium or vehicle in itself. The human image is generically called *tiki* in the Marquesas. For a full body carved in the round (figs. 9, 11), the Marquesans used media as diverse as stone, wood, whale tooth, and human bone. *Tiki* could be as small as 3 centimeters in height (fig. 7) or as much as 3 meters (fig. 10). The body also appeared in relief on objects

## 13 Fan

Pandanus fiber. Hardwood handle. Ordinarily, the wood or, more rarely, ivory handles of artifacts such as these incorporate carvings of two human figures one on top of the other. In the present example, the handle has been worked into the shape of the head of a ʻuʻu club (see figs. 16 a, 16b). Height 43 cm. Inv. 5801.

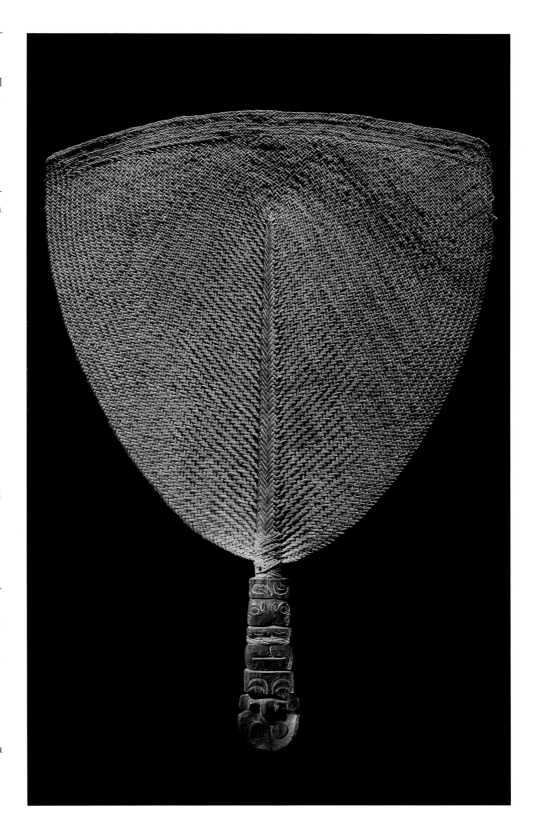

which reflected personal status or prestige, and which were worn or carried at ceremonial occasions, such as staffs (figs. 12a, 12b), head ornaments, ear ornaments, and fans (fig. 13).

In Marquesan art, Gauguin said, there is the face, always the face. It is a distinctive face, with its arched eyebrows, large and often outlined eyes, flattened nose, and wide band of a mouth. This face appears on an enormously wide range of objects, including utilitarian ones, such as stone pounders to mash breadfruit (fig. 14) and wooden covers for gourd or coconut containers (fig. 15). It is at its most sophisticated and complex in the ʻuʻu, the well-known Marquesan war club, where it appears over and over again, as faces within faces, in high and low relief, or incised (figs. 16a, 16b). It can also be seen in the wooden figures decorating canoe prows (fig. 17).

It is interesting that, in addition to human bone, the Marquesans used another part of the human body to decorate their objects and themselves: human hair. Hair from the head was cut, heated in earth ovens to curl it, and attached to clubs, staffs, and conch shell war trumpets (fig. 18). It was also fixed around the ankles, wrists, arms, waist, and shoulders. Hair from the face—the *pavahina*, or beard of an old man—was used as headdresses and as finger ornaments, and was also attached to objects. These were the most valuable possessions for a Marquesan and were almost impossible to collect until the near collapse of the culture in the late nineteenth century.

Why the face? The head itself, as in Polynesia generally, was the most sacred, or *tapu*, part of the body. Further explanation may also be found in the Marquesan term *mata*, used for

**14 Pestle (ke'a tu'ki)**

Basalt. The upper part is carved, with two *tiki* heads placed back to back. Original Josef Mueller Collection. Acquired before 1942. Height 21 cm. Inv. 5818-B.

**15 Vessel**

Made from a coconut (*ipu a ehi*) furnished with a hardwood lid on which is carved a face. The fiber cords used to suspend it are decorated with beads, tube-shaped ornaments, and a pair of *tiki ivi po'o* made of human bone. According to John Hewett, from whom this object was acquired in 1976, it formed part of an English collection from before 1850. Height of bowl with cover 18 cm. Inv. 5805.

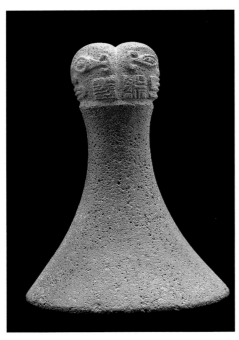

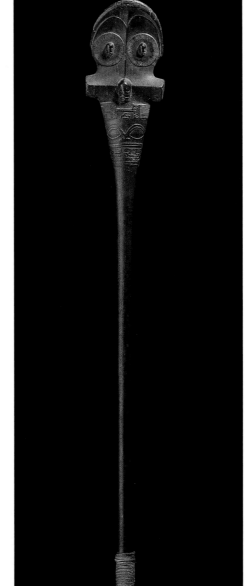

**16 a and b Club ('u'u)**

Hardwood. The lower part of the shaft is wrapped with a plaited fiber band with tufts of human hair. The detail shows the broad upper part, which is carved into the shape of a face whose eyes are composed of little *tiki* heads. Original Josef Mueller Collection. Acquired before 1942. Height 151 cm. Inv. 5804-A.

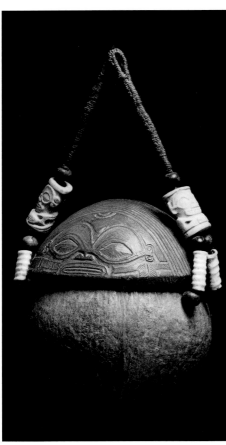

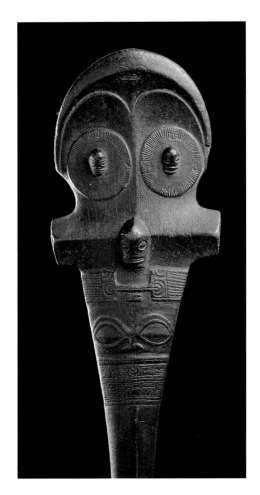

Hardwood. Dugout ornament presenting signs of long use: the two small *tiki* on which the figure's feet rest are so worn as to be scarcely recognizable. Original Josef Mueller Collection. Acquired before 1942. Length 36.8 cm. Inv. 5813.

Made from a triton shell decorated with tufts of human hair held in place by a *tiki ivi po'o* ornament and tightly plaited lengths of fiber cord. Original Josef Mueller Collection. Acquired before 1942. Length 37 cm. Inv. 5820.

face, eye, and the stitch or link in a net. Significantly, *mata tatau* means literally to count or recite faces (or eyes), but idiomatically has the meaning of genealogy,[1] and knotted strings were, in fact, used as aids in the reciting of genealogies. It is very possible, then, that the visual representation of a face or eye was used symbolically to stand for one's genealogy as a whole, to recall specific ancestors or the ancestral world, or as a means of invoking their power. In any case, the head, face, and eye are central to recognizing and understanding Marquesan art.

By the late nineteenth century, the old reasons for making art had ceased. Yet carving as an art form did not die out. With a resiliency that could be called awesome, the Marquesans began making objects for sale both to outsiders and among themselves: wooden bowls, model canoes, smaller clubs, and paddles. A new style of carving emerged, which emphasized low-relief surface patterns drawn from Marquesan tattoo designs. This later style has survived through the twentieth century and forms the basis for Marquesan carving today. Carving is flourishing on several of the islands, especially Nuku Hiva and Ua Huka, and with biannual expositions in Tahiti, the regular arrival (every three weeks) of tourists on a freighter/cruise ship, and a Marquesan Festival of the Arts now held every four years, the future of Marquesan art seems assured into the twenty-first century.

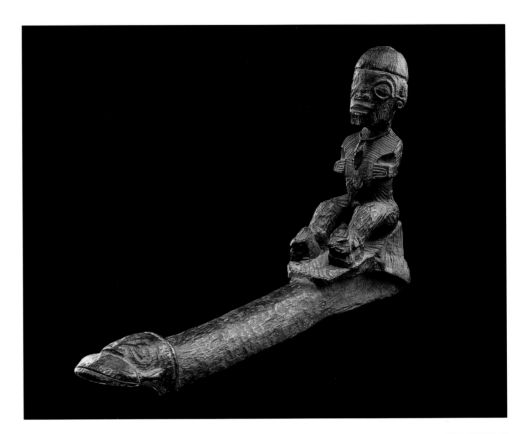

# Easter Island

## Beneath the Eyes of the Gods

Catherine and Michel Orliac

Lying 4,000 kilometers from Tahiti and 3,700 kilometers off the coast of Chile, Easter Island (or Rapa Nui) is one of the most difficult ocean islands in the world to reach. Created by volcanic activity three million years ago, a major eruption 200,000 years ago gave it its characteristic triangular shape and present-day surface area (166 square kilometers). Despite its isolated location, Easter Island was still within the reach of those masters of the ocean, the Polynesians, who arrived probably after the fifth century A.D., settling at Anakena Bay by the end of the first millennium. At that time great palms and other trees grew plentifully on the island,[1] providing the wood necessary for constructing the monumental stone platforms (*ahu*) and for transporting the giant statues (*moai*) that the population dedicated to the memory of their ancestors.

By the sixteenth century, 300 *ahu moai* were in place, embodying the land rights of the social groups that shared the island; almost a thousand statues had by that time been hewn in stone extracted from the Rano Raraku quarry (fig. 4). In the seventeenth century *moai* were still being erected, but the forest was gradually disappearing and eventually only a brushwood steppe survived. During the second half of the seventeenth century, a major internecine conflict broke out between the island's two confederations, inaugurating a period known as *huri moai* ("the overturning of the statues"). The people began to neglect their great *ahu moai* and the statues fell into disrepair, the last one collapsing in 1840. These events could have had the same cause as the disappearance of the forest: for some scholars, they were the result of extreme demographic pressures and overexploitation of natural resources;[2] for others, the cause

was probably climatic.[3] The arrival of the Europeans in 1722 was followed by a sharp drop in population as a result of epidemics; in 1862, hundreds of Easter Islanders were uprooted from their land and sent into forced labor in Peru. After 1871, the unrest occasioned by the settlement on the island of the buccaneer Dutrou Bornier reduced the population—who had begun converting to Catholicism in 1868—to fewer than two hundred souls. In 1880, the island was turned over to pasture for sheep, there being

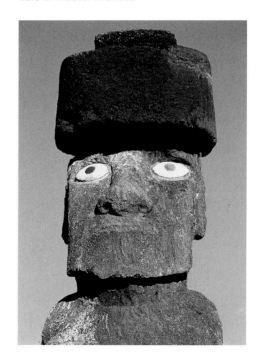

1  Restored monumental *moai* statue of Ahu Nau Nau at Anakena. The cylindrical "hat" made of red tuff and the white eyes, a few specimens of which have been found buried on the island, have been replaced. Photograph Jean-Louis Sosna. Barbier-Mueller Archives.

by that time probably no religious adepts or sculptors among the mere handful of people who had managed to live through the recent traumatic events.

Everything known about early Easter Island society derives from brief notes made by missionaries and others landing on the island, from witness statements taken down from the surviving islanders in the 1880s, and finally from what the inhabitants themselves passed on to their children and grandchildren between 1911 and 1935. This tradition tells how a highly structured and hierarchical society came to exist on the island, headed by a hereditary aristocracy whose members were not only responsible for a particular tract of land but also for a whole series of undertakings calling for competence in certain specific areas. The title *tahunga* (or *maori*) was used to refer to these "experts," be they builders of ships or monuments, stone sculptors, or wood carvers.[4] The *tahunga* sculptor was at one and the same time artist and priest; he who transformed wood, an essentially divine substance, performed rites entreating the traditional divinities to inspire his mind, guide his hand, and empower his tools. These sculptors were organized into a guild responsible for safeguarding the knowledge of their craft.[5] Generally speaking, a father would pass his trade on to his son, but membership of the guild was open to anyone who could prove his skill. Sculptors were paid in kind, receiving fish, chickens, crayfish, sweet potatoes, or barkcloth. They used various types of tool: basalt adzes, chisels, and even chips of basalt or obsidian rock. The razor-sharp cutting edge provided by obsidian and shark's teeth could be used to engrave *rongorongo* writing signs and allowed for considerable sophistication in modeling form. Sand, coral, and

rough sharkskin twisted round a stick were used as polishing tools.

Easter Island flora included around a dozen tree and shrub species providing workable timber. Research on the species used for carving approximately one hundred sculptures

2 *Rongorongo* tablet made from driftwood. It is not known whether the inscription represents a true writing system or a mnemonic technique. Drawing after Stephen Chauvet.

3 Giant *moai* statues, reerected at Ahu Akivi. Photograph Jean-Louis Sosna. Barbier-Mueller Archives.

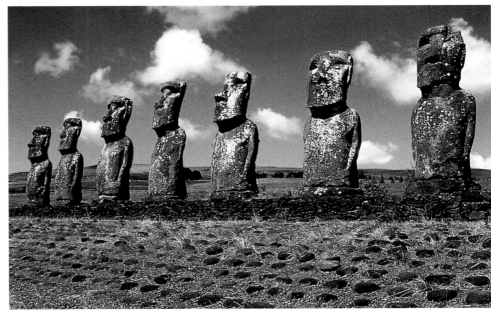

shows there existed a marked preference for driftwood, thought to be a gift from the gods,[6] but particularly for *Thespesia populnea* (the portia tree, an Oceanic rosewood) and *Sophora toromiro* (toromiro tree). The former was sometimes worked into sticks called *ua* (fig. 5)[7] and probably into *kohau rongorongo* tablets (fig. 2),[8] but the favorite timber was *Sophora toromiro*, which was considered sacred and provided immensely hard and almost totally rot-resistant wood of a reddish color.[9]

Far more than on its carvings, however, the fame of Easter Island rests on the profusion of massive monolithic anthropomorphic statues weighing up to 80 tons. Some of these wore

4 *Moai* statue lying in a quarry. Still visible is a section of the rock that had to be hacked away to allow removal. Photograph Jean-Louis Sosna. Barbier-Mueller Archives.

a cylinder headdress or hat of red volcanic tuff (fig. 1). These *moai*, almost all from stone quarried from Rano Raraku, were hauled to the *ahu* where the deep eye-sockets were gouged out. Once hoisted onto platforms, they represented the ancestors of the clan over whose territory they towered (fig. 3). Their name *'ariga ora* ("living face")[10] is explained by the piercing eyes, which were carved separately and inset with a snow-white sclerotic encircling a dark, flaming pupil.

The great round eyes of Makemake the creator god stare out all over the island, daubed in red paint on cave walls or carved into rocks. This fixed gaze is omnipresent in Easter Island sculpture: illumined by the flames of the inset obsidian and rendered all the more penetrating by the use of various colors and media, it imbues most objects carved in wood with life. The importance the image of the eye attained on Easter Island embodies an undying tradition that can be traced from Southeast Asia and the islands of Melanesia to the Marquesas, Hawai'i, and New Zealand.[11]

Oral tradition has bequeathed us no information concerning this salient characteristic of Easter Island imagery. However, numerous versions by legendary ruler Tuu ko Iho detailing the creation of the most famous examples of the art survive: the statuettes with a protruding torso known as *moai kavakava* ("ribbed statuettes"; fig. 6), and the flattened statuettes known as *moai papa* ("old woman statuettes"), each of which was the visible manifestation of the spirit of a deceased person (*akuaku*).[12] The former—tall, slender, and rather hunched—are painfully emaciated, at least on the upper body; the latter are

broader and flattened out like boards. Two-headed examples of both types occur. *Kavakava* are male (though a female statuette with an exposed rib cage exists in the Musée Calvet in Avignon), whereas *papa*, albeit sporting the occasional goatee, are all female.[13] On the other hand certain less ambivalently male figures, the *moai tangata*, which probably represent ancestors, are treated with a sensuality and anatomical realism uncommon in Polynesia. Like the large stone sculptures, all these stylized statues portray the aristocracy through certain distinctive physical traits, such as a circle around the lumber region and long fingers. The skull is often inscribed with figures and animals reminiscent of themes on petroglyphs.[14] The *tahunga* also carved a host of other anthropomorphic types, male or female, asexual or bisexual, often obese or deformed, in the most diverse poses. The statuette in the Musée Barbier-Mueller belongs to this category of polymorphic types (fig. 7). Its pose is almost unique in Polynesia and appears to be the depiction of some pathological state: the whole right-hand side of the face is deformed, from the obliterated eye-socket and zygomatic arch to the contorted mouth and the fold of dewlap hanging from the jawbone, flapping over the collar bone onto the chest. Another example of this type of sculpture, though cruder in execution, is preserved in the Übersee-Museum in Bremen.[15]

Carvers also fashioned wood into detached limbs (hands, feet), as well as into separate heads and genitalia: doubtless these formed part of the paraphernalia of a sorcerer or medicine man. Some of these composite creatures combined human characteristics with those of a lizard or bird. Stereotyped *moai tangata moko* present the overall body

Like the *rapa* type, the *ua* form was seen by Captain Cook, indicating that it was being made prior to contact with Europeans. Increasingly frequent during the nineteenth century, these contacts brought about a gradual deterioration in style, which was corrupted by commercial production. Acquired by Josef Mueller before 1942. Overall height 156.3 cm. Inv. 5704.

shape of a pot-bellied lizard with the buttocks, legs, and genitalia of a man. More varied in shape, *moai tangata manu* portrayed instead the various stages of a man being transformed into a bird[16] or into a *kavakava* (bird-man).[17] *Tangata moko* and *tangata manu* both possess a kind of hump out of which grows a short fantail. Some *tangata manu* resemble *kava* in their protruding spines and emaciated rib cages, *akuaku* characteristics recorded by oral tradition. On the skull there often appear glyphs similar to those on the stereotyped anthropomorphic statuettes. Finally, there exists a body of figurines portraying the island fauna: seals, rats, birds, turtles, fish, and mollusks. The treatment is often naturalistic, a disk of bright obsidian set in a bone ring serving for the eyes.

The sheer size of *ua* staffs, double-bladed paddles, and *ao* proclaims their elevated status as emblems of authority. Their all-seeing, all-knowing power is manifested in two stylized heads growing out of a single neck which are able to look backward and forward, and survey both the visible and - invisible realms. The schematically constructed face (eyebrows, nose, eyes) is strongly reminiscent of the numerous petroglyphs in which the god Makemake appears. On the top of an *ua* staff, taken from a single length of scantling between 1 and 1.60 meters long, stands an androgynous janiform head (*bifrons*) carved in the round. The example in the Musée Barbier-Mueller is of the classic type (fig. 5): hair neatly arranged in curved, visorlike bands across the forehead; almond-shaped eyes inlaid with bone and obsidian; striated ears vertically distended by a disk; high, protruding cheekbones; a slender nose slightly turned up at the end, and a narrow, straight mouth.

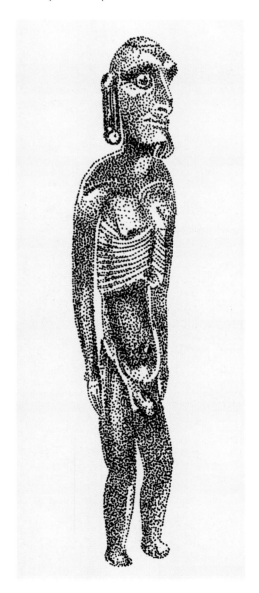

6 Statuette of the *moai kavakava* type in toromiro wood. Drawing after the example formerly in the Stephen Chauvet Collection.

Toromiro wood. Eyes in obsidian and bone (the left is missing). The carving is of a figure with a goiter. The growth on the neck conceals a small hole for suspending the statuette from a strap or cord. Formerly Sir Jacob Epstein Collection. Height 19.2 cm. Inv. 5701.

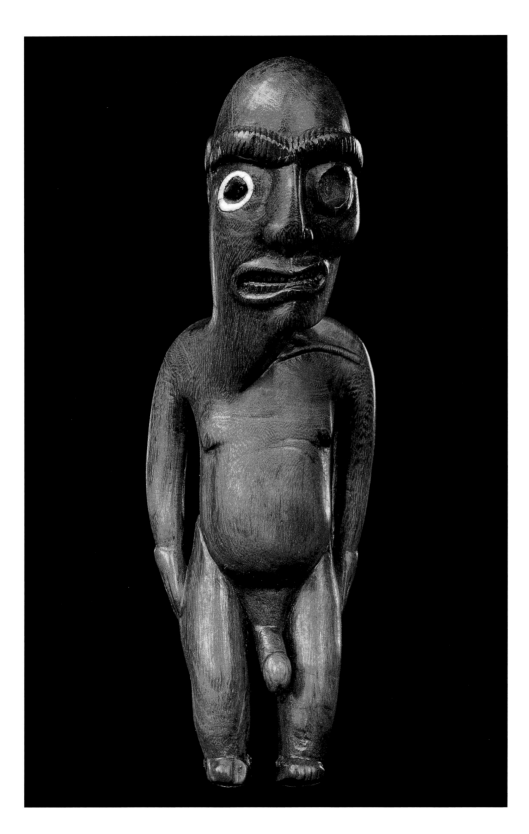

Both *ao* and *rapa* are hewn from a plank shaped into a kind of paddle, the two blades held together by the thinnest of shafts. The upper blades of the larger *ao* (1.50 to 2.20 meters) are adorned with a more or less schematized Janus head with eyes that may be either painted on[18] or inlaid with obsidian and bone.[19] Such regalia would have been used by dignitaries as they danced before the king. The *rapa* (0.45 to 1 meter) possesses no eyes, however, and the face is represented by two curves in light relief for the ears and eyebrows meeting to form the bridge of the nose (fig. 8). Being of smaller size, *rapa* were used during seated ritual dances. Under the name *rapa ika*, such paddles played an important part in ceremonies intended to avenge a murder victim, at which the chief officiant (*timo ika*) would conjure up deadly forces and direct them against the guilty party.[20]

Other insignia of authority, called *rei miro*, were hung around the necks of nobles of both sexes. Hewn from a single plank, or sometimes from the bone of a whale, they are always bowed in shape: the inward concave side is gouged with a crosswise, crescent-shaped rut in which dyestuff is laid. *Rei miro* vary enormously in size (anything from 28 to 92 centimeters) and come in two types: the first is crescent moon in form, the ends carved with rooster heads or with some other symmetrical design of the same lunar shape, such as bearded faces or shells; the second type presents roosters or fish. Some *rei miro* also exhibit traces of *rongorongo* writing. Other, smaller, pendants (6.5 to 14 centimeters) called *tahonga* were often attached to each other in pairs. They are carved in the shape of a human heart, or else of a testicle or coconut.[21] The top is occasionally adorned with the head of a bird, or with

## 8 Dance paddle (*rapa*)

Toromiro wood. Eighteenth century. Formerly
Butler Museum, Harrow School. Height 78.8 cm.
Inv. 5702.

---

two men's heads emerging from a single
neck.

Stone *moai* present a singular uniformity of
morphology, though naturally the six or seven
centuries during which the islanders produced
them resulted in differences of style and size.[22]
Wooden objects acquired prior to the conver-
sion of the island to Catholicism (between
1774 and 1868)[23] display considerable diversity
in terms of mode of expression and quality of
execution. Some show consummate mastery
of volume and surface as well as anatomical
detailing, whereas others, more sketchy or
even schematic in their overall design, are
evidence of the work of lesser talents. Such
variations were surely related in some way to
the status of the sculptor and his patron.[24]

Following evangelization, a pronounced dip in
the quality of craftsmanship was evident as
much material was produced for export: tra-
ditional themes began to be treated in a stiff
style characterized by clumsy anatomy. In this
so-called "Salmon" period (1879–88)—named
after a Tahitian trader who mixed these
mediocre pieces in with some older material
that had escaped the depredations of the
missionaries—facial structure is derived
from the stone *moai*. A modern style of far
superior quality began to appear about 1900,
interpreting freely and sometimes exuberantly
themes from the oral traditions of the past.[25]
The 1960s saw the opening of regular flights
to the island and with them came a plethora of
copies of *kavakava*, *moko*, and *tangata manu*,
accompanied by the inevitable miniature
wooden replicas of the famous stone giants.
However, ancient themes are still being ex-
pressed in the religious context of Hanga Roa
church, in the form of some vigorous statues
of the Virgin and the Catholic saints.

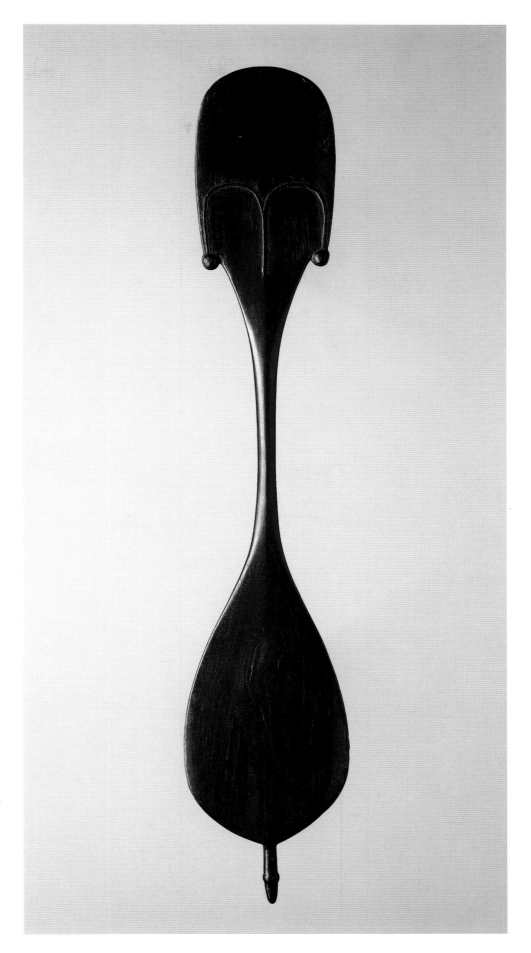

# New Zealand

**F. Allan Hanson**

No Polynesian people produced as wide a variety of outstanding artworks as the Maori of New Zealand. In addition to the house and canoe carvings, stone implements, and weapons represented in the Musée Barbier-Mueller, traditional Maori art includes feather and dogskin cloaks, flax mats and capes with decorated borders, woven house panels, elaborate tattooing, intricate painted designs on canoe paddles and house rafters, and

fine carving on a wide variety of wooden implements and utensils (fig. 7).

Beyond sheer appreciation of its virtuosity, the scholar seeks to place art in its cultural context. What role does art play in the overall social life of the people? What information can art convey about a culture's predominant values, assumptions, and concerns?

1 **Three clubs**

Basalt. Original Josef Mueller Collection. Acquired before 1942. Heights respectively 30.5 cm, 42.2 cm, 34 cm. Inv. 5116-A, B, and C.

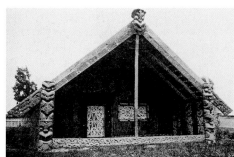

2 Maori meeting house. Barbier-Mueller Archives.

3  **Two ear ornaments**

Nephrite. Original Josef Mueller Collection.
Acquired before 1942. Lengths respectively 8.3 cm,
13.8 cm. Inv. 5108-A and C.

4  **Club (*patu paraoa*)**

Hewn from a whale jawbone. Original Josef
Mueller Collection. Acquired before 1942.
Height 34 cm. Inv. 5116-F.

### The Place of Art in Maori Society

In traditional Maori culture, as in many others, art served as a marker of wealth, power, and prestige. Finely decorated wood, bone, and stone ornaments (figs. 9, 10), weapons (figs. 1, 4, 12), and implements (fig. 5) were markers of the high social status of their owners. In the same way that a cathedral was a source of pride for a medieval town, large, elaborately carved canoes and houses testified to the wealth and power of Maori tribes and their chiefs.

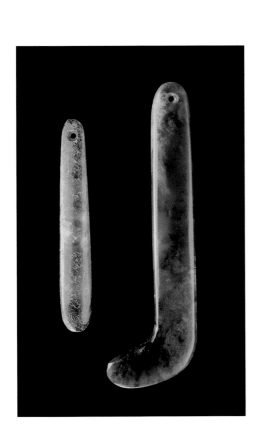

A feature considerably more unique to Maori art was its relation to religion. Augustus Earle, who spent about six months in New Zealand in 1827–28, observed that the Maori attributed any event or circumstance for which a cause was not immediately apparent to the work of spiritual beings.[1] This included rainbows, shooting stars, lightning, and thunder. These beings, called *atua*, were also deemed responsible for many human conditions. Illness, excessive anxiety, and confusion were sure signs of the influence of *atua*, as was fear. If, for example, a normally brave warrior should be overcome by terror before battle, the fault was attributed not to him but to some *atua* meddling with his psyche.

In addition to such unwelcome outcomes, *atua* were also thought to be responsible for desirable processes such as the growth of crops and the abundance of fish and shellfish. Here we encounter the first association of Maori art with religion. Maori were not content to let the *atua* move hither and yon as they wished. Instead, they often took measures to bar them from places where they were not wanted and to convey them to places where they were. For example, they would place an image carved in human form in a sweet potato field that had just been planted. This *taumata atua*, or "spirit resting place," was thought to attract an *atua* to take up residence and stimulate growth of the crop, perhaps in the same way as people today set out bird houses to attract certain kinds of birds.[2] Interestingly, while they can be considered among the most sacred objects in the repertoire of Maori art, such *taumata atua* manifest the least virtuosity. Often they were roughly hewn from porous volcanic rock.

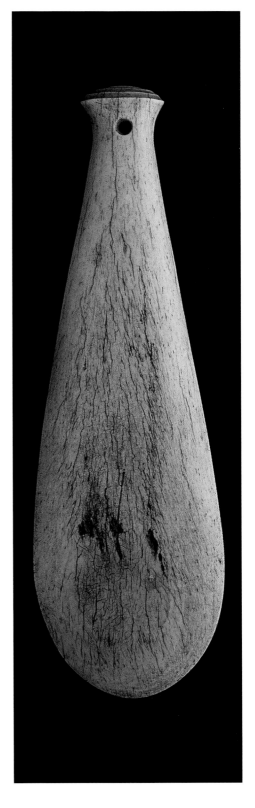

**5 Digging-stick footrest**

Hardwood with shell inlay. Used for preparing the earth for planting. Te Huringa period (after 1800). Formerly James Hooper Collection. Length 18 cm. Inv. 5104.

**6 Two panels**

Hardwood. From an old Maori granary house (*pataka*). In the nineteenth century, this was originally a single side panel (*epaepa*) that an adroit French cabinetmaker has skillfully divided into two and made good. Comparing the present state of the panel with its earlier appearance (see fig. 8) gives one an opportunity to appreciate the quality of Te Huringa carving. Formerly Charles Ratton Collection, then original Josef Mueller Collection. Acquired before 1942. Heights respectively 82 cm, 82.5 cm. Inv. 5110-A and B.

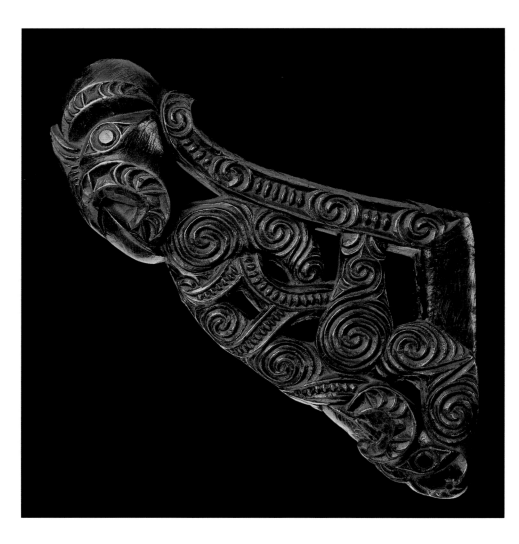

*Atua* were also deemed to be responsible for uncommon or outstanding human abilities and accomplishments. Success in battle and the power to heal were animated by *atua*, and so was the creativity and skill of the artist. Nobody, it was thought, could weave, carve or paint without the active assistance of some *atua*. The state of being under the influence of an *atua* was known as *tapu* and (as with the sweet potato field) steps were taken to bring the artist into this condition. A student would bite part of the loom in order to acquire the *tapu* necessary to learn the art of weaving.[3] When construction of a new canoe or house was begun, a wooden chip from the work site would be placed under the latrine beam[4] to invite the *atua* to endow the workers with their influence.[5]

Essential as it was, being in the state of *tapu* entailed a number of restrictions on ordinary behavior, such as not being allowed to use one's hands while eating because food (especially cooked food) was considered to be completely antithetical to the state of *tapu*.[6] Indeed, among the finest examples of Maori wood carving are ornate funnels that were used to feed highly *tapu* persons while they were being tattooed, together with their tattooers.

In recent years art has come to serve as a means of linking Maori with their cultural heritage. One of the greatest figures in Maori mythology is Maui, a culture hero who gave fire and numerous other benefits to humankind. One of his outstanding accomplishments was to haul up the North Island of New Zealand, known to Maori as Te Ika a Maui ("Maui's Fish"), from the bottom of the sea. He accomplished this herculean task with a hook made from his grandmother's jawbone and baited with his own blood, which he obtained by striking himself on the nose.

**The Aesthetics of Maori Art**

The significances discussed thus far do not depend on any particular artistic form.

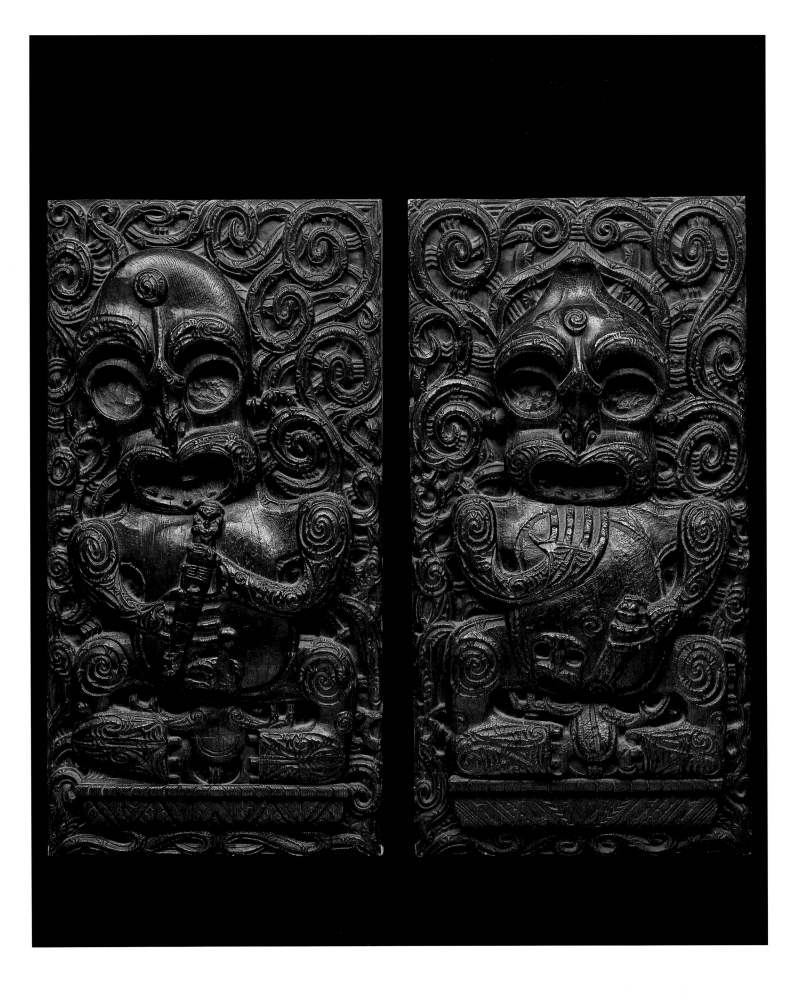

**7 Underside of a box (*wakahuia*)**

Hardwood. Formerly used as a container for feathers, jade ornaments, and all the especially sacred objects that had come into contact with the chief's head. Only the base and sides of the box are decorated. The lid is smooth, inscribed underneath with a date that is still legible: 1817. Te Puawaitanga period (1500–1800). Formerly Museum für Völkerkunde, Leipzig. Length 47 cm. Inv. 5102.

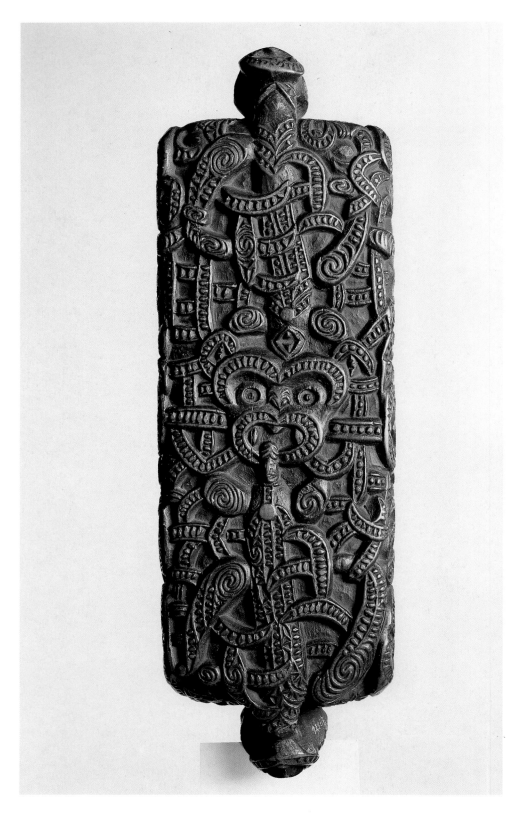

Objects of all possible descriptions can and, in one part or another of the world, do convey information about the wealth and prestige of their owners or forge powerful links with the ancestors or a cultural heritage. When we inquire into the particular forms that art takes, and what it is about those forms that evokes certain meanings and responses, we enter the realm of aesthetics.

8 Historic photograph showing the original appearance of the side panel (fig. 6), which was purchased in 1891 by Sarah Bernhardt and was split into two screens and adjusted by her cabinetmaker. Photograph Josiah Martin. Courtesy D. R. Simmons.

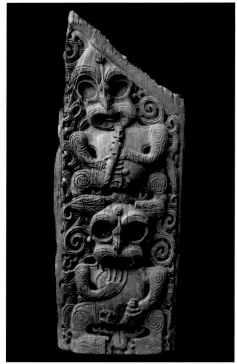

## 9 Carving (*taurapa*)

Once a stern ornament on a large Maori war canoe. Formerly Astbury (before 1855 according to a 1972 letter from Mrs. Doris Astbury) and Charles Ratton collections. Height 192 cm. Inv. 5100.

Over the years scholars of Maori art have pursued a wide variety of strategies in attempting to explain the forms of Maori art. At the end of the nineteenth and the beginning of the twentieth century, the general trend was to posit ancient connections between the Maori and other civilizations on the basis of artistic similarities. For example, Maori low-relief wooden sculptures of the human form frequently (but by no means invariably) have three fingers (fig. 6). This can be seen on panels originally from the facade of a food storehouse and the magnificent boxes for feathers. Edward Tregear postulated a connection with ancient Tunis, where carved doors also feature a three-fingered hand, called "Fatima's Hand."

By the 1920s and 1930s, the primary interest of students of Maori art had shifted to questions of style. It was (and still is) generally accepted that New Zealand was settled from Polynesian archipelagoes to the north, such as the southern Cooks, Societies, or Marquesas. Art in those islands is more restricted than in New Zealand; figures tend to be small and intricate, and the style is rectilinear. The profuse and elaborate Maori art, with its bold, curvilinear style (quintessentially represented by the spiral), was thought by many scholars to differ dramatically from those Polynesian styles and actually to be more reminiscent of the curvilinear style found in much of Melanesia. How can this discrepancy be explained? Virtually all logically possible answers to this question have, at one time or another, been seriously proposed. One is that a people of Melanesian extraction called the Maruiwi inhabited New Zealand prior to the Maori. While inferior to Maori in most ways, their distinctively Melanesian art style was adopted by the Maori, accounting for its curvilinear

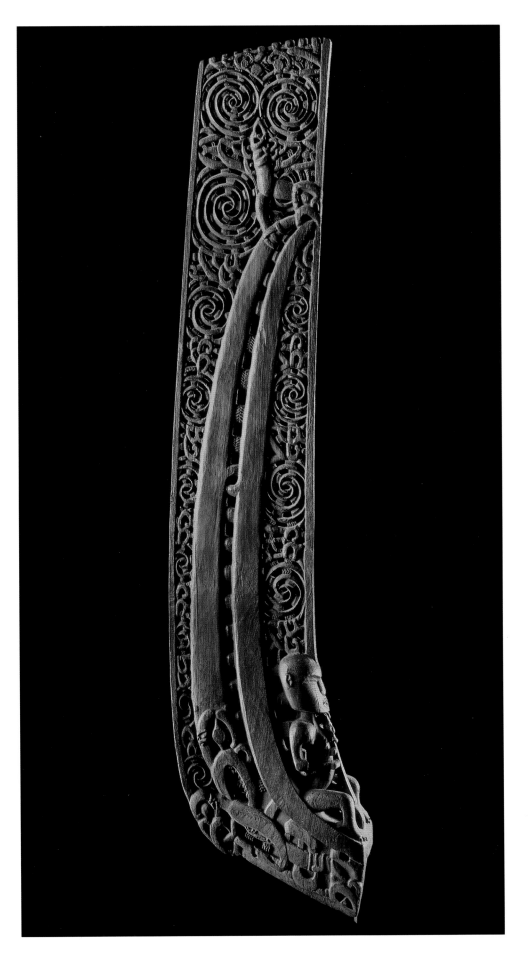

### 10 Pendant (*hei tiki*)

Nephrite. Te Puawaitanga period (1500–1800). Height 6.5 cm. Inv. 5107-F.

### 11 Pendant (*hei tiki*)

Nephrite. Te Puawaitanga period (1500–1800). Height 10.2 cm. Inv. 5107-E.

### 12 Staff or weapon (*hoeroa*)

Carved from the rib of a whale. It embodied the chief's authority. According to Hamilton, long staffs such as these (also called *tata paraoa*) were used, among other things, as two-handed broadswords. This piece was given by Chief Tamati Waka (Thomas Walker) Nene, of the Nga Puhi tribe to Colonel Dunn, on the occasion of the treaty of Waitangi on February 6, 1840 (note in the Hooper sales catalog). Note the curvilinear decoration on the top of the shaft. Formerly James Hooper Collection. Length 121.3 cm. Inv. 5103-B.

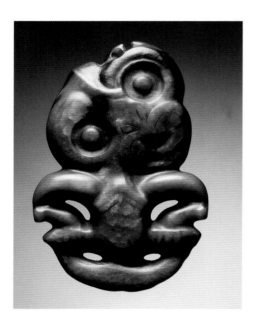

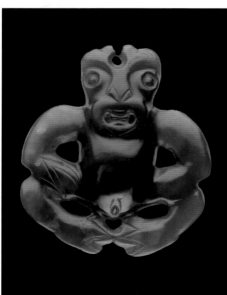

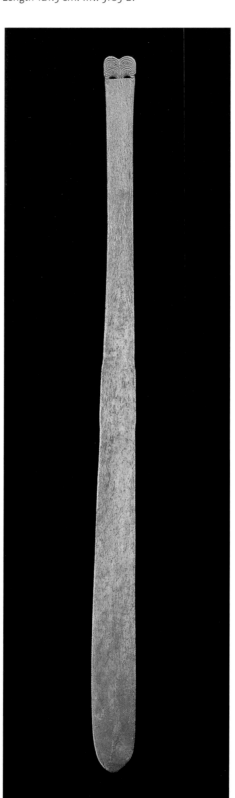

style.[7] Another explanation is that the more ancient style is the curvilinear one, having its deepest roots in India and China and having been carried to the central Pacific by the ancestors of the Polynesians. Those Polynesians, who were to become Maori, took the aboriginal curvilinear style with them to New Zealand, and only later did the style in the Cooks, Societies, and Marquesas become rectilinear.[8] Still another proposal is that as the ancestors of the Polynesians passed through the Micronesian atolls on their way to Polynesia, their arts and crafts were impoverished. After they had dispersed throughout Polynesia, with its abundance of materials suitable for artistic production, style developed differently in different places. In the Societies and nearby archipelagoes a rectilinear style emerged, while New Zealand art took a curvilinear path.[9]

The difficulty with all of these theories is that they rest heavily on historical conjectures about migration routes and sequence of settlement, most of which have now been disproved or discarded. More recently Sidney Mead has addressed the question on the basis of archaeological findings within New Zealand. He found that the earliest art objects manifest intricate rectilinear forms and the bold curvilinear ones appear only later.[10] This constitutes strong evidence for the hypothesis that the distinctively Maori curvilinear style developed in New Zealand.

Gilbert Archey analyzed Maori style in terms of a developmental sequence from representations of familiar objects to increasingly abstract and stylized forms. Noting that Maori spirals are virtually always double (fig. 9), Archey analyzed them as the end point of a sequence that begins with interlocking jaws of the *manaia*, a form which he understood

as depicting a human profile. The difficulty here is the absence of historical evidence proving that the earlier examples in Archey's sequences predated the later ones.

Another family of approaches has been concerned with the symbolic meanings of Maori art forms. One line of inquiry has pursued iconography. The assumption is that Maori art forms are pictures of something, and that their meanings are to be found in what is depicted. A limitation of this approach is that most of Maori art is decorative rather than pictorial, although a few representational figures can be identified.

A more recent avenue of symbolic analysis has started with composition. Working primarily with rafter paintings and facial tattooing, my own suggestion has been that structures of dualism, symmetry, and near-symmetry in art convey messages about the Maori view of reality, messages which are also conveyed by homologous patterns in Maori mythology and folklore, proverbs, and patterns of social and political relations.[11] In a similar vein, Roger Neich has noted that Maori carvers used an "aspective" style which represents their subjects (often ancestors) not as they would be seen from a particular viewpoint and at a particular moment in time (as is the case for much of Western art) but as ageless ideals.[12] This mode of representation connotes the traditional Maori concept of time as organized around concrete events rather than being an abstract continuum in its own right, and as containing "the timeless ever-present world of the ancestors."

13 **Model of a Maori war canoe (*wakataua*)**

Wood and fiber. Nineteenth century. Original Josef Mueller Collection. Acquired before 1942. Length 149 cm. Inv. 5112.

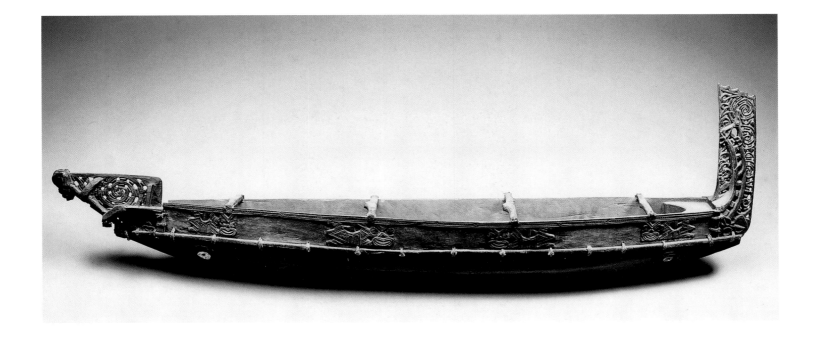

# Micronesia

Donald H. Rubinstein

1 Ruins of a gigantic funerary monument at Pohnpei (Ponape). Caroline Islands. Photograph G. Weiss. Courtesy Museum für Völkerkunde, Vienna.

Micronesia, meaning "tiny islands," includes three vast archipelagoes of widely scattered islands in the western Pacific. The Mariana Islands, all volcanic in origin, border the Philippine Sea and sit atop the undersea shelf of the Asian continent. South of the Mariana Islands and lying east-west close to the equator are the Caroline Islands, a 3,300-kilometer-long archipelago of scattered clusters of partly submerged volcanic islands and hundreds of tiny coral islets. The Marshall Islands and Kiribati (Gilbert Islands) mark the eastern edge of Micronesia. Composed entirely of coral islands and atolls, these chains lie in a north-south direction.

Micronesian cultures, languages, and arts reflect a complex history of migrations and continuing contacts between Micronesia and the islands of Southeast Asia and Melanesia. The term "Micronesia," coined by the French cartographer Domeny de Rienzi in 1831, is a geographic label that cloaks considerable cultural diversity within the area it defines. At least sixteen separate languages (all within the great Austronesian language family) are spoken within the region. The languages of the western Micronesian islands—Palauan, Yapese, and Chamorro (the indigenous language of Guam and the northern Mariana Islands)—are related most closely to languages of the Philippines and Indonesia, reflecting the Southeast Asian origins of these Micronesian peoples, perhaps about 2000 B.C. The languages of the central Micronesian islands —Chuukese, Pohnpeian, and Kosraean— show relationships to languages of northern Melanesian islands in Vanuatu, while the languages of eastern Micronesia, especially Gilbertese, show Polynesian affinities. Two Polynesian outliers, Nukuoro and Kapingamarangi, lie near the equator within

the Micronesian region. Several small islands (Wuvulu, Ninigo, Hermit, Luf, and Kaniet) near the Admiralty Islands north of New Guinea are considered "para-Micronesian" although the cultural relationship of these outlying islands to other Micronesian islands is not well described.

Many Micronesian arts display an aesthetic interest in fine geometric and rectilinear surface designs that appear related to archaic Indonesian forms. This influence is especially visible in architectural structures, in the patterned decorations on loom-woven and plaited materials, and in the incised and painted surface of wooden objects. It is apparent also in the concern for symmetry of lines and colors that appears in shell ornaments, woven garments, and tattoos. Figural and representational carvings take a minor place among Micronesian arts, and may represent later cultural influences from Melanesia.

## Everyday Life and Material Aspects of Micronesian Art

Micronesians rank as one of the great seafaring peoples of the world. Their cultures and arts, despite the diversity of origins, reflect common concerns with maritime motifs and shared problems of adaptation to small, isolated tropical islands. The ancestors of present-day Micronesians constructed perhaps the world's first seaworthy oceangoing vessels: a deep-hulled, single-outrigger sailing craft with a large triangular sail. These vessels, now found throughout the Carolines, Marshalls, and Kiribati, are designed to sail with either end forward, thus the outrigger is always to windward.

Many utilitarian containers in everyday use copy the double-ended shape of the sailing

vessels. Food bowls in the shape of canoes are common throughout the Caroline Islands; the T-shaped lugs at the two ends often resemble a stylized human face formed from straight brow ridges and nose. In Chuuk, immense bowls carved from breadfruit logs are used at large ritual feasts, and require four or more men to lift them onto their pallets. Elongated, canoe-shaped bowls from Kaniet Island show delicate openwork carving at the two ends, resembling canoe prows, with abstract anthropomorphic motifs and occasionally with carved human faces. In the outer islands of Yap, fishermen carve small, canoe-shaped tackle boxes with tightly fitted lids, which they use to carry their valuable shell hooks, lures, and other paraphernalia.

Several bird species play useful roles in these seafaring societies; terns and frigate birds are important as navigational aids for finding land, and the bird feathers and bones are useful in making fish lures, tattoo needles, and personal ornaments such as decorative combs. Bird motifs appear in both utilitarian and ritual arts. In Yap and its neighboring islands, bird figures carved in softwood are hung as decorations in meeting houses, and small bird-shaped bowls, also designed to be hung, serve as paint palettes for canoe builders. The aesthetic adaptation of utilitarian

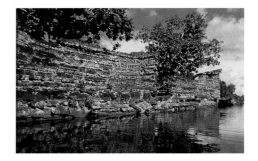

2  **Shallow platter**

Hardwood. Stained red. Mother-of-pearl inlay. Belau. Formerly (prior to 1900) Umlauff Museum, Hamburg. Length 44.5 cm. Inv. 4980-1.

3  **Stool**

Zoomorphic design. The head was once equipped with a sharpened shell blade used for scraping coconut pulp. Nukuoro Atoll, Caroline Islands. Formerly Ralph Nash Collection. Length 66 cm. Inv. 4980-4.

objects to birdlike shapes is visible in coconut-grating stools—carved with a wide, sway-backed seat and an outstretched neck like that of a bird in flight—from the Polynesian outliers of Nukuoro (fig. 3) and Kapingamarangi south of Pohnpei. Palauans carved splendid covered containers in the form of birds, with mother-of-pearl inlay suggesting feathers and eyes. In Yap and Chuuk, canoe prows display highly stylized bird imagery. The ends of the Yapese canoe feature a carved, flaring prong resembling the tail of the frigate bird, while in Chuuk a canoe prow ornament represents two confronting sea swallows.

The precarious ecology of life on coral atolls and small islands influenced the development and material aspects of Micronesian art in many ways. Wood, plant fibers and vegetable pigments, turtle shell, and various sorts of seashells are the predominant artistic media. Pottery was made until recent times in the islands of Palau and Yap, and archaeological evidence reveals ceramic production at the time of early settlement on all the mountainous volcanic islands of Micronesia.

A variety of marine shell and bone is used in the production of fishhooks and lures, adz blades and scrapers, small cutting tools for preparing yarns for weaving, and personal ornamentation such as belts, rings, bracelets, necklaces, and pendants. In the Marshall Islands, a graceful fish-shaped beater made from giant clam shell is used in preparing pandanus fiber for plaiting. Yapese produced smoothly polished, tusk-shaped betel nut pounders from giant clam shell. A gigantic version of the betel nut pounder is also made in Yap; although too heavy to use, it has importance as a ceremonial object of wealth for ritual payments and display.

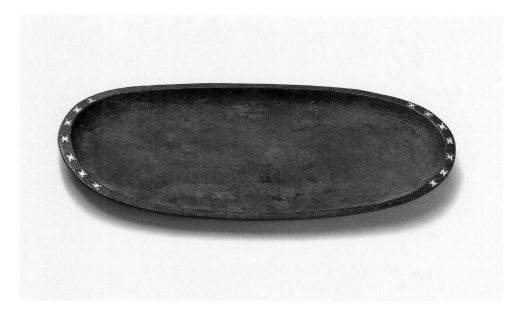

6 **Statuette**

Hardwood. Carved without the aid of metal tools, it represents a divinity. Nukuoro Atoll, Caroline Islands. Formerly collections of Paul Guillaume and Georges Ortiz. Height 40.2 cm. Inv. 4980-5.

4  Large stone disk utilized as currency. Metal tools made it feasible to work such enormous disks; previously they were far smaller. Yap Island. Photograph C. Petrosian-Husa. Courtesy Museum für Völkerkunde, Vienna.

5  Men's meeting house. Palau. Photograph R. Schmid. Courtesy Museum für Völkerkunde, Vienna.

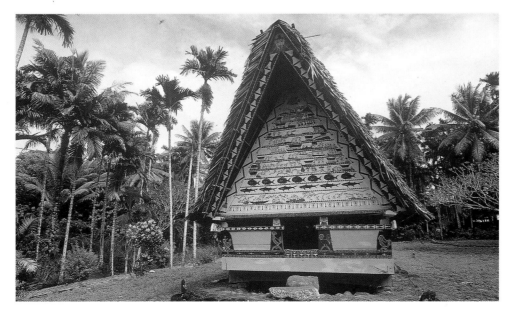

Stone is used rarely in Micronesian arts, and appears mostly in architecture. House platforms made from basalt stonework are common throughout Micronesia, and in two sites in Pohnpei and Kosrae long blocks of columnar basalt were laid upon each other to build up the foundations and walls of megalithic structures (fig. 1). Yapese quarried limestone in Palau and laboriously fashioned gigantic disks over 3 meters in diameter, with a hole in the middle to allow for transport by a carrying pole (fig. 4). These disks were rafted back to Yap and displayed in front of houses and along paths as repositories of wealth, and occasionally they were carried to village meetings and used as ceremonial payments.

In Palau, archaic stone carvings are found in association with house platforms or village ceremonial grounds. Ranging in height from about 60 to 220 centimeters, they portray roughly carved features of a human head, sometimes associated with more realistic lizard or crocodile forms. Other uses of stone are mainly in food pounders. The bell-shaped pounders from Chuuk, made from coral limestone, are the most beautifully proportioned.

Separated by long distances between islands, and occasionally devastated by natural disasters such as typhoons and floods, Micronesians developed various inter-island relationships that provide mutual assistance in times of emergency. The inhabitants of the low coral atolls especially need occasional assistance from neighboring high island communities that have more secure food resources, while the high islanders often relied in the past upon the navigational skills of the atoll dwellers. This situation fostered a good deal of regional specialization and inter-island trading of art items and valuables. Many personal items of utilitarian and ornamental use—such as bundles of coconut coir rope, loom-woven skirts and loincloths, and a large variety of shell adornments such as earrings, belts, and necklaces—also function as forms of currency in complex inter-island trade and tribute systems, and in ceremonial exchanges among families living on the same island.

Inter-island or inter-village relations in some areas of Micronesia involved occasional warfare. One of the most remarkable artifacts associated with warfare anywhere in Oceania is the full-body armor formerly worn in battle by men of Nauru and Kiribati. Made from tightly knotted coconut fiber, the armor included trousers, a heavy jacket and vest, and a large helmet and neck guard. Human hair sometimes was used to produce chevron motifs in the fabric, or was added as tufts to the helmet and neck guards.

Details of the publications referred to in the notes are given in the bibliographies of the corresponding chapters.

## The Austronesian Dispersal

### Notes

1 Bellwood et al. 1995.
2 Bellwood 1997a, 1997b.
3 Pawley and Ross 1993; Bellwood et al. 1995; Blust 1996.
4 Blust 1984–85, 1995, 1996.
5 Dyen 1995; Wolff 1995.
6 Bellwood 1996a.
7 Bellwood 1991, 1996a; Renfrew 1992.
8 Bellwood 1996b.
9 Zorc 1994.
10 Chang 1995; Tsang 1995; Chang and Goodenough 1996.
11 Ipoi and Bellwood 1991.
12 Kirch 1997.
13 Irwin 1992.
14 Bellwood 1993.
15 Blust 1984–85; Bellwood 1993, 1997a.
16 Adelaar 1995; Dewar and Wright 1993.
17 Anderson 1991.
18 Green 1991.
19 Dutton 1995.
20 Pawley and Green 1984.
21 Spriggs 1995, 1997; Kirch 1997.
22 Kirch 1988.
23 Bellwood and Koon 1989.
24 Houghton 1991; Hagelberg and Clegg 1993.
25 Hill and Serjeantson 1989.
26 Green 1991.
27 Bellwood 1987.
28 For example, Bahn and Flenley 1992.
29 See Irwin 1992, p. 100, favoring a prehistoric Polynesian discovery of the South American coast.

### Bibliography

Adelaar, A. "Borneo as a Cross-roads for Comparative Austronesian Linguistics." The Austronesians: Historical and Comparative Perspectives, edited by P. Bellwood, J. J. Fox, and D. Tryon, 75–95. Canberra: Department of Anthropology, Research School of Pacific and Asian Studies, Australian National University, 1995.
Anderson, A. J. "The Chronology of Colonization in New Zealand." Antiquity 65 (1991): 767–95.
Bahn, P., and J. Flenley. Easter Island, Earth Island. London: Thames and Hudson, 1992.
Bellwood, P. The Polynesians. 2nd edition. London: Thames and Hudson, 1987.
———. "The Austronesian Dispersal and the Origin of Languages." Scientific American 265/1 (1991): 88–93.
———. "Cultural and Biological Differentiation in Peninsular Malaysia: The Last 10,000 Years." Asian Perspectives 32 (1993): 37–60.
———. "The Origins and Spread of Agriculture in the Indo-Pacific Region." The Origins and Spread of Agriculture and Pastoralism in Eurasia, edited by D. Harris, 465–98. London: UCL Press, 1996a.
———. "Early Agriculture and the Dispersal of the Southern Mongoloids." Prehistoric Mongoloid Dispersals, edited by T. Akazawa and E. Szathmary, 287–302. Oxford: Oxford University Press, 1996b.
———. Prehistory of the Indo-Malaysian Archipelago. 2nd edition. Honolulu: University Press of Hawaii, 1997a.
———. "Ancient Seafarers." Archaeology (March–April 1997b): 20–22.
Bellwood, P., and P. Koon. "Lapita Colonists Leave Boats Unburned!" Antiquity 63 (1989): 613–22.
Blust, R. A. "The Austronesian Homeland: a Linguistic Perspective." Asian Perspectives 26 (1984–85): 45–67.
———. "The Position of the Formosan Languages." Austronesian Studies Relating to Taiwan, edited by P. J-k Li, C-h Tsang, Y-k Huang, D-a Ho, and C-y Tseng, 585–650. Taipei: Institute of History and Philology, Academia Sinica, 1995.
———. "Austronesian Culture History: The Windows of Language." Prehistoric Settlement of the Pacific, edited by W. H. Goodenough, 28–35. Philadelphia: American Philosophical Society, 1996.
Chang, K. C. "Taiwan Strait Archaeology and Proto-Austronesian." Austronesian Studies Relating to Taiwan, edited by P. J-k Li, C-h Tsang, Y-k Huang, D-a Ho, and C-y Tseng, 161–84. Taipei: Institute of History and Philology, Academia Sinica, 1995.
Chang, K. C., and W. H. Goodenough. "Archaeology of Southeast China and its Bearing on the Austronesian Homeland." Prehistoric Settlement of the Pacific, edited by W. H. Goodenough, 36–56. Philadelphia: American Philosophical Society, 1996.
Dewar, R. E., and H. T. Wright. "The Culture History of Madagascar." Journal of World Prehistory 7 (1993): 417–66.

Dutton, T. "Language Contact and Change in Melanesia." The Austronesians: Historical and Comparative Perspectives, edited by P. Bellwood, J. J. Fox, and D. Tryon, 192–213. Canberra: Department of Anthropology, Research School of Pacific and Asian Studies, Australian National University, 1995.
Dyen, I. "Borrowing and Inheritance in Austronesianistics." Austronesian Studies Relating to Taiwan, edited by P. J-k Li, C-h Tsang, Y-k Huang, D-a Ho, and C-y Tseng, 455–520. Taipei: Institute of History and Philology, Academia Sinica, 1995.
Green, R. C. "Near and Remote Oceania." Man and a Half, edited by A. Pawley, 491–502. Auckland: Polynesian Society, 1991.
Hagelberg, E., and J. Clegg. "Genetic Polymorphisms in Pacific Islanders Determined by Analysis of Ancient Bone DNA." Proceedings of the Royal Society of London series B, 252 (1993): 163–70.
Hill, A. V. S., and S. Serjeantson. The Colonization of the Pacific: a Genetic Trail. Oxford: Clarendon Press, 1989.
Houghton, P. "The Early Human Biology of the Pacific: Some Considerations." Journal of the Polynesian Society 100 (1991): 167–96.
Ipoi Datan and P. Bellwood. "Recent Research at Gua Sireh and Lubang Angin." Bulletin of the Indo-Pacific Prehistory Association 10 (1991): 386–405.
Irwin, G. J. The Prehistoric Exploration and Colonization of the Pacific. Cambridge: Cambridge University Press, 1992.
Kirch, P. V. "The Talepakemalai Lapita Site and Oceanic Prehistory." National Geographic Research 4 (1988): 328–42.
———. The Lapita Peoples. Oxford: Blackwell, 1997.
Pawley, A., and R. C. Green. "The Proto-Oceanic Language Community." Journal of Pacific History 19 (1984): 123–46.
Pawley, A., and M. Ross. "Austronesian Historical Linguistics and Culture History." Annual Review of Anthropology 22 (1993): 425–59.
Renfrew, C. "Archaeology, Genetics and Linguistic Diversity." Man 27 (1992): 445–78.
Spriggs, M. "The Lapita Culture and Austronesian Prehistory in Oceania." The Austronesians: Historical and Comparative Perspectives, edited by P. Bellwood, J. J. Fox, and D. Tryon, 112–33. Canberra: Department of Anthropology, Research School of Pacific and Asian Studies, Australian National University, 1995.
———. The Island Melanesians. Oxford: Blackwell, 1997.
Tryon, D. "Proto-Austronesian and the Major Austronesian Subgroups." The Austronesians: Historical and Comparative Perspectives, edited by P. Bellwood, J. J. Fox, and D. Tryon, 1–16. Canberra: Department of Anthropology, Research School of Pacific and Asian Studies, Australian National University, 1995.
Tsang, C-h. "New Archaeological Data from Both Sides of the Taiwan Straits." Austronesian Studies Relating to Taiwan, edited by P. J-k Li, C-h Tsang, Y-k Huang, D-a Ho, and C-y Tseng, 185–226. Taipei: Institute of History and Philology, Academia Sinica, 1995.
Zorc, D. "Austronesian Culture History Through Reconstructed Vocabulary." Austronesian Terminologies. Continuity and Change, edited by A. Pawley and M. Ross. Canberra: Research School of Pacific Studies, Pacific Linguistics Series C, 127 (1994).

## Bronze and Iron Age Indonesia

### Notes

1 Rawson 1996, pp. 133–35.

### Bibliography

Barbier, J. P., and D. Newton, eds. Islands and Ancestors: Indigenous Styles of Southeast Asia. New York: The Metropolitan Museum of Art; Munich: Prestel, 1988.
Bellwood, P. Man's Conquest of the Pacific. The Prehistory of Southeast Asia and Oceania. New York: Oxford University Press, 1979.
———. Prehistory of the Indo-Malayan Archipelago. Sydney: Academic Press, 1985.
Bernet Kempers, A. L. The Kettledrums of Southeast Asia. A Bronze Age World and its Aftermath. Modern Quaternary Research in Southeast Asia 10. Rotterdam, 1988.
Glover, I., and B. Syme. "The Bronze Age in Southeast Asia: Its Recognition, Dating and Recent Research." Man and Environment 18, 10 (1993): 41–74.
Higham, C. The Bronze Age of Southeast Asia. Cambridge: Cambridge University Press, 1996.
Rawson, J. The Chinese Bronzes of Yunnan. The Bowater Library of Chinese Civilization. London: Sedgewick and Jackson Limited; Beijing: Cultural Relics Publishing house, 1983.
———, ed. Mysteries of Ancient China. New Discoveries from the Early Dynasties. London: British Museum Press, 1996.

## The Island of Nias

### Notes

1 Nias was already known in the ninth century to Arab merchants, who mention its large cities and the custom of cutting off heads, as well as its coconut exports, slave trading, and the making of gold jewelry (Ferrand 1913–14).
2 It is said on Nias that the most precious examples were made not from coconut but from coco de mer from the Seychelles that chance or the Indian ocean current sometimes carried as far as the west coast of the island.
3 As recently as the 1970s and 1980s, almost all the adult men in the largest villages in the south of the island still possessed an old shield, sword, and suit of iron armor. The majority of these weapons have since been cheaply sold off and have been replaced by modern copies.
4 It is the head of a mythical animal that combines the antlers of a local deer, the "horn" of a hornbill, and the curved tusks of a wild boar. It is supposed to provide adequate protection by instilling terror in the enemy. The lasara is in the exclusive use of the chief; the great house of the headman (omo sebua) where it is met with is hence termed a "house with lasara" (omo nifolasara).
5 Depending on the region concerned, this ball is called either leka balatu or riba balatu (in the south of the island). The amulets (with teeth or talons of an animal or with other sorcery charms) are daludalu. The iron blade is called fasoli balutu.
6 This gift necessitated a counter gift in return, provided on the occasion of some later feast (Ziegler 1986).
7 In some headmen's houses, this treasure could weigh several kilograms and could serve to pay a ransom or a "fine" imposed in reparation of a serious offense committed against a neighboring village.
8 Schröder (1917) reproduces an exceptional example photographed in the center of the island.
9 All over the island, individuals from the nobility distinguish themselves from commoners by asserting the great age of their lineage, tracing it back to the eponymous founding ancestors of their clan descended from heaven (tetehöli ana'a). See Stöhr 1968.
10 Equivalent to a six-story building.
11 Reports differ on this subject: according to some, only nobles had the right to possess gold, commoners having to make do with copper or brass; others assert that all those who were wealthy enough to purchase personal adornments in gold were permitted to do so, the nobles being simply more likely to have amassed the means necessary.
12 In some regions, this element is said to represent the mythical bird Garuda, the same animal that has lent its name to the national airline. Such anecdotal evidence shows how the inhabitants of Nias like to reinterpret features in their own culture by means of models issuing from a quite different field (contemporary Indonesia, in this example).
13 In the south, the assembly area (gorahua newali) also incorporates the meeting house (bale), the unique preserve of freeborn male adults—and thus, until recent times, of warriors who had cut off at least one head.
14 It should be emphasized that carved stone anthropomorphic statues do not occur in the south—they are only to be found in the center and to the north.
15 In the center and north, wooden osa osa exist in which the recipient could be carried around the village nine times by members of the community.
16 See the plate reproduced in Sundermann 1905.
17 The rules governing the use of fetishes are based on a corpus of myths. For example, "Song of the Father of the Hia Clan," published in Thomsen (1979), a lengthy poem relating the myth of a clan's origin, details all the varieties of wood in which adu have to be made.
18 Salawa means "chief" in northern Nias. Modigliani states that adu siraha salawa were affixed to the overhanging eaves of some houses.
19 This finding has urged some to theorize on a hermaphroditism combining such dualities. It is more probable that the presence of breasts in conjunction with male attributes signifies that the chief or the power invoked is "a mother of the people," a hypothesis confirmed by the regular appearance of breasts on the stone osa osa of the central Nias, as well as on numerous statues and figurines.
20 On Bali and Java, on the contrary, countless so-called antique dealers offer up grotesque caricatures of this type of work, all identical and mass-produced.

### Bibliography

Feldman, J. The Architecture from Nias, Indonesia, with Special Reference to Bawömataluo Village. Ph.D. diss. Columbia University, 1977.
Ferrand, G. Relations de voyages et textes géographiques arabes, persans et turks, relatifs à l'Extrême-Orient du VIIIe au XVIIIe siècles. 2 vols. Paris: E. Leroux, 1913–14.
———. The Eloquent Dead. Ancestral Sculpture of Indonesia and Southeast Asia. Los Angeles: UCLA, Museum of Cultural History, 1985.
Modigliani, E. Un viaggio a Nias. Trier and Milan: n.p., 1890.
Schröder, E. E. W. G. Nias, ethnographische, geographische en historische aanteekeningen en studiën. 2 vols. Leiden: E. J. Brill, 1917.
Stöhr, W., and P. Zoetmulder. Les Religions d'Indonésie. Paris: Payot, 1968.
Sundermann, H. Die Insel Nias und die Mission daselbst. Barmen: Verlag des Missions Hauses, 1905.
Thomsen, M. G. T. "Die Sage vom Stammvater Hija, ein Gesang aus Mittelnias." Zeitschrift für Ethnologie Band 104, Heft 2 (1979): 209–77.
Ziegler, A. "Pratiques festives et mégalithiques dans le centre de Nias." Bulletin du musée d'Ethnographie de Genève 28 (1986): 53–75.

## The Mentawei Islands

### Notes

1 The absence of the bow and arrow in western Indonesia should not be thought of as definitively established. I agree, with some misgivings, with the opinion of Edwin E. Loeb (1935, p. 170) who states that Batak warriors used to arm themselves with the bow, before adopting the musket at an early date. Some elderly men refer to the bow as one of the weapons used by their distant ancestors, though the word they use to designate it is Malay.
2 Schefold 1980.
3 Schefold 1980, figs. 209 and 207 respectively.

### Bibliography

Lelièvre, O. Mentawei, la forêt des esprits. Paris: n.p., 1992.
Loeb, E. M. Sumatra, Its History and People. N.p., 1935.
Schefold, R. Spielzeug für die Seelen: Kunst und Kultur der Mentawei-Inseln (Indonesien). Zurich: Museum Rietberg; Delft: Museum Nusantara, 1980.
———. Mentawei Shaman, Keeper of the Rain Forest: Man, Nature and Spirits in Remote Indonesia. New York: Aperture, 1992.

## The Batak of Northern Sumatra

### Notes

1 Some information on the Kalasan can be found in Barbier 1998.
2 See Barbier and Newton 1988.

### Bibliography

Barbier, J. P. En pays toba: les lambeaux de la tradition. Geneva: n.p., 1982.
———. "A Stone Rider of the Batak of Sumatra." Islands and Ancestors: Indigenous Styles of Southeast Asia, edited by J. P. Barbier and D. Newton. New York: The Metropolitan Museum of Art; Munich: Prestel, 1988.
———. "Of stone and pride: a Commemorative Statue of the Toba-Batak"; "De pierre et d'orgueil: une statue commémorative Toba Batak." Art tribal: 3–35. (1993)
———. Monuments de pierre batak: à l'ombre des ancêtres pétrifiés. Milan and Singapore: n.p., 1998.
Bartlett, H. H. "The Labors of the Datoe." Papers Michigan Academy of Science, Arts and Letters (Ann Arbor) 12 (1930): 1–74 (part 1), 13 (1931): 1–34 (part 2).
———. "The Sacred Edifices of the Batak of Sumatra." Occasional Contributions from the Museum of Anthropology of the University of Michigan. Ann Arbor, 1934.
Sibeth, A. The Batak, Peoples of the Island of Sumatra. London: Thames and Hudson, 1991.
Tichelman, G. L., and P. Voorhoeve. Steenplastiek in Simaloengun. Medan: n.p., 1938.
Vergouwen, J. C. The Social Organisation and Customary Law of the Toba-Batak of Northern Sumatra. The Hague: N. Nijhoff, 1964.
Warneck, J. G. Die Religion der Batak: ein Paradigma für die animistischen Religionen des indischen Archipels. Leipzig: Dieterich, 1909.
Winkler, J. Die Toba-Batak auf Sumatra in gesunden und kranken Tagen. Stuttgart: n.p., 1925.

## Lampung

### Notes

1 Interpretation of the data gathered by Du Bois (1952, p. 330 et seq.) seems to imply that this is another instance of the widely held belief in a celestial divinity in conflict with a snake (divinity of the underworld). It is probably too late to establish whether any points of similarity might exist with the creation myths of various Sumatran populations, where the dualistic theme based on the complementarity between the higher realm and the lower (linked by the World Tree) has been ascertained. It should be recalled that among the Nias high-ranking chiefs were compared to the Tree. In Lampung as well, the Tree appears to

adopt a human form and it is tempting to see this as a reference to an ancient ancestor. However, all this is of the realm of pure hypothesis.

2 The word *adat* is generally translated by "custom," but it really designates the "divine law" on which both social and political organization depend (for instance the obligation imposed on a man to take a wife from outside his native clan). Transgression of the *adat* is an extremely serious matter. In the aforementioned example, marrying a woman of one's own clan is treated on a par with incest. In former times, such crimes were punishable by death. Observing the rules imposed by *adat* is so deep-rooted in the social structure that it persists in groups long ago converted to Christianity or Islam.

3 Our main source of information is the two-volume work by F. W. Funke (1961), containing field research undertaken in 1953. A classification of the stylistic differences between the coastal (*pasisir* style) and inland (*darat* style) cloths has been proposed by Spertus and Holmgren (1980).

4 "Les tissues à jonques du Sud de Sumatra" in *Revue des arts asiatiques*, Sept. 1937 (Musée Guimet) and "Das kultische Schiff in Indonesien" in, *Ipek, Jahrbuch für Prähistorische und Ethnographische Kunst* (13–14, 1939–40).

5 The technique known as ikat consists in tying a little bundle of ten or so lengths of yarn together and dipping them in dyestuff. When the cord attaching the strands is untied, the covered part appears undyed in resist while the remaining yarns are colored. These ties of thread are then used for weaving the desired design. All ikat fabrics are woven with "stepwise" designs. Both weft and warp yarn can be employed in ikat.

**Bibliography**

Dijk, T. van, and N. de Jonge. *Scheepjesdoeken der Lampung.* Amsterdam: n.p., 1977.
———. *Ship Cloths of the Lampung (South Sumatra): a Research of their Design, Meaning and Use in their Cultural Context.* Amsterdam: Mabuhay Gallery, 1980.
Du Bois, C. *De Lampongsche districten op het eiland Sumatra. Tijdschrift voor Nederlandsch-Indië.* N.p., 1852.
Funke, F. W. *Orang Abung, Volkstum Süd-Sumatras im Wandel.* 2 vols. Leiden: E. J. Brill, 1958–61.
Gittinger, M. *A Study of the Ship Cloths of South Sumatra: Their Design and Usage.* Ph.D. diss. Columbia University, New York, 1972.
———. *Splendid Symbols: Textiles and Traditions in Indonesia.* Washington: Textile Museum, 1979. Reprint, Oxford: Oxford University Press, 1991.
———. "A Reassessment of the Tampan of South Sumatra." *To Speak with Cloth: Studies in Indonesian Textiles,* edited by M. Gissinger. Los Angeles: Museum of Cultural History, 1989.
LeBar, F. M. *Ethnic Groups of Insular Southeast Asia.* Vol. 1. New Haven: Human Relations Area Files Press, 1972.
Spertus, A. E., and R. J Holmgren. "*Tampan pasisir.* Pictorial Documents of an Ancient Indonesian Coastal Culture." *Indonesian Textiles,* edited by M. Gittinger. Washington, D.C.: Textile Museum, 1980.
———. *Early Indonesian Textiles from Three Island Cultures: Sumba, Toraja, Lampung.* New York: The Metropolitan Museum of Art, 1989.
Steinmann, A. "Les 'tissus à jonques' du Sud de Sumatra." *Revue des arts asiatiques* (Paris) 11 (1937).
———. *Das Seelenschiff in der Textilkunst Indonesiens.* Leiden: n.p., 1965.

## The Iban of Sarawak

**Notes**

1 Freeman 1970, pp. 124–42.
2 Sather 1996, p. 84.
3 Pringle 1970, p. 245.
4 For details, see Gavin 1991, p. 28.
5 See, for example, Ong 1986; Jabu 1991; Kedit 1994.
6 For examples, see Gavin 1996, figs. 43–50.
7 For examples, see Gavin 1996, figs. 43, 38.
8 Haddon 1936.
9 For illustrations, see Haddon 1936, p. 13, and Morrison 1962, p. 92.
10 Richards 1981, p. 403.
11 For an illustration of a trap, see Ling Roth 1896, vol. 1, p. 437.
12 For examples, see *Expedition* 1988, front and back cover; Gavin 1996, fig. 20.

**Bibliography**

Barnes, R. *The Ikat Textiles of Lamalera: A Study on an Eastern Indonesian Weaving tradition.* Leiden: E. J. Brill, 1989.
*Expedition* (The University Museum Magazine of Archaeology/Anthropology, University of Pennsylvania), vol. 30, no. 1 (1988).
Freeman, D. *Report on the Iban.* London: Athlone Press, 1970.
Gavin, T. "Kayau indu—the Warpath of Women (a Ngar Ritual at Entawau in October 1988)." *Sarawak Museum Journal* 63 (1991): 1–41.
———. *The Women's Warpath: Iban Ritual Fabrics from Borneo.* Los Angeles: UCLA Fowler Museum of Cultural History, 1996.
Haddon, A. C., and L. Start. *Iban or Sea Dayak Fabrics and their Patterns.* Cambridge: Cambridge University Press, 1936. New edition, Carlton: Ruth Bean Publishers, 1982.
Jabu, E. "Pua Kumbu—The Pride of the Iban Cultural Heritage." *Sarawak Cultural Legacy: a Living Tradition,* edited by L. Chin and V. Mashman. Kuching: Society Atelier Sarawak, 1991.
Kedit, V. A. "The Pua Kumbu: Sacred Blanket of the Iban of Sarawak." *The Crafts of Malaysia,* edited by S. Bhanu. Singapore: Editions Didier Millet, 1994.
Ling Roth, H. *The Natives of Sarawak and British North Borneo.* 2 vols. London: Truslove & Hanson, 1896.
Morrison, H. *Life in a Longhouse.* Kuching: Borneo Literature Bureau, 1962.
Ong, E. *Pua: Iban Weavings of Sarawak.* Sarawak: Society Atelier Sarawak, 1986.
Pringle, R. *Rajahs and Rebels: The Ibans of Sarawak under Brooke Rule, 1841–1941.* London: Macmillan, 1970.
Richards, A. *An Iban-English Dictionary.* Oxford: Oxford University Press, 1981.
Sather, C. "'All Threads are White': Iban Egalitarianism Reconsidered." *Origins, Ancestry and Alliance,* edited by J. J. Fox and C. Sather, 70–110. Canberra: Australian National University, 1996.

## Kalimantan

**Notes**

1 Among the classic works on the Dayak, the most recent as well as the best is that by Bernard Sellato, *Hornbill and Dragon,* first published in 1989. In an all too brief introduction, the author sketches an outline of the major groups in Sarawak, Kalimantan, and Sabah. It is nonetheless obvious that the ceaseless population movement in the territories since World War II has rendered problematic any stylistic classification.
2 "Some Tribal Art Styles of Southeast Asia," in Fraser 1966, p. 165.
3 Bellwood 1978, p. 45.
4 The Iban are the subject of the chapter "The Iban of Sarawak" by Traude Gavin.
5 The reader should be advised that, through lack of space, some authors may be drawn to inescapable generalizations. When, for example, it is asserted that the Dayak made *mandau* swords, it should be understood that in fact certain Dayak—those belonging to the Kenyah-Kayan complex to the east of the island—specialized in the manufacture of these artifacts. The same goes for the wooden shields decorated with curvilinear motifs (figs. 9, 10): they are employed by groups in the eastern and central-eastern areas of Kalimantan, but not among the Iban or the Ngadju in the south.
6 "Les religions tribales du Bornéo," in Stöhr and Zoetmulder 1968, p. 28 et seq.
7 The name alone is indicative of the Islamic influence that was already becoming widespread by the fifteenth century. Mahatala would certainly appear to be derived from an imprecation to Allah.
8 See the chapter "The Iban of Sarawak."

**Bibliography**

Barbier, J. P. *Indonesian Primitive Art.* Dallas: Dallas Museum of Art, 1984.
Bellwood, P. *Man's Conquest of the Pacific.* Auckland and London: Collins, 1978.
Elshout, J. M. *De Kenja-Dajaks uit het Apokajangebied.* The Hague: Koninklijk Instituut voor de Taal-, Land- en Volkenkunde van Niederlandsch-Indiën, 1926.
Fraser, D. *The Many Faces of Primitive Art.* Englewood Cliffs, N.J.: Prentice-Hall, 1966.
Gittinger, M. *Splendid Symbols.* Washington, D.C.: Textile Museum, 1979.
Hans-Schärer, H. *Ngaju Religion ...* The Hague: n.p., 1963.
Harrisson, T. *Borneo Jungle: an Account of the Oxford University Expedition of 1932.* 2nd edition. Oxford: Oxford University Press, 1990.
Hose, Ch., and W. McDougall. *The Pagan Tribes of Borneo: a Description of their Physical, Moral and Intellectual Condition, with some Discussion of their Ethnic Relations.* 2 vols. London: MacMillan, 1912.
LeBar, F. M. *Ethnic Groups of Insular Southeast Asia.* Vol. 1, *Indonesia, Andaman Islands and Madagascar.* New Haven: Human Relations Area Files Press, 1972.
Lumholtz, C. *Through Central Borneo.* 2 vols. London: Fisher Unwin, 1920.
Molengraaff, G. A. F. *Borneo Expedition: Geological Explorations in Central Borneo (1893–1894).* 2 vols. Leiden: E. J. Brill, 1902.
Nieuwenhuis, A. W. *In Centraal Borneo.* 2 vols. Leiden: E. J. Brill, 1900.
———. *Quer durch Borneo.* 2 vols. Leiden: E. J. Brill, 1904–7.
Revel-Macdonald, N. "The Dayak of Borneo: on the Ancestors, the Dead and the Living." *Islands and Ancestors: Indigenous Styles of Southeast Asia,* edited by J. P. Barbier and D. Newton. New York:

The Metropolitan Museum of Art; Munich: Prestel, 1988.
Rodgers, S. *Power and Gold. Jewelry from Indonesia, Malaysia, and the Philippines in the Barbier-Mueller Collection.* Geneva: Musée Barbier-Mueller 1985.
Roth, H. L. *The Natives of Sarawak and British North Borneo.* London: Truslove and Hanson, 1896.
Sellato, B. *Hornbill and Dragon: Arts and Culture of Borneo.* 2nd edition. Singapore: Sun Tree, 1992.
Stöhr, W., and P. Zoetmulder. *Les Religions d'Indonésie.* Paris: Payot, 1968.

## Lombok

**Notes**

1 Krulfeld in LeBar 1972.
2 Barbier and Newton 1988.

**Bibliography**

Barbier, J. P., and D. Newton. *Islands and Ancestors: Indigenous Styles of Southeast Asia.* New York: The Metropolitan Museum of Art; Munich: Prestel, 1988.
Cool, W. *De Lombok Expeditie ...* Batavia: 's Gravenhage, 1896.
Krulfeld, R. "Fatalism in Indonesia ..." *Anthropological Quarterly* (Washington) 39 (1966).
———. *Indonesia, Andaman Islands and Madagascar.* Vol. 1 of *Ethnic Groups of Insular Southeast Asia,* edited by F. M. LeBar, 65–69. New Haven: Human Relations Area Files Press, 1972.

## Sulawesi

**Notes**

1 For this variety of house shape, see Kis-Jovak et al 1988.
2 For the bewildering variety of ornaments, see Kadang 1960 and Pakan 1973.

**Bibliography**

Kadang, K. *Ukiran Rumah Toraja.* Jakarta: Balai Pustaka, 1960.
Koubi, J. *Rambu Solo', La Fumée Descend. Le culte des morts chez les Toraja du Sud.* Paris: Centre de Documentation et des Recherches sur l'Asie du Sud-Est et le Monde Insulindien (CNRS), 1982.
Kris-Jovak, J. I., H. Nooy-Palm, R. Schefold, and U. Schulz-Dornburg. *Banua Toraja, Changing Patterns in Architecture and Symbols among the Sa'dan Toraja, Sulawesi Indonesia.* Amsterdam: n.p., 1988.
Lévi-Strauss, C. *The Way of Masks.* Seattle: University of Washington Press, 1982.
Nooy-Palm, H. *The Sa'dan Toraja, A Study of their Social Life and Religion.* Vol. 1, *Organization, Symbols and Belief.* The Hague: Martinus Nijhoff, 1979.
———. "The Sa'dan Toraja and their Art." *Art of the Archaic Indonesians.* Geneva: Musée Rath, 1981.
———. *The Sa'dan Toraja, A Study of their Social Life and Religion.* Vol. 2, *Rituals of the East and West.* Dordrecht: Foris, 1986.
———. "The Mamasa and Sa'dan Toraja." *Islands and Ancestors: Indigenous Styles of Southeast Asia,* edited by J. P. Barbier and D. Newton, 86–105. New York: The Metropolitan Museum of Art; Munich: Prestel, 1988.
Pakan, L. *Rahasia Ukiran Toraja. The Secret of Typical Toraja Patterns.* Ujung Padang: n.p., 1973.
Volkman, T. A. *Feasts of Honour. Ritual and Social Change in the Toraja Highlands.* Urbana: University of Illinois Press, 1985.
Waterson, R. *The Living House. An Anthropology of Architecture in Southeast Asia.* Singapore: Oxford University Press, 1990.

## Flores

**Notes**

1 Rodgers 1985.
2 LeBar 1972.
3 Kennedy 1955.
4 See Stöhr 1965.
5 Van Suchtelen 1920.
6 Rouffaer 1937.
7 Rodgers 1985.
8 Rodgers 1985.
9 DuBois 1944.

**Bibliography**

Arndt, P. "Die Religion der Nad'a (West Flores, Kleine Sunda-Inseln)." *Anthropos* 26 (1931): 353–405, 697–739.
———. "Aus der Mythologie und Religion der Riunger." *Tijdschrift voor Taal-, Land-, en Volkenkunde* 75 (1935).
———. "Gesellschaftliche Verhältnisse der Ngada." *Studia Instituti Anthropos* 8. Modling, Vienna: Verlag der Missionsdruckerei St. Gabriel, 1954.
DuBois, C. *The People of Alor: a Social-Psychological Study of an East-Indian Island.* 1944. New edition, New York: Harper, 1961.
Erb, M. "Flores: Cosmology, Art and Ritual." *Islands and Ancestors: Indigenous Styles of Southeast Asia,* edited by J. P. Barbier and D. Newton. New York:

The Metropolitan Museum of Art; Munich: Prestel, 1988.
Kennedy, R. *Fieldnotes on Indonesia: Flores 1949–1950.* New Haven: Harold Conklin, 1955.
Lebar, F. *Ethnic Groups of Insular Southeast Asia: Indonesia, Andaman Islands and Madagascar.* New Haven: Human Relations Files Press, 1972.
Rodgers, S. *Power and Gold: Jewelry from Indonesia, Malaysia, and the Philippines in the Barbier-Mueller Collection.* Geneva: Musée Barbier-Mueller, 1985.
Rouffaer, G. P. *Ethnographie van de kleine Soenda eilanden in beeld.* The Hague: n.p., 1937.
Stöhr, W., and P. Zoetmulder. *Les Religions d'Indonésie.* Paris: Payot, 1968.
Suchtelen, J. B. C. M. M. van. "Een Offerfeest bij den Nageshtam op Flores." *Tijdschrift voor Indische Taal-, Land-, en Volkenkunde* 49, 3 (1920): 191–201.
Vroklage, B. A. G. "Beeldhouwwerk uit de Manggarai (West Flores)." *Cultureel Indie* (Leiden) 1 (1939).
Vatter, E. *Ata Kiwan.* N.p.,1932.

## Ataúro

**Bibliography**

Baudin, L. *A vida quotidiana no tempo dos Últimos Incas.* Lisbon: Ed Livros do Brasil, n.d.
Codrington, R. H. *The Melanesians. Studies in their Anthropology and Folklore.* Oxford: Clarendon Press, 1891. Reprint, New York: n.p., 1972.
Correia, A. P. *Gentio de Timor.* Lisbon: n.p., 1934.
Cuisinier, J. *Sumangat.* 8th edition. Paris: Gallimard, 1951.
Duarte, J. B. *Timor: Ritos e Mitos Ataúros.* Lisbon: Instituto de Cultura e Lingua Portuguesa, 1984.
Fürer Haimendorf, C. von. *Moral and Merit.* London: Weidenfeld and Nicholson, 1967.
Magalhaes, L. de. "A Ilha de Ataúro." *Boletin de la Sociedad de Geografia de Lisboa* 1–3, 36 (1918).
Makarius, R. and L. *L'Origine de L'Exogamie et du Totémisme.* Paris: Gallimard, 1961.
Mead, M. *New Lives for Old.* London: V. Gollancz, 1956.
Raglan, L. *The Temple and Houses.* London: Routledge and Kegan Paul, 1964.
Thomas, L. F. R. "Timor: Notas historico-linguisticas." *Historia.* (Lisbon) 2 (1974).

## Timor

**Notes**

1 Hicks 1988, p. 5.
2 See the essay on Ataúro, pp. 124–29.
3 Hicks 1988, p. 6.
4 Cinatti 1987.
5 Schulte Nordholt 1971, p. 44, pl. 13.
6 Schulte Nordholt 1971, p. 46.
7 See Hicks 1988 for a more detailed description of the relationship between art and religion in Timor.
8 *Povos de Timor* 1993.

**Bibliography**

Appel, M. "An Antoni Sliding Door and Waterscoop Handle from Timor." *Tribal Art* (1988): 67–79.
Barbier, J. P., and D. Newton, eds. *Islands and Ancestors: Indigenous Styles of Southeast Asia.* New York: The Metropolitan Museum of Art; Munich: Prestel, 1988.
Cinatti, R. *Motivos Artisticos Timorenses e a Sua Interaçao.* Lisbon: Instituto de Investigaçao Cientifica Tropical, Museu de Etnologia, 1987.
Hicks, D. *Tetum Ghosts and Kin.* Waveland Heights, Illinois: Prospect Heights, 1988.
*Povos de Timor, Povo de Timor: vida, aliança, morte.* Conference December 12–16, 1989. Fundaçao Oriente, Instituto de Investigaçao Cientifica Tropical, Museu de Etnologia, Lisbon, 1993.
Schulte Nordholt, H. G. "The Political System of the Atoni of Timor." *Verhandelingen van het Koninklijk Instituut voor Taal- Land-, en Volkenkunde.* The Hague: M. Nijhoff, 1971.
Vroklage, B. A. G. *Ethnographie der Belu in Zentral-Timor.* Leiden: E. J. Brill, 1953.

## The Southern Moluccas

**Notes**

1 The present-day province of Maluku (the Moluccas) is divided into three districts (*kabupaten*): north, center, and south. It is with this last, called Maluku Tenggara, that we are concerned here. The chain of islets comprising it runs from those bordering Timor in the west (Wetar, Leti, etc.) to those close to Irian Jaya (Indonesian New Guinea) in the east (Aru, Kai, etc.).
2 McKinnon 1983, 1987, and 1988.
3 Drabbe 1940.
4 Stöhr and Zoetmulder 1968.
5 Riedel 1886.
6 Barbier and Newton 1988, fig. 175.
7 See the bibliography for the chapter on Irian Jaya.

**Bibliography**

Barbier, J. P., and D. Newton. *Islands and Ancestors: Indigenous Styles of Southeast Asia.* New York: The Metropolitan Museum of Art; Munich: Prestel, 1988.

De Jonge, N., and T. van Dijk. *Forgotten Islands of Indonesia: The Art and Culture of the Southeast Moluccas*. Singapore: Periplus Editions, 1995.

Drabbe, P. "Het Leven van den Tanembarees: ethnographische Studie over het Tanembareesche Volk." *Internationales Archiv für Ethnographie* 38, Leiden: E. J. Brill, 1940.

Jensen, A. E. "Hainuwele: Volkserzählungen von der Molukken und Inseln Ceram." *Ergebnisse der Frobenius-Expedition 1937–1938 in die Molukken und nach Holländische-Neu-Guinea*, Vol. 1. Frankfurt: Klostermann, 1939.

McKinnon, S. *Hierarchy, Alliance and Exchange in the Tanimbar Islands*. University of Chicago Press, 1983.

———. "The House Altars of Tanimbar: Abstraction and Ancestral Presence/Les Autels domestiques à Tanimbar, abstraction et présence des ancêtres." *Art tribal* (Geneva) 1 (1987): 152–69.

———. "Tanimbar Boats." *Islands and Ancestors: Indigenous Styles of Southeast Asia*, edited by J. P. Barbier and D. Newton. New York: The Metropolitan Museum of Art; Munich: Prestel, 1988.

Martin, K. *Reisen in den Molukken, Ambon, den Uliassern, Seram (Ceram) und Buru*. Leiden: n.p., 1894.

Merton, H. *Forschungreise in den Südöstlichen Molukken (Aru- und Kei-Inseln)*. Frankfurt: Senckengergische Naturforschende Gesellschaft, 1910.

Riedel, J. G. F. *De Sluik-en-Kroesharige Rassen tusschen Celebes en Papua*. The Hague: Nijhoff, 1886.

Stöhr, W., and P. Zoetmulder. *Les Religions d'Indonésie*. Paris: Payot, 1968.

## The Philippines

### Bibliography

Barton, R. F. *The Half-way Sun: Life among the Headhunters of the Philippines*. New York: Brewer and Warren, 1930.

———. "The Religion of the Ifugaos." *American Anthropological Association* (Menasha, Wisconsin) Memoir series 65 (1946).

Casino, E. S. *Ethnographic Art of the Philippines, an Anthropological Approach*. Quezon City: Brookman Print House, 1973.

Conklin, H. C. *Ethnographic Atlas of Ifugao: a Study of Environment; Culture and Society in Northern Luzon*. New Haven: Yale University Press, 1980.

Jurman, S., ed. *People and Art of the Philippines*. Los Angeles: Museum of Cultural History, University of California, 1981.

Keesing, F. M. *The Ethnohistory of Northern Luzon*. Stanford University Press, 1962.

Rochon, G. *Sulu, Coordinated Investigation of Sulu Culture*. Notre Dame of Jolo College, 1973.

## Taiwan

### Notes

1 Peng 1972, p. 3.
2 Chen Chi-Lu 1968, pp. 302–4.

### Bibliography

Chen Chi-Lu. *Material Culture of the Formosan Aborigines*. Taipei: The Taiwan Museum, 1968.

MacGovern, B. L. *Among the Head-Hunters of Formosa*. London: n.p., 1992.

Peng, Y. *Customs and Traditions in Plain and Highlands of Taiwan*. Taiwan: n.p., 1972.

## Early Papuans and Melanesians

### Notes

1 Thiel 1987, p. 239.
2 Swadling and Hope 1992, pp. 17–19.
3 Fullagar et al. 1996.
4 Foley 1986, pp. 269–75.
5 Groube et al. 1987; Swadling 1996, pp. 2–3.
6 Pavlides and Gosden 1994.
7 Allen et al. 1988; Allen et al. 1989.
8 Wickler and Spriggs 1988.
9 Swadling and Hope 1992, pp. 13–42.
10 Haberle 1993.
11 Swadling and Hope 1992, p. 22.
12 Watson and Cole 1977, pp. 46–51.
13 White 1972, p. 98; Watson and Cole 1977, pp. 199–200.
14 White 1972, p. 96.
15 White 1972, pp. 96–97, 108–9.
16 Ballard 1992.
17 Groves 1981; Groves 1983, p. 119.
18 Swadling 1996, p. 52, citing Glover 1986 on phalangers, and Daniels and Daniels 1993 on sugarcane.
19 For a survey of these objects, see Newton 1979.
20 S. Bulmer 1977, pp. 61–73; V. Watson and Cole 1977: pp. 28, 130, 193. There is unfortunately no definite date for the best fragment of a bowl found archaeologically at Nombe. However, White suggests that "all the [Nombe] deposit is earlier than Horizons I-II at Kafiavana" i.e., pre-4690 +/-170 BP (White 1972, pp. 134, 140, figs. 24, 28).
21 Ambrose 1991; Reay 1991.
22 Swadling et al. 1988, p. 18, fig. 41.
23 Swadling et al. 1988, pp. 16–17, figs. 35–39.
24 Swadling and Hope 1992.
25 Gorecki et al. 1991; Gorecki 1992.
26 Hughes 1971, p. 115–32.
27 Bellwood 1985, pp. 204–5; Swadling 1996, pp. 51–52.
28 Spriggs in Spriggs ed. 1990, pp. 83–122.
29 Craig 1995; Newton 1986.
30 Green 1979.

### Bibliography

Allen, J., C. Gosden, R. Jones, and J. P. White. "Pleistocene Dates for the Human Occupation of New Ireland, Northern Melanesia." *Nature* (London) 331 (1988): 707–9.

Allen, J., C. Gosden, and J. P. White. "Human Pleistocene Adaptations in the Tropical Island Pacific: Recent Evidence from New Ireland, a Greater Australian Outlier." *Antiquity* (Cambridge) 63 (1989): 548–61.

Armstrong, W. E. *Rossell Islands: an Ethnological Study*. Cambridge: Cambridge University Press, 1928.

Austen, L. "Megalithic Structures in Trobriand Islands." *Oceania* 10, 1 (September 1939): 30–53.

Ballard, C. "First Report of Digital Fluting from Melanesia. The Cave Art Site of Kalate Egeanda, Southern Highlands Province, Papua New Guinea." *Rock Art Research* 9 (1992): 119–21.

Bartlett, H. K. "The Heavy Wooden Shield of Missima, Papua." *Records of the South Australian Museum* (Adelaide) 8 (1947): 607–11.

Battaglia, D. *On the Bones of the Serpent: Person, Memory and Mortality in Sabari Island Society*. Chicago: University of Chicago Press, 1990.

Bulmer, S. "Between the Mountain and the Plain: Prehistoric Settlement and Environment in Kaironk Valley." *The Melanesian Environment*, edited by J. H. Winslow. Canberra: Australian National University Press, 1977.

Craig, B. "Arrow Designs in Northern and Central New Guinea and the Lapita Connection." *Pacific Material Culture, Essays in Honour of Dr Simon Kooijman on the Occasion of his 80th Birthday*, edited by D. Smidt, P. ter Keurs, and A. Touwhorst. Leiden: Rijksmuseum voor Volkenkunde, 1995.

Foley, W. A. *The Papuan Languages of New Guinea*. Cambridge: Cambridge University Press, 1986.

Fullagar, R. L. K., D. M. Price, and L. M. Head. "Early Human Occupation of Northern Australia: Thermoluminescence Dating of Jinmium Rockshelter, Northern Territory." *Antiquity* 70 (1996): 751–73.

Gorecki, P. "A Lapita Smoke Screen?" *Poterie Lapita et peuplement*, edited by J.-C. Galipaud. Actes du colloque Lapita, Nouméa, January 1992. ORSTOM, Nouméa, 1992: 27–47.

Gorecki, P., M. Mabin, and J. Campbell. "Archaeology and Geomorphology of the Vanimo Coast, Papua New Guinea: Preliminary Results." *Archaeology in Oceania* 26 (1991): 19–122.

Green, R. C. "Early Lapita Art from Polynesia and Island Melanesia: Continuities in Ceramic, Barkcloth and Tattoo Tradition." *Exploring the Visual Art of Oceania. Australia, Melanesia, Micronesia and Polynesia*, edited by S. M. Mead. Honolulu: University Press of Hawaii, 1979: 13–31.

Groube, L., J. Chappell, J. Muke, and D. Price. "A 40,000 Year-old Occupation Site at Huon Peninsula, Papua New Guinea." *Nature* 324 (1987): 453–55.

Groves, C. P. *Ancestors for the Pigs: Taxonomy and Phylogeny of the Genus Sus*. Canberra: Australian National University, Department of Prehistory, 1981.

Haberle, S., and B. Fankhauser. "Pleistocene Vegetation Change and Early Human Occupation of a Tropical Mountainous Environment." *Sahul in Review: Pleistocene Archaeology in Australia, New Guinea and Island Melanesia*, edited by M. A. Smith, M. Spriggs, and B. Fankhauser. Canberra: Australian National University, 1993: 109–22.

Hughes, I. "New Guinea Stone Age Trade." *Terra Australis* (Australian National University, Canberra) 3 (1977).

Newton, D. "Reflections in Bronze: Lapita and Dong-Son Art in the Western Pacific." *Islands and Ancestors: Indigenous Styles of Southeast Asia*, edited by J. P. Barbier and D. Newton. New York: The Metropolitan Museum of Art; Munich: Prestel, 1988.

Pavlides, C., and C. Gosden. "35,000-year-old Sites in the Rainforests of West New Britain, Papua New Guinea." *Antiquity* (Cambridge) 68 (1994): 604–10.

Spriggs, M. "The Changing Face of Lapita: Transformation of a Design." *Lapita Design, Form and Composition*, edited by M. Spriggs. Canberra: Australian National University, 1990.

Swadling, P., B. Hauser-Schäublin, P. Gorecki, and F. Tiesler. *The Sepik-Ramu: An Introduction*. Boroko: The National Museum, 1988.

Swadling, P., and G. Hope. "Environmental Change in New Guinea since Human Settlement." *The Naive Lands. Prehistory and Environmental Change in Australia and the South-west Pacific*, edited by John Dodson, 13–42. Melbourne: Longmans Cheshire, 1992.

Watson, V., and J. D. Cole. *Prehistory of the Eastern Highlands of New Guinea*. Seattle: University of Washington Press, 1977.

White, Peter J. "Ol tumbuna. Archaeological Excavations in the Eastern Central Highlands, Papua New Guinea." *Terra Australis* (Australian National University, Canberra) 2 (1972).

Wickler, S., and M. Spriggs "Pleistocene Human Occupation of the Solomon Islands, Melanesia." *Antiquity* 62 (1988): 703–6.

## Irian Jaya

### Notes

1 "Art" is a Western concept. The words "art" and "artists," used for convenience in this article, do not occur in New Guinea languages.
2 Thomas 1995.
3 Frankel 1978, p. 46.
4 Frankel 1978, p. 57.
5 Gerbrands 1979, p. 123.
6 Zegwaard 1959, pp. 1040–41.
7 Konrad and Konrad 1996.
8 Hoogerbrugge 1995.

### Bibliography

Baal, J. van. *Dema. Description and Analysis of Marind-Anim Culture (South New Guinea)*. Translation series no. 9. The Hague: Koninklijk Instituut voor Taal-, Land- en Volkenkunde, 1966.

Baaren, Th. P. van. "Korwars and Korwar Style. Art and Ancestor Worship in North-West New Guinea." *Art in its Context, Studies in Ethno-aesthetics*. Museum series vol. 2. Paris: Mouton; The Hague: A. A. Gerbrands, 1968.

Barbier, J. P., and D. Newton. *Islands and Ancestors: Indigenous Styles of Southeast Asia*. New York: The Metropolitan Museum of Art; Munich: Prestel, 1988.

Frankel, H. *Canoes of Walomo*. Boroko: Institute of Papua New Guinea Studies, 1978.

Gerbrands, A. A. "Symbolism in the Art of Amanamkai, Asmat, South New Guinea." *Mededelingen van het Rijksmuseum voor Volkenkunde* 15. Leiden: E. J. Brill, 1962.

———. "Wow-ipits: Eight Asmat Woodcarvers of New Guinea." *Art in its Context*, field reports, vol. 3. The Hague and Paris: Mouton & Co., 1967.

Goldwater, R. *The Art of Lake Sentani*. Exhibition catalog. New York: The Museum of Primitive Art, 1959.

Greub, S. *Art of Northwest New Guinea: From Geelvink Bay, Humboldt Bay, and Lake Sentani*. New York: Rizzoli, 1992.

Hoogerbrugge, J. "Sentani-meer, mythe en ornament." *Kultuurpatronen* (Ethnographisch Museum, Delft) 9 (1967).

———. *Ukiran-ukiran kayu Irian Jaya: The Art of Woodcarving in Irian Jaya*. Jayapura and Djakarta: n.p., 1978.

Konrad, G., and U. Konrad. *Asmat: Myth and Ritual, the Inspiration of Art*. Venice: Erizzo, 1996.

Konrad, G., U. Konrad, and T. Schneebaum. *Asmat: Leben mit den Ahnen: Steinzeitlich Holzschnitzer unserer Zeit*. Hofheim a. Taunus/Glashütten: F. Brückner, 1981.

Kooijman, S. *The Art of Lake Sentani*. Introduction by R. Goldwater. Exhibition catalog. New York: The Museum of Primitive Art, 1959.

———. *The Art Areas of Western New-Guinea. Three Regions of Primitive Art*. Lecture Series 2. New York: The Museum of Primitive Art, 1961.

———. "Ancestor Figures from the McCluer Gulf Area of New Guinea. A Variation of the Korwar Style." *Mededelingen van het Rijksmuseum voor Volkenkunde* 15. Leiden: E. J. Brill, 1962.

———. "Art, Art Objects and Ritual in the Mimika Culture." *Mededelingen van het Rijksmuseum voor Volkenkunde* 24. Leiden: E. J. Brill, 1984.

Renselaar, H. C. van. *Asmat: Art from Southwest New Guinea*. Royal Tropical Institute no. CXXI, Department of Cultural and Physical Anthropology, no. 55. Amsterdam, 1956.

Rockefeller, M. C. *The Asmat of New Guinea: The Journal of Michael Clark Rockefeller with his Ethnographical Notes and Photographs made among the Asmat People during two Expeditions in 1961*, edited with an introduction by A. A. Gerbrands. New York: The Museum of Primitive Art, 1967.

Schneebaum, T. *Asmat Images from the Collection of the Asmat Museum of Culture and Progress: Text, Photographs and Drawings*. Minneapolis: Asmat Museum of Culture and Progress, 1985.

———. *Embodied Spirits: Ritual Carvings of the Asmat: A Traveling Exhibition from the Gajdusek Collection of the Peabody Museum of Salem and the Crosier Asmat Museum Collection of Hastings*. Salem, Nebr.: Peabody Museum of Salem, 1990.

Smidt, D. A. M. *Asmat Art. Woodcarvings of Southwest New Guinea*. Singapore: Periplus; Leiden: Rijksmuseum voor Volkenkunde, 1993.

Thomas, N. *Oceanic Art*. London: Thames and Hudson, 1995.

Van der Sande, G. A. J. "Ethnography and Anthropology." *Nova Guinea* 3. Leiden: E. J. Brill, 1937.

Wirz, P. *Die Marind-anim von Holländisch Süd-Neu-Guinea*. 2 vols. Hamburg: L. Friederichsen: 1922–25. Reprint, New York: Arno Press, 1978.

———. "Beitrag zur Ethnologie der Sentanier (Hollandisch Neuguinea)." *Nova Guinea* vol. 16, book 3 (1928): 251–369.

## The Sepik

### Bibliography

Bülher, A. *Kunst der Südsee*. Zurich: Atlantis, 1969.

Forge, A. "Art and Environment in the Sepik." *Proceedings of the Royal Anthropological Institute*. London, 1965: 23–31.

Greub, S. *Art of the Sepik River*. Basel: Tribal Art Centre, 1985.

Kelm, H. *Kunst vom Sepik*. Vol. 1 *Mittelhauf*; Vol. 2 *Oberlauf*; Vol. 3 *Unterlauf und Nachtrage*. Veröffentlichungen des Museums für Völkerkunde Berlin N. F. 10, 11, 15. Abteilung Südsee 5–7. Berlin: Museum für Völkerkunde, 1966–68.

Lutkehaus, N., ed. *Sepik Heritage: Tradition and Change in Papua New Guinea*. Durham: Carolina Academic Press, 1990.

Mead, M. *Sex and Temperament in Three Primitive Societies*. 1935. 2nd edition, New York: William Morrow & Co., 1967.

Newton, D. *New Guinea Art in the Collection of the Museum of Primitive Art*. New York: Museum of Primitive Art, 1967.

———. *Crocodile and Cassowary: Religious Art of the Upper Sepik River, New Guinea*. New York: Museum of Primitive Art, 1971.

Reche, O. *Ergebnisse des Südsee-Expedition 1908–1910, II. Ethnographie, A. Melanesian*, Bd 1. Hamburg: Friederichsen, De Gruyter & Co., 1913.

Thomas, N. *Oceanic Art*. London: Thames and Hudson, 1995.

Tuzin, D. *The Voice of the Tambaran: Truth and Illusion in Ilahita Arapesh Religion*. Berkeley and Los Angeles: University of California Press, 1980.

## Astrolabe Bay, Huon Gulf, and West New Britain

### Notes

1 See Dark 1979, pp. 150–55.
2 Bodrogi 1953 and 1959.
3 Bodrogi 1959, p. 44.
4 Hogbin 1951, p. 91.
5 I visited Mandok and Aramot in 1964 and the production of traditional-style bowls and other items was very active then (Dark 1974, p. 29).
6 Dark 1974, p. 31.
7 See Bodrogi 1961, pl. VI. See also examples in Dark 1974, figs. 96–98, and Dark 1979, figs. 6–15, collected by Lewis. A modern *tago* mask, made for sale, is in Dark 1979, figs. 6–20.
8 Compare a listing of forms for the Kilenge of west New Britain (Dark 1983, pp. 42–44) with one from the Huon Gulf (Bodrogi 1961, p. 57). See Bodrogi 1953 and 1959 for Astrolabe Bay.
9 Bodrogi 1971.
10 See Dark 1970 and 1984, pp. 15–17; Harding 1967; Hogbin 1947 and 1951.
11 See Dark 1974, ills. 131–53, and Dark 1970, pp. 788, 794, for examples of Kilenge canoes. See Stephan 1907, Tafeln VIII, IX, for similar designs on Bariai canoes sixty years earlier, and his Abb. 101 and 102 for a model Bariai canoe.
12 See Dark 1974, pp. 19–20, 1983, pp. 25–44; Gerbrands 1978; illustrations in Stöhr 1971, Abb. 86–99, pp. 70–71.
13 Dark 1984, p. 18.
14 Dark 1974, figs. 239, 240.
15 Mikloucho-Maclay 1975, p. 178.
16 Bodrogi 1961, p. 10.
17 Bodrogi 1961, pp. 72–73.
18 Dark 1979, pp. 150–53.
19 Chinnery 1926, p. 42.
20 Mikloucho-Maclay 1975, p. 245.

### Bibliography

Bodrogi, T. "Some Notes on the Ethnography of New Guinea: Initiation Rites and Ghost-cult in the Astrolabe Bay Region." *Acta Ethnographica Academiae Scientiarum Hungaricae* (Budapest) 3 (1953): 91–184 and plates 1–4.

———. "New Guinean Style Provinces: The Style Province 'Astrolabe Bay.'" *Opuscula Ethnologica Memoriae Ludovici Biro Sacra* (Hungarian Academy of Sciences, Budapest) 6 (1959): 39–99.

———. *Art in North-East New Guinea*. Budapest: Hungarian Academy of Sciences, 1961.

———. "Data Regarding the Ethnography of Umboi and the Siassi Islands (Northeast New Guinea)." *Acta Ethnographica Academiae Scientiarum Hungaricae* (Budapest) 18 (1969): 187–228.

———. *Zur Ethnographie der Vitu – (French) Inseln*. Band 19, Heft 1. Berlin: Baessler Archiv, 1971: 47–71.

Chauvet, S. *Les Arts indigènes en Nouvelle-Guinée.* Paris: Société des Éditions géographiques, maritimes et coloniales, 1930.

Chinnery, E. W. P. "Certain Natives in South New Britain and Dampier Straits." *Anthropological Report* 3, New Guinea Territory, Canberra, 1926.

Dark, P. J. C. "South Sea Islands Economics." *Geographical Magazine* 42, 11 (1970): 787–94.

———. "Kilenge Big Man Art." *Primitive Art and Society,* edited by A. Forge. London and New York: Oxford University Press, 1973.

———. *Kilenge Life and Art: A Look at a New Guinea People.* London: Academy Editions, 1974.

———. "The Art of the Peoples of Western New Britain and their Neighbors." *Exploring the Visual Art of Oceania,* edited by S. M. Mead. Honolulu: University Press of Hawaii, 1979.

———. "Review of Canoes of Walomo." *Pacific Arts Newsletter* (Wellington) 13 (1981): 20–23.

———. "Among the Kilenge 'Art is something which is well done.'" *Art and Artists of Oceania,* edited by S. M. Mead and B. Kernot. North Palmerston: Dunmore Press, 1983.

———. *The Art of Papua New Guinea.* London: The Royal Anthropological Institute, 1984.

Finish, O. *Ethnologische Erfahrungen und Belegstücke aus der Südsee.* Vienna: Naturhistorisches Hofmuseum, 1988.

Frankel, H. *Canoes of Walomo.* Boroko: Institute of Papua New Guinea Studies, 1978.

Gerbrands, A. A. "Talania and Nake, Master Carver and Apprentice: Two Wood-carvers from the Kilenge (Western New Britain)." *Art in Society: Studies in Style, Culture and Aesthetics,* edited by M. Greenhalgh and V. Megaw. New York: St. Martin's Press, 1978.

Hagen, B. *Unter den Papua's: Beobachtungen und Studien über Land und Leute, Thier- und Pflanzen in Kaiser-Wilhelmsland.* Wiesbaden: C. W. Kreidel, 1899.

Hogbin, H. I. "Native Trade Round the Huon Gulf, Northeastern New Guinea." *Journal of the Polynesian Society* (Wellington) 46 (1947): 242–55.

———. *Transformation Scene: the Changing Culture of a New Guinea Village.* London: Routledge and Kegan Paul, 1951.

Kaeppler, A. L., C. Kaufmann, and D. Newton. *Oceanic Art.* New York: Harry N. Abrams, Inc., 1997.

Kaufmann, C. *Papua Niugini: Ein Inselstaat im Werden.* Basel: Museum für Volkerkunde und Schweizerisches Museum für Volkskunde Basel, 1975.

Lewis, A. B. "Melanesian Shell Money in Field Museum Collections." *Anthropological Series* (Field Museum of Natural History, Chicago) 19 (1929).

———. *The Melanesians: People of the South Pacific.* Chicago: Field Museum of Natural History, 1945.

Mikloucho-Maclay. *New Guinea Diaries 1875–1883,* translated from the Russian with biographical and historical notes by C. L. Sentinella. Madang: Kristen Press, 1975.

Newton, D., H. Waterfield, and P.-A. Ferrazzini. *Tribal Sculpture: Masterpieces from Africa, South East Asia and the Pacific in the Barbier-Mueller Museum.* London: Thames and Hudson, 1995.

Reichard, G. A. *Melanesian Design: A Study of Style in Wood and Tortoisehell Carving.* 2 vols. New York: Columbia University Press, 1933.

Stephan, E. *Sudseekunst: Beiträge zur Kunst des Bismarck-Archipels und zur Urgeschichte der Kunst überhaupt.* Berlin: Dietrich Reimer, 1907.

Stöhr, W. *Melanesien, Schwarze Inseln der Südsee.* Cologne, 1971.

## Massim

### Notes

1 Egloff 1972.
2 Lapita pottery has been found in many Melanesian and Polynesian island groups, usually in the form of shards. Its production commenced about 2000 B.C. and it is named after an archaeological site in New Caledonia (see Specht 1988, pp. 15–16).
3 See Austen 1939–40, Egloff 1972, and Seligman 1910, pl. LXXVIII.
4 Gerrits 1974.
5 See Meyer 1995, fig. 154, and Leach and Leach 1983, p. 12.
6 Haddon 1894.
7 Another aspect of Massim art that is not well understood is its relation to the art of other Oceanic culture districts (Newton 1975, pp. 12–16).
8 The *kula* is described in *Argonauts of the Western Pacific* (1922). See also Malinowski 1920 and 1934.
9 Examples of most of the types of Massim artworks and artifacts mentioned in this article are published in Newton 1975, Beran 1980, and Shack 1985. Brizzi 1976, Schlesier 1986, and *Oceania Nera* 1992, also illustrate a good range of Massim artworks. Beran 1980 illustrates Massim betel-chewing utensils comprehensively.
10 Fellows 1897–98. A complete exposition of the interpretation is provided in Glass 1986.
11 For another interpretation of Trobriand shields, see Glass 1986.
12 See Leach 1954, Berndt 1958, and, for the interpretation of the shell-money holders, Battaglia 1990, p. 128. Splashboards that unmistakably show human figures in their lower sections are published in Seligman and Dickson 1946, pl. F, fig. 3, and Mikloucho-Maclay 1950–54, vol. 5, ill. 250.
13 MacGillivray 1967, vol. 1, p. 272.
14 One of the clubs is illustrated in Force and Force 1971, p. 309. Evidence that these clubs were used by the Suau people is presented in Beran 1996, ch. 5.
15 Narubutal 1975 and Narubutau 1979.
16 Malinowski 1922, Campbell 1984, and Scoditti 1990.
17 Abel 1974.

### Bibliography

Abel, C. "Suau Aesthetics." *Gigibori* 1 (1974): 34–35.

Austen, L. "Megalithic Structures in the Trobriand Islands." *Oceania* 10 (1939–40): 3–53.

Battaglia, D. *On the Bones of the Serpent.* Chicago: The University of Chicago Press, 1990.

Benitez-Johannot, P. "From the Profane to the Sacred and Beyond: a Trobriand Decorated War Shield in the Barbier-Mueller Collection." *Tribal Art* (1998): 49–57.

Beran, H. *Massim Tribal Art.* Wollongong: Wollongong City Gallery, 1980.

———. *Betel-chewing Equipment of East New Guinea.* Aylesbury: Shire, 1988.

———. *Mutuaga. A Nineteenth-Century New Guinea Master Carver,* Wollongong: Wollongong University Press, 1996.

———. "Massim Lime Spatulas by the Master of the Prominent Eyes." *The World of Tribal Arts* 3 (1997): 68–76.

Berndt, R. M. "A Comment on Dr. Leach's 'Trobriand Medusa.'" *Man* article 65 (1958): 65–66.

Egloff, B. J. "The Sepulchral Pottery of Nuamata Island, Papua." *Archaeology and Physical Anthropology in Oceania* 7 (1972): 145–63.

Force, R. W., and M. Force. *The Fuller Collection of Pacific Artefacts.* London: Lund Humphries, 1971.

Gerrits, G. J. M. "Burial Canoes and Canoe Burials in the Trobriand and Marshall Bennett Islands (Melanesia)." *Anthropos* 69 (1974): 224–31.

Glass, P. "The Trobriand Code: An Interpretation of Trobriand War Shield Designs." *Anthropos* 81 (1986): 47–63.

Haddon, A. C. *The Decorative Art of British New Guinea.* Dublin: Academy House, 1894.

Leach, E. R. "A Trobriand Medusa?" *Man* article 158 (July 1954): 103–5.

Leach, J., and E. Leach, eds. *The Kula.* Cambridge: Cambridge University Press, 1983.

MacGillivray, J. *Narrative of the Voyage of H.M.S. Rattlesnake.* 1852. Reprint, Australian Fascimile editions, no. 118. Adelaide: Libraries Board of South Australia, 1967.

Malinowski, B. *Argonauts of the Western Pacific.* London: Routledge and Kegan Paul, 1922.

Meyer, A. J. P. *Oceanic Art.* Cologne: Könemann, 1995.

Chief Narubutal [Narubutau]. "Trobriand Canoe Prows." *Gigibori* 2 (1975): 1–14.

Chief Narubutau. "Eleven Canoe Prows from the Trobriand Islands." *Gigibori* 4 (1979): 40–46.

Newton, D. *Massim: Art of the Massim Area, New Guinea.* New York: Museum of Primitive Art, 1975.

Scoditti, G. M. G. *Kitawa.* Berlin and New York: Mouton de Gruyter, 1990.

Seligman, C. G. *The Melanesians of British New Guinea.* Cambridge: Cambridge University Press, 1910.

Weiner, A. B. *Women of Value, Men of Renown: New Perspectives in Trobriand Exchange.* Austin: University of Texas Press, 1976.

## Gulf of Papua, Papua New Guinea

### Bibliography

Beaver, W. N. *Unexplored New Guinea: a Record of the Travels, Adventures and Experiences of a Resident Magistrate amongst the Head-hunting Savages and Cannibals of the Unexplored Interior of New Guinea.* Philadelphia: Lippincott, 1920.

Crawford, A. L. *Aida: Life and Ceremony of the Gogodala.* Bathurst, N.S.W.: National Cultural Council of Papua New Guinea with R. Brown & Associates, 1981.

Foy, W. "Ethnographische Beziehungen zwischen Britisch- und Deutsch-Neu-Guinea." *Globus* 82 (1902): 379–38.

Holmes, J. H. *Primitive New Guinea: an Account of a Quarter of a Century Spent amongst the Primitive Ipi and Namau Groups of Tribes of the Gulf of Papua.* Introduction by A. C. Haddon. London: Seeley Service, 1924.

Newton, D. *Art Styles of the Papuan Gulf.* New York: Museum of Primitive Art, 1961.

Williams, F. E. *The Natives of the Purari Delta.* Anthropology Report no. 5. Port Moresby: Territory of Papua, 1924.

———. *Drama of Orokolo: The Social and Ceremonial Life of the Elema.* Oxford: Clarendon Press, 1940.

Wirz, P. "Die Gemeinde der Gogodara." *Nova Guinea* vol. 16, book 4 (1934): 371–499.

———. "Beiträge zur Ethnographie des Papua-Golfes, Britisch-Neuguinea." *Abhandlungen und Berichte des Museums für Tierkunde und Völkerkunde zu Dresden* 19, no. 2. Leipzig: B. G. Teubner, 1934.

## Torres Strait

### Bibliography

Fraser, D. F. *Torres Straits Sculpture: a Study in Oceanic Primitive Art.* New York and London: Garland, 1978.

Haddon, A. C. *Reports of the Cambridge Anthropological Expedition to Torres Straits.* 6 vols. Cambridge: Cambridge University Press, 1901–35. New edition, New York: Johson Reprints, 1971.

Moore, D. R. *The Torres Strait Collection of A. C. Haddon: a Descriptive Catalogue.* London: British Museum, 1984.

———. *Arts and Crafts of Torres Strait.* Aylesbury: Shire, 1989.

## The Admiralty Islands

### Bibliography

Badner, M. L. "Admiralty Islands 'Ancestor' Figures?" *Exploring the Visual Art of Oceania,* edited by S. M. Mead. Honolulu: University Press of Hawaii, 1979: 227–37.

Fortune, R. F. "Manus Religion. An Ethnological Study of the Manus Natives of the Admiralty Islands." *American Philosophical Society* vol. 3 (1935).

Mead, M. *Growing up in New Guinea: a Comparative Study of Primitive Education.* New York, 1930.

———. *New Lives for Old. Cultural Transformation: Manus 1928–1953.* New York: Morrow; London: Gollancz, 1956.

Mitton, R. D. *The People of Manus.* Record 6. Boroko: National Museum and Art Gallery, 1979.

Nevermann, H. *Admiralitäts-Inseln.* Vol. 3 of *Ergebnisse der Südsee-Expedition, 1908–1910, II. Ethnographie, A. Melanesien.* Hamburg: Friederichsen, De Gruyter & Co., 1934.

Ohnemus, S. *Zur Kultur der Admiralitäts-Insulaner in Melanesie: Die Sammlung Alfred Bühler im Museum für Völkerkunde Basel.* Basel: Museum für Völkerkunde, 1996.

Tiesler, F. "Bemerkungen zu zusammengesetzten Nackenstützen von den Admiralitäts-Inseln." *Abhandlungen und Berichts des Staatlichen Museums für Völkerkunde in Dresden* 28 (1968): 49–72.

## New Ireland

### Notes

1 The Institute of Ethnology in Basel has made enormous progress in unraveling the inconsistencies of place-names and language areas as used in the literature of the colonial and post-colonial period; see Wassmann 1995.
2 The term has many orthographic variations, some reflecting regional variations in pronunciation.
3 See Gosden and Robertson 1991.
4 For a summary of the current discussions in Lapita studies see Spriggs 1996.
5 Sharp 1968.
6 Under German control the external name of the island was changed to Neu-Mecklenburg.
7 Phillip Lewis has tallied about 15,000 northern New Ireland objects in European and North American museum collections, most from this period. While some were purchased or received as barter in New Ireland, others were forcibly removed.
8 Lajós Biró, a Hungarian adventurer, quoted in Bodrogi 1967.

### Bibliography

Bodrogi, T. "Malagans in North New Ireland. L. Biró's Unpublished Notes." *Acta Ethnographica* (Budapest) 16, 2 (1967).

Gifford, P. C. *The Iconology of the Uli Figure in Central New Ireland.* Ph.D. diss. New York: Columbia University, 1974.

———. "Uli Figures." *Connaissance des arts tribaux* (Musée Barbier-Mueller) bulletin 1 (1979).

Gosden, C., and N. Robertson. "Models for Matenkupkum: Interpreting a Late Pleistocene Site from Southern New Ireland, Papua New Guinea." *Report of the Lapita Homeland Project,* edited by J. Allen and C. Gosden. Canberra: Department of Prehistory, Research School of Pacific Studies, Australian National University, 1991.

Gunn, M. *Arts rituels d'Océanie. Nouvelle-Irlande dans les collections du Musée Barbier-Mueller.* Milan: Skira, 1997.

Hall, H. U. "New Ireland Masks." *The Museum Journal* (University of Pennsylvania, Philadelphia) 10, 4 (1919): 184–87.

Helfrich, K. *Malanggan, I. Bildwerke von Neu-Irland.* Veröffentlichungen des Museums für Völkerkunde, N. F. Bd 25, Abteilung Südsee 10. Berlin: Museum für Völkerkunde, 1973.

*Îles Tabar, Océanie.* Paris: Galerie Jacques Kerchache, 1971.

Krämer, A. F. *Die Malanggane von Tombara.* Munich: G. Muller, 1925.

Krämer-Bannow, E. *Bei kunstsinnigen Kannibalen der Südsee: Wanderungen auf Neu-Mecklenburg 1908–1909.* Berlin: D. Reimer, 1916.

Küchler, S. "Malangan: Objects, Sacrifice and the Production of Memory." *American Ethnologist* 15, 4 (1988): 625–37.

Lewis, P. H. "The Social Context of Art in Northern New Ireland." *Fieldiana Anthropology* 58 (1969).

———. "Changing Memorial Ceremonial in Northern New Ireland." *Journal of the Polynesian Society* 82, 2 (1973): 141–53.

Lincoln, L., ed. *Assemblage of Spirits: Idea and Image in New Ireland.* Exhibition catalog. Minneapolis: Minneapolis Institute of Arts; New York: George Braziller, 1987.

Parkinson, R. *Dreissig Jahre in der Südsee: Land und Leute, Sitten und Gebräuche im Bismarckarchipel und auf den Deutschen Salomoninsel.* Stuttgart: Strecker und Schröder, 1907.

Schlaginhaufen, O. *Muliama: zwei Jahre unter Südsee-Insulanern.* Zurich: Orell Füssli, 1959.

Sharp, A. *The Voyages of Abel Janszoon Tasman.* Oxford: Clarendon Press, 1968.

Spriggs, M. *The Island Melanesians.* Oxford: Blackwell Publishers, 1996.

Stöhr, W. *Melanesien. Schwarze Inseln der Südsee: eine Austellung des Rautenstrauch-Joest-Museums für Völkerkunde der Stadt Köln.* Exhibition catalog. Cologne: Kunsthalle, 1972.

———. "Kunst und Kultur aus der Südsee. Sammlung Clausmeyer Melanesien." *Ethnologica* (Rautenstrauch-Joest-Museums für Völkerkunde, Cologne) 6 (1987).

Walden, E., and H. Nevermann. "Totenfeiern und Malangane von Nord Neumecklenburg: nach Aufzeichnungen von E. Walden." *Zeitschrift für Ethnologie* (Berlin) 72, 1/3 (1940): 11–38.

Wassmann, J. *Historical Atlas of Ethnic and Linguistic Groups in Papua New Guinea.* Vol. 3. Basel: Institute of Ethnology, 1995.

## East New Britain

### Bibliography

Barbier, J. P. *Indonésie et Malaisie.* Geneva: Musée Barbier-Mueller, 1977.

Corbin, G. A. "The Art of the Baining: New Britain." *Exploring the Visual Art of Oceania,* edited by S. M. Mead. Honolulu: University Press of Hawaii, 1979.

———. "Chachet Baining Art." *Expedition* 24, 2 (1982): 5–16.

———. "The Central Baining Revisited. 'Salvaga' Art History Among the Kairak and Uramot Baining of East New Britain, Papua New Guinea." *Res* 7/8 (1984): 41–69.

———. "Appendix: a Short Checklist of Kairak and Uramot Night Dance Masks." *Res* 11 (1986): 88–99.

———. "Salvage Art History among the Sulka of Wide Bay, East New Britain, Papua New Guinea." *Art and Identity in Oceania,* edited by A. and L. Hanson. Honolulu: University Press of Hawaii, 1990.

Damm, H. "Bemerkungen zu den Schädelmasken aus Neu-Britannien (Südsee)." *Jahrbuch des Museums für Völkerkunde zu Leipzig* 26 (1969): 85–116.

Errington, F. K. *Karavar: Masks and Power in a Melanesian Ritual.* Ithaca: Irvington, 1974.

Foy, W. "Tanzobjekt vom Bismarck-Archipel, Nissan und Buka, Zoologisches und Anthropologisch-Ethnographisches Museum." *Publikationen aus dem Königlichen Ethnographischen Museum zu Dresden* 13 (1900): 1–40.

Hesse, I. *Die Darstellung der menschlichen Gestalt in Rundskulpturen Neumecklenburgs.* Hamburg: n.p., 1933.

Hesse, K., and A. Aerts. *Baining Dances.* Port Moresby: Institute of Papua New Guinea Studies, 1979.

Jeudy-Ballini, M. "Masques Sulka." *Arts d'Afrique noire* (Arrouville) 90 (1994): 32–38.

Koch, G. *Iniet: Geister in Stein: die Berliner Iniet-Figuren-Sammlung.* Veröffentlichungen des Museums für Völkerkunde Berlin, N. F. Bd 39, Abteilung Südsee 11. Berlin: Museum für Völkerkunde, 1982.

Kroll, H. "Der Iniet: Das Wesen eines Melanesischen Geheimbundes." *Zeitschrift für Ethnologie* 69 (1937): 180–219.

Laufer, C. "Rigenmucha: das Höchste Wesen der Baining." *Anthropos* 41–44 (1946–49): 497–560.

———. "Aus Geschichte und Religion der Sulka." *Anthropos* 50 (1955): 32–60.

———. "Jungendinitiation und Sakraltanze der Baining." *Anthropos* 54 (1957): 905–38.

———. "Notizen zur materiellen Kultur der Sulka." *Acta Ethnographica* (Budapest) 11 (1962): 447–56.

————. "Die Mandas-Maskenfeier der Mali Baining." *Jahrbuch des Museums für Völkerkunde zu Leipzig* 27 (1970): 160–84.
Luschan, F. von. "Schilde aus Neu-Britannien." *Zeitschrift für Ethnologie* 32 (1900): 496–504.
Meier, J. "Steinbilder des Iniet-Geheimbundes bei den Eingeboren des nordöstlichen Teiles der Gazelle-Halbinsel, Neu-Pommern (Sudsee)." *Anthropos* 6 (1911): 837–67.
Meyer, A. B., and R. Parkinson. "Schnitzereien und Masken vom Bismarck Archipel und Neu Guinea." *Publikationen aus dem Königlichen Ethnographischen Museum zu Dresden* 10 (1895).
Meyer, P. O. "Die Schiffahrt bei den Bewohnern von Vuatom (Neu-Pommern, Sudsee)." *Baessler-Archiv* 1 (1911): 255–68.
Newton, D. *Sculpture, Chefs-d'œuvre du Musée Barbier-Mueller.* Paris: Imprimerie nationale, 1995.
Parkinson, R. *Dreissig Jahre in der Südsee: Land und Leute, Sitten und Gebräuche in Bismarckarchipel und auf den Deutschen Salomoinseln.* Stuttgart: Strecker und Schröder, 1907.
Rascher, P. "Die Sulka: Ein Beitrag zur Ethnographie von Neu-Pommern." *Archiv für Anthropologie* 1 (1903–4): 209–35.
Stephan, E., and F. Graebner. *Neu-Mecklenburg (Bismarck-Archipel). Die Küste von Umuddu bis Kap St. Georg: Forschungsergebnisse bei der Vermessungsfahrten von S. M. S. Möwe im Jahre 1904.* Berlin: D. Reimer, 1907.

## The Solomon Islands

### Notes
1 Brenchley 1873, p. 253.
2 Davenport 1962.
3 Waite 1983, pp. 62–63, 127.
4 Davenport 1990.
5 Ivens 1938, p. 13.
6 Ivens 1927, p. 296.
7 Waite 1983a.
8 Knibbs 1929, pp. 32–34.
9 Waite 1983a, pp. 38–39, 117–19.
10 Waite 1983b.
11 Waite 1983, pp. 40–41, 120–21.
12 Cheyne 1852, pp. 303–14.
13 Somerville 1897, pp. 400–1.
14 Waite 1983, pp. 44–45, 122–23.
15 Krause 1906, pp. 46–48.
16 Parkinson 1907, p. 299; Waite 1983, pp. 20–21, 113.
17 Krause 1906, p. 49.
18 Spiegal 1967, p. 34.
19 Spiegal 1967, pp. 36–37.
20 Blackwood 1935, p. 119; Spiegal 1967, p. 40.
21 Stöhr 1987, pp. 235–37; Waite 1983, pp. 24–25, 114–15.
22 Frizzi 1914, p. 35.
23 Thurnwald 1912, vol. 1, p. 58.
24 Thurnwald 1912, vol. 1, p. 36.
25 Waite 1983, pp. 26–27, 115.

### Bibliography
Blackwood, B. *Both Sides of Buka Passage.* London: Milford, 1935.
Brenchley, J. L. *Jottings during the Cruise of H.M.S. Curacoa among the South Sea Islands in 1865.* London: Longmans/Green, 1873.
Cheyne, A. *A Description of Islands in the Western Pacific Ocean North and South of the Equator.* London: Tribner and Potter, 1852.
Davenport, W. "Red Feather Money." *Scientific American* 206, 94 (1962): 103.
————. "Sculpture of the Eastern Solomons." *Expedition* 10, 2 (1968): 45.
————. "The Figurative Sculpture of Santa Cruz." *Art and Identity in Oceania,* edited by A. and L. Hanson. Honolulu: University Press of Hawaii, 1990.
Frizzi, E. "Ein Beitrag zur Ethnologie von Bougainville und Buka mit Spezieller Berücksichtigung der Nasioi." *Baessler Archiv* 6 (1914): 12.
Ivens, W. G. *Melanesians of the Southeast Solomon Islands.* London: Kegan Paul, 1927.
————. "Solomon Islands Clubs called Wari-i-hau." *Ethnologica Cranmorensis* 2 (1938): 88.
Knibbs, S. Q. C. *The Savage Solomons as They Were and Are.* London: Seeley Service, 1929.
Krause, F. "Zur Ethnologie der Inseln Nissan." *Jahrbuch der Stadtlichen Museum für Völkerkunde zu Leipzig* I (1906): 44–159.
Mead, S. M. *Material Culture and Art in the Star Harbour Region, Eastern Solomon Islands: Southeast Solomon Islands Culture History program.* Introduction by R. C. Green. Toronto: Royal Ontario Museum and University of Toronto Press, 1973.
Parkinson, R. *Dreissig Jahre in der Südsee: Land und Leute, Sitten und Gebräuche in Bismarckarchipel und auf den deutschen Salomoinseln.* Stuttgart: Strecker und Schröder, 1907.
Somerville, H. B. T. "Ethnographical Notes in New Georgia." *Journal of the Royal Anthropological Institute of Great Britain and Ireland* 26 (1897): 357–412.
Spiegal, H. "A Study of Buka Passage (Solomon Islands) Ceremonial Paddles." *Records of the Australian Museum* (Sydney) 27, 8 (1967): 338.

Stöhr, W. *Kunst und Kultur aus der Südsee. Sammlung Clausmeyer, Melanesien.* Cologne: Rautenstrauch-Joest-Museum für Völkerkunde, 1987.
Thurnwald, R. *Forschungen auf den Salamo-Inseln und dem Bismarck Archipel.* 2 vols. Berlin: D. Reimer, 1912.
Waite, D. B. *Art des îles Salomon dans les collections du musée Barbier-Mueller.* Geneva: Musée Barbier-Mueller, 1983.
————. "Form and Function of Tridacna Shell Plaques from the Western Solomon Islands." *Empirical Studies of the Arts* 1, 1 (1983a): 554.
————. "Shell-Inlaid Shields from the Solomon Islands." *Art and Artists of Oceania,* edited by S. M. Mead and B. Kernot. Palmerston North: Dunmore Press, 1983b.
————. *Artefacts from the Solomon Islands in the Julius L. Brenchley Collection.* London: British Museum Publications, 1987.

## Vanuatu

### Bibliography
Bolton, L. "Tahigogona's Sisters: Women, Mats and Landscape on Ambue." *Arts of Vanuatu,* edited by J. Bonnemaison et al. Bathurst: Crawford House, 1997.
Bonnemaison, J., C. Kaufmann, and D. Tryon. *Arts of Vanuatu.* Bathurst: Crawford House 1997.
Codrington, R. H. *The Melanesians: Studies in their Anthropology and Folklore.* 1891. Reprint, New Haven: HRAF Press; Oxford: Clarendon Press, 1957.
Deacon, A. B. *Malekula: a Vanishing People in the New Hebrides.* London: G. Routledge, 1934.
Edge-Partington, J. *An Album of the Weapons, Tools, Ornaments, etc. of the Natives of the Pacific Islands.* 2 vols. London: Holland Press, 1969.
Guiart, J. "Société, rituels et mythes du nord Ambrym." *Journal de la Société des Océanistes* 7 (1951): 2–103.
————. *Nouvelles-Hébrides.* Auvers-sur-Oise: Archée, 1965.
————. *L'Océanie.* Paris: Gallimard, 1963.
Huffman, K. "Masks, Headdresses and Ritual Hats in Northern Vanuatu." *Arts of Vanuatu,* edited by J. Bonnemaison et al. Bathurst: Crawford House, 1997.
————. "Cultural Exchange and Copyright: Important Aspects of Vanuatu Arts." *Arts of Vanuatu,* edited by J. Bonnemaison et al. Bathurst: Crawford House, 1997.
————. *Vanuatu: Kunst aus der Südsee.* Basel: C. Merian, 1997.
Kaeppler, A. L. *"Artificial Curiosities" Being an Exposition of Native Manufactures Collected on the Three Pacific Voyages of Captain James Cook, R.N.* Honolulu: Bernice Pauahi Bishop Museum, 1978.
Layard, J. *Stone Men of Malekula.* London: Chatto and Windus, 1942.
Speiser, F. *Ethnology of Vanuatu. An Early Twentieth Century Study.* Translated from the German by D. Q. Stephenson. Bathurst: Crawford House Press, 1991.

## New Caledonia

### Note
1 Reproduced in the catalog to the exhibition "De jade et de nacre," 1990.

### Bibliography
Boulay, R., ed. *De jade et de nacre, patrimoine artistique kanak.* Paris: Réunion des Musées Nationaux, 1990.
Guiart, J. *L'Océanie.* Paris: Gallimard, 1963.
Kaeppler, A. L., C. Kaufmann, and D. Newton. *Oceanic Art.* New York: Harry N. Abrams, Inc., 1997.
Patouillet, J. *Voyage autour du monde. Trois ans en Nouvelle-Calédonie.* N.p., 1873.
Sarasin, F. *La Nouvelle-Calédonie et les îles Loyalty. Souvenirs de voyage d'un naturaliste.* Basel: Georg; Paris: Fischbacher, 1917.

## Tonga and Samoa

### Note
1 Williams 1837, pp. 324–25.

### Bibliography
Buck, P. H. (Te Rangi Hiroa). *Samoan Material Culture.* Bulletin 75. Honolulu: Bernice Pauahi Bishop Museum, 1930.
————. "Material Representatives of Tongan and Samoan Gods." *Journal of the Polynesian Society* 44 (1935): 48–53, 85–96, 153–62.
————. "Additional Wooden Images from Tonga." *Journal of the Polynesian Society* 46 (1937): 74–82.
Davidson, J. M. "The Wooden Image from Samoa in the British Museum: A Note on Its Context." *Journal of the Polynesian Society* 84 (1975): 352–55.
Gifford, E. W. *Tongan Society.* Honolulu: Bernice Pauahi Bishop Museum, 1929. Reprint, Millwood: Klaus Reprint, 1985.
Green, R. C. "Early Lapita Art from Polynesia and Island Melanesia: Continuities in Ceramic, Barkcloth, and Tattoo Decorations." *Exploring*

the Visual Art of Oceania, edited by S. M. Mead. Honolulu: University Press of Hawaii, 1979.
Kaeppler, A. L. "Eighteenth Century Tonga: New Interpretations of Tongan Society and Material Culture at the Time of Captain Cook." *Man* 6, 2 (1971): 204–20.
————. *"Artificial Curiosities" Being An Exposition of Native Manufactures Collected on the Three Pacific Voyages of Captain James Cook R. N.* Honolulu: Bernice Pauahi Bishop Museum, 1978a.
————. "Exchange Patterns in Goods and Spouses: Fiji, Tonga and Samoa." *Mankind* 11, 3 (1978b): 246–52.
————. "Art, Aesthetics, and Social Structure." *Tonga Culture and History,* edited by P. Herda, J. Terrell, and N. Gunson. Canberra: Australian National University, 1990.
————. "Poetics and Politics of Tongan Barkcloth." *Pacific Material Culture: Essays in Honour of Dr. Simon Kooijman.* Mededelingen van het Rijksmuseum voor Volkenkunde 28. Leiden, 1995.
McKern, W. C. *Tongan Archaeology.* Honolulu: Bernice Pauahi Bishop Museum, 1929.
————. *Tongan Material Culture.* MSS. Bernice Pauahi Bishop Museum Archives, n.d.
Neich, R. "Material Culture of Western Samoa: Persistence and Change." *Bulletin of the National Museum of New Zealand* 23 (1985).
Ratzel, F. *Völkerkunde. Bd 2: Die Naturvölker Ozeaniens, Amerikas und Asiens.* 3 vols. Leipzig: Verlag des Bibliographisches Instituts Leipzig, 1885–88.
Williams, Rev. J. *A Narrative of Missionary Enterprises in the South Sea Islands.* London: J. Snow and J. R. Leifchild, 1837.

## Fiji

### Bibliography
Clunie, F. "Fijian Weapons and Warfare." *Bulletin of the Fiji Museum* 2 (1977).
————. "The Fijian Flintlock." *Domodomo* (Suva) 1, 3 (1983): 102–22.
————. "Fijian and Tongan War Arrows." *Domodomo* (Suva) 3, 1 (1985): 11–40.
————. *Yalo I Viti – Shades of Viti: A Fiji Museum Catalogue.* Suva: Fiji Museum, 1986.
————. "Drua or kalia? The Great Tongan Voyaging Canoe." *Islands* (January–March, 1988): 11–16.
————. "A Sacred Yaqona Dish from Fiji." *Tribal Art.* Geneva: Musée Barbier-Mueller, 1996.
Clunie, F., and W. Ligairi. "Fijian Mutilatory Practices. 1: Ear-lobe Slitting and Distortion." *Domodomo* (Suva) 1, 1 (1983): 11–21.
————. "Traditional Fijian Spirit Masks and Spirit Maskers." *Domodomo* (Suva) 1, 2 (1983): 46–71.
Damm, H. "Scheibenförmiger Brustschmuck aus Pottwalzähnen, Fidschi-Inseln: nach Material der Staatlichen Museen für Völkerkunde in Dresden und Leipzig." *Abhandlungen und Berichte aus dem Staatlichen Museum für Völkerkunde Dresden* 34 (1975): 523–40.
Ewins, R. *Fijian Artefacts: the Tasmanian Museum and Art Gallery Collection.* Hobart: Tasmanian Museum and Art Gallery, 1982.
Henderson, G. C. *The Journal of Thomas Williams, Missionary in Fiji, 1840–1853.* 2 vols. Sydney: Angus and Robertson, 1931.
Kleinschmidt, T. "Notes on the Hill Tribes of Viti Levu, 1877–1878." Translated by S. Waine. *Domodomo* (Suva) 2, 4 (1984): 138–91.
Larsson, K. E. "Fijian Studies." *Etnologiska Studier* (Etnografiska Museet, Göteborg) 25 (1960).
Lester, R. H. "Kava-Drinking in Viti Levu." *Oceania* (Sydney) 12, 2 (1941): 97–121; 12, 3 (1942): 226–54.
Lyth, R. B. Manuscripts conserved at the Mitchell Library, Sydney, 1939–54.
Neyret, J. M. *Pirogues océaniennes.* 2 vols. Paris: Association des Amis du musée de la Marine, 1976.
Ratzel, F. *Völkerkunde. Bd 2: Die Naturvölker Ozeaniens, Amerikas und Asiens.* 3 vols. Leipzig: Verlag des Bibliographisches Instituts Leipzig, 1885–88.
Roth, G. K. "The Manufacture of Barkcloth in Fiji." *Journal of the Royal Anthropological Institute of Great Britian and Ireland* 64 (1934): 289–303.
————. "Pottery-Making in Fiji." *Journal of the Royal Anthropological Institute of Great Britain and Ireland* 65 (1935): 217–33.
Roth, J., and S. Hooper. *The Fiji Journals of Baron Anatole von Hügel.* Suva: Fiji Museum, 1990.
Von Hügel, A. A. A. *Miscellaneous Notes on Fijian Artefacts.* MSS., Cambridge University Museum of Archaeology and Anthropology, n.d.
————. *150 Lithograph Plates and Pencil Sketches of Fijian Artefacts.* Unpublished. Cambridge University Museum of Archaeology and Anthropology, n.d.
Waterhouse, J. *The King and People of Fiji.* London: Wesleyan Conference, 1866.
Wilkes, C. *Narrative of the United States Exploring Expedition During the Years 1838, 1839, 1840, 1841, 1842.* Vol. 3. Philadelphia: Lea and Blanchard, 1845. Reprint, Suva: Fiji Museum, 1985.
Williams, T. Manuscript conserved at the Mitchell Library, Sydney, 1840–53.
————. *Fiji and the Fijians: the Islands and their Inhabitants.* London: Heylin, 1858. Reprint, Suva: Fiji Museum, 1982.

## Central Polynesia

### Notes
1 Vinton Kirch 1984.
2 See for example Aitken 1930, pp. 107, 165–66.
3 Te Rangi Hiroa (Peter H. Buck) 1944.
4 Teuira 1928, p. 170. For a full account of *unu,* see Rose 1971. For an account of closely related art forms in the Cook Islands, see Buck 1944, pp. 331–37.
5 D'Alleva 1997; for a broader discussion of gendered practices in the visual arts of the Pacific, see Thomas 1996, pp. 115–29.
6 Henry 1928, p. 151.
7 Morrison 1935, p. 162.
8 For extensive studies of central Polynesian *marae* structures, see Aitken 1930; Bellwood 1978; Emory 1933; Vérin 1969; Wallin 1993.
9 Babadzan 1981, pp. 8–39.
10 Kaeppler 1997, pp. 70–71; D'Alleva 1996, pp. 1–8.
11 Henry 1928, p. 151.
12 Kaeppler 1982, pp. 82–107; Kaeppler 1997, pp. 65–66.
13 Shore 1989, pp. 151–52.
14 Williams 1837, pp. 98–99.
15 Wallis n.d., f. 40.
16 Williams 1837, pp. 98–99.
17 For the complete chant, see Henry 1928, p. 191.
18 Rongokea 1992.
19 Stevenson 1990, pp. 255–78; Stevenson 1993.

### Bibliography
Aitken, R. T. "Ethnology of Tubuai." *Bernice Pauahi Bishop Museum Bulletin* 19. Honolulu: Bernice Pauahi Bishop Museum, 1930.
Alleva, A. d'. "Representing the Body Politic: Status, Gender, and Anatomy in Eighteenth-Century Society Islands Art." *Pacific Arts* (Honolulu) 13–14 (1996).
————. *Shaping the Body Politic: Gender, Status, and Power in the Arts of Eighteenth-century Tahiti and the Society Islands.* Ph.D. diss. Columbia University, 1997.
————. "Stone Sculpture of the Society Islands." *Tribal Art* (1998): 49–57.
Babadzan, A. "Les Dépouilles des dieux: essai sur la symbolique de certaines effigies polynésiennes." *Res* (New York) 1 (1981).
Barrow, T. *Art and Life in Polynesia.* Rutland: Tuttle, 1973.
————. *The Art of Tahiti and the Neighbouring Society, Austral and Cook Islands.* London: Thames and Hudson, 1979.
Bellwood, P. *Archaeological Research in the Cook Islands.* Honolulu: Bernice Pauahi Bishop Museum Department of Anthropology, 1978.
Buck, P. H. (Te Rangi Hiroa). "Arts and Crafts of the Cook Islands." *Bernice Pauahi Bishop Museum Bulletin* 179, Honolulu: Bernice Pauahi Bishop Museum, 1944.
Dodd, E. *Polynesian Art.* Vol. 1, *The Ring of Fire.* New York: Dodd, Mead, 1969.
Ellis, W. *Polynesian Researches. Polynesia.* Rutland and Tokyo: Charles E. Tuttle, 1969.
————. *Polynesian Researches. Society Islands, Tubuai Islands, and New Zealand.* Rutland and Tokyo: Charles E. Tuttle, 1969.
————. *Polynesian Researches. Society Islands.* Rutland and Tokyo: Charles E. Tuttle, 1969.
Emory, K. "Stone Remains in the Society Islands." *Bernice Pauahi Bishop Museum Bulletin* 116. Honolulu: Bernice Pauahi Bishop Museum, 1933.
Hall, H. U. "Woodcarvings of the Austral Islands." *The Museum Journal* 12, 3 (1921): 179–200.
Henry, T. *Ancient Tahiti.* Honolulu: Bishop Museum, 1928.
Kaeppler, A. L. *"Artificial Curiosities" Being an Exposition of Native Manufactures Collected on the Three Pacific Voyages of Captain James Cook, R.N.* Honolulu: Bernice Pauahi Bishop Museum, 1978.
————. "Genealogy and Disrespect: A Study of Symbolism in Hawaiian Images." *Res* (New York) 3 (1982).
————. "Polynesia" and "Micronesia." *Oceanic Art,* by A. L. Kaeppler, Kaufmann, and D. Newton. New York: Harry N. Abrams, Inc., 1997.
Morrison, J. *The Journal of James Morrison, Boatswain's Mate of the Bounty.* London: The Golden Cockerel Press, 1935.
Oliver, D. *Ancient Tahitian Society.* 3 vols. Honolulu: University Press of Hawaii, 1974.
Rongokea, L. *Tivaevae: Portraits of Cook Islands Quilting.* Wellington: Daphne Brasell Associates Press, 1992.
Rose, R. G. *The Material Culture of Ancient Tahiti.* Ph.D. diss. Harvard University, 1971.
Shore, B. "Mana and Tapu." *Developments in Polynesian Ethnology,* edited by A. Howard and R. Borofsky. Honolulu: University Press of Hawaii, 1989.
Stevenson, K. M. "'Heiva': Continuity and Change of a Tahitian Celebration." *The Contemporary Pacific* 2 (1990).
————. "The Museum as a Research Tool: A Tahitian Example." *Artistic Heritage in a Changing Pacific,* edited by P. J. C. Dark and R. G. Rose. Honolulu: University Press of Hawaii, 1993.
Teuira, H. "Ancient Tahitian Society." *Bernice Pauahi Bishop Museum Bulletin* 48. Honolulu: Bernice Pauahi Bishop Museum, 1928.
Thomas, N. *Oceanic Art.* London: Thames and Hudson, 1996.

Vérin, P. *L'Ancienne Civilisation de Rurutu (îles Australes, Polynésie française). La période classique.* Paris: ORSTOM, 1969.

Vinton Kirch, P. *The Evolution of the Polynesian Chiefdoms.* Cambridge and New York: Cambridge University Press, 1984.

Wallin, P. *Ceremonial Stone Structures: The Archaeology and Ethnohistory of the Marae Complex in the Society Islands, French Polynesia.* Uppsala: Societas Archaeologica Upsaliensis, 1993.

Wallis, S. *His Majestys [sic] Ship Dolphin's Logbook.* Unpublished MSS. (Adm 55/35), Public Records Office, London, n.d.

Williams, J. *A Narrative of Missionary Enterprises in the South Sea Islands.* London: J. Snow and J. R. Leifchild, 1837.

## The Marquesas Islands

### Notes

1 Dening 1980, p. 79.

### Bibliography

Claret de Fleurlieu, Ch. P. *Voyage autour du monde pendant les années 1790–1792 par Étienne Marchand.* 5 vols. and atlas. Paris: Imprimerie de la République, 1798–1800.

Cook, J. *A Voyage Towards the South Pole, and Round the World. Performed oin His Majesty's Ships the "Résolution" and the "Adventure" in 1772, 1773, 1774 and 1775.* 2 vols. London: W. Strachen and T. Cadell, 1777.

Crook, W. P. *An Account of the Marquesas Islands.* Unpublished journal. Mitchell Library, Sydney, 1800.

Dening, G. *Islands and Beaches: Discourse on a Silent Land. Marquesas 1774–1880.* Honolulu: University Press of Hawaii, 1980.

Gracia, M. *Lettres sur les Îles Marquises ou Mémoires pour servir à l'étude religieuse, morale, politique et statistique des Îles Marquises et de l'Océanie orientale.* Paris: Gaume, 1843.

Handy, E. S. C. "The Native Culture in the Marquesas." *Bernice Pauahi Bishop Museum Bulletin 9.* Honolulu: Bernice Pauahi Bishop Museum, 1923.

Handy, W. "Tatooing in the Marquesas." *Bernice Pauahi Bishop Museum Bulletin 1,* Honolulu: Bernice Pauahi Bishop Museum, 1922.

———. *Native Culture in the Marquesas.* New York: Kraus Reprints, 1971.

———. *Forever the Land of Men: An Account of a Visit to the Marquesas Islands.* New York: Dodd, Mead, 1965.

Ivory, C. S. *Marquesan Art in the early Contact Period, 1774–1820.* Unpublished thesis, Washington University, 1990.

———. "Contemporary Marquesan Sculpture." *Le Pasefika 1, 4* (Summer 1996): 27–30.

———. "Art, Tourism and Culture Revival in the Marquesas." *Unpacking Culture: Art and Commodity in Colonial and Postcolonial Worlds,* edited by R. Phillips and C. Steiner. Berkeley: University of California Press, forthcoming.

Ivory, C. S., and D. Kimitete. "The Fourth Marquesan Festival of the Arts." *Pacific Arts 13–14* (July 1996): 43–46.

Kruzenstern, I. V. *Voyage autour du monde fait dans les années 1803, 1804, 1805 and 1806.* 2 vols. and atlas. Paris: Gide, 1821.

Langridge, M., and J. Terrell. "Von den Steinen's Marquesan Myths." *Target Oceania/The Journal of Pacific History.* Canberra: n.p., 1988.

Linton, R. "The Material Culture of the Marquesas Islands." *Bernice Pauahi Bishop Museum Bulletin 8.* Honolulu: Bernice Pauahi Bishop Museum, 1923. Reprint, Bayard Dominik Expedition Publication 5. New York: Reed/Kraus Reprints, 1974.

Melville, H. *Typee: a Peep at Polynesain Life, During a Four Months Residence among the Natives of a Valley of the Marquesas Islands.* 1846. New edition, Oxford: Oxford University Press, 1996.

Panoff, M. *Trésors des îles Marquises.* Paris: Musée de l'Homme/ ORSTOM/ Réunion des Musées Nationaux, 1995.

Porter, Captain D. *Journal of a Cruise made to the Pacific Ocean, 1812–1813.* Philadelphia: Bradford and Inskeep, 1815. 2nd edition, New York: Wiley and Halsted, 1822.

Radiguet, M. *Les Derniers Sauvages: la vie et les mœurs aux Iles Marquises (1842–1859).* Paris: Duchartre and Van Buggenhoudt, 1929.

Robarts, E. *The Marquesan Journal of Edward Robarts: 1797–1824.* Pacific History Series 6. Canberra: Australian National University Press, 1974.

Steinen, K. von den. *Die Marquesaner und ihrer Kunst: Studien über die Entwicklung primitiver Südseeornamentik ... nach eine Reise.* 3 vols. Berlin: Dietrich Reimer, 1925 and 1928.

Stevenson, R. L. *In the South Seas: the Marquesas, Paumotus and Gilbert Islands.* 1896. New edition, London: Penguin, 1998.

Thomas, N. *Marquesan Societies: Inequality and Political Transformation in Eastern Polynesia.* Oxford and New York: Clarendon Press, 1990.

## Easter Island

### Notes

1 Flenley, King, Teller et al. 1991, pp. 85–115.
2 Bahn and Flenley 1992, p. 176.
3 McCall 1993, pp. 65–70; Orliac and Orliac 1998.
4 Bierbach and Cain 1996, pp. 113–34; Métraux 1941, p. 77.
5 Métraux 1941, p. 78.
6 In recent times, as timber began to become scarce.
7 Orliac 1994, pp. 61–62.
8 Macroscopic analysis of the two Santiago tablets exhibited at the Musée d'Aquitaine in Bordeaux in 1996.
9 Orliac 1993, pp. 202–4.
10 Bierbach and Cain 1996, p. 153.
11 The oldest surviving evidence of wooden statuary are the obsidian disks from their pupils, identified on an *ahu* and in cremation structures at Maunga Tari and Tahai Ahu ko te Riku. They date from the fourteenth century. See Seaver 1993, pp. 191–92.
12 Orliac and Orliac 1995, p. 52.
13 A *moai papa* in The Ulster Museum in Belfast possesses a penis.
14 Various bird and anthropomorphic figures, a head of a bearded personage, scroll forms— all possible representations of tutelary beings belonging to the different lineages; see Lee 1992 and Forment 1993.
15 Inventory no. D. 318; collected before 1855.
16 One of these intermediary stages clearly shows a bird-man with a bird mask; inventory no. in London, 1928, 5–171.
17 The Peter the Great Museum of Anthropology and Ethnography, St. Petersburg, no. 736–204.
18 Smithsonian Institute, National Museum of Natural History, Washington, D.C., no. 129–749.
19 Museum für Völkerkunde, Vienna, no. 22–845.
20 Bierbach and Cain 1996, pp. 141–42.
21 The latter hypothesis is unlikely, since *tahonga* were in general split into four equal parts by low-relief veining, whereas coconuts have only three sections.
22 Van Tilburg 1994.
23 We counted at least 174.
24 Orliac and Orliac 1996, p. 106.
25 London, no. 1904 12–20.1
26 Seaver 1997, pp. 51–52.

### Bibliography

Bahn, P., and J. R. Flenley. *Easter Island, Earth Island.* London: Thames and Hudson, 1992.

Bierbach, A., and H. Cain. "Religion and Language of Easter Island: an Ethnolinguistic Analysis of Religious Key Words of Rapa Nui in their Austronesian Context." *Baessler-Archiv.* N. F. Beiheft 9. Berlin: D. Reimer, 1996.

Flenley, J. R., S. M. King, J. T. Teller et al. "The Late Quaternary Vegetational and Climatic History of Easter Island." *Journal of Quaternary Science* (Chichester) 6, 2 (1991): 85–115.

Forment, F. "'You are Crab, Crayfish, and Octopus': Personal and Group Symbols in Rapanui Wood Sculpture." *Easter Island Studies: Contributions to the History of Rapanui in Memory of William T. Mulloy,* edited by S. R. Fischer. Oxford: Oxbow Books, 1993.

Lee, G. "The Rock Art of Easter Island." *Monumenta Archaeologica* (Institute of Archaeology, University of California, Los Angeles) 17 (1992).

McCall, G. "Little Ice Age, Some Speculations for Rapanui." *Rapa Nui Journal* (Los Osos, California) 7, 4 (1993): 65–70.

Métraux, A. *L'Île de Pâques.* 1941. New edition, Paris: Gallimard, 1980.

Orliac, C. "Types of Wood Used in Rapanui Carving." *Easter Island Studies: Contributions to the History of Rapanui in Memory of William T. Mulloy,* edited by S. R. Fischer. Oxford: Oxbow Books, 1993.

———. "Reflexion on the Use of Thespesia Populnea as Wood for Carvings on Easter Island." *Rapa Nui Journal* (Los Osos, California) 8, 3 (1994): 61–62.

Orliac, C., and M. Orliac. *Bois sculptés de l'île de Pâques.* Marseille: Parenthèses and L. Leiris, 1995.

———. *Bois sculptés de Rapa Nui, Voyage vers l'île mystérieuse.* Exhibition catalog. Bordeaux: Musée d'Aquitaine; Venice: Erizzo Editrice, 1996.

———. "La disparition de la forêt de l'île de Pâques: surexploitation ou catastrophe climatique?" *Rapa Nui Journal* (Los Osos, California). Acts from the colloquium at Albuquerque. 1998.

Seaver, J. "Rapanui Crafts: Wooden Sculptures Past and Present." *Easter Island Studies: Contributions to the History of Rapanui in Memory of William T. Mulloy,* edited by S. R. Fischer. Oxford: Oxbow Books, 1993.

Seaver, J. T. *Ingrained Images, Wood Carvings from Easter Island.* Woodland: Georgia Lee, Joan T. Seaver, and Easter Island Foundation, 1997.

Tilburg, J. A. van. *Easter Island: Archaeology, Ecology and Culture.* London: British Museum Press, 1994.

## New Zealand

### Notes

1 Earle 1966, p. 197.
2 Archey 1977, p. 88.
3 Gudgeon 1906, p. 30.

4 For discussions of the Maori use of the latrine as a site for ritual, see Hanson 1982, and Hanson and Hanson 1983, pp. 77–86.
5 Best 1912, p. 121.
6 Hanson and Hanson 1983, pp. 94–99.
7 Best 1915.
8 Skinner 1924, p. 241.
9 Hiroa 1950, pp. 325–29.
10 Mead 1975.
11 Hanson 1983a, 1983b, 1985, Hanson and Hanson 1983, pp. 189–90, see also Donnay and Donnay 1985.
12 Neich 1983, pp. 248–49.

### Bibliography

Angas, G. F. *Savage Life and Scenes in Australia and New Zealand.* 2 vols. London: Smith and Elder, 1847.

Archey, G. *Whaowhia: Maori Art and its Artists.* Auckland: Collins, 1977.

———. "Evolution of the Maori Patterns." *Journal of the Polynesian Society* (Auckland) 42 (1993): 171–90.

Barrow, T. "Material Evidence of the Bird-man Concept in Polynesia." *Polynesian Culture History,* edited by G. Highland et al. Special Publication 56. Honolulu: Bernice Pauahi Bishop Museum, 1967.

Bechtol, C. O. "Hei-Tiki." *Journal of the Polynesian Society* (Auckland) 76 (1967): 445–52.

Buck, P. H. (Te Rangi Hiroa). *The Coming of the Maori.* 2nd edition. Wellington: Whitcombe and Tombs, 1958.

Donnay, J. H. D., and G. Donnay. "Symmetry and Antisymmetry in Maori Rafter Designs." *Empirical Studies of the Arts* 3 (1985): 23–45.

Earle, A. *Narrative of a Nine Month's Residence in New Zealand in 1827.* London: Longman, Rees, Orme, Brown, Green, 1832. Reprint, Oxford: Clarendon Press, 1966.

Gudgeon, W. E. "The Tipua-Kura and Other Manifestations of the Spirit World." *Journal of the Polynesian Society* (Auckland) 15 (1906): 27–57.

Hamilton, A. *Maori Art.* Wellington: New Zealand Institute, 1901.

Hanson, F. A. "Method in Semiotic Anthropology; or How the Maori Latrine Means." *Studies in Symbolism and Cultural Communication.* Publications in Anthropology 14. Lawrence: University of Kansas, 1982.

———. "Art and the Maori Construction of Reality." *Art and Artists of Oceania,* edited by S. M. Mead and B. Kernot. Palmerston North: Dunmore Press, 1983a.

———. "When the Map is the Territory: Art in Maori Culture." *Structure and Cognition in Art,* edited by D. K. Washburn. Cambridge: Cambridge University Press, 1983b.

———. "From Symmetry to Anthropophagy: the Cultural Context of Maori Art." *Empirical Studies of the Arts* 3 (1985): 47–62.

———. "The Making of the Maori: Culture Invention and its Logic." *American Anthropologist* 91 (1989): 890–902.

Hanson, F. A., and L. Hanson. *Counterpoint in Maori Culture.* London: Routledge and Kegan Paul, 1983.

McEwan, J. M. "Maori Art." *An Encyclopaedia of New Zealand,* edited by A. H. McLintock. Vol. 2. Wellington: Government Printing, 1966.

Mead, S. M. "The Origins of Maori Art: Polynesian or Chinese?" *Oceania* (Sydney) 45 (1975): 173–211.

———. *Te Maori: Maori Art from New Zealand Collections.* New York: Abrams, 1984.

———. *Magnificent Te Maori: Te Maori Whakahirahira.* Auckland: Heinemann, 1986.

Neich, R. "The Veil of Orthodoxy: Rotorua Ngati Tarawhai Carving in a Changing Context." *Art and Artists of Oceania,* edited by S. M. Mead and B. Kernot. Palmerston North: Dunmore Press, 1983.

Robley, H. G. *Moko, or Maori Tattooing.* London: Chapman and Hall, 1896.

Skinner, H. D. "The Origin and Relationship of Maori Material Culture and Decorative Art." *Journal of the Polynesian Society* (Auckland) 33 (1924): 229–43.

Tregear, E. "Maori Spirals and Sun Worship." *Transactions and Proceedings of the New Zealand Institute* 32 (1899): 28–93.

———. "Three Fingers in Maori Carving." *Journal of the Polynesian Society* (Auckland) 29 (1920): 224.

## Micronesia

### Notes

1 Loom-weaving is not practiced in the Palau Islands, and only a limited variety of loom-weaving appears in the main islands of Yap, whose inhabitants obtained much of their loom-woven cloth from the low-lying coral islands to the east which traditionally owed fealty to Yapese chiefs.

### Bibliography

Bourgoin, P. "The Forgotten Islands of the Bismarck Archipelago: The Hermits and Kaniets." *Tribal Arts 4, 1* (1997): 64—79.

Davidson, J. M. "A Wooden Image from Nukuoro in the Auckland Museum." *Journal of the Polynesian Society* 77 (March 1968): 77—79.

Feldman, J., and D. H. Rubinstein. *The Art of Micronesia.* Honolulu: The University of Hawaii Art Gallery, 1986.

Jernigan, E. W. *Lochukle: A Palauan Art Tradition.* PhD. diss., University of Arizona, 1973.

Koch, G. *Materielle Kulture der Gilbert-Inseln.* Berlin: Museum für Völkerkunde, 1965.

Mason, L. "Micronesian Culture." *Encyclopedia of World Art.* Vol. 9. New York and Toronto: McGraw-Hill, 1987.

Mitchell, R. "The Palauan Story-board: The Evolution of a Folk Art Style." *Midwestern Journal of Language and Folklore 1* (autumn 1975): 1–12.

Morgan, W. N. *Prehistoric Architecture in Micronesia.* Austin: University of Texas Press, 1989.

Riesenberg, S. H., and A. H. Gayton. "Caroline Island Belt Weaving." *Southwestern Journal of Anthropology* (autumn 1952): 342–75.

Robinson, D. "The Decorative Motifs of Palauan Clubhouses." *Art and Artists of Oceania,* edited by S. M. Mead and B. Kernot. Palmerston North, New Zealand: Dunmore Press, 1983.

Rubinstein, D. H. "The Social Fabric: Micronesian Textile Patterns as an Embodiment of Social Order." *Mirror and Metaphor: Material and Social Constructions of Reality,* edited by D. W. Ingersoll and G. Bronistky. Lanham, Md.: University Press of America, 1987: 63–82. Reprinted in Anderson, R. L., and K. L. Field. *Art in Small-Scale Societies: Contemporary Readings.* Englewood Cliffs, N. J.: Prentice-Hall, 1992.

Smith, D. R. "The Palauan Storyboards: From Traditional Architecture to Airport Art."*Expedition: The Magazine of Archaeology/Anthropology* 18 (fall 1975): 2–17.

Spennemann, D. H. R. *Marshallese Tattoos.* Majuro Atoll: Republic of the Marshall Islands Historic Preservation Office, 1992.

Tilburg, J. A. van. "Anthropomorphic Stone Monoliths on the Islands of Oreor and Babeldaob, Republic of Belau (Palau), Micronesia." *Bishop Museum Occasional Papers* 31 (July 1991): 3–62.

Winkler, Captain. *On Sea Charts Formerly used in the Marshall Islands, with Notices on the Navigation of these Islanders in General.* Translation of *Über die in Früherer Zeit in Den Marshall-Inseln Gebrauchten Seekarten, mit Einigen Notizen Über die Seefahrt der Marshall-Insulaner Im Allgemeinen, 1898.* Marine-Rundschau, Jahrg, Pt. 10. 1418–1439. Smithsonian Institute Report for 1899 54 (1901): 487–508.